Cubism
and its
Enemies

Cubism and its Enemies

Modern Movements and Reaction
in French Art, 1916–1928

Christopher Green

Yale University Press
New Haven and London · 1987

For Toby, Abigail and Charlotte

Published with the assistance of
The J. Paul Getty Trust

Copyright © 1987 by Christopher Green
Second printing 1988

Designed by Gillian Malpass
Set in Monophoto Apollo and
printed in Great Britain by
Jolly & Barber Limited, Rugby

Library of Congress Cataloging-in-Publication Data

Green, Christopher, 1943 June 11 –
 Cubism and its enemies.

 Includes index.
 1. Cubism—France. 2. Art, Modern—20th century—
France. 3. Avant-garde (Aesthetics)—France—History—
20th century. 4. Modernism (Art)—France. I. Title.
N6848.5.C82G7 1987 709'.44 87–2154
ISBN 0-300-03468-7

Acknowledgements

This book has grown out of my earlier *Léger and the Avant-garde*; perhaps more accurately, it has come of my own criticisms of that book. The process of reassessment started with a project on Juan Gris of a fundamentally similar kind with which I made considerable headway in Paris in the spring and summer of 1977, thanks to a research grant from the Leverhulme Trust. It was then that I began to see the eventual shape of this book and the routes of my enquiry.

During the long period of research and writing that followed I have found support from among a wide range of people, but most consistently of all I have found it among my colleagues and students at the Courtauld Institute. I have received unstinting help from the staff of the book library, Witt, Conway and Slide libraries, and the photography department. Lorraine Crown, Kathy Trudget, Susan Wellsford, Elizabeth Real and Rebecca Hurst have all helped me with typing and photocopying. Sarah Wilson has offered useful suggestions; John House provided effective criticisms of the Introduction in its earlier forms; Alan Bowness, both at the Institute and since, has provided encouragement when most needed; and John Golding read the lectures which acted as a first sketch for the book, making criticisms which changed the whole character of the final product. Of my students I am particularly endebted to the following: Eleanor Gregh (now of the University of Glasgow), Valerie Holman, Alexandra Parigoris, John Welchman and Romy Golan. And I feel I should make special mention of certain M.A. and doctoral theses written at the Institute which I have found invaluable and, where I have been supervisor, from which I know I have received more than I have given: Elizabeth Legge's M.A. thesis on Ernst and Jung and her subsequent doctoral thesis on Ernst and psychoanalysis generally; Ingrid Jenckner's M.A. thesis on Ernst and Eluard; Martin Caiger-Smith's on Severini at Montegufoni; David Cottington's doctoral thesis on the ideological role of Cubism before 1914.

Outside the Courtauld Institute, as I suggested, the range of those who have directly or indirectly helped me is extensive. I thank the following for making what has often seemed an impossible task possible: the late Mme Josette Gris and the late D.-H. Kahnweiler for being so open to my questioning; Monsieur Maurice Jardot, Monsieur Quentin Laurens and Madame Louise Leiris of the galerie Louise Leiris for their unfailing courtesy and generosity; Monsieur Christian Derouet for the interest he has always shown in my work and for allowing me to see his remarkable dossier of material on Léonce Rosenberg and his artists; Madame Claude Laugier of the Service de Documentation at the Musée National d'Art Moderne in Paris, Monsieur François Chapon of the Bibliothèque Littéraire Jacques Doucet, Señora Rosa Maria Malet, director of the Fundació Joan Miró in Barcelona, and Señora Baró of its staff, for their patient helpfulness at various stages of my research; Malcolm Gee of the Polytechnic of Newcastle-upon-Tyne, Kenneth Silver of New York University, Alan Doig and Angelica Zander Rudenstine for the impetus their work has given me and for sustaining my confidence; and David Sylvester and Sarah Whitfield, working with whom on another project has, however indirectly, acted as a vital stimulus for my own.

A major aspect of my work has been the first-hand study of painting and sculpture. I have been helped in this by many exhibitions of the last decade, from *Dada and Surrealism Reviewed* at the Hayward Gallery, London, to *Léger et l'esprit moderne* at the Musée d'Art Moderne de la Ville de Paris; from the massive retrospective of Picasso at the Museum of Modern Art, New York, to the more modest but beautifully selected *Amédée Ozenfant* at St Quentin. The crucial job done by such exhibitions should not be underestimated or go unacknowledged. Otherwise, collectors have continued to show the warmth and responsiveness that I first discovered in my work on *Léger and the Avant-garde*. My sincere thanks go to the following: the late Harold Diamond, Hester Diamond, the late Douglas Cooper, Mrs George L. K. Morris, Mr and Mrs Ralph Colin, Mr Armand Bartos, Mrs Lydia Malbin, Mr and Mrs Daniel Saidenberg, Mr David Rockefeller, Mrs Gabrielle Keiler, and the painter Judith Rothschild.

I owe a special debt to those who have given their time and attention to reading either a part or the whole of my text in its various stages. Jill Lloyd of University College, London, read the Introduction in an early draft and her sharp, precisely directed criticisms led to important changes. But I owe no one more than Dawn Ades of the University of Essex, who read the text in its entirety when it was longer than it is now and then later read the final version of Part I. There are few who could have been as effective an adviser and yet at the same time as sympathetic and diplomatic in the execution of that role.

Tracing and ordering the photographs for the illustrations has been a task made appreciably less daunting by the help of curators, administrators, auctioneers, dealers, scholars and collectors everywhere. I would like particularly to thank the following: Madame Monique Schneider-Maunoury of the Galerie Artcurial, Paris; Monsieur Pierre Alibert; Pamela Griffin of the Arts Council of Great Britian; Madame Henriette Asch; Theodora Vischer of the galerie Beyeler, Basel; Annabel Wilson of Christies, London; Mary H. Mills of Dallas Museum of Art; Hester Diamond (again); Mr Victor Ganz, Paul Josefowitz and Ellen Melas Kyriazi; Regula Suter-Raeber of the Kunstmuseum, Basel; Monsieur Maurice Jardot and Monsieur Quentin Laurens of the galerie Louise Leiris, Paris (again); Monsieur Marcel Mabille; the galerie Maeght, Paris; Mrs Lydia Malbin; Patricia Weber of the Marlborough Gallery, London/New York; Madame Olga Ignatinovitch of the Musée d'Art Moderne, Troyes; Madame Josette Gabigue of the Musée Départmental de l'Oise; Mr Erwin J. Goetz; Mr Thomas D. Grischkowsky of the Museum of Modern Art, New York; Monsieur Oscar Ghez and the Petit Palais, Geneva; Mr Joseph R. Shapiro; Mrs Constance Pemberton and Cordula Von Keller of Sotheby and Co, London; Professor Dr Werner Spies; Monsieur A. Stassart; Madame Vierra da Silva; Gustav Zumsteg.

Then there are those with whom I have worked on the production of the book: John Nicoll, whose directness and judgement I have learned to respect enormously, and Gillian Malpass, who has seen this book through from a messy, unwieldly pile of typescripts to its final form. I thank them both for their patience, skill and commitment.

Finally, there are debts which cannot be estimated let alone described. I owe much to the calm and the beauty of the place where this book was mostly written, St Germain l'Herm in the Monts du Livradois, and to the many who have been so welcoming there. But most of all I owe a debt to the tolerance, sympathy and vitality of Toby, Abigail and Charlotte, to whom this book is dedicated.

Contents

Introduction

Explicitly or implicitly every text on the art of this century is situated in relation to something dubbed 'Modernism'. The difficulty is that the idea of Modernism held up for consideration and then usually crumpled up and thrown out has different shapes,[1] and even when given a definitive form appears far too absurdly simple an abstraction.

When the post-modern is measured against Modernism, the shape of Modernism most often defined is that provided in the USA during the fifties and sixties by critics whose leader was Clement Greenberg and by such paradigmatic artists as Morris Louis or David Smith.[2] In fact, the art and writing of these figures cannot be dismissed as merely reductive; it was too subtle and sometimes too unpredictable for that. But certain basic propositions—and the undeniably simple shape of a possible art history—were extracted from it. The proposition most often extracted was that the artwork be isolated in its own aesthetic field as an internally consistent material fact with its own special characteristics. From this followed the hypothesis that a history of twentieth-century art should be a history of progress without end towards an ever more materially pictorial or sculptural art, 'honest' (therefore anti-illusionist) and increasingly literal. A special status was given in sculpture to the assertion of three-dimensionality, and in painting to that of flatness.[3]

Crucial to the drawing of the Modernist line was, according to this notion of Modernism, the work of the Cubists in France, especially between 1909 and 1914.[4] Modernism defined thus, therefore, includes Cubism, but Cubism understood in a very special way, Cubism as centrally concerned with the materiality of the work (in painting, flatness), and as committed to the new at the expense of the old.[5] I start this book from the contention that Cubism did indeed play a major part in what can be called a history of Modernism, but that this view of its concerns and its role in that history is a diversionary caricature. The problem is that priorities arrived at in a later Modernist phase have been read back into the manifestations of an earlier phase, and, the habits of historians being what they are, all that does not fit has simply been set aside or hurriedly passed over.

If one looks at the range of art considered Cubist in France at the time (taking the whole period from 1909 into the late 1920s), and if one asks what Cubist works were understood to say *then* by their makers and their first audiences, one does not find a sixties' Anglo-American fixation with flatness in painting. Flatness is a factor, certainly, but only one alongside many others. There is, however, as I see it, a clear enough relationship to be discerned between the Cubists at that time and the Anglo-American Modernists of the sixties for a consideration of them together to work. They may not share a set of fixed propositions about the material essence of painting and sculpture, but they do share a broad stance concerning the status of art in relation to lived experience and to society. From its first public emergence in the Salon des Indépendants of 1911, there was among Cubists an increasing commitment to practices and theories which isolate art in its own aesthetic field—which, in very general terms, divide the cultural from the social. It is to the extent that the Cubists and the post-war Anglo-Americans in the wake of Greenberg shared this commitment that they

belong together as Modernists. And I take the history of Modernism to be not necessarily the history of a nineteenth- and twentieth-century obsession with the pictorially or sculpturally literal, but the history of various attempts to achieve and then theorize a kind of aesthetic isolation.[6]

As I suggested, that view of Modernism which has given precedence to flatness and sculptural three-dimensionality as such has accompanied a stress on Cubist art *before* 1914; one needs to go further and say, a stress on what has been called the 'true Cubism' of Picasso, Braque, Gris and Léger before 1914.[7] If one thinks more flexibly in terms of a Modernist will to aesthetic isolation and of the broad theme of the separation of culture and society, it is actually Cubism *after* 1914 that emerges as most important to a history of Modernism, and especially, as I hope this book will show, Cubism between around 1916 and around 1924. The pre-1914 period, at least so far as Cubism is concerned, will always be more attractive: it is a period of remarkable innovation, and, even across more than sixty years, the sheer daring of the artists involved is almost palpable. But, like many periods of accelerated change, it is a period full of confusions when often conflicting possibilities were opened up within what was called Cubism. The will to aesthetic separatism was certainly there, but it was not at all clearly dominant and a cluster of contradictory aspirations simultaneously claimed attention.[8] Only after 1914 did Cubism come almost exclusively to be identified with a single-minded insistence on the isolation of the art-object in a special category with its own laws and its own experiences to offer, a category considered above life. It is Cubism in this later period that has most to tell anyone concerned with the problems of Modernism and post-modernism now, because it was only then that issues emerged with real clarity in and around Cubism which are closely comparable with those that emerged in and around Anglo-American Modernism in the sixties and after. This is my reason for giving so much attention to late rather than early or so-called 'high' Cubism, and I have approached the subject especially mindful of the theme of cultural separation.

A notion of Modernism applicable to developments after 1946 has, then, guided me in picking out the central issues explored in this book (though a less limited one than some), but I have tried as far as possible to look at Cubism and art in France between 1916 and 1928 in terms of the meanings available then. It is this concern that has led me to structure the book in terms of oppositions, and this again differentiates what I have done from other treatments of Cubism, indeed other treatments of most modern movements in the art of this century. The histories of Cubism, Surrealism, Abstract Expressionism, etc., have normally been presented as linear developments set apart in special milieux: paintings and sculptures produced by artists in loose groupings supported by small circles of like-minded dealers, critics, writers and collectors. My own *Léger and the Avant-garde* was limited in this way. In this present book a major intention is to explore the works, theories and attitudes of the Cubists, not as if in some hermetically sealed area set apart, but in contradistinction to other very different works, theories and attitudes in other milieux. I have not found it enough to look at Cubism without looking at what it rejected. My reasons for this are twofold: first, that all signification depends on the making of distinctions, so that the analysis of differences must take precedence over the analysis of similarities; and second, that modern movements, including Cubism, have repeatedly tended to the polemical, embodying an element of response to real or hypothetical opponents. Explorations of stances and meanings in modern movements are obliged, I believe, to take account of what is *not* meant as well as what *is* meant,

what is rejected as well as accepted. In the case not only of the Cubists but of the Naturalists or the Surrealists in the twenties, patterns of acceptance and rejection were there embedded in the works they made, a crucial aspect of meaning responded to instantly by their first audiences.

My ultimate intention may be to extract the Cubists from the isolated linear history into which they have been squeezed, but initially Part I could well give the impression to some of simply another linear history. Between 1916 and 1928 the Cubists did exist as a loose but recognizable group of artists within particular milieux, Cubist art did change, and the ways in which it changed are indeed the main topic of Part I. I have started with this short history of stylistic change for two main reasons; first, to provide a basic armature articulated in time on which to flesh out the meanings explored in Parts III and IV (no such chronological history of late Cubism exists); second, to bring out certain meanings taken by the Cubists themselves to be conveyed by their work, meanings which are only to be laid bare, I believe, by a stylistic analysis with a chronological structure.

The introductory function of Part I has led on the one hand to its accent on straightforwardness and on the other to its sub-division into short, headed sections within chapters. It can both be read as a continuous narrative and used for reference in the later parts of the book. The limits of the simple picture outlined here are determined by the area of dissension and debate covered in those later parts, that is, the range of opposing stances explored there. 1916 marks the real starting-point of the outline because it was around 1916 that the debates centred on Cubism in the post-1918 decade opened most clearly. Particular artists are given special attention because of their relative importance in those debates: most obviously, Picasso, Braque, Gris, Léger, Gleizes, Lipchitz and the Purists. Others hardly appear at all, because of their lack of importance in them: most contentiously, Roger de la Fresnaye (exiled from Paris after the war by ill-health), and the Delaunays (never central figures again after their late return from Spain and Portugal in 1921); less contentiously, Serge Férat, Jean Lurçat or Léopold Survage, for instance. The guiding principle in the treatment of artists here is the need to characterize their work so as to clarify its specific situation in relation to the oppositions brought out in the debates of the period, hence the focus not on biographical material but on the work as such: how it changed and how it can be analysed in terms of late Cubist practices generally.

To limit a narrative account of Cubist art to the post-1916 period and to France invites two major criticisms; first, that it is like making a study of a plant that ignores its roots, its stem, even perhaps its main branching points; second, that to ignore developments outside France is to ignore the most significant legacy of the movement. Since my topic is the situation and meanings of Cubist art in French cultural history at a particular (long-drawn-out) moment, I see these limitations as inevitable. Only if my project were *fundamentally* a linear one, dedicated to an ideal evolutionary interpretation of twentieth-century art in terms of movements, could they be shortcomings.

The danger of a separate chronological account of styles is clear enough: it can give the impression of separating too completely the investigation of styles from that of meanings (stylistics from iconology). My other main reason for writing one, however, is specifically that a certain level of meaning in Cubist art is to be got at only by way of a well-focused look at style, and this is so because styles *as such* (above all styles changing) have come to act as sign. One of the central meanings signified by late Cubist works was the authorial

power, the shaping creativity of the artist. It was essentially through style as sign that this was actually achieved: Cubism was seen both as *a* style and as a cluster of distinct styles. Each Cubist work signified, through its stylistic distinctiveness, at once its broad Cubist identity, the authorial individuality of the artist and the artist's openness to change. Only a stylistic analysis which discriminates between artists and which narrates can bring out how styles signified thus.

In its role as introduction, the basic task of Part I is to provide an outline of late Cubist art which applies the full range of current knowledge on the subject. I therefore bring to bear here my own previous work on Léger, Purism and Gris as well as the work of others: to mention just a few, that of Pierre Daix and William Rubin on Picasso, of Deborah Stott on Lipchitz, of Douglas Cooper on Gris and Braque, of Isabelle Monod-Fontaine, Nadine Pouillon and the curatorial staff of the Musée Nationale d'Art Moderne (Paris) on Braque, Laurens and on Kahnweiler's artists generally. Beyond that I have attempted a new analysis of late Cubist art in terms of process (both conceptual and technical), in order to bring out a central feature of its development in most individual cases: its progressive distillation or 'purification', especially between 1916 and 1919 (a feature which is crucially important to discussions of meaning). Yet, perhaps the aspect of Part I which will be least familiar is not so much to be found in the main plot as in the sub-plots that give its context, for, since the history of late Cubist styles is not told as an end in itself, I have set alongside it an account of the mounting attacks on Cubism through the period: their leading protagonists, the issues targeted, and their multiplication as the years succeeded one another. In this way the oppositions that are the topic of the later parts of the book are in view from the outset.

Three central points will, I hope, emerge from Part I: that later Cubism manifests a powerful and increasingly well-defined commitment to what can be called the Modernist stance; that it was characterized, nonetheless, by plurality and volatility—openness to change—(both of which embody essential aspects of the meaning of late Cubist work); and that, contrary to many previous views, it continued a central and dynamic feature in French cultural history beyond 1921, at least as far as 1924—25.

Between Part I and the discussion of stances and meanings in Parts III and IV I have placed a section entitled 'Art Worlds' which is short but of pivotal importance. This is an attempt to tie the linear history unravelled in Part I back into the complexities of the larger and more tangled situation in which it was only ever a single strand. This is necessary before the conflicts characteristic of the situation and so vital to the understanding of meanings can begin to be grasped. The aim here is to clarify just what avant-garde status actually meant in Paris during the period, and in what senses different stances and styles could be perceived as radical or conservative. The notion of the avant-garde treated is that which developed from the early years of the century, rooted, as has often been argued, in Saint Simonian theories of the 1830s, but detached from the social/political sphere to be applied specifically within the cultural sphere.[9] Radical and conservative in this instance does not, therefore, imply a radical or conservative political ideology, and indeed it should become plain in Part III that radical avant-garde status could go with comparatively conservative ideological connections. The relativities of stance and style are explored here in the context of changes in the position of anti-academic art as a whole (not merely Cubism) *vis-à-vis* the official establishment and the dominant social groups that formed the market, and also changes in dealing, collecting, the Salons

and State patronage. In important ways the argument here is my own, but I owe a debt to the exceptional pioneering work of Malcolm Gee, without which this section could not have been written.

The broad division between Parts III and IV is determined by the distinctions made in 'Art Worlds' between the culturally conservative and radical. In Part III, 'Cubism and the Conservative Opposition', I give about equal attention to the stances of the Cubists and of their less progressive adversaries, including those Maurice Raynal called the Naturalists and the Eclectics (from Dunoyer de Segonzac to André Favory),[10] as well as artists positioned between Cubism and Naturalism, especially André Lhote. It is in the exploration of late Cubism alongside these opponents that the character of Cubist cultural separatism is exposed most explicitly, and the priorities that went with it: the Cubists' attitudes to their possible audiences, the Cubists' approach to process and to the question of representation, the Cubists' notions of tradition, progress and the modern. The material I deal with here is largely culled from the statements of artists and their allies, and from criticism in the art literature and the press; much of it will be unfamiliar. I hope that its deployment will reveal how Modernism in its late Cubist form indeed reached a particularly distilled and refined state, but reached this, not in hermetic isolation, but in opposition to stances that were just as vigorously presented and far more widely disseminated.

Part IV, 'Radical Alternatives', is also thematically structured and deals too with material culled from the statements of artists and from contemporary criticism, but it entails a major change of emphasis, for my primary focus switches away from the Cubists to their adversaries in such a way that it becomes necessary to consider the work of those adversaries as well as their theories and stances. I am led here to the writing of extensive studies of non-objective art, Dada and Surrealism in France, though with a new stress on their oppositional relationship to Cubism. Yet, still here my larger concern is to make a contribution to the understanding of Modernism in the cultural history of the period. For I hope that what will emerge is the role of non-objective art, Dada and Surrealism as *counter*-Modernist movements, the depth, comprehensiveness and pointedness of the critique of late Cubism's Modernist priorities that they carried through. And I hope too that readers will not miss the parallels with and differences between this reaction against an earlier Modernist climax and the reaction that has followed the later climax of the sixties. The post-modern situation in the French art worlds of the twenties was illuminatingly like and unlike the post-modern situation of the seventies and eighties. The issues and the way they were tackled then have much to tell us now.

Again, in this section I believe that I have offered something new, especially because the relationships between Cubism and Neo-Plasticism, and Cubism, Dada and Surrealism in the twenties have never been thoroughly examined; but here much more than in Part III I have been helped by the essential research of others. I mention as particularly important the work of Nancy Joslin Troy, Yves-Alain Bois, Allan Doig and Gladys Fabre on De Stijl and non-objective art in Paris, of Michel Sanouillet on Dada, William Camfield on Picabia, Werner Spies and Elizabeth Legge on Ernst, Caroline Lanchner and Françoise Levaillant on André Masson, Marguerite Bonnet on André Breton, Margit Rowell and Rosalind Krauss on Miró, and Dawn Ades on all aspects of Dada and Surrealism.

At this point something needs to be said about my approach to meanings in the culminating parts of the book. This is not, in Foucaultian terminology, an 'archaeological' study; it is not concerned (except indirectly) with the structures of discursive formations, rather it is concerned with works of art as utterances in particular contexts. And yet, I have come to believe that what I have explored in this book is a wide range of statements (verbal, pictorial, sculptural) within a particular discourse which does have unity, a discourse whose currency is not merely French. My conviction is that there is unity in what might be called the discourse of culture from at least the beginning of the century, within which Modernism is a theme.[11] In Foucaultian terms the 'possible objects' of this discourse, the 'forms of description and the perceptual codes' prescribed, and the possibilities for 'characterization' allowed are clear enough.[12] The 'objects' of the discourse are the author/ subject (the artist as hero) and the art-work as autonomous entity, or the absence of the author/subject and the work as anti-art. Formal and anti-formal analysis are the prescribed 'forms of description'. And the question of the relationship between art and life, art-work and nature, consistently guides the 'characterization' of art. It is a discourse whose medium is not only texts about art, but art-works themselves.[13] The salient features of a painting or sculpture can of themselves signify its autonomy and the shaping role of its author (or the reverse), and so can invite certain sorts of description and characterization, something which is especially so when it is presented within a network of verbal statements that act as corroboration.

So the book deals with what I have come to believe is a single discourse of culture which is far more wide ranging and longer lasting than the art and debates actually covered; but the way I deal with this discourse has its limitations too, and these need to be indicated. Most important, I have not related the discourse of culture to others (say, the discourse of economics or psychiatry), and I have not systematically related it to such non-discursive domains as institutions, political events, economic practices or processes.[14] I have discussed meanings especially as they circulated in the restricted worlds of the artists and writers themselves, and of the dealers, critics and collectors who constituted their first and most immediate audience.

The reasons for these limitations are twofold. First, they are simply pragmatic: to attempt an exploration of what art-works were taken to say just within these circles has proved a large enough undertaking. Second, and much more importantly, they follow from the very nature of the discourse of culture itself as it has existed and continues to exist in the West. It is a discourse at whose centre, as I suggested in my discussion of Modernism, is the problem of the integration or separation of art and life, culture and society. Further, it is a discourse which has been addressed to specialists, individuals who actually, therefore, constitute the members of a relatively enclosed social group defined by cultural engagement. A rhetoric of cultural separatism and its complementary, a rhetoric of cultural integration, have gone with the development of practices and institutions (specialist galleries, periodicals, art-history faculties, etc.) which accentuate separation as fact. A kind of symmetry has existed between the theories and themes of cultural separation in the discourse of culture and the isolation of the region in which its meanings have circulated most potently. To explore those meanings as I do in Parts III and IV is, it can seem, to be sucked into an ever inward-turning vortex.

Important questions follow from this. Does the decision to focus on the discourse of culture merely lead one to underpin the separations maintained in and through it? Should one not, therefore, turn instead to those other discursive formations that traverse painting and sculpture which have a

much wider adequacy of address: the discourse, say, of nationalism or of sexuality? Studies with such a focus are emerging,[15] but I believe that they should not displace studies centred on the discourse of culture, indeed should preferably follow studies which underline rather than blur its rhetoric of separation.[16] To forget or obscure that rhetoric is to evade issues that remain serious, for any Western analysis of the visual arts is itself a feature in the continuing discourse of culture, that discourse is still penetrated by cultural separatism, and, even where it is not, still operates in a region where survival is assured only for specialists (art professionals), and where the bracing solitude of avant-gardes still attracts the most energetic aspirants.[17] We should look this situation in the face.

Since the book is not 'archaeological', and since it is concerned with what works said and were taken to say in the period of their making, I have ignored the prohibitions that go with a Foucaultian analysis at the level of the discursive: I do not avoid dealing with individual works and the œuvres of individual artists. Yet, an awareness of discourse theory has encouraged me on the one hand to resist the temptation to search for an overall internal coherence in the culture of the period (a style or spirit of the time),[18] and on the other to realize that there are essentially common objects and modes of thinking in the apparently opposing positions of the artists and writers with whom I deal (a discursive unity).[19] Most obviously, there is a common insistence on the primacy of the author/subject central both to advanced Cubism in its late form and the Naturalism advocated by Vlaminck, Florent Fels or Jacques Guenne. Less obviously, though the Surrealists attempted to void the privileged place where the author/subject had been for so long and to render the work merely another event in lived experience, even they compulsively return to the issue of the author and the 'poem'.

Finally, I have been attracted by the efficacy of certain conceptual tools adapted for use in cultural history by Raymond Williams, especially the notions of hegemony and counter-hegemony, of the emergent, the residual and incorporation.[20] These seem to me to be helpful even when applied in the relatively restricted area of cultural activity in France between 1916 and 1928, for what one sees in action there is a complex set of *processes* whereby certain stances attain dominance (hegemony) within that area and at the same time or afterwards, through modes of incorporation which are extremely varied, become absorbed into attitudes that have a wide social currency. Now Williams has established that the distancing of culture from society has a history that stretches back into the eighteenth century,[21] and it is tempting to see the Modernist stance, with its especially abrupt separation of art from life, as consistently hegemonic within the circles of the culturally engaged from at least the end of the Great War, if not earlier. The subtlety and responsiveness to change, however, of Williams's adaptation of the notion of hegemony and its derivatives has led me to see the gross over-reductiveness of this picture. This book makes a case for seeing the Naturalist stance (broadly defined) as dominant in France at least until the mid-twenties, and Modernism in the guise of late Cubism as in certain senses *counter*-hegemonic even then.

Far more important, I have come to see the 'high' cultural history of the century not in terms of a single development towards the triumph of Modernism followed by its failure or defeat, but rather in terms of a field of forces where different but interrelated conflicts can be observed and in which clearly distinct stances (including Modernism) achieve periods of hegemony. First, there is an aspiration (usually conservative) to relate art to nature through the subjective medium of the artist, who is considered at once self-expressive and responsive, an aspiration often combined with a residual attraction to the natural and the rustic (manifest in the Naturalism of the twenties). Second, and in conflict with it, there is an innovative aspiration (not necessarily radical) to separate art from nature as clearly as possible, with the artist, like the *guru* or scientist, as new god, creative and absolutely independent (the Modernist aspiration). Third, in conflict with both the former, there is an aspiration (usually radical) to tie art and life back together again as completely as possible by treating art as a way of living continuous with any other aspect of living, not merely as a mode of self-expression—an aspiration often combined with emergent social and political stances (manifest to some extent in both non-objective art and Surrealism in the twenties). It is the main aim of the culminating sections of the book to open the way to understanding how these conflicting aspirations acted against one another in one centre at one time.

I end these introductory remarks with a note on terminology. So far I have not avoided the terms currently used in theoretical debates among cultural and art historians. The specific meanings of key words in these debates are both extraordinarily dense in their connotations and clear enough. I have decided, however, not to deploy these terminologies extensively in the main text of the book except either where they are especially apt or where meanings are widely accepted. Recently there has been a growth in a kind of writing that is actively resistant to penetration by the unprepared lay-person. It is loaded with technical terms which are roughly collaged together in an over-complex prose, always grating and dissonant. It says instantly that there is no possible entry without wholesale theoretical re-education. It is a wall against the reader of coffee-table glossies. I am not tempted in this direction, because I see the production of a self-perpetuating group of cultural technocrats as the most likely result of the triumph of such writing. Finally, I have avoided the over-pervasive use of the new terminologies because, focused as my book is on what works of art and related texts said and were taken to say in the period of their production, one of my main tasks has been to make once again familiar the terminologies used then. A book in which the reader has to negotiate so many specialist vocabularies of another time risks sinking into total obscurity under a mass of indigestible verbiage if it adds to these yet another eclectic repertoire of words for specialists.

I
Late Cubism in France, 1916–1928: A Narrative

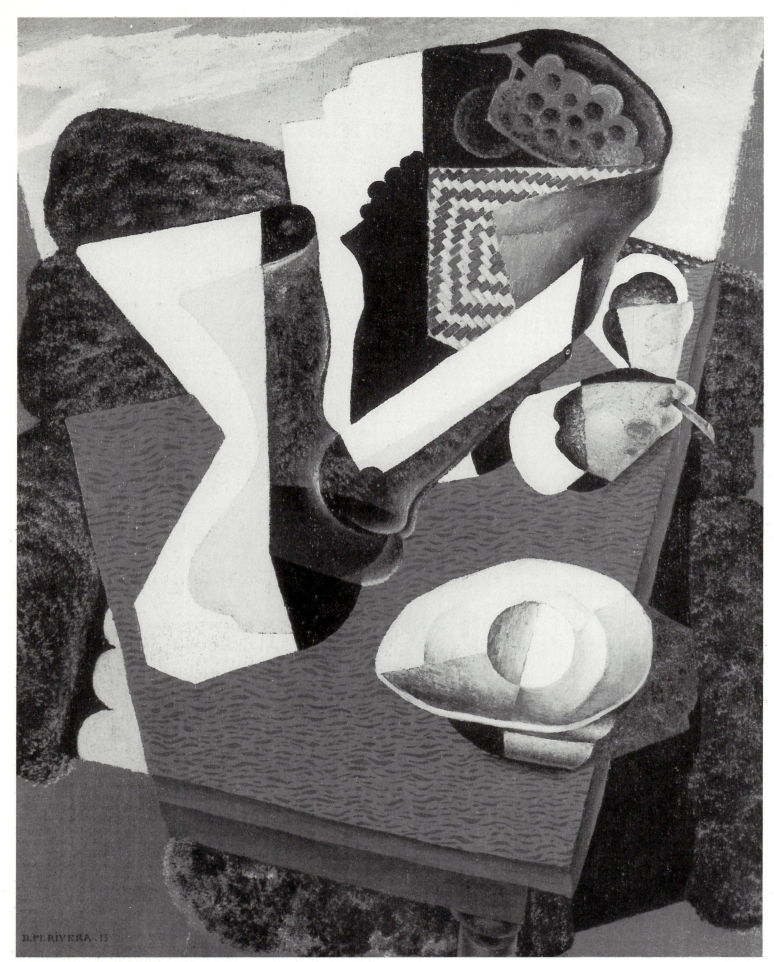

1. Diego Rivera, *Still Life with Fruit-bowl*, 1915. Oil on canvas, 31¼ × 25¼in. Lyndon Baines Johnson Library and Museum, Austin, Texas.

1
'The Cube Tires'

The Attacks of 1918–19

It was with relish that the critic Louis Vauxcelles, writing under the pen-name 'Pinturrichio', announced in June 1918: 'Integral Cubism is becoming exhausted; vanishing; evaporating.'[1] A month later, 'Pinturrichio' confidently predicted Cubism's final disappearance by the autumn.[2] That autumn of 1918 brought the end of the Great War. Cubism was to continue as a central issue for artists in France at least for another half-decade; and yet when Vauxcelles made his prediction he had what seemed good reason to be confident.

His immediate reason was the defection from the Cubist circle of two artists, and their public commitment to an approach that obviously denied much of what the Cubists had stood for. The two were André Lhote and the Mexican Diego Rivera.

Rivera's first positive contacts with leading Cubists had been with Juan Gris and Pablo Picasso early in 1914, and for more than two years from the spring of 1915 he had been himself a leading Cubist in Paris, constructing figure paintings and still lives with flat elementary shapes and resisting the consistency of perspectival spaces (Plates 1 and 2).[3] In particular; he had contributed a highly distinctive type of Cubist portraiture (Plate 2), which held in balance overt compositional artifice and engaging characterization. During 1917, however, Rivera's painting had developed in a new direction which increasingly stressed the importance of a direct, first-hand study of the sitter or motif. This was not a simple development: it involved obscure experiments with an optical device for visualizing things in 'four dimensions', but it led at the turn of 1917–18 to a clear enough result.[4] Rivera arrived at a practice which combined on the one hand a pictorial style which was overtly Cézannist, and on the other a smooth Ingrist drawing style dedicated especially to

2. Diego Rivera, *Portrait of Maximilien Voloshin*, 1916. Oil on canvas, $43\frac{1}{4} \times 35\frac{1}{2}$in. Instituto Nacional de Bellas Artes, Museo Nacional de Arte, Mexico City.

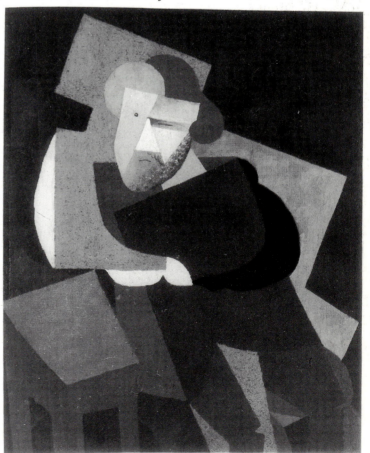

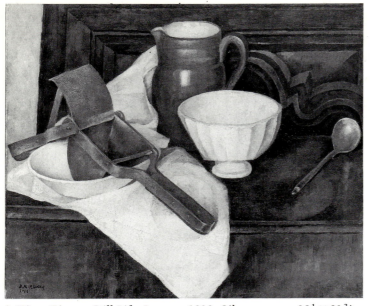

3. Diego Rivera, *Still Life*, January 1918. Oil on canvas, $18\frac{1}{8} \times 21\frac{3}{4}$in. Statens Museum for Kunst, Copenhagen. Gift of Tora Garde f.Fischer.

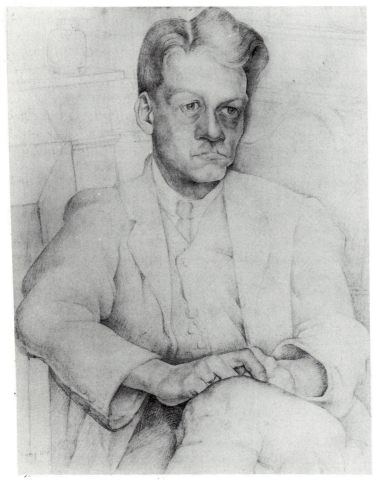

4. Diego Rivera, *Portrait of Adam Fischer*, 1918. Pencil, $20\frac{1}{2} \times 15\frac{3}{4}$in. Sale: Sotheby & Co, London, 29 November 1972, lot 67.

as Juan Gris and Gino Severini in 1916–17, and had made paintings whose advanced Cubist credentials at that time would have been unquestioned (Plate 5). What he produced from early 1918 into 1919 was neither a brand of Naturalism that responded to Cézanne nor a brand of graphic Neo-Classicism; it was a revived 'early Cubism' which gave almost pattern-book definition to the representational methods pioneered by Picasso in 1908 and 1909. A good instance is the

5. André Lhote, *Public Gardens*, 1916. Oil on canvas laid down on board, $35\frac{1}{2} \times 24\frac{1}{2}$in. Sale: Christies, London, 30 June 1970, lot 17.

small *Portrait of Mme Lhote* (Plate 6), which could be either 1918 or 1919, where the image is unmistakably the result of a near systematic study of the sitter, whose features have been transmuted into easily manipulated pictorial parts (conceived in the round, not as flat shapes), and have then been rearranged (timidly) as if by slight shifts of viewpoint. Lhote's extensive critical writings in *La Nouvelle Revue Française* from 1919 on show that he remained committed to certain principles then and always associated with Cubism, above all to the belief that art should be concerned with formal relationships and not merely with counterfeiting nature; but the fact that his painting so obviously restored the model or the motif to its primacy could only identify him as another defector alongside Rivera.[6]

From the time of Cubism's first public manifestations in Paris in 1911–12, Louis Vauxcelles had written against it. For him the moves made by Lhote and Rivera signalled the beginning of wider moves among the Cubists that could end in the fulfilment of a long-established desire to see the demise of Cubism. His campaign to persuade at least the readers of *Le Carnet de la Semaine* that Cubism was in a terminal condition gathered pace through the summer of 1918. By

portraiture (Plates 3 and 4).[5] Of the advanced Cubists both Picasso and Gris had already made comparable portrait drawings, but where they had drawn representationally alongside continuing Cubist explorations, Rivera's Cubist exploration stopped altogether. By the summer of 1918 his work could be seen as a thoroughgoing denial of Cubism.

André Lhote's contribution as a Cubist had not been as noticeable, but, like Rivera, he had been among those supported by Léonce Rosenberg, the dealer who replaced the exiled D.-H. Kahnweiler as the sponsor of Parisian Cubism from 1915. He had been close to such members of the Cubist circle

August (always a resourceful polemicist) he was adding a little demoralizing invention to his claims, by way of substantiation, with the stories (quickly denied) that Gris had written to Léonce Rosenberg of how 'he was fed up with mechanical fabrication', and of how Picasso, who was also thinking of severing his links with the Cubists, had said of a Rivera portrait that 'never had any Cubist work suggested depth with such fullness'.[7] As Vauxcelles saw it, Lhote's and Rivera's betrayal and the possibility (however distant) of Picasso himself making the break, joined by Gris, was a compelling demonstration that Cubism could now be considered merely a stage in the careers of a few more or less interesting artists, a stage on the way to something fundamentally distinct; and the something else he envisaged was a more orderly art rooted once again in the experience of nature.

Towards the end of 1918, just before the Armistice, there was further evidence to support this conviction. Vauxcelles manufactured some of it himself by organizing at a small gallery, the galerie Blot, an exhibition of young artists who seemed to stand against Cubism. Among them were Lhote and Rivera, and also Gabriel Fournier, Eugène Corneau and a

6. André Lhote, *Portrait of Mme Lhote*, 1918 or 1919. Oil on canvas, 16 × 12¾in. Sale: Sotheby & Co, London, 11 November 1970, lot 64.

painter who was to know considerable critical success in the twenties, André Favory. as well as the sculptors Paul Cornet and the Dane Adam Fischer (the latter Rivera's sitter in his drawing, Plate 4).[8] Then too, Lhote was given a one-man show at the galerie Druet, and early in 1919, just after the Armistice, a second group exhibition, seen at the time as a gesture against Cubism, was held at another small gallery, the galerie Branger, this one with Raoul Dufy as a star.[9]

Among the critics, moreover, Vauxcelles had important allies: Jean-Gabriel Lemoine of *L'Intransigeant*, Roland Chavenon, a painter-critic who wrote in the financial news-

paper *L'Information*, Gustave Kahn of *L'Heure*, the old champion of the symbolists now apparently fatigued by Cubism, having written of it with a flicker of hope before the War, and even Waldemar George who was soon to be one of Cubism's most clear-headed post-war supporters. Just a couple of reactions to these events can give an idea of the attitude to Cubism and to the future of art shared by these writers at the time.

First, there is Gustave Kahn writing on the Lhotes at the galerie Branger early in 1919. For him, they are evidence that Lhote is moving into 'a freer art liberated from that array of recipes which marred certain of his earlier canvases.'[10] Cubism is made synonymous with captivity: its rejection is liberation. Then there is the response of Waldemar George to the work of the now little-known Eugène Corneau who showed with Lhote and Rivera at Vauxcelles's galerie Blot exhibition of 1918. George presents Corneau as Vauxcelles himself might have presented those who more noticeably had made their exit from Cubism, since Corneau too had dabbled on the fringes of the movement. He is, for George, a painter who, having accepted briefly 'the Cubist discipline' has understood the compelling need to go back to nature. He is praised for seeing the danger of Cubism, which, George suggests, is its anti-individualism and its tendency 'to supplant natural vision with scientific vision' (to supplant the painting of appearances with the painting of things as they are understood intellectually). George has nothing but enthusiasm for what he calls Corneau's revival of an 'Impressionist' approach 'face to face' with nature.[11] Lhote, Rivera, Favory, Corneau and other young artists like Vauxcelles's friend and protégé Angel Zarraga, were briefly heroes because they could be seen to have confronted Cubism and purged themselves of its artifices.

And this was not all the evidence that existed in support of Vauxcelles's claim that Cubism was on its way out as the War came to an end. Not only were Cubist painters seen to be defectors, but there were influential writers who had been among the Cubists' most articulate supporters before 1914 who now seemed to have sided with the sceptics.

There was in the first place the poet-critic André Salmon, whose scepticism found expression in a lecture given late in 1917 on the occasion of an exhibition featuring five non-Cubist painters (including Moïse Kisling) with several of the Cubist circle (including Gris and Metzinger) among his audience. Salmon's talk apparently lasted no more than fifteen minutes, but it caused deep resentment among the Cubists and something of the cause of that resentment can be gleaned since something of what he said is known. 'Cubism', he said, 'cannot be the last word in art, because the only value of Cubism was precisely the capacity for renewal, for further development which it brought to art.'[12] Very much like Vauxcelles, Salmon presented Cubism as merely a stage on the way to another kind of art; and by expressing this view at an exhibition of works strikingly dependent on the study of nature, he implied, again like Vauxcelles, that this other kind of art would be once more closer to nature.

A year later, looking back to this lecture, Salmon expanded on his view, revealing a strong hostility not merely to the apparent rejection of the natural in Cubist art, but to the claim, promoted especially by Léonce Rosenberg, that Cubism was a group phenomenon, a movement. 'It is possible', he wrote, 'to be interested in the intelligent researches, the geometric and plastic investigations of one or two artists responsible for Cubism, without raising one's hat in front of the products of all these members of the school.'[13] Such other Cubists as Herbin, Severini, Lipchitz, Laurens and even Gris were to be dismissed out of hand. 'I have defended and

paid hommage to M. Picasso,' he went on, 'who long ago, before Cubism, proved himself a great artist. For me, M. Braque is a conscientious disciple. But I refuse to take up the whole Cubist family.'[14] For Salmon in 1917–18, Cubism was not merely under imminent sentence of death, but was anyway no more than a phase in the work of a great painter, Picasso, and his follower Braque: a phase whose successes had attracted a gaggle of insignificant imitators rather than led the way to a coalition of styles. Cubism would not merely lead on to a new art closer to nature, but had never been big enough to be called a style or a movement at all.

Besides Salmon's, there were two other betrayals of the Cubists that came from committed pre-war allies: Roger Allard's and Blaise Cendrars's. Allard had been one of the few to stand up against the general outrage which greeted the Cubists at the Salon des Indépendants in 1911.[15] Writing in his own new periodical, *Le Nouveau Spectateur*, in 1919, he joined the wave of anti-Cubist attacks set going by Vauxcelles, especially disgusted by the Cubists' apparent retreat from the energy and the variety of lived experience into a world of purified figure emblems and still lives. Cendrars remained committed to those Cubists who he thought were still involved in the themes of modern life ('the depth of the present'), but his support of Vauxcelles's claims that Cubism as a school was dying would have been especially welcome, for he had been more than merely a supporter, he had been a creative collaborator with the Cubists in 1913–14, the ally above all of Fernand Léger and the Delaunays. 'The Cube Tires' was the title of an article he published in May 1919. 'The formulae of the Cubists', he wrote, 'are becoming too narrow, and can no longer embrace the personality of painters.'[16] He too identified Cubism with constriction, a kind of captivity.

Just one more piece of evidence to support Vauxcelles's claim that Cubism was on the point of extinction needs to be mentioned here: it would certainly have deepened his confidence. This was another small exhibition, held this time in the converted premises of the couturier Madame Bongard (sister of Paul Poiret) renamed for the occasion the galerie Thomas. It was the so-called 'first exhibition of Purist Art', which consisted of paintings and drawings by Amédée Ozenfant and the young Swiss architect Charles-Edouard Jeanneret (Le Corbusier, as he was later called). The opening took place on 21 December 1918.[17]

Ozenfant had edited his own little magazine in 1915 and 1916, *L'Élan*, and in its penultimate issue especially (no. 8, January 1916) he had written of Cubism in a distinctly affirmative way, underlining the analogy to be drawn between its outward orderliness and the current wartime stress on national order and on classical notions of the French tradition.[18] By the date of the last issue (December 1916) he was in close touch with Gris and Severini, but his 'Notes on Cubism' published there revealed signs of doubt, especially regarding the relative abstractness of Cubism and its vaguer theoretical pretentions.[19] He spent the year after the collapse of *L'Élan* only fleetingly in touch with Parisian avant-garde circles, but he had begun his own serious reassessment of Cubism, and he spent the spring and summer of 1918 in the Bordeaux region giving that reassessment expression in writings and also in drawings and paintings of a concise stability based on the direct study of nature.[20] Nearby in the region were the two causes of Vauxcelles's clamour, André Lhote and Diego Rivera, and certainly Ozenfant was in touch with Lhote.[21] In September Jeanneret, whom he had met in Paris late in 1917 and whom he had persuaded to take up painting, arrived.[22] It was together during the autumn, while they worked virtually in partnership, that they set down the principles of Purism.

With Lhote certainly an ally, Purism in its initial form emerges plainly enough as an enterprise sanctioned by the betrayals of 1918. What Ozenfant and Jeanneret showed at the galerie Thomas was consciously designed as the logical sequel to a moribund movement; Cubism was to be seen as having played out its historical role. The presumptuous title of the manifesto-like book published in advance of the galerie Thomas exhibition was *Après le cubisme*, a heavy enough hint. 'The War ends,' wrote the Purists, 'all is organized, clarified and purified.'[23] The better to shove Cubism off into the past, they dismissed it as a movement that had disintegrated into disparate individual idioms, a movement whose fragmentary lack of unity could be associated with the chaos of war, since 11 November a part of history.

Like Lhote, the Purists remained faithful to the Cubist conviction that form above all counted; hence their claim to the title Purist.[24] But simultaneously (again like Lhote) they laid a heavy stress on the lucid presentation of subject-matter, something obvious enough in everything they showed. Among the exhibits was Ozenfant's *Bottle, Pipe and Books* (Plate 7), a painting whose structure and whose tilted and flattened surfaces relate directly to the wartime Cubism of Gris in particular, but which is the unconcealed result of direct observation.[25] Things have volume here and space is perspectival with only a little Cubist distortion; such was the case in all their exhibits. For them in *Après le cubisme*, the failure of Cubism lay not merely in its fragmentary dispersal of effort, but in a refusal to go beyond the 'plastic': beyond form. They dismissed Cubist pictures as 'beautiful in the fashion and to the degree of carpets, that's all'.[26] Their subjects were hardly varied: there were two figure paintings in the exhibition and otherwise only unremarkable landscapes and everyday still lives. But their attitude to those subjects was positive and deeply serious. The structural order to be observed in everything, they believed, was reflective, as in a microcosm, of the order behind existence altogether. The

7. Amédée Ozenfant, *Bottle, Pipe and Books*, 1918. Oil on canvas, $28\frac{3}{4} \times 23\frac{1}{2}$in. Galerie Katia Granoff, Paris.

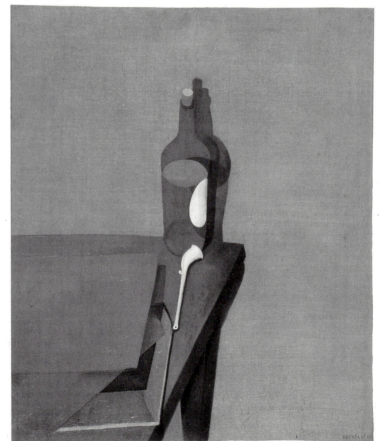

order of their paintings was to be grasped, they hoped, as an order inherent not merely in the painting but in its subject as well; and their almost systematic adaptation of Cubist shifts of viewpoint was geared above all to lucidity in the representation of things. Multiple perspective was for them a means of revealing the essential character of the things they painted.[27]

Ozenfant's and Jeanneret's claim to be the successors of Cubism assured them of serious interest from many critics in the press, a degree of interest which is surprising when one realizes how relatively unknown they were as painters. The anti-Cubist critic Paul-Sentenac gave them generous space (in a time of paper shortage), and wrote in *Paris-Journal* that, even if Cézanne was their basis, 'Purism deserves to be followed by criticism,' adding how pleased he was by Ozenfant's 'modesty, a modesty to which the Cubists have not accustomed us'.[28] Above all it was the clarity of their subject-based art that pleased. Jean-Gabriel Lemoine enthused in *L'Intransigeant*, 'We salute', he wrote, 'this new school which demonstrates the vitality of French art. Purism comes after Cubism and claims to replace it, declaring that "every freedom [should be] taken up by art, except [the freedom] not to be clear", it is an opinion which the public will rightly like.' He went on to make flattering comparisons with Poussin and Le Brun, and concluded: 'The Purist manifesto adds: "The work must justify the aim." An excellent response, for so long intentions have been taken for realizations.'[29] The Vauxcelles view of Cubism as a stage on the way through to something more substantial had long gone with the view that Cubism was an unfulfilled experiment; for Lemoine at least, Purism already showed itself to be far more than that.

In Defence of Cubism: Reverdy and Léonce Rosenberg

As France made the transition at last from war into peace at the turn of 1918–19 there were, then, many artists and critics who wished Cubism dead and who took the row of their joined voices to mean that it must indeed be dead already. For Vauxcelles, Lhote, Rivera, their allies and the Purists, Cubism had only a past. The Cubists themselves took a very different view, and they had their own champions and sympathizers to give it public expression.

The most pugnacious of Cubism's champions in 1918–19 was the poet and theorist Pierre Reverdy. Reverdy's connections with the Cubists went back to the pre-war years when he had been Juan Gris's neighbour at 13, Place Ravignan in Montmartre. Like Gris he was still based in Montmartre, and he remained especially close to the Spaniard, but he was close as well to Lipchitz, Laurens, Severini, Braque—to all the Cubists—and from early 1917 he had operated as the leader of a trio of emergent poets who shared his sympathies with the movement. The other two were the Belgian Paul Dermée and the Chilean Vicente Huidobro, the latter of whom wrote in both French and Spanish. In March 1917 Reverdy had edited the first issue of another little magazine, *Nord-Sud*, and through 1917 and 1918, helped especially by contributions from Dermée and Braque, he had used this publication with its tiny circulation of initiates to set down the outlines of a coherent Cubist theoretical position which applied both to poetry and to the visual arts. His own essay 'On Cubism' in the first issue was perhaps the most influential text to have done so.[30] Reverdy met both Rivera's defection and Salmon's lecture of 1917 at 'Lyre et Palette' with damaging bursts of

irony and satire: he could switch from the remote beauty of his poetry and the clarity of his theorizing to a wounding and witty contempt which made him a formidable polemicist. He may not have written for so wide a public in *Nord-Sud* as Vauxcelles in *Le Carnet de la Semaine* or Lemoine in *L'Intransigeant*, but he was a worthy adversary.

This is his first published reaction to Vauxcelles's campaign of 1918:

> How many times has it been said that...Cubism has been extinguished! Each time that a purge occurs the critics of the other side, who ask only that their desires be taken as facts, shout defection and howl for its death. This is nothing basically but a ruse because, Pinturricchichio [*sic*], of *Le Carnet de la Semaine* and the others know very well that the serious artists of this group are extremely happy to see go...those opportunists who have taken over creations the significance of which they do not even comprehend...[31]

Reverdy rarely defended if he could attack, and his defence against Vauxcelles was the extremely effective one of an assault on the credibility of Lhote and Rivera, who were simply not to be taken seriously. As he presents them that autumn in *S.I.C.* (another periodical edited by a Cubist sympathizer, Pierre Albert-Birot), Rivera is to be dismissed as a profiteer in search of publicity, and Lhote simply as 'a bad painter' ignored by 'the good ones'.[32]

The other major champion of Cubism at this moment was the dealer Léonce Rosenberg. As already established, Rosenberg had stepped into the space left with the exile of D.-H. Kahnweiler. By the end of 1918 he was buying the work of virtually all the Cubists active in France. His defence was more lastingly effective than Reverdy's could have been. His first move was a letter to *Le Carnet de la Semaine* denying Vauxcelles's most imaginative claims, especially the announcement of a volte-face by Picasso and Gris.[33] Much more difficult to resist, however, was his second move: a series of exhibitions at his galerie de l'Effort Moderne in the smart 8*me* showing Cubist work of the war years right up to the moment by almost all the major Cubists. He had wished to put these exhibitions on through the summer and autumn of 1918 and had started them with a show of work by Auguste Herbin, but the bombardment of Paris by 'Big Bertha' put a stop to his plans. The exhibitions followed the Armistice, therefore, occupying the first six months of 1919 for the most part. They began with a show of Henri Laurens's sculpture in December 1918, and went on with Jean Metzinger in January, Léger in February, Braque March, Gris April, Severini May, and, the culmination, Picasso in June. These were often large exhibitions, taking in the whole range of these artists' production from 1914 to the month of the shows themselves. One major Cubist based in Paris was missing, the sculptor Jacques Lipchitz (who was given a show early in 1920), and, of course, those who had left France during the War were missing too, most noticeably Albert Gleizes and Robert and Sonia Delaunay. But, nevertheless, this was an astonishingly complete demonstration that Cubism had not only continued between 1914 and 1917 but was still developing in 1918 and 1919. In the face of such a display of vigour, it really was difficult to maintain convincingly that Cubism was even close to extinction.

What, then, was the Cubism that Pierre Reverdy defended and Léonce Rosenberg bought and then exhibited in 1918–19? What kind of Cubist painting and sculpture was produced in France during the war years and survived it? These are the questions which the next chapter will address.

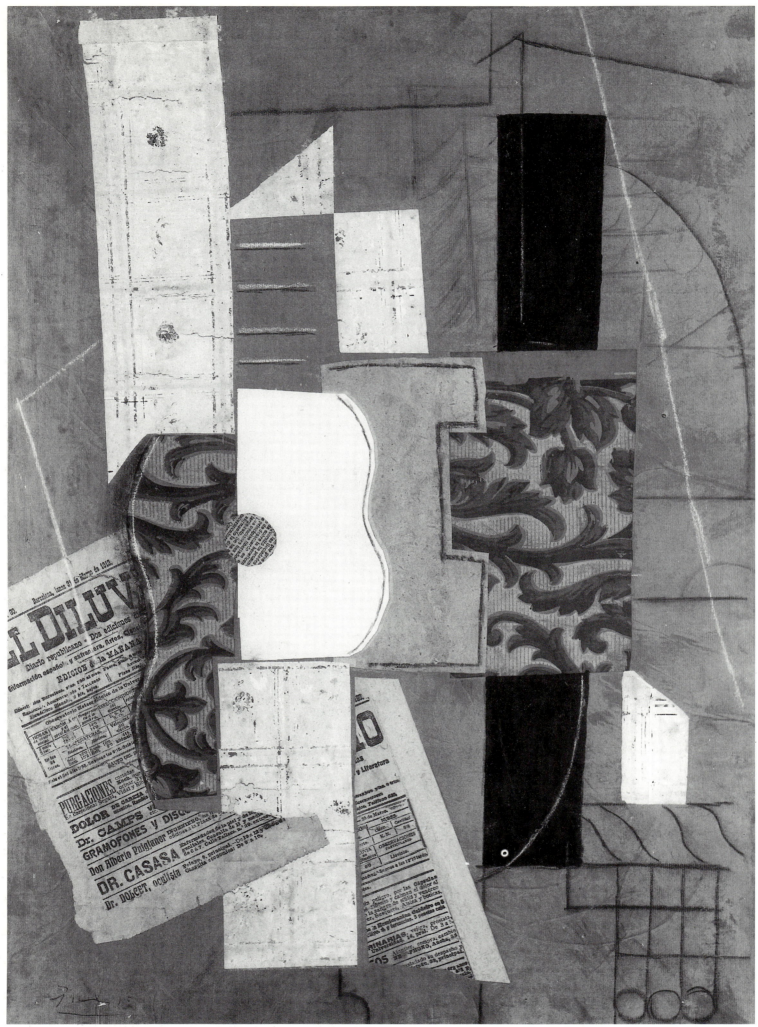

8. Pablo Picasso, *The Guitar*, 1913. Charcoal, crayon, ink and pasted papers, $26\frac{1}{8} \times 19\frac{1}{2}$ in. Collection, The Museum of Modern Art, New York, Nelson R. Rockefeller Bequest.

2
The War and After: the Survival of Cubism

Between 1912 and August 1914 Cubism was a movement with many futures. This at least is a judgement made by almost all its historians when they have considered the various evolutions that can be described as originating in it. Even when it is confined by the Platonic notion of 'Essential Cubism' so that it includes only the work of Picasso, Braque, Gris and Léger, there have been constructed upon the 'beginnings' represented by the Cubism of those eighteen months very different linear histories.[1] The flat orthogonal structures of De Stijl non-objective painting (Plate 236), the overlapping, hovering planes of post-Suprematist non-objective painting, the polyphony of the shattered images brought together in Dada collage and photomontage (Plate 352), the collusion of word and image in Dada graphics and early Surrealist painting (Plate 61), every kind of constructed sculpture, all have been taken to have their beginnings in Cubist art then.

Whatever the ultimate validity of this species of historical picture-making, it throws into sharp relief one point which is difficult to question: the point that Cubism between 1912 and 1914 was characterized by a diversity that could stimulate a wide range of positive responses, often contradictory. It is a point made not merely by the diversity of the individual Cubists and their work, but even by such a single composition as Picasso's *papier collé* of 1913, *The Guitar* (Plate 8). It is a composition in which can be read certainly four of the 'beginnings' listed above: its overlapping cut-out shapes 'hover' as if in a space in front of the picture surface, yet its elements are flat planes which cohere in a structure tending to the orthogonal; things and the material with which they are represented are untidily torn apart, fragmented; words can be read among the shapes and the objects.

Diversity in the sense of a multiplicity of recognizable individual idioms was to remain a feature of late Cubism after 1918, indeed a crucial feature, but the range of possible beginnings to be read into it was by 1918 drastically reduced. What can be observed in advanced Cubist art during the war years is a process of distillation; it made possible the clarity of the theoretical positions that were argued by the Cubists and their allies from 1917 on, it simplified the lessons drawn from Cubism, but it represented a diminution. The process and its immediate outcome were visible enough in the galerie de l'Effort Moderne exhibitions of December 1918 to June 1919.

With the declaration of war in August 1914 many of the Cubists were mobilized: Léger, Braque, Metzinger, Gleizes, de la Fresnaye and the sculptor Duchamp-Villon almost at once. Those in uniform who found the time and the mental space to make art (Léger and de la Fresnaye especially) sustained, each fairly separately, a kind of Cubism during the war years (usually in the form of sketches). They found a generalized linkage between the newness and the anonymity of mechanized warfare and that of Cubist idioms, usually early ones.[2] In the case of Léger at least what he took thus from the visual facts of front-line experience was to provide the starting-points for post-war Cubist developments (Plate 9), but the survival of Cubism as a recognizable movement in France still alive enough to develop beyond pre-war attitudes and forms was generally left to those who stayed out of uniform or were demobilized, like Braque. It was what happened on the home front that gave Cubism a future after the Armistice.

Paris was not more than 100 kilometres from the front line for almost the entire duration of the War, but the life that was lived there by the few young men who remained out of uniform was utterly different. On the most basic level, it was a life full of privations, but, most tellingly, it was a life where propaganda gave a transparent mendacity to everything, where young men in civilian clothes were uncomfort-

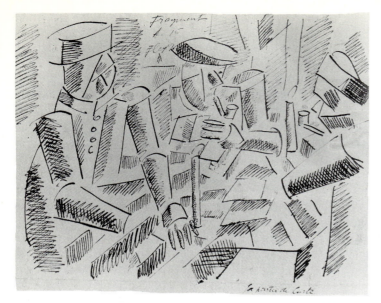

9. Fernand Léger, *Fragment, Study for the Card Game*, 1916. Pen and ink, 7 × 8¾in. Collection, Museum of Modern Art, New York. Gift of Mr and Mrs Daniel Saidenberg.

ably out of place, and where, especially if foreign, they were the object of continual suspicion.[3] These were not the circumstances to encourage a direct confrontation with realities, least of all with the realities of war.

The newly fashioned sense of national identity that was established on the home front even in the first year undoubtedly had its effect on the Cubism that emerged from the Great War—as Kenneth Silver has shown—encouraging, from at least 1917, a more or less conscious pursuit of classical or 'Latin' virtues, of the reasonable and the well-ordered.[4] But in a very real way the history of Cubism between 1914 and 1918 is a history as much of evasions as of adjustments to the pressures of nationalist mythologies, evasions which came of the profound need among those who stayed away from the front to set aside its inconceivable horrors and the threat it presented to their survival (not merely physical). While the Cubists who experienced war on the front adapted Cubist modes to the task of saying something about it and the mass of people involved in it, the Cubists at home took Cubism further and further away not only from the depiction of things, but from any recognizable response to the conditions of life.

With the need to evade went the complementary need to distil their art, and with both went a growing accentuation of the division between art and life. The accompanying accent on the 'Latin' virtues, with all their connotations of Frenchness, was not at all antipathetic to it. By the time of the Armistice and the Effort Moderne exhibitions that division between art and life had become the key to Cubist orthodoxy; it was to continue as such in the peace that followed.

Picasso's *papier collé* of 1913, *The Guitar*, is in no sense conceived as a thing immaculately set apart: its scruffy provisional appearance, the pieces of paper so obviously cut, torn and stuck on in haste, its newspaper so loaded with inferences of authentic topicality, signify a breakdown of the habitual distinctions between the ephemera of daily living and the sanctity of the work of art made for exhibition and preservation. It is one of many images that can illuminate the gap between the Cubism of 1912–14 and the distilled late Cubism of 1918–19. By the end of the Great War such a blurring of distinctions was almost never to be found in the work of the advanced Cubists in France, not even in Picasso.

Picasso

Before 1914 there was no argument as to the 'inventor' of Cubism, and, as already pointed out, Salmon at least still presented Picasso in the role in 1918. Both the space given to

10. Pablo Picasso, *Couple Playing Cards*, 1914. Pencil, 19½ × 15in. Musée Picasso, Paris.

the Picasso exhibition in the press and the fact that it was the last of the Effort Moderne suite of Cubist exhibitions, underlined its status as a culmination. And yet the last two years of the Great War had seen Picasso move into a new social arena as an artist and simultaneously set himself apart from the Cubists as a group. He was still often perceived as their leader, but he stood somewhat aloof.

Picasso's withdrawal came with his involvement after the summer of 1916 with Diaghilev's Ballets Russes.[5] It went with a move away from Montparnasse (the centre of things for the Cubist artists and poets) to Montrouge, and led in 1917 to many months of absence from Paris altogether (in Rome between February and April, in Barcelona and Madrid between spring and autumn).[6] The ballet *Parade* was the initial reason for this change in social milieu, an enterprise intended, at least by its instigator Jean Cocteau, as a first step towards making Cubism acceptable to a wider, more influential haut bourgeois and aristocratic audience.[7] On this score, its first night in Paris on 18 May 1917 must be counted a failure, but certainly Picasso's involvement lifted him into a special, socially elevated élite. His marriage to the Ballets Russes dancer Olga Koklova in July 1918 consolidated his position there, followed as it was by a honeymoon at the Biarritz villa of the rich Chilean Madame Errazuriz and by a further move, this time from Montrouge to a stylish apartment on the rue la Boëtie close to Léonce Rosenberg's gallery. It is perhaps symptomatic of his new position that when his exhibition opened at the galerie de l'Effort Moderne in 1919 he was not even in Paris, having left the month before to design the costumes and sets for a new ballet, *Le Tricorne*, which was to open in London that summer under the auspices of Diaghilev's company.[8]

There was, too, another factor that set Picasso apart from the Cubist group in 1918–19: his decision, first in the Ingrist portrait drawings of 1915 and after, then increasingly in ambitious oils from 1917, to revive for himself representational styles more or less capable of standing for both Catalan and

French ideas of tradition. In 1917 he painted Olga as if he were Ingres painting a young French girl of good family (Plate 204); at Biarritz in the summer of 1918 he made inventive variants of the *Bain turque*, including the almost too exaggerated but still graceful little *Bathers* (Plate 75) which literally quotes poses; in 1919 he was painting and drawing still lives where objects are presented not only straightforwardly but in the most palpable, substantial fashion.[9] There was some reason for Vauxcelles's suggestion in the summer of 1918 that he too was on the brink of defection.

Yet, the fact remains that in 1918–19 Picasso continued energetically as a developing Cubist, and had done throughout the war years. His art was still watched and talked about by all who were called Cubist, and the Effort Moderne exhibition of June was supplemented by another in October at the gallery of Léonce Rosenberg's brother Paul to widen the opportunities for artists to keep in touch with his work, his continuing Cubism included. More than this, old friends like Braque, Gris and Reverdy were well aware of what was happening in his studio, even if no longer so close to him. He was still a leading Cubist, and not merely because André Salmon said so.

Certainly Picasso's first major picture of the war years was the tall *Harlequin*, finished at the end of 1915 (Plate 11). He painted it when he was spending much of his time on the Métro travelling to see his dying mistress Eva in hospital, but he still had the confidence to tell Gertrude Stein that it was 'the best thing I have ever done'.[10]

Harlequin is figurative in the most minimal of ways. A few schematic signs and the chequered costume-pattern are all that fix this array of broad, flat rectangles in a black surround as a *commedia dell'arte* character. Yet, with such simple means Picasso gives expression to his figure almost to the point of comic-strip caricature: the eye stares unblinking above the grin, and the figure assumes a light jauntiness, such is the effect of the placing of those tell-tale features and of the obliquely overlapping constituent planes. Within the black setting that jauntiness and that stare are disturbingly out of key, adding a clear note of disquiet. This use of so simple a set of means to give an expressive vitality to his subjects had been peculiar to Picasso's post-*papier-collé* Cubism in 1913 and 1914, and in Avignon in the summer of 1914 he had taken it to extremes in a series of figure drawings where the shrinkage of heads and the distension of limbs create images that teeter on the edge of the absurd, even the horrifying (Plate 10). The tendency to the expressive remained almost unique to his Cubism at this time; by 1918–19 it had become only intermittently a feature of his Cubist art, but he was never to lay it aside altogether.

Figurative and expressive *Harlequin* may be, but it is important to stress that the image is not the result of a process by which Picasso took a model or his memory of a model and stylized or simplified it. During the War, Picasso might have been at once both a Cubist and, apparently, a traditional representational artist, but, for him, the two modes were absolutely distinct. He never worked from a straightforward depiction of a figurative subject *into* such a Cubist image as *Harlequin*. This is especially clear in the case of another canvas of 1915, probably painted earlier in the year, *Man with a Pipe* (Plate 14). Behind this picture lie a group of drawings of seated men made at Avignon in the summer of 1914, which are altogether more moderate than those already mentioned. Some are straightforwardly representational in a loosely Cézanne-like way (Plate 12); others take a figure in almost identical pose, elbow on table, cheek on palm, but are built from contrasted elementary shapes, ripplingly curved or angular (Plate 13). The significant thing about these draw-

ings taken together is that there are none which lie *in between* the two modes: the representational drawings do not lead into the Cubist drawings by any transitional route. Indeed, there is one drawing of 1914 where, notoriously, the two modes are used together, but not with the Cubist emerging from the representational—rather with the Cubist overlaid.[11] The effect is of a clear pair of alternatives with a wide gap in between. Picasso seems to have grasped these figures whole in either mode. On the Cubist side, the elaborate and highly eventful *Man with a Pipe* seems to have had its beginning initially in simple, schematic signs for figures put down on paper without an instant's hesitation. From such starting-points Picasso either elaborated, as in this case, or simplified even further, as in the far more abstracted and more ambitious sequel to the Avignon drawings of seated men, the over-life-sized *Man Leaning on a Table*, which he slowly worked up between summer 1915 and spring 1916 (Plate 15).[12] All his Cubist work, however simple or complex, was conceived broadly in this way between 1914 and 1919.

In general terms, then, throughout the war period Picasso built up his Cubist images, not, it seems, by stylizing from the seen or remembered, but rather in what has been called the 'synthetic' way, by working directly with simple combinations of shapes which could act as signs for figures and

11. Pablo Picasso, *Harlequin*, 1915. Oil on canvas, $72\frac{1}{2} \times 41\frac{3}{4}$in. Collection, Museum of Modern Art, New York. Acquired through the Lillie P. Bliss Bequest.

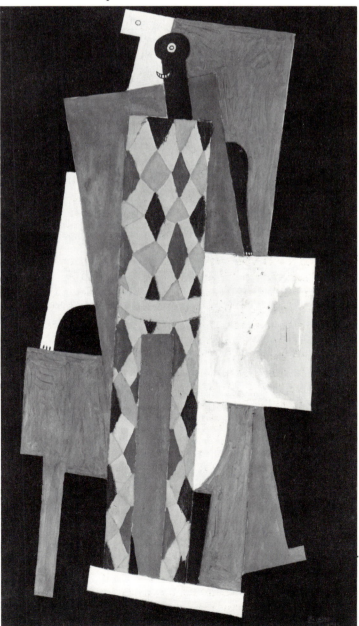

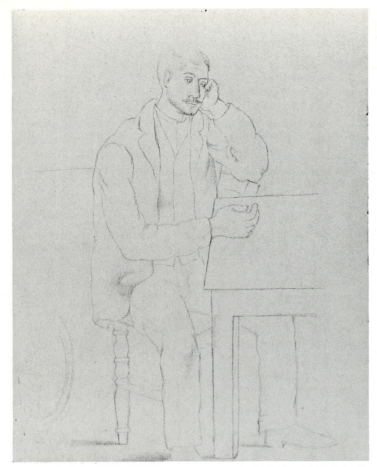

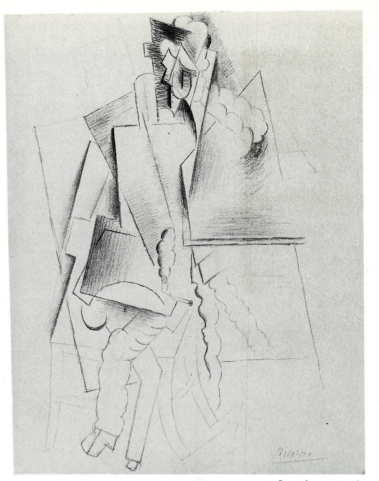

12. Pablo Picasso, *Seated Man*, 1914. Pencil, $12\frac{1}{8} \times 9\frac{1}{2}$in. Musée Picasso, Paris.

13. Pablo Picasso, *Seated Man*, 1914. Pencil $12\frac{7}{8} \times 9\frac{1}{2}$in. Musée Picasso, Paris.

objects. As a Cubist, he did not 'analyse' things on the basis of observation arriving at a representation by breaking them down part by part, he built up his images synthetically: he *invented* his figures or objects without the immediate stimulus of models or motifs. His decision once again to become the painter of representational pictures suggestive of tradition had no effect on the way he continued to work as a 'synthetic Cubist'.[13]

In this sense, Picasso the Cubist remained committed to accentuating the gap he had already established between art conceived of as artifice or invention (however expressive), and art as the 'natural' representation of the world offered to the eye, with its necessary basis in the direct visual experience of things. At the same time, the war years saw him move towards a synthetic Cubism which was increasingly often concise, rid of the extraneous, and compositionally stable. It was this that, by 1918–19, had made the blurring of distinctions between the aesthetic and the quotidian, so overt in *The Guitar* of 1913, no longer a feature of Cubism.

With hindsight it is possible to see the beginnings of this move already in the 1915–16 *Man Leaning on a Table* (Plate 15). As already suggested, it was itself the result of a process of distillation, of abstracting from an already synthetic, if far more variegated, starting-point (Plate 13). The degree of its abstraction was not to be achieved again by Picasso during the period, but the process led him to stress compositional qualities which he was to find increasingly attractive.[14] There is very little to deflect attention now from the structure of flat, angular planes, from its stable, harmonious *rapport* with the tall, rectangular format. The process of building an image from such simple components has obvious analogies in general with construction: here it has led to an image which gives compelling emphasis to that analogy with built structures. By 1918–19 Picasso's Cubist compositions had become far more often than not architectural in this sense. *The Guitar*, painted at Montrouge early in 1918, and the combined oil and *papier-collé Guitar* put together in 1919 in the context of

Picasso's designs for the safety-curtain of *Le Tricorne* are good enough instances (Plates 16 and 17).

With the notion of the 'built' image went, of course, Picasso's experiments in construction, begun in 1913 and continued at least into 1915 (Plate 22). It is significant that late in 1919 he dabbled once again in the making of constructions, for the constructions he made underpinned what was a growing concern not only for two-dimensional stability but for a clarity of structure so firm that in some cases an invitation seems to be made for translation into three dimensions. Working with cut and painted cardboard, Picasso constructed two of these pieces; they are tiny. Both relate to a series of watercolours and gouaches of table-top still lives set in an open window with a balcony and a blue-sky back-drop, produced earlier at St Raphaël during the summer of 1919;[15] they are just the sort of compositions where transposition into three dimensions is hypothesized (Plate 18). One of the constructed pieces takes the still life and open-window theme as a whole: it is frontal and, as a succession of pierced and cut planes framed by curtains, has the look of a theatrical maquette (the whole series had followed the designs for *Le Tricorne*).[16] The more daring, however, takes just the central motif of the still life, closely following other gouaches which focus on the interlocking of the fruit-bowl and guitar (Plate 19).[17] Small and almost carelessly painted it may be, but this is yet by far the most fully all-round Cubist construction Picasso had so far made, its fanned-out planes in black, white and grey swivelling around the tilted horizontal surface of the fruit-bowl to initiate an exploration of every vantage-point. The piece is unique, a 'one-off' experiment that led to no others in three dimensions, but it reveals just how intense was Picasso's impulse in 1919 not only to structure his paintings firmly as flat arrangements of shapes but also to build them as if stable planar compositions that can stand solidly in space. The framing window and the interior setting of the watercolours and gouaches are there as if to amplify the architectural analogy.

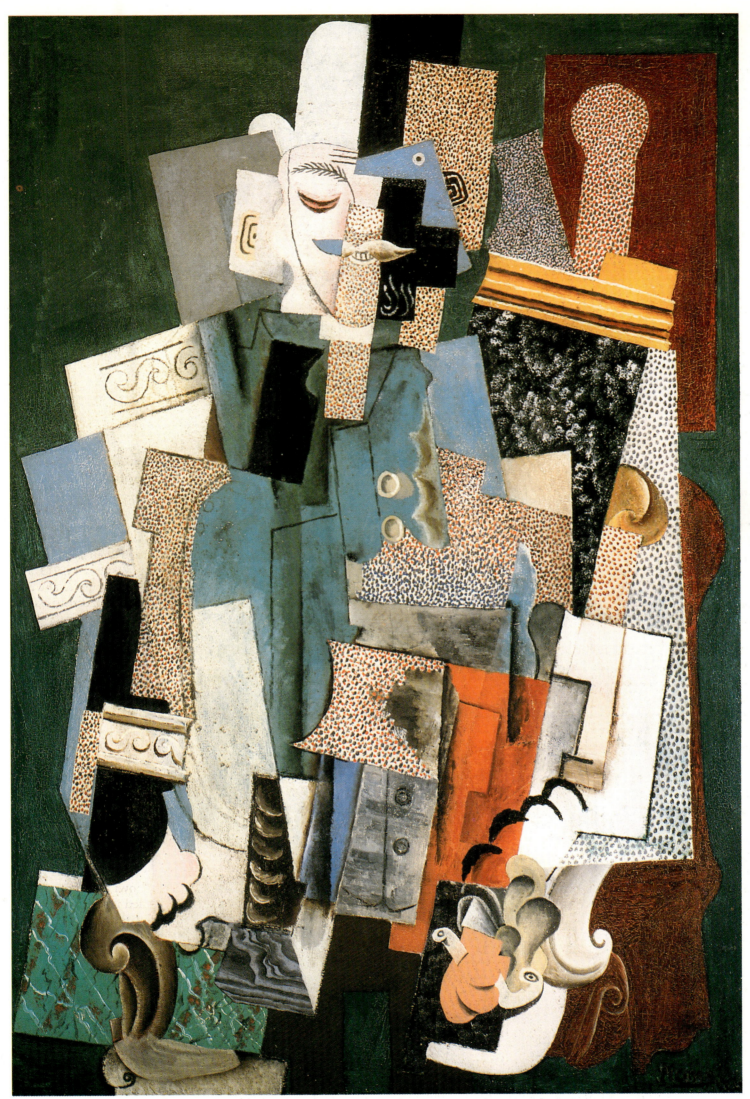

14. Pablo Picasso, *Man with a Pipe*, 1915. Oil on canvas, 51¼ × 35¼in. The Art Institute of Chicago. Gift of Mary L. Block.

15. Pablo Picasso, *Man Leaning on a Table*, 1916. Oil on canvas, 78¾ × 52in. Private Collection, Switzerland.

The clarity and firmness of Picasso's picture making in 1918–19 is distinct from the much less substantial structures of his 1912–14 *papiers collés*, but ultimately this is a question of degree. After all a *papier collé* like the 1913 *Guitar* is also simple and its composition is governed too by verticals and horizontals. Indeed, the very practice of building compositions by using flat 'cut-out' planes was, of course, made possible by *papier collé* as Picasso and Braque used it in 1912–13. If the gap between the pre- and post-war condition of Picasso's architectural Cubism is to be fully brought out, another factor has to be touched on, one that is crucial to the impression given by so much of his work in 1918–19 of relative aestheticization, of retreat from the ephemeral, from the day-to-day. This factor is Picasso's almost total abandonment of *papier collé* as a technique. Not only are the two card-board constructions rarities in 1919, but so too is *The Guitar* of that year (Plate 17), for from the autumn of 1914 right up to this date Picasso almost never actually cut and fixed paper to fabricate a composition. The flimsy *ad hoc* character of those pinned or glued *papiers collés* of 1912–14 gave way to a much more substantial, permanent look which by 1918–19 had become the rule. This is something already visible in the thickly laminated paint surfaces of *Man Leaning on a Table* in 1915–16 (Plate 15), where compositional order is inte-

grated with the material effect of homogeneous durability (subsequently undermined by the development of *craquelure*). But it is especially visible in the sheer substantiality and tactility of the surfaces Picasso worked up, often using sand,

17. Pablo Picasso, *The Guitar*, 1919. Oil, charcoal and pasted paper on canvas, 85 × 31 in. Collection, The Museum of Modern Art, New York. Acquired through the Lillie P. Bliss Bequest.

16. Pablo Picasso, *The Guitar*, 1918. Oil on canvas, 31¾ × 17½ in. Collection, Rijksmuseum Kröller-Müller, Otterlo, The Netherlands.

in his most concise architectural compositions of 1918–19: in the 1918 *Guitar* (Plate 16) and the smaller, tightly organized still lives that relate to it.[18] It is as if the disposable fragility of *papier collé* simply could not supply a solid enough antidote to wartime destabilization. Whatever the reason, the enhancement given to the architectural analogy by this insistence on the durable is obvious. It was crucial to the impression his work so often gave by the Armistice of possessing an autonomous and transcendent aesthetic status.

If the dominant French nationalist theme of a return to the discipline and order of Classicism indeed penetrated the Cubism that emerged from the war at the turn of 1918–19, then it found particularly clear form here in these highly distilled architectural images, absolved as they are from any of those expressive qualities found in the 1915 *Harlequin* or the most disturbing of the Avignon drawings. But even such images as these were given other, less stable qualities that had been a feature of post-*papier collé* Cubist composition since before 1914 and were not to be obscured. Both *The Guitar* of 1918 (Plate 16) and *The Guitar* of 1919 (Plate 17) unambiguously distinguish the central 'object', the musical instrument, from its setting, but in both Picasso uses the overlappings of flat planes to open up an enthralling game with ambiguous spatial suggestions. In the 1918 picture the prickly sanded surface might fix attention on the surface, but the overlappings are so judged that the piled-up shapes seem to push outwards to occupy the space in front, denying the flatness of that surface. This is, of course, a typical post-*papier collé* effect, and its dependence on the possibilities released by the discovery of Cubist *papier collé* is underlined by the enhanced contradictoriness of the 1919 composition with its actual paper additions. That effect of flat fixture challenged by 'hovering' planes which seem to detach themselves from the ground plane is there again, but with complications. The guitar is a piece of paper pinned to the canvas. It is loosely enough attached for the edges to curl, creating real shadows, but it also acts as a white ground for the black sign for a shadow which schematically denotes a smaller guitar placed on top of it. The 'true' and the 'false' are even more clearly in conflict and, as if to sharpen the point, the tiny pin that fixes the paper guitar is partnered by a giant cut-out paper pin beside it. Stable these compositions may be, but the way their elements work to signify surface and space simultaneously is not at all static. Picasso's pre-war pursuit of paradox continued uninterrupted.

Indeed, the wartime distillation of Picasso's synthetic Cubism went with a deepening absorption in the kind of games with paradox that could be played by exploiting conflicting assertions of flatness and space, something that is clearest often in the most elaborate compositions. The most eventful of all Picasso's 1918–19 pictures, *Girl with a Hoop*, painted probably in the spring of 1919, is a case in point (Plate 20); so are the open-window gouaches and watercolours of that summer (Plate 18). There is an added complication in these images: they combine confrontationally both the planimetric suggestions of depth derived from *papier collé* overlappings *and* the perspectival. So coherent is the representation of a stage-like setting in the St Raphaël still lives that the result is, in effect, almost without paradox: something planimetric and Cubist stands firmly in a non-Cubist space. But in *Girl with a Hoop* the perspectival suggestions are only fragmentary and do not begin to cohere, so that the result is throughout paradoxical. There are just enough indications to give the fireplace, the mantle and the ornately framed mirror, and to situate the figure on the parquet floor *in front*. But the figure and her setting simultaneously combine as an arrangement of planes which as ever seem to push out from the

18. Pablo Picasso, *Still Life in front of a Window*, 1919. Gouache, $6\frac{1}{2} \times 4\frac{1}{4}$ in. Musée Picasso, Paris.

picture-plane cancelling those indications of a depth behind it. And the confusions are compounded by the placing of the girl's head inscribed within the frame of the mirror, for it becomes possible to see it as a reflection, an effect which, of course, both pulls it back into depth and pulls the mirror forward into the girl's foreground plane. In 1912–13 Picasso and Braque had used coloured and news printed paper to establish a clearly demarcated back-plane in relation to which their 'hovering' elements could be situated, here Picasso uses the straightforward description of the mirror behind the figure to establish a back-plane which is anything but fixed. Nothing is more immediately grasped as both a surface and a deep space than a mirror.[19]

So abrupt or elaborately ambiguous a confrontation between planimetric and perspectival spaces as here in *Girl with a Hoop* or in the St Raphaël still lives has no precedent in Picasso's synthetic Cubism of 1912–13; this is a kind of games-playing with contradictory codes for the representation of space that he developed during the War with the open window and the mirror (as phoney window) essential devices. Just as his more durable, 'classical' Cubism was not isolated, neither was this decision sometimes to complicate things spatially. As we shall see, the open window was to become one of the most ubiquitous Cubist devices of the twenties, and indeed owed its introduction into the Cubist repertoire more to others than to Picasso himself: to Juan Gris and Diego Rivera above all.[20] Such a development represented unequivocally an expansion of scope, an expansion of possibilities, and as such might seem inconsistent with those processes of distillation otherwise dominant in the wartime

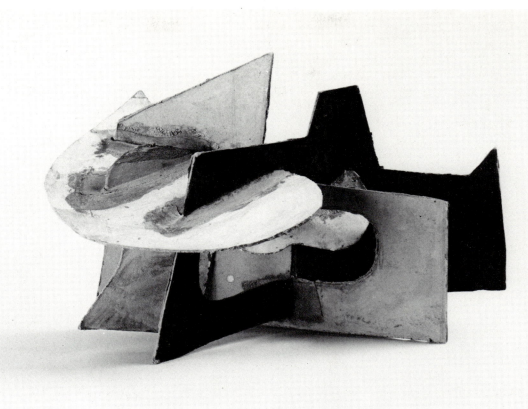

19. Pablo Picasso,
Still Life, 1919.
Construction in
painted cardboard,
$8\frac{1}{2} \times 7 \times 2\frac{5}{8}$ in.
Musée Picasso, Paris.

development of Cubism. It can, however, be argued that this expansion of possibilities in the work of Picasso alongside the other Cubists was, in an important sense, thoroughly consistent with the distillation of Cubism. For what we see when the Cubist's gaze moves outside is actually the further elaboration of games which are strictly contained, exclusively pictorial. It is not the space in the mirror or the view of a Mediterranean outdoors as such that matters, but rather the pictorial codes by which they can be denoted and the ambiguities that can emerge when these conflicting codes are pitched one *against* another. What we see is a taking of possession: the other kinds of space to which painting can allude are drawn into the ambit of Cubist painting. The Mediterranean at St Raphaël, the room deep in the mirror, are entrapped, locked into an aesthetic game whose rules the artist controls.

In its solid sense of material worth, in its discipline and its spatial eventfulness Picasso's Cubism, then, did not stand apart at the end of the Great War, as he did socially in his new élite milieu. It was a fundamentally different kind of Cubism only in that one aspect which we have picked out as so important to his major canvas of 1915, *Harlequin* (Plate 11): the way he could give it expressive urgency. And this was an aspect of only a few works by 1918–19. That it can be found at all, however, is significant, since therein lay the openness of Picasso's Cubism to future Surrealist appropriation, as we shall see. The expressive was an unmistakable aspect of *Girl with a Hoop* (Plate 20).

Ironically, if the distilled purity of Picasso's late wartime Cubism followed from the basic abstractness of his formal vocabulary and the simplicity with which he used it to synthesize his figures and still lives, so, to a surprising extent, did its expressiveness. With his ability to work inventively using simple pictorial elements went a flexibility in his manipulation of signs that opened up a whole new range of possibilities. It was William Rubin who first observed the oddly close relationship between the elongated rectangle of *Harlequin* topped by its thin neck and pin-head, and the bottle of Anis del Mono that rocks just perceptibly away from the vertical at the centre of a bright little still life also of

1915 (Plate 21).[21] They are almost interchangeable, harlequin and bottle, and the slight tilt given the bottle combined with the suggestion of bifurcation at the base endow it with unexpected animation: the inanimate borrows a vitality originally the preserve of the figurative. Certainly Picasso makes his *Girl with a Hoop* eloquent, as he had his harlequin, by exploiting the physiognomic: a sense of the stiff and the repressed is carried by the staring eye and the pursed slit of the mouth, as if the child's game has been stopped for her unwillingly to pose for the adults. But, just as important to the vitality of the figure, are features which follow once again from transference, from the semantic elasticity of Picasso's signs: in this case transference from the inanimate to the animate. For the repeated curvy motifs that give rhythmic continuity to the body, arms and hat of the child are actually adapted from the pages of a sketch-book of 1918 where Picasso allowed the scroll-shaped sign for a chair-arm to dictate terms to a suite of seated figures.[22] Played against the rigidity of the little girl's pose and the firmness of the composition's architecture, these are the key to her liveliness. Simple, flexible means open the way to the expressive as well as the pure.

Yet, it cannot be emphasized enough that such expressive eloquence was seldom a feature of Picasso's Cubism by the end of the Great War. The comedy and latent horror of the most extreme of the 1914 Avignon drawings (Plate 10) had as yet no late-Cubist sequel. It may be true that from time to time Picasso did challenge the immaculate aestheticism of his most architectural works; but the challenges he provided now were relatively gentle as well as rare. At the galerie de l'Effort Moderne in June 1919 his Cubism most obviously of all presented a composed, well groomed public face: an image of control.

Laurens

Of the members of the Effort Moderne circle, the artist whose work was attuned most closely to Picasso's at the end of the Great War was the sculptor Henri Laurens, whose

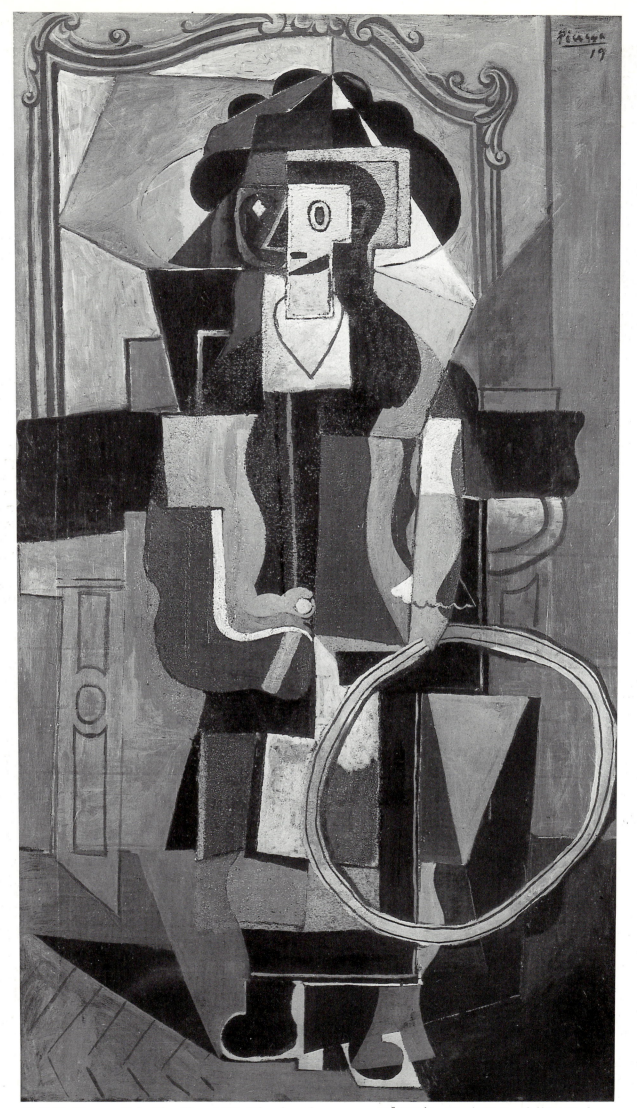

20. Pablo Picasso, *Girl with a Hoop*, 1919. Oil and sand on canvas, $55\frac{7}{8} \times 31\frac{1}{8}$ in. Musée National d'Art Moderne, Centre Georges Pompidou, Paris.

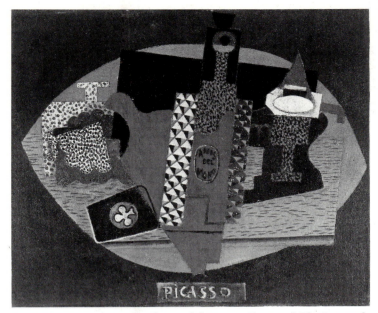

21. Pablo Picasso, *Bottle of Anis del Mono, Glass and Playing-card*, 1915. Oil on canvas, 18¼ × 21⅝in. Detroit Institute of Arts. Bequest of Robert H. Tannahill.

exhibition in December 1918 launched the run of Léonce Rosenberg's post-Armistice shows. Kept from the front by ill health, Laurens made his first moves as a Cubist sculptor in 1915, responding initially to pointers provided before the war by his close friend Braque and to the memory of Alexander Archipenko's polychromatic constructions shown at the Salons of 1913–14.[23] He lived, like Gris, in Montmartre, cut off from the group activity centred on Montparnasse, but that year Picasso was a visitor and before it ended he had brought Rosenberg to see the sculptor.[24] Not surprisingly, perhaps, Laurens's work between 1916 and 1919 represented above all a deeply personal response to Picasso's initiatives in Cubist sculpture, and especially to the multi-media constructions the Spaniard had begun in 1912 and brought to a first conclusion with pieces like *Violin and Bottle on Table* in 1915 (Plate 22).

It is not merely that such fully developed Laurens constructions as his *Bottle and Glass* of 1917 and his *Fruit-bowl with Grapes* of 1918 (Plates 23 and 24) deploy a vocabulary of signs for still life objects that look back directly to precedents (both flat and three-dimensional) in the Picasso of 1914–15; it is that Laurens too focuses on a Picassian pursuit of the paradoxical and expressive. And, just as the key to paradox in Picasso's post-*papier-collé* painting is the conflict between actual flatness and the apparently three-dimensional or spatial, so the key to paradox in Picasso's and Laurens's constructions is the conflict between actual three-dimensional relations in space and apparent ones which are contradictory. While, just as the key to expressiveness in Picasso's Cubist painting is the flexibility of his simple signs, so it is in Laurens's constructions.

Both made constructed pieces which are instantly to be grasped as real objects that occupy space. Picasso's *Violin and Bottle on a Table* is conceived to be seen from in front, not all round, but it is a sturdily material thing: a free-standing structure of nailed-together planks sawn roughly to shape and then painted, to which has been added a neatly cut fragment probably from a chair standing in for the bottle neck and top, and a few lengths of pluckable string stretched for the violin. Laurens's constructions are frontal too, but *Fruit-bowl with Grapes* in particular is conceived to work even more fully from different vantage-points in the 180° arc it commands, and the sharp-cornered jut of the metal plane from which the fruit-bowl sign is cut, projecting as it does

right out into the spectator's own space, renders the whole three-dimensional with striking decisiveness.[25]

Then too, both made such actual three-dimensional structures the armatures for a whole range of contradictory effects of space and solid. Colour flattens planes which recede, solids are suggested by voids. Picasso's bottle is an area of emptiness rather than enclosure, topped by a jagged hunk of wood denoting the surface of the liquid within and bottomed by a disk denoting its base. Laurens's variant in *Bottle and Glass* is an angular hole which houses a white-painted cylinder denoting (solidly) the fugitive highlight to be expected on the curved glass surface.[26] Planes which denote the spatial settings of the objects, especially in Laurens's pieces, jaggedly appropriate the real space around them, sharp-edged, resistant to touch like blades. The ways that signs for the substantial and the insubstantial reverse the direct evidence of the senses multiply. In sculpture, the post-*papier-collé* playing of the 'true' against the 'false' acquires a special immediacy, and this is so the more those jagged extrusions from the core of these pieces take surrounding space into their sphere of influence, the more these constructions give that 'real' space a role in the game with conflicting illusion and allusion which has become the focus of attention. Expansion here, the actual reaching of these pieces out into their surroundings, quite literally involves a taking of possession.

There is a distinctly personal quirkiness in Laurens's pursuit of paradox, and the same can be said for the expressiveness of his constructions; but again the means to that expressiveness were supplied, initially, by Picasso. Laurens too exploited the semantic elasticity of simple Cubist signs to create transferences, especially transferences from the figurative to the inanimate, to still life. As early as December 1916 a newly published letter from Laurens to Léonce Rosenberg reveals

22. Pablo Picasso, *Violin and Bottle on a Table*, 1915. Construction in wood, string, paint and charcoal. 17⅞ × 16⅜ × 7½in. Musée Picasso, Paris.

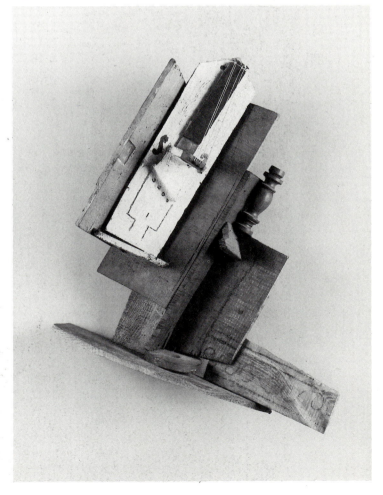

him at least implicitly aware of the semantic openness of his Cubist vocabulary. He writes of working only with 'geometrically determined forms', in other words not with descriptive forms at all, the unmistakable suggestion being that, to begin with at least, his forms could be given different identities, could be made to mean quite different things.[27] *Bottle and Glass* as a whole is distinctly figurative, with its slender body and staring eye-like disk above; and indeed that disk set in its surround of cut-out shapes, one jutting far to the right, fixes a direct relationship between the bottle here and head studies begun in 1915 and continued into 1917 (Plate 25). These heads are indeed almost interchangeable with the bottle (at least its top). There is no question of confusion, the bottle and glass are explicit as such; yet they combine with a jaunty vivacity that follows alone from the infallible allusion to the figurative.

Laurens's metal and wood constructions are his most Picassian pieces. He continued to make them into 1918, but possibly as early as 1917 he had begun to make more solid pieces in stone and terra cotta.[28] Solid and fully three-dimensional as they are, these sculptures acknowledge Picasso far less clearly, but they remain both paradoxical and often expressive. Most are coloured, and Laurens uses his subdued range of bottle green, deep blue, browns and white, not to enhance the actual substantial structure of works like *Man's Head* (Plate 26) and *Guitar* (Plate 166), but rather to break surfaces up and to act against the form-giving contrasts between real light and real shade.[29] At the same time his simple Cubist signs remain flexibly interchangeable, openly so. Thus, *Man's Head* (possibly one of the earliest terracottas) acquires a disturbing resonance by alluding almost comically to the female figure. It relates again, like the bottle of *Bottle and Glass*, to the head studies of 1917 (Plate 25), but here the flat, out-swung triangle on which the ear is often placed in those studies becomes a solid protrusion on the end of which Laurens has stuck the eye. Beside the tall vertical of the nose the possibility that it could be a breast with the eye as surrogate nipple is irresistible. There is nothing so witty about the stone *Guitar* (usually dated 1919);[30] but even here the form as a whole can seem to allude to the idea of a female figure and acquires a certain dignity thereby.

One final point is to be made about Laurens's sculpture between 1915 and 1919; it is a point which at once aligns his work more closely with Picasso and stresses its personal character. The point is that Laurens too moved towards a more firmly structured, more architectural Cubism, and did so on the basis of a relatively refined approach to the making of Cubist sculpture. The refinement is there in the multimedia constructions from the beginning (Plates 23 and 24). They are conspicuously well made, their parts neatly cut and discretely fixed, their surfaces painted with care. They are absolved, therefore, from all those connotations of the temporary and the discarded still carried by Picasso's constructions in 1915 (Plate 22): they are presented unequivocally as crafted, aesthetic objects. This stress on the solidly made and the enduring is, of course, enhanced in the terracotta and stone pieces, where, if colour is applied, it is made to seem integral with the material itself. At the same time, especially in what seems to be the later of these (1918 or 1919), there is a tendency to condensation and an insistence on compositional stability that decisively differentiates them from the playfulness of the constructions. In works like *Guitar* (Plate 166) there are no idiosyncratic extrusions, and the clear, geometrical structuring keeps the now-contained play of ambiguities strictly under control.

By 1919 Laurens had ceased making multi-media constructions, and indeed so dominant had the theme of order

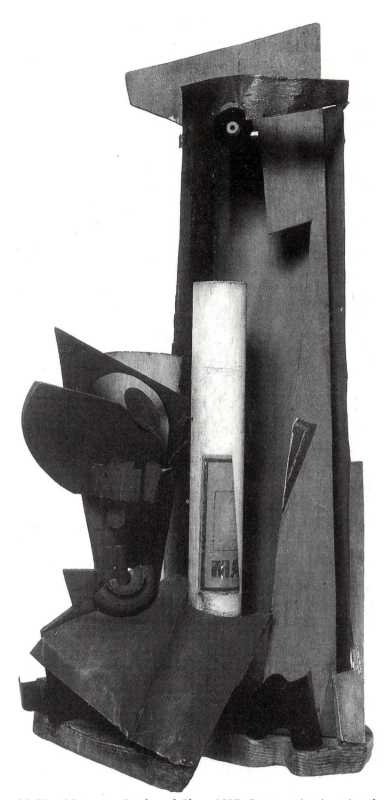

23. Henri Laurens, *Bottle and Glass*, 1917. Construction in painted wood and metal, height 23⅝in. Musée National d'Art Moderne, Centre Georges Pompidou, Paris. Kahnweiler-Leiris Collection.

become in his sculpture that he began to leave some of his stone pieces uncoloured: *Woman with a Guitar* is one of these (Plate 27). The wit remained: there is a light decorative quality here (in the pleats of the bodice and the waved fall of the hair) which becomes amusing in so heavy a material as stone. But the lack of colour adds a feeling of austerity to the simplicity of the signs, and the sensed presence of an underlying geometry is as insistent as in the most disciplined of Picasso's architectural compositions of 1918–19 (Plate 16). Where the architectural analogy was underplayed in the constructions, it became a central factor in Laurens's free-standing uncoloured sculptures. Still built up initially in *papier collé* with great openness and flexibility but subjected now to a new geometric control, corrected, it seems, by proportional divisions derived

from the Golden Section ratio, these pieces, however small, are presented as monumental structures in stone. By 1918–19 Laurens too had arrived at a Cubist 'call to order'.

Gris, Lipchitz and Metzinger: crystal Cubism

It was their lucidity and their accentuation of the architectural that most clearly allied Picasso's and Laurens's Cubism to the rest of what was shown as advanced Cubism by Léonce Rosenberg at the end of the War. The 'Latin' virtues of clarity and order were indeed dominants in the recent work of most who exhibited. Nowhere was this more so than in the work of three artists who had been in close contact with one another from 1916 and who had spent some time together during the summer of 1918 escaping the bombardment of Paris by 'Big Bertha' in the small Touraine town Beaulieu-près-Loches: the painters Gris and Jean Metzinger, and the sculptor Jacques Lipchitz (though Lipchitz, of course, did not show until 1920). It is above all the wartime work of these three Cubists that can be analysed as a move towards order alongside a process of distillation. The key years in both the distillation and the disciplining of their Cubism were 1917 and 1918; the process of distillation is most easily followed in the work of the two who were the closest friends, Gris and Lipchitz.

1917, it will be remembered, was the year of the foundation of Pierre Reverdy's little magazine, *Nord-Sud*. Reverdy was an old intimate of Gris from before 1914, and it is no mere coincidence that as these Cubists more consciously turned to a 'purified' mode of invention the theorizing of the

24. Henri Laurens, *Fruit-bowl with Grapes*, 1918. Construction in painted wood and metal, height 25¼in. Private Collection.

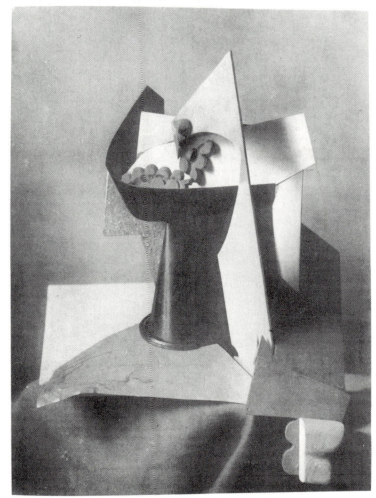

25. Henri Laurens, *Head*, 1917. Gouache, chalk and pasted paper on board, 19¾ × 23¼in. Collection, Viera da Silva – Arpad Szenes, Paris.

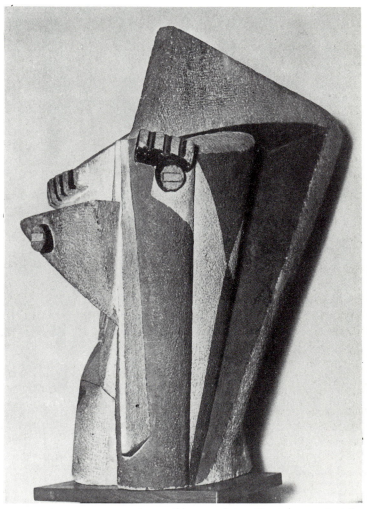

26. Henri Laurens, *Man's Head*, 1917. Painted terracotta, height 31½in. Collection, Alberto Magnelli, Paris.

Nord-Sud writers placed the accent squarely on 'purity'. Reverdy and Dermée showed themselves unconcerned with such pre-war diversions as the celebration of modern life or the simultaneity of experience; they concentrated almost exclusively on the freedom of Cubist art and of their poetry from the description of things. What was important now, they said, was that artists should create or invent their own images out of their own imaginations without using observed reality as a basis. It was in the context of this increasing stress on the distance between the art-work and all that it referred to in life that Gris and Lipchitz began to work towards procedures which would exclude any starting-point in observed reality altogether. Picasso had of course achieved

27. Henri Laurens, *Woman with a Guitar*, 1919. Stone, height 23¼in. Private Collection.

this long before, capable as he was of visualizing directly his figures and objects as schematic Cubist signs, and so almost certainly had Laurens with his first Cubist constructions in 1915; but Gris and Lipchitz seem to have required a more definite guarantee of their freedom from the model or motif. Gradually they shifted towards a working process (later called the 'synthetic method') in which the manipulation of shapes in the abstract was the ideal starting-point, those shapes only later being made to denote figures or objects or landscapes.

The possibility of a shift in this direction is already signalled by certain paintings that Gris made on his first visit to Beaulieu-près-Loches in the autumn of 1916, most obviously by a large interpretation in oils of a Corot of the 1860s, *Woman with a Mandolin* (Plate 212), and by its sequel, his full-length portrait of his companion Josette in elegant Corot-esque pose (Plate 28). What is striking about these pictures from the point of view of process is the manifest primacy of the geometric armatures which control almost every detail of the composition. Gris seems to have ensured an overall unity of the parts in relation to the whole by constructing his figures on the basis of armatures consisting of overlapping triangles whose bases and apexes are at bottom and top of

the canvas. The shaping and orientation of every element, even the small planes of the faces, respond to that simple containing structure drawn from the edges of the format; such idiosyncratic features as eyes, nostrils and finger-nails are tacked on as inessential additions. In both pictures Gris seems to have started with his figure subject clearly in mind, but the possibility is unmistakably announced of the abstract geometric structure itself as the starting-point, its main lines generating configurations of flat shapes which need not be given a specific denotational meaning until the pictorial idea is quite far advanced.[31]

It was not until 1919 and especially 1920 that artists and commentators began to write recognizably about the 'synthetic method'[32] and insist on its importance; and it is impossible to say with certainty that either Gris or Lipchitz in 1917 (or even later) conceived every part of any particular composition in this way, beginning with the manipulation of abstract shapes alone. There simply is not enough evidence in the works themselves to say so. Yet, that such a working process became more and more a possibility is certain and that these artists came closer to its application is certain too.

The case of Lipchitz is the clearer cut, the Lipchitz of such important figure sculptures as *Seated Bather* of early 1917 and *Bather III* of late that year, both carved in stone and also cast in bronze (Plates 29 and 30). In extensive interviews with him shortly before his death, Deborah Stott has established that he believed these figures to have indeed begun as abstract arrangements of shapes visualized in the block.[33] Undoubtedly he saw them as arrived at quite differently from such stone carvings of 1916 as *Man with a Guitar* (Plate 31), where he had built on or abstracted from a schematic figurative beginning much as Picasso had in developing the idea of *Man Leaning on a Table* (Plate 15). And the way he talks about his new working process specifically connects it to his use of a geometric structuring of the kind developed by Gris in his figure paintings at the end of 1916. He remembers making detailed preparatory drawings using 'a chart of proportions based on the Golden Section', his geometric pattern of triangles being applied at the start to the image of the cubic stone block with which he had to work.[34] In this way an abstract schema does seem to have become the generator of his figures, a schema visualized always in three dimensions. Actually, as Stott realizes, the process was probably not at all straightforward, and he was not rigid about his application of the Golden Section. Given the proportions of the stone blocks he carved (or had carved) and his exclusive interest in the figure between 1915 and 1917, there is little doubt that he always had a figure in mind from the beginning, but it was apparently the intersecting triangles of his abstract armatures that generated the particular qualities of shaping and posture in these *Bathers* and probably to a higher degree than in Gris's Corot variation and his Corotesque *Portrait of Josette*.

Ironically, this purification of Lipchitz's working method did not lead to greater abstraction, but to the reverse. Moving more from the abstract manipulation of shapes to synthetic Cubist figures, he achieved results which are instantly legible; something most clearly so in the *Seated Bather* but so too in the far more complex and contorted *Bather III*. Lucidity was often to be a characteristic of the images made by artists who claimed to work thus. And yet the results of such a method were, of course, profoundly anti-naturalistic, still further distanced from the appearance of things in life.

Lipchitz's move towards a more distilled Cubism in 1917 was guided as much by the need to arrive at tightly integrated structures as by the need to purify; so was Gris's, and as in the figure paintings of late 1916 the primary function of the

28. Juan Gris, *Portrait of Josette Gris*, October 1916. Oil on canvas, $45\frac{5}{8} \times 28\frac{1}{2}$ in. Museo del Prado, Casón de Buen Retiro, Madrid.

29. Jacques Lipchitz, *Seated Bather*, 1917. Bronze, height 32¾in.
Marlborough Gallery, New York/London.

30. Jacques Lipchitz, *Bather III*, 1917. Plaster, height 28¾in. Musée
National d'Art Moderne, Centre Georges Pompidou, Paris.

geometric armature continued a crucial factor.[35] Again in
The Chequerboard of March 1917 (Plate 32), everything is
dictated by a flat architecture of overlapping triangles drawn
from the edges of the canvas; and, though it can be demon-
strated that Gris still probably composed from the outset
with fairly fixed ideas for a limited range of objects in mind,
the generative power of that armature is obvious, for only
the over-size glass (centre left) has been fully elaborated and
Gris has yet to add the details that would make the syphon
on the right and the other objects of the still life finally
identifiable without difficulty.[36] They and the abstract struc-
ture of planes are still one.

As the year went on, so Gris's painting developed in such
a way that the possibility of starting *without* figure or still
life in mind visibly increased. The basic role of the geometric
armature remained a factor, but there was a second key
factor in this: Gris's development of a vocabulary of shapes
or pictorial elements, which (like Picasso's interchangeable
signs) could be used flexibly to denote different things, and
so to build different objects. During 1917 Gris's vocabulary
never became as elastic as either Picasso's or Laurens's, but
by the end of the year the relations between things in his
painting had become interchangeable enough to create
ambiguities, occasionally of a bewildering kind, something
very clear in two elaborate canvases, one finished in November
the other in December: *Fruit-bowl, Pipe and Newspaper* and
Still Life with Plaque (Plates 33 and 306). They are both, for

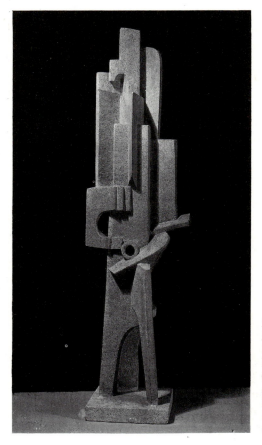

31. Jacques Lipchitz,
Man with a Guitar,
1916. Stone,
height 38¼in.
Collection, Museum
of Modern Art,
New York.
Mrs Simon
Guggenheim Fund.

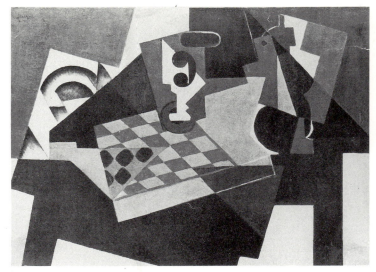

32. Juan Gris, *The Chequerboard*, March 1917. Oil on panel, 28¾ × 39⅜in. Collection, Museum of Modern Art, New York.

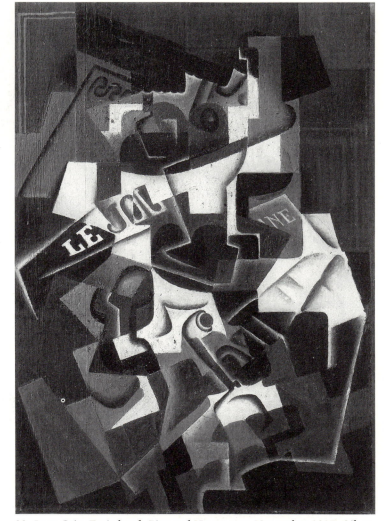

33. Juan Gris, *Fruit-bowl, Pipe and Newspaper*, November 1917. Oil on canvas, 32 × 25¾in. Oeffentliche Kunstsammlung Basel, Kunstmuseum.

34. Jean Metzinger, *Still Life, Fruit-bowl and Cup*, November 1917. Oil on canvas, 31½ × 25½in. Sale: Sotheby & Co, London, 16 April 1975.

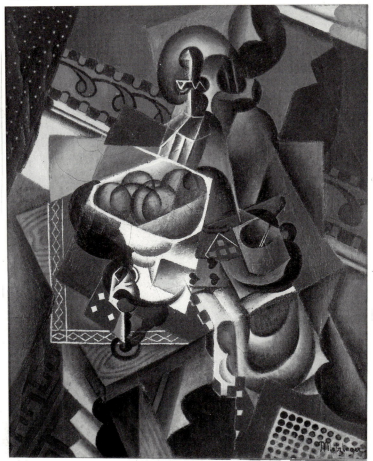

Gris, dynamic, open compositions, the jostling diagonals of the first attuned to the mobility of Lipchitz's *Bather III*, but in both he structured his compositions again by means of underlying armatures, almost certainly drawn out with measuring instruments on the primed canvas, the Golden Section ratio firmly in mind. The two compositions, however, are complex enough to mask the order on which they are based, and with this goes their relative ambiguity. So flexible have the meanings of configurations become that identities are obscured. In the November picture the black profile shape of the fruit-bowl could also be the liquid in the bottle or even the top of a wide-bowled glass; in *Still Life with Plaque* the fruit-bowl, the glass and the carafe's upper portion are almost interchangeable. and especially in the latter new objects can seem on the point of 'appearing' in the empty spaces between things, so elastic has become the relationship between Gris's habitual ways of combining shapes and signifying objects.

Though the evidence is more partial (both visual and documentary), by the end of November Metzinger too was working with a comparable dependence on underlying geometric armatures, integrating structure and sign so that a comparable flexibility is at least plausible. He was capable of producing pictures closely attuned to the Gris of *Fruit-bowl, Pipe and Newspaper* and the Lipchitz of *Bather III*. His *Still Life, Fruit-bowl and Cup* is one such (Plate 34).[37] The three artists were moving very much in the same direction.

1918–19 saw the consolidation of this move towards a 'purified' synthetic Cubism rooted, as a matter of principle, in the abstract. In this all three were together, but the completeness of the record of Gris's work through the period and the precision with which it can be dated makes it easiest to follow the process of distillation by looking first and most fully at his case.[38] The crucial period for Gris was the spring and summer of 1918 which he spent at Beaulieu-près-Loches, joined there for a relatively brief stay by Metzinger and a much longer one by Lipchitz, as already mentioned, and also joined by Reverdy's Chilean ally, the poet Vicente Huidobro, and by the Spanish painter María Gutíerez Blanchard.[39] While Ozenfant, Jeanneret, Lhote and Rivera contemplated the death of Cubism near Bordeaux, the movement flourished in the Touraine, with Gris a central figure.

Oddly, the distillation of Gris's Cubism at Beaulieu went with his decision to take up new subjects for painting, and, once again, to draw from nature. He allowed himself to respond directly to the new everyday objects at hand, to his

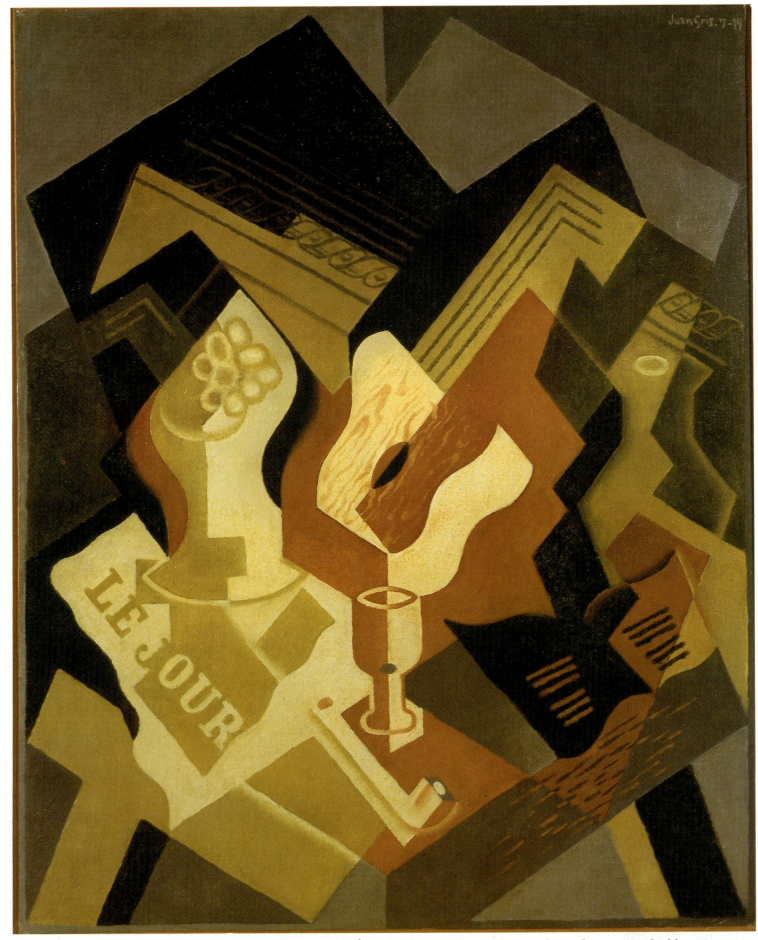

35. Juan Gris, *Guitar and Fruit-bowl*, July 1919. Oil on canvas, 36¼ × 29in. Sonja Henie – Niels Onstad Foundations, Høvikodden, Norway.

country neighbours and to the prettiness of the weathered limestone buildings of Beaulieu in their soft fluvial land-scape.[40] Yet, though his new subjects certainly encouraged him to vary his repertoire of forms, what is striking about the pictures he made is their distance from their models or motifs. This is clearest of all in the one known instance of a

Cubist composition with a representational starting-point in a drawing, *Pipe and Tobacco-pouch* (Plate 38), whose stark combinations of flat shapes in blue and yellow seem almost unaffected by the subtleties of the naturalistic drawing that lies behind it (Plate 37). Like Picasso in 1914 (Plates 12 and 14), Gris seems either to have worked at this stage represen-

tationally altogether or to have visualized his subjects directly in the simple terms of his synthetic Cubism. Further, at Beaulieu in 1918 the configurations he manipulated became even more semantically elastic as signs, something already to be seen in the structural and formal similarities between two pictures of April and March with very different subjects, *Houses at Beaulieu* and *Harlequin* (Plates 39 and 40).[41] Not merely different still-life objects but even buildings and figures have become virtually interchangeable. It was this increasing semantic elasticity more than the primacy of the geometric armature that was the key to the continuing processes of distillation in Gris's work; and the most obvious evidence of distillation is to be seen in the most obvious product of that elasticity: the visual rhyme.

By the end of Gris's stay at Beaulieu rhyming had become a particularly noticeable feature of his painting, nowhere

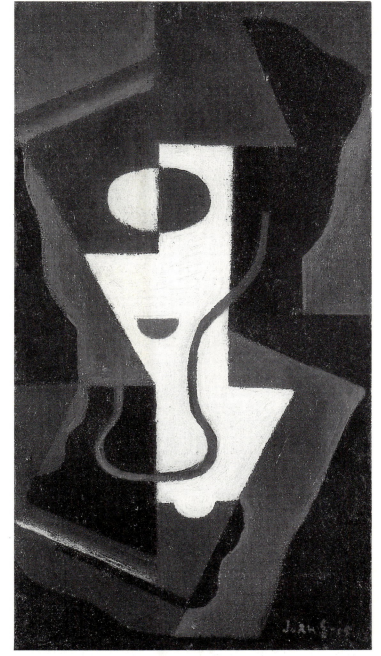

36. Juan Gris, *The Glass*, March 1919. Oil on canvas, $13 \times 7\frac{1}{2}$in. Collection, A. Thustrup, Djursholm, Sweden.

more so than in the sturdy *Man from the Tourraine*, which he finished in September 1918 (Plate 174). The buttons, eyes and the bottle-top are simple rhyming circles, the pipe and glass-bowl reply to one another, as do the bottle-neck and shoulder

taken together and the head and hat taken together, while the hand and the sleeve-creases above it are almost exact echoes. Similar configurations everywhere take on different meanings: rhymes tie the painting together.

Kahnweiler was the first to underline the purifying role of Gris's development of pictorial rhymes in 1918–19. He did so by pointing to their relationship with the poetic 'image' as understood by Reverdy and the *Nord-Sud* poets at the time. 'The image', Reverdy had written in a brief but influential piece published the month before Gris's departure for Beaulieu, 'is a pure creation of the spirit. It cannot be born of comparison but [only] of the *rapprochement* of two or more distant realities.'[42] Thus conceived, for Reverdy the 'image' was an especially potent way of rendering the poem autonomous: a composition with its own conjunctions and therefore its own emotional charge. An image like Huidobro's 'Wings raining/Cover the earth', from a poem of 1917, detaches the two 'realities' rain and wings from their usual situation in life and gives them a new identity because of their coming together, which is further transformed by its absorption into the idea of autumn and leaves falling.[43] Gris's rhymes could be thought of (and were) as conjunctions which worked similarly to lift the ordinary things they denoted onto the plane of the Reverdian poetic image.[44] And yet, at the same time it is worth stressing that on the simplest *formal* level (rhymes as rhymes and no more) they led perhaps even

37. Juan Gris, *The Tobacco-pouch*, April 1918. Pencil. Galerie Louise Leiris, Paris.

38. Juan Gris, *Pipe and Tobacco-pouch*, 1918. Oil on canvas, $18\frac{5}{8} \times 22$in. Collection, Olivier Bernier, New York.

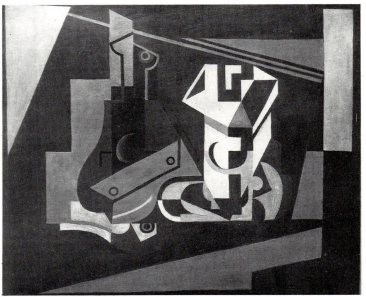

more effectively to a purification in practical terms. For on this level they asserted especially clearly the switch in Gris's priorities that had been going on for at least a couple of years, from subject-matter to formal relations. At Beaulieu Gris might have turned to new subjects, but these subjects were adapted *to* his increasingly elastic pictorial language, not his pictorial language to them. The way he built his pictures came first. All the Cubists, including Gris himself, had used rhymes before (even before 1914), but at Beaulieu he exploited them with a decisiveness that gave them a fresh significance.

Back in Paris after the Armistice, by the summer of 1919, Gris was developing pictorial rhyming with great confidence and freedom in all genres, from a new series of *commedia dell'arte* figures to new still-life inventions, and it is certain that often by this time he really did work from the abstract to the concrete. The development and expansion of one particular still-life idea in two related pictures shows unusually well what was open to him. The earlier of these is the small canvas *The Glass*, probably painted in March 1919 (Plate 36), an arrangement of flat shapes which are in a very real sense non-objective since they have no *definite* objective identity (except in the detail of the pipe).[45] In July Gris expanded on the idea to make *Guitar and Fruit-bowl* (Plate 35). The pipe and glass (the latter's identity now definite) are the core of an elaborate grouping of objects which seems literally to have grown upwards from it. The guitar seems to have been generated in response to the wavy contour which echoes in silhouette the glass's profile in the earlier picture; the fruit-bowl and grapes seem to have been generated in rhyming response to the guitar; and the carafe seems to have been generated by the angled lines of the armature built to discipline the whole. It is possible to see plainly how Gris could indeed now work from the abstract (the suggestively but ambiguously general) to the concrete (the specific); such a practice operated in such a way could very well lie behind all the still lives he made in 1919. The proliferation of visual rhymes was its clearest symptom, and it was marked rather by lucidity in the presentation of its subject-matter than high abstraction.

Alongside Gris at Beaulieu Lipchitz made his own exploration of the semantic elasticity of Cubist signs and structures; significantly he did so that spring and summer of 1918 in two dimensions because he had neither the material nor the equipment to produce free-standing pieces.[46] There were drawings and gouaches and a couple of polychromatic bas-reliefs which led to a series of reliefs in Paris. *Bas-relief I* is presumably the first of the two reliefs made in the Touraine (Plate 41).[47] Later Lipchitz was to say that these reliefs were 'purely rule from beginning to end', but drawings survive from 1918–19 which show how freely he experimented to arrive at his ideas and how flexible was his vocabulary of shapes, how open to changing identities.[48] So unspecific is the complex of interlocking shapes in the charcoal study (Plate 42) that no clear-cut subject has emerged, and one can only guess at the possibility of a future guitar, while the evidence of an open-ended process, constantly redirected by erasure and new decisions, is obvious. In *Bas-relief I* the forming of the bottle's head and shoulders is almost exchangeable with that of heads and shoulders in earlier figure pieces like *Seated Bather* (Plate 29). As in Gris's painting, the deliberate development of visual rhyming came with Lipchitz's increasing exploitation of this flexibility, and this is especially apparent in the pieces he made back in Paris during 1919, where once again he could produce free-standing figures: pieces like *Pierrot with Clarinet* (Plate 43).

Preliminary drawings show how Lipchitz was still work-

39. Juan Gris, *Houses at Beaulieu*, April 1918. Oil on canvas, $35\frac{1}{2} \times 25\frac{3}{8}$in. Collection, Rijksmuseum Kröller-Müller, Otterlo, The Netherlands.

40. Juan Gris, *Harlequin*, May 1918. Oil on canvas, $32 \times 23\frac{5}{8}$in.

41. Jacques Lipchitz, *Bas-relief I*, 1918. Painted plaster, 22 × 14 × 2⅜in. Marlborough Gallery, New York/London.

42. Jacques Lipchitz, *Study*, 1918. Charcoal, 13¾ × 9¾in. Marlborough Gallery, London/New York.

ing from geometric armatures visualized in the block, and the clear oblique accents established by those armatures give both movement and coherence to a sculpture like *Pierrot with Clarinet*.[49] Typically here a rocking equilibrium is created around a sensed central axis which echoes the structure of Gris's *Guitar and Fruit-bowl* (Plate 35), and, as there, the composition is tied together on this framework by a pattern of rhymes, except rhymes which work in three dimensions. An early drawing for the piece shows that the succession of circular rhymes centred on the concentric face, hat and ruff was a theme introduced at the outset.[50] In the sculpture, sound-holes, buttons and the clarinet's aperture all join in, their interrelations exploited fully in the round. Hat and face are cylinders which interpenetrate; on the concave surface of the face (a negative rather than a positive), the eyes are protrusions which echo the protruding holes of the instrument. These are not mere echoes of Gris's pictorial rhyming, they are thoroughly sculptural. The mark left on Lipchitz's sculpture by pictorial rhyming was more than skin deep.

There can be no doubt: the paintings of Gris and the sculpture of Lipchitz represented Cubism in its distilled condition most quintessentially of all in 1918–19; but by the time of his Effort Moderne exhibition Metzinger's painting was seen as very much akin and highly significant. He was treated as one of the leaders.[51] *Woman with a Coffee-pot* (Plate 45) was almost certainly painted after his exhibition, probably towards the end of 1919;[52] it is a very complete essay in the new purified Cubism. A primary geometric armature clearly disciplines everything, but it is not obtrusive

and the effect of integration is complete. Woman, still life and setting flow together and the main lines of the armature are so skilfully fused with their shaping that it is not felt as alien. Pictorial assonances and rhymes proliferate: the handle of the coffee-pot echoes the back of the chair, the saucer flows into the hand, the hand is echoed by the matchbox and then above by the pattern of shadows laid across the woman's head, the curves of the shoulder flow into those of the pot and echo the curtain; analogies and coalescences of form are everywhere. So flexible has Metzinger's vocabulary become, indeed, that he even attempts a pictorial joke: the spout of the coffee-pot is too easily read as a substitute breast for it to be an accident.

The distillation of the Cubism of Gris, Lipchitz and Metzinger meant certainly a narrowing of its scope, but it did not bring with it the end of those games with spatial suggestion and ambiguity that continued so to absorb Picasso and Laurens. All three continued to play them, but, especially in the period 1917–19, they played them within a distinctly limited area. The paradoxical was allowed the space it needed, but not too much of it.

As we have seen, it was Gris (alongside Diego Rivera) who had initiated the exploitation of the open-air backdrop as the pretext for more elaborate games with pictorial space. His most ambitious early exploration of the theme was *Still Life and Landscape (Place Ravignan)*, finished in June 1915 (Plate 47), and already here he was able to play virtually all the paradoxical games opened up by the window. Different lighting effects, warm and cool, along with telling perspectival markers fix the brackets of a possible depth behind the flattened indoor still life, but foliage and railings cross unhindered from outside to inside and the central planar structure extends to contain and flatten everything up onto the surface, its

elements pushing forward into the spectator's space as one plane overlaps another with typical post-*papier-collé* persistence. At the end of 1917, Metzinger too explored the whole range of these conflicting effects in such pictures as *Still Life, Fruit-bowl and Cup* (Plate 34), adding other effects by setting his tipped-up tables almost dizzyingly upon patterned floors.[53] But by that date Gris had already begun to contain his pictorial spaces (he did not use the open-window backdrop at all in 1916–17), and in 1918–19 Metzinger followed suit.

By the spring and summer of 1918 Gris and Metzinger together had decided to confine their pursuit of paradox within a suggested pictorial space whose maximum depth was rarely more than that of relief sculpture. A positive point is made of this already in Gris's *Still Life with Plaque* (Plate 306), but it is a feature too of both Metzinger's *Still Life with Fruit-bowl* of early 1918 (Plate 179) and *Woman with a Coffee-pot* (Plate 45). Even in a picture like *Harlequin at a Table* (Plate 46), where Gris allows his ambiguous spatial

43. Jacques Lipchitz, *Pierrot with Clarinet*, 1919. Bronze, height 31in. Private Collection, New York.

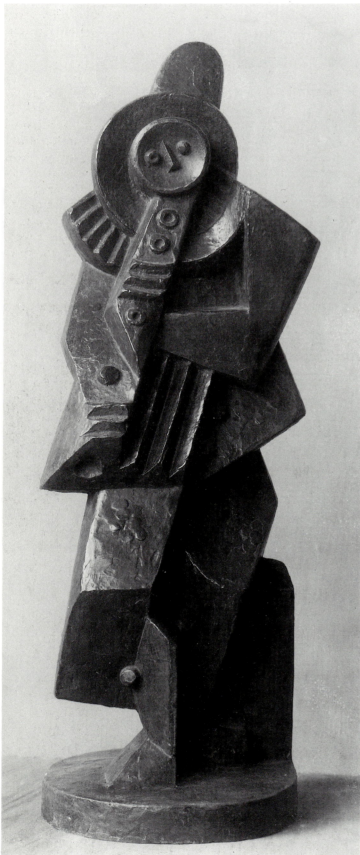

44. Jacques Lipchitz, *Demountable Figure*, 1915. Bronze, height 27¼in. Private Collection, New York.

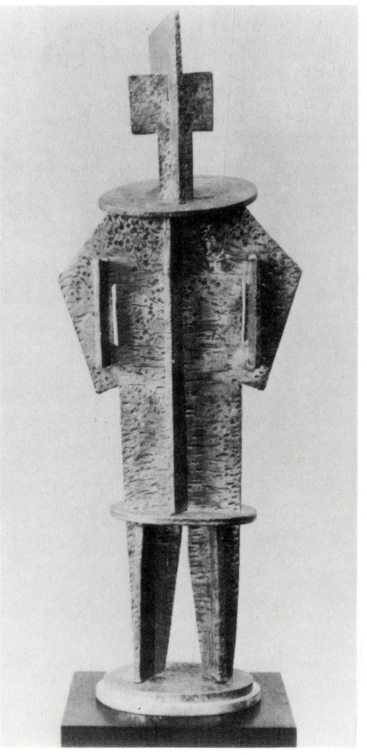

effects a little more room, the accent is on containment: the easily read floor establishes firmly enough the idea of a three-dimensional structure in depth, but Gris shuts off any possibility of deep recession by fusing indissolubly the figure and background wall. The conflicts between flat fact and

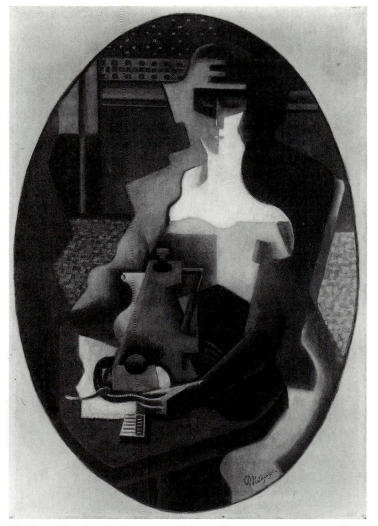

45. Jean Metzinger, *Woman with a Coffee-pot*, 1919 or 20. Oil on canvas, 45¾ × 31⅞ in. The Tate Gallery, London.

spatial fiction remain, but they are condensed, closed-in, shut away; and the thick, immaculate paint surface, homogeneously sealing the picture plane, enhances the effect.

If the taking into Cubist compositions of outside space (by way of the open window or the mirror) represented a taking of possession, such a contraction of space represented by the same token containment. Here too a space is created which is patently under the control of the artist, subject to the artist's manipulations, but in this case that fact is even more made manifest. Gris and Metzinger respond to the uncontrollable impetus of war, the transience it repeatedly and painfully brought home, by constructing condensed spaces, rigorously kept under control, in which things can acquire a kind of immaculate inviolability.

Lipchitz had no need to restrict the room for spatial games-playing in his sculpture of 1918–19. Unlike Picasso and Laurens, he had never been tempted to entrap surrounding space by means of jagged extrusions from the main body of his pieces. His synthetic Cubist sculptures were from the beginning both paradoxical and compact, something already clear in *Demountable Figure* of 1915 (Plate 44) which was, he later said, the starting-point for his entire exploration of the relationship between solid and void in sculpture, a sort of three-dimensional diagram to illustrate for himself just how intersecting planes could be used to suggest volume without enclosure.[54] Lipchitz was as committed as any Cubist to the pursuit of paradox, and, in fact, though he remained loyal to stone and bronze, he composed very much in a 'constructive' way. His carved and cast figures of 1916–19 (Plates 31 and 43), despite their palpable solidity, are actually the most lightweight of inventions; conceived in drawings, they are

as if constructed, like all synthetic Cubist ideas.[55] There is no question of 'truth to material' (and indeed from the beginning of his contract with Léonce Rosenberg the stone pieces were carved by a mason hired for the purpose, not by Lipchitz at all).[56] Stone and bronze are treated as so much stuff to be cut, shattered or shaped to the contours of an idea. It could even be said that such a use of traditional materials ultimately enhanced the impact of his sculptural paradoxes, for the instantly grasped density and weight of stone or bronze gives extra force to the reversals of solid and void so straightforwardly declared in a piece like *Seated Man with Guitar* (Plate 175) or so subtly developed in concert with the rhymes of *Pierrot with Clarinet* (Plate 43). Yet, the fact remains that however open and 'constructive' the conception, however forceful the paradoxes, Lipchitz's sculpture offered a consistently compact silhouette to the spectator. It was contained, closely controlled; it too shut out the extraneous.

There is a final point to be made about the condensed and distilled Cubism of Lipchitz's sculpture and of Gris's and Metzinger's painting in 1918–19; it follows from Lipchitz's loyalty to traditional materials. The point is that the palpable substance of Lipchitz's stone and bronze, and the carefully built-up paint surfaces of Gris's and Metzinger's pictures become, in conjunction with their stable compositional structures, the signs of solid 'worth', just as they do in Laurens's stone and terracotta pieces and Picasso's sanded oils. If Lipchitz rejected the disposable look of multi-media construction, so Gris and Metzinger, like Picasso, rejected the obvious impermanence of collage and *papier collé* (and Gris did so too from

46. Juan Gris, *Harlequin at a Table*, June 1919. Oil on canvas, 39⅝ × 25⅝ in. Private Collection, Chicago.

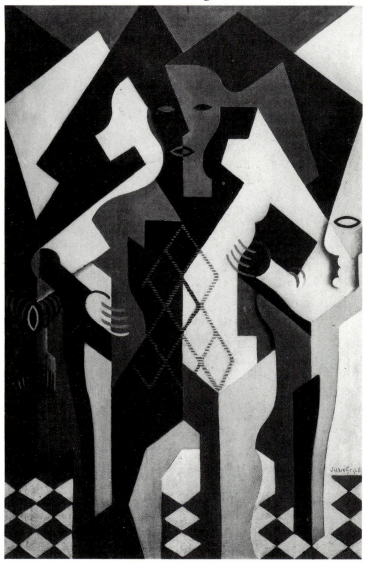

47. Juan Gris, *Still Life and Landscape (Place Ravignan)*, June 1915. Oil on canvas, $45\frac{5}{8} \times 35$in. Philadelphia Museum of Art. The Louise and Walter Arensberg Collection.

the very beginning of 1915). Their work made a *material* statement of its resistance to the transience of everyday life, and by doing so accented the gap between the aesthetic and the non-aesthetic with a new and deliberate insistence. Every-thing about it was to be seen as stable, enduring and pure; everything about it invited that most adhesive and durable of analogies, the classical analogy, with all that it implied concerning art and the ideal.

From at least the beginning of 1917, as we have seen, the need to align Cubism with the Latin virtues of clarity and order was a dominant within the circles of Rosenberg's galerie de l'Effort Moderne and Reverdy's *Nord-Sud*. That year Reverdy made a point of stressing the 'eternal' in his analysis of Cubism,[57] Braque published a series of aphorisms in which he spoke of 'limitation' as the route to 'style',[58] and Paul Dermée declared open 'a period of organization, of classification, that is to say, a classic age'.[59] The distillation of Cubism was habitually made the complement to the ideal of Classicism. And the artists themselves supplied the necessary substantiation not only by the material and aesthetic qualities of their work but by turning more often to such figures as Cézanne and Corot for support, and occasionally by signalling as much in their choice of subjects. Gris's *Portrait of Josette* (Plate 28) with its origins in *Woman with a Mandolin (After Corot)* (Plate 212) and in a series of studious pencil drawings made after reproductions of Cézanne is an obvious case in point, and so is Picasso's *Italian Girl* of 1917 (Plate 219) with its equally Corotesque fancy-dress subject;[60] while the decision (initially made by Picasso) to return to *commedia dell'arte* subjects was certainly made with a traditional lineage in mind, the lineage that went back through Cézanne to the Watteau of *Gilles* (Plate 216). (Significantly, when Lhote exhibited a *Homage to Watteau* at the Salon d'Automne of 1919, he centred his composition around the personage of harlequin (Plate 60).)

This Cubist Classicism is, again as we have seen, to be placed within the context of that wartime campaign for a national 'call to order' so vividly recovered by Kenneth Silver.[61] But it is important to realize (as Silver does) that this was a campaign that did not slacken with the sudden coming of peace in November 1918. Order remained the keynote as post-war reconstruction commenced. It is not surprising, therefore, to find a continuity in the development of Cubist art as the transition was made from war into peace, an unbroken commitment to the Latin virtues along with an unbroken commitment to the aesthetically pure. The new Cubism that emerged, the Cubism of Picasso, Laurens, Gris, Metzinger and Lipchitz most obviously of all, has come to be known as 'crystal Cubism'.[62] It was indeed the end-product of a progressive closing down of possibilities in the name of a 'call to order'. Limitation (to use Braque's word) had indeed led to what could be seen as a style: a Cubist style shared by a group of the movement's leaders too prominently in the foreground to ignore.

Herbin and Severini

There were others who, at the end of the Great War, could have been taken as living evidence that Cubism still flourished. Of the important figures of the pre-war period, Raymond Duchamp-Villon had died from wounds sustained on the front, Roger de la Fresnaye's health was broken, Gleizes and the Delaunays were not to return from self-imposed exile until late 1919 and 1921 respectively; but Archipenko had been at work throughout the War in Nice from where he had returned to Paris by May 1919, and both Braque and Léger began to work again from 1917, and exhibited in the sequence of Effort Moderne exhibitions as leaders once more. Besides them there were lesser Cubists who continued as lesser Cubists: Léopold Survage, Josef Csaky and Auguste Herbin; and there were new-comers too: the one-time Futurist Gino Severini, the Pole Henri Hayden and the Spaniard María Gutíerez Blanchard. All these 'lesser' or 'new' Cubists were also involved with the galerie de l'Effort Moderne, and certainly the work of three

of them can be described too as crystal Cubist in a complete enough sense: Blanchard, Herbin and Severini. Blanchard's Cubist painting in 1918–19 is distinctive but at the same time closely linked to Gris's (she was one of those at Beaulieu-près-Loches in the summer of 1918).[63] Herbin and Severini each made their own far more independent contribution, and therefore invite separate consideration. Both stressed the ideal of purity, but while Herbin took this as the cue for increasing abstraction, Severini moved in the opposite direction, prophetically as it turned out.

Herbin was to see his development from 1917–20 as culminating in total abstraction, and certainly by 1920 he was producing paintings and coloured wooden reliefs which are in effect symmetrical abstractions (Plate 247).[64] He justified the geometric self-sufficiency of these works as the pioneering statements of a new monumental art, and yet there is no doubt that they were made possible by his own decorative variant of crystal Cubism. During 1919 Herbin made a number of large-scale compositions that came close to the abstract look of the ornamental works of 1920, but even as late as November he could still paint a picture like *Composition (Landscape)* (Plate 48) where the subject is made to tell. Also clear, however, in such a picture is the abstract decorative potential of his vocabulary of signs. Clouds, trees and hills are interchangeable, and this has led not merely to a proliferation of rhymes, but to passages that have the predictable repetitiveness of pattern-making. The firm compositional structure and the semantic elasticity of Herbin's rhyming signs make this a brighter, prettier variant on the Beaulieu style of Gris and his friends; what allowed Herbin to use it as the springboard for abstraction was the way he worked with those signs and with that mode of structuring.

Behind the abstract works of 1920 lie sequences of drawings the early stages of which show Herbin working with recognizable motifs much as he does in *Composition (Landscape)*. His practice was to start with simple synthetic signs for such things as trees or figures and then to refine and abstract them, guided by an overall (usually symmetrical) geometric armature.[65] It was a streamlined adaptation of the abstracting process that had led Picasso in 1915 to the almost indecipherable *Man Leaning on a Table* (Plate 15); it *reversed* the process common to Gris, Metzinger and Lipchitz, with its starting-point in the abstract, and *ended* in the abstract. What resulted in 1920 (Plate 247) was deeply alien to the distilled Cubism of those three, but, ironically, with its decorative role in the unrealized vision of a new monumental art, it was perhaps the most extreme manifestation of one of the central themes of crystal Cubism: painting as architecture. The structural core of the new Cubist style (the geometric armature), with a few embellishments, had finally been isolated and left to stand on its own.

While Gris, Blanchard, Lipchitz and briefly Metzinger worked at Beaulieu, Gino Severini spent the spring and summer of 1918 in the Haute-Savoie, first near Aix-les-bains, then high in the mountains at Le Châtelard.[66] Though completely out of touch there, he too had arrived at a structured, purified Cubism by his return to Paris, something already clear in *The Guitar* (Plate 50), one of the earlier pictures of his Alpine stay.[67] The neat rhyming relationship between guitar and glass in this picture testifies to the flexibility of his simple Cubist signs, and indeed the razor-sharp objects seem actually to have been generated by the underlying armature of triangles keyed to the format; it is quite possible that he too, on his own, had begun to work as far as he could from the abstract in the ideal synthetic manner (probably using drawings).

Yet, certainly by May 1919, the date of his show at the galerie de l'Effort Moderne, Severini's priorities were changing.

48. Auguste Herbin, *Composition (Landscape)*, 1919. Oil on canvas, 29 × 35½in. Private Collection, London.

50. Gino Severini, *The Guitar*, 1918. Oil on canvas. Collection, G. Mattioli, Milan.

49. Gino Severini, *Still Life with Mandolin*, 1919. Oil on canvas, 17½ × 26in. Private Collection, Florence.

He spent the summer and autumn of 1919 making pictures which were increasingly freed from the manifest purity of Gris's, Metzinger's or Blanchard's crystal Cubism. Already in 1916 he had dabbled in representation, painting, most notably, a portrait of his wife and child in a dry, vaguely Florentine Renaissance style (Plate 207), but where then he had kept such interests on one side, like Picasso, now he allowed them actually to transform such essentially Cubist works as *Still Life with Mandolin*, the product almost certainly of autumn 1919 (Plate 49).[68] The geometric armature still tells visibly here, but there is no longer any question that the shaping of objects has been generated by it, for a dry descriptive realism crisply discriminates between leaves, grapes, open book, mandolin and table-cloth. Severini still constructs the fruit-bowl from a Cubist kit of parts, and he restricts everything to a shallow pictorial space, but such pictures are unmistakably the first signs of a broader development among the Effort Moderne artists which would eventually lead to the end of crystal Cubism. Only their restraint and their structural clarity aligns them still with that style.

Strangely perhaps, this move towards the descriptive did not mean a muting of compositional artifice: Severini ordered his compositions with more rather than less geometric emphasis, a point signalled very directly here by the open book revealing a page from a treatise on number. As he moved towards representation, the Italian actually strengthened his grip on the architectural character of his art by attempting to give it a

solid mathematical basis and by making this plain. Gris, Metzinger and Lipchitz might all have worked with the Golden Section from at least 1916 to 1917, but, as Severini saw it, 'None of them had precise notions'.[69] During 1918 and 1919 he determined to redress this vagueness. He took to spending industrious hours researching the architectural treatises of Vitruvius, Leon Battista Alberti, Viollet-le-duc, Choisy, etc., with his wife Jeanne pressed into service to copy the most useful passages.[70] It was this that was the foundation of the increased rigour so obvious in the mandolin still life, and it was to lead not only to a more literally measured kind of painting but to Severini's own treatise, *Du Cubisme au classicisme*, published in 1921. Ironically, as Severini moved into a more mathematically controlled kind of painting, Gris and Lipchitz loosened their attachment to systems of all types. Stability and the *look* of precise control were to remain crucial to their Cubism for a while yet, but they no longer felt the need of systematic measurement to support these virtues. It is a further irony that, as Severini turned away from all that was abstract about Cubism towards a more visibly descriptive art, he immersed himself deeper in the abstractions of proportional mathematics.

Whatever the direction taken by Auguste Herbin and Gino Severini, their Cubism combined with that of Picasso, Laurens, Gris, Lipchitz and Metzinger during the first six months of 1919 to give the impression that a single type of Cubist art had emerged from the War. It invited classical analogies and it wore its purity on the sleeve. Behind this Cubism lay attitudes which were in the process of being highly refined: they encouraged an interest (however short-lived) in proportional systems, a sense of contact with traditional lineages, and (though there were exceptions) a working-method as abstract in its starting-point as possible. Crystal Cubism was good-mannered towards the past, lucid, controlled and, stressing the gap between art and life, made as much as possible of its aesthetic exclusivity. It was the outcome of four years in which the home front Cubists had sustained an unflagging determination to avoid the destructive realities of wartime in the interests of survival as artists. And its appearance of organized cohesion endorsed the prevailing ethos of the sudden new peace: the ethos of reconstruction.

Archipenko

In 1918–19 Cubism could appear, thus, a single phenomenon, but even then it was not all of a piece. There was one major

51. Alexander Archipenko, *Two Glasses on a Table*, 1919. Papier maché on wood, 22¼ × 18¼in. Musée National d'Art Moderne, Centre Georges Pompidou, Paris.

exception and at the same time two important directions were opened up in these years that were distinct enough to be taken as real alternatives. The major exception was the émigré Ukranian sculptor Alexander Archipenko, and the two alternative directions were opened up by Georges Braque and Fernand Léger.

Archipenko was in every sense a Cubist apart at the end of the Great War. He had spent the war years well away from Paris working in a villa at Cimiez above Nice, and when he returned to Paris at the end of 1918 or early in 1919 he did not enter the circle of Léonce Rosenberg.[71] What is more, though he was based on the fringes of Montparnasse until his move to Berlin in 1921, he spent much time during 1919 and 1920 on the move in Switzerland, Germany and Italy.[72] At Nice, however, he had been immensely productive, and his wartime work was certainly another reason for accepting Cubism's

survival as fact: in May 1919 he showed ten pieces at the gallery of the publishers Georges Crès et cie, and he showed also at the Salon d'Automne that year and at the Indépendants early in 1920. Neither he nor his sculpture was sucked into the debates that revolved around the pronouncements of Louis Vauxcelles and the exhibitions at l'Effort Moderne, but his Cubism could not be ignored and in Maurice Raynal he had an influential supporter from among those at the centre of the Cubist 'call to order'.[73]

An exception Archipenko might have been, but from 1916, he too moved towards a more condensed and controlled Cubist style, one that avoids paradoxical complexity for the sake of paradoxical complexity. The great bulk of his wartime work was in the form of what he called 'sculpto-painting'. It was assembled and constructed in relief; it brought together glass, wood, metal, papier mâché and plaster; but it used applied

colour as an overlay, often concealing the material qualities of these things far more comprehensively than either Picasso or Laurens in their constructions. In 1915–16 Archipenko made his painting of relief structures evoke elaborate illusory effects to play against the actual situation of elements in space; and he, like Picasso, took special pleasure in confronting the image with its mirror-reflection (or a painted suggestion of a mirror-reflection), something he had begun to explore already in 1913.[74] But by the date of his move back to Paris, he had turned to a far simpler combination of flat background support and projecting relief forms (often in plaster or papier mâché alone), with colour applied to sharpen spatial distinctions. Such is the case both in *Two Glasses on a Table* of 1919 (Plate 51) and in the sleek *Woman Standing* which was finished by March 1920 (Plate 52).[75]

His schematic synthetic Cubist signs for figure parts and objects are pared down to the utmost simplicity, and, though there is no evidence to suggest that he too worked now from the abstract to the denotational, they were interchangeable enough for there to be certainly one case (as early as 1916) where a confusion between figurative and still-life identities was knowingly exploited.[76] What is more, simplicity of sign goes with simplicity and clarity of structure, so that both pieces betray an underlying geometric armature as explicitly as either Lipchitz or Laurens at this time. The linear elegance of *Woman Standing*, the *éclat* of her polished surfaces and of the colour in the still life may be distinctly Archipenko's own, but neither of these pieces stands against the 'call to order' and the aestheticized refinement of crystal Cubism. At the same time, as one of the very first before 1914 to have exploited the reversal of solid and void in Cubist sculpture, he remained, like Lipchitz and Laurens, fascinated by the ambiguities thus released.[77] The head of his *Woman Standing* can be read as either concave or convex; one flank of her body is a negative to be read as a positive. Her most obtrusive relief forms are also the least palpably material, shaped as they are from bent sheets of metal polished to reflect (distorting mirrors made part of the figure). And she is so positioned in relation to the picture frame containing the flat painted support as to compound the ambiguity of the relationship between painting and sculpture.

For the brief while that Archipenko spent in Paris before his exit from the scene he was a Cubist to be taken seriously. He himself was indeed an exception, but, for all its obvious independence, his work was not. There may be few direct links between his sculpto-paintings and the sculpture (even the coloured reliefs) of Lipchitz and Laurens shown at l'Effort Moderne,[78] but the latest among them would not have looked at all out of place in Léonce Rosenberg's sequence of Cubist exhibitions.

Braque

Archipenko had been another non-combatant; Braque and Léger were both, significantly, combatants who returned late from the front to the milieu of the Parisian avant-garde, Braque only at the end of 1917, Léger only in the summer of 1918. Yet, the alternative directions that they opened up were very different.

War hero and war casualty Braque might have been, but the recent work he showed at l'Effort Moderne in 1919 gave not the slightest hint of what he had seen as a soldier. Behind it lay the priorities of a convalescent: a determination to

52. Alexander Archipenko, *Woman Standing*, 1920. Sheet metal and oil on burlap on wood panel, 73½ × 32¼in. Collection, The Tel Aviv Museum.

forget, to remake himself as he had been before. Braque did not avoid the realities of war, but he found it necessary that his art should. He too, like the non-combatants, was drawn to stress the purity of his Cubism, and in this at least he was not an exception.

More clearly perhaps than any other pre-war Cubist, Braque's exploitation of *papier collé* (after his invention of the technique in autumn 1912) had allowed him to use as a starting-point in his compositions an abstract play of shapes.[79] During 1918 he too, like so many, seems to have become aware of working once again thus. What is more, much of his painting from late 1917 through 1918 has qualities of structure and economy that echo those of crystal Cubism: the qualities stressed, of course, in his aphorisms for *Nord-Sud*. This is most obvious in the life-size *Musician* painted at the turn of 1917–18 (Plate 53). It is as if Braque had wished here to reinterpret his pre-war *papier collé* figure style with a new tightness and clarity.[80] Like the group at Beaulieu, he too works for an integration of subject and format, establishing an inner rectangle to impose demands on his figure; but his interchangeable vocabulary of space planes and figurative elements still has the look of *papier collé* and his pursuit of complicated overlapping relationships between planes creates a far more eventful pictorial space than anything to be found in, say, Gris's current painting, a space which is activated in front of the picture surface without the intrusions of paradoxical perspectives. The tricks of Braque's pre-war Cubism have been clarified and straightened up; he seems consciously to have held back his pictorial imagination so as to reconsider where he had been in 1914 in the Cubist terms of 1917–18. A continuity is established which gives the illusion that he had never been to the front.

This need to identify so closely with the dominant tendency in the Effort Moderne circle was, however, short-lived, and by the end of 1918 Braque's painting had begun to assert its independence from the crystal Cubist model. He had begun to make pictures which were looser and sometimes hardly at all geometric. On the reverse of the canvas *Waltz* (Plate 203) a label indicates a date of December 1918; for this little picture the metaphor of the crystal is obviously irrelevant. At Braque's exhibition three months later, *The Musician* was confronted by three unusually large pictures, whose subject was to be a recurrent obsession of his for a decade, objects placed on a full-length pedestal table; they share the looseness of *Waltz*. One of them was *The Pedestal Table* (Plate 54), its exact contemporary.[81]

The Pedestal Table is not without structural rigour, but the shaping of guitar and fruit-bowl, echoing to the extent of pictorial assonance the ogee curves of the table's pedestal, threatens that effect of control, and the subject as a whole has provoked a spatial treatment even more elaborate than *The Musician*. In 1918 Braque began to work his paintings up from dark grounds, and this is so here. The dark ground is dominant towards the peripheries intimating a depth behind, indeed fixing quite clearly a background plane part of which is the window with the fragment 'fé-Bar'. The deep tones of that background plane are allowed right through into the solid heart of the still life, but so clearly has Braque managed the overlapping of one surface by another that they are pulled forward with compelling effect here as the table tips up to thrust the still life out at the spectator. This tipping up of the table-top, and this fusing of depth and surface had, of course, become Cubist habits, but by so palpably suggesting interior space, and by taking the table whole, pedestal and all, Braque gives it unusual immediacy. Picasso was to explore the same possibilities in the open-window series later in 1919 (Plate 18), and it is worth remarking that, though they

were no longer the inseparable allies of 1913–14, his and Braque's Cubism came quickly to share now a spatial richness found hardly at all in the Cubism of the other Effort Moderne painters.

It was not, however, in its spatial richness that Braque's work opened up another direction in 1919; it was most of all in the growing sensuality that went with the loosening up of his formal vocabulary.[82] An overtly sensitive line and a softness of contour complemented a delight in textures and in the glow lent colour by his dark grounds, something especially to be found in a few small pictures like (alongside *Waltz*) *Still Life: The Newspaper* (Plate 55). Warm hues light up, edges wriggle and quiver as immediate records of the artist's touch, paint is lusciously tactile. At the turn of 1918–19 Braque could still paint pictures characterized by restriction, chromatically unappealing and almost repellent to the touch, but the appearance he could present of sensitive informality in the pedestal-table still lives and their smaller relatives told most of where his painting would move on to in 1920.

Braque's exhibition at l'Effort Moderne excited a particu-

53. Georges Braque, *The Musician*, 1917–18. Oil on canvas, 87 × 44½ in. Oeffentliche Kunstsammlung Basel, Kunstmuseum.

54. George Braque, *The Pedestal Table*, 1918. Oil on canvas, 51 × 29¼in. Philadelphia Museum of Art; The Louise and Walter Arensberg Collection.

larly thoughtful response from one of those whose betrayal of Cubism had launched Vauxcelles on his campaign of 1918, André Lhote. He too wrote of a dying movement, its ambiance of death captured in what he felt was the funereal sombreness of Braque's colour; and, typically, led on by Braque's epigrams of 1917 in *Nord-Sud*, he stressed the restraint of the paintings. Yet, dimly he perceived other qualities, the very opposite of morbid. He saw in Braque a latent 'baroque' charm and power, and he delighted in the material attractions of the paint surface. 'The "recipes" of Gustave Moreau', he wrote, 'crushing precious stones [into the paint] are easy tricks alongside the extraordinary refinement at which [Braque] arrives. In his sand, dirt, the most earthy of materials are ennobled with unsurpassable science.'[83] Lhote did not yet see that such unconcealed sensuality could lead away from the spirit of austerity so plain in the *Nord-Sud* epigrams; neither did any other critic, at least in print. Very soon, however, it was to take Braque so far from the others in the Effort Moderne circle that for some it would make him no longer a Cubist at all.

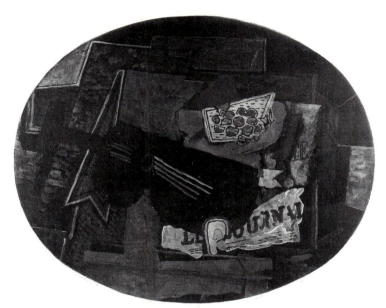

55. Georges Braque, *Still Life: The Newspaper*, 1919. Oil on canvas, 25¾ × 31⅞in. Musée d'Art Moderne de la Ville de Paris.

Léger

An ambiance of death did not, for any critic, characterize the exhibition at l'Effort Moderne in February 1919, the month before Braque's: the Léger show. Such was the *éclat* of Léger's colour that André Salmon even went so far as to mention the Fauves, finding him infinitely superior in the way he could use high-keyed hues without destroying volumes or the sense of space between them.[84] The alternative direction opened up by Léger could hardly have been further removed from Braque's.

The contrast between Léger and Braque is as obvious as anywhere in the way their Cubism relates to their war experience. Unlike Braque, Léger had been one of those mobilized artists who sketched avidly what he saw as a soldier (Plate 9). For him, his period on the front in the Argonne, the Aisne and at Verdun was perhaps the most crucial in his life.[85] As much as what he saw, it was the way he lived that marked him: his companions were peasants, working men and artisans, and he identified completely with them.[86] Like Braque's, his war ended with shattering injury and slow recovery, but what he had experienced was too important for him to employ selective amnesia as a route to health. There had to

be a direct relationship between what he had seen on the front, along with the change wrought in him by his life there, and the new direction of his art.

The major immediate effects of his determination not to break the link between his work and his life as a soldier are, at first glance, surprising. It meant that, like Braque, he made no post-war break with his pre-war Cubism. The reason for this is two-fold. First, it followed from a strong antipathy Léger felt towards the distilled Cubism he found on his return to Paris from convalescence, an antipathy that was the natural complement to his determination not to forget the realities of the front. Second, it followed from the use he made of his war drawings as a starting-point for much of his new work, because those drawings, with their accent on the anonymity and destruction of mechanized warfare, had kept alive in many respects his pre-war idioms. Where war on the home front had encouraged the process of refinement and purification that we have followed, war on the front deepened Léger's pre-war convictions as a painter. He was a pre-war painter of modern life whose beliefs had been intensified by survival as a soldier.

In his review of Léger's Effort Moderne exhibition, André Salmon picked out one picture for special mention; it was for him the most remarkable evidence of Léger's decision ('the first after Picasso') to 'humanize' his art.[87] This was *The Card Game* (Plate 56); it was one of the major works on show and it was a war painting (finished while Léger was hospitalized in December 1917). The subject here is not ordinary objects, a well-tamed landscape or a politely posed model; the subject counts, and Léger uses simple pictorial elements, metallic cylinders clashing against flat angular shapes, to say something about it. The properties of his pictorial elements are made integral with the presence of the soldiers who wait: it is the soldiers as such who are rendered mechanically anonymous and given the potential for irresistible action.

A subject picture based on observation (indeed directly on drawings made at the front) (Plate 9), this might seem a kind of picture well adapted to André Lhote's or Louis Vauxcelles's idea of where most beneficially Cubism could lead, but this is a misconception and Salmon at least realized as much, writing that here Léger humanized 'figures more removed from nature than those Picasso has dared...to construct'.[88] Already before the War Léger's pictorial vocabulary of geometric solids and flat angular planes had proved as flexible semantically as Picasso's then or as Gris's in 1918, capable of building representations of figures, still lives and landscapes equally well. It was thus in a thoroughly synthetic way that he visualized these soldiers, and it is not, therefore, surprising to find that *The Card Game* led to more rather than less abstracted works: to pictures like *Composition (Study for the Card Game)* (Plate 57) where metallic volumes and flat coloured planes collide without any clear reference to the figure at all. As in the cases of Picasso's *Man Leaning on a Table* (Plate 15) and Herbin's geometric compositions, a process that started with elemental Cubist representations and then proceeded by abstraction led inevitably away from the subject.[89] But even in these, the so-called cylinder paintings of 1918–19, Léger used the curvature of his volumes and their gleaming metallic highlights to stress their connection with things mechanical, something underlined when the cylinder paintings are compared to the very similarly conceived stone carvings of 1919 by Josef Csaky, the so-called *Abstract Sculptures*, where the cylinders, spheres and cones are left fused together as columns of pure Platonic solids stranded in abstraction because of their demechanized stone surfaces (Plate 58).[90] Léger's determination to draw together his painting with what he had seen at the front (guns as well

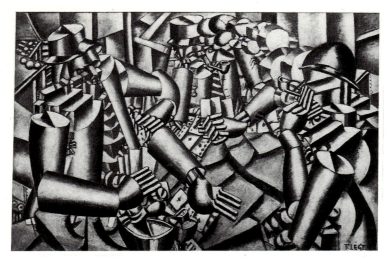

56. Fernand Léger, *The Card Game*, 1917. Oil on canvas, $50\frac{3}{4} \times 76$in.
Collection, Rijksmuseum Kröller-Müller, Otterlo, The Netherlands.

as soldiers) remained a factor. For Csaky, who had himself
volunteered for the front, it did not.

In 1918 and more often in 1919 Léger accompanied the
cylinder paintings with pictures where more fragmentary
elements are used in more dispersed compositional structures,
where the effect is more of disintegration than concentration.
The most daring and ambitious of these was *Composition
(The Typographer)* (Plate 59) which, despite the '17–18' date
on the canvas, was probably finished in 1919. Léger's dis-
integrated compositions relate more recognizably to develop-
ments in home-front Cubism during the War, but still he
adapts what he learns to his own special need to create
effects *equivalent* to certain kinds of modern-life experience;
still there is a range of connoted meanings not displayed by
home-front Cubism. In *Composition (The Typographer)* there
is an obvious relationship with the stable structures of pre-
war *papier-collé* and wartime architectural Cubist images,
and again the process behind the work is one of abstracting
and manipulating the elements of a simple Cubist represen-
tation, once more the figure.[91] The impression of dynamic
rotation has gone, but the effect of energy is sustained in the
colour collisions and the continual cutting into and over one
form by another with all the consequent sensations created
of projection and recession in front of and behind the picture
plane; while the fragmentary tubes and the dark stencilled
letters generate obvious associations with mechanisms and
with advertising. This is patently another kind of modern-life
picture.

There was a third strand in Léger's painting during 1918
and 1919, and it was this that most stood against the distilled
crystal Cubism dominant in the Effort Moderne circle. It
gave subject-matter a central role again in painting, but
in a way different from *The Card Game*; its most ambitious
product was the huge canvas of 1919, *The City* (Plate 159).
This was as much pre-war painting as the cylinder pictures.
It took further a brand of modern-life painting developed
between 1912 and 1914 above all by Robert and Sonia Delaunay
alongside the poetry of Blaise Cendrars and Guillaume Apol-
linaire. Virginia Spate has called it 'literary simultanism'.[92]
Even more than *Composition (The Typographer)*, *The City* has
the look of a gigantic *papier collé*, its pattern of interlocking
and overlapping shapes held in balance, and certainly the
work was composed in a broadly synthetic way (elements
from other themes and earlier versions being recombined
freely). Its basic abstract structure, however, has not in the
ideal synthetic way generated the details of the city, the
subject. These details have been *interjected* into the frame-
work of colour planes, each of them presented with almost
heraldic clarity: its men, mechanized, descending stairs, puffs
of smoke, steel derricks, serried windows, enormous letters

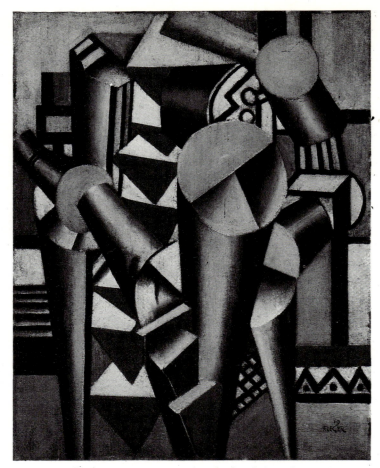

57. Fernand Léger, *Composition (Study for the Card Game)*, 1918.
Oil on canvas, $36\frac{1}{2} \times 29$in. Staatsgalerie, Stuttgart.

58. Josef Csaky, *Abstract Sculpture*, 1919. Stone. Collection, Musée
d'Art Moderne, Liège.

from advertising hoardings. A loose scattering of items, brought together without regard for the unities of space and time, instantly makes the connection between the reality of the modern metropolis (peace-time Paris) and the clashes of shape and colour; a teaming field of connotation is opened up.

Léger showed *The City* at the first Salon des Indépendants after the Armistice which opened at the end of January 1920. André Lhote, still contemplating the significance of his own defection from the Effort Moderne circle, was one of many struck by its frank independence. For him, this was a kind of painting as far from the 'pure Cubism' of Gris or Metzinger as his own, and he categorized it under the heading 'emotive Cubism', a brand of Cubism which was based, he said, on 'sensation', on 'life', and which therefore focused on its subject-matter as much as on pictorial structure.[93] More even than *The Card Game* this post-war simultanism could be seen as something new which could replace the purity of wartime Cubism. Significantly, when Blaise Cendrars wrote of the exhaustion of 'the cube' in 1919, he exempted Léger (still a close friend).[94] For him, Léger and the other French-based painter who still practised a colourful literary simultanism, Léopold Survage, were alone capable of recharging Cubism so long as the Delaunays were still away.[95]

Yet, the fact remains that Léger *was* accepted into the Effort Moderne camp, and that his painting and indeed his entire approach to pictorial invention was aligned with that of the other Cubists who showed there. In the first place, the structured firmness of the disintegrated and the simultanist pictures was akin; but, more fundamentally, his way of working was actually as pure, as synthetic as theirs. He did not work from the motif; he built his pictorial structures up, as we have seen, with a range of elements set free from any origins they might have had in observation, and where he used explicit detail, as in *The City*, he used it only to create a

59. Fernand Léger, *Composition (The Typographer)*, 1919. Oil on canvas, 97 × 71½in. Collection, Hester Diamond, New York.

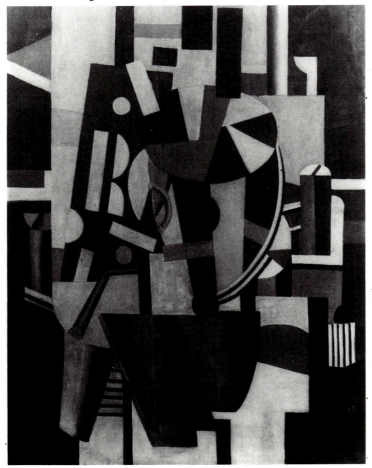

scattered pattern of clues, not to divert attention from pictorial effect — in principle, a long-established synthetic Cubist practice. He might have returned to the subject, but, writing in 1919 to Kahnweiler, he insisted that his purpose was still to create 'equivalences' for the experiences of life, and to create them in the purest pictorial terms.[96] The alternative direction he provided might have set him apart, but it was indisputably a Cubist alternative.

Cubism by 1920

The current work of so many, from Picasso and Laurens to Gris, Metzinger and Lipchitz, to Herbin and Severini, to Archipenko, Léger and Braque, to Survage, Hayden, Csaky and Blanchard, was evidence enough that Cubism had survived the last year of the War. For any who saw them, the cumulative effect of Léonce Rosenberg's exhibitions through to their climax in June 1919 must have been overwhelming. The hypothesized 'death of Cubism' was simply overtaken by events too public to be ignored.

From among the critics the impact of the shows inspired certainly one important change of heart. As early as February 1919, writing in his regular column in the periodical *L'Europe Nouvelle*, André Salmon accepted that, though the inventor of Cubism, Picasso was no longer the leader, and named Braque in his place, elevating him from the status of disciple.[97] By March he had accepted that 'The Cubist school exists, in multiple and varied form...',[98] and he did so without that scorn for schools so stressed earlier on. Yet, if Cubism manifestly survived despite Vauxcelles, and even Salmon could say so, it remained possible to claim that the movement was so obviously ailing that it would assuredly die soon, and the most common way of suggesting this was to dismiss what was shown at the galerie de l'Effort Moderne as merely obscure or decorative or both.

Having remarked on Laurens's claim to simplicity, Jean-Gabriel Lemoine continues in *L'Intransigeant*: 'One is sorry that so simple an aesthetic gives the appearance of being so complicated.'[99] Gustave Kahn in *L'Heure* liked Léger's colour but found him generally obscure.[100] Allard and Cendrars were on the whole dismissive;[101] and 'Pinturrichio' (Vauxcelles) of *Le Carnet de la Semaine* managed to write weekly throughout the seven months of the exhibitions with hardly a word on his old enemies, as if to ignore them was the best way of ensuring their actual demise. In April 1919, with Laurens, Metzinger, Léger, Braque and Gris all just recently shown, he could still keep his eyes averted effectively enough to write: 'And our friends the Cubists, I am asked, what has become of them?... The fact is that these gentlemen are sleeping, and the rhomboids are vanishing from the shop windows.'[102]

Picasso, already set aside as an almost demonic talent, was sometimes exempted from criticism even by the most conservative critics, but he too, in his Cubist guise at the galerie de l'Effort Moderne, could be presented as an obscurantist experimenter in need of a new start. In *L'Intransigeant* Lemoine bemoans the waste of such talent thus:

> For twenty years [Picasso] has searched reality and he has not found himself. For our part we think that he should have left behind the...abstractors of the quintessence, as well as the self-interested advice of those merchants of the temple [an anti-semitic swipe at the Rosenbergs], and should have produced good, tasteful work as he knows how. An artist is not judged by his sketches..., neither by his ideas, but by his finished works...Picasso, who reveres Ingres, should remember that the great corrective of the master was this: 'Be careful: you will not be understood!'[103]

In *L'Heure* Kahn states his opinion that those who appreciated Picasso's earlier harlequins will be given pause at l'Effort Moderne: 'in front of this play of surface planes, flatly coloured, with its theoretical allure, which today Picasso offers as the synthesis of the truth of a harlequin.' He ends by echoing the Purists' distrust of the abstractness of Cubism: 'Yet, since Picasso has much talent, these works are agreeable in colour and decorative vision; at first glance, one generally has the impression of a beautiful carpet, bizarre and precious . . .'[104] Typically faint praise softens the hefty charge of obscurity.

If Rosenberg's exhibitions made it virtually impossible to claim the death of Cubism in 1919, many had still to be convinced, then, of the movement's fundamental hardiness and vitality. It needed something further successfully to demonstrate (at least for the meantime) that Vauxcelles's attempt to kill off Cubism had indeed failed. This came early in 1920 in the form of two much noticed public showings of Cubist art: the Salon des Indépendants, and the exhibition of the revived Section d'Or (a loose, Cubist-inspired exhibiting group which had last shown in 1912, to great effect). When the Indépendants opened, among the more than three thousand works on show, there were contributions from almost every artist then considered Cubist (except, significantly, Picasso): Braque, Gris, Léger, Metzinger, Herbin, Severini, Lipchitz, Survage, Gleizes (newly returned from America and the Caribbean) and Archipenko were all there. It was a planned demonstration of Cubist solidarity. Gleizes was the organizing force behind the revived Section d'Or, which was conceived as such too, undoubtedly adding to the impact of Cubism as a living phenomenon when it opened a month later.

Confronted by the Indépendants, Lemoine in *L'Intransigeant* could only admit defeat: 'In the first sector [of the Salon],' he writes, 'we find the Cubists in imposing numbers. One was perhaps a little too hurried in announcing the death of Cubism.'[105] By April 1920, confronted by the Section d'Or too, Lemoine seems actually to have changed sides with the pressure. 'Cubism', he announces in the periodical *Le Crapouillot*, 'has won back its place in the evolution of modern art . . . Not only is Cubism very alive, but we hold that it can no longer die, for it represents a useful reaction and it expresses—still only imperfectly—lively and fruitful ideas.'[106] Not all who had been with Vauxcelles made such a change, but nonetheless it is a symptom of the impact made by the Cubists at the Indépendants and the Section d'Or of 1920. Even critics deep in the middle of the road, like Paul-Sentenac of *Paris-Journal* and Georges Laure of *La Revue de l'Époque*, though fundamentally hostile, were suddenly willing to find qualities in Cubist work, to admit its direct colouristic and formal appeal and its usefulness as a corrective to the abuses of hedonism in art.[107]

Yet, of course, the most telling measure of Cubism's impact early in 1920 is to be taken from Vauxcelles's 'Pinturrichio' column in *Le Carnet de la Semaine*, for even he was forced to adapt, to soften (strategically) his hostility. 'The Cubists evolve,' he writes of them at the Indépendants.

> The Cubists first denied the object and were plunged into the abyss of the abstract. Little by little they are liberating themselves, restoring themselves, coming to nature, without which as a foundation art has never been viable. Metzinger, whom I fought when he entangled himself in his logarithms, shows a grey and blue series whose matter and atmosphere is charming; Juan Gris pursues a course parallel to Metzinger's. As to Braque, his contribution is perfect in its taste and tranquility. One reads their works; they are still more allusions to the object than transcrip-

tions. But one notices that they have stripped themselves of their aloof hardness, and that . . . they have decided to give sensibility as large a part as intelligence.[108]

It is certainly true, as has been seen, that the purer practices of the Cubists had *not* necessarily led to the appearance of greater abstraction in 1918–19. Indeed, Gris, Metzinger and Lipchitz had all arrived at more legible modes, given exemplary expression in their contributions to the Indépendants (Gris sent a figure and a still life (Plate 173), Lipchitz sent three figures, including *Pierrot with Clarinet* (Plate 43)). Braque's informality had not meant a loss of legibility, whilst Severini's rigour had meant a gain in legibility. Then too, Léger's contribution included *The City* (Plate 159), intentionally easy to grasp as a subject painting, while Survage was comparable and so was Gleizes, whose exhibits were circus paintings in a simultanist manner which looked back to his expatriate wartime career in America and elsewhere. In sum, Vauxcelles had good reason to write of an emergent legibility in Cubist art. With characteristic shrewdness he found the one outward aspect of advanced Cubism that could sustain him in his beliefs, now that he could not ignore the movement's continued vitality. For his appreciation of the Cubists amounts, in the end, to a subtle attempt to undermine the movement by extracting as the most significant feature of Cubist work that which most threatened its claims to purity, the appearance of a return to nature. The development of Cubist styles —especially crystal Cubism—might have converged around the central themes of distillation and construction between 1918 and 1920, but Vauxcelles could still insist that Cubism was a route to a more structured art which would return to nature. At the Indépendants of 1920 he persuaded himself that the Cubists were still on their way out, following the path marked for them by Lhote and Rivera.

By 1920, despite Vauxcelles's suggestions, the re-emergence of Cubism after the War was obvious, and increasingly it was possible to see what the movement now stood for and the issues it raised. After six years Cubism had been established again as the progressive tendency with the most formidable reputation, though, as will be seen, no longer the loudest.

There may have been individual variations and alternative directions within the Cubist circle, but at least from 1917 onwards there had been, as this chapter has set out to show, a recognizable shift towards a purer synthetic range of styles, which included Braque and with which Picasso's Cubism was in tune; the modern-life painting of Léger was seen as an exception (an exception which itself was pure in the most fundamental sense). 1918–20 saw the full development of the theories introduced by Reverdy and the *Nord-Sud* writers in 1917, and those writers were joined by another old friend of the Montmartre Cubists from before the War, Maurice Raynal, whose pamphlet 'Quelques Intentions du cubisme' of 1919 was particularly influential. As these theorists tried to clarify the basis of Cubism, it was possible to accept the work the Cubists produced as emanating from a cohesive set of attitudes to art and the world.

In 1919 Paul Dermée made the following assertions in the periodical *S.I.C*: 'An aesthetic whose first truths were discovered by Mallarmé and Rimbaud, has spread itself out miraculously in Cubist painting and in the literature of the new spirit.'[109] For him there was a single 'aesthetic' that embraced both his own poetry and the painting and sculpture to be seen at l'Effort Moderne, and he announced his intention, by looking at each Cubist in turn, to discover 'that which essentially constitutes Cubism'. He accepted that there was great diversity, as the beginning of the first of his pro-

jected articles (on Metzinger) demonstrates: 'I had wanted to ask each of the Cubists to clarify his aesthetic attitude in the ensemble of the movement. Sacrilege!...Immediately the whole beehive was set buzzing, queen, workers and drones, and launched themselves on the interloper.' Yet, he was sure that there *was* unity: 'The Cubist painters', he wrote, 'willingly discourse on their aesthetic and, even though they talk about it completely differently, the content rarely changes. Strength and force of a school.'[110]

Dermée's article on Metzinger was the only one of the projected series to be published, so it cannot be known just how he would have pulled together into a single aesthetic the individual stances of such different figures as Picasso or Braque, Léger or Severini, Lipchitz or Archipenko. But the fact is that he could convince himself at close range that there was unity in the movement. In spite of Léger, the newly distilled state of Cubism was obvious enough to those who knew it well: it had indeed largely shed such diverting concerns as simultaneity, the fourth dimension, poetic or musical analogies, so much the stuff of the pre-war scene. At the beginning of 1921 Waldemar George could streamline the history of the movement thus: '...Cubism, healthy at its beginnings, corrupted later...with the introduction of certain extra-plastic elements, [has] now rediscovered its original vigour.'[111] And looking back critically in 1923, André Lhote could speak of the development of 'another Cubism' in the Great War, a Cubism 'cultivated by the Spaniards Picasso and Gris', which had finally shut nature out of art altogether and rooted it in the mind, in abstraction.[112]

Incontrovertibly there was a fundamental and essentially simple set of principles shared by the Cubists, and it is this that Dermée in the end would almost certainly have isolated in order to put together a cohesive Cubist aesthetic. The evidence for it is there in Reverdy's and Dermée's own writings in *Nord-Sud*, in Braque's epigrams of 1917, Raynal's 'Quelques Intentions du cubisme' and in a group of short statements made by some of the other artists and sent by Léonce Rosenberg to be published in the Italian review *Valori Plastici* in 1919. A full discussion of the Cubist stance at this time is a central feature of Part III, but a brief summing up of the artists' shared convictions is needed here, since their verbal articulation was so integral a part of the distilled image of Cubism constructed by friends and enemies alike at the end of the Great War.

'To create and not to imitate or interpret'; that was how Laurens summed up his purpose in his *Valori Plastici* statement.[113] Most fundamentally of all, the Cubists were agreed that art should not be concerned with the description of nature, and this has been implicit in the entire account given here of Cubist art at the end of the War. The rejection of Naturalism was intimately bound up with the second basic principle shared by them all: that the work of art, being not an interpretation of anything else, was something in its own right with its own laws. Both were convictions arrived at in the very beginning of the movement; now they had become central and dominant to an unprecedented degree. A further principle followed from these two, one that was clarified only at this stage in Cubist theory: the principle that nature should be approached as no more than the supplier of 'elements' to be pictorially or sculpturally developed and then freely manipulated according to the laws of the medium alone. It was during 1919 in the critical writings of Lhote and Dermée especially that there emerged clear signs of a conscious realization that, for the Cubists, a starting-point in the abstract had become a necessity. Aesthetic purity had been fixed at the core of the Cubist image, purity of means as much as ends. By 1920, for Lhote at least, 'advanced' Cubism had become synonymous with 'pure Cubism'.[114]

As a simple consequence, the charges levelled against Cubism singled out the central issue of purity. Above all, the Cubists were dismissed as too removed from nature, too obscure. In the search for possible successors to them, who would render the movement obsolete, those singled out were therefore those who tried to achieve a compromise between the observance of pictorial laws and the clear presentation of subject-matter: Lhote and Rivera, Ozenfant and Jeanneret. They stood as proof that the laws of painting could be observed without turning away from nature: the obscurity of the Cubists was made to appear perversity and no more. Linked to this sort of thinking was a mixture of anger and bewilderment at the barrage of theory that accompanied the showing of Cubist work between 1917 and 1920.

In the final analysis, behind the attacks of 1918–20 lay strong, essentially simple antagonisms: stong feelings of anti-élitism and anti-intellectualism. The confident sense of unity which Cubism gave off by 1920 was soon to disintegrate, in ways more threatening to the movement's survival than in 1918, but those basic antagonisms which gave a certain unanimity to its conservative adversaries were to remain behind all the attacks that followed in the next half-decade.

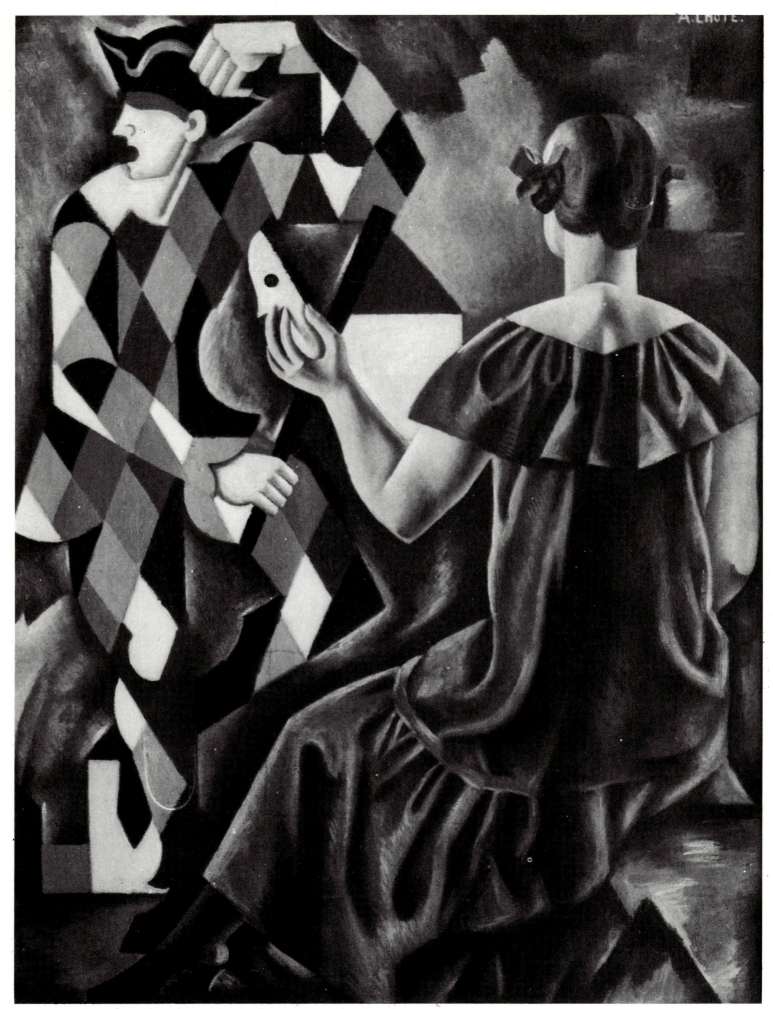

60. André Lhote, *Homage to Watteau*, 1919. Oil on canvas, $45\frac{3}{4} \times 35$ in. Musée Petit Palais, Geneva.

3
The Signs of Decline and their Interpretation

Dada and Cubism; Picabia and Gleizes

After the relative success of the Cubists at the Indépendants and the Section d'Or, many did not show at the Salon d'Automne in November 1920. Predictably this was the pretext once again for those who wished it dead to believe that at last it might be. 'It is a fact,' wrote Louis Léon-Martin in *Le Crapouillot*. 'This Salon...marks the abrupt halt of Cubism... Except for a few belated followers whose names I kindly pass by in silence, there remains here only Monsieur Braque who has much talent...and Monsieur Gleize [*sic*] who...has none at all...'[1] Cubism, of course, had not died, but the ease with which such critics convinced themselves that it had is evidence enough of the continuing will among the more conservative to kill it off once and for all. And by that autumn such observers were very much aware of the fact that their challenge had been strengthened by the appearance of a bizarre new ally: a phenomenon they despised quite as much as Cubism itself, but which was just as hostile as they to its survival. This was Dada: Dada especially as represented by another who emerged as a defector from the Cubist camp at the end of the Great War, Francis Picabia.

Pierre Reverdy's article 'On Cubism' of March 1917 was perhaps his most unadulterated statement of the purity of Cubist art. Significantly, the piece was prefaced by a vigorous attack on the notion of a merger between visual art and literature. This was one of the earliest responses from within the Cubist circle to the new threat which was to become known as Dada, for, as Etienne-Alain Hubert was the first to point out, what Reverdy referred to was the merger between word and visual image presented by the covers of a new little periodical whose first issues had been produced by Picabia early in 1917 in Barcelona, *391*.[2] By the summer of 1917 Picabia had moved his base from Barcelona to New York, where he had already spent a long period of time after the outbreak of war; back there again he continued to publish *391* with its characteristic covers, including *American Woman*, the cover of no. 6 in July (Plate 61).

These fused visual and verbal images had not emerged suddenly in Picabia's work; they were the outcome of drawings made earlier in New York which were simple adaptations of mechanical diagrams or graphic representations of such items as cameras and sparking-plugs.[3] In all of them meaning is generated by the pulling together of conflicting yet suddenly apt associations: the words seem to light up the images (very obviously with the cover of no. 6). And in this stressed interdependency can indeed be discovered the beginning of a campaign of subversion against Cubist convictions, especially those convictions in the form given them between 1912 and 1914 by Guillaume Apollinaire, Robert and Sonia Delaunay.

Before 1914 Apollinaire had never separated painting from poetry as the Cubists did at the end of the War. Indeed, he had initiated developments that integrated the two. But fundamental to his understanding of the tendency that he had dubbed Orphism was the notion of 'pure painting', and it was this notion that was isolated and refined at the core of the distilled aesthetic of Reverdy and the Cubists later.[4] This is the notion against which Picabia's fusions of word and visual image struck; they denied the Orphic ideal of purity and so, as yet unknowingly, they denied the new synthetic Cubism that was evolving in France. Picabia's inscriptions gave the word a special status as the prerequisite of signification even in visual art, for, as in Marcel Duchamp's 'readymades', the ordinary is made extraordinary in an image like *American Woman* only by its verbal attachments. What is more, simple illusionistic even photographic representation

61. Francis Picabia, *American Woman*, 1917. Photograph retouched in ink. *391*, no.6, July 1917.

was welcomed. The light-bulb might be made to become an American woman by words, but it is still, also, simply a photograph of a light-bulb.

In 1917, therefore, *391* displayed the signs of a profound hostility to Cubist attitudes at their most fundamental, and Reverdy at least did not miss those signs, but right through from 1917 to the beginning of 1920, as Picabia moved between Barcelona, New York, Paris and Switzerland, his own stance in relation to Cubism remained ambivalent. He did not unequivocally express his hostility, and one of his best friends, Albert Gleizes, was a Cubist (though initially in exile) who had been one of the convivial group of poets and artists in Barcelona in whose company Picabia had founded *391*. It was to be when Picabia's friendship with Gleizes broke apart in 1920 that his hostility to Cubism became finally explicit, and with it the full implications of the challenge mounted by Dada.

In the interim a great deal happened, most importantly Picabia's alliance was cemented with Tristan Tzara under the name Dada, and then the alliance between these two and the group of young writers based in Paris who founded early in 1919 the periodical *Littérature*: André Breton, Louis Aragon and Philippe Soupault.[5] Ambivalence characterized the relationship between the *Littérature* group and the Cubists too, above all because of their respectful friendship with Reverdy, the marvellousness of whose poetic imagery they would always marvel at and the support of whose patronage in *Nord-Sud* they happily exploited.[6] But Tzara's position was absolutely clear from the appearance of his *Dada Manifesto* in *Dada* no. 3 of December 1918 onwards (this was the text that persuaded the *Littérature* group to seek him out as an ally); by 1920 it was especially he who had given Dada in its Parisian form its uncompromisingly destructive edge. By that date, far more than in 1917, Picabia's attack on aesthetic purity had become, alongside those of Tzara and the *Littérature* group, an attack on the value of art altogether.

Though he returned to Paris in March 1919, Picabia did not actually meet Breton, Aragon and Soupault until the very beginning of 1920, and Tzara did not follow him from Switzerland until February that year. Only then were the alliances at the heart of Paris Dada formed. But already by the end of 1919 the imminence of his break with the Cubists was clear. The Cubists as a group did not show at the Salon d'Automne of 1919 (the first big non-academic Salon after the Armistice), but Picabia did, one of his contributions being *Child Carburettor*, a late painted example of the mechanomorphic style that had developed out of his earlier graphics, replete with verbal infusions (Plate 62). So did Gleizes, who had also just arrived back in Paris. *Child Carburettor* was hung under the stairs in the Grand Palais, where as few people as possible would see it; Picabia interpreted this as an attempt to gag him and used *391* combined with a suitably insulting open letter in *Comédia* to attack all he could think of as culpable.[7] Gleizes could not have missed either the challenge mounted by *Child Carburettor* or the disturbing fact that his was one of the names singled out for insult by Picabia's collaborator Georges Ribemont-Dessaignes in *391*.[8]

The final irreparable break between Picabia and Gleizes came the month of Tzara's arrival in Paris, February 1920. It was the indirect result of the success of the Cubists, and its immediate cause was Gleizes's role in the organization of the revived Section d'Or. Picabia was involved in the project from the first discussions between Gleizes and the other organizers, Survage and Archipenko, in 1919, and he, of course, was responsible for bringing in the Dadaists, who, it was agreed in February 1920, were to provide poetry readings of their own.[9] Already the first hectic Dada demonstrations put together by Tzara, Picabia and the *Littérature* group had had their effect, and, though Gleizes tried to avoid disaster, Archipenko and Survage feared what would happen if the Dada reading went ahead. An open meeting was held in the Closérie des Lilas (a café meeting-place near the Observatoire Gardens) on 25 February, and a vote was held for or against the inclusion of the Dadas; Gleizes finally turned against them and they were expelled. Léger, Braque and Laurens were among those who took their places in the centre of the room; Juan Gris alone showed regret for what had happened (possibly because his close friend Dermée now counted himself with the Dadas).[10] As an account in *391* concluded: 'And there we are, Cubism, nicely combed and curled; it smiles courteously at "Monsieur" and no longer picks its nose.'[11] In the most publicly symbolic way possible Dada staked its claim as the radical alternative to Cubism. And just how profound was the split between them is finally indicated by the fact that not only were the Dada poets rejected by the Cubists but also another artist introduced by Picabia, Max Ernst, who sent from Cologne a work called *Hypertrophic Trophy* strikingly akin to Picabia's *391* graphics (Plate 63).

It was the Section d'Or quarrel which ensured that Cubism in general and Gleizes in particular would become one of Dada's favourite targets. Ably abetted by Ribemont-Dessaignes, Picabia delighted during 1920 in creating a whole new spectrum of insult and grievous mental harm for the Cubists. Gleizes especially was targetted in *391* no. 12, the number that immediately followed the Section d'Or; and the bile spilled over into manifestos and articles for many months. No. 12 included Picabia's own Dada manifesto, which was a manifesto specifically for Cubist-haters. The Cubists, says Picabia, 'think that Dada can prevent them from carrying on their odious commerce... Art is more expensive than sausage, more expensive than women, more expensive than everything.' The Cubists 'have cubed the pictures of the primitives, have cubed negro sculptures, have cubed violins, have cubed

guitars, have cubed illustrated newspapers, have cubed shit and the profiles of young girls, now it's necessary to cube money!!!'[12] On the next page, he turns on Léonce Rosenberg: 'Monsieur Rosemberg [*sic*] has told us: "The apples and the napkins of Cézanne represent the great human tradition of the cathedrals just as Cubism represents the modern cathedral." Monsieur Rosemberg, you are a curate and the mass you say in your cathedral is a ceremony for pears. What! What! What!'[13] Rosenberg's exhibitions had not been conspicuous commercial successes (though Braque had sold, like

62. Francis Picabia, *Child Carburettor*, 1919. Oil, gilt, pencil and metallic paint on plywood, $49\frac{3}{4} \times 39\frac{7}{8}$in. Collection, Solomon R. Guggenheim Museum, New York.

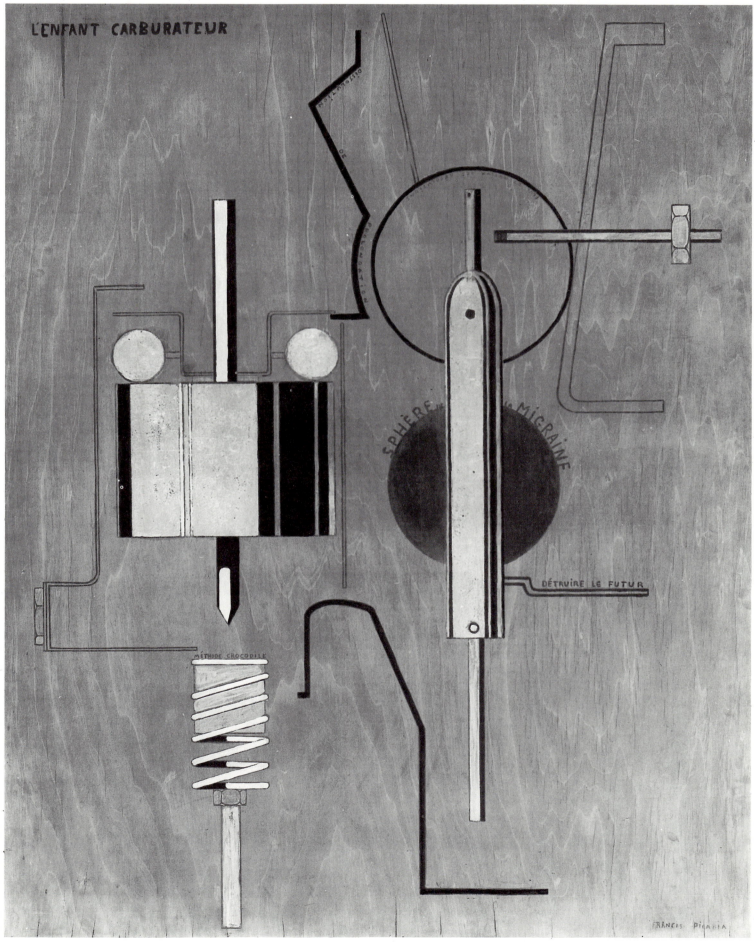

63. Max Ernst, *Hypertrophic Trophy*, 1920. Block-pull and pen, $15\frac{1}{8} \times 7\frac{1}{2}$in. Collection, The Museum of Modern Art, New York.

Picasso). The only explanation of Picabia's charge of commercial avarice is that it was made with a sharp sense of irony and a cruel appreciation of where to hurt the Cubists most effectively (Gleizes in particular despised commercialism and made a public point of it).[14]

Picabia and the *Littérature* group might have maintained an ambivalent relationship with the Cubists before the beginning of 1920 (and even occasionally afterwards), but the Dadaists were, without doubt, as much the natural adversaries of the Cubists as Vauxcelles had ever been. The straight-faced, classical Cubism that emerged from the War could not have had a more complete opposite; Dada and Cubism represented two of the most divergent responses conceivable to the destruction of war and to the nationalist ideologies that sustained it. The Section d'Or crisis of February 1920 merely brought their opposition unambiguously into the open, and, as Dada established its subversive credentials, made it clear that Cubism had acquired a new kind of adversary, not conservative but radical, indeed more loudly radical than itself.

Classicism: Metzinger, Léger and Severini

With critics like Léon-Martin so ready to interpret a few Cubist absences from the Automne in 1920 as evidence that the movement's day was over, and with Dada so noisily present, it needed but a few signs of dissension and of defection in the Cubist camp for the claims of its death to be

heard as ubiquitously as ever, and the signs were not slow coming.

First of all, the tightness of the Cubist group did not last. In the spring of 1920 D.-H. Kahnweiler returned to Paris. Within a year Braque, Gris and Laurens had left l'Effort Moderne to join his new galerie Simon.[15] Picasso had already given Léonce Rosenberg's brother Paul first refusal on his work. There was no question of such moves changing attitudes, but they caused deep resentment among those who remained with Léonce Rosenberg, including Léger, and certainly fragmented the Cubist enterprise.[16] Much more significant than this, however, was the fact that even within the Effort Moderne circle a distinct shift away from the extreme anti-Naturalist purity of Cubism at the end of the War seemed undeniable from the turn of 1920–21.

One critic, it will be remembered, had changed his stance because of the Cubist showing at the Indépendants in 1920, Jean-Gabriel Lemoine of *L'Intransigeant*. Lemoine, however, was able to adapt Vauxcelles's earlier thinking on Cubism to his positive new opinion of the movement, and to go further than Vauxcelles himself had in 1920. He too presented Cubism as a movement which was in the process of turning back to nature, but so optimistic did this make him that he rejected the idea of its death as unnecessary. He no longer saw Cubism as a phase on the way to a constructive Naturalism (the Vauxcelles hypothesis), he envisaged instead a sustained Cubism that would within itself go back to nature rather as Lhote had gone back to an 'earlier', less pure, 'analytic' Cubism.[17] It was this compromise view—that a return to nature could take place *within* Cubism—that led Lemoine to welcome Jean Metzinger's exhibition at l'Effort Moderne at the beginning of 1921.[18]

Metzinger had spent the summer of 1920 at Tréboul in Brittany and in September had written to Rosenberg of a return to nature which seemed to him both beneficial and not at all a renunciation of Cubism.[19] His exhibition was entirely of landscapes, and, though they are carried through with the same formal vocabulary as *Woman with a Coffee-pot* (Plate 45) in 1919, though linear perspective is avoided and rhymes abound, they indeed showed a willingness to bring together the pictorial and the 'natural', something clear in the *Landscape* of 1920–21 at Troyes (Plate 64). In particular, Metzinger seems to have tried in such pictures to give a real sense of weather. This willingness to adapt Cubist language to the look of nature was quickly to affect his figure painting too.

From that exhibition of 1921 Metzinger continued to cultivate a style that was not only less obscure, but clearly took

64. Jean Metzinger, *Landscape*, 1920 or 21. Oil on canvas, $21\frac{1}{2} \times 30$in. Musée d'Art Moderne, Troyes. Donation Pierre et Denise Lévy.

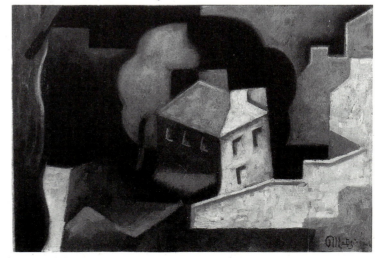

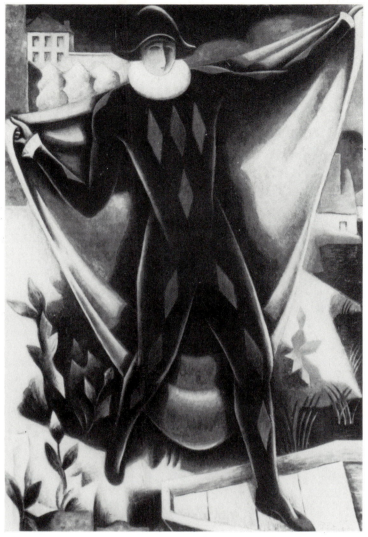

65. Jean Metzinger, *Embarkation of Harlequin*, 1923. Oil on canvas, 63½ × 44¼in. Sale: Parke-Bernet, Los Angeles, 20 November 1972, lot 85.

subject-matter as its starting-point far more than an abstract play with flat pictorial elements. His contribution to the Indépendants two years later, in 1923, was a far from obviously synthesized *Embarkation of Harlequin* (Plate 65). Yet, style, in the sense of his own special way of handling form and colour, remained for Metzinger the determining factor, something imposed on his subjects to give them their special pictorial character. His sweet, rich colour between 1921 and 1924 was unashamedly artificial, and is itself symptomatic of the fact that his return to lucid representation did not mean a return to nature approached naturalistically.[20] Another symptom of that fact is his recurrent interest in artificial subjects during these years, above all the make-believe world of the circus and the *commedia dell'arte*, where reality is habitually represented without naturalism. Perspectival space is alluded to in *The Embarkation of Harlequin*, but only by changes of scale not by co-ordinated linear convergence, and the result is a simplified, clarified space perfectly adapted to the condensation of a stage-set. The subject counts, but it is entirely controlled by pictorial conventions, just as stage characters are controlled by theatrical conventions. Like Lemoine, Metzinger himself, writing in 1922, could claim quite confidently that this was not at all a betrayal of Cubism but a development *within* it. 'I know works,' he said, 'whose thoroughly classical appearance conveys the most personal...the *newest* conceptions... Now that certain Cubists have pushed their constructions so far as to take in clearly objective appearances, it has been declared that Cubism is dead [in fact] it approaches realization.'[21]

Yet, the fact is that for many what had happened in

Metzinger's painting did amount to a betrayal and the way he felt compelled to deny it only establishes that he knew as much. Confronted by *The Embarkation of Harlequin* even the sympathetic André Salmon was forced to ask whether Metzinger had rejected Cubism,[22] and, so eager were the editors of *Montparnasse* to see evidence of betrayal, that they published a letter of his not under the title he gave it, 'Is Cubism Dead?' but under the far more sensational: 'Cubism is Dead'.[23] By 1922–23 Metzinger's was not the only apparent betrayal of Cubism to be noticed. The early twenties saw Hayden, Herbin, de la Fresnaye and Severini all shift to more straightforwardly representational styles, and saw Léger too, in his figure painting, develop his own mechanized variant of Neo-Classicism. After the geometric abstraction of his ornamental pictures and reliefs of 1920 (Plate 247), Herbin's was perhaps the most dramatic volte-face. Yet, Severini's and Léger's probably had the most impact, for theirs had been more considerable Cubist reputations, and they were far more in the foreground than de la Fresnaye, who had been exiled to the Midi by tuberculosis.[24]

Léger made his move not long after showing *The City* at the Indépendants. While Metzinger was painting landscapes in Brittany, he was painting highly polished figures which by the end of 1920 had led into a sequence of grouped female nudes culminating the year after with the *Large Lunch Party (Le Grand Déjeuner*, Plate 66). Later he was to call it a direct reaction against *The City*.[25] Among the early versions of the theme was *The Odalisks* (Plate 67), and two of them (possibly including this) were shown at the Indépendants of 1921. The *Grand Déjeuner* itself appeared in public for the first time at the Salon d'Automne that November.[26] Léger's move away from the simultanism of *The City* was dramatic indeed, and it was made very much in the open.

Throughout the *Grand Déjeuner* sequence it is likely that Léger developed his classical nudes *from* his vocabulary of cylindrical, metallic volumes of earlier days; that, in an essentially synthetic way, he transformed those volumes into nudes rather as Gris transformed flat shapes into fruit-bowls or harlequins. A clear indication of this is the fact that the *Grand Déjeuner* and the final group of oils altogether, are actually less generalized, more specific in the description of figurative detail, than the earlier 'states' like *The Odalisks*, where forms are still comparatively abstract. Yet, though the method of working thus remained Cubist, the result was obviously not. The nude decoratively posed in the *Grand Déjeuner* generated a whole array of classical associations (with Poussin, David, Ingres and even the later Renoir) to give the picture a place within a notion of tradition; a notion of tradition where idealized representation was based on aspirations to order. The *look* of the result was not of nudes synthesized from geometric parts and then shaped to a classical ideal, but of nudes represented in idealized, classical form. Further, those gleaming, polished surfaces maintained the link with modern life, but it was no longer the speed and energy of the modern city that Léger's nudes referred to, it was rather the controlled precision of machinery.

Alongside the nudes, Léger developed a new kind of open-air-subject painting, where the human figure populated landscapes invaded by modern buildings and stark advertizing hoardings. These smaller *Animated Landscapes* were another reply to *The City*, suburban rather than urban, and no longer conspicuously simultanist (Plate 68). Both here and in the classical nudes he tended to accompany a move towards more traditional representational idioms with a move away from Cubist planimetric spaces. The earlier nudes, like *The Odalisks*, were simply suspended in front of a screen of overlapping flat planes, but in the *Grand Déjeuner* itself there

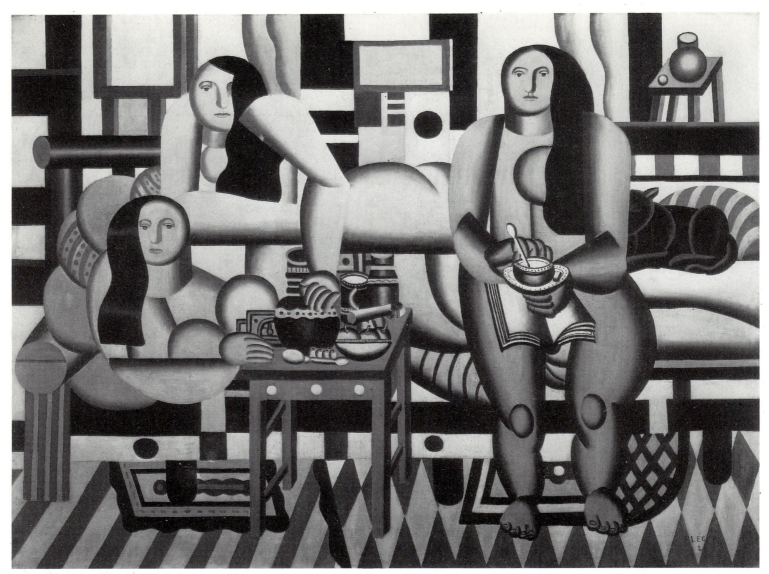

66. Fernand Léger, *Large Lunch Party (Le Grand Déjeuner)*, 1921. Oil on canvas, 72¼ × 99in. Collection, The Museum of Modern Art, New York. Mrs Simon Guggenheim Fund.

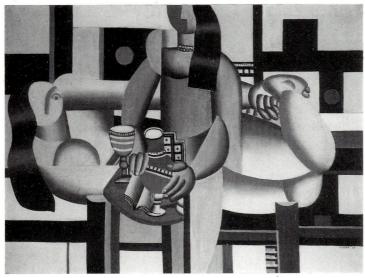

67. Fernand Léger, *The Odalisks*, 1920. Oil on canvas, 38 × 51in. Collection Mr and Mrs William A. Burden, New York.

is an appearance of quasi-perspectival coherence: objects, figures and setting are clearly situated one in front of another, and the angling of strips and diamonds on the floor suggests a surface for everything to stand on. Yet, neither here nor in the *Animated Landscapes* is there anything like co-ordinated linear convergence, everything is placed parallel to the picture plane, and often there are obvious shifts of viewpoint and ambiguities to disturb the continuity of the space. These are by no means naturalistic spaces or perspectives in the post-Renaissance tradition.

It was in 1922 that Léger brought together the indoor space and classicized figures of the *Grand Déjeuner* with the outdoor space of the *Animated Landscapes*; he did so in a sequence of pictures which ended with *Mother and Child* (Plate 218). The result was to give his ideal figures a setting quite as spatially exciting as the settings given to the open-window still lives of Picasso or Gris in the teens. And once more the shift of emphasis that came of his espousal of representational modes is to be seen in the character of that space as much as in the things that inhabit it. The interaction of flat colour planes and

68. Fernand Léger, *Man with a Dog*, 1921. Oil on canvas, 25½ × 36½in. Collection, Nathan Cummings, Chicago.

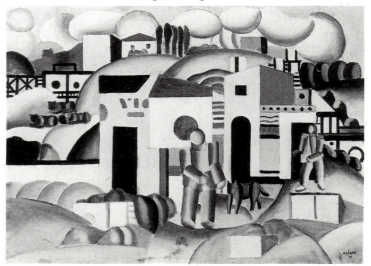

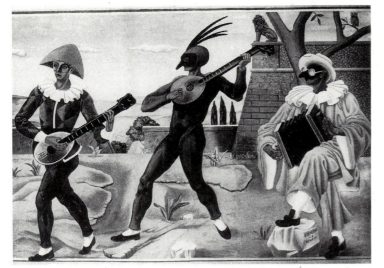

69. Gino Severini, *Harlequin, Scaramouche and Tattaglia*, 1921–22. Fresco. Montegufoni, Tuscany.

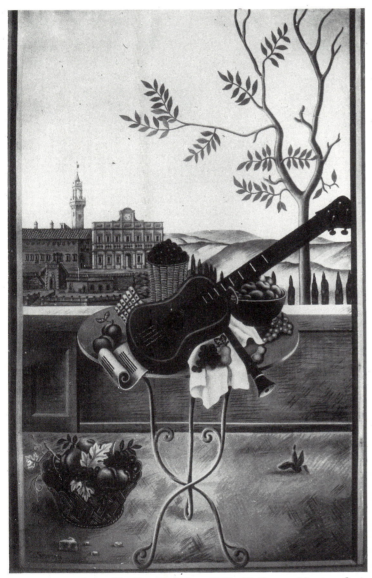

70. Gino Severini, *Still Life with Guitar*, 1921–22. Fresco. Montegufoni, Tuscany.

the surprises of sudden changes of viewpoint interrupt and enrich what is felt instantly to be a simplified illusion of volumes in depth. The spaces of advanced synthetic Cubism, of crystal Cubism or Léger's own *City*, would always be alien to his new, classical figure style.

As Léger and Metzinger made their moves towards idealizing traditional styles in 1920, so did Severini, but the real break with the look of Cubism came for him in 1921 as the result of

a remarkable piece of luck.[27] While recovering from a chest infection early that year, he received through Léonce Rosenberg a commission to decorate a room in the castle recently bought by Sir George Sitwell at Montegufoni near Florence.[28] The initiative for the commission came, in fact, from Sitwell's sons, the writers Osbert and Sacheverell, who were to become good friends: it gave Severini the opportunity of a year in Italy, a good income and walls to paint in a distinguished trecento and Baroque setting. He arrived in Italy (for the first time since 1914) in the spring of 1921, and, after a short visit to his family, started work. By the following spring the room he had been given to decorate with frescoes was finished (Plates 69 and 70); when he returned to France in June and new studios in a villa outside Paris at Nanterre, the pictures he produced declared a rejection of the look of Cubism altogether more complete even than Léger's *Grand Déjeuner*. One of these paintings of later 1922 was *The Two Pulcinellos* (Plate 78).

Severini had made his payment to Léonce Rosenberg for getting him the commission before he left for Italy; it consisted of twenty gouaches on the *commedia dell'arte* theme asked for by the dealer.[29] The Sitwells bought one of these gouaches with drawings of related subjects, and liked them enough to ask him to take the same theme for the frescoes. Severini's playful theatrical subject-matter was, therefore, requested, but he himself already had taken up the *commedia dell'arte* subject, and was delighted to comply. In his autobiography he recounts how the subject 'permitted me to keep in between the human and the abstract', a highly significant comment on the way that Harlequin, Pierrot and Pulcinello and their companions allowed artifice and the figurative to go together. On the painter's arrival at the castle Sir George had welcomed him with airs played by local musicians and, as if in response, Severini made his frescoes charmingly musical. In each corner of the ceiling a still life with musical instruments was repeated, another monochrome musical-instrument still life was placed beneath one of the two windows and on either side of the other was a further pair with local Tuscan views as backdrops (Plate 70). Then too, the major fresco was given over to a Harlequin, Scaramouche and Tartaglia all making music in front of one of the terraces of the castle (Plate 69).

Before Severini, the Sitwells had approached Picasso and, according to Sacheverell, he had led them to hope that his frescoes would be 'In the Florentine manner, that is to say under the influence of Botticelli, Benozzo Gozzoli, Alessio Baldovinetti...'.[30] Severini consciously aimed to satisfy their desire, reaching out, as he had before in his *Maternity* of 1916, to the Tuscan tradition of which he wanted so much to be a part. The fresco technique he applied, with the aid of a local Florentine craftsman, was painstakingly based on Cennino Cennini's treatise on fresco, *Trattato della pittura*, and he worked now with a thorough knowledge not only of Tuscan fresco styles, but of classical and Renaissance theories of proportion and perspective (Vitruvius, Alberti, Pacioli and Leonardo).[31] The structures of his compositions as a whole and of his figures individually were established by carefully laid out geometric armatures as in his Cubist phase, but his *commedia dell'arte* characters and decorative still lives perform in spaces even more perspectively traditional than Metzinger's, let alone Léger's—spaces which are entirely coherent. The result is a self-consciously traditional fresco style, which is both highly conventionalized and highly illusionistic, in the service of an entertaining, light-weight subject-matter.

This shift of style had been prefigured before Severini's trip to Italy, and Léonce Rosenberg cannot have been surprised by works like *The Two Pulcinellos* that followed. When he returned neither he nor Rosenberg interpreted his new manner as a betrayal of Cubism, and, like Metzinger and Léger, he re-

mained an Effort Moderne painter. Severini believed that by building on the classical character of Cubism (as he understood it) he had extended not betrayed the movement. And indeed, there *are* aspects of his Montegufoni style that were only possible given his earlier Cubist priorities as a painter: it is not a complete volte-face. Thus, though the space is perspectivally coherent, the frescoes are distinctly planimetric in conception: foreground surfaces, including table-tops, are deliberately tipped up, and abrupt breaks between the near and the far turn the Tuscan landscapes into flat scenic backdrops, a result summed up by the way the two façades of the castle included in the landscape behind *Still Life with Guitar* (Plate 70) are unfolded on to a single plane. Moreover, though the figures seem to play parts in some sort of narrative, actually the way they were moved and regrouped in the preparatory drawings indicate that they were manipulated purely for pictorial effect, not to tell a story.[32] Of the gouaches with which he paid Rosenberg for the Montegufoni commission, Severini wrote as he might have about the frescoes, that they no longer had 'the appearance of Cubism', but yet preserved both the 'construction' and the 'spirit' of Cubism.[33] Idiom and composition still came before subject-matter however anecdotal they seemed.

Braque and Neo-Classicism

By 1922 Metzinger, Severini, Herbin and Hayden had all left the distilled Cubism of 1919 far behind them; they pursued tradition. So did Roger de la Fresnaye in Grasse, and friends like Cocteau, Dunoyer de Segonzac and Jean and Valentine Hugo made sure that this was known in Paris.[34] Yet, two other apparent betrayals of Cubism had far more impact, and, like Léger's (which involved only his figure painting), these were neither as uncompromising nor as complete. They were those of Braque and Picasso, the first Cubists.

As suggested, the signs of impending change were already to be read from Braque's latest pictures in his Effort Moderne exhibition of 1919. The dark grounds, the looseness of contour, the informality of shaping and the sheer enjoyment of surface textures continued central to his work in 1920–21; all are features of *Guitar and Glass (Socrates)* of 1921 (Plate 196). Thus, here he makes a centre-piece of Erik Satie's score for *Socrate* with all its then current associations of reason and discipline, but around it indulges in delicious broken surfaces of white and lush green and develops the frothiest and most playful sequence of curves to link music to glass to guitar. Such pictures, however, were nonetheless thoroughly Cubist, their space planimetric, their objects invented, often rhyming with one another (the squashy glass here has been shaped to fit that unifying theme of echoing curves).

Still at the Salon d'Automne of 1920 critics treated Braque as a Cubist, but habitually they used words for his art in 1920–21 rarely applied to Cubist painting, the word 'finesse' for instance; differences were noticeable. Something else, however, was required before that identification began widely to be questioned. This came in November 1922 when Braque was given the honour of a special showing at the Salon d'Automne. Among the eighteen pictures he exhibited were two catalogued simply as 'Decorations'; we know them now as the *Basket-carriers* (or *Canéphores*) (Plate 71).

These pictures too are worked up from dark grounds, and, though the use of black suggests light and shade, their surfaces remain unmodelled. They too are loose in shaping and they do not give a strong impression of depth, because, even if overlappings are not exploited neither is perspective. What sets them apart, of course, is their subject-matter and its

71. Georges Braque, *The Basket-carrier (Le Canéphore)*, 1922. Oil on canvas, 71 × 28¾in. Musée National d'Art Moderne, Centre Georges Pompidou, Paris.

distinctly natural form. Again, as in Léger's case, it is clear that these classical females are developed *from* the artist's existing pictorial vocabulary, but, since Braque's irregular, non-geometric forms were always far more 'natural', his females take on a distinctly naturalist look. This, coupled with their swelling proportions and their baskets laden with fruit, meant that they generated connotations rather different from

Léger's nudes, not with the dry idealizing of David and Ingres, but with the sensual idealizing of Renoir. 1919 had seen the death of Renoir and the years 1920–21 were years when his reputation gained unparalleled lustre, aided by a series of exhibitions including a grand retrospective at the Automne of 1920. For many besides Braque, Renoir stood for the possibility of an ordered art, open to distortion in pursuit of pictorial effect, which did not need to be austere—a structured hedonism of great refinement—and with these pictures Braque unmistakably committed himself to the future of such an art.[35]

André Salmon was too committed to the idea of Braque as a leader of the Cubists to see the *Canéphores* as anything else but a compromise. For him, they could only be the result of doubt or even idleness.[36] Most often they were accepted in relation to Cubism more positively, but one critic in particular took them as a clear sign of betrayal, a betrayal which was to be celebrated not deplored. 'One has the right [now]', wrote Roger Allard, 'to go back to the aestheticians, the abstractors of the quintessence...to say to them, once and for all, that the work of Georges Braque has nothing to do with that international Cubism, bazaar merchandise of elementary art and intellectual deception.'[37]

Between 1922 and 1924 Braque's still-life painting too took on a naturalistic look, something visible especially in his range of small works for the less spendthrift of his clientele. Already in such a picture as *Still Life with Brown Jug* of 1922 (Plate 235) the jug has been returned close to its natural shape and so have the squishy yellow peaches, which are as if lifted from the baskets of the *Canéphores*. While in such a canvas as *Pitcher, Fruit-basket and Knife* of 1924 (Plate 79) not a single geometric invention competes with the near natural shaping of everything. Small paintings like these would certainly have strengthened Allard's claim that Braque was no longer a Cubist, though it is clear too that these were pictures that *could* be seen in Cubist terms (a point to be taken further later).

Picasso and Neo-Classicism

Braque's apparent decision at the Salon d'Automne of 1922 to join the defectors was important enough, but, of course, the one defection (or apparent defection) that mattered most was Picasso's, for Picasso was the accepted 'great painter' among the Cubists, accepted as such even by many of its adversaries. His decision to resuscitate various of the accepted classical styles of the past, from Roman fresco to Ingres and Corot, created a splendid opportunity for the anti-Cubist critics.

For those without access to his studio, the exhibition of Picasso's Cubist work at l'Effort Moderne in June 1919 had made it clear enough that this decision did not mean defection from Cubism at all, but, with so much stress laid by the Cubists themselves on the rejection of straightforward representation, it seemed nonetheless to question the very basis of the Cubist position; and he did not keep his other artistic life secret. Just three months after his Effort Moderne exhibition, Paul Rosenberg, Léonce's brother, put on another Picasso show.[38] It included early work, but also recent drawings and water-colours in sympathy with the little Biarritz *Bathers* (Plate 75) and the Ingrist portraits (Plate 204). At the end of 1919 Jean-Gabriel Lemoine was still scornful of Cubism, and his reaction is to be expected. For him, the exhibition at Paul Rosenberg's was a demonstration that Picasso's blunders (as a Cubist) were 'a clever bluff. He pirouettes with agility outside Cubism, of which he is tired. He jumps over

72. Pablo Picasso, *Portrait of Igor Stravinsky*, 24 May 1920. Pencil, $24\frac{3}{8} \times 19\frac{1}{8}$in. Musée Picasso, Paris.

Impressionism, he jostles Courbet in passing, and falls to his knees in front of M. Ingres, to whom he makes a big salute. We applaud.'[39]

Early in 1920 Picasso made pen-and-ink portraits of such ballet personalities as Erik Satie and Igor Stravinsky (Plate 72), drawings which are perhaps too hard-hitting to ask direct comparison with Ingres; there were paintings of massive female figures too. Then, after a summer spent on the Mediterranean at Juan-les-Pins, he adapted his sense of traditional style to a new kind of subject for him, classical myth. In September he produced a series of small works on the theme of a mythical rape: the attempted rape of Hercules' bride Dejanira by the centaur Nessus. Related to these is the tiny tempera on panel *Rape* (Plate 73), which he crafted with

73. Pablo Picasso, *The Rape*, 1920. Tempera on wood, $9\frac{3}{8} \times 12\frac{7}{8}$in. Collection, The Museum of Modern Art, New York. The Philip L. Goodwin Collection.

the precision and the patience almost of a miniaturist (at least in his treatment of the figures). Stylistically this is a work which demands comparison with Poussin more than Ingres, which creates an atmosphere of classical myth even though no particular story is told, and which anticipates the full-blown Neo-Classicism of Léger's *Grand Déjeuner* far more tellingly than do Picasso's more Ingresque inventions. It anticipates also the larger, grander Neo-Classical figure pieces

Picasso would produce in the summer of 1921, spent idyllically with Olga and their baby son Paolo at Fontainebleau, the grandest of which is *Three Women at the Spring* (Plate 74).

Picasso's Fontainebleau Neo-Classicism might relate most to such antique and classicizing sources as Hellenic sculpture, Roman fresco and Poussin, but in 1921 the perceived link between Picasso and Ingres was not merely mentioned, it acquired the status of a symbol; Ingres after all stood for the

74. Pablo Picasso, *Three Women at the Spring*, 1921. Oil on canvas, $80\frac{1}{4} \times 68\frac{1}{2}$in. Collection, The Museum of Modern Art, New York. Gift of Mr and Mrs Allan D. Emil.

Academy as well as an idea of tradition.[40] Much was made of
the fact that when, in May 1921, before his departure to
Fontainebleau, another Picasso exhibition was held at Paul
Rosenberg's gallery featuring his traditionalizing work (in-
cluding the Biarritz *Bathers*), it opened just before the close
of a major exhibition of Ingres at the rue de la Ville-l'Evêque.
Yet, sympathetic critics could still link Picasso to Ingres and
see no significant break with Cubism, just as Metzinger
or Severini could see their own return to representation
as a continuation of Cubism. Earlier André Salmon had often
mentioned Picasso's interest in Ingres and had suggested,
as a witness, that it had actually played a role in the
initial development of Cubism.[41] His view was so widely
discussed, indeed, that on an official visit to the Ingres
exhibition the President of the Republic, Millerand, was
actually reported to have asked his guide for an explanation
of how, so incredibly, Cubism and Ingres could be mentioned
in the same breath. For Salmon, the answer was simple.
'Ingres', he wrote in *L'Europe Nouvelle*, 'was a great draughts-
man, that is to say, a great deformer, that is to say a great
constructor.'[42] What Salmon stressed (and with him others,
like Lhote) was that, though he worked from the model,
Ingres was so deeply concerned with the development of
formal relations that inevitably he was led to distortion: he
distorted in order to construct and so showed the way to
Cubism.[43]

Picasso's relationship with Ingres could, thus, be seen as
just an unexpected gloss on Cubism, and by implication so
could his entire relationship with styles from the past. He was
not merely recreating styles, he was using their ways of re-
constructing the visible with a freedom that is Cubist. Rarely
are specific models from the past alluded to straightforwardly,
the relationship is almost always made not quite direct,
blurred or rendered ironic; almost always the special quality
of his distortions is a central factor. This is so of the entire
period between 1917 and 1924.

The closest Picasso came to declaring a straightforward
relationship was in certain of the portraits, most obviously
the Ingrist drawings, the *Portrait of Olga in an Armchair* of
1917 (Plate 204), and the portraits of 1923–24, including the
series of harlequins made early in 1923, with Jacinto Savaldo
as sitter (Plate 77). When he painted *Seated Harlequin* (working
in tempera), it was to Corot rather than Ingres that he looked.
The harlequin as sitter is, of course, his own obsession, but
he situates him in a line of costume portraits with Corot as the
obvious reference point by virtue of the cool tones, the crisp
handling of light and dark, and the abstracted, pensive calm
of the sitter. Corot is hardly challenged here, and, though
there are unexpected elisions and distortions in the drawing
of legs and of chair, Picasso does not distort in a conspicuously
alien fashion. In *The Bathers*, the tiny tempera *Rape*, and the
Three Women at the Spring relationships with the past are very
different: in these cases, more typically, Picasso identifies
himself with past styles in ways that are both blurred and
ironic; and distortion counts.

The Bathers (Plate 75), like the portrait of Olga, was a picture
with deep private significance for Picasso; he kept it for
himself. It is perhaps *the* paradigmatic statement of his ideal
relationship with past styles. The model *is* specific, the Ingres
of the *Bain turque* (Plate 76), and each of the poses is an ampli-
fied echo of that model: the upright bather of Ingres's dancing
nude, the reclining bather of the sprawled nude on the right
of Ingres's picture, the seated bather of the lute player. Even
the colour has a jewel-like brilliance which is in tune. But the
references are of course blurred, however specific the poses
make them, for the context has so completely shifted to the
twentieth-century seaside. and so exaggerated have the twist-

75. Pablo Picasso, *Bathers*, 1918. Oil on canvas, 10⅜ × 8⅝in. Musée
Picasso, Paris.

76. Jean-Auguste Dominique Ingres, *The Turkish Bath*, 1864. Oil
on canvas, diameter 40½in. Musée du Louvre, Paris.

ings of posture and gesture become that the authority of Ingres
is almost, it seems, made fun of. It is as if Picasso is making
explicit to himself the release that the *Bain turque* had given
him: the licence to elongate, emaciate and contort as he wished.
Had Salmon wanted a single image to sum up his notion of
the relationship between Ingres and Cubism through the
mediation of Picasso, he could have found none better.

Poussin rather than Ingres was probably the crucial model

77. Pablo Picasso, *Seated Harlequin*, 1923. Tempera on canvas, 51⅜ × 38⅝ in. Oeffentliche Kunstsammlung Basel, Kunstmuseum.

for *Three Women at the Spring*, as for *The Rape*, in this case specifically the right-hand group of figures in the Louvre's *Eliezer and Rebecca*, which was a painting given special treatment as a talisman by reproduction in the Purist periodical *L'Esprit Nouveau*.[44] Again, however, the relationship is blurred, this time by an avoidance of all that was studiously archaeological about Poussin's painting (either biblical or mythological), by generalization (in draperies and setting)

78. Gino Severini, *The Two Pulcinellos*, 1922. Oil on canvas, $36\frac{1}{4} \times 23\frac{7}{8}$in. Haags Gemeentemuseum, The Hague.

as well as by distortion. As in *The Rape*, the distortions are striking and are given powerful sculptural presence: the broadening of the torsos, the thickening and shortening of limbs, the remarkable enlargement and strengthening of the hands around whose play of gesture all is arranged, every diversion from natural or classical proportion increasing the sense of bulk. Much has been made of the way that the clear tonal contrasts that build the figures create a strong effect of relief on a single plane.[45] Yet perhaps this stress on flatness is at its most compelling in the way that Picasso allows his technique of forming masses by broadly brushed over-painting on a broken, loosely worked dark ground, to declare itself openly. It is impossible to be unaware of the fact that these hefty figures are thus flatly articulated from the surface interaction of ground and over-painting; and in this they are like Braque's *Canéphores*, clearly the work of a Cubist but clearly something other than Cubism.

Anything like a discriminating look at Picasso's traditionalizing pictures in relation to the references to past styles that they wore on the sleeve must have revealed how blurred, ironic and personal was that relationship, and have underlined the Salmon hypothesis regarding Picasso, Ingres and Cubism. No critic was ready for such a thing, however, and the Salmon hypothesis was defended by rhetorical restatement rather than critical elaboration. The fact is that the regular showing of Picasso's traditionalist pictures in Paris, especially at Paul Rosenberg's in 1921 and 1924, constantly reinforced the opinion that Cubism was dying and that the major symptom of this was the defection of its inventor. With Picasso very clearly in mind, this is how Maurice Vlaminck summed up the situation in 1924: 'Do you know what the Cubists have discovered now? Alarmed...at having destroyed everything ...they have gone back to school like kids! I am told that M. Ingres gives them excellent lessons.'[46]

The Kahnweiler and Uhde Sales, and the *Revue de l'Époque* Enquiry

In December 1921 the non-objective painter Piet Mondrian wrote disgustedly to his friend J.J.P. Oud: 'All the good artists return [to figuration]: they put water in their wine.'[47] By 1922 the air was so thick with betrayals that the time was ripe again for the claims of Cubism's final demise to multiply. This was all the more so because of another sequence of events which seemed only to be interpretable as another sign of Cubism's imminent end.

During the War the property of all Germans in France had been sequestered by the French state, and this included the entire stock of D.-H. Kahnweiler and the collector/dealer Wilhelm Uhde. Between 1921 and 1923 just over seven hundred pictures by Picasso, Braque, Gris, Léger, Derain and Vlaminck were sold at the Hôtel Drouot. The Uhde sale was held in spring 1921; there were two Kahnweiler sales in 1921, another in 1922 and the last in 1923. A complete analysis of the movement of prices in these sales has been made by Malcolm Gee. He demonstrates that in general prices for all the painters fell (a reflection of the brief period of economic recession in 1921–22, and also of the flooding of the market), but that the Cubist work, especially of Gris and Léger, fared appallingly alongside the more accessible work above all of Derain, most obviously in the last two sales of July 1922 and May 1923.[48]

Not only did the sales exhibit commercial failure, they also underlined the fragmentation of the Cubist enterprise, because they brought into the open the factionalizing of the movement around competing dealers. Kahnweiler and his Cubists, naturally, fought the sales, but his rival Léonce Rosenberg convinced himself that the only policy was to make them a publicity vehicle for the movement, and he was installed as official expert at the Hôtel Drouot. Such was the tension created that, in an incident made famous by a grateful press, Braque struck Rosenberg publicly. Rosenberg, of course, would not admit that the sales were a débâcle, but the press was not deceived and, eagerly led as ever by Vauxcelles, the very most was made of an unhappy misfortune for the reputation of the movement. 'To come back to the Kahnweiler sale,' Vauxcelles wrote of the second of them,

> it seems to me that the reign of the Cubists comes to an end...I have seen cubes cleared at derisory rates. If it had not been for the push given to Picasso's and Braque's prices by the ardent Lipschitz [*sic*] and the generous Villard [*sic*], all this would have ended in a sad fiasco. The non-Cubist Derains have 'held up', as one says at the Stock Exchange.[49]

The scene was set for Cubism to 'die' yet again.

In March 1922 a small literary and arts magazine well in the middle of the road, *La Revue de l'Époque*, published the answers to an enquiry sent out to artists and critics in Paris asking the following: 'For several months one has often heard it said: "Cubism is dead." Do you think that Cubism really is dead? If yes, what sickness did it die of?'[50] That such questions should be asked is, of course, a demonstration of their topicality in 1922 after the defections and failures of the previous two years, and certainly this enquiry excited widespread notice at the time.[51] The editors claimed that nine-tenths of the replies came from what they styled the 'avant-garde', though of the leading Cubists themselves and their sympathizers only Maurice Raynal answered; whatever the character of the sample, the answers can give some approximate idea of the range of attitudes hostile to Cubism that went with the desire once more in 1922 to see it finally dead.

There were flippant replies, for instance Kees Van Dongen's laconic: 'from the 'flu', and this elaboration on the same theme by Moïse Kisling: 'I don't think Cubism is dead. I met it yesterday—unshaven—watery eyed; it must have had a little 'flu. I don't believe in sudden deaths.'[52] But there were, too, serious replies, and these reveal very much the same range of feelings and arguments revealed by the critics at the time of Vauxcelles's assault on Cubism in 1918–19. Found still is the view that Cubism owed its importance to one man, Picasso: 'a madman of genius', as one respondent put it.[53] Then, more commonly, there are variations on the established Vauxcelles hypothesis that Cubism was only ever significant as a way on to a constructive Naturalism. Predictably, the evidence of the defectors had strengthened the case for this view considerably, for much sophistication was needed to comprehend that defection meant merely an extension of the basic principles of Cubism.[54] And then, just as commonly, there is the view that Cubism had died or was dying because of its impenetrable intellectualism, and allied to this view, the conviction (not so often expressed before 1920) that the movement was doomed by its rigidity. 'Cubism is dead', wrote the architect Frantz Jourdain, 'because of verbal incontinence.' 'Imprisoned in abstraction,' wrote one Georges Jamati, '...the Cubists have only realized inert and shapeless schemes.'[55]

Of course, as we shall see, Cubism was not dead, and the fact could not be ignored that, even in 1922, the movement was still a living issue. As Raynal's reply put it: 'There is but one thing to say to this frivolity, it is that the readers of the periodic announcements of the death of Cubism are not so naïve as to ignore the fact that only those are dead of whom one never speaks.'[56]

Maurice Hiver

There remained, then, after 1922 a movement for the anti-Cubists to attack, a continuing need for important critics to capitalize on the defections, on the contradictions of Picasso, and to point out the frailties of the Cubist enterprise. Undoubtedly in 1923 the most violent attacks of all came from a critic who wrote for the periodical *Montparnasse*, Maurice Hiver. They are, in fact, a special case, unique in their almost obsessive intensity: they seethe with malice. Hiver was especially provoked by Lipchitz's contributions to the Indépendants of 1923, by the interest of the American millionnaire Dr Alfred Barnes in Cubism and specifically in Lipchitz while visiting Paris during the summer, and by the exhibition of Gris which opened in Kahnweiler's galerie Simon in April 1923. Neither Lipchitz nor Gris could have been called defectors from Cubism so his targets are perhaps understandable.

Much of what Hiver wrote is too malevolently personal to be significant, but at times he approaches the important issues. 'This display of absurdities', he writes of Gris at the galerie Simon, 'immediately gives the impression of a closed door, a ludicrous labyrinth which leads nowhere.'[57] He finds Gris's pictures 'a crushing nothingness; there is to be extracted from them a freezing impression of emptiness...'.[58] Then there is more, to confirm the predictable anti-intellectual core of Hiver's hostility, for there follows an attack on 'the vile intellectuals who have swollen this enormous bladder [Cubism],' among them Waldemar George, now a firm friend of the Cubists. Again predictably, the anti-intellectualism went with a profound anti-élitism, for in an earlier number of *Montparnasse* Hiver had identified his target (besides the Cubists themselves) as: 'a little clique who have sworn to make the snobs swallow a new brand of condensed ugliness as a result of their publicity,'[59]

Cubism and the Emergent Generation: Favory, Lhote, Bissière and Miró

If Maurice Hiver's articles in *Montparnasse* add up to no more than an isolated phenomenon, between 1922 and the middle of the decade the most persuasive and coherent body of opinion set against Cubism was centred on a few other periodicals. This was the loose grouping of artists and critics, most of whom sympathized with art which took nature as its starting-point, centred on the far from avant-garde periodicals *Le Crapouillot*, *Les Nouvelles Littéraires*, and, after 1924, the off-shoot of *Les Nouvelles Littéraires*, *L'Art Vivant*. They include Robert Rey (who wrote for *Le Crapouillot*), Paul Fierens, Claude Roger-Marx and the two editors of *L'Art Vivant*, Jacques Guenne and Florent Fels. Vauxcelles, writing prolifically throughout these years for several publications, from *Le Carnet de la Semaine* to *L'Éclair* was also really one of them, and, of the artists, particularly vociferous was Vlaminck.

The attacks of these men focused much more sharply than Hiver's the major issues raised by Cubist art both in relation to 'the natural' and to the public; they are, therefore, central to Part III. At this stage it is necessary only to record that they too were at root anti-intellectual and anti-élitist, and, more importantly, to pick out a particularly effective technique they habitually used to underline the irrelevance and the decline of Cubism in the twenties. The technique in question was simple even if it was often indirect. It was to suggest, sometimes by no more than innuendo, that Cubism was obviously at its end because it had become dated, because it was hopelessly *déjà vu*.

Léger, as has been seen, showed either his *Mother and Child* (Plate 218) or a related picture at the Salon d'Automne of 1922, and it is a measure of the muddle that existed in the minds of some that Robert Rey could lump it together in his mind with Cubist painting (perhaps he too could see it as an extension of Cubism). In doing so, Rey uses the technique in question very plainly. 'There are', he comments in *Le Crapouillot*, 'no more Cubists; or almost none; those that remain are in Room 16. The great big eskimo puppet by M. Léger makes one think of times very long ago, of the *baraques* on the Champs-de-Mars before the war [the Indépendants], ...how far away it is! How peripheral.'[60] Writing otherwise generously about Braque in 1924, Claude Roger-Marx cannot resist a remark about allusions in his painting 'to the times, already long ago, of Cubism...'.[61] Such asides were calculated quietly to turn vague suspicions and prejudices into agreed assumptions. They were, undoubtedly, a far more effective weapon than the hysteria of Maurice Hiver.

The proliferation of apparent betrayals and the fact of commercial failure were not all that converged to lend support once again to the claim that Cubism was dead. The effectiveness of this particular subversive technique in the conservative criticism of Cubism is important to bring out here because it points to a third factor: the image of Cubism as a movement increasingly out of date was effective simply because it could be substantiated. The undeniable fact is that between 1918 and 1925 there was in Paris not a single *young* recruit to Cubism of any importance. All the young painters agreed by pro- and anti-Cubist critics to have talent seemed to keep away from the Cubist circle. If Cubism survived so many betrayals and still lived, it survived as a movement almost exclusively for the over-forties, the revolutionaries of before the Great War. In 1922 Léger, Picasso, Braque, Herbin and Louis Marcoussis were all forty or over, and the youngest of the Cubists, Gris and Lipchitz, were thirty-five and thirty-two respectively, while the newest recruit whose Cubist credentials were unquestioned, Georges Valmier, was already thirty-seven years old. Alongside the apparent defections of so many from within, Cubism was threatened by the decision of young artists to look elsewhere.

The problem for young artists confronted with Cubism after 1918 is outlined in one reply to the *Revue de l'Époque* questionnaire of 1922. Jan Gordon, the British illustrator and writer, comments that even for those who pursued 'scientific analysis' Cubism had lost its interest: it was 'boring to make the same experiment twice'.[62] To be a young Cubist was to come second. So evident was this problem that at least one committed champion of the Cubists, Maurice Raynal, actually encouraged the young to look elsewhere for possible points of departure by praising those who had: in 1923, for instance, picking out André Beaudin, and in 1924, Pierre Charbonnier.[63]

Whatever the reason, between 1918 and 1923 ambitious young artists were almost all drawn either towards the various brands of Naturalism in circulation or towards variants on Neo-Classicism or towards the revived and tamed early Cubism whose main mentor was Lhote. Following Vauxcelles, many critics had shared in creating an atmosphere in which modern revivals of past styles or a revitalized Naturalism could seem not to be a retreat but rather genuinely progressive, and in which the most effective way to arrive at a new, independent art was to confront either nature or the past or both directly, outside what appeared the strait-jacket of Cubism. Dada, as a negative force and moreover above all a literary phenomenon, did not draw to it young painters, and Surrealism was not to act as a magnet for the most daring young artists until at the earliest 1923 (just before the official founding of the movement). In a real sense, the younger generation of French artists be-

79. Georges Braque, *Pitcher, Fruit-basket and Knife,* 1924. Oil and sand on canvas, $10\frac{1}{4} \times 25\frac{1}{2}$in. Private Collection, Buenos Aires.

tween 1918 and 1923 was a lost generation, lost at least to the Modernist history of art with its charts of revolutionary change. They were too late to be Cubist and could find no alternative that was both strong and obviously progressive. To underline what is an important aspect of the perceived decline of Cubism in the early twenties, a brief glance is needed, in parenthesis, at the directions this younger generation chose to pursue as preferable to Cubism. What follows is not an attempt at a balanced account of 'young painting' in Paris in the period, but a sketch of some of the major alternatives taken up by young artists, given substance by a few selected cases.

Alongside Lhote and Rivera, one of the artists chosen by Vauxcelles for his anti-Cubist show at the galerie Blot in 1918 was André Favory. At that date Favory was in his mid-twenties and Vauxcelles picked him as an artist who had tried Cubism and found it wanting.[64] Into the later 1920s he was consistently to be picked out as one of the most gifted of the young, even by a friend of the Cubists like Maurice Raynal. His is an exemplary case.

Favory remained for a couple of years after 1918 true to Vauxcelles's ideal of the painter freed from Cubism but at the same time strengthened by it, something clear from his contribution to the Automne of 1920, *The Bathe in the Village* (Plate 80). He was consistently still close enough to the constructive aspect of Cubism to be paired with André Lhote in 1921, with whom he was reported on good terms. From 1921, however, his work lost even such vague Cubist undertones. His contribution to the Salon d'Automne of 1922 was *Maison clos* (Plate 81), a robust brothel scene, and in 1924 he sent *Under the Bower* (Plate 195), a simpler scene of seduction; both were considerable successes in the press. The celebration of late Renoir in 1920 and 1921 had left Favory's painting dominated by a Renoiresque love of soft, plump female forms, an extravagantly free technique and a highly compatible love of twisting poses and complex Baroque compositions.

Early in 1926 *L'Art Vivant* published an interview with him, and it is surprising to find him stressing, not the pleasure principle, but the lineage of Rubens, Jordaens, Titian, Tintoretto, Courbet and Delacroix.[65] Salmon in *La Revue de France* had already castigated Favory for trying to make 'museum art', and, though some critics took his art primarily on a sensual level, his broad stance in relation to modern and past styles closely relates him to the painter who even more than Picasso made revivals seem an acceptable way forward, André Derain. Derain's use of models from the past was as blurred as Picasso's during the period, but it was never ironic; his was an essentially

supportive and therefore conservative use of seventeenth-century still life or of Corot as models (Plate 82). Favory did not take Derain directly as a source or even turn to Derain's sources, but his attitudes to his own High Renaissance and Baroque sources was in very much the same way corroborative, conservative. Where Derain led was certainly one major direction away from Cubism taken by young painters at the time.

With Vauxcelles's stress on 'constructive Naturalism' so important a factor, the reassessment of Cézanne (yet again) presented another attractive major alternative for younger

80. André Favory, *The Bathe in the Village,* 1920. Oil on canvas, size and whereabouts unknown. As illustrated in *L'Amour de l'Art*, October 1920.

artists like Charbonnier and especially Simon Lévy,[66] but for the more daring such a reassessment could not ignore Cubism altogether and so the 'neo-' or non-synthetic Cubist stance given visual and verbal substance by André Lhote proved extremely appealing. Several of the most able younger painters were attracted by it, including both Roger Bissière and Marcel Gromaire. Lhote's stance in relation to Cubism was less clear-cut than Derain's or Favory's, but it is possible to unravel its subtleties after his initial break with l'Efforte Moderne in 1918 because it is so lucidly delineated in his published writings of the time, most of all in *La Nouvelle Revue Française*.

Reverdy or Raynal might have dismissed Lhote as irrelevant to Cubism, but, surprisingly, he actually presented himself *as* a Cubist after 1919. Thus, responding to the large Cubist showing at the Indépendants of 1920, he maintained that there were two continuing currents in Cubism: one was synthetic and based on abstract construction, the Cubism of 'the *a priori* Cubists or the pure Cubists', the other was analytic, that of the '*a posteriori* Cubists', and based on a direct study of

82. André Derain, *Nude in front of a Green Curtain*, 1923. Oil on canvas, $36\frac{1}{4} \times 28\frac{3}{4}$in. Musée National d'Art Moderne, Centre Georges Pompidou, Paris.

81. André Favory, *Maison clos*, 1922. Oil on canvas, size and whereabouts unknown. As illustrated in *L'Amour de l'Art*, October 1922.

nature.[67] Lhote saw himself as an *a posteriori* Cubist (Plate 6). Thus, what Vauxcelles had called a rejection of Cubism in 1918 was, as Lhote saw it, the development of another kind of Cubism. Certainly, as we have seen, this could be called merely a revived 'early Cubism', yet it had a distinctly post-war look for two reasons: its tidiness and its openly advertized identification with a (French) traditional lineage. The tidiness went with a continuing use of geometric armatures as a discipline; the advertizing of links with tradition in works like his *Homage to Watteau*, shown at the Automne of 1919 (Plate 60), went with a comfortably chauvinist notion of tradition.

Lhote saw the French tradition as always rooted in the direct observation of nature, pointing to Claude, Poussin, Ingres and

Cézanne; the Italian tradition he saw as always rooted in synthesis, pointing to Michelangelo and Raphael.[68] He was thus able to fit his analytical, nature-based version of Cubism into a reassuringly nationalist view of tradition, and to remove the synthetic, the 'pure' Cubism of Picasso, Gris and their French allies into the more doubtful category of foreign art. His appeal was that of a solid French traditionalist who looked (in his work) and sounded (in his writing) like a modernist, and it was an appeal augmented by the choice of attractive popular subjects, anti-élitist and lively. At the Indépendants in 1923 he showed a country-fête picture, *The 14th July at Avignon*

83. Roger Bissière, *Figure Group, c.*1922. Oil on canvas, $44 \times 51\frac{1}{4}$in. Sale: Sotheby & Co, London, 7 July 1971, lot 154.

(Plate 222), and at the Salon d'Automne a sporting picture, *Football*. If this was indeed a brand of Cubism, it was one that attracted the appreciative attention of many anti-Cubist critics, not merely of Vauxcelles but also of those who wrote for *Le Crapouillot*, *Les Nouvelles Littéraires* and *L'Art Vivant*. Robert Rey enthused about his *14th July at Avignon*: 'André Lhote', he writes, '...finally cheers up too and shows an *avignonais* dance full of the noise of cornets. One can be consistent with oneself without condemning oneself to keep a solemn air as proof...'.[69] Of *Football*, Edmond Jaloux remarked: 'It shows that his theories can be attuned to life and the sense of movement.'[70]

There were other respected middle-generation artists who occupied the space between post-war synthetic Cubism and Naturalism with styles that bring to mind a tidied-up image either of late Cézanne or of early Cubism, notably Jean Marchand and Luc-Albert Moreau; but for Roger Bissière and Marcel Gromaire, as for many young artists, Lhote as a painter, writer and teacher was a particularly significant figure. Bissière especially was an ally, if not an actual follower. Like Lhote, he was a painter-writer, and early in the twenties published memorably clear essays on Seurat, Corot and Ingres in *L'Esprit Nouveau* (the Purists' periodical) and on Picasso and Braque in *L'Amour de l'art*.[71] From 1923 he took the Braque of the *Canéphores* as his guide, but between 1920 and 1923 he was certainly what Lhote would have called an *a posteriori* Cubist in pictures like *Figure Group* probably of 1922 (Plate 83). He too worked with simplified volumes from nature, using small shifts of viewpoint in a highly controlled way, and his choice of subjects and his slightly Cézannist facture made the right historical connections. Gromaire was perhaps the only other young French painter to follow in the direction signalled by Lhote who equalled Bissière in the impact he made, but his distinct alternative to advanced Cubism was not to become really significant until 1925.[72]

One other painter deserves special treatment as a young artist who reacted in a way broadly comparable with that of Lhote, Bissière and Gromaire against the purity of advanced Cubism, but he was not French and his reaction was right out of the ordinary: this is the Catalan Joan Miró.

It was in March 1919 that Miró first arrived in Paris, and he arrived well aware of the newly distilled values associated with 'pure Cubism'. In Barcelona, in the small avant-garde circle centred on the Dalmau galleries, he had certainly had access to *Nord-Sud* and was already an avid reader of Apollinaire.[73] On his departure for Paris he wrote to a friend 'One must go ...ready to pitch into the battle, not as a non-combatant spectator,'[74] and when he arrived the 'battle' he found there, of course, was the controversy instigated by Vauxcelles over the prematurely announced 'death of Cubism'. His mentors were Picasso (a family connection) and Maurice Raynal (who had dealings with Dalmau and had visited Barcelona in 1917).[75] Immediately brought into the centre of things, Miró could not have observed the situation without considering where he stood, and the point is underlined by the fact that he arrived with Léonce Rosenberg's sequence of Cubist exhibitions in full swing. He could have seen the Braque, Gris, Severini and Picasso exhibitions before his return to Catalonia for the summer. In that atmosphere of passionate debate he could have seen the most recent distilled products of synthetic Cubism presented as a concerted rejoiner, it will be remembered, to the conviction that art should begin in nature. It was two years later, in 1921, as the history of Cubist betrayals gathered pace, that Miró, now a winter Parisian, showed the results of his first immersion in the French situation, at the galerie La Licorne. Raynal wrote the preface to the catalogue. Two of the pictures included were *Nude with a Mirror* of 1919 (Plate 84)

84. Joan Miró, *Nude with a Mirror*, 1919. Oil on canvas, $44\frac{1}{8} \times 40\frac{1}{8}$in. Kunstsammlung Nordrhein-Westfalen, Düsseldorf.

and *The Table* of 1920 (Plate 85), both painted during his periods of reflection back home at Montroig.

The position Miró took in the Parisian 'battle' is clear enough. He rejected the purity of the Reverdian Cubist stance with its insistence on a starting-point for poet or painter in language itself or in pictorial elements, in favour of a stance still dependent on the initial stimulus of nature, a stimulus whose force was preserved with remarkable intensity in his

85. Joan Miró, *The Table (Still Life with Rabbit)*, 1920. Oil on canvas, $51\frac{1}{8} \times 43\frac{1}{4}$in. Collection, Gustav Zumsteg, Zurich.

pictures. Raynal saw this plainly: he called Miró's approach 'natural' and set it against the 'chemical', the one (Miró's) rooted in experience, the other in artifice.[76] For him, it was an observable fact that Miró had responded to Cubism by deepening his involvement in nature. Yet, it was also an observable fact that he had not rejected Cubist means out of hand: he had simply adapted Cubist flattening and structuring to the task of setting off the acuteness of his reaction to things seen—in *The Table*, the very scales of the fish, the very hair of the rabbit. Combining Cubist means and Naturalism thus,

86. Joan Miró, *Table with Glove*, 1921. Oil on canvas, $45\frac{1}{4} \times 35\frac{3}{8}$ in. Collection, The Museum of Modern Art, New York. Gift of Armand G. Erpf.

he can only be placed (at least in the Parisian context) along-side Lhote; he was another *a posteriori* Cubist.

Between 1919 and 1921 Miró painted many subjects. Besides figures and still lives which gave a place to the living as well as the dead, there were Montroig landscapes. To range so widely was, as with Lhote, a denial of the restrictiveness of advanced Cubism (when Léger is excluded). But Miró's anti-pathy to Cubism is perhaps best grasped when his painting of the key Cubist subject, still life, is confronted. *Table with Glove* (Plate 86), painted in the winter after his exhibition at the galerie La Licorne, is his work of this phase that most directly challenges the Cubists: the character of the rebuff is clear enough.

Here too there is a bold fusion of Cubist flattening and acute observation. The objects recorded are observed first-hand in Miró's borrowed Parisian studio on the rue Blomet, but they are thrust out from the picture plane with a force that comes of what he seems to have learned from Braque's pedestal-table still lives (Plate 54), and there is a stark stridency in the image that invites comparison with Léger (Plate 227).[77] There are also rhymes: catchy echoes between the general formation of the glove with its splayed out fingers, the leaves that frame the cockerel on the water-jug, and the ornate bows that tie the

cover of the sketch-book. The flatness of the picture clearly enhances the acuteness of Miró's record of detail observed, but the rhymes do indicate an interest in purely formal relations; and yet it is they, above all, that throw into relief the distance between Miró's and, say, Gris's painting. The point is that, where Gris's rhymes in 1919 (Plate 35) emerge from an initially abstract manipulation of shapes which can mean many things, Miró's have been *seen*: they have been noted in the objects of his studio and then brought out by meticulous depiction and arrangement. Miró has started by looking, not by shaping and manipulating. This compulsive involvement with things seen was to lead very soon to something different, and the capacity of the Cubist rhyme to encourage changes of identity was to generate fantastic results hardly hinted at here; but these were developments for the future. In 1921 Miró was a strange yet recognizable representative of that youthful reaction against advanced Cubism which demanded a new look at nature in all its variety.

Ozenfant and Jeanneret, the Purists, were of an emergent if not strictly speaking a younger generation, and, as has been suggested, a link existed between their alternative to Cubism and Lhote's. They also stressed subject-matter, and continued to do so between 1920 and 1925. Yet, during the period they moved towards much flatter planimetric as well as perspectival spaces, and their mode of picture construction was as close to the synthetic Cubists as to Lhote. It is not legitimate to see Ozenfant and Jeanneret as recruits to Cubism, but their re-lationship with advanced Cubism after 1920 was direct enough for it to be said that they were the only two emergent artists of any importance in this period to produce a variant on Cubism in its advanced state, a variation on crystal Cubism which was influential. For this reason they are best considered with the Cubists; their art was, in the end, more a variant on Cubism than an alternative.

Without the Purists, the prospects for the future must have looked bleak to any of the leading Cubists or their supporters who pondered long on the contribution of the young to the countless dealers' exhibitions and the Salons of this time. The Salon d'Automne of 1922 provoked Metzinger to publish an article in *Montparnasse* with the title 'Autumn Sadness'. 'One does not laugh at the Salon,' he wrote, 'one yawns there! *But for some twenty names*, it is a fact that contemporary painting is becoming mightily boring. Return to tradition, it is said. Why not say: sleepiness and bourgeoisification?… How I admire the art critics! They can discern tendencies! I see only influences…First the flotsam of Impressionism, then the Cézannists and the sub-Cubists, finally those who do Rousseaus.'[78] Those glanced at here (Favory, Bissière, Gromaire Miró) all believed that they had found a way on from Cubism which would widen the possibilities for a free and progressive art: they wanted to make fact out of Vauxcelles's influential hypothesis that Cubism was a way through. Metzinger, one of the defectors in the eyes of such as these, saw only retreat and plagiarism in the generation that followed his. But the fact remains that early in the twenties the resistance of youth to advanced synthetic Cubism tellingly substantiated the image of Cubism as an ageing movement, robbed of strength, whose day was over.

Kisling and Picasso in 1924

The year 1924 saw two events which seemed at the time to sum up a situation in which betrayal, commercial failure and the apathy of the young threatened once and for all the survival of Cubism.

The first of these events was the opening in March of Moïse

Kisling's first one-man exhibition for five years at the fashionable Right Bank gallery of Paul Guillaume on the rue la Boëtie. The second came a week or so later at Paul Rosenberg's gallery a few doors away with the opening of an exhibition of twelve carefully chosen figure paintings by Picasso and a quantity of drawings. Kisling at this time was thought one of the leaders

87. Moïse Kisling, *Nude*, 1924. Oil on canvas, 45 × 31¼in. Sale: Sotheby & Co, London, 27 June 1977, lot 64.

of the new young generation. As Salmon had it, writing on the exhibition: 'Kisling is…one of the most complete representatives of young French painting.'[79] His statements at the time are not hostile to Cubism or to Picasso, but insist on his independence from both, and on a directness and an expressiveness in painting that he clearly considered alien to Cubism.[80] He was quoted thus by Jacques Guenne in 1925: 'One must read in a picture the joy felt by a painter in creating it. It's for this reason that I say: pooh to the problems of geometry, painting must sing.'[81] He set himself up and was set up by sympathetic critics as the type of the young artist who had been able to develop without Cubism, and whose directness and openness to his audience kept him apart from the closed, élitist character of Cubism. Thus, his work, his sumptuous nudes (Plate 87), his fluffy landscapes and his coy or cowed children scored an immediate critical and commercial success, inevitably taken as another symptom of the irrelevance of Cubism. According to Florent Fels, such was the impact of his exhibition that it actually stood up to the challenge of Picasso's—praise indeed.[82]

Yet, of course, the Picasso exhibition was a far more remarked on event than Kisling's, whatever Fels might have written, and for those who watched for symptoms of Cubism's decline its significance was far more emphatic. It included not a single Cubist work, and it could seem for many really to mark the end of the movement. Writing in *Les Nouvelles Littéraires* Claude Roger-Marx was almost beside himself with glee at the prospect:

Spring offensive? Intensive firing? The rue la Boëtie is decked out in honour of Picasso [and] Kisling… One is crushed at Rosenberg's where collectors and dealers of all nationalities pass through… It must be recognized that these twelve large compositions and these thirty drawings, with their touch so clear, are brought off marvellously for a public delighted to hear Picasso, the one-man orchestra, after the long preparatory creakings of Cubism, finally using an overture in the purest style of the Italian opera. The harlequin cut to pieces has come back together again… Cubism was only a means; neither the public, nor Picasso were wrong. The farce is ended.[83]

If farce it was, it had not, of course, ended in 1918 or 1922, and it was not even ended in 1924. The signs misled.

4
Living Cubism, 1920–24

It was in June 1925 that Jacques Guenne's interview with Kisling appeared in *L'Art Vivant*. Guenne ended it thus: 'A conversation on painting would be very incomplete if I did not ask what you think of Cubism.'[1] This is but one among many signs in the art press of the mid-twenties that Cubism was still a central issue.

The view that the Cubism of the period 1918–25 was merely a 'restatement of a pre-war style' is a commonplace.[2] It has become almost the rule to date the ending of Cubism as a movement of real significance to around 1918–21, the most usual choice being 1921.[3] Oddly, the conventions of Modernist art history have done more to fix the idea in our minds that Cubism died then than all the anti-Modernist propaganda of Vauxcelles and his allies at the time. Certainly Cubism was a movement whose vanguard status was under threat from 1918, yet the fact is that in the pure, distilled form it had been given at the end of the Great War, it continued and at the time was seen to continue. Guenne was not the only one to see it as a central issue, many saw it still as *the* leading manifestation of Parisian avant-gardism, even in 1925. What is more, not only did Cubist painting and sculpture survive those years, but they grew and within themselves they changed. Cubist art in the early twenties was not characterized by restatement. Compromise there was, but just as prominently there was amplification and extension too.

Picasso

Most strikingly of all, Cubism was taken further by Picasso. What critics like Claude Roger-Marx chose to ignore at Paul Rosenberg's in 1924 was the fact that, back at the studio, Picasso was still at times undeniably a Cubist. Indeed, in the months following that exhibition right through to December the Spaniard was to produce some of his most ambitious Cubist works ever (Plates 88 and 91). It is easy to understand the irritation of Maurice Raynal at most responses to Picasso's twelve figure paintings. 'It is regrettable', he wrote in *L'Intransigeant*, 'that Paul Rosenberg did not think he should put together a group of works representing the different *current* tendencies of Picasso. The coffin-bearers of Cubism are once more about to bury the formula which stands in their way, when in Picasso's studio it is possible to see the most rare and subtle "plastic" combinations...'. He deplored the decision to show only those of his styles 'which please...'.[4]

The Cubist pictures that Picasso painted in 1924 are not obviously unseductive in colour and form, as the austere, angular Cubism of 1918 and 1919 had been, but their colour is hard and flat, they make a virtue of formal invention at the expense of description and they are often spatially as challenging as anything he had previously produced. Among the most ambitious was *Mandolin and Guitar* (Plate 91), painted in the summer at Juan-les-Pins. It is a late and elaborate attempt to exploit the potential for rich spatial incident released by an open-window backdrop, and therefore takes further themes launched during the war. Picasso uses three blues: two recognizable sky blues for the sky with its fluffy clouds, a deeper one to go with the black of indoor shadows. The result is to enhance colouristically the effect of outdoor depth opened up by the easily read window. The tiles of the floor, though not converging, create a complementary indoor depth for the table to stand in. Yet, the absolute lack of modelling or atmospheric modulation and the way that the composition is built of flat shapes that cross over and deny implied spatial divisions pulls these intimations of depth up on to the surface to create that characteristic Cubist tension exploited so fully by Gris nearly a decade earlier in *Still Life and Landscape (Place Ravignan)* (Plate 47). The shaping of objects has a soft elasticity

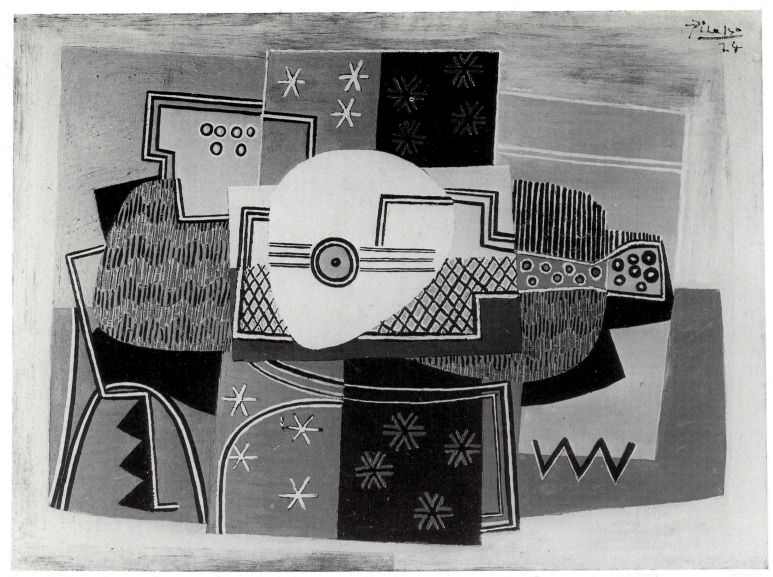

88. Pablo Picasso, *Still Life with Mandolin*, 1924. Oil on canvas, $38\frac{3}{4} \times 52$in. Collection, Stedelijk Museum, Amsterdam.

at odds with the crisp geometry of crystal Cubism, but objects are still obviously synthesized. Then, finally, everything is contained in a stable structure endowed with simple architectural features—window, panels, dado. The architectural analogy is still strong. In 1924 Picasso's position was not one of compromise. He worked in two distinct directions at once, as he had from 1914, and almost never blurred the distinctions between them. His Cubism was full-blooded: pure and utterly anti-naturalistic. Throughout the period 1920–24 two alternatives had been developed in this clearly delineated way, so that two stylistic histories of Picasso's painting then can be written: the Cubist one is not without incident.

The completeness of the alternatives was never clearer than in the summer of 1921 at Fontainebleau, where, alongside the Neo-Classical works (Plate 74) he painted his equally ambitious pair of Cubist pictures on the theme of *Three Musicians* (Plate 89). That Picasso worked directly with schematic signs for Pierrot, Pulcinello and Harlequin, manipulating them as flexibly as ever, is clear enough from the gouaches of 1920 that lay behind these canvases, the immediate sequel to his work with *commedia dell'arte* characters in the ballet *Pulcinella*.[5] That, without compromise, they took further the central concerns of his wartime Cubism is clear from the crisp concision of their interlocking parts, the stability of their structures, and, in the New York version (Plate 89), the clarity of the confrontation between perspectival and planimetric spaces. The *Three Musicians* are the culmination of Picasso's crystal Cubism and his most elaborate pictorial gloss on the spatial discoveries he had made in the open window studies of 1919 along with their tiny constructed relatives in cardboard (Plates 18 and 19). Once again, in the New York picture, Picasso fixes

the perspectival limits of a compressed stage-like space, but instead of piercing the 'backdrop' by means of an open window, he leaves it closed and builds outwards from it. Flat shapes in brightly contrasted colours are projected one in front of another out into the spectator's space as it were, and so convincingly three-dimensional is the effect that an actual construction could be read off from the painting with ease. A possible planar construction, sturdy and compact, seems to project from and at the same time contradict a perspectival space behind the picture-plane. Synthetic, architectural and paradoxical, this version especially is a work attuned to *Mandolin and Guitar* of three years later; its crystal Cubist geometry is all that sets them apart, at least in the terms of a formal analysis.

In both versions *Three Musicians* is patently, of course, theatrical: the *commedia dell'arte* theme spotlights as ever invention, disguise, artifice. As such it has recently invited the ingenious attentions of iconographers who have sought to unmask meanings deeper than the formal: Theodore Reff most notably has read the painting as a lament for a lost pre-war Bohemia, with Harlequin as Picasso himself, Pierrot as the pipe-playing poet Apollinaire (now dead), and the monk as Max Jacob (now in retreat as a Benedictine). Such private meanings, if they existed for Picasso, remained private; but it cannot be denied that a hidden dimension of meaning, intensely felt, is suggested by an element of the expressive which is unmistakable, again especially in the New York version.[6] It is there in the shadow-silhouette of the dog in this version, in the pervasive sombreness of the setting in which the figures make so brave a show, in the stylized physiognomies of the masks, and the comic miniaturization of the hands. This too

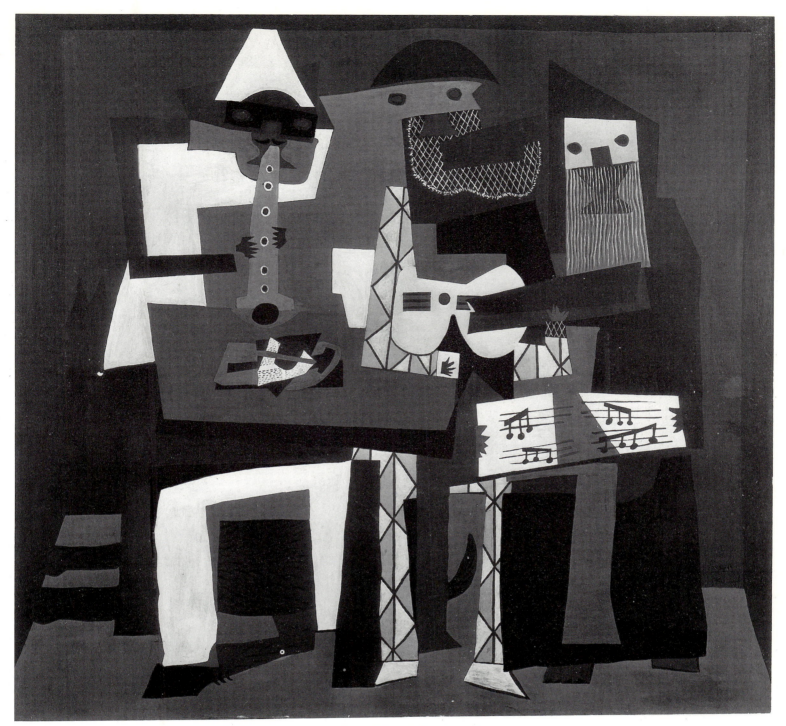

89. Pablo Picasso, *Three Musicians*, 1921. Oil on canvas, 79 × 87¾in. Collection, The Museum of Modern Art, New York. Mrs Simon Guggenheim Fund.

establishes a continuity between not only Picasso's Cubism here, in 1921, and his wartime Cubism, but between both and his Cubism of 1924: the expressive factor is there too in the soft, stretchable, organic forms of the objects in *Mandolin and Guitar* of 1924 as it had been in the awkward vitality of *Girl with a Hoop* (Plate 20) and the grin of *The Harlequin* of 1915 (Plate 11). Between 1921 and 1924 Picasso's Cubism was only rarely to take on a theatrical quality with such expressive effect again, and it was almost exclusively to focus on less eloquent still-life subjects, bereft either of dark suggestions or of light comic relief. Yet, the development of his Cubism in these three years opened the way to a new, far more dramatic expressive phase, beyond both Cubism and Neo-Classicism.

During the summer of 1922, while staying at Dinard, Picasso painted a series of still lives which are interrelated, one of them is *Glass, Bottle and Packet of Tobacco* (Plate 182). These pictures are characterized by great simplicity in their signs for objects which goes with the spatial and denotational complexities created by the separation of overlapping linear patterns and flat colour patches. Indirectly, the Dinard series relates to a much freer and more elaborate idea developed in

1924 in a group of drawings and given its most complete pictorial form in *Still Life with Mandolin* (Plate 88). Here a much more decoratively varied arrangement of colour areas (blues, greens and terracottas) are criss-crossed by rhythmic traceries of line which sometimes denote the parts of a wrought-iron table and a mandolin yet always seem to move freely.[7] The working apart of line and colour has led to an ornamental Cubism, which depends on the simplest of signs to create its subject-matter. The flexibility of this apparently rather undemanding mode was to be one of the two most telling factors behind the expressive departure of 1924 and after. Picasso's Cubist signs became as interchangeable again (potentially between figure and object) as they had been in 1914–15, very soon with devastating effects.

The flexibility of this new mode and its expressive potential is unmistakable in another group of drawings, this one made as a sequel to *Still Life with Mandolin* (Plate 90). In these drawings made at Juan-les-Pins Picasso reduced his vocabulary of marks to the dot and the line alone, and manipulated them with inexhaustible invention to make signs for objects like guitars and to activate as pattern the entire surface of the sheet;

the result is that, once again, signs that denote the inanimate become almost figurative and hence acquire a vitality usually associated with the animate. This kind of latent vitality, triggered by figure analogies, is not there in *Still Life with Mandolin*, but it is perhaps revealing that this is a still-life idea that makes almost uncanny visual contact with Picasso's best-known figure idea of the time: the reclining pin-man surrounded by the word 'étoile' repeated many times that served as backdrop for the ballet *Mercure* in 1924.[8]

The second most telling factor behind the expressive departure of 1924 has already been mentioned: it was the decision more obviously in *Mandolin and Guitar* to shape objects organically rather than angularly, and hence to fuse the qualities of the living and the dead. A few still lives of 1923 pointed the way in this development,[9] but it was with works like *Mandolin and Guitar* that it was consolidated. Objects here have become expressive as if physiognomically and by gesture; their stretchings and twistings have a borrowed animal energy. Clearly now Picasso does not need *commedia dell'arte* masking to instil expressive urgency.

In 1924 Picasso was on the brink of an expressive art whose power would be of a new kind, at least as some saw it. The possibility of such a development had in fact existed by 1914 (most evidently of all in the bizarre elastic forms of the women that populate his so-called Avignon drawings (Plate (10)), but in 1925 the potential so long present in his Cubism was to be released without restraint. For the moment, however, he kept to the sense of aesthetic decorum essential to Cubism in its post-war form. The expressive factor did not divert from the spatial tensions and the structural order of what were still indisputably Cubist pictures.

1924 saw the emergence of Surrealism, an event that will be returned to later. It was to be especially the Surrealists who would encourage Picasso to make the departure he did in 1925, and 1924 was the year when he was taken up publicly by André Breton and his friends as a hero, notably in June at the opening performance of *Mercure*.[10] Nothing could better sum up the distance at which Picasso and his Cubism continued to stand from Cubism as a group phenomenon. To be celebrated by the Surrealists was to be treated as a figure apart, someone isolated and special. Picasso still moved in the world of Diaghilev's Ballets Russes; he spent the summers of 1923 and 1924 at Antibes and Juan-les-Pins on the Côte d'Azur, living a socialite's life, involved especially with the extravagant circle of the Comte Etienne de Beaumont. He was indeed a special case. Yet, a large part of what he produced made a highly significant contribution to Cubism as a movement in the early twenties, and can only be understood in that context.

Léger

Fernand Léger was not a Cubist apart in the sense that Picasso was, and, unlike Gris, Lipchitz and Braque, he stayed with Léonce Rosenberg's gallery, a member of an enterprise which promoted Cubism as a 'collective style'. However, Léger's attitude to Cubism as a style among styles allowed him too, like Picasso, to work with clear alternatives, blurring neither by compromise.

At the same time there were basic differences between Picasso's and Léger's attitudes to art in relation to lived experience that went back to the Frenchman's response to the front line in 1915–17. The point is simple: both as a classical figure painter and as a Cubist Léger wanted his pictures still to stand as equivalents for his experience of modern life. With his development of the classical nude as a symbolic surrogate for the machine had gone a more exacting and ordered view of modern life. This became dominant in 1923–24, affecting

90. *Pablo Picasso, Drawings*, 1924. As published in *La Révolution Surréaliste*, 15 January 1925, pp.16–17.

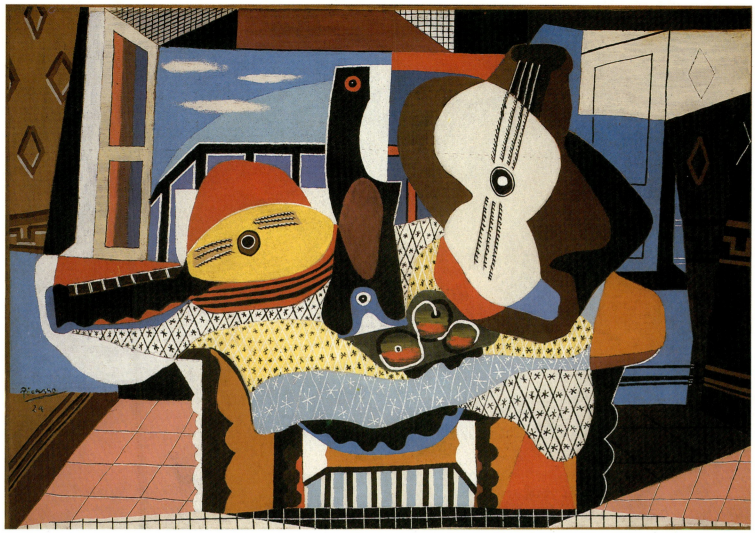

91. Pablo Picasso, *Mandolin and Guitar*, 1924. Oil and sand on canvas, $55\frac{3}{8} \times 78\frac{7}{8}$in. Collection, The Solomon R. Guggenheim Museum, New York.

the whole range of his art, but it was never entirely to expunge the other side of his modern-life view, his stress on movement and energy as released visually in the brutal contrasts of the city: he was to pursue strong pictorial contrasts as compulsively as the look of stability and precision. It is in his still-life painting above all that the point is made, and with it his distance from Picasso demonstrated; and it is in his still-life painting of 1921–22 that he presented his initial Cubist alternative to the Classicism of the *Grand Déjeuner*.

Ironically (and very unlike Picasso) Léger's Cubist alternative was almost literally a by-product of the large classical figure compositions themselves and certain of its central qualities followed from this, something one can see in his only still-life theme of 1921, which reached its most complete form in *The Beer Mug* (Plate 227). For a Cubist, Léger's creative practice was atypical. From 1918 he repeatedly invented new pictorial ideas by mutilating or reusing in new ways old ones. Often he developed a new idea by drastically transforming an old one, but often too he worked very simply, generating a new composition merely by extracting and then slightly changing a part of an old composition. Thus, for instance, alongside the *Grand Déjeuner* (Plate 66) he produced three separate, self-sufficient compositions using parts of the large idea.[11] It was in just this way that the figure paintings of 1921 led him into still life with *The Beer Mug*. Quite simply, the table-top still lives which were a feature of the figure paintings invited separate treatment too. Léger did not produce *The Beer Mug* merely by extracting one of those table-top still lives, however: it is a fusion of the ideas explored in the still-life props of the figure paintings, but its dependence upon them is undeniable.[12]

By thus focusing on the settings of his nudes, Léger arrived at an image deprived both of the classical connotations carried by the nude itself and of the weight of its volumes. Large contrasts between volumes and planes no longer dominate, and the smaller, staccato contrasts of surface pattern take over. Pattern is no longer merely an adjunct, it acts to differentiate and to unify, and also, crucially, to counteract the suggestions of adroitly placed and easily read perspectival clues. The table set askew on the decorated floor creates a broad impression of depth which is persistently challenged by the over-riding effect of flat pattern, and Léger repeatedly subverts his perspectival indications to amplify the conflict, for instance by folding up the left flank of the table-top entirely to destroy its consistency as a structure seen in depth. Nothing here is an effect absent from the figure paintings, but the fact is that without the nude Léger has produced a very different kind of picture, one in which Cubist spatial incident is central, one which is more dazzlingly decorative, more forceful, an image whose still-life subject generates associations not with Neo-Classicism but rather with Cézanne and the entire earlier history of Cubism up to that point. In 1922 Léger painted only a few still lives, but in them he expanded on the possibilities released by *The Beer Mug*. *Interior* is one of these (Plate 92);[13] it shows Léger also attracted as a still-life painter to the room as a stage and to the open window as a theme. But the surface stridency of its patterning along with the sheer force of its flat contrasts and spatial contradictions are a long way from, say, Picasso's *Mandolin and Guitar* of two years later.

Two further points should be made about the still lives of 1921 and 1922, points that inevitably follow from Léger's particular attitude to the relationship between art and modern life and which apply across the whole range of his work. First, Léger's pursuit of contrast led to a kind of stylistic pluralism very much more exaggerated than any other Cubist's, and

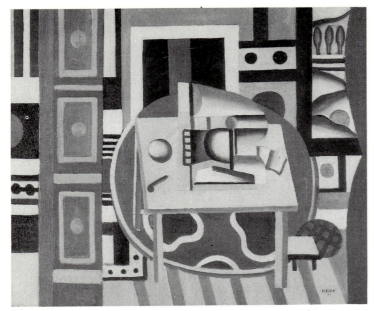

92. Fernand Léger, *Interior*, 1922. Oil on canvas, 21 × 25½in. Mutual Fine Art, New York.

93. Fernand Léger, *The Beer Mug*, 1921. Pencil, 15 × 10in. Collection, Dr and Mrs Barnett Malbin, New York (The Lydia and Harry Winston Collection).

second his idea of the artist in the modern world led him to manufacture his paintings in a distinct way, a way made explicit, made a carrier of meaning.

In all the still lives of 1921–22 Léger used at once a flat synthetic idiom and a solidly modelled, almost naïve idiom for his objects, the latter a descriptive mode which has been compared with fifteenth-century Northern European styles.[14] The 'advanced' and the 'primitive' were brought into direct conflict to create powerful dissonances, both visually and

94. Fernand Léger, *The Syphon*, 1924. Oil on canvas, 36 × 23½in. Collection, Mrs Arthur C. Rosenberg, Chicago.

connotationally, the result being altogether too paradoxical to be called a compromise. At the same time, though so forceful, a picture like *The Beer Mug* is the result of a working method characterized by painstaking preparation and application, and this is made to tell visibly. Léger did not only see his art as a visual equivalent of the energy and order of modern life, he saw it also as something manufactured in a modern way, though his self-image was more that of the small artisan than of the engineer.[15] According to Waldemar George in 1924, well briefed as he was by the artist, Léger was a 'French artisan' with the temperament of a worker, who made his pictures 'with the admirable professional conscientiousness of a painter-decorator or a coach-work painter'.[16] And certainly he worked thus patiently and methodically. *The Beer Mug* is inscribed on the back 'Etat définitif' (definitive state), and is the final phase in a sequence of stages that included a small 'state' and a highly finished drawing (Plate 93). Typically, it was scaled up by squaring from a study before being coloured in, the outlines being carefully laid out first with pencil on the primed canvas; and the visible traces of this process with the dryness of the laboriously filled-in paint surfaces conveys directly its designed character. Much is made of planning, almost nothing of the intuitive.

The designed character of Léger's art aligned it with the current painting of Ozenfant and Jeanneret, the Purists, a point which will become clearer later. Purist painting was the product of a modern-life view that was exclusively ordered and exact, that cut out the heightened qualities of contrast so important to Léger; from 1920 it was concerned with still life alone, still life treated in an austere, structured way. It was in the direction of Purist order that Léger's still-life painting

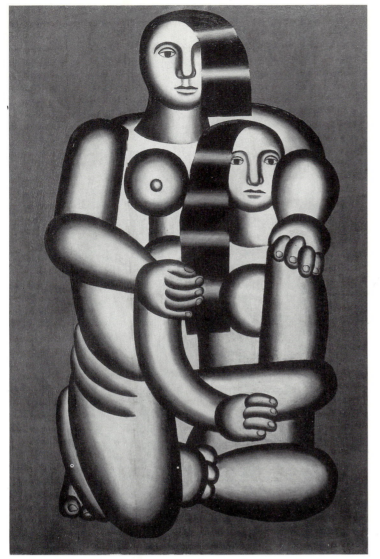

95. Fernand Léger, *Nudes on a Red Ground*, 1923. Oil on canvas, $57\frac{1}{2} \times 38\frac{1}{2}$in. Oeffentliche Kunstsammlung Basel, Kunstmuseum.

he left them whole, unfragmented and unchallenged by synthetic intrusions, and he turned for his models not to fifteenth-century Northern European art but to technical illustrations and advertizing graphics.[20] Yet, what was produced can only be described as Cubist, however much Purism lies in the background and however elementary the depiction of things; for these objects are absorbed into pictorial environments obviously built up synthetically from flat elements that stabilize the compositions, and they still act out intriguing spatial paradoxes in concert with those synthetic elements.

More than in 1921 or 1922, the still lives and mechanical element pictures of 1924 present an alternative to the classical figures, for neither are in any way derived or extracted from figure paintings, and yet the single modern-life view that informs all Léger's work meant that his alternatives were unified at a deep level. For him, there was an important sense in which his mechanized classical nudes and his Cubist still lives or mechanical elements were different aspects of the same thing, in which there was an unbroken continuity across themes and modes. The way that he could take a discovery made in the figure paintings, the use of the strong red ground in *Nudes on a Red Ground* of 1923 (Plate 95), and apply it to give a new kind of force to his *Mechanical Elements* a year later is a mark of that continuity.[21] In the end, like Picasso, Léger saw his Cubist and classical styles—however apart they may seem—as not at all contradictory.

Braque, Gris, Laurens and Lipchitz: Compromise

In the cases of Picasso and Léger, then, there was no question of compromise in their Cubist work between 1920 and 1924. It remained obviously distinct from their openly traditional styles, even if Léger could at first move directly from one to the other. Their Classicism could appear a betrayal, but, for them, it was not: it was simply the expansion of a practice which included Cubist styles too. Yet, for several of the leading Cubists the anti-Cubist pressures of the early twenties, above all the attacks on Cubist austerity, did lead to compromise.

The case of compromise most talked about was that of Braque, and certainly, as we have seen, this could *appear* actually a case of betrayal. Braque's was a compromise that affected the whole range of his art, leading, again as we have seen, to the increasingly naturalistic shaping of things in his still lives after 1922. Yet, in fact, his work remained in every fundamental sense Cubist, and it is worth returning to his still-life painting at the time of most obvious compromise, in 1924–25, to see how. *Pitcher, Fruit-basket and Knife* (Plate 79) has already been mentioned for its thoroughly naturalistic shaping of fruit and objects, but even this picture can be analysed in the strictest, Cubist terms, even here there is a stress on flatness to counteract the initial sense of depth created, and even here it is possible to see how flexible is Braque's forming of things. Part of his preparation of the black ground for this picture consisted of the random scattering of sand into the wet paint to give the surface an uneven roughness, a texturing which does not relate to what is depicted. Nowhere does Braque model illusionistic volumes, and all around, penetrating into the jug, fruit, knife and basket is the impervious blackness of the ground, which everywhere acts as a reminder that each positive form is the product of flat, coloured paint marks brushed freely over that ground.

The full Cubist character of Braque's still-life painting in 1924–25 is, however, best grasped in his most demanding compositions, and above all the full subtlety and richness of

moved during 1923 and 1924, as his own dissonant view of modern life increasingly gave way before the propaganda of the Purist magazine, *L'Esprit Nouveau*; both his painting and his statements about it came to give a central status to the calculated and the precise.[17]

Léger painted his most Purist works in 1924. They included a series of severe, smoothly finished still lives, and an entirely new series of pictures on the theme of the 'mechanical element'; *The Syphon* (Plate 94) is one of the former, *Mechanical Elements* (Plate 230) one of the latter. Dissonance remains, but behind them all lies Léger's orderly, more exacting approach to the world.

The still lives of 1924 were not at all dependent on figure painting; they presented an even more distinct alternative sanctioned by a new way of using the object in painting which emerged in that year. The Purists attached a special value to certain objects as perfected functional designs, refined over centuries; they called such objects (wine-bottles, glasses and musical instruments, for instance) 'type-objects' and saw them as symbolic of an entire evolutionary process of adaptation in life.[18] Aided by this notion of the object, Léger argued from 1922 that the object was the key to the new painting, but he focused not on age-old items but on what he called the modern 'manufactured object'. He did not take over from the Purists the idea of perfection arrived at by evolution, he took over the conviction that a special beauty, at once age-old and up-to-date, was to be found in those manufactured items that exposed an underlying geometrical structure.[19] In 1924 he built his new still lives around a straightforward presentation of such objects for their own sake: the lamp, syphon and glass of *The Syphon* all qualify. He styled them simply, as he had in 1921–22, but

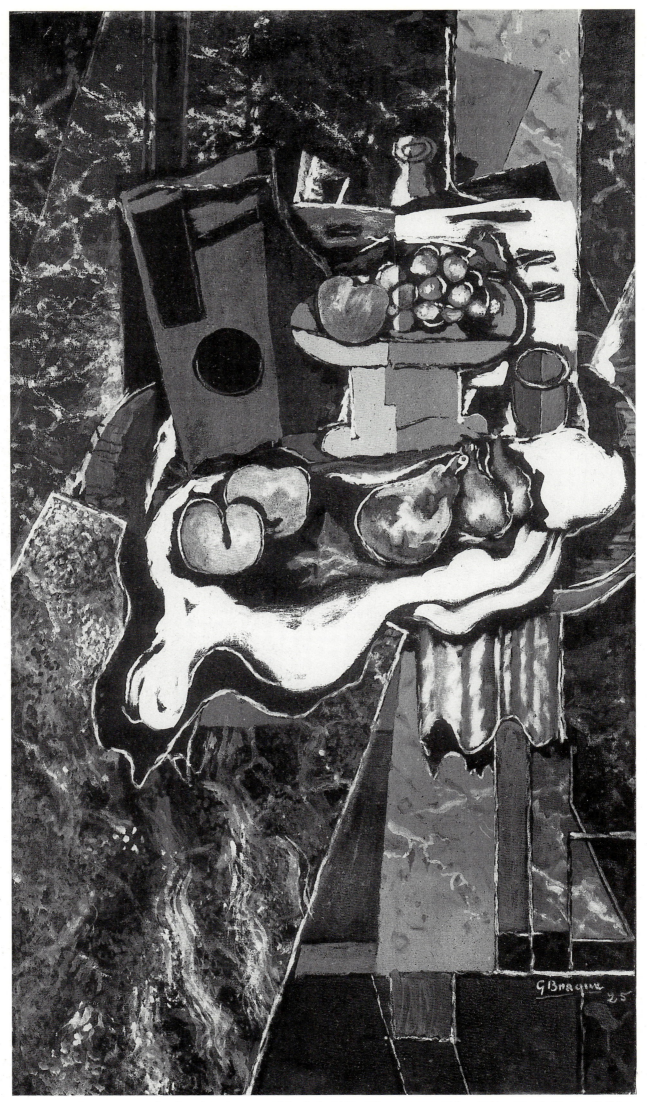

96. Georges Braque, *Fruit-bowl and Fruit on a Table-cloth*, 1925. Oil on canvas $51\frac{1}{2} \times 29\frac{1}{2}$in. Musée National d'Art Moderne, Centre Georges Pompidou, Paris.

his still-Cubist treatment of pictorial space. Perhaps the most daring of all was *Fruit-bowl and Fruit on a Table-cloth* of 1925 (Plate 96). The positioning of things, the angling of a couple of lines beneath the table and the use of forms in light against deep recessive shadows all stimulate sensations of depth and of objects softly lit within it. But Braque counters these suggestions everywhere. The round-topped wooden table is tilted up to push the fruit, cither and the rest of its load out at the spectator, just as in the first pedestal-table still lives of 1918 (Plate 54), but instead of enhancing this effect by a downward view of the floor, Braque does it by taking one of the marbled wall-panels from behind the table, tilting it obliquely and placing it to the left in a completely arbitrary way.[22] This marble surface is so placed and treated that it is felt to be on the picture plane, but, once again using the black ground ambiguously, Braque suggests that the draped table-cloth could be either in front or behind that marble surface. So tactile is the painting of the marble that when the table-cloth is read as in front the effect inevitably is to make it seem as if the objects upon it are literally there in the space before the canvas, and this is enhanced by the directness with which Braque uses them to attract touch. It is here that the naturalistic shaping takes on a Cubist role, for the softness and texture of the fruit intensify the desire to touch as it subliminally arouses appetite. Braque's quasi-Naturalism and his sensuality operate in the end as an active factor in a still-Cubist exploitation of the tension between flat fact and spatial fiction.

Braque, then, approached pictorial space in an obviously Cubist way, and, even if he veered towards naturalistic shaping, the evidence indicates that he continued to work fundamentally in a synthetic way (or at least thought he did), working as he saw it from the manipulation of formal relationships *towards* nature, not from a starting-point *in* nature. His range of still-life objects was strictly limited and his ways of forming them were flexible enough for rhyming to be a factor, though it is not in *Fruit-bowl and Fruit on a Table-cloth*.[23] That he himself had indeed believed that he worked from the abstract to the concrete from 1919–20 onwards is strongly supported both by later statements and by the recent publication of an exchange of letters with Kahnweiler at the end of 1919 and particularly of notes taken by Kahnweiler after a visit to his studio on 25 February 1920. These notes begin: 'The painter thinks in forms and colours'; yet they underline clearly the importance of the subject: 'One cannot paint anything else...'. While in a letter of 17 September 1919 Braque had insisted that 'Art begins in synthesis alone.'[24] If such purity of conception was indeed his aim in 1924–25, it is difficult to believe that he ever altogether achieved it, but the fact remains that from 1919–20 he did not seek to work from nature and never set up a group of objects actually to provide a starting-point. Consciously, he sought to conceive his pictures from the abstract.

Only in a superficial sense can Braque's art between 1922 and 1925 be called compromising, and if behind it there lay any real spirit of compromise, it did not come of the pressure applied by the enemies of Cubism. For the fact is that his exhibition of 1919 at l'Effort Moderne had been a success, the pictures had sold, and criticism had been generally positive when he showed at the Salons in 1920 and 1921, excluding him from the charges of obscurity and intellectual frigidity levelled against the Cubists in general.[25] For him, the failure of the Uhde and Kahnweiler sales and the rise of Neo-Classicism could not of themselves have provided the stimulus to take his work in the more legible and more sensual direction he took it.

The other Cubists who compromised remained, like Braque, fundamentally Cubist still, but in these cases whatever element

of compromise there was does seem to have been a direct response to the pressures of the time. The most important of these Cubists were Juan Gris, Jacques Lipchitz and Henri Laurens, though mention should be made of Léopold Survage, Jean Lurçat and especially Louis Marcoussis, the last of whom took part in the Section d'Or exhibition of 1920, showed regularly at the Indépendants between 1920 and 1923, and in 1922 moved into an idiom that combined naturalistic shaping (comparable to Braque's) with a thick, luscious *pâte* reminiscent of the fully Naturalist painting above all of Dunoyer de Segonzac (Plate 97), a striking compromise indeed.[26] For all of these Cubists the crucial years of compromise were the most severe years of anti-Cubist pressure, 1922 and 1923.

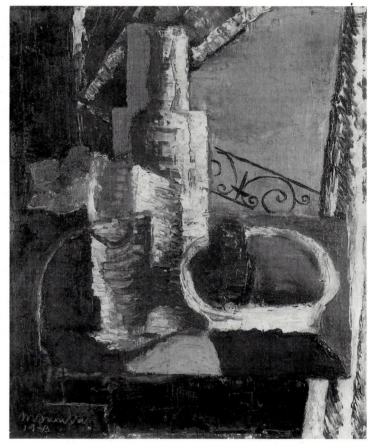

97. Louis Marcoussis, *Still Life and Bottle*, 1923. Oil on canvas, $17\frac{3}{4} \times 15$in. Sale: Sotheby & Co, London, 6 April 1978, lot 328.

Not long after his involvement in the Cubist showing at the Indépendants of 1920, Gris became seriously ill. It has never been clearly established what the true nature of his illness was, but the evidence points to pulmonary tuberculosis which was left undiagnosed and uncured, leading to developments which would kill him seven years later.[27] Whatever the cause, for over a year spent in hospital and then convalescing back at Beaulieu-près-Loches and in the Mediterranean resort of Bandol—until, in fact, his arrival in October 1921 at Céret in the French Pyrenees—he was often robbed of strength; he would never be wholly well again.[28] Yet, extraordinarily enough this was a period which saw him produce exquisitely cared-for drawings and a succession of paintings as assertive and resolved as any that he had made before his illness. It saw him bring to an extended climax the synthetic Cubist style at which he had arrived in 1918–19, and do so without a sign of compromise.[29]

At Bandol and Céret in 1921 Gris resurrected the open window theme of the Place Ravignan still life (Plate 47), rehearsing with a new clarity the whole range of paradox it had opened up, from the contrasts of indoor and outdoor light to

the effects of interpenetration, but now taking as his vantage-point a tourist's room with a view. Finished in June, *View over the Bay* is the culmination of the Bandol series (Plate 108). More even than a Braque like *Pitcher, Fruit-basket and Knife*, the impression is given here that this is a composition refined from an actual motif. In fact, like all these new open-window paintings, it seems clear that it was elaborated in a basically synthetic way with, at first, only the most generalized notion of the subject in mind. It was painted in a room on the harbour front at Bandol which indeed did have a view across to the mountains, but we can be sure that there was no actual guitar, and these mountains are formed markedly differently from those in the other Bandol open-window pictures, and so is the shutter.[30] Gris may have begun with a general idea of a still life in front of a backdrop of sea and mountains, but the particular character of all the parts followed from a relatively free pursuit of formal relationships.

And again as in 1918–19, the clearest symptom of the purity of Gris's synthetic method is there in the proliferation of rhymes, significantly the single most obvious difference between this composition and the Place Ravignan still life. They are everywhere. The top of the glass rhymes with the sound-hole of the guitar, its squashy curves pick up the rhythm of the guitar's curves, while the upper curve of the guitar continues, defining the top edge of the fruit-bowl. Then, above, an area made up of the flank of the pears, the lower range of mountains and the upper flank once more of the guitar rhymes with the body of the guitar as a whole. Qualities of surface and shape are all determined by Gris's need to create *rapports* by rhyme and rhythm, and that the quality of a thing could change actually in the process of painting is revealed by the fact that the wavy right edge of the glass, which finally completes its distinctively soft form, was added late. Gris still works as freely and as purely with his elastic vocabulary of elements as in 1919, but, in the interests of amplified paradox, he allows them to resolve into so substantial an idea of things in depth that the fundamental purity of his approach is all but concealed.

At Céret during the early months of 1922 Gris began to put on weight again and his strength increased rapidly, the first of several periods of better health which were to alternate with periods of fatigue over the next five years. In April he and Josette returned to Paris, to a new studio in Boulogne-sur-Seine. By the end of 1920 he had left Léonce Rosenberg for a new contract with Kahnweiler, and it was the dealer who found him his new home.[31] Here, even more than in Montmartre, he was isolated from the centres of the Parisian art world, but his exhibition at Kahnweiler's galerie Simon in March 1923 meant continued notice within the Cubist circle, close friends like Maurice Raynal were in touch still, and Kahnweiler was a neighbour. Things were looking up, and yet by the turn of 1922–23, the signs of compromise were manifold.

Already in Céret at the turn of 1921–22 Gris had responded as a Cubist to the Neo-Classicism of Picasso and Léger, even though he had not been involved in the Parisian scene since his illness.[32] Real signs of compromise were to emerge, however, not because he chose to respond to the Neo-Classical fashion, but because, late in 1922, he chose to combine his increasingly straightforward presentation of subject-matter with an attempt at the alluring and the sensual. That winter he painted two pictures whose qualities in combination were unprecedented in his art; one of them was *Young Girl* (Plate 98). Everything is of one ingratiating piece here: warm chromatic appeal goes with decorative interlacings of curves (unearthly purples and mauves, almost perfumed in effect, complementing feminine outlines); and these unctuous visual characteristics are the

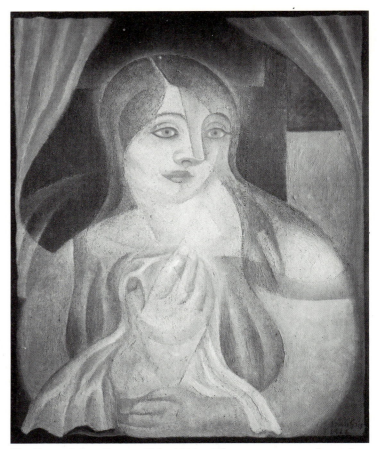

98. Juan Gris, *Young Girl*, 1922. Oil on canvas, $25\frac{5}{8} \times 21\frac{1}{4}$in. Collection, Gustave Leven, Paris.

attributes of a subject whose appeal is simple, the coy sexual quality of which is left undisguised. Thus was introduced a new kind of figure painting into Gris's repertoire, and by early the next year he had extended it to reshape his range of *commedia dell'arte* characters, completing, for instance, *Seated Harlequin* (Plate 99) in time for his exhibition at the galerie Simon (a picture which, despite its sweet colour, is not so obviously ingratiating).

The traditionalizing styles of Picasso, Léger and Braque may not in themselves have been the stimulus behind this development, but it is clear that Gris's new figure painting was designed to signal an alignment with certain masters of the past. Kahnweiler has described visits to the Louvre with Gris after his move to Boulogne-sur-Seine, and has mentioned the painter's respect for Ingres, Seurat and Cézanne, and then, in passing, remarks that he 'was very attracted to Raphael'.[33] Interviewed by Georges Charensol in 1924, Gris was to place Raphael with El Greco above all the masters he admired.[34] With perhaps a sideways glance at Seurat's *La Poudreuse*, it was especially to Raphael's female portraits and Madonnas that he looked when he moved into the softness of theme and manner of *Young Girl*, and, even accepting the difference in the subject, there is a clear connection between *Seated Harlequin* and, say, Raphael's *'Alba' Madonna* (Plate 100).

Made easy and traditionalizing these pictures might have been, yet spatially and formally they are Cubist and so is the synthetic approach behind them. It is for this reason that they can mark only a compromise, not the beginning of another distinctly different direction. Significant here is the way André Lhote should have taken Raphael as the leader of the Italian tradition which he defined, it will be remembered, as dedicated to styles based on the abstract elaboration of composition, not on the study of nature, contrasting Raphael with Ingres—an idea taken up by Bissière too.[35] Certainly it was the way that Raphael's mode of composing could be adapted to Cubist synthetic practices that seems to have attracted Gris:

the way that a pictorial interweaving of lines could dictate the shaping and positioning of figures and therefore appear to generate them. Gris's unmasked actor in *Seated Harlequin* is almost certainly the result of working away from an abstract harmony of curves, and the Raphaelesque manner by which the figure remains bound into that abstract rhythm makes the process plain. Gris still worked synthetically, proliferating rhymes, and insisted on the point in his published statements. Charensol expresses disbelief when he asks in the interview of 1924: 'But the objects that I see grouped in this still life, did you not have them before your eyes when you were painting?' Gris is unshaken and sure when he replies: 'I never work from nature and I create the objects which I need to compose my canvas as I paint.'[36]

These pictures of late 1922 and early 1923 were the prelude to a sequence of pictures that openly ingratiate themselves, often aided by attractive subject-matter. They occupied Gris for almost two years and they included a full range of figures, still lives and even a few pretty landscapes.[37] *Pierrot with Book*

99. Juan Gris, *Seated Harlequin*, 1923. Oil on canvas, $28\frac{3}{4} \times 36\frac{1}{4}$ in. Carey Walker Foundation, New York.

100. Raphael, *The 'Alba' Madonna*, 1510–11. Diameter $37\frac{1}{2}$ in. National Gallery of Art, Washington, D.C.; Andrew W. Mellon Collection.

101. Juan Gris, *Pierrot with a Book*, 1924. Oil on canvas, $25\frac{5}{8} \times 19\frac{5}{8}$ in. Collection, Gustav Kahnweiler, England.

(Plate 101) is one of the most accommodating of the figures; Cooper dates it to the first half of 1924. *Fruit-bowl and Glass* (Plate 180) is typical of the still lives; Cooper dates it to the second half of 1924.[38]

An underlying structure is there to be sensed beneath the lush surfaces of both the still life and *Pierrot with Book*, though by now there is no question of a rigorous geometric armature. In the figure painting the opened book is lined up with the panelled shutter, the general form of torso and shoulders fits snugly within the architectural framework, and the light catches the face in the shape of a triangle. Forms here are exaggerated and manipulated freely (the enormous hands, the nose swung to the right), and light and shade are suggested by flat areas of warm and cool hues graded tonally rather than modelled by nuance—a Cubist equivalent of natural lighting obviously borrowed from Braque.[39] Conception in both paintings was almost certainly synthetic (the fruit-dish is conspicuously a Cubist invention in the still life) with only a very general idea of the subject fixed from the outset, and the give and take between the sense of surface and the suggestion of depth is still Cubist. Compromise, however, naturalizes: the fruits in the still life are lushly Braque-like, and, in both works, lights and darks come together to create an unbroken effect of light falling across and unifying the smallest details, while colour is obviously keyed to the pleasure principle: emerald greens for the shadows at the centre of the Pierrot painting, mauves, violets and deep red elsewhere. Sensuality and the appearance of Naturalism are pervasive: Gris's Cubism has lost its cool look of purity.

As suggested, Gris's was not merely an apparent compromise: it was backed, however subliminally, by a real spirit of compromise. The question of how far this was so is a difficult one which must be addressed. It will be left, however, until the cases of Laurens and Lipchitz have been discussed too,

for what can be said of Gris throws light on their compromises as well; it throws light, indeed, on the way the pressures could act on any Cubist in the early twenties.

Like Gris, Laurens moved away from Léonce Rosenberg. From 1920 he too was involved with Kahnweiler's galerie Simon.[40] He continued in his Montmartre studio, away from groups, but his relationship with Braque remained warm and close, the source of much that was positive. Again like Gris's, his compromise can be aligned with Braque's, but it is possible that he gave his friend as much as he learned from him.

With Archipenko based in Berlin from 1921, the sculptors in Paris consistently called Cubist during the early twenties were Lipchitz, Laurens and Csaky. Occasionally Ossip Zadkine was included, but more often he was set on one side to be seen, like Brancusi, as a rather different kind of sculptor. Yet, where Lipchitz was treated to a great deal of wordy critical comment, almost as little appeared on Laurens as on Csaky. If Laurens was paired with Lipchitz, it was always as a much less significant Cubist. At the same time hints were made now and again that Laurens's sculpture was the less 'pure'. Certainly his was the more unmistakable compromise and it led him to a more 'natural', more 'human' Cubism in sculpture.

1920 saw the culmination of the weighty, substantial style with its preference for the massing of simple volumes rather than the play of coloured surfaces that Laurens had developed at the end of the War. But already his move towards compromise had been anticipated, for 1919 is the date traditionally given to a small bronze reclining figure, *Woman with Fan*, which is undoubtedly the first pointer in the direction he would follow (Plate 102).[41] The idea of this big-hipped, sprawling figure was to be taken up almost exactly in a bronze relief and in a smaller terracotta statuette during 1921 to set the key-note for his immediate future as a sculptor (Plate 228). This curvy, fruitful image of woman (a civilized Cubist echo of prehistoric Godesses) was to be the starting-point of much to come.

Already in *Woman with a Fan* all the essentials are there.

The prodigiously proportioned nude is the site for the strongest of contrasts in which bulging, softly curved surfaces are but one opposing force set against flat planes, sharply angled. In 1921 Laurens stripped the idea to its essentials (cutting out the rumpled drapery most obviously), and clarified it so that the contrasts are strengthened and the figure reads more simply and more gracefully as a whole. In both pieces the oppositions between angular and curved are pulled together around the interlocking of the upper and lower body: the hand, lower shoulder and upper body all cohere as block-like, sharp-cornered masses which at the midriff meet the swelling membrane of the stomach. Like Gris later, Laurens now did not give his new Cubism so soft and sensual a character that it banished the angular geometry of earlier phases altogether, and indeed an underlying geometric armature of interlocking triangles can be sensed disciplining even the forms of the curvacious stomach and thighs. It is this sensed armature that allows him still to indulge in that special pleasure of the Cubist sculptors, the negation of volume or mass, for the sharp-angled outlines of the framework can be felt, as it were, to slice into and through the hefty substance of the nude, seeming consistently to rob it of weight. At the same time the decision to get rid of the breasts as tangible protrusions in the later variant achieves the characteristic Cubist effect of signalling the presence of form by its absence, by negative space. In conception and handling these reclining nudes are still Cubist; and indeed it seems clear that the initial idea in 1919 was a direct response to a series of *papiers collés* and two metal constructions which develop the theme of the reclining guitar in uncompromising Cubist terms, the ample bulge of the guitar body the obvious stimulus for the generous bulge of the female's hips.[42] But the basically natural proportions of the reclining nudes, their organic aspect so sensually presented, along with their place in a classical lineage, mark them as something very different from say, *Woman with a Guitar* of 1919 (Plate 27).

102. Henri Laurens, *Woman with a Fan*, 1919. Bronze, length 23½in. Whereabouts unknown.

Laurens's nudes relate, of course, to the Neo-Classical figures of Picasso and Léger, but most telling is their relationship with the *Canéphores* of Braque which they anticipate (Plate 71). That so sensual and apparently natural an image of the female nude was possible without seriously curtailing the freedoms of Cubist art must have encouraged Braque in his move, but, when he made it, the overpowering confidence and the public success of the pictures he produced must in turn have encouraged Laurens to go further in the direction opened up. Between 1922 and 1924 the new, less obscure, more appealing character of his sculpture was deepened, often with a stronger stress on classical reference. Perhaps most aptly to be compared with Braque's *Canéphores* was the standing female nude conceived for a fountain sculpture in the garden of the wealthy couturier Jacques Doucet (Plate 103), part of a commission on which he had begun work by the autumn of 1921 and which included a columned gate with carved capitals, lintel and keystone. The figure is deeply cut in relief to appear as if squeezing out of an embracing polygonal stone pillar (an idea that echoes a nude in an obelisk produced earlier by Lipchitz).[43] Like Braque's nudes, she carries a fruit-basket and is both flat yet substantial, though the slickness with which Laurens makes her an orderly geometric ornament is much more thoroughly decorative than Braque's so-called 'decorations'. Jacques Doucet was not a client for whom a Cubist needed to compromise, but there is no doubt here that Laurens's new style for the female nude made possible something easy in its appeal: a well-behaved furnishing for the garden of a stylish haut-bourgeois patron.[44]

Jacques Lipchitz left Léonce Rosenberg too, but for him the result was at first much more critical than for the others, because when he left in 1920 he bought back his sculptures from the dealer and was forced to take on another studio in which to store them. His exhibition at the Effort Moderne early in 1920 was a success, but in these circumstances the financial pressures on him during 1921 and much of 1922 were intense.[45] Help came with commissions from Coco Chanel in 1921, but it was not until late in 1922 that the pressures were lifted. Lipchitz was fortunate enough, as we have seen, to be one of those picked out by Dr Alfred Barnes, and through 1923 he worked on an elaborate group of architectural sculptures in relief to decorate the stripped classical façades of the foundation the millionaire was building at Merion outside Philadelphia.[46] He lacked the security of Kahnweiler's support, but he was defended as enthusiastically still by Raynal and Waldemar George and, though a misunderstanding early in 1923 broke off his friendship with Gris for a year, they seem to have continued close up to that point, the two of them being neighbours in Boulogne-sur-Seine during the crucial summer and autumn of 1922.[47]

The first influential article from an ally to establish Lipchitz as the leading Cubist sculptor was published by Paul Dermée in *L'Esprit Nouveau* at the end of 1920. The sculptor told Deborah Stott that much of it was paraphrased by Dermée from his own remarks, so it is a case of an artist's image being shaped by the artist himself through the medium of a committed writer.[48] The image fixed here was that of the ideal synthetic Cubist (quite as ideal as Gris), and indeed Dermée extracted from Lipchitz one of the most lucid early accounts of the synthetic process (with its beginning in the abstract). In thus verbalizing the synthetic process, the poet, prompted by the sculptor, made a clear distinction between Cubist practice and what he called 'stylization'. According to Dermée, the 'stylizer' did not work from 'pure plastic intentions' to 'the discovery of the motif [the subject],' but 'abstracted' from his subject to produce 'a transcription of the model'.[49] Dermée did not mention him, but *the* paradigm of the 'stylizing' sculptor in

Paris at this time was Brancusi, who had been criticized as such earlier in 1920 by André Salmon, and from then on Lipchitz was to be held up as *the* Cubist antithesis to Brancusi's reductive art, the ultimate outcome of which Salmon had defined as 'zero'.[50] Seen thus, for instance by Waldemar George in 1923, Lipchitz is celebrated not simply as the leading Cubist sculptor but as among the most uncompromising of the day, a model of Cubist integrity to be held up for edifying comparison.[51]

Certainly it can be argued that Lipchitz was a Cubist who compromised only sometimes and most of whose work was as *un*compromising as Picasso's and Léger's. Like them, in 1920 he had developed (though only for a brief while) a clear traditionalist alternative to a manifestly tough Cubist style; and still in 1922 he could conceive sculptures in that tough style as severe and substantial as anything he had conceived before 1920, for instance *Seated Man* (Plate 104). But during 1921 Lipchitz began to explore his ideas in a new way; he started to make small clay sketches much as Gris used relatively abstract 'automatic' sketches on paper as the starting-point for paintings, and it was at least partly in this small way that the element of compromise first entered his Cubism.[52] It did so in 1921 with a couple of clay sketches made alongside a pair of ornamental fire-dogs. The sketches were for garden sculpture, and they and the fire-dogs (Plate 105) were the result of that helpful commission from Coco Chanel.

In both his subject was the new one for him of a reclining woman on a sofa (a trigger for Lipchitz, as for Laurens). The idea he arrived at, initially it seems in the fire-dogs, was deeply in tune with Gris's most elaborate rhyming compositions of the time. It was organized around a simple all-embracing rhyme which actually fuses figure and sofa, taking the fusion to more elegant and fluent conclusions in the sketches for garden sculpture. The rhyming fusion is handled, as ever, simply, but there is something novel in the sensuality of the soft curves that complete the effect. Very aptly, it seems from his later statements that Lipchitz's inspiration for these curves came when he initially conceived the fire-dogs (not the garden sculpture), and that the stimulus was provided by the extravagant curlicues of Coco Chanel's Louis XV fireplaces.[53] He gave his Cubism an appealing curvaciousness to fit it agreeably to a

103. (left) Henri Laurens, *Fountain Sculpture*, 1921–4. As erected in the garden of Jacques Doucet, Paris.

104. Jacques Lipchitz, *Seated Man*, 1922. Bronze, height 20½in. Marlborough Gallery, London/New York.

lavish bourgeois apartment, and having done so he felt free to go further in the sketches for the garden.

These ornamental ideas may have been peripheral, but looking back Lipchitz knew their importance well enough. In his eyes they released a fresh, freer 'curvilinear tendency' which progressively remoulded his Cubism between 1922 and 1924.[54] Most prominently this was so in the sculptures he made for the Barnes Foundation in 1923, especially the clay sketches which were left relatively loosely and softly modelled (Plate 106). But perhaps more strongly it was so in certain free-standing pieces, like *The Guitar Player* of 1922 (Plate 107). A softened-up relative of *The Seated Man* of the same year, *The Guitar Player* adapts to a squat vertical format the idea of the fused figure and chair conceived for Coco Chanel's salon and garden, adding the guitar as a tertiary rhyme fused with the body in the form of a negative recessed shape (a typically compelling sculptural adaptation of the habitual Cubist synonym, guitar/torso). The proliferation of rhymes indicates, of course, that this piece, like all the work of Lipchitz at the time, is the product of a Cubist working synthetically with a flexible vocabulary of elements, but above all this is clear in the clay sketches for the Barnes Foundation reliefs, none more so than the still life with open book and guitar (Plate 106). Here the neat slotting together of the open music-book with the double image of the guitar, every part of which seems interchangeable, makes an open secret of the process and particularly of the generative power of the six-sided format.

Lipchitz was not tempted to dilute the purity of his Cubism either in fact or in effect, and, unlike Braque, Gris or Laurens, his move to the more organically sensuous did not mean a move to more 'natural' shaping. His Cubist work never even *appears* to have begun in nature with a subject. Thus his compromise was never either as complete or as profound as that of the others, but it was a compromise nonetheless and the circumstances of its initiation expose plainly the spirit of accommodation from which it came. To begin with at least, Lipchitz softened his Cubism quite simply to make it more pleasantly decorative. He took his commissions both from Coco Chanel and from Barnes as an escape route from poverty; he needed to remain a Cubist for such clients as these, but perhaps too, as he saw it, he needed to please more directly, more infallibly.

Too little evidence has yet been uncovered to make possible a fair discussion of the degree to which a real spirit of compromise lay behind the move made by Laurens towards

106. Jacques Lipchitz, *Still Life*, sketch for a relief commissioned for the Barnes Foundation, Merion, Pennsylvania, 1923. Terracotta, 6¼ × 7in. Musée National d'Art Moderne, Centre Georges Pompidou, Paris.

107. Jacques Lipchitz, *The Guitar Player*. 1922. Stone, height 15¼in. Oeffentliche Kunstsammlung Basel, Kunstmuseum.

105. Jacques Lipchitz, *Fire-dog*, 1921. Bronze, height 14in. Marlborough Gallery, London/New York.

the natural and the sensual, but the case of Gris is clearer and indeed it makes possible a more complete understanding of the way that pressures could act in the early twenties to soften Cubism than does the case of Lipchitz. Briefly then, it is worth returning to Gris to sum up the underlying character of Cubist compromise in those years.

The first point to stress is that, just as for all of them, for Gris there were persuasive reasons for the move he made that had nothing to do with a hostile press and commercial failure. On the one hand, there was a need, expressed in a well-known earlier letter to Kahnweiler, to counter his own tendency to the cold and the calculated.[55] On the other, there was the encouragement given by pro-Cubist writers, most of all by his friend Waldemar George. Between 1921 and 1923 George repeatedly argued in the pages of *L'Amour de l'Art* and *La Vie*

108. Juan Gris, *View over the Bay*, June 1921. Oil on canvas, 25⅝ × 39⅜in. Musée National d'Art Moderne, Centre Georges Pompidou, Paris. Kahnweiler-Leiris Collection.

109. Georges Valmier, *Sailing Boats*, 1921. Oil on canvas. Private Collection.

des lettres that the constructive strength of post-war French art should be allied to the discoveries of the colouristic revolution in painting that had been built upon Impressionism. Gris could well have been struck by such a passage as this, written in August 1922 just months before his chromatically enriched *Young Girl* and *Seated Harlequin*: 'There will be no question of taking up for ourselves the ideas of Claude Monet and his contemporaries. The painter of today has no intention of representing the ephemeral and superficial aspect of a view, submitted to the external action of lighting, but he can, he must even, benefit from the experience in the realm of colour acquired by his seniors.'[56] For George, at least since 1921, the key to the future of modern painting had seemed to lie in the possible bringing together of the constructive lesson of Cézanne and the colouristic lesson especially of Renoir. Gris had good reason to see his move as a positive one made within the pure untrammelled context of Cubism.

Yet, it is equally clear that other more mundane pressures planted in him at some level the need to accommodate. Highly significant is the fact that Gris's move into compromise co-incides exactly with his involvement as set and costume designer with Diaghilev's Ballets Russes. It was in November 1922 that the Russian impresario came to see him at Boulogne-sur-Seine and commissioned the designs for *Les Tentations de la bergère*, a ballet set in the eighteenth century with music by Montéclair.[57] The production was not put on until January 1924 at Monte Carlo, but Gris seems to have built the maquettes for the set and designed the costumes towards the close of 1922, just when he was painting his first wholly hedonist pictures. For *Les Tentations* and the lavish *Fête merveilleuse* in the Hall of Mirrors at Versailles (June 1923) he worked with luxurious richly coloured materials, designing for the artificial light of the stage. There is an obvious link between such delightful pursuits and the new surface sensuality of his painting.

The Diaghilev connection is so revealing not merely because of visual relationships, however, but also because Gris's letters leave no doubt that, for him, to be welcomed into that glamorous milieu was to know a kind of worldly success he desperately wanted, a kind of success he had long envied Picasso.[58] How gratefully he must have grasped at it after the catastrophe of the Uhde and Kahnweiler sales where his had been the most humiliating prices of all. The fact is that he accepted Diaghilev's commissions because he hated the grinding anonymity of commercial failure and critical isolation, that he responded to those commissions in the most visually ingratiating way, and that this response went with his rejection of austerity for the pleasure-principle in his painting too. Despite his great seriousness and strength of mind what happened *was* in some measure the result of bending to external pressures, but, of course, it will never be possible to say exactly how much or how consciously. With the possible exception of Braque, the same was almost certainly so of all the Cubists who compromised, but the special quality of the drives behind their individual compromises have been even more effectively obscured by time.

Gleizes, Valmier, Csaky and Villon: Cubism Extended

Compromise and the multiplication by two of broad stylistic alternatives were not the only stances taken up by Cubists in the early twenties. A further possibility existed, which was taken up by one leading Cubist, Albert Gleizes: the development of a single-minded, thoroughly uncompromising Cubism without the diversion of a traditionalist alternative.

Gleizes's was an important contribution, because both his writing and his painting had a big impact on the image of Cubism in Paris. His was also a special case: he was in almost every sense a maverick Cubist, as will emerge. Before turning to him, however, comment is needed on three others, two of whom, on the face of it, developed uncompromising styles as well. One was a new post-war recruit to the galerie de l'Effort Moderne, Georges Valmier; another was Marcel Duchamp's and Raymond Duchamp-Villon's elder brother, veteran of the pre-war Section d'Or, Jacques Villon. These two, like Gleizes, almost touched abstraction, and so did the third, the sculptor Josef Csaky; but where Valmier and Villon did not compromise in 1923–24, Csaky did, drawn however to an hieratic Cubist variant of ancient Egyptian art rather than to a French Neo-Classicism.[59]

Valmier made contact with Léonce Rosenberg in 1919, and from early 1920 was welcomed into the group shows at l'Effort Moderne. In January 1921 he was given his own exhibition, but he seems not to have been the most saleable of Léonce Rosenberg's artists and the dealer frequently let him know his doubts.[60] Perhaps even more than Gris, Valmier had cause to bend before the pressures, but between 1920 and the end of 1924 his commitment hardly wavered. When he replied to the enquiry on Cubism launched by the *Bulletin de la vie artistique* in 1924, 'At Home with the Cubists', that commitment was firm. For him, Cubism was not 'a passing phenomenon', it was the essential current phase in the evolution of art, and, though he acknowledged that 'it will be humanized more and more' and was himself to move for a while to a more legible idiom in 1925, the fact is that the process of 'humanizing', as he put it, had barely touched his work up to that point.[61]

In 1920–21 Valmier worked with something like the decorative sense of purpose that took Auguste Herbin close to total geometric abstraction at the same time, but he did not, like Herbin, move away towards representation after that date. By contrast, he developed a highly refined geometric Cubism, abstruse and difficult in its presentation of the subject, the style of *Figure* and *Sailing-boats* of 1921 (Plates 110 and 109). Typically, these are smoothly worked oils, painted with the artisan-like care of Léger and almost certainly based on studies. In 1919 Valmier had built up his compositions initially with *papier collé*, using carefully cut-out pieces of coloured paper and sometimes newsprint to establish flat planes over which he added fragmentary linear markings to supply clues and decorative accents.[62] From 1920 he continued to use cut paper in exploratory studies, and larger works like *Figure* and *Sailing-boats* are still built as if in this way, though the linear accretions have been tidied away in the latter. Their crisp clarity makes them obviously post-war, and their sharp colour (never modulated) is distinctly personal. Yet, their *papier-collé* conception at the same time relates them to Picasso's synthetic Cubism of 1914–16, that of the highly abstract *Man Leaning on a Table* (Plate 15). Valmier's approach was fully synthetic and his sense of precision thoroughly of its period, but in the end the key to the uncompromising toughness of his painting and its proximity to total abstraction was his continuation of practices learned from the Cubism of earlier, more heroic times.

Csaky, as we have seen, had also neared total abstraction with the *Abstract Sculptures* of 1919 (Plate 58), and he too had done so almost certainly by abstracting from already schematic Cubist signs. For him, the model had been the cones, cylinders and spheres of Léger's pre- and post-war painting (easily translated into three dimensions), but briefly in 1920–21 he worked with a combination of broad areas and minor linear accents closely comparable to Valmier's then-current painting (sig-

painting bears this out. *Coloured Perspective* of 1922 is one of his most abstract compositions (Plate 113); related to it there survive both other versions and a series of studies on paper (Plate 114) which reveal that here certainly an elaborate process of refinement was followed.[66] Villon's starting-point was an analysis of a horse and rider seen half from above (possibly a photograph). This motif was broken down into flat angular planes overlapping one another in layers, and progressively this configuration was reduced to arrive at the very simple result. Villon did not directly visualize his subject in schematic planar terms, he methodically translated from the round to the flat and then abstracted. He was to the synthetic Cubist painters of the period what Brancusi was to Lipchitz (though without the animism so important to the Rumanian): he was not a 'Cubist constructor' but a 'stylizer', to use Paul Dermée's terminology.

In his statement of 1924 Villon made a point of stressing the importance of Gleizes in codifying the laws that governed the new kind of flat, planar pictorial composition.[67] This is but one sign of the respect accorded Gleizes in the early twenties, and indeed he was given on occasion the status of a trend-leader. For Lhote (in 1922), he was the leader of a new tendency which threatened to take over advanced Cubism

110. Georges Valmier, *Figure*, 1921. Oil on canvas, $38\frac{1}{4} \times 29\frac{1}{2}$ in. Musée Départmental de l'Oise, Beauvais.

nificantly at first in bas-relief rather than fully in the round).[63] A coloured stone relief like *Two Figures* (Plate 111) would have provided a sympathetic and equally uncompromising compliment to Valmier's paintings when the two were included in the group shows at l'Effort Moderne.

Jacques Villon's studio at Puteaux in the western suburbs of Paris had been the centre of much activity before 1914, but when he returned there after his demobilization in 1919, he was no longer a central figure in the Cubist groupings that emerged. Furthermore, his Cubist work was seldom shown and excited little comment. When he was given a show at the galerie Povolozky in June 1922 only Raynal gave it serious press coverage, and commercially it failed.[64] Villon made his own kind of compromise in response to his personal failure to capture a market for his advanced work: in 1922 he took his graphic skill to the galerie Bernheim-Jeune and over the next decade he earned a regular income by making coloured prints after the paintings of the successful (including Picasso and Braque). Yet, his painting outside this commercial arrangement uncompromisingly developed concerns initiated before 1914, concerns that were thoroughly his own and thoroughly anti-Naturalist.

Villon too replied to the enquiry 'At Home with the Cubists' in 1924, and what he wrote indicates a very distinctive stress on the abstractness of Cubism. He considered Cubist painting to have entered a final stage where 'planes freely created and positioned' had replaced volume, but, significantly he did not suggest that this late Cubism was synthetic, he suggested instead that it always started 'in nature'.[65] The indication was that, far from starting with the manipulation of abstract shapes, his practice was to work reductively, to abstract from a subject towards a perfected image, and the evidence of his

111. Josef Csaky, *Two Figures*, 1920. Painted stone, $31\frac{3}{4} \times 15\frac{7}{8}$ in. Collection, Rijksmuseum Kröller-Müller, Otterlo, The Netherlands.

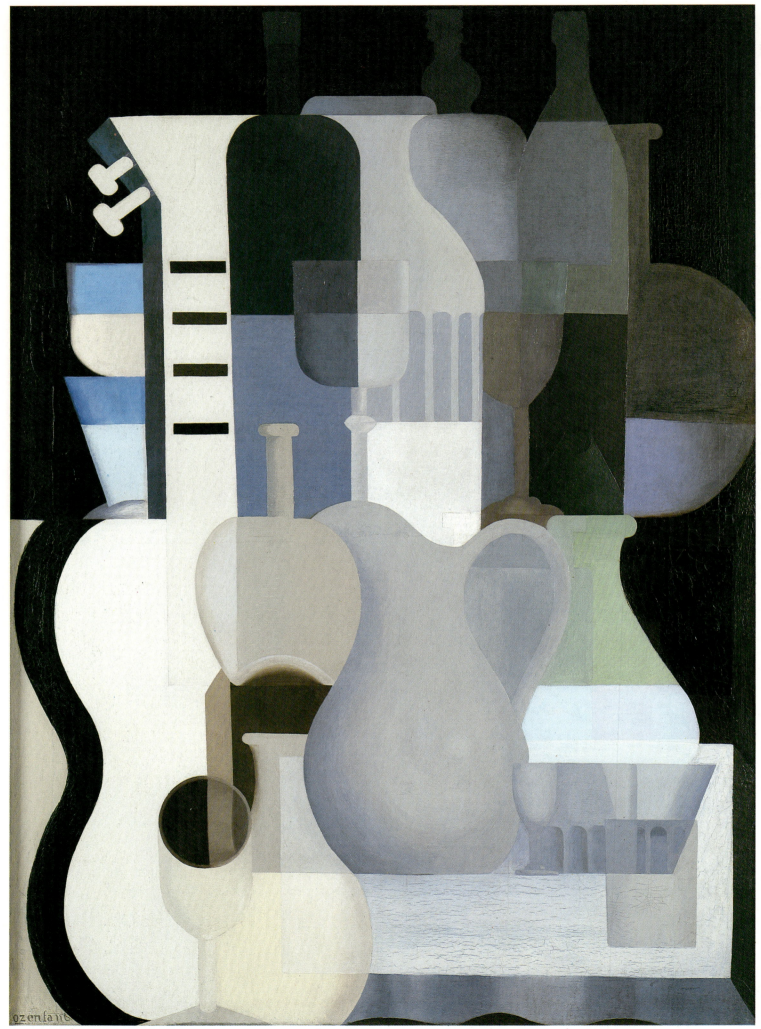

112. Amédée Ozenfant, *Accords, c.* 1922. Oil on canvas, $51\frac{1}{2} \times 38\frac{1}{4}$ in. Honolulu Academy of Arts. Gift of John W. Gregg Allerton, 1967.

113. Jacques Villon, *Coloured Perspective*, 1922. Oil on canvas, $23\frac{5}{8} \times 36\frac{1}{4}$in. Yale University Art Gallery, New Haven, Connecticut. Collection, Société Anonyme.

altogether, a tendency which, 'using "pure" materials, ends by drawing decorative arabesques on the canvas, and [does so] rigorously in two dimensions'.[68] Few considered him quite so important, but many took seriously his flirtation with abstraction (far more seriously than Villon's, Csaky's or Valmier's).[69] Gleizes, however, was not a 'stylizer' like Villon, he was throughout a synthetic Cubist, though of a very atypical kind.

The Gleizes who was seen at the Salon d'Automne in 1919, the Indépendants and the Section d'Or of 1920 would have appeared still a pre-war Cubist, for what he showed were pictures in a bright simultanist style in tune with Léger's *City*. However, in his last months in the United States (in 1919) he had moved towards Roman Catholicism, and in Paris he re-shaped his thinking in a sweeping idealistic way. It was this that lay behind his highly abstract brand of synthetic Cubism as it developed between 1920 and 1922. *Composition, Picture* of 1921 marks an early stage in this development (Plate 115). *Octagonal Composition* (Plate 177), almost certainly of 1922, is one of its most abstract products. Ultimately, Gleizes was led to mural-sized works like *Composition* (Plate 123), alongside pictures whose subject-matter is easily read such as *Composition, Serrières*, 1923 (Plate 178).

Not only from inside but from outside, Gleizes was seen as a key figure; it was after all he who was picked out by Picabia as the model of Cubist good behaviour. He showed regularly at l'Effort Moderne and both Léonce Rosenberg and the dealer-publisher Povolozky printed his writings, for his art was backed by prodigious theoretical effusion, most import-antly of all in the long text *La Peinture et ses lois*, first pub-lished in the periodical *La Vie des lettres* in October 1922, and then as a book a year later. For Gleizes, practice undoubtedly

114. Jacques Villon, *Study for the Jockey, no.7*, 1921. Pen and ink on tracing paper, $10\frac{5}{8} \times 17\frac{3}{4}$in. Yale University Art Gallery, New Haven, Connecticut. Collection, Société Anonyme.

obeyed theory and 'the laws of painting' as he understood them, while his works were given their critical commentaries by writers who could not but interpret them through his pub-lished ideas. Briefly his theories have to be discussed, there-fore, if the special character of his Cubism is to be isolated.

Gleizes's idea of the status and function of art fused aesthetic, metaphysical, moral and social priorities. His ideal artistic whole was the cathedral and, in painting, the mural art of the Middle Ages whose purpose, he insisted, had been collective and which, he believed, had given a fundamental compositional role to abstract rhythms that echoed the sensed rhythms of the universe. Cubism, he said, had turned painting back to an analogous concern with pictorial rhythms at the expense of Naturalism and therefore had made possible a new universal

115. Albert Gleizes, *Composition, Picture*, 1921. Tempera on panel,
$36\frac{1}{4} \times 28\frac{3}{4}$in. The Tate Gallery, London.

collective art.[70] Thus far his thinking simply adapted the anti-Naturalist aspect of Cubist theory to an idiosyncratic social idealism with a metaphysical core, but he was led to a far more restrictive approach to the making of paintings than any major Cubist. This was already clear by 1920, but its implications were not fully set out until *La Peinture et ses lois* in 1922.

Gleizes's first principle for painting was that it should be flat, something that distanced him from the continuing concern with fragmented perspectival spaces and modelled elements characteristic of Picasso's, Braque's or Léger's Cubism, as Waldemar George remarked in 1921.[71] For Gleizes, the future of painting lay in the study of the laws by which the flat surface could be 'animated', and, though rhythm had been the sole essential in the eleventh- or twelfth-century mural, he believed, now another basic factor was to be understood and exploited: space. He saw the understanding of space as the legacy left by the invention of perspective in the Renaissance, but by this he did not imply that pictorial space in the twentieth century would use the linear convergences and vanishing-points of the sixteenth; he was too insistent on flatness and too aware of the spatial properties of *papier collé* for that.[72] In Gleizes's system rhythm was to be proportionally controlled in relation to the format of the work. It could be understood arithmetically. Still imbued with Bergsonian notions of dynamic continuity, he stressed the importance of unbroken rhythms in painting and of containing completed movements within the composition. He claimed that medieval painters had achieved this in two dimensions by circular themes; now, with the spatial factor introduced, 'From the closed circle rhythm will become spiralling...'.[73] Just how all this was to be achieved in modern terms he set out with elementary clarity in diagrams (Plate 116). Flat planes were simultaneously to be set in motion and made to evoke space by being shifted across one another as if rotating about tilting, oblique axes.

Many of Gleizes's pictures between 1920 and 1922 were, in fact, merely explorations of the techniques outlined, experiments in what he called 'the simultaneous movements of rotation and shifting of the plane'.[74] *Composition, Picture* (Plate 115) deals with spiral rotation in depth in a relatively limited way; *Octagonal Composition* (Plate 177) does so with more freedom and sophistication (it was so directly the outcome of the diagrammatic exercises in *La Peinture et ses lois* that it supplied the idea for the black and white tailpiece to the text when it first appeared).[75]

Such pictures, aimed at their audiences, as they were, with metaphysical intent, were certainly not Cubist in any normal sense; but unquestionably they *were* Cubist in their concern with planimetric space, and in the fundamentals of their relationship with subject-matter. This latter is a point that needs stressing, so often was it missed by contemporaries and so easily can the abstract appearance of these compositions mislead even now. The evidence is indisputable: Gleizes was a synthetic Cubist, not a 'stylizer'. His commitment to synthesis is there in words (however obscure) in an essay of 1921 written probably as he was working on *La Peinture et ses lois*. He describes how artists had freed themselves from the 'subject-image' as pretext, to work exclusively from the subjectless 'image', from 'nebulous forms', until they reached a point where there came together 'the images known from the natural world' and those 'nebulous forms' which were thus made 'spiritually human'.[76] As much as Gris or Lipchitz, he too thought of his art as initially abstract and only afterwards denotational.

Octagonal Composition has been left at the abstract stage. Close as it is to the diagrams, it is without subject-matter. The flat shapes of *Composition, Picture* have been just enough inflected to cohere for the informed spectator as a Cubist representation of a woman. But it is most transparently in a work like *Composition, Serrières* (Plate 178) that the synthetic nature of Gleizes's painting is revealed, and the approach so manifest here lies too behind the mural-scale works of 1923–24. The subject in this case is specific: Serrières is a village south of Lyon where Gleizes had begun to spend much time. Again, however, as in *Composition, Picture*, he has built his painting up with the simplest overlapping shapes, set in rotating motion by conflicting oblique shifts, and he has interpreted the idea

116. Albert Gleizes, *Diagram*, first published in *La Vie des lettres*, Paris, October 1922.

of a landscape by the most minimal means: three window-like openings in planes, and a few contours that swell like foliage. Colour is keyed to suggest outdoors in the summer countryside too: a background blue above, leafy greens for the foliage shapes, but even so Serrières is obviously an idea which has been made to merge with a pictorial structure that need not ever have become a landscape. In 1924 Gleizes painted a group of pictures which he called 'imaginary still lives'; it was a title designed to underline the fact that his objects were inventions: pictorial end-products not starting-points. In a sense, his practice in these works as in *Composition, Serrières* was a model of ideal synthetic Cubist practice.[77]

At times in the early twenties Gleizes was tempted to see his painting as beyond Cubism, to offer, as it were, an obverse variant on Vauxcelles's vision of Cubism as merely a way through. Thus, concluding an article in 1922, he could write of his belief that: 'From Cubism a new collective expression aims to be born, in conformity with the general regeneration of the human organism...',[78] the implication being that when born this new, more abstract art would render Cubism obsolete. He hoped that finally he would escape Cubism, but he could not. Such wishful thinking does not conceal the fact that he remained a Cubist, perhaps the most unyielding of them all.

Ozenfant and Jeanneret:
The Purists

An account of late Cubism between 1920 and 1925 cannot be complete without finally turning to the only significant artists of the emergent generation who actually extended the movement further: Ozenfant and Jeanneret (Le Corbusier), the Purists. The Purist periodical *L'Esprit Nouveau* first appeared in October 1920: its last issue came out early in 1925, and as it ceased publication so Ozenfant's and Jeanneret's ties loosened. A second Purist exhibition was held in January 1921 at the galerie Druet, each artist showing twenty works (including drawings), and from that date to 1925 they were taken up by Léonce Rosenberg to be exhibited regularly in his gallery. Both Gris and Léger were involved personally with them, and they operated very much at the centre of the Cubist circle. But, of course, their relationship with Cubism was hardly straightforward, and since it was the key to their very sense of identity as artists, it needs preliminary examination.

The Purists' sympathy is clear enough: they published regular articles on the leading Cubists between 1920 and 1922, and welcomed contributions from champions of the Cubists like Raynal, Waldemar George and Reverdy.[79] And they themselves were often positive, most revealingly in three articles of 1924 which were brought together in their book *La Peinture moderne*.[80] For them here, the major achievement of the Cubists had been to redirect artists to the essentially 'plastic' character of art. They picked out 1912 as the climax of the movement, and after that date, they asserted, the Cubist effort had fragmented, but still their view of recent Cubism was laudatory. The Cubists were on their way, they wrote in the third of these articles, towards both 'a state of clarification', 'a veritable virtuosity in the play of forms and colours', and 'a highly developed science of composition': 'towards the crystal'.[81] No mention was made of compromise (the Purists seemed to see none), and they illustrated that third article with Laurens, Gris and Braque alongside Picasso, Léger and Lipchitz implying that all equally suited the metaphor of the crystal.

Yet, for all their gratitude and respect, the Purists situated themselves beyond Cubism even more emphatically than Gleizes. When in 1925 Ozenfant wrote an article with the title 'On the Cubist and Post-Cubist Schools', there was no doubt in his mind that Purism was 'post-Cubist'. It was, he contended, one of the three living branches which had issued from the 'trunk' of the Cubist tree, the other two being Neo-Plasticism and Constructivism, and, as he saw it here, the key to its distinctness from the Cubist 'trunk' was its theoretical coherence.[82] Like Gleizes, the Purists too put the order of theory before painting and so distanced themselves from all that was 'fragmentary' about Cubism. Their theory also needs, therefore, to be discussed at the outset.

The mere elaboration, however, of a coherent theory was not most profoundly what Ozenfant saw as differentiating Purism from Cubism; in his assessment of 1925, much more far-reaching was the Purist preoccupation with 'universality'. Ultimately their thinking had the scope of Gleizes's, but their notion of the universal came more from mathematics and the natural sciences than metaphysics. From mathematics came their particular ideal of order, which tied together everything from the nebulae to the organic and inorganic on earth. The perception of an order reducible to numerical expression was for them the highest of all 'joys'.[83] From Darwinian theory came their particular view of order in society. The optimism with which they approached the industrialized world was an immediate response to the dominant theme of post-war reconstruction, but it was built on the conviction that the modern was the latest stage in an evolutionary process of adaptation by the use of machines to the demands of life.[84] It was this that led them to isolate 'the Law of Economy' as the primary law determining all things by means of natural and 'mechanical selection', and, of course, in the products of industry they found it easy to recognize the workings of this 'Law' in a newly exacting guise. Thence came the belief, touched on already, that useful human products could, through their beauty, convey invariable truths, and that certain objects, 'type-objects', were especially suited to doing so.[85]

This was the reasoning that gave the object as subject such importance in Purist painting, and it was indeed their treatment of the object that Ozenfant and Jeanneret picked out as their key point of difference with the Cubists. Writing in 1924, they insisted that, where the Cubists happily 'modified' the object, they (the Purists) did not recognize 'the right to re-shape objects beyond a certain limit'. They took as their 'points of departure', 'things arranged normally'; they did not start in the abstract.[86] Yet, in the final analysis, the Purists' focus on the 'plastic' or formal beauty of things (learned from the Cubists) led them to highlight above all the formal properties of painting, so long as the object's identity was not lost; and, ironically, a major aspect of the appeal to the Purists of 'type-objects' was their banality, their capacity, whatever their ultimate symbolic content, for self-effacing understatement in the interests of form. Purist theory, therefore, emphasized the formal properties of the picture just as much as the Cubists, and the laws they outlined, initially in *L'Esprit Nouveau* 1 and 4, are actually more concrete and far-reaching in support of the ideal of aesthetic autonomy than Gleizes's.

They defined a hierarchy of sensations. There were first, they said, 'primary sensations' which were 'fixed' and were stimulated by 'primary forms': the forms of Euclidean geometry. Then there were 'secondary sensations', which were dependent on heredity and culture and were therefore 'variable for each individual'.[87] The primary forms were to be the fixed and basic elements of all art, and in an article of 1921 it is announced that the secondary aspect was to be supplied essentially by the objects chosen as the painter's subject with the associations they aroused.[88] Colour was to be subordinate

to form and never to threaten the integrity of form. Thus, misleading associations were to be avoided so that, for instance, blue, with its sky and distance associations, was not to be used for solid volumes. Thus too, colours like vermilion or citrus yellow or cobalt blue which, they maintained, appear to advance or recede in space, were to be avoided, along with nuanced tints. Ochres, reds, earth colours, ultramarine, white and black were to be preferred.[89] Last, faithful to their mathematical ideal of beauty, the Purists insisted on giving composition a proportional basis, in particular a basis controlled by the Golden Section ratio.[90]

Between 1920 and 1925 the Purists' theory of painting stayed still as if frozen. It is a sign of the theory's lesser status in practice that during those five years Purist painting actually changed; enough, on the one hand to reveal unsuspected room for flexibility in their theory of form, and on the other effectively to undermine the authority of their statements about colour. At first, the pictures they showed in January 1921 were obvious illustrations of their theory. Such are works like Ozenfant's *Guitar and Bottles* and Jeanneret's *Composition with Guitar and Lantern* (Plates 198 and 117). After a fairly loose initial process of conception, these pictures (more than Léger's) are the products of a careful design method, and at a late stage every component object has been corrected to fit a proportional division of the picture surface.[91] 'Type-objects' are presented both more clearly in plan and elevation and more simply as 'primary forms' than in the pictures of 1918 (Plate 7); distortion is always used diagrammatically to give a fuller idea of each. Colour too is kept to what the Purists called the 'great scale'. Yet, in tune with the Cubism of such as Gris and Lipchitz, there is in both these works a subtle exploitation of rhymes, and, though colour underwrites the solidity of things, it acts to create a far from supportive space in which they stand: background walls and receding table-tops merge in the least material of spatial colours, a pale grey in the Jeanneret, a creamy white in the Ozenfant. Even in 1920 the possibilities are announced of a more elaborate rhyming development of objects grouped together, and a more open, suggestively coloured space.

Ozenfant's *Accords* and Jeanneret's *Vertical Still Life* (Plates 112 and 199) are two of the major Purist paintings of 1921–22. They reveal clearly the direction of the Purists' development. These are richer works. In the case of the Jeanneret, a process of elaboration from a simpler picture of 1921 has led to this

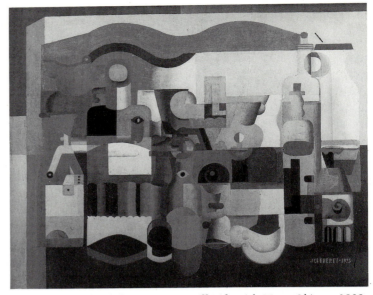

118. Charles-Edouard Jeanneret, *Still Life with Many Objects*, 1923. Oil on canvas, 45 × 57½in. Fondation Le Corbusier, Paris.

result, much as Gris extended a simpler idea (Plate 36) to arrive at *Guitar and Fruit-dish* in 1919 (Plate 35).[92] But Jeanneret has sought richer formal relationships not by allowing his compositional armature or his objects to generate new objects, but simply by piling up and up the quantity of 'type-objects', and by using the rhymes he discovers linking one to another to pull them into a cohesive whole. Everywhere the contours fuse and create echoes. Ozenfant's ends are just the same, and he achieves them in just this way, except more elegantly (particularly graceful is the sequence of ogee curves that link the guitar to the trio of flasks and the water-jug below). Colour in these pictures is more subtle or sensual, but space is still not opened up, since, especially in the Jeanneret, there is a clearly delineated table-top on which things stand before a plain background. Yet, formal elaboration has opened up new spatial possibilities even so, perhaps at first accidently, for so interwoven a complex of rhymes has only been achieved by means of a tight crowding together of objects, and this has led both artists to a novel display of overlapping and transparent effects. Within the groupings of objects these are effects exclusively of planar overlapping without linear perspective or the indication of depth by diminishing scale. The space here has inevitably become less the condensed perspectival space of early Cubism simplified, and more the planimetric space of post-*papier-collé* Cubism complicated and refined.

Both the development of elaborate rhymes and of a central jig-saw of overlapping shapes in a late Cubist space characterize the ambitious Purist pictures of 1923. Jeanneret (as Le Corbusier) now had buildings to design and oversee, but that year he produced a major composition, *Still Life with Many Objects* (Plate 118). Here at last the Purist use of colour in practice has begun to challenge Purist theory, for there are volumes coloured an airy blue, and strong notes of red set dynamically against complementary greens. Jeanneret, like so many, has responded to the shift away from the chromatic austerity of crystal Cubism. By the year of the dual demise of *L'Esprit Nouveau* and Purism, the still lives put together by Ozenfant and Jeanneret were very different from those demonstration pieces of 1920. Ozenfant's *Mother of Pearl*, of 1925 or 1926, makes the point (Plate 119).[93] His cluster of glass and porcelain hangs in a space evoked by colour alone, by the misty grey-blue associated with distance; there are no linear markers set out to indicate perspectival space at all. Objects are reduced to simple flat shapes which merge and reverberate with echoes of one another, and the

117. Charles-Edouard Jeanneret, *Composition with Guitar and Lantern*, 1920. Oil on canvas, 31¾ × 39¼in. Oeffentliche Kunstsammlung Basel, Kunstmuseum.

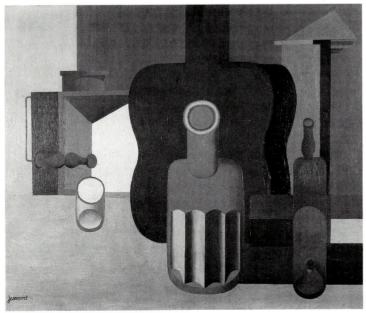

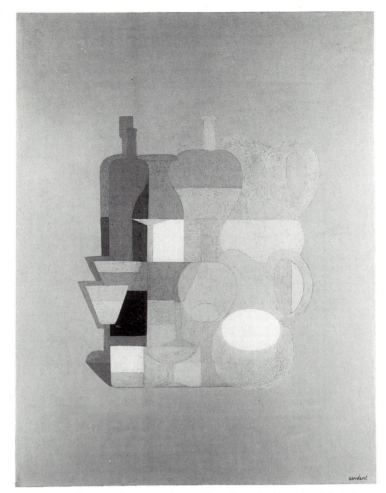

119. Amédée Ozenfant, *Mother of Pearl, no.2*, 1925 or 26. Oil on canvas, 55 × 40in. Philadelphia Museum of Art. Purchased: The Edith H. Bell Fund and The Edward and Althea Budd Fund.

entire solid core of the picture is robbed of substance by the invasion of spatial blues and greys relieved only intermittently by a palid pink and a deep crimson. Forbidden nuanced tints have taken over to initiate effects of luminous space, and the image has been given thus a glowing atmospheric appeal quite at odds with the Purist paintings of 1920. Ozenfant's range of form is still limited, and the Golden Section still connects

relationships, but he has moved a considerable distance from the kind of work he had shown in 1921. In the end it can be said that an apparently rigid theory backed an actual pictorial style which approached closer to the current advanced Cubism of the twenties the more it subverted that theory.[94]

If finally the question is asked just how far was Purist painting identifiable with advanced Cubist painting towards the end of *L'Esprit Nouveau*, it is possible to pull together some of the factors that characterized the whole range of Cubist art during the period 1920–25. Most revealingly the question should be asked by way of another: why should Purist painting be seen as an extension of Cubism and not as a conservative retreat to a tidied-up 'early Cubism' like André Lhote's?

Broadly speaking, there can be no doubt that Purist painting was analytic, not synthetic, and that even in 1925 the explanatory presentation of 'type-objects' was central.[95] The Purists worked *from* nature just as Lhote did. At the same time, however, their insistence on the banality of their ideal still-life subject-matter contrasted with Lhote's liking for popular subjects which drew attention to themselves (Plate 222). The fact is that so 'pure' did the Purists' accent on banality allow their treatment of objects to become, that by 1922 they were constructing their pictures with a freedom and formal bias closely attuned to synthetic Cubism. Their 'type-objects' became *as if* the elements of an abstract pictorial vocabulary to be manipulated as the need for rhyming relationships demanded. The symbolic connotational meanings carried by these objects were not lost, but they were, for the Purists, 'secondary', and therefore never diverted them from the essential 'purity' of their compositional inventions. There was little to prevent them in the end from developing their own variants on the pictorial space of late synthetic Cubism.

From at least 1922 Purist painting was not, after all, the retreat it had threatened to be in 1918; it was aligned with the new Cubist painting, even where there was no compromise; it had little to do with Lhote's conservative diversion. Purism may have come 'after Cubism', according to the Purists, but there is a strong case for seeing it as one more proof that Cubism survived the years 1920–25, and survived them with the capacity still to change.

5
The New Avant-gardes

'La Peinture Surréaliste' and 'L'Art d'aujourd'hui'

In October 1925 the information column of the periodical *L'Art Vivant* carried the announcement: 'Galerie Pierre. 13 rue Bonaparte—*The Surdadaists*'.[1] The mistake is of interest: it establishes how closely the new phenomenon Surrealism was associated with Dada from the early twenties, and how unfamiliar the term and the movement still were. Yet, already during 1925 the pages of the relatively conservative *L'Art Vivant* reveal how the term 'Surrealism' was beginning to be a signal for abuse quite as effective as the term 'Cubism', and the exhibition 'La Peinture Surréaliste' at the galerie Pierre was, in fact, a very significant event. It was here that Surrealism and painting came together with enough force to mount a genuine challenge to the status of Cubism at the sharp end of avant-garde activity in Paris.

To those approaching the exhibition from the outside, the painters included could seem a diverse grouping indeed: mixed together were the well-known figures Picasso and Giorgio de Chirico and a variety of others less well-known in Paris, including the Swiss Paul Klee, the German Max Ernst, the Alsatian Dadaist Arp, and the very different young artists André Masson, Man Ray, Pierre Roy and the Catalan Joan Miró. What pulled them together was their public engagement with the stance of the ex-Dadaist André Breton and the periodical which had been founded at the end of 1924 by him and a group of writers: *La Révolution Surréaliste*.

The following month (December 1925) another, much larger exhibition opened at the rue de la Ville l'Evêque. In this case *L'Art Vivant* made no mistake with the title: 'L'Art d'aujourd'hui, Exposition Internationale', but it reported also that there had been some trouble before the organizers had settled on this, and that originally the title was to be: 'L'Art abstrait'.[2] A Polish artist, Y.V. Poznanski, a follower of Gleizes, was behind this exhibition, and he did not claim to represent anything as coherent in its aims as a movement. The range of artists included was much wider that in 'La Peinture Surréaliste', moreover. Picasso, Léger, Gris, Gleizes, Marcoussis, Lipchitz and Laurens all gave late Cubism a showing. Villon and the Delaunays were shown too, and there were even Arps, Ernsts, Massons, Mirós and Klees.[3] But the central rationale of the exhibition, revealed by its original title, was obvious enough in the way that the Cubists were relegated to a separate room as 'precursors', and in the abstractness or non-objectivity of so much of the art shown. There were some twenty works from artists who were or had been associated with the Dutch De Stijl group. Moholy-Nagy, the Bauhaus artist, sent six. And then there was a significant number from young foreign pupils of Léger who were tempted by the abstract and the non-objective.[4] Most commentators, however obtuse, got the point of the new title. Poznanski's exhibition was designed to fix in the minds of those who visited it the idea that current art at its most up-to-date and international was moving irresistibly towards abstract and non-objective art. By displaying the Cubists as precursors, the challenge to Cubism's avant-garde status could hardly have been made clearer.

'La Peinture Surréaliste' and 'L'Art d'aujourd'hui' were not exhibitions that started anything; they capitalized on developments that had been going on in French art for some time. But they were particularly noticeable signs of a major change which by the end of 1925 was well underway. They mark the displacement of Cubism from the position it had continued to enjoy for more than half a decade since 1918 as the major radical tendency among Parisian avant-gardists. It

is important to consider the challenge offered by the movements for which they stood, and especially their relationship with Cubism, before turning to Cubist painting and sculpture as such after 1924.

The Radical Challenge:
Non-Objective Art

In the years immediately following the Great War, the pursuit of abstract and non-objective art in France was almost completely submerged. Villon, as we have seen, made highly abstract (or abstracted) paintings, and so did Auguste Herbin, along with equally abstract polychromatic reliefs; but Villon was treated as peripheral, and Herbin's geometric compositions were given a definite and limited ornamental purpose as embellishments for a future monumental architecture. At first after the Great War there were only two major artists in France who were not merely peripheral Cubists and who saw a future for abstract or non-objective art without giving it a secondary architectural role: the Czech painter Františck Kupka and the Dutchman Piet Mondrian.

Kupka was quick to show at the Automnes of 1919 and 1920, and in 1921 was given a one-man exhibition at the galerie Povolozky. His work found a certain amount of positive response and support, but never enough to become more than a curiosity.[5] Initially, though taken up by Léonce Rosenberg, Mondrian seems to have been even more isolated. His pamphlet *Le Néo-Plasticisme*, published by Rosenberg in 1920, went virtually unnoticed in the art press; his four canvases in the Effort Moderne group exhibition of 1921 went almost unmentioned; and his correspondence with the architect J.J.P. Oud reveals that in 1921 and 1922 Rosenberg could not sell his work, found the investment too risky to pay him for it, and showed it only as part of his own private collection. As Mondrian tells it, the dealer appears to have seen in him an artist of the future whose time was not yet come. As Van Doesburg put it in a letter of September 1922: 'In Paris everything is completely dead. Mondrian suffers a great deal because of it.'[6]

Yet, Mondrian's role was to be far more central than Kupka's, and it was to be so, on the one hand because of his situation within the group De Stijl, and on the other because of Léonce Rosenberg's galerie de l'Effort Moderne; for the emergence of non-objective art after 1922 as a major avant-garde alternative was to be instigated by De Stijl as a 'collective' movement with a charismatic leader, Theo Van Doesburg, and was to be promoted by l'Effort Moderne. Despite the threat it posed, non-objective art was actually allowed to become more than a marginal issue in Paris by the Cubists' own dealer within a Cubist context.

As early as February 1920, the date of Van Doesburg's first post-war visit to Paris, Rosenberg's relationship with him and his attitude to De Stijl as a whole was positive, more so than it was to Mondrian alone. He approached De Stijl much as Herbin approached his ornamental abstract painting, seeing it as a stage in the development of a modern monumental art which would be collaborative and would combine painting and architecture.[7] By April 1921, with Van Doesburg briefly back in Paris, Mondrian had been drawn into plans for an exhibition at l'Effort Moderne which would involve the collaboration of architects (headed by Oud) and painters and would centre on designs for a large villa notionally commissioned for Rosenberg's own occupancy.[8] In fact, the exhibition did not take place until November 1923, and when it came neither Mondrian nor Oud were involved after

all, but De Stijl had been toughened in the interim by Van Doesburg's engagement with the international Constructivists in Weimer, Düsseldorf and Berlin, the scope of the project had grown and its ultimate impact was probably the greater for the delay.[9]

When Mondrian first showed with l'Effort Moderne, he showed as an easel painter alongside other easel painters; his non-objective canvases could therefore be taken as decorative painting without a decorative role. At the De Stijl exhibition in November 1923 Van Doesburg allowed painting only a role as part of a coloured architecture. Working with a new collaborator, the young architect Cor Van Eesteren, he produced drawings and models not only for the villa originally commissioned in 1920–21, but for a further 'Private House' and for an 'Artist's House' (Plate 243).[10] No longer, as in the case of Herbin, was the painter to be a mere secondary embellisher of architecture, for Van Doesburg and Van Eesteren here gave colour a role in architecture which was fundamental. Used flatly on the surface, as far as possible preserving the planar identity and rectangular format of the walls, it was made to seem an integral element, enhancing the stability of the whole, and at the same time in effect opening up structures by the creation of fluctuating sensations of space. For Van Doesburg, this polychromatic architecture, like Mondrian's paintings, ultimately drew its authority from the metaphysical 'truth' it was believed to embody (something which will be returned to in Part IV), but this was not made much of in the manifesto which he and Van Eesteren signed probably the following year in the context of the exhibition, 'Towards Collective Construction'. Set firmly in a hard-headed Constructivist framework of ideas, the stress here was on the power of artists and architects working together to change the physical fabric of the world.

The De Stijl exhibition of 1923 was perhaps the single most important event to give non-objective art a future in France, and what assured it of its impact was the way it exclusively associated non-objective art with architecture and minimized the metaphysical factor.[11] There were many observable positive results. Despite an initially negative reaction in *L'Esprit Nouveau*, it was the stimulus behind Le Corbusier's decision during the mid-twenties to open up his buildings by the use of colour planes inside and sometimes outside; it led to the extensive publication of De Stijl designs and statements in *L'Architecture Vivante* and the *Bulletin de l'Effort Moderne*; and French collectors, led by the Comte de Noailles, began to show an interest.[12] But most important of all was the response of Fernand Léger. It was especially he who eased the way for artists in France to take Van Doesburg and Mondrian seriously. It can be said, therefore, that non-objective art as a challenger to the status of Cubism at the head of the French avant-garde was not only brought to France by the Cubists' own dealer, Léonce Rosenberg, but was made acceptable by one of the leading Cubist painters. Léger's achievement, however, was to see that even if it was given a major role in architecture, so long as non-objective art was considered exclusively architectural it could be welcomed without threatening the survival of Cubism at all: that it could, in fact, be absorbed into the range of recognized Cubist attitudes and practices just as Herbin's ornamental abstraction, with its less fundamental architectural role, had been. Van Doesburg and Van Eesteren integrated painting and architecture partly in order to render easel painting obsolete; Léger saw the potential of non-objective painting as a primary factor in architecture, but did not see it as rendering easel painting obsolete. He was able, therefore, to separate the issue of non-objective painting from the issue of the survival of Cubist attitudes to subject-matter in art; with the continuation,

separately, of easel painting Cubism could continue too, relatively untouched. It was this kind of convenient reasoning that ensured that abstract and non-objective art would never present so dangerous a challenge as Surrealism.

Léger's preparedness for the lessons of the De Stijl exhibition was already clear some months before it, in June 1923, and so were the general outlines of his mature attitude to non-objective art. That month he published a seldom cited interview with Florent Fels in *Les Nouvelles Littéraires* and, besides signalling his awareness of Constructivist developments in Germany, introduced the distinction between mural painting and easel painting that was to become central to his position. There is, Léger said: '1. the art-object (picture; sculpture, machine, object), *its value strictly its own*, made with concentration and intensity, anti-decorative, against the wall...' (easel painting among other things); and then, '2', there is: 'Ornamental art, dependent on architecture, its value strictly relative (fresco tradition) adaptable to the necessities of the site, respecting surfaces, living and acting only as the destroyer of dead surfaces (Realization in flat coloured planes, abstract, volumes given by architectural and pictorial masses)' (mural painting).[13]

The De Stijl exhibition did not change the fundamentals of the stance outlined by Léger in this interview (he could already have been meeting and arguing with Van Doesburg before it, since the Dutchman had been based in Paris from the spring of 1923). What it did was to persuade him that mural painting should be totally non-objective, could be much more than mere decoration, and that his own attempt earlier in the year to produce a mural scheme with Josef Csaky for the Indépendants had been inadequate precisely because it had been too busily, too superficially decorative (Plate 248).[14] It finally committed him to the project of a non-objective mural art, but without weakening his commitment to the clashing volumes and surfaces of easel painting as the only pictorial vehicle for matching the vigour of modern life. The mural was to provide a setting for life; easel painting was to continue to produce a pictorial response to it.

By late 1924 all this had been made clear in a wide-ranging if short text published by Léger in *L'Architecture Vivante*, 'Polychromatic Architecture',[15] but, in fact, as we shall see, Léger's work between 1924 and 1928 was overwhelmingly in easel painting. All he produced to go with his public commitment to non-objective painting for architecture were a few non-objective easel paintings which he endowed with mural pretensions by simply calling them 'mural paintings' (Plate 121). The example he contributed to Mallet-Stevens's Hall for an Embassy at the Exposition Internationale des Arts Décoratifs in 1925 was the only one to be shown conspicuously in an architectural context, and, though the original intention seems to have been to execute this in mosaic, it would have stood out as a self-sufficient entity however it had been executed, still far more an addition to the wall than an integral part of it (Plate 120).[16]

The work of Gladys Fabre has placed Léger's attempt to relate as a Cubist to abstract and non-objective art at the centre of something larger, and there can be no doubt that when he showed at 'L'Art d'aujourd'hui' critics at the time could see him not just as a 'precursor' but as a leader around whom were grouped followers.[17] The followers to whom they referred were Léger's pupils from the afternoon classes that he ran with Ozenfant at the Académie Moderne in the rue Notre-Dame-des-Champs: Marcelle Cahn, Otto Carlsund, Franciska Clausen, Florence Henri, Ragnhild Keyser, Waldemar Lorenson, Vera Meyerson, Olaf Osterblom and Charlotte Wänkel.[18] Theirs was a significant penetration of the Parisian art world, with a high profile, but, as Fabre has shown, their

approach to abstract and non-objective painting came not second-hand from Léger, but second-hand from Germany and the East above all.[19] They constituted a second wave of influence from abroad to follow that of De Stijl. Several of these young artists on occasion used Léger's term 'mural painting' for easel paintings composed as models for possible mural application, conscious of the crucial distinction their teacher made, but several too (including Carlsund and the Englishman Joseph Mellor Hanson) produced what appear to be self-sufficient non-objective pictures, confusing things (Plate 122). Ultimately, they can be seen to have brought into Léger's ambit advanced Westernized Constructivist attitudes which only underline further the Frenchness of his still Cubist stance, with its conditional, strictly limited acceptance of abstract and non-objective art. Yet, the very fact that they could do so says much for the opening up of the Parisian art world to such art after 1923.

120. Robert Mallet-Stevens, Entrance Hall for the Ideal Embassy at the Exposition Internationale des Arts Décoratifs, Paris, 1925, with *Mural Painting*, 1924–25 by Fernand Léger. Illustrated in *L'Amour de l'Art*, August 1925.

Between 1925 and 1928 the presence of abstract and non-objective art as an avant-garde force in France was undeniable, and its potential lay manifestly in what it offered architecture. De Stijl (above all Van Doesburg's and Van Eesteren's collaboration of 1923) was the centre-piece of an ambitious exhibition initiated by the architect Robert Mallet-Stevens at the Ecole Spéciale d'architecture in 1924, an exhibition which drew in other leading French architects like Sauvage, Guévrékian, Perret and Le Corbusier. Positive responses by painters to De Stijl and to the art of Mondrian, such as Félix del Marle's and Jean Gorin's, were made at first in the context of the coloured interior, in these cases Mondrian's studio as a totality combining paintings and walls; while perhaps the most important positive response of all, though it was well hidden behind a sceptical front, was that of Le Corbusier as architect rather than painter.[20] Fittingly, it was as a designer of coloured architectural spaces that Van Doesburg found his niche in France during those years: first providing the colour enhancement of a small room devoted to the cutting of flowers in the Comte de Noaille's new villa being built at Hyères; then, between 1926 and 1928, doing so for the extensive complex of dance-halls, bars and restaurants in the 'Aubette' at Strasbourg.[21] 1925 brought a total split between Mondrian and Van Doesburg with the latter's introduction of the diagonal in his so-called 'counter-compositions' whose culmination

122. Joseph Mellor Hanson, *Static Composition*, 1927. Oil on canvas, $47 \times 22\frac{1}{2}$in. Private Collection, France.

121. Fernand Léger, *Mural Painting*, 1924–5. Oil on canvas, $71 \times 31\frac{5}{8}$in. Collection, Solomon R. Guggenheim Museum, New York.

was the *ciné-dancing* at the 'Aubette' (Plate 246), and, in fact, the actual impact of the new environmental idea of a polychromatic architecture was both fragmentary and limited. But at 'L'Art d'aujourd'hui' it was the unity of the new direction that was stressed, and not until later did its failure to make a really significant contribution in France, distinct from Cubism, become obvious. Though Léger

had made what De Stijl stood for adaptable to the Cubist stance, between 1925 and 1928 abstract and non-objective art did present a recognizable radical alternative, and one that was new.

The fact that Cubism's avant-garde status *was* challenged and was seen to be challenged, however successful Léger's work as a mediator, is perhaps best indicated by one particular

123. Albert Gleizes, *Composition*, 1923. Oil on canvas, $75\frac{3}{4} \times 63\frac{1}{4}$in. Succession Gleizes.

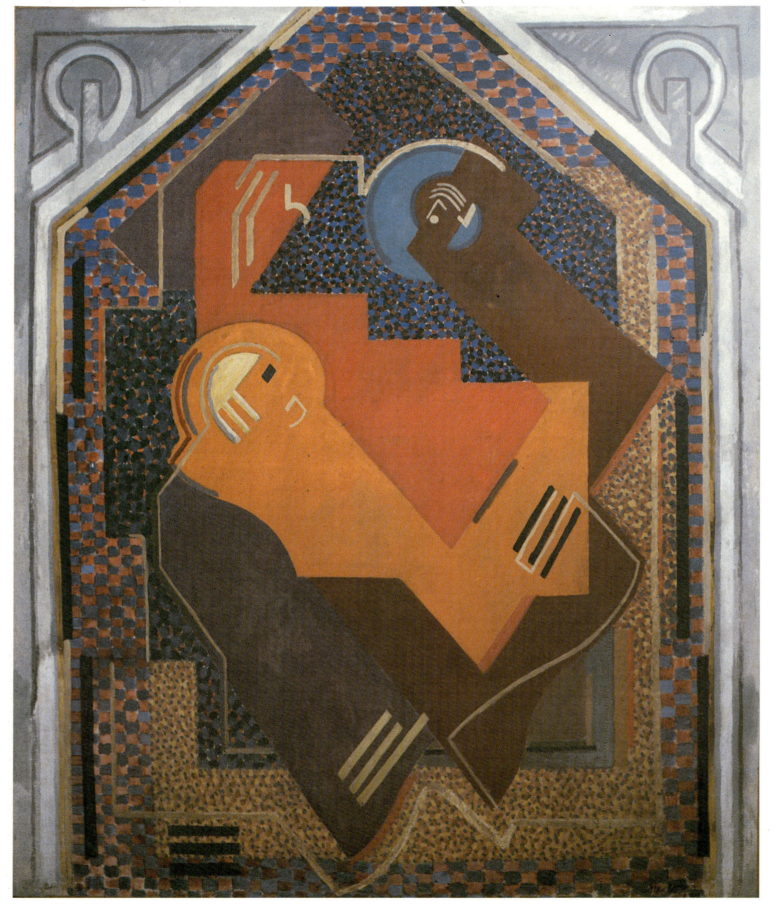

reaction to 'L'Art d'aujourd'hui': that of the loyal champion of the Cubists, Maurice Raynal. Actually, like Léger, Raynal could accept what was happening so long as it was kept to its architectural and environmental context, but, of course, what was put on show at 'L'Art d'aujourd'hui' was not non-objective painting exclusively given an architectural role; it was a great range of work that obviously implied a possible future for non-objective painting as easel painting too: as a self-sufficient alternative in its own right. The critic's reaction was paranoid and openly contemptuous.

Raynal, significantly, started by making a point of ridiculing Poznansky's claim to represent the young; the generation gap was an uncomfortable fact that he felt compelled to confront. For him, the young painters here were to be characterized dismissively as the 'pupils' of Léger, Ozenfant, Gleizes and Delaunay, and their work had merely turned 'the intentions of the Cubists into decorative pretexts' lacking all the 'plastic intensity' of the work of their masters, a fact that made it doubly intolerable that the Cubists had been put on one side, 'relegated to a little room which has maliciously been called the "Salon des Refusés"'. He could not deny that the exhibition represented an 'international' phenomenon, but he saw that phenomenon as evidence of a decline that had come with the distortion of Cubism: it was, he said, Cubism fallen into 'the cult of procedures, of appearances and of formula'.[22] As so many had dismissed Cubism itself for its seeming rigidity and decorative superficiality alongside its progressive pretensions, so Raynal dismissed the new wave of abstract and non-objective art. The vigour and the bias of his reaction is a measure of the seriousness of the threat that he saw to Cubist values and especially to the status of the Cubist movement.

The Radical Challenge: Surrealism

Picabia, it will be remembered, challenged Cubism in its distilled post-war form particularly effectively because he made a point of blurring the distinction between painting and poetry, the visual and the verbal. Mondrian, Van Doesburg and the artists of De Stijl did not challenge the core of the Cubists' set of beliefs: they repeated the Cubist focus on formal relationships and themselves made as clear a distinction between the visual and the other arts. Without this, even Léger could not have absorbed the ideal of a non-objective mural art as he did. The Surrealists took further the breakdown of the boundaries between painting and poetry and then between art and life which Dada had promoted, and by doing so struck too hard at priorities too central to the Cubist stance for the Cubists ever to be able to neutralize Surrealist ideas by absorbing them. Only Picasso was able to direct Surrealist means to ends that were both his *and* attuned to Surrealism; and he, as we have seen, stood apart. Perhaps the most telling indication of the strength of the challenge offered Cubism by the Surrealists is the fact that, where the Cubists could find no way of absorbing Surrealist ideas, André Breton in particular could approach Cubism as if it was merely a primitive form of Surrealism. The roles were reversed.

Breton was the crucial figure in the initial emergence of Surrealism, and the point of its emergence was the group of writers around him centred on the periodical *Littérature*. For them, a prerequisite of the developments that led to its emergence was the extinction of Dada. One less serious threat to the Cubists was replaced by another far more serious because far more positive and better co-ordinated.

Breton's first public break with Dada came early in 1922 with the collapse, significantly, of an initiative aimed at bringing together the leaders of the Parisian avant-garde (including Léger and Ozenfant) in the hope of debating coherently 'the modern spirit', his so-called 'Congrès de Paris'. Such a project was simply intolerable to Tzara. The Congrès was launched with a public announcement in *Comœdia* in January; by the end of February Tzara had seen to its failure with Picabia joining in (on Breton's side) to cause the maximum amount of mischief.[23] Breton reacted with an article 'After Dada' (the rather briefer sequel to the Purists' *Après le cubisme*) in which he reported the interment of Dada (following 'those of Cubism and Futurism').[24] And in April 1922 he added to it the passionate 'Invitation to a journey': 'Leave everything./Leave Dada./Leave your wife, leave your mistress./Leave your hopes and your fears./...Go out onto the highways.'[25] From time to time since his first engagement with *Dada* (the periodical) by correspondence and then personally with Picabia and Tzara, Breton had betrayed a desire to establish aims and to clarify a moral position for himself and for the *Littérature* group in society. The collapse of the Congrès brought him finally to the conclusion that the destructiveness of Dada had become merely a way of comfortably avoiding issues by never accepting the responsibility of hope. By the end of 1922 he could write that Dada had served only one purpose: 'to keep us in that state of perfect availability where we are [now]...';[26] all that was needed was a sense of direction.

When Breton reported the death of Dada in *Littérature*, he dated its 'obsequies' to 'around May 1921'.[27] By doing so he picked out two earlier events as especially significant: the mock trial he had organized of the nationalist poet Maurice Barrès and the exhibition of Max Ernst at the galerie Au Sans Pareil. The Barrès trial had been another provocation to Tzara (and also Picabia), for it was Breton's most comprehensive attempt to implicate the Dadaists in the clarification of a coherent moral stance and at the same time to establish a definite sense of priority.[28] The single major characteristic of the moral stance set out at the trial was its rejection of all values, laws and institutions which restrained the individual; and the single priority that lay behind this was the release of each individual's imagination. At the Ernst exhibition what could be generated by such a release from confinement of all kinds was, Breton believed, there to be seen by any open to it. Ernst himself did not arrive in Paris until 1922, but he sent a great deal of material, including early collages like *Hypertrophic Trophy* (already refused at the Section d'Or in 1920) (Plate 63) and such recent collages as *The Sand-worm* (Plate 253). The style of the exhibition (from the invitation cards, to the opening, to the nonsensical texts incorporated in the collages) was resolutely and aggressively Dada, and so the contradictions and lack of coherence in the collages carried a strong anti-art message, but they were introduced by a catalogue preface from Breton which suggested something further. He associated Ernst's collages with a new concern, particularly the distinctly un-Cubist way they brought together the contradictory in visual illusions and words. He called this concern 'the marvellous', and he defined the marvellous as the 'spark' that was extracted by the meeting of 'two distant realities' in a situation designed 'to disorient us...'.[29] Coherence was to be given to the activities of Breton and his friends in the two years following the doomed Congrès de Paris and his break from Dada by the moral force with which they endowed the need to liberate the imagination, and by the goal they increasingly gave the liberated imagination: 'the marvellous'.

The scene was set for the emergence of Surrealism by the

first numbers of a new version of *Littérature*, the so-called *Nouvelle série*. Between mid-1921 and early 1922 the periodical ceased publication. This new *série* opened immediately after the débâcle of the Congrès, in March 1922. To begin with, Breton and Philippe Soupault were joint editors; after no. 4 Breton took over as sole editor. The *Nouvelle série* marked the formation of a new grouping around Breton; Picabia was still involved, and so too were Aragon, Eluard and Soupault, but now too there were Jacques Baron, Robert Desnos, Max Morise, Roger Vitrac, Pierre de Massot, René Crevel and Benjamin Péret, while Ernst had, of course, managed to enter France and join in.[30] During 1923 others would become involved, most importantly a group of writers including Michel Leiris, Roland Tual, Georges Limbour and Antonin Artaud, and the painter André Masson, the neighbour in the rue Blomet of Joan Miró.

The eighth number of the *Nouvelle série* of *Littérature* (1 November 1922) carried an important article by Breton, 'The Entrance of the Mediums'. In it Breton set down his considered reaction to what had become his own dominant passion and that of the whole group: the exploration of hallucination and dream. This new pursuit he linked to his own experiments with Soupault in automatic writing during 1919, *Les Champs magnétiques*, and called both 'Surrealist' (pilfering the term from Apollinaire). Surrealism, he wrote, was understood by the group to be 'A certain psychic automatism which corresponds reasonably well with the dream state...';[31] they were committed to it in all its ramifications from the production of automatic texts to the stimulation of trance states. Early in 1923 the group's experiments with artificially induced hallucination came to a halt (the dangers proved too great).[32] But, looking back in 1924, Aragon had no doubt about the importance of what he called the 'epidemic of trances', and certainly it convinced the group around Breton that if the marvellous was to be obtained and the imagination was to be liberated the key was automatism: that is, the encouragement of procedures of all kinds that would minimize conscious control in the production of poetic images. Since the end (the marvellous image which brought together 'distant realities' in an unprecedented way) was seen to depend on the means ('psychic automatism'), the two became fused into the single word: Surrealism. As a movement with a manifesto and a periodical, Surrealism did not finally emerge until the end of 1924, but the 'epidemic of trances' played a crucial part in preparing the way.[33]

The *Manifeste du Surréalisme* and the first number of *La Révolution Surréaliste* were preceded through the spring and summer of 1924 by a chain of controversies, naturally. The most revealing, perhaps, involved the term 'Surrealism' itself, for it accentuated the gap between the group around Breton and the Cubists (poets and painters). In May, writing in *Paris-Soir*, the '*Littérature* group' (they signed themselves as such) explicitly separated their idea of 'Surrealism' from the idea originally associated with it by Apollinaire, citing as justification early 'manifestations' of Surrealism as automatism in Lautréamont's *Les Chants de Maldoror* and Rimbaud's *Les Illuminations*.[34] This was followed by a series of attacks from writers (especially Yvan Goll and Paul Dermée) who wished to retain Apollinaire's stress on the *image as such*—its artistic 'purity' (above reality)—and who deplored the *Littérature* group's stress on the *process* that produced it, automatism. The argument can appear petty, but for Goll and Dermée the theft of the term 'Surrealism' was symbolic. It threw into relief a deep schism that now existed within Parisian avant-garde circles between those who still held to what Apollinaire had stood for (the making of 'pure' art-works, inviolate in their own space) and those who rejected the consciously directed making of art-works altogether, and stood for the discovery of the marvellous in automatism and the dream. It left no doubt that these new Surrealists led by Breton had rejected the priorities not only of the Dadaists and Apollinaire but of many others, including the Cubists.[35]

At the date of Surrealism's emergence its relevance to painting was not very clear. Picabia had finally broken away from Breton during 1924, left in no doubt that a coherent movement was in the making;[36] Max Ernst, though he had been linked to the *Littérature* group, was out of France; and Picasso, though he was celebrated by the group, had been accepted entirely on his own terms as a painter so open to the marvellous as to be beyond reproach.[37] On the fringes of the group were two other painters, Masson and Miró, but Miró had yet to make a real impact publicly, and Masson was engaged in the very different circle around Kahnweiler and the galerie Simon as well.[38]

The alliance between Surrealism and painting was finalized with great speed and completeness in the year between Breton's manifesto and the opening in November 1925 of 'La Peinture Surréaliste' at the galerie Pierre, and certainly the main text to cement the alliance was Breton's series of articles 'Surrealism and Painting', the first of which appeared in *La Révolution Surréaliste* in July. Painting was picked out within the Surrealist circle as a major way to the marvellous, and a Surrealist stance was established *vis-à-vis* painting that rejected out of hand almost everything of significance for which Cubism stood. What this stance entailed and just how it was opposed to that of the Cubists are topics for Part IV, but the main routes to the marvellous available to painters, as they were understood by the Surrealists, need at least to be identified here. The very first number of *La Révolution Surréaliste*, in December 1924, carried an article which identified them clearly enough: Max Morise's 'Enchanted Eyes'. Morise isolated two routes. One was by way of dreams in drawn or painted records. The other was by way of mark-making, where the marks made by pen, pencil or brush were the equivalents of the words that were the raw material of automatic texts.[39]

At 'La Peinture Surréaliste' there was to be seen both the painting of dreams and the automatism of the mark, or at least work that gave the impression of approximating to both. Ernst, now back in Paris, showed *Two Children Menaced by a Nightingale*, a picture easily consumed as a dream image and, though already rejected by the Surrealists, Giorgio de Chirico (for Breton *the* dream painter) was represented. Much more important at the galerie Pierre, however, was the automatism of the mark, which was seen there in several striking forms, among them pictures by Masson which were the partners of quasi-automatic drawings (Plates 263 and 124) and a picture by Miró which at least could *seem* the immediate result of simple mark-marking, *The Music-Hall Usher*.[40] The opposition between the consummate dream images (artificial though they were) of Ernst or de Chirico and everything that the 'pure Cubists' had produced could not have been clearer: it is summed up in Aragon's readiness to dub Ernst that figure most despised by the Cubists, a 'painter of illusions'.[41] As we shall see, Masson's and Miró's opposition was deep too, but the relationship between the automatism of the mark as they developed it and the practices of the Cubists is far from a straightforward, contradictory one. If Léger was able to neutralize non-objective art by absorbing it into the range of Cubist possibilities, Masson and Miró were able to neutralize Cubism by adapting certain of its practices to the Surrealist search for the marvellous. Just as it is in Léger's work between 1923 and 1926 that non-objective and Cubist painting made the most direct contact, so it is in Masson's and Miró's in those years that Cubist and Surrealist painting did. Their work too, therefore, deserves special scrutiny here, not merely

124. André Masson, *Mar.*, 1925. Oil on canvas, $39\frac{1}{4} \times 25\frac{1}{2}$ in. Collection, Mr and Mrs Joseph R. Shapiro, Oak Park, Illinois.

as Surrealist painting but as an aberrant off-shoot of Cubism itself.

Picasso, Masson and Miró: Between Cubist and Surrealist Painting

Breton and the Surrealists were not as tempted as Picabia to polarize their relationship with Cubism. For them there would have been nothing unacceptable about the fact that major Surrealist painters could learn from Cubism. Picasso, it will be recalled, was from the outset a Surrealist hero; and it was Picasso the *Cubist* who was shown alongside Ernst, Masson, Miró and the others in 'La Peinture Surréaliste'.[42] The special character of Picasso's Cubism and the mythical reputation it enjoyed in Breton's circle were important reasons for the contribution Cubism made to the early development of Surrealist painting.

It was, of course, the expressive in Picasso's Cubism that made it so especially adaptable to Surrealist ends: his ability to use the semantic elasticity of Cubist signs either to give an anthropomorphic vitality to inanimate things or to encourage often disturbing associations. The enhancement of the associative power of Cubism was particularly striking in certain of the drawings he made at Avignon in the summer of 1914 (Plate 10), and it was *Woman in an Armchair* of 1913, the picture that more than any other was the starting-point for those drawings, that Breton pointed to in 'Surrealism and

125. Pablo Picasso, *The Three Dancers*, June 1925. Oil on canvas, $84\frac{5}{8} \times 55\frac{7}{8}$in. The Tate Gallery, London.

Painting' (Plate 301). Here in these images not only are identities sometimes interchangeable (figures and musical instruments in one of the drawings at least), but grotesque distortions of scale and a general inclination to the soft and the bulbous encourage erotic suggestions or unlikely similies. For Breton, Picasso's Cubism was so important because with the release it offered from the simple depiction of things went the possibility of an unprecedented imaginative freedom: *Woman in an Armchair* and the kind of inventions to which it led were the most effective demonstration of this.

It can be no coincidence that 1924, the year of Surrealism's emergence, saw the beginning of a return by Picasso to the more overtly expressive morphology of *Woman in an Armchair* and the Avignon drawings, something already noted in the still life *Mandolin and Guitar* (Plate 91). 1925 saw him incalculably increase the direct expressive force of his painting by applying this mode of suggestive forming and aggressive distortion to the figure once more, most of all in *The Three Dancers* and *The Embrace* (Plates 125 and 126), pictures which research has shown to have deep, private autobiographical meanings.[43] Emotionally charged to a point where the separation of art from life (in the sense of biography) can hardly be sustained, these canvases used Cubist means for hyperexpressive ends which were obviously alien to Cubism in its late distilled form. They show how easily Picasso could divert the possibilities opened up by his own Cubism along routes increasingly attractive to Breton.

The pictures that Miró and Masson showed in 'La Peinture Surréaliste' were in their very different ways autobiographical, expressive and highly suggestive, but, perhaps surprisingly, neither developed the kind of work they were producing late in 1924 and during 1925 with Picasso's expressive Cubism as a stimulus. After all, *Woman in an Armchair* had yet to make its Surrealist reputation, and the Avignon drawings were hidden away somewhere in Picasso's studio. What mattered most to both Miró and Masson was not the way Cubism's associative and expressive power could be enhanced by new formal repertoires or extremes of distortion, it was, rather, the way that Cubism, especially late synthetic Cubism, encouraged the exchange of identities: metamorphosis. This was to be crucial to their development of automatic practices.

Of the two, it was Miró who took most from Picasso's synthetic Cubism specifically, and the lessons he learned were there to be learned most effectively in the sparest and simplest of Picasso's pictures, works like the *Harlequin* of 1915 or the Detroit still life of the same year with its harlequin-like bottle (Plates 11 and 21).[44] Miró was to base much on the realization that a single shape inflected in slightly different ways could denote many different things, and that a certain level of simplicity in the vocabulary of signs carried with it a high degree of availability for metamorphosis. Formally, the vocabulary of signs that he developed by 1925 was not at all like Picasso's crisp synthetic Cubist vocabulary either of the 1910s or of the 1920s, but there are connections with the childlike figures of Picasso's designs for *Mercure* in 1924 (Plate 127), and both the decorative idiom of *Still Life with Mandolin* (Plate 88) and the dot-and-line drawings related to those designs (Plate 90) (the latter of which appeared in the right context as a double-page spread in the second number of *La Révolution Surréaliste*).[45] As we have seen, these were perhaps Picasso's clearest late Cubist endorsement of the potential for metamorphosis that had been inherent in synthetic Cubism since 1912.

Picasso above all might have represented the acceptable face of Cubism for the Surrealists, but, strangely, Surrealism received just as telling a stimulus from Cubism at its purest: from the distilled synthetic Cubism of Juan Gris. Masson is

126. Pablo Picasso, *The Embrace*, 1925. Oil on canvas, $51\frac{1}{4} \times 38\frac{1}{8}$in. Musée Picasso, Paris.

127. Pablo Picasso, Decor and costumes for the ballet *Mercure*, Paris, 1924.

the painter whose work reveals this most clearly, and it was he who had the opportunity to learn most from Gris, since as a member of the Kahnweiler circle, he was close to him during the crucial period between 1923 and 1925.[46] That Gris had lessons to teach a future Surrealist followed from the fact that, however pure, his painting revealed the potential for metamorphosis in the semantic elasticity of Cubist signs even more plainly than Picasso's; after all, as Gris repeatedly insisted, it was based on the capacity of abstract shapes to take on different identities, something made manifest by the proliferation of visual rhymes in his painting, as we have seen.

William Rubin and Carolyn Lanchner have established the now commonly accepted view that the painting Masson

produced between 1923 and 1925 was most of all a response to the pre-1913 Cubism of Picasso and Braque.[47] It is a view supported strongly by the clear formal connections between Masson's painting of this period and the 'hermetic' Cubism of that earlier period, and by the equally clear formal dissimilarities between it and Gris's late work. The argument to be developed here is that, though the look and the technical means of Picasso's and Braque's earlier Cubist painting indeed helped shape Masson's style at this stage, the late Cubism of Gris helped at the deeper level of pictorial thought and process, and that this especially was the stimulus that made possible Masson's automatism, his mode of pictorial Surrealism. Certainly what he produced is different, which is why Masson himself and Kahnweiler have minimized the connections, but in the history of Surrealism processes can mean more than results.[48]

The argument against Rubin and Lanchner hinges first on the role of rhyming in Masson's work from 1923 (something they recognize) and second on the relationship between that work, its cursive calligraphy and angular structures, and the softened Cubism of Gris's period of compromise (something they do not recognize). *Opened Pomegranate* of 1924 (Plate 128), shows how quickly Masson learned to make rhyme act metamorphically with an imaginative freedom far beyond Gris. A nude rises from the open mouth of a glass, her torso fused with it while her shoulders rhyme with the bottle that stands beside her. Gris's rhymes had revealed clearly the interchangeability of things; Masson seems actually to freeze the moment of metamorphosis. Venus is actually seen to be born of a still life.

Opened Pomegranate shows less well the loose flowing quality typical of Masson's line than works like *Nudes and Architecture* (Plate 270). It is closer, however, to a drawing which conveys especially well how his approach to this brand of calligraphy as a challenge to structure parallels Gris's then current practice (Plate 129). The drawing was reproduced (upside-down) with Max Morise's 'Enchanted Eyes' in *La Révolution Surréaliste*, and centres on the figure of a nude with circular breasts rising between rudimentary architectural forms. What is striking about it is the relationship between the basic geometric armature and the figure, for the figure and suggested still-life objects below seem initially to have been generated by that armature, the slant of the torso and the inclination of the head following dominant 'regulating lines'. And the armature is not at all like the broken scaffolds of Picasso's and Braque's hermetic Cubism, it is precisely the proportionally controlled type developed by Gris as a compositional basis after 1916.

Masson's practice revealed in this drawing (a practice relevant to all his work of 1924–25) was essentially the same as Gris's had become after 1922. He laid a firm geometric foundation and then challenged it, sometimes, as here, by means of organic ideas actually generated from it. Then, too, this drawing reveals just how deep was the relationship between Gris's synthetic process and the beginnings of Masson's automatism. It is not an automatic drawing in the sense of the drawings usually so described (Plate 260), but in broadly the same way it shows Masson finding images in the abstract (in lines without a denotational purpose). The difference is that the starting-point is a geometric armature, not a free calligraphic flow. Masson's automatism was to be based *both* on the capacity of one form to mean many things by rhyming analogy, *and* on the possibility that signs could be found in marks without clear signification. His automatic practice was, in fact, a variant on Gris's 'synthetic method' (Kahnweiler recalled Gris making 'automatic' drawings too as a starting point).[49] But Masson took it in a far from Cubist direction, one

128. André Masson, *Opened Pomegranate*, 1924. Oil on canvas, 16¼ × 13in. Collection, Mr and Mrs Joseph Slifka, New York.

129. André Masson, *Drawing*, 1924. Measurements and whereabouts unknown. Reproduced in *La Révolution Surréaliste*, December 1924.

that undermined the artist's role as the shaper and manipulator of signs, placing the stress on the *finding* of images and using it to generate images which were rarely neutral.

Miró, it has been suggested, took Picasso above all as his guide, and, of course, resisted the purity of Gris's Cubism in the early twenties. But, as we have seen, in works like *Table with Glove* of 1921 (Plate 86) he too had been drawn to rhymes, and though these were rhymes *seen* in the objects of his studio, they too had carried the potential for metamorphosis.[50] Rhyming played, in fact, a conspicuous enough part in Miró's development between 1923 and 1925, but rhyming as an adjunct to kinds of metamorphosis more like Picasso's than Gris's.

Recently more light has been thrown on how metamorphosis actually worked in Miró's case by the evidence to be found in his sketch-books preserved in Barcelona.[51] In the wake of his proto-Surrealist work, *The Tilled Field*, Miró moved into Surrealist painting most conspicuously by way of a suggestive kind of figure painting with pictures like *Portrait of Mme K* (Plate 290), and elaborate story-telling compositions peopled by Mme K's relatives, like *The Hunter (Catalan Landscape)* (Plate 133). Neither kinds of painting involved anything like automatic mark-making, but they cleared the way to it by the sheer freedom of their metamorphoses and the basic simplicity of their signs. Only a couple of significant still lives were painted at this time, of which *The Bottle of Wine* is one (Plate 134), but the sketch-books show that, in fact, still life played a far more significant role than previously suspected, the key to that role being the flexibility of the relationship between object and figure opened up by Cubism.

The Bottle of Wine is related to two drawings, both from a sketch-book probably filled between 1923 and the end of 1925.[52] The one most directly related to the oil is also the most obviously based on intense observation (Plate 130), but significantly its relationship with the oil is metamorphic and not at all straightforward. The positioning of the fly and the cracks on the right makes the link clear, but the cracks in the picture are more elaborate, they have become patterns in sand,[53] the fly is now clad in gorgeously decorated wings, and, especially remarkable, the bulbous, erect pear of the drawing has *become* the bottle, which appears as if lying in a landscape traced on the sand, while below, the absurd whiskered sardine from *The Hunter (Catalan Landscape)* takes a look in. The second related drawing (Plate 131) comes earlier in the sketchbook, but seems likely to come later in time, after a further metamorphosis.[54] The bottle now accompanies the pear back indoors on to the table with various new companions, and it has changed yet again. Miró gives it a single Cyclopic eye in the picture, but here unequivocally he turns it into a standing figure complete with Catalan hat, only the label 'Vin' confusing its identity. In this case it is not simple observed rhyming relationships (as between pear and bottle) that have promoted the metamorphosis, but the adaptability of Miró's new mode of constructing figures using simple armatures of crossed lines; his bottle of wine is obviously the direct relative of Mme K.

These transformations, hidden in a private sketch-book, may seem only marginally important, but they are in fact centrally important to understanding how metamorphosis worked to such suggestive effect in much of Miró's current figure painting, a point underlined by the later history of these initially still-life motifs. A little further on in the same sketch-book as the still-life drawings there is a fresh variant on Mme K, pointedly captioned 'Portrait of Mlle K', as if to announce its status as off-spring (Plate 132). Here still life and figure actually coalesce: the peeled pear dripping pips like blood or tears becomes a breast, while the other breast becomes

an apple or an orange. Miró never made a painting from this idea, but it had another stage of metamorphosis to go, for it seems to be the trigger for the fused image of woman and plant in the picture of 1926, *Nude* (Plate 300), the large bean to the right having become the head, the pear-breast turned inwards in the guise of a bulb or root, and the breast (definitely an orange now) peeled. Still life has become figure.

It was above all this kind of metamorphic fusion of plant or still-life signs with the parts of the human figure, especially its sexual, erotic or digestive parts, that was essential to the figure variations that Miró developed in 1924 and that provided the 'dramatis personae' of the story-telling pictures like *The Hunter (Catalan Landscape)*.[55] From among the Cubists only Picasso (and far less influentially Laurens) had dared thus to disturb the emotional peace by the *merger* of animate and inanimate, of figure and still life.

Miró's figure painting in 1924 was characterized by an almost *faux-naïf* simplicity, and it is in the simplicity of his signs inscribed on their flat, broadly divided grounds, that the relationship with late synthetic Cubism is clearest. *The Hunter (Catalan Landscape)* is a collection of fragments—the Toulouse-Rabat aeroplane, the hunter's various parts, from ear to flaming heart to sex to guns, the eye with rays, the tree with leaf, etc.—fragments which are each rendered by a simple sign.[56] Many of these are virtually interchangeable, setting up

130. Joan Miró, *Still Life*, 1923–24. Pencil, $7\frac{1}{2} \times 6\frac{3}{4}$in. Fundació Joan Miró, Barcelona.

a pattern of rhymes which, as in Masson (or Gris), communicate the continual possibility of metamorphosis: the set-square, the sardine's tail, the gun and the boat are all triangles, the eye and the leaf are echoes, and so too the hunter's sex and the spider-like, root-like sun.[57]

The transformation of still life, metamorphosis, rhyming, fragmentation— in all these ways Miró's painting in 1924, like Masson's in 1924–25, reflected a relationship with Cubism which was simultaneously positive and negative; but in Miró's case at least the evidence of the sketch-books indicates that

the negative side predominated, consciously. Both the drawings related to *The Bottle of Wine* have a further connotative meaning, so far unmentioned: they convey how acute was Miró's desire to deflate the dignity of the Cézannist tradition and its offspring Cubism. If to take as a subject a bottle and fruit on a table was to place oneself in the context of Cézanne and Cubism (and it was),[58] then to make of the bottle a tipsy Catalan filled with wine, and to dare to peel Cézanne's pear so that it shed a formless trail of skin, was to accord them the minimum respect.

What was most obviously anti-Cubist about Masson's and Miró's painting in 1924–25 was, of course, its imagery: its capacity to seem marvellous to Breton and his friends. Not only did it bring together 'distant realities' in disorienting ways, but it brought together 'realities' that could not be called

131. Joan Miró, *The Bottle of Wine*, 1923–24. Pencil, $6\frac{3}{4} \times 7\frac{1}{2}$in. Fundació Joan Miró, Barcelona.

132. Joan Miró, *Portrait of Mlle K.*, 1924. Pencil, $7\frac{1}{2} \times 6\frac{3}{4}$in. Fundació Joan Miró, Barcelona.

133. Joan Miró, *The Hunter (Catalan Landscape)*, 1923–24. Oil on canvas, $25\frac{1}{2} \times 39\frac{1}{2}$in. Collection, The Museum of Modern Art, New York.

emotionally neutral: Masson's knives and pomegranates and wounds, Miró's roots and genitalia or fruit and erogenous zones. As Masson said of the Cubists later: 'They rejected the representation not only of the dream, but of the instincts which are the roots of being: hunger, love and violence.'[59] The images he and Miró invented confronted these instincts head-on and, at the same time, effectively undermined the Cubist distinction between painting and poetry (something which will be explored further in Part IV).[60] By the sheer freedom with which they exploited the potential for meta-morphosis in late Cubism they were able to break out of it. In Miró's case this freedom was to make possible the brand of automatism he had developed by the date of the galerie Pierre exhibition. In Masson's case it was itself made possible by a kind of automatism, the mark-making and subsequent image-finding of the 'automatic drawings' (Plate 260) which partnered paintings like *Nudes and Architecture* (Plate 270).

All the leading painters included in 'La Peinture Surréaliste' were working by the end of 1925 in ways that could be called more or less automatic. Besides Masson and Miró, this was true certainly of Ernst, Arp and Man Ray. What this automatism actually entailed is again a topic for Part IV; the point to be stressed here is that this work was presented *as* automatic. And in this too it offered a deeply disturbing challenge to the priorities and practices of late Cubism. The key point has been hinted at already with reference to Masson: the desire to loosen the grip of conscious control, the emphasis on the *discovery* of images rather than their creation, inevitably went with a serious devaluation of the artist's role as the active inventor of pictorial ideas, as the *composer* of compositions. Not only did the disturbing character of the marvellous in these Surrealist images constitute a rejection of the aesthetic purity aspired to by the Cubists, but the automatism that was

claimed to produce them constituted a rejection of the ultimate Cubist ideal of the artist-creator.

Raynal and 'La Peinture Surréaliste'

The fury with which Maurice Raynal reacted to 'La Peinture Surréaliste' at the galerie Pierre far exceeds that of his reaction to non-objective art at 'L'Art d'aujourd'hui'. Confronted with the work of Miró, Masson, Arp, Ernst, Man Ray, etc., and with the suggestive phrases of Breton's and Desnos's catalogue preface, he is brought close to incoherence by something too unpalatable to be tolerated.

His *L'Intransigeant* review opens with sarcastic comments on the solidarity of the new group, and then lets fly: 'The aim pursued: to make "something other" than painting. And this by describing by means of images our dreams and the pathological and unreal data which our sub-conscious can suggest... It... concerns little medical histories...'. For Raynal, Surrealism in painting is the way back to the very worst: to 'anecdote, evocation, description. One creates no more..., one suggests.' He is appalled by the Surrealists' fêting of Picasso: 'The "father of Cubism" has become the adopted son of the Surrealists who, no doubt, consider him, for the time being at least, "their [young] lad of a father".' And, since it has set aside 'all concerns of... the plastic', he can see no future for Surrealist painting. His writing pulsates with fury: 'Lovable nick-nacks, one-day fashions, blemished already by intoler-able... jargon, Surrealist paintings make one think... of all those products of amateurs and [nice] young ladies.'[61]

The phenomenon of Surrealism, even more than that of non-objective art, forced Raynal to take on all the characteristics of the conservative out to deflate a radical initiative. Such a

134. Joan Miró, *The Bottle of Wine*, 1924. Oil on canvas, 28¾ × 25⅝in. Fundació Joan Miró, Barcelona.

change of tone and role could not more clearly convey the change in Cubism's avant-garde status that came with the emergence of Surrealism. By the end of 1925 there was a vantage-point in Paris from which Cubism could appear just another species of reaction, and from the vantage-point of Cubism there was plainly in view something altogether more radical than itself.

6
The Cubists after 1924

In the months November and December 1925 'L'Art d'aujourd' hui' and 'La Peinture Surréaliste' immeasurably increased the visibility of the non-objective and the Surrealist painters as the real radicals, and hence hastened the relegation of Cubism to a more secondary avant-garde position. It is, however, impossible to chart this process of relegation precisely; there is no exact date when Cubism ceased to be perceived as the undisputed avant-garde leader. All that can be said is that the process began a little later than conventionally thought, in 1923–24, was well underway by the end of 1925 and had almost certainly run its course by the end of 1928.

This is not to suggest that Cubism's place in the foreground was lost altogether. The leading Cubists retained their sense of significance, and it was supported by those dealers and critics who had, since the war, championed them. Léonce Rosenberg's *Bulletin de l'Effort Moderne* continued to represent the Cubist position well beyond 1924, despite the welcome it extended to Van Doesburg, Mondrian and De Stijl.[1] And when, in 1927, Raynal published his survey and collection of brief monographic articles, the *Anthologie de la peinture en France de 1906 à nos jours*, he displayed no qualms over Cubism's position: for him it was one of the three major continuing tendencies in French art, Naturalism and what he called 'Eclecticism' being the others, and indisputably it was the most radical.[2] Then too, 1926 saw the appearance of a new periodical, *Cahiers d'Art*, beautifully produced and illustrated, whose editor Christian Zervos thought of it as avant-garde and yet which took a stance that fundamentally can only be called Cubist in its particular range of priorities centred on 'the plastic'.[3]

Yet, *Cahiers d'Art* reveals especially plainly the changed position of Cubism in Paris. The immaculate de luxe character of the publication itself makes the point, which is repeatedly underlined by the tone as well as the content of both Zervos's own writing and that of such contributors as Tériade and Cassou. Cubist art now is supported by a kind of writing that entirely lacks the vigour of polemic and that substitutes a blithe line in eulogy. The impression is that most of the serious arguments have been won, that there are no more really dangerous threats to be fought off, and that all Picasso, Braque, Gris, Léger and the others have stood for has come to stay. Writing of Braque in 1928, Cassou displays signs of awareness and regret in looking back to harder times. 'After so slow, so complete, so heroic a conquest', he writes, 'it was difficult [for Braque]...to find an excitement and enthusiasm again, to set up...new obstacles and new hostilities'.[4] Cassou sees the deep effect of Braque's success on the painter himself, the psychological change that went with it and the problems it raised in a milieu where the *élan* and tough-mindedness of the radical were so admired.

Cahiers d'Art does not, however, give the impression that by 1928 there were no threats to be resisted at all. More firmly, less hysterically perhaps than Raynal in 1925, Zervos developed serious criticisms of non-objective and above all Surrealist painting in recognition of their emergent significance. Reviewing Mondrian's first one-man show at the galerie Jeanne Bucher in 1928, once again Zervos takes that position (so common in the Cubist circle) which accepts the non-objective in an architectural context as a valid form of mural painting, but cannot accept it as a self-sufficient alternative in easel painting.[5] Once more absorption within the limited context of the mural neutralized the threat and little has to be said. Surrealism was a different matter, but Zervos went a step further than Raynal and here too was not merely dismissive but actually attempted to absorb its painters into a Cubist ambit. The distinctions, however, remained just as they had been for Raynal.

Following Max Ernst's exhibition at the galerie Van Leer in 1927, Zervos published a short note early in 1928 which stated bluntly his conviction that 'there is no Surrealist painting', and giving as his reason for this judgement that such painting was 'bereft of true pictorial qualities'.[6] An issue later Zervos expanded on this statement, unveiling a thoughtful and sophisticated understanding of Surrealism and setting out the terms according to which he could accept the work of Surrealist painters (though never of Surrealist painting as such). He could see no reason why the cultivation of dreams and 'automatic' revelation should have anything to do with art, and pointed tellingly to the technical problems (especially in painting) that stood in the way of such a thing. But most importantly he deplored the Surrealists' determination to render all questions of style and 'plastic' quality irrelevant: 'The pre-conceived elimination of the most essential pictorial elements in painting seems to me a chimera and a route to nothingness.' He completely dismissed the Surrealist illusionists like Magritte, but saw some hope for those closest to Picasso (whom he could not but admire), naming Ernst (the Ernst of *grattages* like *The Kiss* (Plate 135) shown in 1927). To them he addressed a plea, recognizing that 'around the Surrealist poets' there were painters who could play 'a certain role in young painting today', and imploring them to understand 'that if they wish to express themselves pictorially it is indispensable to take account of the plastic'. Zervos, thus, offers a

future to the Surrealist painters so long as they cease to be Surrealist and help stretch the scope of the Cubist stance to include (as Picasso had done already) an element of expression.[7]

Zervos and *Cahiers d'Art*, then, offer some evidence of how the avant-garde status of Cubism had changed by 1928: the facility with which the art of the leading Cubists could be celebrated, the awareness of a victory won, and the appreciation of the existence of new radical alternatives, here treated with the easy confidence of the well established. Yet, as already suggested, Cubism survived still, and indeed would survive beyond 1928, especially as a product for export to other avant-gardes (for instance, Britain and the United States).[8]

There can be no denying that after 1924 the movement in France lost its coherence and therefore identity, as well as its significance to the linear, progressive histories of twentieth-century art. It is the intention of this chapter to establish that, despite this, fresh developments of considerable interest can still be traced in Cubist art certainly until 1928.

Picasso

In January 1925 Picasso's dot-and-line drawings of the previous summer provided a double-page spread, as has been seen, for *La Révolution Surréaliste* (Plate 90). The July issue carried reproductions of five Picassos, including *The Three Dancers*

135. Max Ernst, *The Kiss*, 1927. Oil on canvas, 50⅜ × 63in. Peggy Guggenheim Collection, Venice; The Solomon R. Guggenheim Museum, New York.

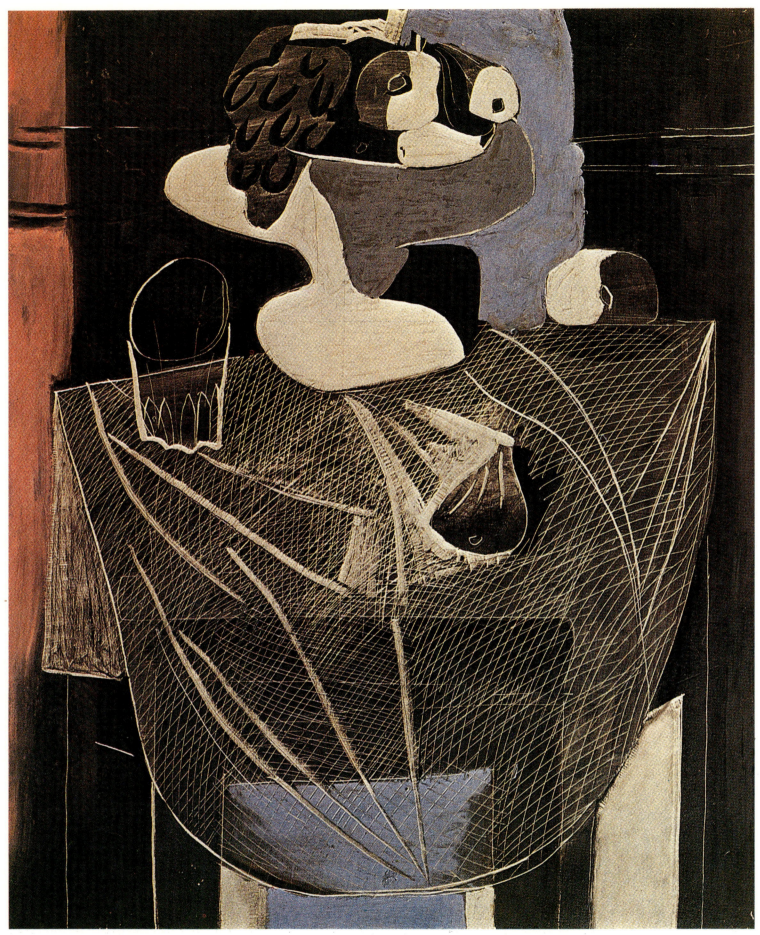

136. Pablo Picasso, *Still Life with Fishing-net*, 1925. Oil on canvas, 39½ × 32in. Sale: Sotheby & Co, London, 3 July 1977, lot 31.

(Plate 125), to go with the first of Breton's articles on 'Surrealism and Painting'. At this time Breton was intimately aware of developments in Picasso's work and Picasso was intimately aware of Surrealist developments. When the Spaniard returned to Juan-les-Pins for the summer of 1925, he could still produce paintings grounded in his Cubist style, and predictably much that was new about them came of his involvement with Surrealism. Where his Cubism still developed in 1925–26,

it seems to have done so because of a need to adapt certain Surrealist priorities to his Cubist practice: the Surrealist focus on subconscious drives and the discovery of 'marvellous' convergences, along with the Surrealist devotion to automatism.

Still Life with Fishing-net was painted that summer of 1925 and is obviously in essence a Cubist work (Plate 136). Picasso still plays the spatial games of 1924 and earlier, using the suggestion of an open window (the sky blue behind), the reverse

137. Pablo Picasso, *Studio with Plaster Head*, 1925. Oil on canvas, $38\frac{5}{8} \times 51\frac{5}{8}$in. Collection, The Museum of Modern Art, New York.

perspective of the table and the novel way it is revealed through the transparent envelope of the net; the elastic fruit-bowl could almost have been lifted off the tables of still lives from the year before.[9] But the rough informality of his technique is more than a superficial difference. The lines of the table, the mesh of the net with its falling folds, the glass, the apple and the pear placed upon it, all were scratched and gouged into thick paint while it was still wet. There is, thus, an accent on the gestural act of making signs. Such an accent is visible sometimes in Picasso's Cubism of the earlier twenties, but here it becomes particularly insistent.[10] The connection with the automatism of the mark so dominant in Surrealist painting during 1925 does not need to be laboured.

It was also at Juan-les-Pins in the summer of 1925 that Picasso painted the work most often presented as a meeting-place of Surrealist and Cubist preoccupations, *Studio with Plaster Head* (Plate 137).[11] Here the Surrealist connection is with the de Chiricoesque evocation of dream environments. The very approach to Cubist sign-making in *Still Life with Fishing-net* and *Studio with Plaster Head* echoes this fundamental difference of Surrealist reference. The signs in the former are flexible, rhyming and schematic, evidently open to metamorphosis; the signs in the latter are clear, almost devoid of rhyming and specific. Identities in the latter are fixed and there is no display of gesture; the enamel-like paint surfaces have been slowly, laboriously built up.

Spatial games-playing again remains crucial in *Studio with Plaster Head*, but Picasso's decision to place his son Paolo's toy theatre at the heart of the composition, so that the sky seen through the open window doubles as its backdrop, intro-

duces another level of confusion and adds a note of disquiet. Besides the relationship of inside and outside, the scale of everything is put in question, and the sheer compactness of the toy theatre's spaces within a tightly compressed structure of planes provokes claustrophobia. As has often been pointed out, this anxiety-inducing pictorial environment reflects the metaphysical de Chirico, and Picasso increases the capacity of the work to disturb by the sheer vitality he gives to the severed plaster arm and the head with its single staring eye. This is a Cubist representation, but what it represents is that kind of convergence of 'distant realities' called marvellous by Breton, and the setting of their convergence is one made more for dream than for Cubist paradox.

There was no important sequel to *Studio with Plaster Head*, but the following spring and summer of 1926 Picasso took further the simpler Cubism of the dot-and-line drawings (though not in drawing) and of the gesturally incised *Still Life with Fishing-net*. Back once more in Juan-les-Pins he painted perhaps his most suggestive still life to date, the large, casually worked *Musical Instruments on a Table* (Plate 138). It brought Cubism and the automatism of the mark still closer together. The wavering line is sometimes drawn with the brush in white over the rough brown ground, and sometimes incised into the paint while it is wet with a sharp pencil; pentimenti, left unconcealed, are everywhere. Picasso has made something with the look, superficially, of Miró's then current 'dream paintings' (Plate 139); he has actively encouraged, thus, the association with Surrealist automatism. His signs for fruit-bowl and stringed instruments had never been more organic, more stretchable, promoting a merger of still-life and figure ideas

which were Picassian of course, but Miró-like too. By making a Cubist picture with so Surrealist a presence, it is as if Picasso wanted to substantiate Breton's suggestion in 'Surrealism and Painting' that his Cubism and Surrealist painting were actually one and the same thing.

As suggested, the sequel to the dot-and-line drawings of 1924 was not another series of drawings; it was, in fact, a series of snappily assembled reliefs made in Paris in April and May 1926, combining string, buttons and tulle on cardboard. Several of these are tiny, like *Guitar* of May (Plate 140), but there are two that are larger and on canvas, the best known of which is another *Guitar* (Plate 141), where a dishcloth takes the place of tulle, and nails are hammered through from the back to menace the spectator. The simplicity of the signs, as in the drawings of 1924, heightens their flexibility of reference: all the small reliefs are guitars, but all can be read as figures too. There is a directness about drawing easily associated with automatism, and it seems likely that *La Revolution Surréaliste* published the dot-and-line drawings as instances of automatism.[12] Here in these reliefs Picasso does not approximate through drawing the look of automatic mark-making, he stresses the automatic by leaving overt the active role of the hand in their assemblage, and also the role of chance. He had used pinning as well as glueing in the early *papiers collés* of 1912–13, but the means of fixing were not

usually made much of.[13] Here they are. The strings that are the major forming elements in the small reliefs have literally been threaded through the cardboard, something instantly seen, and so they have in the larger *Guitar*, where the nails have obviously been hammered. The technically immaculate product, so much a feature of Picasso's Cubism of the early twenties, is a long way from this; Picasso has made contact once again with the scruffy, heterogeneous products of his first phase of *papier collés* and constructions before the war. Now in 1926 he seems to have realized not only that the act of assemblage was more visible the less immaculate the construction, but that the very scruffiness of his early constructions had brought out the potential of the unplanned accident to great effect. The dishcloth lies on the canvas in the larger *Guitar* just as it might have been found spread out on a drainingboard. The fact that it is left whole and unshaped, but for the circle cut out of the middle, enhances the impression of a 'find' nailed to the canvas. Further, not merely is *Guitar* unkempt, it is positively unpleasant too, aggressive (with its outward pointing nails) in a way that signals as never before in Picasso's Cubism a contempt for the very idea that the art-object should be harmlessly beautiful and no more.[14]

In 1925 and 1926, then, Picasso continued to produce a certain amount of essentially Cubist work which he developed in ways directed by new priorities that came out of Surrealism.

138. Pablo Picasso, *Musical Instruments on a Table*, 1926. Oil on canvas, 66⅛ × 80¾in. Galerie Beyeler, Basel.

His new priorities both took him away from Cubism into the hyper-expressive figurative mode introduced by *The Three Dancers* and *The Embrace (Mother and Child)*, and stimulated brief bouts of fresh Cubist exploration. Even between 1926 and 1929 he could still work occasionally in a Cubist way, but from the summer of 1926 the expressive possibilities opened up by his new figurative mode took over to an unprecedented degree, a change marked by the fact that he almost ceased to make still lives. His association with Cubism became tenuous indeed.

139. Joan Miró, *Painting*, 1925. Oil and gouache on canvas, $57\frac{1}{2} \times 44\frac{7}{8}$in. National Galleries of Scotland, Edinburgh.

140. Pablo Picasso, *Guitar*, May 1926. Construction in tulle and string with pencil on cardboard, $4\frac{1}{8} \times 4\frac{3}{4}$in. Musée Picasso, Paris.

141. Pablo Picasso, *Guitar*, 1926. Cloth, paper, string and nails on painted canvas, $38\frac{3}{8} \times 51\frac{1}{4}$in. Musée Picasso, Paris.

Léger and his Students

If Picasso's Cubism was redirected by his new Surrealist priorities, Léger's was to some extent redirected by his engagement with De Stijl and international non-objective art. However, the impact of international non-objective art on the main body of his work could be only limited, since as an easel painter (as distinct from a mural painter) he remained committed to the figure and the object. It was these that supplied 'the volume...the fullness of life' so essential to the vigour of his easel paintings. As in life, the flat coloured planes of the new non-objective art could provide only a setting: the spatial envelope, not its contents. Léger could never think of the non-objective mural without thinking of the people and objects in front of it; naturally, when he took it into his easel painting it was to set off their contrasting forms.

The end of 1924 had seen Léger develop a matter-of-fact kind of still-life painting, backed by the Purists' celebration of the 'type-object'; *The Syphon*, with its straightforward advertizer's image of a syphon, glass and pouring hand, is a case in point (Plate 94). During 1925 and through to 1928 he painted a number of large, sleekly finished Neo-Classical figure pieces as well as the few so-called murals, but his work

was dominated by the further development of this new object painting and it was within this that what Léger learned from Mondrian, De Stijl and international Constructivism was given its major role.

The propaganda of the Purists helped concentrate Léger's gaze on the 'manufactured object', but his decision to use it whole or in fragments with so little distortion, suspended in a Cubist picture space, was above all backed by another very different stimulus, a practical one. The crucial factor was the making of Léger's film *Ballet mécanique* in 1923–24. A version of the film was complete for showing at the Vienna theatre exhibition in September 1924; it was first shown in Paris that November, just before the completion of *The Syphon*.[15] Current research promises a reassessment of Léger's role in the making of *Ballet mécanique* and an increased recognition of the role played by his American collaborator Dudley Murphy, but whatever their respective contributions Léger's involvement in the project supplied an impetus of incalculable importance for his development as an easel painter.[16]

Léger's old friend Cendrars, the example of Abel Gance's film *La Roue* (in which he was involved in 1920–21), the film criticism of Jean Epstein and René Clair had together by 1925 encouraged an awareness of the power of the object or figurative fragment seen enlarged and detached from its usual frame of reference, on the cinema screen. But the making of *Ballet mécanique* allowed Léger to *see* what this could mean; the matter of factness of *The Syphon* was based on direct experience. *Ballet mécanique* was packed with visual incident, but the rhythmic cutting from image to image, the use of mirrors to complicate images, the heraldic presentation of objects isolated on a blank ground had relatively small effect on Léger's object paintings. There were two kinds of incident that provided more than any others their jumping-off point: first, the visual collision between the head (isolated and made impersonal by make-up) and angular panels with holes cut out of them which swing across slicing it into fragments; and then the simple contrast between orderly arrangements of objects and backgrounds of flat, crisply defined shapes (Plate 142). Along with what he learned from his non-objective mural painting, these two kinds of cinematic incident were the stimulus for a new kind of object painting.

There are two essential features that link *The Syphon* to the still-life painting that came before it (Plate 227): the preservation of a coherent sense of still-life grouping, and the placing of that still life on what can be read (just) as a table-top. Barely indicated, the table-top falls away at the base of the painting,

142. Still from the film *Ballet mécanique*, made by Fernand Léger with Dudley Murphy, 1923–24.

and is partly integrated (rather uncomfortably) with a mural-like arrangement of rectangles, but it remains a factor, supplying a pedestal for the glass and other objects to stand on (at least notionally). There are suggestions of a complete scene. In *Composition with Hand and Hats* of 1927 (Plate 160), one of the most ambitious of the new object paintings, neither an interior setting nor a coherent still-life group is suggested, and neither is a table on which the objects can stand. Except for the halved profile head and the dismembered hand, the objects are all whole, but there is no possible coherence in their arrangement (seen from an every day point of view), and their fragmentary effect is exacerbated by disruptive changes of scale: the huge head and biscuits, the tiny hand and hats. As in *Ballet mécanique*, an impersonal profile emerges from behind sharp-edged planes, and objects seem to hang in front of an architecture of flat shapes. The architecture, however, has changed: even more obviously than in the background of *The Syphon*, it is the pictorial architecture of the non-objective murals: it has the same breadth, undecorated simplicity and *gravitas*.

The experience of *Ballet mécanique* led first of all (in *The Syphon*) to Léger's decision to use the figurative fragment and the object, simply represented and heavily modelled, without excessive distortion. Then, in 1925 and especially in 1926 and 1927, it led him to explode the habitual coherence of the Cubist still-life subject, scattering its components. What the murals provided was a firm pictorial architecture against which and in which this dispersal of objects could be set.

It might seem at first that a work like *Hand and Hats* stands clearly outside Cubism. The way so much is represented is, after all, straightforward to the point of naïvety, more even, at times, than in *The Syphon*, and the architecture of coloured planes refers so clearly to De Stijl. But Léger's belief in the self-sufficiency of easel painting as a rival to modern life remained unchecked, and so did his consequent stress on 'plastic' contrasts. Both in *Ballet mécanique* and here he used the object and figurative fragments for their 'plastic' potential: they are contrasting 'elements' (in the Reverdian sense) playing their part in a pictorial whole.[17] At the same time, the architecture of coloured planes around them is only superficially De Stijl-like, for the way these rectangles suggest often ambiguous spatial relationships by their highly contrived overlappings has more to do with the *papier-collé* space of late Cubism than with the Neo-Plasticism of Mondrian or Van Doesburg. The late Cubist love of perspectival intrusions has gone (there are no more open windows), but not the Cubist delight in suggesting a space full of beguiling paradoxes by means of nothing but flat shapes on a flat surface. Further, that Léger's priorities were still pictorial is clearly signified in the way that he combines very different kinds of representation; consistency is irrelevant, as well as everyday relationships. The hand, head and hats are accompanied by a typewriter rendered in a distinctly schematic manner: an obviously synthesized combination of bars, planes and circles in rows (the keys).

Alongside the object paintings, Léger produced in 1925 and early 1926 a number of large-scale compositions where objects were exclusively synthesized. One of these was *Composition* of 1925 (Plate 143), the most ambitious of a group of at least three closely related canvases which take the motif either of an angle-poise lamp or some other mechanical apparatus.[18] So schematic was Léger's use of signs in these exclusively synthetic pictures, and so thoroughly at times did he bind together subject and setting, that the superficial impression given is of almost complete abstraction or even, as here, of non-objectivity.[19] Indeed, with *Composition*, knowingly it seems, Léger actually captures the look of international

Constructivism, specifically the post-Suprematist *prouns* of Lissitzky and the Bauhaus paintings of Moholy-Nagy (Moholy showed at 'L'Art d'aujourd'hui'). The circles bobbing in an 'infinite' space, and the slanting bars, like an aerial view of roads for high speed cars, are obviously akin.[20] If Picasso's *Studio with Plaster Head* and *Musical Instruments on a Table* (Plates 137 and 138) are the works where late Cubism and Surrealist painting come closest to fusion, this picture and its relatives are where late Cubism and international non-objective painting do so. It is ironic that simultaneously they emphasize so plainly Léger's continuing late Cubist priorities: his readiness to conceal straightforward modes of representation if his pictorial aims led him to.

'Let us go to the Temple district on the outskirts [of the city]; here you enter the realm of shoes and ties... Jack, from New York, rue de Belleville, will seduce you with his poetry of caps.'[21] This is Léger in 1928 on the profusion of objects that fill the shop-windows of working-class Paris. It is another, deeper irony that such a focus on the 'poetry' of the banal finds echoes in the writings of the Surrealists (one thinks especially of Louis Aragon's *Le Paysan de Paris*), and that the unexpected conjunctions of hats and spoons or vases and typewriters that came with the fragmentation of the more matter-of-fact object paintings strangely parallel the 'marvellous' convergences of 'distant realities' so important to Breton and his friends.[22] For the fact is that Léger could not have been further from the Surrealists. He might have developed a deep sympathy for international Constructivism especially through De Stijl, but such a sympathy for Surrealism was simply out of his reach. For him in 1928 the object remained an 'element' that was made to function on a picture surface with purely pictorial elements (non-objective shapes) out of a sense of competition with modern life and an undiminished belief in

143. Fernand Léger, *Composition*, 1925. Oil on canvas, $51\frac{1}{4} \times 38\frac{1}{4}$ in. Collection, The Solomon R. Guggenheim Museum, New York.

the significance of art. The object, he said, belonged 'to the realm of pure plasticity...'.[23]

The status of Cubism at the head of the Parisian avant-garde might increasingly have been questioned between 1924 and 1928, but, because of the successful way they bridged the gap between Cubism and Surrealism on the one hand and Cubism and non-objective art on the other, Picasso and Léger retained their position as leaders, even for the emergent generation. In Léger's case the afternoon teaching he took on in 1924 at the Académie Moderne gave him a particularly effective purchase on the minds of a number of younger artists, most of whom, as we have seen, came from abroad and had experience of Constructivist developments in Germany. Certainly a couple of these students are worth attention here, because in their own ways they made significant contributions as modern-life Cubists encouraged by Léger's example. Critics sympathetic to Cubism, like Raynal, were slow to praise most of Léger's Académie Moderne students, but one who was invariably picked out was the Norwegian, Otto Carlsund. The young Dane Franciska Clausen was not so fortunate, but she produced work which was just as resolved and just as distinctive.

Carlsund arrived in Paris in 1924 and very soon was enrolled with Léger at the Académie Moderne.[24] He showed two 'murals' at 'L'Art d'aujourd'hui' and from 1927 to 1928 moved into an exclusively non-objective kind of work, but in 1925–26 he produced paintings with mechanical element references or subjects that are comparable with certain of Léger's more synthesized pictures of the time. A major instance is *The First Machine (Red Machine)* of 1926 (Plate 144).

Carlsund worked with arrangements of absolutely flat coloured shapes without the intrusion of volumes, let alone recognizable objects.[25] Yet, the way here he pulls together into a tight cluster an orderly vocabulary of bars, strips and planes reminiscent of Léger's murals and a few machine references obviously relates to the work of his teacher, and so does the precision of finish. The sharp colour contrasts and the way the over-lappings shunt shapes backwards and forwards generate a jerky vitality, while everything is gripped in a strictly ordered asymmetry. And once again entirely in tune with Léger, there is a keen tension between dissonance and stability of structure.

Franciska Clausen had studied in Berlin with Moholy-Nagy. In 1923 she had also attended Archipenko's classes there, and she arrived, therefore, with a more complete avant-garde apprenticeship behind her than Carlsund.[26] She too responded not so much to Léger's emerging object paintings as to his murals and especially to the machine elements of 1924 (Plate 230) alongside the most synthesized works of 1925–26. That overt stress on precise workmanship and impersonal finish is there again in a picture like *Composition with Piping* of 1926 (Plate 145), and so is that merger of non-objective and mechanistic elements found in Carlsund, but Clausen's painting is distinct enough from Léger's.[27] Tonal modelling finds a role in *Composition with Piping* and so even does the carefully depicted object (the ribbed turn-screw seen in profile and the curved piping). But Clausen does not allow modelling so fully in the round that complete volumes are suggested in the manner of Léger; she sets shining surfaces that gently swell into three dimensions against the flat, rectangular areas of grey and mustard. The result is less disruptive than in Léger's object paintings, but nonetheless vigorous.

Only a brief look at the work of Carlsund and Clausen is possible here, but it is enough to establish that Léger was not the sole artist to produce new developments in modern-life Cubism between 1924 and 1928. However dominant a leader he was, distinctive work emerged from at least these two of the young students he taught, work that can still be understood

144. Otto Carlsund, *The First Machine (Red Machine)*, 1926. Oil and ripolin on wood, $49\frac{1}{4} \times 22\frac{3}{4}$in. Private Collection, Stockholm.

145. Franciska Clausen, *Composition with Piping*, 1926. Oil on canvas, $51\frac{1}{4} \times 37\frac{1}{2}$in. Private Collection, France.

146. Gerald Murphy, *The Razor*, 1924. Oil on canvas. The Dallas Museum of Art. Gift of Mr Gerald Murphy.

as essentially Cubist. It is surprising that Léger's most striking innovation of the period, his new kind of object painting, should have had so little effect on his circle of students. It is worth recording, however, before moving outside his ambit, that certainly the work of two artists relates positively to that development, and both made contributions of their own. One was Jean Metzinger (in 1925–27),[28] the other was an American in France, Gerald Murphy (especially in 1925–26). Murphy's production was very limited, but in his case, in fact, so independent was his contribution that he can be seen actually to have anticipated Léger with the surprising fusion of late Cubist structure and the matter-of-fact, achieved in a canvas like *The Razor* (Plate 146).[29]

Braque

Picasso, Léger and a few of those who were attracted by the tough vigour of Léger's alternative significantly extended Cubism after 1924; those who before 1924 had stood out as especially uncompromising and capable of adding something, added little. Gleizes and Villon produced more pictures in the styles at which they had arrived by the early twenties.

Valmier moved into a more legible use of Cubist signs, producing slick, often witty figure paintings and still lives in 1925–26.[30] With the break-up of the Purist enterprise, Ozenfant and Jeanneret, as painters, retreated from the foreground. Unexpectedly perhaps, the other Cubists who most demand consideration here alongside Picasso and Léger are those who had compromised before 1925.

It might seem that the most predictable scenario for the further development of these artists would be retreat into still more ingratiating sensuality and still more the look of Naturalism. In fact, this is not what happened in the work either of Braque, Lipchitz or Gris. These three retained their bent towards the visually seductive, but not one of them took a step closer to Naturalism. They could not, like Picasso and Léger, identify enough with the new radical alternatives to sustain positions in the forefront of the avant-garde, but they each made important contributions as still-developing Cubists. It was they (above all Gris) who remained the most loyal to Cubist means and ends, and it was in their work that Cubism in its late distilled form remained most quintessentially alive.

As we have seen, sensitivity, taste and a sense of continuity with the past had been features of Braque criticism since at least 1920; they are features too of a couple of eulogistic articles which appeared in *Cahiers d'Art* at the beginning and end of 1928, the earlier by Cassou, the later by Tériade.[31] Along with eloquent support for Braque's special compromise between 'tradition' and the modern, the single thread through these articles is the idea that Braque's development is characterized not by rupture but by a smooth and unbroken continuity. Cassou wrote of how 'the work of Braque is extended and enriched';[32] Tériade wrote of a 'flowering'.[33] Indeed, Tériade's article opened beneath a reproduction of one of Braque's earliest Cubist still lives, which was included in company with three of his most recently finished canvases in a carefully arranged shot of pictures in his studio (Plate 147). Both for Tériade and Braque there was a visible continuity even between works as far apart in time as 1908 and 1928.

Certainly there was an unbroken continuity in Braque's painting between 1924 and 1928, as there had been since 1922. He went on producing both Cubist still lives and classical figure paintings (one of the grandest sequels to the *Canéphores*, the *Large Nude* in the Washington National Gallery, was painted in 1925), but it is more revealing of his capacity to keep up the impetus for development without fundamentally changing his priorities to look at what was a type of painting that he attempted only from 1924, the small flower piece. In 1925, 1926 and 1927 he produced a suite of these, to join the small, usually horizontal still lives aimed at his less wealthy clientele for a place above the villa or apartment mantelpiece. They had few Cubist precedents of any kind, and the reason was simple. Like the nude, they demanded great concessions to the informality of the organic, and, even more than the nude, to the brilliance or subtlety of natural colour. As with the *Canéphores*, Braque's success in keeping his priorities as

147. Georges Braque's studio as shown in *Cahiers d'Art*, 1928. Reading from left to right, above: *The Table*, 1928, collection Mr and Mrs Daniel Saidenberg, New York; *The Large Table*, 1929, National Gallery of Art, Washington, D.C.; *The Pedestal Table*, 1928, Statens Museum for Kunst, Copenhagen. Below: *Still life with Musical Instruments*, 1908. Private Collection, Paris.

a 'pure Cubist' intact while developing a loose, organic formal vocabulary and a taste for chromatic richness allowed him to accept the challenge with relish.

Anemones and Two Lemons of 1925 was one of the first of these flower pieces (Plate 148). Yet, with enormous sophistication and subtlety Braque has resolved most of the problems. The massing of the flowers and the definition of the lemons give them the effect of physical substance; they are placed solidly on a table in front of a bare wall. The flowers and their foliage are naturally formed and tinted in white, red and pink, the lemons are naturally formed and lemon yellow. The space is darkly atmospheric, the things in it palpable. But these powerful impressions of appearance recorded are, as ever, denied by Braque's handling of surface. The dark ground is a pervasive presence across the entire canvas. Every shape and area of brushed colour is felt instantly as a mark or group of marks made on it, and especially effective is the way this operates in relating the flowers to the background wall. The flowers are set as a bunch of coloured scrumblings on and in a surround provided, like an embracing shadow, by the dark ground, while the brown of the wall is airily brushed over that ground. The result is that the brown of the wall is felt right up on the picture surface and the flowers are, as it were, sunk into a hole behind it: a Cubist reversal of a kind that Braque had long made his own. Once more, the arbitrary scattering of sand across the surface has enhanced the overall flat materiality of the work.

Between 1925 and 1927 Braque's painting was consistently characterized by an apparent naturalness challenged by this

148. Georges Braque, *Anemones and Two Lemons*, 1925. Oil and sand on canvas, 19⅝ × 24in. Sale: Sotheby & Co, London, 3 July 1979, lot 47.

always pervasive stress on the surface. In 1928 he began to move away from the natural again, but he did not break the continuity of his development thereby. Both the direction of the move and its continuous relationship with Braque's past come over most clearly in a particular group of canvases largely painted in 1928. This group takes up once more the theme of the pedestal-table still life; there could be no more obvious declaration of Braque's commitment to continuity than his decision to do so. Two of them, pointedly, bracket the *Musical Instruments* of 1908 in the photograph reproduced in *Cahiers d'Art* mentioned above (Plate 147), but perhaps the most remarkable is *The Round Table* in the Phillips Collection, which, though dated 1929, was finished, except for a very few touches, by the end of the previous year (Plate 149).

The placing of the table on a parquet floor, the way the combination of that upward-tilting floor and the pedestal itself, seen as if head-on, enhances the forward thrust of the objects on the table-top, the use of colour notes to connect background and foreground, in all these features the earlier *Pedestal Table* series is recalled (Plate 54); and the fruit are the squashy, appetizing, naturalistic fruit of the more recent ones from 1924–25 (Plate 96). But Braque has made important changes. The dark ground has gone, and instead of using it in alliance with techniques of scumbling and airy brushing to accentuate flatness, he has turned once more to a structure of interlocking angular planes and to bright colour areas set in light surroundings. Most novel of all, however, is his shaping of the guitar and the bottle, for here he reveals himself aware of recent developments around him and ready to respond. These are not at all naturalistic; they are freely synthesized. And the organic elasticity of their forming leaves little doubt that Braque has taken his cue from the stretchable or squashable objects of Picasso's earlier still-life paintings. The elements of the apparent compromise between Cubism and Naturalism that had dominated his paintings for at least six years are still present, but so are the signs of a willingness to move on from it.

Braque did move on after 1928. It should be emphasized, however, that he did so without almost ever taking the expressive potential of Picassian distortion far enough for his work to be dissociated from Cubism.

Lipchitz

Lipchitz was the one Cubist other than Picasso and Léger to make a significant innovative break away in a new direction after 1924; and he was perceived by sympathetic critics as an innovator at the time. Both Waldemar George and André Salmon recorded the move and its importance in *L'Amour de l'Art* and *Cahier d'Art* almost at once.[34] Yet, Lipchitz's move was not seen as in any sense a break away from Cubism (at least at first), and it had nothing to do with the novelties of Surrealism or non-objective art: it constituted a fresh extension of Cubism in sculpture.

By 1924, as has been seen, Lipchitz had begun to approach a level of success at least comparable with Braque's, his commission from Dr Alfred Barnes being the crucial opening he had needed. Continuing success went with a renewed commitment to experiment, both as a reaction against his work for Barnes and in order to take further possibilities developed by it.[35] He reacted against the enclosed frontality of the reliefs he had produced in 1923 and 1924 for Barnes's gallery-cum-mansion, and developed the soft curvaciousness of form exploited especially in the clay sketches for those reliefs (Plate 106).

Initially, the breakthrough he achieved by way of reaction prevented him from further satisfying his appetite for the curvy, because it went with a return to the planar vocabulary of crystal Cubism at its most ordered. As so often with breakthroughs, a look back triggered a sudden switch of direction. According to his own recollections, Lipchitz saw his way in a moment, with a single sculptural idea arrived at while daydreaming in an incomprehensible lecture at the Sorbonne.[36] The idea, first put together at speed in cardboard, became the tiny *Pierrot* of 1925 (Plate 150); it was followed, in 1926, by such small bronzes as *Pierrot with Clarinet* (Plate 151). Deborah Stott was the first to point out the stimulus from the past that triggered these pieces: it was the crisply constructed figures of Picasso's *Three Musicians* (Plate 89) with their clear sense of three-dimensional structure.[37] Since this clarity of structure

149. Georges Braque, *The Round Table*, 1928–9. Oil on canvas, 57¾ × 45in. The Phillips Collection, Washington, D.C.

in Picasso's Cubism of 1921 had been founded on his own private experiments actually in three dimensions, the tiny cardboard constructions of 1919 (Plate 18), it could not have been more apt as a trigger for the earliest of Lipchitz's so-called 'transparencies'.

The special qualities of these new opened-up bronzes follow as much, however, from the fact that they came in reaction to the prior dominance of relief in Lipchitz's work for Barnes as from the fact that their spring-board was Picasso's *Three Musicians* style. That initial idea, *Pierrot*, gave the essentials

150. Jacques Lipchitz, *Pierrot*, 1925. Bronze, height 5in. Marlborough Gallery, London/New York.

151. (left) Jacques Lipchitz, *Pierrot with Clarinet*, 1926. Bronze, height 10¼in. Whereabouts unknown.

152. Jacques Lipchitz, *Woman with a Guitar*, 1927. Bronze, height 10¼in. Whereabouts unknown.

of an entire development, just as *Demountable Figure* had a decade earlier (Plate 44); and in a sense it was the obverse of the earlier piece. For where *Demountable Figure* is based on the interlocking of flat planes set at right angles, with a clear central axis at its core, this piece is based on the setting of planes one in front of another, and holes are cut into them to reveal an inner space so that an empty void replaces the central axis at its core. It is as if, impelled to open the way to a spacious, fully three-dimensional sculpture again, Lipchitz had taken the flat plane that is the notional back plane of the Barnes reliefs (and all reliefs), pulled it apart as if it were laminated to form separate layers in space and then punched

153. Jacques Lipchitz, *Pierrot Escapes*, 1927. Bronze, height 18¼in. Kunsthaus, Zurich.

holes right through it. Significantly, the lozenge of the foremost plane in *Pierrot* loosely quotes the formats of certain Barnes reliefs. The result was a kind of sculpture which had no precedent (at least in France): a figure sculpture whose core was air. The repercussions of Lipchitz's move are still being experienced in Modernist sculpture today.

Pierrot and *Pierrot with Clarinet* are planar; it was when Lipchitz transposed the discoveries he had made through such pieces into a freer linear mode that he was able to give this new opened-up sculpture something of the sensuality in which he now delighted. It was a simple step to allow the bronze bars and bent strips that act as adjuncts to the planes in the earlier pieces to take over and create a free, curvilinear drawing in space. He took the step in 1926, but produced his most successful bronzes in this manner in 1927–28, for instance *Woman and Guitar* (Plate 152). That taste for pliable curvaciousness brought out by the Coco Chanel commissions was now given an even freer release, and, though embracing voids, Lipchitz's swinging, wriggling bronze strips and bars define volumes that can imaginatively be endowed with substance, a substance which is both soft and corporeal. Once again such pieces as this obviously relate to Picasso's work as a painter, this time to the elastic organic forms of his expressive Cubist painting of the mid-twenties (Plates 91 and 138), but, as an innovator in sculpture at least, Lipchitz anticipated the Spaniard with them and provided a trigger for him in his turn.[38]

The transparencies were not the sole fresh development in Lipchitz's sculpture between 1924 and 1927; they deserve emphasis here because they were the most striking and influential. What was common to all these developments was that they went with a marked exaggeration of the expressive, which anticipated a shift in 1928–29 into mythological and sexual themes. Before 1928 his innovations can only be understood as a late extension of the infinitely flexible but essentially 'pure' Cubism of the post-war period; after 1928 this is not

so. Towards the end of his life Lipchitz brought out two very general aspects of this final move away from Cubism: his rejection of the compositional restrictions of Cubist practice, and his decision to make 'content' a primary factor. In this connection he gave one specific transparency special significance. Formally it is one of the least interesting: it is *Pierrot Escapes* of 1927 (Plate 153). 'Pierrot', he said, 'is myself escaping from the iron rule of syntactical Cubist discipline, from all the taboos, regulations, and restrictions...to become a free man.'[39] The image of the prison had general currency in relation to Cubism from the vantage-point of its adversaries. Having achieved a major new development for sculpture within Cubism, it is remarkable how fast Lipchitz changed sides, how quickly he too persuaded himself that the prison image fitted, and 'broke out'.

Gris

Picasso, Léger and Lipchitz were all artists who innovated as Cubists between 1924 and 1928; they were also escapers. All three to some extent, Picasso most obviously, broke away from the limits of Cubism in its late distilled form. There were others besides Braque who neither made striking new innovations as Cubists nor broke out, but instead took further already established means and practices. Marcoussis was one and so was Laurens who remained close to Braque;[40] but the Cubist, other than Braque, who more than any maintained the continuity of post-1918 Cubism in its 'pure' state was Juan Gris.

Between October 1925 and 1927 Gris's health declined in two devastating periods of crisis, first from October 1925 to the spring of 1926, and then from October 1926. May 1927 brought his death.[41] During these phases of crisis there is no doubt that the constant worry, pain and fatigue now weakened his work; but during much of 1925 and the spring and summer of 1926 his condition was good enough to allow a real intensity of commitment again. His painting seems to have supplied a kind of reassurance through its continuing vigour. What he produced has a serenity that is thoroughly insulated against anxiety, and its undiminished variety, even within a limited range of subjects, is the measure of his determination to maintain his energy as an artist. That his work so effectively stands for continuity is, then, a direct reflection of his desperate fight against illness, but, even still, it constitutes a final demonstration that Cubist art *could* survive. What it cannot conceal is the gradual demise of Cubism as an avant-garde movement with a clear, strong identity. There is a bizarre and appropriate symmetry in the fact that 1927 brought both Lipchitz's *Pierrot Escapes* and Gris's death.

Like Léger and Braque, Gris continued to paint figure pieces, and it was most of all in these that the compromise between Cubism and the look of an ingratiatingly sensual Naturalism remained present in his work. Certainly the compromise reached in *Young Girl* at the end of 1922 (Plate 98) has not been superseded in *Woman with a Basket* (Plate 154), which Cooper dates between February and April 1927, probably the last ambitious painting of Gris's life.[42] Between 1925 and 1927, in his still-life painting, Gris went much further than he was willing to here: he renounced the look of Naturalism almost entirely and became once again a synthetic Cubist who made no attempt to cushion the effect of his anti-Naturalism. As such, not only did he preserve the continuity of his effort, but at the same time he asserted more plainly than ever the Reverdian purity of his Cubism. Through the first six months of 1925 Gris went on as before producing still lives in which he reached a comfortable accommodation with Naturalism,[43]

but by the end of the year his move back to an uncompromising synthetic Cubism, at least in still-life painting, was complete. If Cooper's dating of *The Blue Cloth* to 'June–August 1925' is correct, it is one of the first pictures of the year where this is so (Plate 214); and if he is right to date *The Painter's Window* 'September–November 1925', it was made when the move was already well underway (Plate 161).[44]

There was no return to the dryness and coolness of crystal Cubism; the appeal to the senses made by the paintings of 1922–24 was sustained. Gris still controlled colour by balancing warm against cool hues, and still used tonal contrasts to suggest the fall of light, but as a colourist he nudged the naturalistic increasingly rarely. *The Blue Cloth* is built around the simple contrast between the sumptuous blues of the cloth, and the browns everywhere else dominant; the whole is set, unnaturalistically, against a black back plane. *The Painter's Window* takes up once more the challenge of the open window, and, once more, is built around the simple contrast between a cool, airy outdoors and a warm, shady indoors. There is, of course, a generalized chromatic relationship with nature, but no more than in the Bandol open-window pictures of 1921 (Plate 108). The blobs of unmixed colour glowing on the dark palette are left there like a token of the painter's faith that his colour can rival the colours of nature on his own terms. Both pictures exhibit the signs of an evident pleasure taken in the varied working of surfaces, and, like Braque, Gris uses an accented texturing to heighten awareness of colour as pigment and medium applied to the flat expanse of the canvas. There is no sand sprinkled into the paint, but where one area (say, the beige of the guitar in *The Painter's Window*) may be immaculately smooth, another (say, the silvery grey of the fruit-bowl here) is painted with a free scuffling and swirling of the brush, and sometimes (in the sky and the fruit-bowl) a lighter ground is allowed to breathe through.

154. Juan Gris, *Woman with a Basket*, 1927. Oil on canvas, $36\frac{1}{4} \times 28\frac{3}{4}$in. Musée d'Art Moderne, Centre Georges Pompidou, Paris.

Yet, it is in the forming and grouping of the objects of these still lives that the artist as pictorial inventor makes himself most conspicuous, and indeed Gris's self-imposed role, turning simple shapes into signs for guitars or fruit-bowls, is more conspicuous in these compositions than in the most elaborately rhyming pictures of 1918—22. They make a contrasting pair: the objects of *The Blue Cloth* pulled together in a cluster of curves, an elastic cellular structure; those of *The Painter's Window* in a jig-saw of sharp interlocking pieces, a tight crystalline structure. In both everything is subordinate to the formal order thus imposed, something perhaps clearest in *The Painter's Window* where the angularity of the forming is least natural. It is not simply that everything rhymes with everything else and so is visibly interchangeable, it is that objects are interdependant in their interlockings to such a degree that they cannot be imagined outside this particular structure. Lipchitz had anticipated this degree of fusion between synthesized objects in certain of his reliefs for Barnes (Plate 106), but here Gris takes it to an extreme. It became the central compositional principle for his still-life painting until his death. The reason for its appeal to him is obvious: it signified in the most telling way he had yet found the continuing synthetic purity of his work. It made plain the fact that his inventions could exist only in a separate order of pictorial relationships, and it did so with a simplicity and directness he had not equalled before.

The Painter's Window is centred on an item which had never appeared in Gris's Cubist still lives before 1925: the palette. It is one of a group of pictures made in 1925—26 that dwell on this habitual accessory of the artist: the ubiquitous stage property of so many painter's self-portraits. As a still-life item it does not approach in frequency of use the fruit-bowls, musical instruments and drinking vessels of Gris's established repertoire. Yet, there is perhaps significance in the fact that Gris was drawn to this the most accepted attribute of the painter as he reasserted his commitment to 'pure Cubism', for it is as if by giving it prominence he could assert still more directly the central, determining role of the artist, his conviction that he, the painter, was the initiator.

In the year of Gris's death Maurice Raynal included in his *Anthologie de la peinture en France* the Spaniard's last published statement. It ended: 'Today, at the age of forty, I believe I am approaching a new period of self-expression, of pictorial expression, of picture-language; a well-thought-out and well-blended unity. In short, the synthetic period has followed the analytical one.'[45] Gris's use of the term 'expression' is evidently limited; he does not use the term Cubism at all, but nonetheless it is clear that he still saw himself as a synthetic Cubist, a pure Cubist in the fullest sense, and that, in the last months of his life, he still saw a future for his highly distilled sort of Cubism. He speaks as if something has only just begun.

II
Art Worlds

7
The Legitimization of Revolt

It was at least as early as the twenties that the modern history of French art in the late nineteenth and the early twentieth centuries acquired the potency of myth. The decade after the Armistice in 1918 saw few writers pause and reflect long enough to draw out a clear, all-embracing shape for the history of the preceding quarter century, but those who did made the mould for most who have tried afterwards. One of them was the poet-critic André Salmon.

As a member of the 'Picasso band' from before the painting of *Les Demoiselles d'Avignon* in 1907, as Montparnasse bohemian socialite of the 1910s and 1920s, Salmon was ideally qualified for myth-making, and in a small way (by anecdote and suggestive aside) he had started before the war.[1] In 1920 he published a book about contemporary French art and its recent history with the title *L'Art Vivant*, and here and periodically in the pages of the journal *La Revue de France* he sketched the outlines of a larger myth: the shape of an ideal history which was immensely attractive. The idea of progress gave dynamism to that shape, though Salmon rarely uses the term; its model was evolutionary.

As he saw it, 'each epoch had its destiny', which was realized on the one hand by those who tried to perfect the received ideas of their seniors; and on the other by those who needed to discover new values. His history took in only the 'searchers', and, as he sums it up in 1921 in *La Revue de France*, it was a history of successive generations and their discoveries. Its beginnings lay with 'the direct inheritors of Impressionism', Bonnard, Vuillard, Vallotton, whose achievement was to put 'colour above drawing', and to realize the potential of that 'clear colour got from the Impressionists, enemies of the bitumens...the famous "fogs" ("embus"), sovereign up to Courbet'. It continued with the 'unknowns of 1900'—Matisse, Rouault, Friesz, Derain, Vlaminck—who invented Fauvism, a movement which gave even greater importance to colour. And finally it came to a head in the reaction that inevitably followed these excesses with the generation of '1906 or thereabouts'. According to Salmon the inspiration for this generation was Cézanne and the rehabilitated El Greco, alongside a revived interest in Chardin, David and Ingres. It had led at once to a turning-back in the direction of the French past on the part of artists like Emile-Othon Friesz and André Derain, and to the invention of Cubism: a rejection of colour in favour of form, and a rejection of direct impressions in favour of the shaping power of the artist's intelligence. With its underlying theme, the progressive assertion of art's autonomy from the imitation of nature, the shape drawn by Salmon was certainly clear and compelling.[2]

It has been, of course, this dynamic linear image of French (and all Western) art history that has led to the fragmentation of our image of the whole, for it has led to the extraction and seperate historical treatment of each of the movements and generations mentioned by Salmon. Yet, within the frame whose boundaries are those of France and of the period between 1906 and 1928, the character and history of art is far better seen not as a corridor for the movement of separate linear strands parallel with one another, but as a frame for a complex, interwoven fabric whose strands move in conflicting directions to form a tight mesh. And moreover Salmon's simple picture excludes many of the strands that gave completeness to that fabric. Part I of this book, as the introduction warned, might seem to sustain the ideal vision that a writer like Salmon established, for it is indeed a narrative which tells the story of a movement initiated and sustained by one generation against the growing challenges of the new, post-1918 generations, and its structure is both chronological and progressive. The aim here and in the later parts of the book is to tie the Cubism of the 1910s and the 1920s back into the

complex fabric of which it was only a part, and to do so not within a chronological but within a thematic structure. Ultimately the emphasis will be on attitudes and meanings rather than on stylistic distinctions between conflicting strands, but to begin with it is necessary to sketch the situation in terms of stylistic oppositions as they were perceived at the time by those committed, like Salmon, to the new art, and then, much more importantly, to sketch a picture of the art world or worlds within which these stylistic alternatives competed for attention. These are the two objectives of this section, 'Art Worlds'.

* * *

There were as few attempts at comprehensive surveys of the current art scene in the decade after 1918 as at comprehensive histories. From a Modernist stand-point perhaps the most revealing was published in 1927; it is Maurice Raynal's *Anthologie de la peinture en France de 1906 à nos jours*, which combines a typically idealized history with such a survey. This, alongside the comments on the situation made in passing by a couple of artists, provides a contemporary starting-point for grasping the sheer range of styles and attendant attitudes current in Paris during and after the Great War.

Moved to anger by plans to reorganize the hanging of the Salon des Indépendants alphabetically rather than according to 'tendencies', Fernand Léger wrote an open letter to the newspaper *Paris-Journal* in 1921. He advocated hanging by tendencies, and he supported his opinion by setting out what for him were the major tendencies in French art. He identified only 'three groups at the Indépendants: the sub-Impressionists, the Cubists and the Sunday painters'.[3] All who were not Cubists, from Henri Matisse to André Lhote, he simply dismissed as 'sub-Impressionists'. There was a certain brute truth in Léger's distinction, since those who were not Cubists would have agreed that their art sprang from the direct experience of nature in some way or another, but such an undifferentiated approach to all that Léger considered non-Cubist could not have satisfied Lhote, and this is clear when Lhote writes in response to another crisis concerning the Indépendants, the decision in 1924 to hang contributions by nationalities. Lhote, like Léger, wanted at once to avoid nationalistic divisions and to return to the clear presentation of tendencies, and he set out four of these rather than Léger's three: '1. academicism; 2. impressionism; 3. constructive naturalism; 4. cubism'.[4] What Lhote meant by 'academicism'

is not clear, and for the moment not relevant. What he meant by Impressionism is clear from his earlier writings in *La Nouvelle Revue Française*:[5] the still-living and working Claude Monet, of course, but also such 'inheritors of Impressionism' as Matisse, Bonnard and their followers (artists concerned with the direct transmission of sensations from nature) (Plates

156. Pierre Bonnard, *The Open Window*, *c.*1921. Oil on canvas, 46½ × 38in. The Phillips Collection, Washington, D.C.

157. Dunoyer de Segonzac, *Drinkers*, 1910. Oil on canvas, 77 × 51¼in. Musée National d'Art Moderne, Centre Georges Pompidou, Paris.

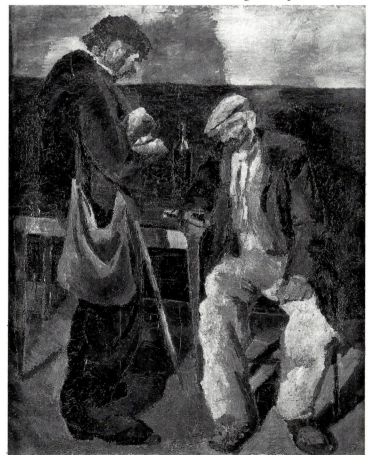

155. Henri Matisse, *Etretat*, 1920–21. Oil on canvas, 21¾ × 25⅝in. Fitzwilliam Museum, Cambridge. A.J. Hugh-Smith Collection.

155 and 156). Constructive Naturalism was, for him, something distinctly different, because it entailed an emphasis on picture-building, on composition, which required the intellectual transformation of nature. The models here were Cézanne and, surprisingly, Renoir, and it embraced the work of a great many artists, from Dunoyer de Segonzac (Plate 157) to André

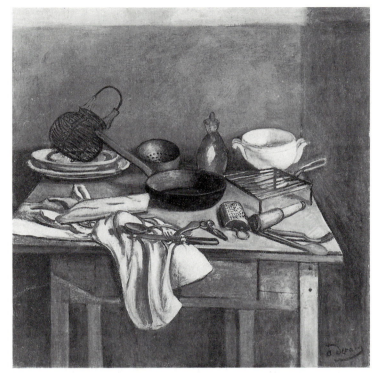

158. André Derain, *The Laden Table*, 1921–22. Oil on canvas, 23¼ × 14¾in. Musée de l'Orangerie, Paris. Jean Walter and Paul Guillaume Collection.

Favory and even, one supposes, Derain (Plate 158). From his writings in *La Nouvelle Revue Française* it seems that Cubism, for him, was something far bigger than Léger would have thought it (a point made in Part I). Lhote saw it as ranging from his own tidied up, early Cubist style based on the analysis of nature to the most advanced synthetic styles whose starting-point was not in nature but in the manipulation of abstract shapes: from himself to Léger, Gris and Picasso (Plates 222, 173 and 138).[6]

In his *Anthologie de la peinture en France* Maurice Raynal divides up French art according to a distinction seemingly as blunt as Léger's. He sees its entire history and current situation in terms of two clear-cut opposing tendencies: Realism and Idealism. He clarifies his distinction thus:

If one categorizes the art of Ingres as Idealist because, even while selecting living elements from reality, he lifts (his art) above nature thanks to style, to lyricism of composition, to plastic inventions born of the artist's imagination; if, on the contrary, we identify Courbet as Realist because he is content to analyse, emotionally to observe nature, to exhibit himself as no more than a painter of behaviour and to place his intentions on the same plane as reality, our distinction of contemporary tendencies...into Idealism and Realism retains...perfect validity.[7]

In this way, Raynal divides the French art scene between Cubism, as the extreme contemporary Idealist tendency, and what he calls 'Naturalism', as the extreme contemporary Realist tendency. De Segonzac is named as the arch-Naturalist and with him are aligned Gromaire, Vlaminck and others like Soutine, while Matisse is presented as a painter whose art is undermined by Naturalist attitudes.[8] Raynal's two poles of Idealism and Realism allow for infinite degrees of

variation in between, but the distinction remains a very blunt instrument for analysing the spread of activity in the art worlds of the twenties. It is, however, refined a little by the introduction of a further category, and this he calls 'Eclecticism'. The Eclectics, he says, have knowledge and taste, and their aim is to link 'Naturalism with the Idealist tradition of the museums and to reconstruct a sort of Classicism, in a different way as logical, worthy and attractive as that of the *Institut*.'[9] They are essentially the imitators of the great 'classic' styles, always looking back beyond Cézanne and Van Gogh for inspiration. He names André Derain as the strongest, a painter preciously gifted, he accepts, 'but above all with the tempting and dangerous qualities of idleness'.[10] And among the other Eclectics he includes Moïse Kisling, André Favory (seen as a follower of Rubens) and Friesz (seen as a follower of Poussin and Delacroix).

Looking back now at the range of art written about in Raynal's *Anthologie*, the question obviously arises, how far can Léger's, Lhote's and Raynal's divisions guide a simple attempt to map artistic activity during the later 1910s and 1920s according to stylistic distinctions? It is immediately clear that their categories *are* too simple to sum up a very complicated changing situation, but broadly there is truth in all their attempts, and they tell how things could be seen at the time from their restricted, rather partial (yet influential) vantage-points. Certainly Lhote's distinction between artists who tried to respond directly to nature and artists who tried to be 'constructive' in their response applied, and makes a valid division of Raynal's rather too wide-ranging Naturalist category. Painters like Matisse, Bonnard, Dufy and (usually) Vlaminck are not easily confused with 'constructive Naturalists' like de Segonzac, Simon Lévy, Luc-Albery Moreau or Jean Marchand. Certainly too, Raynal's category, the 'Eclectics', artists who worked from the model or motif with a respectful eye on museum precedents, existed; and it is clear that the attitude of such as Derain and Favory to styles from the past was distinct from that of Picasso and Léger.[11] And certainly Cubism did exist as an extreme, opposed to both 'direct' or 'constructive' Naturalism, and to the Eclectics influenced by Derain. But these distinctions are often not at all easy to draw clearly and they do not easily embrace the entire range of then current art. Often it is extremely difficult (and seemingly pointless) to distinguish in fundamental stylistic terms between the traditionalist images of 'Eclectics' like Derain (Plate 82) and of Cubists like Picasso or Severini (Plates 77 and 78); and the question of whether Lhote or Bissière are to be seen as latter-day analytical Cubists or constructive Naturalists is in the end unanswerable. Then too, no room is left by these broad divisions for either, say, the idealizing Modernists like Brancusi and Villon (who cannot be called Cubists in the full sense at all), or such expressive individualists as Utrillo, Soutine and Chagall (it simply cannot be enough to put them alongside Matisse or Bonnard and call them Naturalists). Furthermore, the picture presented of the most radical end of the spectrum is so over-simplified as to be positively misleading, at least by 1924, because, of course, Cubism was not the only radical extreme, and Raynal's failure to give any prominence in his *Anthologie* to either geometric non-objective art or Surrealist painting as significant alternatives reveals an astonishing, ostrich-like ability to ignore the obvious where convenient.[12]

It was, then, within an extremely complex shifting scene that artists performed between the last years of the Great War and the eve of the Wall Street Crash, and writers like André Salmon and Maurice Raynal required a highly developed idealizing vision to extract from it the simple outlines of the mythical history of Modernism. Yet, there was one

single factor that kept this great variety of stances and activities together, one issue about which all, from de Segonzac and Derain to Léger and André Masson would have agreed. They were all anti-academics; and, in the end, the most striking omission from Raynal's version of the current scene was academic art, for there still existed in 1927 the long-lived official Salon, the Salon des Artistes Français, and its newer, legitimized rival, the Salon de la Société Nationale. Critics too, from the supporters of de Segonzac and Vlaminck on *L'Art Vivant* to the partisans of Cubism like Raynal, were united in their violent anti-academicism. For all of them, there were two conflicting art worlds: the world of the official Salons with its *Prix de Rome* winners and Ecole des Beaux-Arts medallists, supported by the State through commissions for public buildings and purchases for the Musée du Luxembourg and the provincial museums; and the world of the rebel Salons, the Indépendants and the Salon d'Automne, largely ignored by State patronage. The term *l'art vivant* ('living art'), the title of André Salmon's book and the periodical edited by Jacques Guenne and Florent Fels, was the term applied to the art produced in this other art world. It was interchangeable with *art indépendant* ('independent art'), and, covering the whole range from the new Naturalism to the most advanced Cubism, it stood against the official art world, or seemed to.

This at least was how the artists and the critics who supported *l'art vivant* saw the situation. As André Salmon presented himself in *L'Europe Nouvelle* in 1919, he was not simply a critic, but a propagandist fighting a battle for *l'art vivant* against the official forces of reaction: it was a battle which aimed at the take-over of received ideas not only about the nature of art itself, but about its recent history, hence the need for a compelling myth of modern art history.[13] From Salmon and Raynal to anti-Cubist critics like Louis Vauxcelles and Florent Fels, the common self-image of the critic was as a committed combatant fighting academicism, and, within the 'independent' art world, when one faction wanted to insult another, among the most popular insults was the charge of academicism, for instance, Vauxcelles's pre-1914 charge that Cubism was a return 'to school', often repeated in the twenties, or Lhote's charge that those who had dismissed the discoveries of the Cubists in order to follow Vauxcelles's plea for realization rather than experiment were creating a new academicism.[14] The artists and critics of *l'art vivant* all from their particular viewpoints feared more than anything else the development of a new academicism from within their own ranks.

However, even more than current 'insider' views like Raynal's of the range of activity during this period, the combative, heroic view of the relationship between modern art and the academic, between independent and official art, was ideal and simplistic in the extreme. In 1919 Salmon might have thought that the battle was still to be won, but already in September 1920 he could write of the official Salon des Artistes Français as 'these poor academics abandoned to their last defences',[15] and in 1925 he was ready to claim almost total triumph, for that year at the huge exhibition, 'Fifty Years of French Painting', organized under the auspices of the State in the Pavillon Marsan, official art patently gave

159. Fernand Léger, *The City*, 1919. Oil on canvas, 91 × 117½in. Philadelphia Museum of Art: The A.E. Gallatin Collection.

place to *l'art vivant* (as will be seen more fully later) and he could declare: 'all that has represented official art, official instruction, seemed—and logically—at this point banished from fifty years of (our) national art'[16]. He was not alone in seeing the virtual victory of *l'art vivant* against academicism. As Léon Werth put it, in one of a revealing series of articles published in *L'Art Vivant* in 1925: 'The times have changed. The Philistines are dead...Old provincial dwellings shelter modern paintings. The mistress of the house shows them with pride, with the same sort of pride that she shows a dress from the rue de la Paix.'[17] This widely acknowledged triumph of *l'art vivant* went with crucial changes in its relationship to the official art world, and led to a profound change in its status, a change which was far-reaching in its implications for such notions as radicalism and conservatism as they applied to *l'art vivant*, and therefore in its implications for the character and the future of avant-gardism altogether in Paris. This change is of fundamental importance to this book, because of the key role the distinction between radicalism and conservatism must play here: the fact is that the particular changing meaning of that distinction as it applied to art during the period between 1916 and 1928 is only comprehensible at all if the transformation in the status of 'independent art' is outlined. It is this transformation, therefore, that is the main theme of the rest of this chapter.

* * *

The term 'independent art' naturally came from the major contribution made by the Salon des Indépendants to its development and sustenance. In almost every sense the Salon des Indépendants had been since its foundation in 1884 the very type of the anti-official exhibiting organization. It was genuinely open. For a small entry fee any artist could show at least two paintings.[18] There were no juries and no medals; the only rewards open to the exhibitor were publicity and sales, neither of which had anything to do with the power of the State. It was the central institution, almost the symbol of *l'art vivant* after 1918 until at least 1923, as it had been before. Yet, not long after the Armistice there were signs that the status even of the Indépendants was beginning to alter.

The first Indépendants after the Great War opened in January 1920; it was the Salon that established the health of Cubism as a survivor. Before 1914 the Indépendants had been held on occasion in temporary canvas structures, put up like a great fair for painting and sculpture on, say, the Champs de Mars. For the first time, in 1920 it was held, like the more respectable Salon d'Automne, in the State's Grand Palais, a switch that seemed to some a clear sign of the times. As Salmon remarked on its second showing there in 1921, to exhibit where 'the great societies with juries and medals' exhibited was to be 'made a bit official'.[19] It was inevitable that a certain symbolic slant would be put on the move of this product of 1880s' anarchism into the ambit of State patronage, however indirect was that patronage and however determinedly Paul Signac, President of the Société des Indépendants, kept his Salon free of State control.

If one recalls how laughter had been the currency of common contempt for Cubism at the Salon d'Automne of 1912 and earlier at the Indépendants of 1911, and if one recalls too that one of those in the early years to defend the Cubists against the laughter had been the critic Roger Allard, one realizes the significance of his ironic summing up of the situation at the time of the Indépendants in 1920:[20]

Now one dares no longer laugh at the Indépendants in front of M. Léger's contributions [Plate 159]. But without

embarrassment one roars with mirth in front of the Bonnats and the Rochegrosses at the Grand Palais [leading academics of the 'Artistes Français']. The public go to M. Signac [the Indépendants] for instruction and to see painting as it is, to M. Frantz-Jourdain [sic] [the Salon d'Automne] to find out what's fashionable, to the Nationale to laugh and to see portraits of fashionable people, to the Artistes Français to laugh and to see portraits of generals.[21]

As the Indépendants went into the Grand Palais, a long-time supporter of *l'art vivant* could detect a distinct shift in attitudes across the whole range of the Salon-going public, which meant that even Cubism, though perhaps disliked, could be looked at seriously, without derision.

There went with this shift of attitude an extraordinarily fast growth in commercial activity in painting and sculpture, so that by the end of 1920 Salmon could comment: 'Every day a little more painting sees the day, every day we notice at the same time the emergence of a new dealer.'[22] Happily and without irony, he called it 'a golden age', and it was in the world of *l'art vivant* that this sudden growth occurred, as will be seen more fully in the next chapter. The work above all of Malcolm Gee has pointed unequivocally to the social range and the number of collectors who increasingly turned their attention to unofficial, anti-academic art, from the period of post-war economic expansion that came between 1918 and 1921.[23] They ranged from doctors and dentists like Daniel Tzanck and Dr Girardin, to businessmen like Levasseur and Netter (both of whom came close to the bulk-buying of pictures), to aristocrats like the Comte Etienne de Beaumont and the Baron Gourgaud.[24] A speculative boom in *l'art vivant* was well underway by 1921.[25]

In that year came another, more tangible sign of the changing status of independent art, when, no doubt encouraged by the press and the commercial success of unofficial art, the Société Nationale invited a few independent painters to show at their Salon in a special room (Salle x). Kees van Dongen showed two portraits, including his *Portrait of Anatole France*, and with these were contributions from artists like Jules Flandrin, André Favory, Charles Dufresne, Guérin and Waroquier.[26] The Salon de la Société Nationale des Beaux-Arts was by no means the conservative bulwark that the Salon des Artistes Français was. It had been founded in 1890 as the result of a secession from the Artistes Français led by Roll, Puvis de Chavannes and Albert Besnard, and it had welcomed those artists who had sought to develop the techniques of late or even Post-Impressionism without too risky experimentation, and who were willing to adapt to the constraints of fashionable portrait commissions and State commissions as well. Besnard himself was such a painter, and regular exhibitors at the Nationale included Anquetin, Aman-Jean, Raffaëlli, Le Sidaner and Jacques-Emile Blanche (whom Salmon called 'the soul of the Nationale' in 1921).[27] It was an organization open to compromise, yet still it was by this date an organization no longer thought of as secessionist at all but as thoroughly official, its Salons a regular source of State purchases and indissolubly a part of the world of State patronage. Commentators on both sides were quick, therefore, to see the significance of the move made at the Nationale in 1921: painters who had given Impressionism and its immediate sequel respectability and who enjoyed official recognition were joined by painters associated with the early twentieth-century Fauve and Cézannist tendencies whose outlets had been up to that point almost exclusively unofficial. This was not quite the first time such a thing had happened (there were pre-1914 precedents), but it was considered particularly symptomatic of changes afoot.[28] For Guillaume Janneau, writing

160. Fernand Léger, *Composition with Hand and Hats*, 1927. Oil on canvas, 63¾ × 51¼in. Musée National d'Art Moderne, Centre Georges Pompidou, Paris.

161. Juan Gris, *The Painter's Window*, 1925. Oil on canvas, 39⅜ × 32in. The Baltimore Museum of Art, Maryland: Bequest of Saidie A. May.

in the galerie Bernheim-Jeune's house magazine, the *Bulletin de la vie artistique*, the Nationale had clearly declared its intention to show itself 'not at all hostile to a very modern expressive feeling', even if its new guests were treated as 'the prodigal sons of painting' coming home.[29] For Salmon, so manifold were the implications from the point of view of those independents who had accepted the Nationale's invitation

that the question arose of whether they had done their future reputations harm by this apparent betrayal, 'this sudden desire for officialization'.[30]

The rapprochement between the independent and the official art worlds signalled in this way continued to develop in 1922. One sign of this was André Lhote's involvement as an adviser in the organization of a prestigious exhibition at the

rue de la Ville l'Evêque called 'One-hundred Years of French Painting'. It was certainly remarkable that Lhote, an 'independent' widely considered close to the Cubists, should have been called in to advise two such conservative figures as Koechlin and Jacques-Emile Blanche. At the time Lhote commented on the disagreements between himself and these two, especially concerning the importance of Société Nationale artists like Cottet, Aman-Jean and Besnard as innovators, but there was no mistaking his friendliness, his desire to play a significant part in the enterprise.[31] Moreover, there was even starry-eyed talk of the possibility of a reversion to just one Salon which would combine the Artistes Français, the Société Nationale and the Salon d'Automne, rendering obsolete the Indépendants; and late in 1921 the *Bulletin de la vie artistique* ran an *enquête* on the possibility, something that would have been unthinkable even a year earlier.[32] The sense of conflict remained strong, an attitude which Salmon especially sought to promote and sustain as he pondered the significance of these developments: for him what was wanted were two Salons to concentrate the opposition between those who preserved the values of the past and those who wanted a 'research laboratory' open to experiment for the future.[33] It could not be denied, however, that the conflict was entering a new phase: that the two sides for the first time in the century were willing to talk and act together.

1923 brought a particularly telling manifestation of this mood of co-operation, a development that made even Salmon write of the need to return to 'the single Salon, as in the time of Diderot', to a situation where the conflict would be concentrated into a single arena.[34] Encouraged by the liberalization of their Salon, the Société Nationale painters Aman-Jean and Besnard initiated the foundation of yet another Salon in that year, the Salon des Tuileries. The point about the Salon des Tuileries was that it was organized by the academics alongside the independents from the Salon d'Automne. Artists were invited by two committees, one headed by the Société Nationale's Le Sidaner, the other, the modern one, headed by the one-time Fauve, Emile-Othon Friesz. Brought together with, for instance, Besnard's cartoon for his tapestry, *The Return to Strasbourg of the French University* (a grand official commission) (Plate 162), were pictures by virtually all the leaders of living art, from Friesz to Simon Lévy to Lhote and even to Metzinger, Marcoussis and the most obviously uncompromising Cubist of them all, Gleizes. For a couple of years at least the Salon des Tuileries was an important marker of the profound changes of status that were under way (in 1924 it was moved to a specially constructed temporary building in timber at the Porte Maillot designed by Auguste

Perret). Just how surprising and bewildering these changes could seem is captured by Salmon, commenting on the Tuileries of 1924:

> Is it not admirable, when, tamed hosts at the Grand Palais, the officialized Indépendants mistake their destination, to see a master like M. Albert Besnard, high dignitary of the Légion d'honneur, member of the Institute who tomorrow will be [a member] of the Académie Française, one-time director of our Villa Medici, one of our ambassadors in Rome, receiving but one instruction from his sense of life and the eternal truth of art: to quit the Grand Palais of the half-dead Nationale and of the fully dead Artistes Française to take refuge, with militant youth expressly invited, in the temporary structure of the Tuileries or of the Porte-Maillot, structures identical to those of the old Salon des Refusés?[35]

Such extraordinary developments generated widespread optimism, enough to make it seem briefly that a fifth Salon would not in the end complicate things but would be the prelude to the demise of all the others, to a new, simpler, more cohesive art world. Co-operation of the kind that led to the Salon des Tuileries still did not mean an end to the sense of conflict between even those in the academic and independent art worlds who wanted to work together: its significance was to demonstrate on the one hand a growing recognition within circles considered official of the strength of *l'art vivant*, and on the other hand a growing willingness within independent circles to seek such recognition.

Still, however, in 1923 there were few signs of a complementary openness to *l'art vivant* in those institutions which were at the core of State patronage in France: the State purchasing committees and above all the State's museum of modern art, the Musée de Luxembourg. The director of the Beaux-Arts (the top bureaucrat in the official art world) was the deeply conservative Paul Léon who was to resist any real liberalization of policy. The curator in charge of the Musée du Luxembourg was Léonce Bénédite, who had served there since the 1880s and with the same assistant Charles Masson since 1899.[36] Most of the leaders of *l'art vivant*, were not to be seen at the Luxembourg, the Impressionist pictures of the Caillebotte bequest were displayed in two side-rooms as an embarrassing diversion from the main collection, and the leading academics of the nineteenth and early twentieth century dominated.[37] Hopeful signs that official policies could change were few, the most remarked-on being perhaps the transformation made at the Musée de Grenoble, where a daring and energetic curator, Andry-Farcy, by 1923 had built a collection which included works by Signac, Marquet, Bonnard, Friesz, Dufy, Picasso and as many as fifteen by Matisse.[38]

It was in 1924 and 1925 that major changes in the stances of officialdom itself became clear. Indeed, the situation changed so swiftly and so dramatically that the leaders of *l'art vivant* were actually able to mount a campaign to place at the head of the Musée du Luxembourg (a position of central power and influence) one of their own champions.

In the early summer of 1925 the huge Exposition Internationale des Arts Décoratifs opened in Paris. The Champs de Mars and the area around the Grand Palais were covered with temporary displays of French and international design and architecture; on some days crowds of around a quarter of a million visitors were reported.[39] It was a major State initiative, with Paul Léon deeply involved, and as an accompaniment to it there opened at the Pavillon Marsan the ambitious official exhibition of French art already mentioned, 'Fifty Years of French Painting'. That *l'art vivant* had acquired

162. Albert Besnard, *The Return to Strasbourg of the French University*, 1923. Tapestry cartoon, exhibited at the Salon des Tuileries, 1923.

a new status even from the vantage-point of the Beaux-Arts bureaucrats was obvious in the size and the range of the modern contingent at the Pavillon Marsan: Vuillard, Bonnard, Rouault, Signac, de Segonzac, Friesz, Utrillo, Matisse, Derain, Vlaminck, Dufy, Favory were all there, and Picasso was there too with Braque. As has been seen, Salmon took this as a sign of the triumph of independent art, especially in the context of the absence of so many academics; it could hardly have been taken as anything else.

One reason for this triumph, it seems, was the help given by collectors, some of whom are reported to have refused to lend works by nineteenth-century masters unless they were hung alongside specified works by others (a kind of pressure that was the direct result of the commercial success of *l'art vivant*).[40] But there was another reason which was itself an unmistakable symptom of change: an important part in the selection of the exhibition was played by the critic Louis Vauxcelles. Now, of course, Vauxcelles had long played to the hilt his role as the indefatigable enemy of the Cubists, a critic set therefore against the most radical wing of independent French art between 1911 and 1925; but he was, nevertheless, the most widely respected of the independent critics, respected even by those who defended Cubism, by Maurice Raynal, Waldemar George and Salmon.[41] He was a Republican a 'parti Radical' liberal and still committed anti-academic who had not forgotten the early conflicts of the century and his championship of such as Bonnard and Matisse. For him to have helped organize this official show-piece of French painting was a real step forward for *l'art vivant*, or rather a real step towards the Establishment. Almost immediately he was to take another.

Not long before the opening of 'Fifty Years of French Painting', the otherwise unmovable Léonce Bénédite had died and left the post of curator in charge of the Musée du Luxembourg vacant. That summer or 1925 Vauxcelles put himself forward as a candidate, and he did so not as a gesture but as a considered move which he believed had a real chance of success. As his letter to the director of the Musées Nationaux supporting his candidature made clear, his confidence came partly from his organizing role in 'Fifty Years of French Painting'.[42] It was, no doubt, increased at the end of May 1925 when he received a letter informing him that he had been elevated to the grade of Officer de la légion d'Honneur (only a little later Matisse and Emile-Othon Friesz were to join him on the roll of the Légion d'Honneur).[43] Supported by a letter signed by well over one hundred artists, backed in the press by influential figures like Salmon, lobbied for in the office of Anatole de Monzie, the minister himself, whose sympathetic interest in *l'art vivant* was acknowledged everywhere, Vauxcelles's candidature certainly did seem to have a real chance of success.[44] And such was the optimism generated that it inspired one of the most revealing *enquêtes* of the mid-twenties in *L'Art Vivant*. The main questions asked were these: should a new Musée Français d'art moderne be created by transforming the Luxembourg, and, if so, who should be included? So long as Vauxcelles's candidature was alive, the answers recorded from an exclusively anti-academic range of respondents was a distinctly hopeful 'yes', and much interest was generated by their attempts to name the top ten living artists for inclusion. something which will be returned to.[45] The impression given by these responses is unmistakable: the editors and the most influential readers of the periodical believed that the take-over of the Luxembourg by *l'art vivant* was imminent. The new art was soon to become the new official art of the Establishment, its history the new official myth, thus to conclude the rout of the academics.

Vauxcelles's letter to the director of the Musées Nationaux, as it survives in draft in the archives at the Bibliothèque Doucet, reveals just how drastic his intentions were, even if he attempts to soften them by a show of diplomatic compromise. Reassuringly he insists that he wishes to act with respect for Bénédite's achievements, to show *all* the tendencies in French art (including the academic), but it is obvious that he wishes to leave no more than a rump of the Museum's academic collection, clearing a great deal out to provincial hospitals and galleries, working with 'a lucid courage' to get rid of the 'puffed up vignettes...the scholarly anecdotes...the little pictures of an aggressive commercial vulgarity' that he despised. The Caillebotte collection was, of course, to become a central attraction, and the gaps left by the departing square metres of academic canvases were to be filled by the works of Vuillard, Bonnard, Signac, Marquet, Puy, Vlaminck, Utrillo, de Segonzac, Dufresne, Luc-Albert Moreau, Braque, Derain, Favory along with others, the heroes of independent art; his influence and friendship with artists and collectors was to be used to obtain gifts and purchases at uncommercial prices. Using the phrase that Salmon had coined for the Indépendants, Vauxcelles advocated thus a transformation of the Luxembourg from a 'sanctuary' to a 'laboratory for experiment', a transformation to be completed by a thoroughly unacademic programme of temporary exhibitions.[46]

The hope generated by Vauxcelles's candidature that the Luxembourg could actually become a genuine Musée Français d'art moderne (in the 'independent' sense) proved premature and vain. Even before the *enquête* in *L'Art Vivant* was complete the news broke that Vauxcelles was not to be appointed. Léonce Bénédite was succeeded by his loyal lieutenant of 25 years standing, Charles Masson.[47] Yet, it must be stressed, the loud campaign for Vauxcelles's appointment was not altogether a failure. It reflected the real strength of *l'art vivant* in 1925, and an important new stage in the equally real shift in attitudes to its status. So compelling a display of confidence could not completely be ignored even by Charles Masson. By 22 April 1926, the date of the Luxembourg's reopening, freshly hung and reorganized by Masson, there was a new junior curator working with him, Robert Rey, a young critic, champion of artists like Vlaminck and de Segonzac, who had been taken into the Musées Nationaux; a junior version of Vauxcelles, as it were, had been accepted at least as an assistant. And the re-hang did show that the official stance was adjusting to the new situation.

In very general terms it seems that Masson followed a policy fairly close to that sketched out by Vauxcelles in his draft letter to the director of the Musées Nationaux, except he followed it so much more timidly that the independent critics were not to be satisfied. The Caillebotte bequest was extracted from the two small rooms beside the Sculpture Gallery and hung as a grand centre-piece: such works as Renoir's *Swing*, Monet's *Women in the Garden* and Van Gogh's *Restaurant on the Seine* were acknowledged as major statements in the history of French art. No less than one hundred and eighty academic pictures considered 'too space-consuming for their pictorial value' were consigned to the basement, including such major compositions as Cabanel's *Birth of Venus*, Cormon's *Sons of Cain* and Bouguereau's *Consoling Virgin* (Plates 163 and 164). To works by independent artists like Signac and Cross already owned by the State were added new purchases by Maximilien Luce, Vlaminck, Friesz, Waroquier, Marchand, Utrillo and many more.[48] What angered the critics was the fact that the pure heroic line of *l'art vivant's* legendary history was blurred by the hanging of independents and academics together to present an official view of Modernism and its past which smacked of compromise rather than complete surrender. The canvases of the Caillebotte bequest were, as one writer put it, framed by Degas, Forain,

163. Alexandre Cabanel, *The Birth of Venus*, 1863. Oil on canvas. Musée d'Orsay, Paris.

Gervex and Besnard, the last two irritatingly out of place in any ideal history of Modernism. Elsewhere Renoir, Cross, Matisse, Bonnard, Marquet and others were juxtaposed with Besnard again and other long-established leaders of the Société Nationale, such as Lucien Simon and Jacques-Emile Blanche. 'Renoir', wrote Georges Besson, 'seems the accomplice of Sabbarté, Cross of Martin, Matisse of Ottmann, Bonnard of Le Sidaner...'.[49]

No observer, either independent or academic, could have mistaken the direction of the change, however. Vauxcelles's candidature had been a factor in a real and fundamental shift within the official art world which had advanced the status of *l'art vivant* in far-reaching ways. Alongside the long-drawn-out developments at the Luxembourg, the symptoms of that shift during 1925 and 1926 are countless, especially in the buoyant confidence of independent critics whenever they considered the position of the academics: formidable enemies worthy of insult had now often become no more than a joke to be considered with smug humour. Two instances are enough to make the point. First, there is Salmon commenting in 1925 on a *café-tabac* on the quai Malaquais which had offered its walls to the pupils of the Ecole des Beaux-Arts. 'The humour of the extravagant times in which we live...' he writes, 'makes of these obedient students...some kind of re-builders. The world turns! Tomorrow the eccentric will be Joseph Prudhomme.'[50] Then there is the young journalist Georges Charensol reporting on two concurrent exhibitions held at the Grand Palais early in 1926, one, 'Thirty Years of Independent Art', a retrospective of the Indépendants; the other, 'The Fiftieth Anniversary Exhibition', a selection of official Salon prize-winners. The former, according to Charensol, was full to bursting from morning to evening, the latter received only 'a few old ladies'.[51]

Between 1924 and 1926, thus, a process of change which had already become visible with the arrival of the Indépendants at the Grand Palais in 1920 accelerated to such an extent that the perceived relationship between *l'art vivant* and established institutions and values was transformed. Not quite accepted

164. William Adolphe Bouguereau, *Consoling Virgin*, 1877. Oil on canvas, 80¼ × 58in. Musée des Beaux-Arts, Strasbourg.

without demur by the State, still baulked by surviving academic interests, its strength had become undeniable and, ultimately, of course, would prove irresistible; a process of incorporation with major implications was well under way. The questions remain, however, how far did this shift of status and of attitudes, this process of legitimization, affect *all* the wide range of artists embraced under the heading *l'art vivant*? Were the advanced Cubists, the tamed Cubists (like Lhote), the constructive Naturalists, the 'direct' Naturalists, the Eclectics all equally implicated? And how did it affect the new avant-gardes of the twenties, the Dadaists, Surrealists, and the leaders of international non-objective art? How, as they related to the range of current independent attitudes and styles, were the notions of radicalism and conservatism reshaped by this change? These are the most important questions of all, but to answer them it is necessary to take account of another factor in the immensely increased strength of *l'art vivant* during the decade after the Great War, a factor so far hardly touched on: its commercial success. This will be the starting-point of the next chapter.

8
Conservatives and Radicals; Success and Failure

The commercial dimension of the success of living art after the Great War was for many years ignored, but not at the time. In 1925 Léon Werth sourly sketched the situation thus: '"Modern" painting being victorious,...the Bouguereaus being bankrupt and the Cézannes paying dividends, the idea of novelty is substituted for the idea of prettiness in the spirit of dealers and collectors. For the speculators there must be new painting, emergent painters, future business.'[1] Yet, for André Salmon (always so aware of questions of status and the commercial dimension) the speculative rise of the art market after 1918 was not to be feared or scorned, but to be greeted eagerly. 'Speculation', he writes in 1921, 'has been favourable to the development of taste; it is a powerful aid to the re-evaluation of new works; it has vanquished reactionary resistance. Snobbery has rendered analogous services.'[2] For Salmon, commerce was the engine of *l'art vivant's* victory, and there can be little doubt that in many ways he was right. Fortunately, it is possible now to give some account of how that engine worked, of how artists and art were involved in it, and of the people who drove it, the dealers and their clients especially. This is so because of the work above all of Malcolm Gee, whose remarkable study *Dealers, Critics, and Collectors of Modern Painting: Aspects of the Parisian Art Market between 1910 and 1930* lays the foundation for any such analysis.[3]

*　　*　　*

The first point to make is that the expansion of the art market between 1918 and 1927 was, as Gee has demonstrated, so great that it altered the entire structure of the Parisian art world, and that this expansion almost exclusively affected *l'art vivant*. It was a period of high growth and high inflation: retail prices more than doubled between 1919 and 1926 in two bursts with a short interval when things were more stagnant in 1921–22.[4] But across a wide range of *l'art vivant* prices rose far in excess of general retail inflation. In chapter 7 the emergence of new dealers after the war was mentioned briefly; it went with the expanding activities and profits of old ones. The great majority of commercial activity in the art market was generated here, in the dealers' galleries.

After 1918 the most powerful, best capitalized centre of the market lay in and around the rue la Boëtie on the Right Bank.[5] It was in this area that the two most committed Cubist dealers set up: Léonce Rosenberg opening his galerie de l'Effort Moderne on the rue de Baume, D.-H. Kahnweiler opening his galerie Simon on the rue d'Astorg. Their policies, however, were not typical; much more so were those of such enterprises as the Georges Bernheim, Bernheim-Jeune, and Paul Guillaume galleries and that of Léonce's brother Paul Rosenberg, all of which mixed dealing in a select few contemporaries who had already established a reputation with dealing in safer, accepted nineteenth-century masters. Bernheim-Jeune had been Matisse's dealer since 1909, and took on Dufy, Utrillo and Vlaminck too; Paul Guillaume was Derain's main dealer from 1923, and bought from a wide range of artists including Lipchitz and Marcoussis as well as Soutine; Paul Rosenberg had a first refusal agreement with Picasso from 1918, and after 1923 was Braque's dealer too.[6] Both on the nineteenth- and twentieth-century side the practice of these men was to build up stock and release it slowly, though they all held group shows and single artist shows of contemporary work (Matisse annually with Bernheim-Jeune, Picasso in 1919, 1921, 1924, 1926 and 1927 with Paul Rosenberg, Vlaminck in 1925 with Bernheim-Jeune, Braque in 1924 and 1926 with Paul Rosenberg). On both sides of their activity the inflationary forces released in the period could only

work to the advantage of these dealers, and by the end of the decade after the Armistice their position had been greatly strengthened, a point to be made as well about a less glamorous Right Bank gallery active in the contemporary field, the galerie Druet (which dealt in such older figures as Denis, Friesz and Marquet, and such younger rising stars as Roger Bissière and André Favory).

The other centre of the art market was on the less fashionable Left Bank. It was more dispersed, more volatile, newer and in its rate of growth a far more obvious reflection of the expansion that went with accelerating speculative activity. Its foci were in Montparnasse and in the Quartier Latin around the rue de Seine. Here, much closer to the artists themselves, who more and more were concentrated in Montparnasse and neighbouring areas, predictably expansion and change were to be followed better. Almost all the important Montparnasse and Quartier Latin galleries were new products of the post-war boom.

Among the new Montparnasse galleries were the galerie d'Art de Montparnasse, the galerie de Sèvres, Jeanne Bucher's gallery in the rue du Cherche Midi, and the galerie Vavin-Raspail close to the café meeting-places of the Rotonde and the Dôme. Jeanne Bucher showed Surrealists and Cubists, including Braque, Gris and Marcoussis (1926), and had an agreement with Lipchitz; she opened in 1924.[7] Vavin-Raspail showed Lurçat, Marcoussis and Souverbie, and opened in 1925 with an attempted revival of the Cubists' 'Section d'or'.[8] Developments were more dramatic in the Quartier Latin and the most extreme peripheries of avant-gardism around the Surrealists found several significant supporters among the new dealers who transformed that area. As Gee has pointed out, according to one observer there seems to have been only a single gallery in the rue de Seine in 1913 (Charles Vildrac's), but by 1930 there were thirteen.[9]

Among those to open in the area after 1918 were Pierre Loeb's galerie Pierre, which started in the rue Bonaparte in 1924 and moved to the corner with the rue de Seine in 1927, the galerie Van Leer which opened in 1925, Zborowski's gallery which opened in 1927, and Camille Goemans' gallery which opened in 1928.[10] Goemans specialized in the Surrealists, as did the galerie Van Leer, and the galerie Pierre gave shows to a wide range of independents, Gromaire, Marcoussis and Miró included, and housed the notorious exhibition 'La Peinture Surréaliste' put on by Jacques Viot in 1925. Just around the corner in the rue Jacques-Callot was the galerie Surréaliste itself.[11]

Such Left Bank galleries as these were far less well capitalized than figures like the Bernheims, the Rosenbergs, and even Kahnweiler. They worked therefore with a faster turn-over, concentrating less on building up stock and waiting for prices to rise in the classic manner of Ambroise Vollard and more on temporary exhibitions with their attendant publicity and immediate sales. For many artists they were a stage on the way to the kind of security and relatively high incomes offered by the dealers of the rue la Boëtie (for Soutine, say, on his way to discovery by Dr Alfred Barnes at Paul Guillaume's, or for Ernst on his way to Georges Bernheim and Léonce Rosenberg).[12] Yet, they did on occasion give contracts which assured artists of a regular income, Miró, Marcoussis and Gromaire all, it seems, being contracted in this way to Pierre Loeb, and Lipchitz to Jeanne Bucher. As their numbers and profits increased, especially between 1919 and 1921 and then after 1924, there can be no doubt that they gave temporary security to a growing quantity of artists, including a few of those at the most extreme avant-gardist end of the *art vivant* spectrum.

The key to speculative success for dealers of whatever kind was the price level (the *côte*) that could be established and held for their artists' work, and it was most of all at the auction rooms of the Hôtel Drouot that this level was achieved. Again as Malcolm Gee has shown, the dealers played a central role as buyers at the modern sales which expanded hugely after 1918, often, of course, pushing up the *côte* of certain artists deliberately.[13] The figures for the rise of certain independent artists' *côtes* can be startling. Before 1925 prices worthy of comment in sale reports for Derains, Modiglianis, Utrillos and de Segonzacs ranged between 5,000 and 20,000 francs.[14] At the Hôtel Drouot sale of Paul Poiret's collection in 1925 de Segonzac's *Drinkers* of 1910 (Plate 157) made over 100,000 francs (it was bought by Léon Marseille, de Segonzac's own dealer, in a very successful price-pushing operation).[15] At the spectacular sale of John Quinn's collection late in 1926, a nude by Matisse made 101,000 francs and a self-portrait by Derain made 30,500 francs, while the hero of the independents, the Douanier Rousseau, was lifted by what seems to have been shady price manipulation to unimaginable heights. 520,000 francs were paid for the *Sleeping Gypsy* (Plate 165), a price which Adolphe Basler commented exceeded even those for the masterpieces of Delacroix, Corot or Courbet.[16] In these circumstances huge profits could be made and there is no doubt that a great deal of purely speculative buying went on at the sales and in the dealers' galleries after 1919. One case can suffice as illustration. Early in the twenties, a doctor, Marcel Noréro, had bought more than 100 works for 184,000 francs. The collection included a Gauguin, a Van Gogh, Vuillards, Bonnards, Rouaults, a couple of Légers and six paintings by Gris. Early in 1927 he sold the lot at the Hôtel Drouot for almost 1,000,000 francs, a gain of around five hundred per cent.[17]

The structural change that all this commercial activity led to in the Parisian art world was fairly gradual, but by 1926 it was obvious to many commentators. There was quite simply a move away from the Salon des Indépendants and the Salon d'Automne to dealers' exhibitions as the major means by which independent artists made contact with their audience: the critics, the enthusiasts, the collectors and the speculators. In the case of the Indépendants it is clear that this move was encouraged, at least among the more reputable and more self-consciously avant-garde artists, by two developments mentioned in the previous chapter: the decision backed by the Indépendant's president Paul Signac to underline the openness of the Salon by hanging it alphabetically and not by 'tendencies' (from 1922), and then the decision to hang the Salon by nationalities (from 1924).[18] These developments led ultimately to wholesale resignations from the committee and refusals to exhibit, mostly on the part of the most daring and influential. Léger, Lipchitz and Zadkine all stopped sending to the Indépendants in 1922; Léger resigned from the committee in 1923, and was followed by Luc-Albert Moreau, Yves Alix and Lhote in 1925. Yet, most fundamentally, the move away from the Salons was the result not of such internal adjustments, but of the sheer pace of expansion outside in the Hôtel Drouot and the galleries. Gee sums this up cogently: 'When an artist could have a personal show in a gallery once a year, and have his paintings permanently on sale at his dealers, sending to the *Salon* became a gesture rather than an economic necessity.'[19] By 1925 André Salmon could suggest that it was no longer necessary to visit the Salons to know the current state of modern painting; what mattered above all were the myriad small gallery shows on both banks of the Seine.[20]

So visible a transformation of works of art into commodities to be speculated with like any other certainly induced disgust within the independent art world. Léon Werth, writing in

165. Henri 'le Douanier' Rousseau, *The Sleeping Gypsy*, 1897. Oil on canvas, 51 × 78½in. Collection, The Museum of Modern Art, New York. Gift of Mrs Simon Guggenheim.

1925, commented that 'the picture has become merchandize', and that the economic relationship of the artist 'to his epoch' had so altered the status of the artist that a concierge could remark to him: 'It's a good job...now..., isn't it, painting?'[21] It was an alteration Werth found deeply disturbing. Of the artists, Albert Gleizes was perhaps the one most consistently and passionately to deplore the expanding power of the art market as a determining factor for the artist, and his attacks had become an integral part of his overall view of the history and current direction of art as early as 1921. For him, there was a direct and inevitable connection between the art-work's metamorphosis into a commodity and the hegemony among artists of individualism, which he saw as profoundly alien to his own collective religious and social ideal.[22] There was even one dealer who joined in the attacks, the redoutable Berthe Weill, long-time rival of Vollard. Answering *L'Art Vivant*'s *enquête* on the future of the Luxembourg, Weill suggested that a new Musée Français d'art moderne be called 'Le Musée de la Haute-Cote [*sic*]' and be built opposite the Bourse. She also contributed a little rhyme to celebrate the hypothetical event: 'Je suis cocotte, cotte, cotte,/Le marchand fait la cote,/L'artiste suit bien le mouvement,/Mais n'empoch'que l'pour cent'. (I am a cocotte, cotte, cotte,/The dealer makes the *côte*,/The artist marks well the movement/But takes only his per cent.)[23]

Yet, the art press of the period reveals widespread acquiescence in the situation more than disapproval and disgust. There is no hint of bitterness when Marcoussis answers the *enquête* in *L'Art Vivant* with the lightest possible touch of irony, by suggesting that the solution to the need for a Musée Français d'art moderne was simply to nationalize the rue la Boëtie to create 'a street-museum' with the gallery windows as show-cases, where 'the pictures change constantly'.[24] Gleizes's severe admonitions were not the rule,

and among critics as well as dealers and collectors André Salmon's optimism held sway: his belief in the *need* for a boom to give success to *l'art vivant*, to help it gain its rightful place in French cultural life. The dominant tendency was to stress the role of the boom in changing the status of the new art, to play down the possibility that it affected the motivation of artists, to assert, therefore, the inviolate purity of art despite commercial forces, and to look to the dealers and collectors as the protectors of the future of the new art.

In 1927 *L'Art Vivant* ran another *enquête*, this time asking whether 'Money, commerce, speculation have a happy or unhappy influence on the development of art', and whether the artist's products should be considered identical in kind to those of the worker. In the replies from artists, critics, dealers and collectors the conviction that art was something special even still and that its development was unaffected by such things remained powerful. Even the painter Gromaire, with his popular subject-matter so consciously set in the Realist tradition of Courbet and Millet, could affirm the rightness of giving a high money value to 'a beautiful picture, [as] a rare and precious object', and could insist that 'its money value, an uncertain reflection of its quality, cannot either create or destroy it'.[25] And the young critic Jean Cassou could accept that the artist was forced to adapt to 'social conditions', but blithely declare that if he is 'a true artist', 'art will find itself always and retain its irreducible autonomy despite the modes and subjects he has believed he should adopt to fulfil the conditions of his contract'.[26] It was, of course, however, the dealers who most passionately advocated the harmlessness and the benefits of commercial growth. Pierre Loeb of the galerie Pierre was confident that 'the influence of money is momentary, the speculator plays [the market], the fashion changes and this in no way taints the artistic development of a country'.[27] While Alfred Fletcht-

heim summed up the feelings of many when he wrote: 'Money, commerce, speculation have a happy influence on art. In poor countries, Art is poor. The more a country is rich, the more it encourages the arts.'[28]

Indeed, so strong was the tendency (especially among dealers and collectors) to see commerce as a key factor in the healthy growth of independent art that it was commonly held up as a beneficial force for good *against* State patronage. The shift in the status of independent art towards official acceptance and support did not extinguish the prejudices that had been created by the earlier history of its rise; academic art was still seen as the creature of the State bureaucrats, and the State, therefore, as a negative, oppressive power. The replies to the *enquêtes* of *L'Art Vivant* in 1925 and 1927 are again revealing in this respect. Jean Cassou's was a typical view: 'The State can impose nothing but the impersonal and the anti-artistic. With all my heart I wish for an end to the Beaux-Arts Budget, which is a useless charge on those who contribute.'[29] Even more than the 'bourgeois', the bureaucrat was made the stock character for self-righteous abuse, perhaps most contemptuously of all in this reply from the dealer Paul Guillaume in 1925: 'By definition, the institutions of the State have as their sole object to be offered as fodder for the indecent greed of those political parasites who euphemistically we refer to with the term "civil servants".'[30] And this was a feeling that united both the anarchist-democratic wing of the independent art world and the anti-democratic élitist wing, as represented on the one side by Paul Signac and on the other by Jacques-Emile Blanche.[31] It was a direct reflection of such anti-State feeling that many of the respondents to the *enquête* of 1925 saw the only hope of a vigorous and independent Musée Français d'art moderne in complete severance from the State and in private financing by dealers and collectors, something, of course, that was to happen in New York in the next decade with the foundation of the Museum of Modern Art. No such thing happened in France in the twenties, but the feeling was strong enough for a group of collectors, headed by Daniel Tzanck, to initiate an attempt. Little more than talk was actually achieved, but for a while the attempt gave a focus to hopes shared by many.[32]

The impact of commercial expansion and success on the behaviour, attitudes and aspirations of a large majority in the world of *l'art vivant* was, thus, enormous, and it is indeed true that the confidence of the independents *vis-à-vis* the official art world was the product of that dynamic worldly development. From this latter it follows that commercial performance (relative success or failure) is one measure of how far any category of independent art was implicated in the changes of status discussed in the previous chapter. It is, therefore, by looking at the commercial performance of the advanced Cubists alongside the rest that some opening answers can be offered to the crucial question of how far those artists can be identified with the legitimization of *l'art vivant* and hence with those processes of incorporation that were embodied in growing acceptance by the French middle classes, aristocracy and the State. The same applies to answering the question of just how effectively 'radical' were the new avant-gardists, the geometric abstractionists and the Surrealists.

Malcolm Gee's study has again provided the necessary starting-point, and it is clear from his analysis that before 1925 (though not afterwards as will be seen) commercial success was almost monopolized by artists whose styles were Eclectic (to use Raynal's term) or Naturalist in either the 'direct' or 'constructive' sense.[33] The current stars of *l'art vivant* were Matisse, Derain, de Segonzac, Vlaminck and Utrillo, with Dufy and Soutine (after his discovery) not far behind. The exceptions among the Cubists were Picasso and Braque, especially Picasso, but that was a reflection of the hostile view of Cubism as a *movement*, the view which isolated the art of those two at the expense of the rest. Part I has already introduced the role of the Uhde and Kahnweiler sales between 1921 and 1923 as *the* indicator of the relative commercial failure of Cubism alongside Naturalism and Eclecticism. Gee has shown how Vlaminck's prices were kept up by Kahnweiler's own support (he bought thirteen of his pictures through an intermediary to sell to Flechtheim in Germany), but Derain's prices kept up too without undue support (the sheer numbers made support very difficult), making a significant contrast with Braque's which dropped by more than two thirds and especially Gris's and Léger's which dropped around ninety per cent.[34] Cubist works of the 'heroic' pre-war period when sold alongside the work of Vlaminck and Derain did so badly as almost to humiliate the artists, a point quickly exploited, as we have seen, by the anti-Cubist critics led by Vauxcelles.

Further, this differential was not altogether the result of the fact that these sales flooded the market at a time of relative economic recession (1921–22), for supporting comparisons can still be made between prices recorded in 1924. Thus, at the Paul Eluard sale Gris's now celebrated painting of 1912, *The Washstand*, could make only 330 francs as against that higher than 100,000 figure paid for de Segonzac's *Drinkers* less than a year later; and even Picasso's *Ma Jolie* could only make 6,500 francs at the Aubry Sale in November 1924.[35] It is highly significant that Paul Rosenberg, Picasso's dealer, not only seems to have preferred to show Picasso's representational work, but to have discriminated sharply between the representational and the Cubist work in price terms. The twelve large portraits that were the centre-piece of his Picasso exhibition of 1924 were priced at 110,000 francs apiece, a truly astonishing level, many times higher than any equivalent-sized Cubist picture could have reached.[36] Even Picasso himself seems to have discriminated thus, since in 1922 he offered John Quinn's agent H. P. Roché one of his *Three Musicians* (Plate 89) for 35,000 francs, simultaneously asking 50,000 francs for *Three Women at the Spring* (Plate 74). And equally significantly Braque offered his *Canéphores* of 1922 to Roché for the inflated price of 40,000 francs apiece (Plate 71), obviously aware of their much increased selling potential by comparison with more thoroughly Cubist work.[37] When in 1925 the anti-Cubist critic Florent Fels caricatured the career of the typical young *arriviste* of the time, sycophantically hanging around the Rotonde or Le Jockey in Montparnasse, angling for acceptance from the juries at the Tuileries and the Automne, he did not style him as aspiring sub-Cubist, but the reverse, a painter geared to Naturalism with a safe sense of the right traditions, cleverly mixing 'a little Corot with a little de Segonzac, a little Courbet relieved by a few reds "à la Vlaminck".'[38] Fels was well aware that success lay in that direction, not in the direction of Gris or Léger or the Cubist Picasso.

The extreme imbalance in prices between the leading Cubists and the leading Naturalists or Eclectics in the period 1919 to 1924 was reflected by the fact that only a few, usually committed, dealers dealt in Cubist art. Paul Rosenberg took Picasso as an exception, which indeed he was, since even by 1914 it is clear that his art was a commercial success, his alliance with Cocteau from 1916 had opened the way to acceptance in the highest circles on the Right Bank, and by the early twenties he had gained so strong a position that he did not need to remain loyal to any one dealer at all.[39] Before 1924 the most powerful Right Bank galleries took very few risks with the Cubists, especially those whom Salmon had

described as the lesser members of the Cubist family. In 1922 Paul Guillaume had enough work in stock by Lipchitz and Marcoussis to persuade Dr Albert Barnes to commission the former and buy the latter. In January 1921 the middle-of-the-road galerie Druet took the unusually daring step of putting on the second Purist exhibition, but never followed up the experiment. And in 1924 the galerie Briant-Robert put together a group show including Laurens, Gleizes, Marcoussis, Lurçat, Valmier and Survage But there were few enough initiatives, and before 1924 the pattern was similar even in the smaller galleries of the Quartier Latin and Montparnasse, where only a few adventurous dealers infrequently showed a few minor Cubists or artists loosely associated with the movement, one of the most active being the galerie Povolozky on the rue Bonaparte, which showed Gleizes in 1921 and both Jacques Villon and Jean Lurçat in 1922. Dominant as dealers for the Cubists, of course, were the well-backed but extremely unusual pair of rivals D.-H. Kahnweiler and Léonce Rosenberg, especially the latter. These two were financially solid enough to ensure that most of the Cubists besides Picasso and Braque were reasonably secure. Léger, Metzinger, Gleizes, Herbin all had contracts with Léonce Rosenberg which gave them at least a living from the end of the war.[40] Gris and Laurens also had such contracts until 1920, and from then on were given a similar secure living by Kahnweiler.[41] Yet, these artists were hardly successful in commercial terms, especially as compared with the likes of Derain, Dufy, Vlaminck or de Segonzac, which, along with the press campaigns of the more conservative critics, gives the lie to the idea that after the war came instant acceptance by a public grown used to Cubism.

With this relative lack of commercial success went a relatively unusual sort of relationship between the main body of the Cubists and their dealers. Both Kahnweiler and Léonce Rosenberg *were* strict and single-minded when it came to considerations of profit. Kahnweiler's wartime refusal at first to release Gris from his contract even though it left the painter destitute demonstrates this, as does his insistence that pre-war prices be paid Gris for the works the artist kept for him from the period covered by that contract.[42] And the point is made by the canny attitude to the salaries paid to his artists and to the prices he could sustain revealed by Léonce Rosenberg's correspondence.[43] They were both also shrewd and tireless tacticians in the promotion of their artists and the coaxing of their *côtes* upwards; both of them through their buying policies at the Hôtel Drouot and Léonce Rosenberg through his promotion of exhibitions abroad (at the galerie Moos in Geneva in 1920, and with the sales he organized in Amsterdam in 1921). At the same time, however, they were both thoroughly committed not simply to their artists as individuals but, more importantly, to the art they stood for and the attitude to art that was its foundation. They could be called figures dedicated to Cubism as a cause in just the sense that writers like Reverdy, Raynal or Waldemar George were. Kahnweiler's *Der Weg zum Kubismus*, produced during the war, was transparently a work of conviction as much as promotion, so was Léonce Rosenberg's *Cubisme et tradition*, a pamphlet first published as preface for the Geneva exhibition of 1920; and Rosenberg's house magazine, the *Bulletin de l'Effort Moderne*, which appeared between 1924 and 1927, was again as much an attempt to preach with the collective voice of himself and his artists as to support a commercial enterprise. The *Bulletin's* direct propagandist tone, almost haranguing in its advocacy as artist's statement follows artist's statement, contrasts strongly with the liberal catholicity of the *enquêtes* and the wit of many of the articles published in, for instance, Bernheim-Jeune's *Bulletin de la vie artistique*. Then too, in

their personal relations with their artists, both dealers set themselves up as serious critics of the works they saw, clearly respected as such by the artists. Gris seems to have been deeply dependent on Kahnweiler's critical faculties and to have seen him as an intellectual peer to whom he should always listen;[44] it was not commercial failure that led André Lhote and Diego Rivera, and then Lipchitz to leave Léonce Rosenberg's galerie de l'Effort Moderne but rather disagreement on a serious level of discussion.[45] All this supports the persuasive suggestion that such tolerance of poor commercial performance at a time of boom, on the part of Kahnweiler and Léonce Rosenberg, must point to a mixture of commercial and idealist considerations behind their decisions and policies unusual among dealers in the period. It seems to have been a mixture which tilted the balance noticeably towards idealist considerations, and certainly it set them and their artists to one side in Salmon's 'golden age' for *l'art vivant*.

Furthermore, Gee has pointed to a distinct difference in the pattern of collecting as it relates to Cubist art by comparison with Naturalist or Eclectic art. Broadly, up until the mid-twenties, the great majority of collectors from the various sectors of the middle class concentrated on Naturalist or Eclectic art, and if they bought Cubist work, did so as a peripheral concern. Gee's two most important median bourgeois groups of collectors are the members of the liberal professions, especially doctors and dentists, and businessmen who operated on a fairly large scale, manufacturers and import-export agents. From these groups, which were of course dominant in quantitative terms, he can pick out no instance of a dedicated buyer of the Cubists. Typical was for example the practice of the dentist Dr Girardin, whose few Braques and Picassos cannot divert attention from the huge bulk of over 100 pictures by Rouault and Gromaire that dominated his collection, or the practice of the importer-exporter J. Netter who bought a Cubist Picasso and four Braques at the Kahnweiler sales but concentrated on Soutine, Kisling, Modigliani and Utrillo.[46] Those French collectors who looked with real commitment to the Cubists and to the most avant-garde art generally were haut bourgeois with impeccable social origins, or aristocrats. On the one hand, there were men in banking and stock-broking like Raoul la Roche and André Lefèvre, or in high executive positions, like André Level and Alfred Richet, men whose 'settled bourgeois background', Gee suggests, gave them the social confidence to stand apart from the majority.[47] On the other hand, there were the few, more stylishly unconventional aristocratic figures like the Comte and Comtesse de Beaumont (who collected especially Picasso, Braque and Marie Laurencin), the Vicomte and Vicomtesse de Noailles (who did not really emerge until 1924 as collectors), and the Baron and Baronne Gourgaud. Perhaps more important to the Cubists than the French collectors, however, were foreigners, especially Americans, who bought with the freedom of tourists holidaying in French culture: John Quinn, the Arensbergs, Dr Alfred Barnes, the wealthy Dutch patron Mrs Kröller-Müller and others.[48]

There is no doubt, then, that Cubism was identified both from within and from without by virtue of its poor commercial performance, its unusually single-minded dealers and its socially distinct support, as apart from the general mass of *l'art vivant*. In fact and in image it was different. Again, if its high social connections associated it in many hostile minds with social snobbery, those connections did not necessarily associate it with social conformism, at least as represented in France by the majority of middling bourgeois collectors. Ironically, when one considers its snob-appeal at the time, Maurice Raynal in his *Anthologie* of 1927 identified the Cubists with the Left (the Communist Party), the Naturalists with the

Centre (the Radicals), and the Eclectics with the Right (Action Français).[49] He did not mean this to be taken literally, only metaphorically, but it is a revealing metaphor when it is remembered that between 1919 and 1928 France was governed by the Cartel des Gauches, a centrist alliance of the Socialists and the Radicals under Edouard Herriot, while, after the Congress of the Socialist Party at Tours in 1920, the Communists had isolated themselves as a small, utterly revolutionary cadre. Except in the cases of Gleizes and Léger, there was little obvious politicization among the Cubists in the early twenties, and politically the Eclectics were not more noticeably to be associated with right wing ideologies than were certain of the Naturalists, but Raynal's analogy does illustrate how the Cubists saw themselves as a select group of revolutionaries still, set against the conservatism of those whose willingness to compromise had given them majority acceptance. Certainly until well into 1924 Cubism could be seen as avant-garde, however secure its leaders, and the relative conservatism of its enemies was in fact heavily underlined by the shift in the status of *l'art vivant* since it was disproportionately they who benefited both from commercial success and official recognition.

It is a measure of the relative failure of Cubist art for most independents as against its various opponents on the conservative side that when *L'Art Vivant* added up all its respondents' top ten artists for inclusion in any future Musée Français d'art moderne the final ten in order of preference were: Matisse; Maillol; Derain; de Segonzac; Picasso; Utrillo; Rouault; Bonnard; Braque; Vlaminck. As would be expected, only Picasso and Braque of the Cubists were given a place, and there was just a single further Cubist in the next ten, Léger. Such leading Cubists as Gris, Lipchitz, Laurens, Gleizes and Metzinger were not even in the first thirty.[50] In just the same way, all the Cubists but Picasso and Braque were kept out of the selection made for the State's major exhibition of 1925, 'Fifty Years of French Painting'. Commercial success and growing legitimacy had come to a wide range of *l'art vivant* by 1925; as yet this was not quite true of the Cubists.

From 1924, however, the situation began to change, at least for a couple more Cubists. The change seems to have been exclusively on the commercial front, but inevitably it implicated the Cubists more in the shifts of status that had affected so much of the world of *l'art vivant* already. At the same time, the new avant-gardists, the non-objective artists and the Surrealists, emerged to claim their places on the scene.

Quite simply, Cubist art began to sell better. Braque might have been commercially successful to a considerable extent from 1919, but it was in 1924 that his prices really began to climb and that Paul Rosenberg gave him a contract (a significant mark of success). For Gris, the coming of more successful times was prefaced by involvement with Diaghilev's Ballets Russes between 1922 and 1924, but those times did not come until 1925, as his health began to fail. Alphonse Kann (an important haut bourgeois collector) visited him and began to buy his work, and with genuinely dramatic effect Dr G. F. Reber, a collector from Lausanne, came to the galerie Simon and began to buy in quantity.[51] Léger had achieved a high profile for that sector of the public which was drawn to the Théâtre des Champs-Elysées, with his designs for *Skating Rink* and *La Création du monde* (1922 and 1923), but his breakthrough really came in 1926 when he left the protection of Léonce Rosenberg for a contract with Paul. In 1927 the Vicomte de Noailles was to pay 37,000 francs for his *Woman holding a Vase*.[52] Between 1925 and 1928 Cubist art may still have been developing in the work of Braque, Gris and Léger, as well as Metzinger and Lipchitz, but Cubism as a broader

phenomenon, a movement for and against which to react, was, as we have seen, certainly on the wane. It is both ironic and significant that the arrival of real commercial viability should have accompanied this dilution of the movement's identity and its image. Thought of as a movement, Cubism began to lose its force as its art achieved wide acceptability and respect. However much the pressures of isolation and commercial failure had induced compromise, it can be said that these pressures, underlined by the aggressive contempt of the majority, were the prerequisites of Cubism's survival in France as an avant-garde movement still resistant, to an extent, to the insidious processes of incorporation.

The question, then, remains: as Cubism lost its avant-garde role and became another success story, did the new avant-gardes, the international style, non-objective artists and the Surrealists, move into a similar position on the margins of acceptability? Were they too left on one side by the art-market boom between 1924 and 1928 as the Cubists had been before, and were they too ignored by the Establishment? There is little doubt that this was so of geometric non-objective art: the official art world rejected it and there is evidence of market support only from the same limited directions as earlier in the twenties for the Cubists. *Vis-à-vis* the bureaucrats it was actually capable of creating a public scandal almost in the manner of the scandals of Cubism's heroic years before the Great War. When Paul Léon, in his role as director of Beaux-Arts, visited Robert Mallet-Stevens's 'Hall for a French Embassy' at the Exposition Internationale des Arts Décoratifs in 1925 and was confronted with a work painted by Léger in his new non-objective mural style, he actually ordered its removal, along with a far less non-objective picture by Robert Delaunay.[53] The furore that followed in the newspapers and the art press was noisy enough to ensure widespread sympathy for the two victims, but the point is that such art could excite extreme action from the State's highest fine-art official, especially Léger's modification of De Stijl. Among the dealers, Léonce Rosenberg was the only one to support the new movement consistently, although Jeanne Bucher in Montparnasse did hold Mondrian's first Parisian one-man show.[54] Among the collectors, the most important to turn towards it were the Vicomte and Vicomtesse de Noailles, who bought six pictures from the exhibition 'L'Art d'Aujourd'hui' in 1926, including works by Mondrian and Vordemberge-Gildewart. Yet, the price they paid for their Mondrian says a great deal: 700 francs was a negligible figure.[55]

The case of the Surrealists was rather different. They were, of course, in no sense welcomed by the official art world (and did their utmost to make such a thing inconceivable), but under the leadership of André Breton, despite his savage attacks on the commercial art world, they were not shy of commercial success, and between 1924 and 1928 their painters achieved it surprisingly quickly. In the early twenties Breton and Paul Eluard had acted energetically as agents for the collector Jacques Doucet, and themselves had bought and sold enough almost to be described as 'marchands en chambre' (dealers without premises).[56] But still in 1924 works by Max Ernst and Joan Miró attracted noticeably low prices at the Eluard Sale in the Hôtel Drouot, and, as has been seen, at first it was new, adventurous galleries on the Left Bank that took the Surrealists up, with the one exception of André Masson who, surprisingly, was given a contract by D.-H. Kahnweiler in 1925.[57] By 1928, however, the signs of burgeoning success were many. The galerie Georges Bernheim, one of the most solid of the Right Bank dealers, put on exhibitions of Miró and Ernst, and the prices paid that year by the Vicomte and Vicomtesse de Noailles for pictures by

these two artists indicated a dramatic rise in their *côtes*. 25,000 francs was paid for three Ernsts, and 20,000 francs for a single, large Miró.[58]

Yet, the case of the Surrealists must indeed be seen as a special one, and particularly in relation to that of the Cubists, for one simple, significant reason: the commercial success of the Surrealist painters did not come *after* they had arrived at their own sense of identity, but actually accompanied the initial development of their various stances, and, promoted by Breton so actively, it could not for them imply even the slightest degree of acquiescence to the status quo. Commercial success, therefore, could not undermine their public image or their self-image as hostile outsiders, as avant-gardists. While the Cubists' growing participation in the art-market boom gradually shifted them towards a more conservative situation in the world of *l'art vivant*, the Surrealists retained their radical *cachet* and were able to do so without for long having to accept commercial failure. Their refusal to compromise was sustained in increasingly cushioned circumstances, an odd paradox.

<p style="text-align:center">* * *</p>

The two chapters of this section have set out to establish a few interconnected points which are as simple as they are fundamental. They can be summed up thus: between 1914 and 1928 Cubism is best seen not as a single heroic line of development isolated and inviolate, but as a set of attitudes and styles tied into a complex fabric of interwoven tendencies, a wide range of opposed alternatives which was often known altogether as *l'art vivant* or 'independent art'. Though there had been indications of what could happen before 1914, the period following the Great War saw a major shift take place

in the status of *l'art vivant*.[59] It became commercially successful, sometimes in a dramatic way; it became widely acceptable in the French middle classes; and it began to be recognized by the artists and bureaucrats of the official art world against which it had stood unwaveringly hitherto, the world of State honours and patronage. Before 1925 this shift took in to a limited extent the Cubist art of Picasso and Braque, but mostly excluded the rest of the Cubists. Predominantly it benefited the artists who were described as Naturalists and (by Raynal) as Eclectics. These artists remained passionately anti-academic, but increasingly they took up a position which was obviously conservative *vis-à-vis* middle-class taste and State institutions, thus highlighting the continued radicalism of the Cubists. Between 1924 and 1928 this conservative/radical polarity was gradually blurred as Cubist art itself became more successful commercially and more widely acceptable, and Cubism too increasingly took up a conservative position in relation to the radicalism of the new avant-gardes, the international style abstractionists and the Surrealists, despite the speedy success in the art market of the latter.

The central theme of the rest of the book is the stances of the Cubists and the meanings of late Cubist art explored within the fabric of *l'art vivant* art as a whole. These stances and meanings will be illuminated essentially through oppositions, through seeing them as a pattern of refusals as much as acceptances created in an unstable situation of conflict. For this to be possible there must be assumed a basic understanding of how the simple distinction between the relatively radical and the relatively conservative applies to the Cubists and their adversaries throughout the period between 1916 and 1928. This section has set out to give the framework for such an understanding and so to provide a starting-point for what is to follow.

166. Henri Laurens, *Guitar*, 1919. Painted stone, height 14½ in. Private Collection, France.

III
Cubism and the Conservative Opposition

9
The Elite, the Collective and the Individual

In March 1924 Robert Rey, who was soon to be the representative of *l'art vivant* on the staff of the Luxembourg, published an irritable response to two current events in Paris: one the exhibition of André Lhote at the middle-of-the-road galerie Druet, the other the launching of Léonce Rosenberg's periodical, the *Bulletin de l'Effort Moderne*. He liked Lhote. Then, remarking that for 'the general public' Lhote was undoubtedly a Cubist, he asked why this was not the opinion of 'the pure Cubists' of the Effort Moderne. According to Rey, Lhote was not to be included in such a limited forum as the *Bulletin* simply because the 'beauties' of his art were 'easily conveyed to all spectators with a little persistence'. Obscurity was, he insisted, a prerequisite of 'pure Cubism' and he supported his point with a quotation from Maurice Raynal taken from the pages of the *Bulletin*: 'Cubism', says Raynal, 'has never pretended to be an art "for everybody". Non-Euclydian geometries, Mallarmé's poetry, chamber music, all the sciences too, these are not popular.' Rey's indignation in the face of such wilful obduracy finds solace in sarcasm: 'Don't be so put off ... in front of Cubist pictures,' he advises; 'It is according to plan that we should not understand, that we should feel nothing and we are warned that all this is not at all made for tramps like us.'[1]

Now Robert Rey's quotation from Raynal is adapted from the pamphlet 'Quelques Intentions du cubisme', first published by Léonce Rosenberg in 1919, and it is precisely the passage which, it seems, was most stressed and most angrily criticized in the press when that text first appeared.[2] Rey was not alone in his opinion, since, for those on the conservative side between 1918 and 1925, one of the most common views of Cubism was of it as impenetrable, unashamedly aloof: the self-perpetuating pursuit of a clique, defended by intellectual snobs and supported by social snobs. Charges of obscurity and élitism were common to Louis Vauxcelles (from before 1914, of course), to critics like Jean-Gabriel Lemoine, Paul-Sentenac and Gustave Kahn, confronted by the Cubist exhibitions in the galerie de l'Effort Moderne in 1919, and to Maurice Hiver—most savage of them all—in *Montparnasse* during 1923.[3] Still, in 1925 Jacques Guenne's and Florent Fels's broadly pro-Naturalist *L'Art Vivant* could publish a caricature (Plate 167) naively to ridicule the process of Cubist pictorial invention as a process of destruction ending only in obscure visual muddle.

Such charges from the direction of the conservatives were inevitably undermined by their actual position in the art worlds of Paris, of course. For, as has been seen, both the critics like Rey and the artists they supported could not convincingly have presented themselves as populists in the broadest sense. Their 'general public' was not a mass public. Yet, the charge of obscurity *was* taken seriously, and was a charge to which a response could not be avoided. André Lhote,

167. Strip-cartoon published in *L'Art Vivant*, 15 February 1925, p.39.

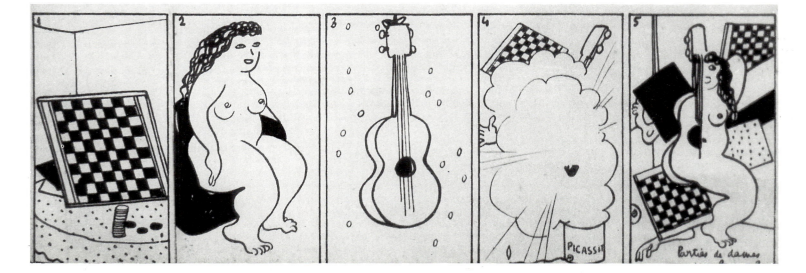

indeed, was a good instance of an artist who had quite consciously turned away from 'pure Cubism' towards an art based on the observation of nature in the hope of developing a more accessible, popular kind of painting. The issues of obscurantism and élitism were real, and were seen as such from every vantage-point; and sometimes consciously, sometimes less consciously, they affected the way that the Cubists themselves thought and even worked.

There was no single Cubist stance on these issues but rather a range of alternatives, from outright acceptance to outright rejection of obscurity in their work and of an élite self-image. It was not the artists but their champions among the poets and critics who most unashamedly accepted and pursued an élite obscurity, above all Maurice Raynal. The rarified aloofness of Raynal's 'Quelques Intentions du cubisme' set the tone for his attitude to Cubist art and the need for popular appeal over the next decade, though in fact it was an attitude whose tone had been fixed at least as early as 1912.[4] From September 1921 he may have written a relatively popularizing column as art critic for L'Intransigeant, but whenever he could he overlaid the work of his Cubist friends with a veil of densely meshed theory in articles and pamphlets that were written, it seems, far more for himself and for them than for any wider circle.[5] Ultimately, he would admit no sympathy for those who were too baffled by Cubist art to respond, and was capable of treating them with barely concealed contempt (in print), as here when writing about Léger in 1927:

> But if you are not moved ..., if you cannot vibrate to the relationships of a representation never before seen, if you prefer to let yourself be taken in by over ingratiating arabesques, ... by the seduction of easy arrangements, if in a word you wish to take the bait offered by the cleverest anglers too readily, it is because the factor of self-control in your sensibility remains anaesthetized and because you are powerless to contain, as you should from time to time, the flux of your narcissistic instincts, as the psycho-analysts put it.[6]

For Raynal, Cubist painting and sculpture was for those with self-discipline and sensitivity enough to look for more than facile visual pleasure. Léger himself would have agreed with that much, and throughout the period deliberately avoided surface or chromatic appeal of the kind so admired by conservative critics in the paradigmatic sensualism of Matisse or Bonnard.

The Cubists—in particular Braque, Gris, Marcoussis, Laurens and Lipchitz—might have been drawn to aspects of that kind of sensualism from 1922 at least, but the cool austerity of crystal Cubism between 1916 and 1921 had already done much to form a received image attuned to Raynal's Puritanism. Paintings like Gris's Man from the Tourraine (Plate 174) and Metzinger's Still Life with Fruit-bowl (Plate 179), with their crisply finished edges and smooth, laboriously built-up surfaces, ward off mere pleasure, or at least the overtly stated painter's pleasure in the handling of the brush and of colour. They signify seriousness and resoluteness in the very way in which they are made; they are indeed hair-shirt paintings. Furthermore, the tough theoretical stance taken by the poets of the Reverdy circle between 1917 and 1921 went with an acceptance of restriction and an open élitism very much attuned to Raynal's. 'In order to be a lover [of Cubist art],' wrote Pierre Reverdy in 1921, 'it is necessary to have an elevated artistic sensibility, an education—everyone lacks it . . .';[7] a statement which should be juxtaposed with another made in 1917 in Nord-Sud: 'I believe that it is not necessary to take too much trouble to educate the public.'[8] It was an acceptance of the idea of art for a cultivated élite that went back above all to the pre-war avant-gardism of Ricciotto Canudo's Montjoie!.[9] The contrast between such an attitude and that, for instance, of Florent Fels, a leading pro-Naturalist, is sharp. 'Once and for all,' wrote Fels in 1925, 'I insist that my articles are not at all written specially for the artists who exhibit, but for the general public. . .'[10]

Connected with the Cubists, the others who most forthrightly claimed an élite status for their art where the Purists: Amédée Ozenfant and Charles-Edouard Jeanneret (Le Corbusier). In 1918–19 they might have been presented as the initiators of a return from the obscurity of Cubism to a new lucidity, but the dryness of their painting from then to the end of L'Esprit Nouveau, its resistance to the optically or tactilely pleasurable (even more firm than that of the crystal Cubists) did not signal in any sense a populist stance (Plates 198 and 199). Their still lives were always ascetic and uninviting. The Purists' belief in the coming of a new sensibility, a new taste for the precise and the ordered, which they called 'the new spirit' ('l'esprit nouveau'), suggests at first a belief in the coming significance of Purist art for a wide public, and certainly whenever this 'new spirit' is mentioned it is presented as a phenomenon that permeates all sectors of society. No one, they imply, can escape the shop windows full of the 'numberless objects of modern industry characterized by that imperative precision which is the inevitable consequence of machines: objects of all sorts which are presented to us in impeccable order. . . .'[11] Further, they rejected altogether the Romantic ideal of the artist as isolated genius, writing in Après le cubisme against the elevation of artists as 'special beings, superior, bizarre, outside the norm', and they repeatedly stressed instead in the pages of l'Esprit Nouveau analogies between the artist and, above all, the engineer (Le Corbusier most often, of course).[12] Yet, they retained for the artist a very special role which, in the final analysis, lifted this being far above the common run, and they identified their ideal audience as a very special social class. 'The art of our time', the Purists wrote in 1921, '. . . is not a popular thing, still less the daughter of the public. Art is only necessary sustenance for the élites whose job it is to commune with themselves so as to lead. Art is in essence lofty.'[13]

Extracted from 'Eyes that do not see', an article signed 'Le Corbusier-Sanguier' (the architectural version of 'Jeanneret-Ozenfant'), this brief passage is more the product of Jeanneret alias Le Corbusier, the architect; and in this guise he was to make the character of his ideal élite audience clear enough as he outlined his plans for a City of Three Million from 1922. It was to consist of top administrators, entrepreneurs and managers from government, industry and commerce, joined by men like himself, the artists and the architects.[14] For the Purists (most obviously for Jeanneret as Le Corbusier) there was a simple correlation between their notion of an élite who would benefit from their art and social class, though their view of social class was itself simplistically meritocratic and idealized.

It has already been demonstrated that Cubist painting and sculpture was especially well supported by the more elevated bourgeois and by wealthy aristocrats as well as by such élitist writers as Reverdy and Raynal. Seen from the vantage-point at least of Maurice Hiver, this was reason enough for twinning its cultural élitism and its obscurity with social snobbery, and the fact that Picasso, the Cubist with the highest public profile, so conspicuously consorted with such as the Comte and Comtesse de Beaumont and their friends strengthened the connection. As Kenneth Silver has comprehensively shown, this was a connection which, certainly in Picasso's case, had been encouraged and pursued with great energy, once the impetus had been provided by the socialite

Jean Cocteau. In 1917 the alliance between Cocteau, Satie and Picasso in the production of *Parade* had not met with the right kind of unqualified welcome from the social élite that followed Diaghilev's Ballets Russes, and that kind of success did not come until its revival in 1921.[15] But Silver has established that from 1916 Cocteau's aim was to make Picasso's Cubism and all that it implied palatable to this small, select, yet socially commanding public.[16] As Cocteau himself put it, he had aimed to bring the monied stylishness of the 'artistic Right' together with the radical audacity of the 'artistic Left', and he saw 'the sumptuous decorative aesthetic' of Diaghilev's Ballets Russes as the vehicle for achieving this.[17] *Parade* was an attempt to win a public by charm and surprise, and was itself a parable of the relationship between the avant-garde and the public (the relationship it set out to transform): its theme was the failure of a troupe of street performers to persuade the audience to enter and see their show.[18] Between 1920 and 1925 Braque, Gris and Laurens were all tempted to take a part in Cocteau's strategy; all became involved too in creating lavish spectacles for Diaghilev's audiences, and in this way consolidated the apparent connection between cultural élitism and social snobbery.[19] What is more, not only did Braque, Gris and Laurens, along with Lipchitz and Marcoussis (Plates 79, 180 and 197), turn to more ingratiating modes from 1922, but Picasso too, as a Cubist, pursued the visually charming and decorative with the Dinard pictures of 1922 and their sequel of 1924, *Still Life with Mandolin*, painted, of course, as an accompaniment to the *mondain* success of his designs for *Mercure* (Plates 182, 88 and 127). Leaving aside the first—Gris's Place Ravignan still life of 1915—one could say that the entire open-window 'genre', as it developed in Cubist art with, say, Picasso's St Raphael series or Gris's *View over the Bay* (Plates 18 and 108), signified a change in the public orientation of Cubism. The hum-drum banality of the studio and the café-table gave way to tables laden with delicious refreshments set in Mediterranean rooms with views, an altogether more privileged, more leisured environment. And yet, despite the development of a campaign so consciously directed at a particular kind of privileged acceptance, unlike the case of the Purists, there is little evidence that any of the Cubists (including Picasso) definitively identified the élite who could respond to their work with a social élite alone.

One telling expression of a tendency to avoid a declared class bias is the shared Cubist openness to the emergence of the modern primitive, the so-called *naïf*. It was an attitude they held in common with the entire range of opinion in the independent art world, and it is significant here because it went with the belief that the highest aesthetic sensibility could be found in the least auspicious social and cultural circumstances. Picasso, Braque, Léger and Delaunay had all been involved with Apollinaire and Salmon in extricating from obscurity the most famous of all modern primitives, Henri (the Douanier) Rousseau. This, of course, had been before 1910, but during the twenties the reputation of the Douanier was taken to previously unimagined heights, especially in 1925 and 1926. Even as early as 1922 he was given a prominent place in the prestigious exhibition 'One-hundred years of French Painting', to such an extent that André Lhote (involved as he was as an adviser on the exhibition) could call the 'Corot-Rousseau confrontation' the 'lynchpin' of the whole thing.[20] Indeed, so high had his reputation climbed in the mid-twenties that a painter called Rimbert could show an *Ascension of the Douanier Rousseau* in the style of an *ex voto* at the Indépendants of 1926 (Plate 168), and to mark the Louvre's agreement to accept Jacques Doucet's promise of *The Snake Charmer*, *L'Art Vivant* could end 1925

168. Rimbert, *The Ascension of the Douanier Rousseau*, 1926. Size and whereabouts unknown. Exhibited at the Salon des Indépendants, 1926.

with a witty photomontage, 'Finale—The Triumph of the Douanier Rousseau' (Plate 169).[21] Such success led to imitators, and the more thoughtful critics who were sympathetic to Cubism (Lhote, Salmon and Raynal) rejected the idea that the Douanier's art could teach lessons like that of a 'master';[22] but they did not question the validity of the phenomenon, the possibility that the highest aesthetic sensibility could be found amongst the least educated. As the Douanier's star rose other new *naïfs* were brought to light, including the Purists' discovery, the nursery-man from the Tourraine, Bauchant-Jeune, and the painter of ships, Paul-Emile Pajot.[23] Among the peripheral Cubists, Louis Marcoussis is known to have sought out the popular in the Parisian flea-markets at least from the late 1910s, and one significant ramification of this serious fad was an exhibition of anonymous paintings and other works found in flea-markets and junk-shops which was held in November 1922 at one of the most exclusive Cubist 'venues', D.-H. Kahnweiler's galerie Simon.[24] Four years later another such show was held at a gallery called 'Le Temps retrouvé' which included such pictures (Plate 169)

from, among others, the collections of Lhote and Raynal, and it was Raynal who wrote the preface for the galerie Simon exhibition. It is perhaps especially significant that he, whose aesthetic élitism was so uncompromising, could have written of the pictures in Kahnweiler's exhibition: 'they bear witness anonymously to that sensitive vitality which one meets with as much among the people as in the aesthetic élite'.[25]

169. Anon. *Finale—The Triumph of the Douanier Rousseau*, photo-montage published in *L'Art Vivant*, 15 December 1925, p.38.

It was, then, the critics Raynal and Reverdy, supported by the Purists, whose advocacy of aesthetic élitism was most forthright in Cubist circles, whether or not it was consciously a socially classed idea, and this was something that expressed itself in the hermetic language and the density of Raynal's most ambitious writing on Cubism throughout the period. There was, however, one critic close to the Cubists whose position as a critic *vis-à-vis* his readership was different. This was Waldemar George, friend of Gris, Lipchitz, Marcoussis and many of the others, editor from the end of 1922 of the widely circulated art magazine, *L'Amour de l'Art*. For him, it seems, criticism *could* have an educational role, above all in easing the relationship between Cubism and the public of the independent art world. It was the need to break down misunderstanding that led him in 1921 to insist on the importance of explaining the 'mechanism' of Cubist works, of ''de-constructing'' pictures and submitting them to the action of critical analysis', as he put it (without any of the inferences that now go with the term 'deconstruction').[26] Raynal only rarely and Reverdy never indulged in such explanatory analysis; George did so, often lucidly. It was perhaps George's more accommodating, less aloof attitude that led him between 1920 and 1922 to launch that campaign in support of a coming-together of Cubist formal structure and post-Fauve colour which to some extent licensed from within

170. Anon. Undated painting, exhibited at the galerie Le Temps Retrouvé, Paris, 1926.

the Cubist circle the move to a more chromatically appealing art in the case of Gris and Marcoussis, especially during 1922 and 1923 (Plates 180 and 97).[27]

Yet, a refusal of the outright élitism of Raynal, Reverdy and the Purists did not inevitably lead to compromise. Indeed, in the two most extreme cases of Cubist anti-élitism it went with a particularly obdurate and uncompromising stance. These are the cases of Albert Gleizes and Fernand Léger. Gleizes's advocacy of a very pure synthetic Cubism to be developed on a mural scale (Plate 123) was based not only on his conviction that such an art could carry the religious truths that were now the core of his world-view, but on a vision of history that did not separate art from its moral and social context. His major text, *La Peinture et ses lois*, first published in 1922, supplies this sketch of the history of art after the Dark Ages:

> . . . the Middle Ages is built upon faith, upon a deep understanding of technique that is left mysterious; the artist is a leader, a wise-man, he works for the collective monument, the church or the cathedral. The Renaissance is built upon logic, upon a brilliant and knowledgeable technique; the artist is a well placed and respected courtier. . . . The seventeenth and eighteenth centuries make painting a virtuoso amusement, technique gives way to 'how to do it', the artist works for the nobles and the bourgeois. The times that come after the middle of the nineteenth century make painting into a commodity which has a rate and which is exploited; no more technique, professional cleverness instead of technique, artists at the same time ignorant and rotten with intellectualism. . . .[28]

For Gleizes, the commercialism of the post-war years and the consequent individualism of *l'art vivant* went inevitably with the divorce of art as easel painting, a luxury commodity, from its highest social purpose, a purpose which was essentially popular. For him, that purpose had most ideally been realized

in the cathedrals of the Middle Ages whose mural paintings had been geared to communicate by the rhythm of flat shapes what he believed were universal rhythms to be sensed in all aspects of existence. The thirteenth-century cathedral was his model because he saw it essentially as a vehicle for bringing universals within the reach of the masses. 'What is painting in these times [the Middle Ages]?' he asks. 'It is a means of propagating the universal idea, it is a technique, [which is] not vulgarized, at the service of religion [and] therefore of understanding.'[29] As Gleizes saw it, the growth of Naturalism in the nineteenth century had been a product of the artist's involvement in the fragmentation of society, with the rise of the bourgeois; for him, Naturalism was not the style of a new popular art, since only an art dealing in simple, universal rhythms could reach across the class divisions of capitalist society, only a more abstract art. It had been the major achievement of the Cubists to point the way towards such an art. 'The idea of form', he wrote in 1921, 'is purified replacing the descriptive naturalism of the street by the realism of images as simple and great as African statues. . . .'[30] He realizes that this development towards 'purity' had carried with it the risk of separation from the 'mentality of the milieu', the risk of rejection in the market-place, but he saw it as the only way to arrive at a new kind of painting which, like the French mural paintings of the eleventh and twelfth centuries, could reach a mass audience.

Along with his anti-élitist view of art's purpose went an anti-élitist, collective view of the artist and the activity of making art. If Gleizes's model art-work was the cathedral ornamented with stained glass and wall paintings, his model of the artist was the ideal medieval artisan, the creation, of course, of nineteenth-century myths of the Middle Ages from Ruskin and Morris to Viollet-le-Duc. When he wrote a piece of criticism on Jean Lurçat's exhibition at the galerie Povolozky in 1922, he insisted that he wrote as a fellow professional and that, as such, all that properly concerned him were questions of technique: 'le *métier*', the job of work.[31] So alien to him was the notion of the elevated artist-genius that he even hoped for a return to the studio-workshop where painters worked collectively, and in *Du Cubisme et les moyens de le comprendre* of 1920, he went so far as to envisage the mass-production of painting, something which he realized would more effectively than anything undermine the market system and so the status of art-works as commodities. 'The multiplication of a picture', he wrote, 'strikes at the heart of the understanding and the economic notions of the bourgeois.'[32] He never achieved such a thing in the twenties, but that he wanted it with such passion sums up the commitment behind his anti-élitist stance, and the flat, dead-pan surfaces of his oils, whether intimate or grand in scale, acted, like those of Purist painting, to deflect any who searched for those idiosyncracies of calligraphy or facture so often read as the marks left by the single, special artist-genius (Plates 177 and 178).

According to Madame Gleizes, Léger was one of those interested in Gleizes's notion of mass-produced painting, and, as we have seen in Part I, he too allowed the dry surfaces of his oils, along with their precision-design character, to set up connotations with artisan or industrial manufacture (Plates 171 and 227). What is more, his development of a non-objective mural style from 1924 was also guided by a distinctly collectivist vision of the social function of mural art. As he had put it, even in 1923, the aim of a large-scale ornamental art for architecture would be to give to the buildings of the city 'a physiognomy of joy', though in his case there was no question of creating a religious mural art concerned with 'universals'.[33] Much more squarely than

Gleizes, however, Léger confronted the dilemma of the anti-élitist committed to Cubist attitudes in the France of the twenties. His work could be almost brutally explicit, as in *The City* (Plate 159) or *The Mechanic* (Plate 171) (despite the knowing hieratic stylization of the latter), and he was careful to avoid the look of refined sophistication as he consciously aimed his easel painting against the 'good taste' of the bourgeois apartment. But he remained firmly opposed to the Naturalist emphasis on subject-matter and on the visually attractive, and firmly for the exclusive Modernist emphasis on pure pictorial values, so that his painting could be both inexplicit and difficult for the uninitiated, most obviously in the *Machine Element* compositions (Plate 143).[34] His anti-élitism was by no means populist, something, of course, that Raynal did not miss.

Léger's particular brand of anti-élitism comes across especially clearly in the lecture he gave for Dr René Allendy at the Sorbonne in the spring of 1923. It was called 'The Machine Aesthetic', and had the telling sub-title, 'The manufactured object—the artisan and the artist'.[35] Here he developed an original variation on the current *art vivant* myth of 'the primitive', a variation with clear social and cultural implications of a wide-ranging kind. He started with an attack on the sort of hierarchical thinking that separated the fine arts from all branches of utilitarian activity. It was only this 'hierarchical bigotry', he maintained, that prevented the artistic value of so many ordinary things, designed and made by ordinary artisans, from being appreciated for their pure 'plastic' beauty. The shop-keeper arranging his window (eagerly observed by himself and Raynal), the artisan and the worker producing objects like compasses or bottles or pipes, or even agricultural machines, were, for Léger, the new primitives, creating marvels without knowing it.[36] He made the point thus in another text of the time, unequivocally linking the worker and the primitive: 'A worker would not dare deliver a product other than clear-cut, polished, burnished. . . . The painter must aim at making a clear-cut picture, clean, with *finish*. The primitives think of these things. *They have a professional feeling for standards* ['la conscience professionelle'].'[37] Yet, the worker, the modern primitive in industry, was, of course, far more telling proof than the Douanier Rousseau or Bauchant-Jeune of the existence of the impulse towards art outside the higher strata of the class structure. Léger's film *Ballet mécanique*, made in 1923 and 1924, was a celebration of the beauty created by these 'artisans' (Plate 142). 'The day', he said in 'The Machine Aesthetic', 'when the work of this whole world of workers is understood and appreciated by those free of bias, who have eyes to see, truly one will be present at a remarkable revelation. The false great men will fall from their pedestal and values will finally be in their place.'[38]

Such a thing, of course, had not yet happened and was but a distant hope for the future. The reason for this, in Léger's opinion, was simple and could be summed up in one word: prejudice; but he realized that the problem lay in the prejudices not merely of the so-called cultivated classes, but of the artisans and workers themselves. It was this realization that allowed him to face the dilemma of Cubist inaccessibility more squarely than Gleizes, for Gleizes managed to convince himself that the least educated were already open to the revolution initiated by Cubism, and that the triumph of that revolution was obstructed only by the materialist prejudices of the bourgeois with their insistence on naturalism. In a lecture of 1921 Gleizes had told a little story to insulate his faith in the working man. As he tells it, he and Marcoussis fell into conversation with a worker at the Salon des Indépendants (either of 1920 or 1921), who offered the blunt opinion

that certain 'stylized sculptures' on display were too disgusting to show his grandchildren (it is not clear exactly which).[39] This led him and Marcoussis to ask the worker what he thought of Lipchitz's Cubist sculptures, which, as Gleizes would have described them, were not sculptures stylized from nature, but synthesized from the abstract (Plate 43). 'Encouraged by our friendliness', Gleizes recalls, 'this worker spoke with all his heart. ''Ah! I like that much better. I [can]

171. Fernand Léger, *The Mechanic*, 1920. Oil on canvas, $45\frac{1}{2} \times 34\frac{1}{2}$ in. National Gallery of Canada, Ottawa.

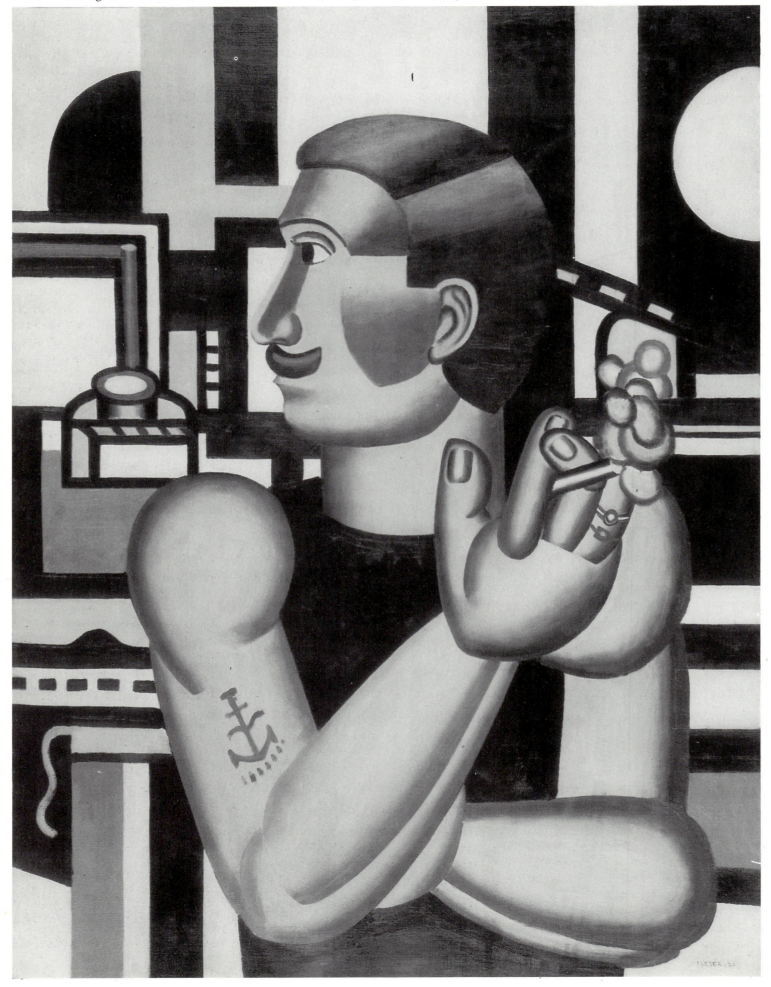

see straight away that it's well made and then I would like to have that at home because that would make me think. It's like an object''.' Rightly anticipating incredulity, Gleizes added: 'I guarantee the authenticity of this. . .'.[40] Marcoussis at least was reported as being staggered, but, according to Gleizes, when they got to the Cubist paintings, the worker continued in this vein, with 'the same mistrust of whatever still aimed to imitate nature'.[41]

In 'The Machine Aesthetic' Léger told his own story about a worker confronted by *l'art vivant*. His story went back to the Salon d'Automne probably of 1912, and its hero was a sixteen-year-old mechanic 'with flaming red hair', but, unlike Gleizes's worker, he had not been drawn to the Cubists or anything like them, but to 'nudes in gilt frames'. As Léger understood it, the men he called 'the true artists' ignored 'the plastic quality which they created', and preferred the pictures which were to be seen in the Louvre (where, for Léger, two in every thousand could be called beautiful) rather than their own products (of which, for him, perhaps three hundred in every thousand could be). As Léger saw it, only a change in such prejudicial preoccupations among the artisans themselves as much as among the cultivated would make possible the break-down of the hierarchies, the revolution in values that he hoped for. Social change and education were, of course, all that could ensure that.[42]

Yet still, even if such a change in mass attitudes to the everyday products of industrial society were possible, Léger did not envisage the end of art as a specialist activity. Maya-kovsky might have remarked that Léger was one of the few French avant-gardists in the early twenties who had thought seriously about current advanced attitudes to art in post-Revolutionary Russia, but Léger did not, like the hard-line Constructivist theorists of INKhUK and *Lef* in the Soviet Union, look forward to the end of art and the absorption of the artist into design for production.[43] He left room in his vision of an ideal future for a creative élite, and saw artists as such an élite. 'Is the artisan all?' he asks in 'The Machine Aesthetic'.

> No. I think that above him there are a few men, very few, capable of elevating something in their plastic conception to a height which overlooks this first level of Beauty [that found in manufactured objects]. These men must be willing to consider the work of the artisan and that of nature as raw material, to order it, to absorb it, to melt it down in their brain with a perfect balance between two values, conscious and unconscious, objective and subjective.[44]

Gleizes would certainly have found a way more rarified still of phrasing it, but, though he wanted workshop painting, and despised the ideal of the artist as isolated genius, he would have shared this sentiment at least. In the end, the anti-élitism neither of Léger nor Gleizes was designed to undermine the special status of art and the artist.[45]

* * *

D.-H. Kahnweiler reports that among the visitors who made the journey to Gris's studio after his move to Boulogne-sur-Seine in 1922 was Dr René Allendy, and as the painter's health worsened early in 1926 the doctor was among those whose advice was consulted.[46] Allendy was deeply involved in Freudian psycho-analysis, and in 1923 collaborated with Dr R. Laforgue to publish an introductory study, *La Psychanalyse et les névroses*. He was, however, a man with a taste for wide-ranging synthesis that embraced both the arts and the sciences, and in 1923 he founded at the Sorbonne a 'Société des études philosophiques et scientifiques pour l'examen des idées nouvelles' to satisfy that taste.[47] The society heard lectures on scientific topics, especially, it seems, psychology, but also on the arts, and it was under its auspices that Léger gave his lecture 'The Machine Aesthetic' and that Gris spoke 'On the Possibilities of Painting' in 1924.[48] Both Ozenfant and Gleizes contributed as well.

In Allendy's view, Léger, Gris, Gleizes and Ozenfant, as Cubists (or post-Cubists), were all part of a single, progressive post-war phenomenon which had its manifestations in physics, chemistry, psychology, politics and religion as well as in art. All this he summed up with admirable cogency for the largely literary and artistic readership of *La Vie des lettres* in a brief article called 'The Orientation of New Ideas', published early in 1923. (This periodical was Gleizes's main platform during the early twenties.) Allendy believed that the period was one of major change in the world of ideas, one in which men were moving from modes of thought based on differenti-ation to modes of thought based on unification. Thus, in physics he pointed to the replacement of the old opposed notions of matter and energy by a single notion of matter as 'nothing but an aspect of universal energy'; and to Einstein's rejection of the old separation of time and space. In society he pointed to what he believed could be the end of an order based on the equilibrium of domination and submission in favour of a co-operative order where the rights of small nations, women and children would be protected. In political economy he pointed to the tendency to organize production and consumption 'scientifically' by way of trade unions and international corporations, while hastily disassociating him-self from Marxist dialectics and the attacks on private property launched by the Communist Party. In psychology he pointed to the tendency to see the psyche and the body as a whole. Everywhere he found a move 'to replace the old order, based on a balanced opposition of contradictory forces, by the unification and co-operation of contrary elements'; and the artist (or at least the Cubist) is seen in this light, replacing the old opposition of art and nature with a new art which is synthetic and whose 'rhythms, proportions, harmonies' are 'of the same order as those of nature'. 'Thus,' Allendy con-cludes, 'we see outlined, in all the branches of human activity, a great synthetic current which replaces everywhere the conflicts of man and nature by a fruitful co-operation and it is credible that the efforts of the present generation are going to replace, in every field, the brutality and cruelty of blind

172. Raoul Dufy, *Boats at Le Havre*, 1922. Oil on canvas, $21\frac{1}{4} \times 25\frac{1}{2}$in. Collection, Samuel Josefowitz, Geneva.

war with methodical, intelligent and brotherly organisation.'[49] The generous, League of Nations breadth of his thinking was very much of its post-war moment.

Both from within the Cubist ambit (as in the case of Dr Allendy) and from outside it, Cubism, when considered as a movement, could appear a distinctly collective enterprise, aimed at just such a unifying synthesis, part of a post-war 'call to order' which cut across all the branches of thought, culture and society. Directly related to the repeated charge of élitism levelled against the Cubists by conservative opinion were the related charges of anti-individualism and intellectualism. The image of an élite group, bent on changing art and consciously promoted by Léonce Rosenberg through his galerie de l'Effort Moderne, seemed for the enemies of Cubism to go with a stress on collective effort and shared artistic formulae obediently to be followed by the Cubist faithful in their pursuit of a cohesive synthesis; all of which appeared to be sanctioned by a belief in the guiding role of ideas. The strait-jacket of rules coupled with the fascination of abstract theory were, according to those who answered the *Revue de l'Époque's enquête* on the death of Cubism in 1922, the most important reasons of all for its actual or imminent failure.[50] And the heroes of the anti-Cubists were often identifiable by the way they presented a totally obverse image of spontaneity and hatred of theory. Praising Raoul Dufy's seascapes at the Salon des Indépendants of 1923 (canvases comparable with *Boats at Le Havre* (Plate 172), André Salmon recalls Dufy's stated desire to save for himself 'the pleasure of effusion', and gives it symbolic force as a plea made 'in the face of the slightly puritan take-over of the second Cubists. . . .'[51] Praising Pierre Bonnard as 'nothing but a painter', indeed a '*naïf*', Léon Werth sees him in 1925 as 'a living insult' aimed against the entire edifice of Cubist collective theory (Plate 259): 'Bonnard the researcher has nothing to do with those laboratories where the ill-bred pedants and the snobs find instruments graduated to their measure.'[52]

This image of Cubism as collectivist, based on formulae and sanctioned by abstract theory was rooted in another image of Cubism which again had been propagated before 1914 and continued to be after the Great War. Maurice Raynal was above all responsible for the nurturing of this image, and it went with his broad historical distinction between the 'idealist' and 'realist' tendencies in French art. Prompted by the earlier writings of Metzinger and Roger Allard, it had been he who had crystallized the basic distinction between what he called 'the reality of conception' and 'the reality of vision' in an article of 1912 with the title 'Conception and Vision'.[53] This distinction remained the starting-point for his pamphlet 'Quelques Intentions du cubisme' seven years later. At its most elementary the Cubist insistence that artists painted or sculpted their 'idea' of an object rather than its appearance meant that they made a representation of what they knew of it from many points of view rather than of what they saw of it from one, and Raynal made that point very clearly in 1912. But at a more sophisticated level it implied that Cubist art was concerned with ideal truth rather than with the ephemeral effervescence of sensory experience, that it presented an *idea* of an object made up of its most eternal aspects, those aspects which were constant and therefore 'true'. Thus, Raynal could write in 'Quelques Intentions du cubisme': 'To conceive an object is, in effect, to wish to know it in its essence, to represent it in its spirit, that is to say, to this end, as purely as possible, in the form of a sign, a *totem,* if you like, absolutely detached from all useless details such as aspects, accidents. . . .'[54] And then: 'Following this idea, the picture offers a guarantee of certainty in itself, that is to say, of pure absolute truth.'[55] His commitment to Cubism, as he put it,

173. Juan Gris, *Guitar, Book and Newspaper*, January 1920. Oil on canvas, $36\frac{1}{4} \times 28\frac{3}{4}$in. Oeffentliche Kunstsammlung Basel, Kunstmuseum.

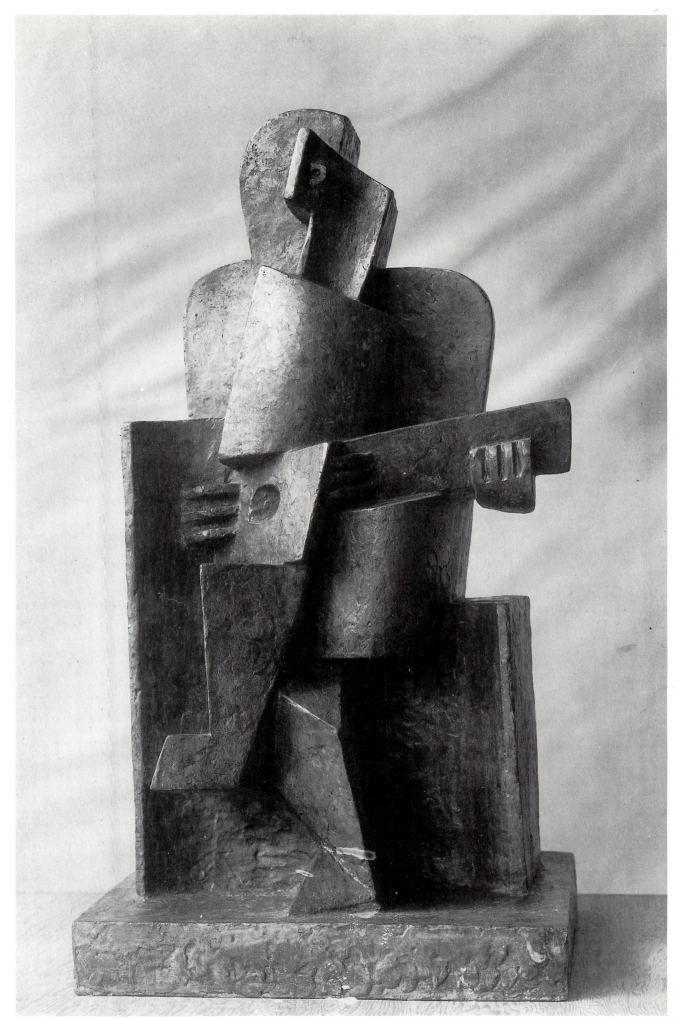

175. Jacques Lipchitz, *Seated Man with Guitar*, 1918. Bronze, height 30in. Marlborough Gallery, London/New York.

174 (facing page, bottom). Juan Gris, *The Man from the Tourraine*, September 1918. Oil on canvas, $39\frac{3}{8} \times 25\frac{5}{8}$in. Musée National d'Art Moderne, Centre Georges Pompidou, Paris.

was founded on his 'faith in philosophical and scientific truth', on his belief that art, like philosophy and science, could reveal the constants beneath visual appearance.[56] Certainly, for him, the then current crystal Cubism of, say, Gris or Laurens or Lipchitz (Plates 173, 166 and 175) had this metaphysical potential.

Such claims that the Cubists painted or sculpted, in Kantian terms, the 'nuomenon', the thing-in-itself, went back again to the years before the Great War when they had first been made by other critics, the most often quoted of whom was Olivier Hourcade;[57] and they formed the core of Pierre Reverdy's crucial theoretical essay of 1917 in *Nord-Sud*, 'On Cubism'. For Reverdy there was no doubt in this essay that the Cubists dealt with absolute truths beyond all other kinds of art. 'The point', he writes, 'is not to give the appearance of [an object] but to detach for use in the picture that which is eternal and constant (for example the round form of a glass, etc.).'[58]

With statements like this from such influential champions of Cubism as Raynal and Reverdy as supportive evidence, it is not difficult to understand those respondents to the *Revue de l'Époque's enquête* who believed the Cubists too concerned with ideas and too restrictive. In particular, Raynal's most ambitious claims for the metaphysical significance of Cubism were repeatedly the passages extracted for quotation and refutation by hostile critics, and, for Vauxcelles, the connection between such idealist thinking and the unacceptable obscurity of Cubist art was a direct one. Writing in response to the Cubist successes of 1920 at the Salon des Indépendants and the revived Section d'Or, he pulls the threads together with his usual trenchant aggression:

> Such is the aim: to express the world in its essence ['esprit'], to suggest the nuomenon. The Cubist substitutes for the reality of vision the reality of concept. Oh perils of seductive intellectualism, of unbridled logic and algebra! [Free] of the Charybdis of the sensorial we founder in the Scylla of the cerebral! As a consequence of rationalization, our metaphysician ends confined in an almost unintelligible image. . . . The reality of concept becomes a chaos of tangled cubes.[59]

As important was the apparently unavoidable link-up between the conceptual image of Cubist art and theory and the anti-individual, the collectivist. The claim that Cubist art was concerned with eternal 'truths' implied a belief in the universal and therefore in artistic ends that transcended the individual. Again there was strong support from within the Cubist circle. It came most of all from two sources: the painter Albert Gleizes and the dealer Léonce Rosenberg. These two were aided and abetted by Gino Severini and with typical persistence and thoroughness by the Purists.

That Léonce Rosenberg agreed with the universal and idealist stance taken up by Raynal and Reverdy is clear from his collection of aphorisms called 'Cubism and Empiricism', dated 1920–26. 'Cubism', he writes here, 'is nothing else but the art of putting together and relating together constant and absolute elements, but different because of a new unity.'[60] That his commitment to Cubism considered thus put him vigorously against individualism is also clear. It is conveyed indirectly by his consistent promotion of the idea of a 'collective style' through the writings from 1924 of Gleizes, Severini, Mondrian, Van Doesburg, Servranckx and others in his *Bulletin de l'Effort Moderne*. It is conveyed sharply and directly by the plain statement, also from 'Cubism and Empiricism': 'Individualism, there is the enemy.'[61] As demonstrated in Part I, even in 1919, at the moment when there was most evident a unity of style among the Cubists, alternative possibilities were opened up by Braque and Léger during the sequence of exhibitions at the galerie de l'Effort Moderne.[62]

For Léonce Rosenberg, however, those exhibitions had been a declaration of collective purpose, and it seems partly to have been the restriction that went with such an attitude that forced first Lhote and Rivera, then Lipchitz, Gris, Laurens and Braque to leave him. What mattered to Léonce Rosenberg was the apparent stylistic unity of, say, Gris's *Man from the Tourraine* and Lipchitz's *Seated Man with Guitar* (Plates 174 and 175), or Metzinger's *Woman with a Coffee-pot* and Braque's *Musician* (Plates 45 and 53). This kind of 'unity' could be read as the sign of a deep, all-pervasive unity.

The Purists too linked a determined pursuit of constants to an equally determined rejection of individualism, and between 1918 and 1920 developed towards a style so unified that it was extremely difficult to distinguish one from the other, Ozenfant from Jeanneret, at their exhibition of January 1921 in the galerie Druet (Plates 117 and 198). Indeed, reviewing this exhibition, Raynal pointed out that they had actually collaborated on certain works (he did not specify which), surely a statement of fact since it was made in the Purists' own periodical, *L'Esprit Nouveau*.[63]

As their enterprise came to an end late in 1924, they were still able to see it, as they had six years before in *Après le cubisme*, in terms of the need to situate their art in a general post-war search for constant standards:

> We shall continue this task which seems to us necessary in this epoch when the notion of relativity is generalized: in the framework of the relative, the search for fixed factors in all things, the constant [factors] in phenomena, in men, of their spirit and their organism, those of their languages and their arts: the only way to a solid foundation.[64]

Like Dr Allendy they saw art after the war as part of something far larger that ranged across the sciences too, a search for unity as the sequel to conflict, and, like Raynal and Reverdy, they saw the order of their art as a revelation of an order that was absolute and eternal, underlying all things. These were the fundamental convictions that led them to aim at the establishment of fixed rules of form, composition (proportion) and colour as the basis for all painting, an aim carried out, of course, in some detail from the first number of *L'Esprit Nouveau* onwards. Individual response or artistic creation was only to be understood within a unifying framework of constants common to all. Art was to deal exclusively with 'primary sensations', with sensations, that is, whose fundamental significance was the same for all, of whatever culture; the individually whimsical was to be cut out. 'Primary sensations', they asserted in the first issue of *L'Esprit Nouveau*, 'constitute the basis of plastic language; they are the fixed words of plastic language; it is a fixed, formal, explicit, universal language, determining subjective reactions of an individual order. . .'[65] On this basis, art, like science, could convey eternal truths, rather than merely express transient feelings; such was the Purists' unwavering belief.

Yet, more even than Léonce Rosenberg and the Purists, it was Gleizes whose extensive writings between 1920 and 1924 gave substance to the received image of Cubism as an idealist art concerned with universals, controlled by pictorial laws, whose purpose was collective and whose antithesis was individualism. This has already figured as an aspect of Gleizes's anti-élitism, but it is worth going further here in order to stress the strength of the anti-individualism inherent in his approach to his own art and to Cubism as a whole. Particularly revealing from this point of view is the way he argued against the hegemony of individualism so obvious in *l'art vivant* as he saw it in 1920 at the Salon d'Automne; the text in question appeared in *La Vie des lettres* early in 1921.

As always for Gleizes, all that is wrong with the art of his

time follows from its social and economic role: its identification with commerce, its new guise as a commodity. Deploring the current celebration of 'originality' by 'professional criticism', he compares the competitive spirit of the shop-keeper with 'the artist in his studio' who ignores his own affinities with other men. In his terms the works of such isolated artists in the Salon d'Automne (the majority) 'come of man-as-a-unity rather than the unity of man'. They are inevitably debased by the intensely personal and transient quality of the emotion which produces them, the result, not of a supra-personal aspiration to arouse shared emotions by the communication of universal rhythms through the rhythms of abstract forms (what he calls here 'natural law'), but the vain desire to capture a sentimental response to nature. He scorns those artists who 'test their pulse in public', who are always 'drunk' with feeling, and holds up the Cubists as 'the first to rebel against this slavery', to commit themselves to 'natural law', to the universal.[66] Disappointingly, he does not face up to the problem of how they had been able to do this while under contract to dealers who still treated their works as commodities. Doubtless he would have answered the sceptical that this was only a temporary expedient as they waited for real social change.

Gleizes's anti-individualism had all the characteristics picked out by conservative opinion as typical of Cubist anti-individualism generally: an insistence on universals, a rejection of sentiment and a dependence on a clearly laid-out system of pictorial rules. For, just as the Purists elaborated rules of proportion and colour, so Gleizes outlined (though not in such detail) a basic science of composition. As Part I showed, this was the point of his text of 1922, *La Peinture et ses lois: ce qui devait sortir du cubisme*, and, when he wrote of a shared awareness of technique as the basis for a collective art, it was this basis of rules that he meant. In 1920 he summed up his position curtly thus: 'Painting based on laws, it is painting once again becoming impersonal.'[67]

Now, the collective picture of Cubism and the Cubists constructed by Dr Allendy, Léonce Rosenberg, Severini, the Purists and Gleizes, backed by the idealism of Raynal and Reverdy, was not merely a feature of Cubism in the post-war decade. Its strength and persistence derived to a significant extent from the accent on anti-individualism and on collective endeavour that went with the effort for national victory in wartime. This point has been made extensively by Kenneth Silver, who has been able to show how resistance to the usual notion of the French as capricious and individualistic went with the construction of a dominant, wartime system of values centred on the importance of collective endeavour, and how this was linked to the attitudes of artists, for example of Ozenfant and Lhote in *L'Elan*, so that it became the underlying foundation for the strength and the appeal of Purism and much else.[68] Silver has also been able to link this kind of collectivism with the ideology of the French Right more than with that of the Left, remarking on its parallels with the supra-individualistic patriotic idealism of Maurice Barrès, Léon Daudet, Charles Maurras and those associated with *Action Française*.[69] The years of the war had indeed both deepened and widened the backing for developments in a more collective direction, and many within the Cubist circle decisively followed the call. Allendy might have written of this post-war phenomenon as merely a part of a vast, all-embracing intellectual change far above the circumstantial twists and turns of national histories, but Silver is probably right to see it as the extension of a mood incalculably strengthened by the French experience of war.

Gleizes had been a non-combatant from early on during the War, had travelled outside France, and can hardly be associated except superficially with the ideology of the French Right;[70] but altogether, even more obviously than the Purists, he was the artist who best fitted Dr Allendy's post-war ideal of the synthesizer working for the common aesthetic good to create compositions of universal significance. At the same time, the impact his views made was very great. With Metzinger, of course, he had been the author of the earliest book on Cubism;[71] in 1920 he was the leading light behind the attempted revival of the Section d'Or, and so enjoyed the dubious distinction of becoming the butt of Picabia and the Dadaists.[72] His was a voice listened to and reacted to in the independent art world. If Raynal more than anyone was responsible for the conceptual image of Cubist art, Gleizes more than anyone was responsible for its collectivist image, despite his far-from-typical religious fervour. This anti-individualist image of Cubism, sustained so effectively for those who projected it by the atmosphere of post-war reconstruction with its grounding in the wartime ideology of the 'Union Sacré', was astonishingly durable and influential during the period. It was, as has been seen, in opposition to it that the spontaneity and sensuality of Dufy and Bonnard were often grasped, and one could add Vlaminck, Kisling, Favory and many others. Yet, it was obviously a misleading, a flawed image, which even at the time was undermined by unmistakable inconsistencies and exceptions.

* * *

Silver's case for the growing force during the Great War of a fundamentally right-wing, anti-individualistic ideology which became linked to the anti-individualism of artists including the Purists and the Cubists is strong enough; and it is certainly true that in 1917 and 1918, within the Cubist circle, a collective emphasis was dominant. The point is made not only by Reverdy in *Nord-Sud*, but also by Paul Dermée's major essay of 1917, 'Un Prochain Age classique', as well as by the relative stylistic consistency of crystal Cubism in those years, particularly 1918.[73] Silver has gone further, however, to argue that after 1918, right into the twenties, this emphasis on the collective remained a clear dominant generally within the French avant-garde (widely defined) and specifically within the circle of the Cubists.[74] His case for this is altogether weaker. The anarchic *laissez-faire* growth of the art market with its attendant proliferation of galleries representing individual artists undoubtedly promoted a speedy return to the pre-war climate of diversity: Gleizes was not alone in identifying an increasingly hegemonic individualism which contradicted his own desire for coherence. After all, most of those from the outside who associated Cubism with anti-individualism saw the latter as a crippling fault, not a desirable virtue. At the same time, Cubism and the Cubists themselves were not exclusively seen either from within or from without as anti-individualist; the situation was far too complicated and contradictory for that.

One intention of the narrative pursued in Part I was to show, by the separate treatment of each artist, how the development of the Cubists, especially after 1919, was *de facto* extraordinarily varied, far from unified. At the same time, the point was made that throughout (from 1916 to 1925 anyway) Picasso styled himself, and was perceived, not at all as part of a movement, but as an isolated genius who pursued his Cubism as a very personal exploration. Picasso most dramatically of all gave the lie to the collectivist image of Cubism, since his protean individualism had already been mythicized and he continued a Cubist. André Salmon was particularly successful at giving lyrical expression to the heroic myth, and does so thus in response to the exhibition of drawings shown at Paul Rosenberg's gallery in 1919:

'Picasso is all alone between the sky and the earth, followed by those for whom his steps have traced the route and preceded by the man he [once] was. . . . Present and future art depend on his philanthropic tyranny. Picasso has invented everything.'[75] By 1925 the myth was so established as to become the subject of ridicule and caricature, for instance notoriously in *L'Art Vivant* (Plate 176). Again as shown in Part I, the practice of detaching Picasso as inventor and dismissing the rest of the Cubists as 'the school' could preserve the image of Cubism as imitative, academic and, by implication, collective, alongside the heroic myth of Picasso, which is of course a central, underlying meaning of *L'Art Vivant*'s caricature. Yet, Picasso's Cubism remained a demonstration that Cubism could develop freely, independent of laws, with no collective purpose; and the fact is that both on the conservative side and on one side of the Cubist circle itself the movement could be harshly criticized actually for being too 'subjective', *too* individualist.

La Solitude de Picasso

176. Cartoon, published in *L'Art Vivant*, 15 January 1925, p.39.

On the conservative side a good instance of this is provided by the critic Jean-Gabriel Lemoine in 1920, reflecting in *Le Crapouillot* on what for him was his new, more positive attitude to Cubism after the Indépendants of that year. He starts with several quotations which spell out the universal, conceptual image of Cubism derived most recently from Raynal's 'Quelques Intentions du cubisme', and then flatly rejects it as totally inaccurate. What he finds most characteristic of Cubism, and ironically most inferior, is its *lack* of unity. How can the Cubists claim to express 'absolute and eternal truth', he asks, when theirs is an art 'on which [their opinions] differ totally?'[76] The distance between, for instance, Léger's *The City* (Plate 159) and Gris's *Guitar, Book and Newspaper* (Plate 173) had indeed been great.

From the edges of the Cubist circle itself it was the Purists who turned upside down the anti-individualist image of Cubism and, faced with its actual dynamism and variety,

tended to stress its individualism; and they did so right from *Après le cubisme* in 1918 to the last issue of *L'Esprit Nouveau*. For the Purists, summing up the contribution of Cubism in 1924, the movement, after the high-point of 1912, had been characterized by its fragmentary proliferation of individual modes. There had been, they agreed, a tendency to search for a common aesthetic foundation with the spate of theorizing in *Nord-Sud* around 1918 led by Reverdy, and the major Cubists had been led by 'a unitary guiding idea', but this had occurred in spite of Cubist individualism and had led to 'highly individualized manifestations'.[77] Ozenfant, looking back on this development in a cogent spirit of evaluation from the vantage-point of 1927, could sum up thus:

> After 1914 and above all after 1918, the Cubist school dispersed, after having obeyed. . . not an organized or dogmatic theory, but the directives implicit in the works of the masters; Cubism was individualized, there was differentiation, and each chose from the new means what was convenient for the expression of his particular conception.[78]

Throughout the period following the Armistice, then, Cubism was repeatedly caught in a cross-fire of contradictory charges on this point: it was a movement which could seem from different angles, either individualistic or anti-individualistic, at one and the same moment. It is a particularly ironic demonstration of this elasticity of image that even Gleizes, so uncompromisingly anti-individualist, could be praised by the conservative critic Schneeberger above all else for the *personal* quality of his. talent, and this in the very same number of *La Vie des lettres* as Gleizes's own vigorous attack on the individualism of the Salon d'Automne discussed above.[79] Gleizes's anti-individualism might really have been uncompromising, like that of the Purists; Léonce Rosenberg might have thought in terms of a collective élite showing in his gallery and fighting individualism through his publications; Raynal and Reverdy might have written of the absolute and the eternal, as if Cubist art could reach it; but the fact is that this contradictory image was possible because for the most part the Cubists and the writers who defended them shared it. The artists were very much aware of the continuing search for common and constant aesthetic principles, but they were as much, and sometimes more, concerned with establishing their very various individual identities as artists.

Reverdy shows how sharply the contradiction could present itself to them at the time. 'It is necessary', he writes in 1921,

> to note two contradictory characteristics of our time. All the young elements are tossed back and forth between two contrary sentiments: first, an unconscious even imperious need for a common direction, a single way, a grouping, even a generalization of the most personal discoveries; then, an extreme pride of authorship, an absolute individualism, a thirst for excessive originality which one finds to the same degree among the most banal, the most commonplace, the most anonymous, one might say altogether among the flattest imitators.[80]

Reverdy's own situation between 1917 and 1920 had dramatized the conflict: on the one hand, the theoretician seeking the clearest possible statement of a common theoretical foundation in his *Nord-Sud* articles; on the other hand, an angry paranoid violently defending his primacy as an innovator in poetry by attacking his own followers for the sin of following him, of plagiarism; and just as he attacked Paul Dermée for his dependence on his poetic discoveries, so he attacked, for

instance, Metzinger for depending on the pictorial discoveries of others (one supposes Picasso and Gris).[81]

Léger's talk in 'The Machine Aesthetic' of the artist, with his rare abilities, reconciling the 'objective' and the 'subjective' shows a typical Cubist's awareness of the dilemma and the need to resolve it. His deep interest in Purist theories never drew him to define for himself rules of proportion, of form and colour, anything like as precise as theirs; but his art remained based on the generalized laws of contrast that he had outlined in 1913 and 1914 with a distinctly objective tone; he acknowledged the existence of constant conditions for architectural equilibrium in manufactured objects as in art; he clearly saw a strong enough objective aspect in his approach for the subjective in him as a painter and observer of the modern-life spectacle to oppose.[82] Even Juan Gris, close friend of Reverdy and Raynal, like Léger always aware of what the Purists were saying, presents just such a contradictory image as artist and theorist. His major theoretical exposition, his lecture given in 1924 for Dr Allendy 'On the Possibilities of Painting', shows him happy, much in the manner of Reverdy, to find a common aesthetic basis for his art, and indeed willing to suggest very general colouristic laws (again of contrast) and compositional laws (again without strict rules based on proportion) governing the 'architecture' of painting.[83] Yet, his other published statements are all more noticeably personal, clarifying *his* particular attitude rather than generally accepted principles, though these may be implied, and his letters through the 1910s and 1920s often reveal the stress he placed on personal judgement and on the distinct personal identity of his Cubism. Particularly telling is the response to the changes in Braque's painting during 1919 and early 1920 revealed in a letter to Kahnweiler. 'I have seen some recent works by Braque', he wrote, 'which I find soft and lacking in precision. He is moving towards Impressionism. It is with some pleasure that I register my dislike, and it takes a great weight off my back; for I was such an admirer of his painting that I was crushed by it.'[84] Lipchitz, looking back in his interviews with Deborah Stott, recognizes the stress on shared aesthetic principles and general rules in the Cubism of 1916 to 1926, but insists that he, more than Gris, retained the personal and the intuitive in his way of working.[85] While later Braque, whose aphorisms of 1917 make so much of restriction and control, would not accept the term 'Cubism' because of its collective flavour. 'I do not know what [Cubism] is', he told an interviewer in 1923; '. . . it is a word in use, a symbol.' And later in the same interview, calling to mind inescapably the myth of Picasso, he said: 'Art is nothing but a single personality's achievement. The schools come afterwards, this is vulgarization.'[86]

With the peripheral exceptions of the Purists and Severini, and the influential exception of Gleizes, the leading Cubist members of what Léonce Rosenberg liked to think of as a collective élite in search of absolute truths, most often, before all else, defended their personal uniqueness. Braque, Lipchitz, Laurens, even Gris and Léger, all to an extent aspired to the kind of personal myth that Picasso made for himself: the myth of the great individual, entirely original, insulated from all outside influence, working out his own personal artistic destiny. In January 1919 Auguste Herbin replied to Léonce Rosenberg's injunctions to his artists to pursue the absolute: 'You write: truth is one. That is a little simple . . . Truth emerges more or less from the well and never ceases to emerge.' Then: 'The evolution of painting is in thinking always more.'[87] Herbin, like most of his Cubist allies, saw his work as a *personal* pursuit of truth; he could not get as close as Rosenberg to contemplating a single, final perfection. As Part I brought out repeatedly, late Cubism can indeed be

read as a cluster of 'individual styles', each of which could work to signify in plainly recognizable terms the special individual character of their authors. Further, if the impervious flatness of crystal Cubist and Purist painting and of Gleizes's and Léger's 'manufactured' compositions of the twenties can seem resistant to connotations of individual 'genius', it cannot be denied that the overt sensitivity of line and of brushed surface in Braque's painting after 1918 and increasingly even in Gris's after 1922, and the stress on intuitive mark-making in Picasso's can seem to promote those very connotations with equal decisiveness.

It was, as we have seen, more the champions of the Cubists than the Cubists themselves who dwelt on the common factors that pulled the movement together, but they too, in the end, insisted on the sanctity of the individual. The case of Reverdy and his hostility to plagiarists, of course, demonstrates this, but so too does the case of Maurice Raynal, who was especially explicit and expansive on the need for the completely personal and original. It is true that certain passages of his 'Quelques Intentions du cubisme' and later writings became *the* support for the widely shared image of Cubism as concerned with the eternal and the absolute, but these were only parts of a whole, and taken out of context they misled then and still mislead now. In fact, it is more difficult to find Raynal writing in this vein in the decade after the Great War than to find him vigorously attacking the threat of rules in art, of fixed constants, and pleading the case for the strong individual.

For Raynal, as for everyone concerned with *l'art vivant*, the most formidable enemy was neither Naturalism nor Eclecticism, it was the academic, and what he most despised in academic art was precisely its dependence on rules and its consequent impersonality. Those attacks on Cubism that focused on its lack of individuality, its rule-bound character, went most often with the suggestion that Cubist art was too mathematical, and so when Raynal deals with the question of rules he deals most with the question of mathematical rules in art. It was his conviction that the definition of mathematical rules as the basis for art was fundamentally academic and therefore unacceptable. Either for reasons of personal friendship or because he realised the freedom for invention they left themselves, he never criticized the Purists for their use of the Golden Section and 'regulating lines', but he did criticize one prominent product of the Cubist circle for his even more elaborate and rigid use of porportional rules. This was Gino Severini.

'Quelques Intentions du cubisme' was given a first airing at the time of Severini's exhibition of 1919 in the galerie de l'Effort Moderne, but already in his response to this exhibition Raynal expresses profound doubts. 'The charming monotony of Severini', he writes in *SIC*, 'has the nuances of convalescence; but he should paint a little more in the first person singular. The time when the understanding of forms should be definable in one way is past; it is necessary from now on that [painting] be intuitive. And, by rigorously examining his conscience, the artist must recognize that which in his work responds to his own intuition.'[88] There seemed to be little that did so in Severini's pictures of 1918–19 (Plate 49), and by 1919 the Italian was already developing the detailed mathematical ideas to be contained in his book *Du Cubisme au classicisme* where the stress was to be emphatically on the objective.[89] This book was published in 1922, and it is in response to it that Raynal amplifies his doubts. Writing in *L'Intransigeant*, he quotes Severini himself: 'One thing I am certain of is that no serious constructive basis [in art] can be established without geometry and number.' This leads him to the following observations:

It seems, right at the outset, that M. Severini is not the

only one to share this idea: he has on his side the entire Ecole des Beaux-Arts, who have made out of this rule what everyone knows. M. Severini seems to forget that man was a painter before he was a geometrician, that art existed before mathematics, that before reasoning our ancestors were first of all sensitive.

For Raynal, an artist whose approach is uniquely based on mathematics 'falls into the academic method, which demands respect for formulae and ready-made standards.'[90]

Raynal's attitude to academicism, the undesirability of fixed rules and the importance of individual invention was deeply thought out both in 'Quelques Intentions du cubisme' and in those monographs and monographic articles where he was at his most searching, where he made none of the concessions to a wider reading public necessary in his regular L'Intransigeant column. Two such texts are enough to reveal the depth and direction of his thinking on these issues; they are his Lipchitz monograph of 1920 and his article on Juan Gris published by L'Esprit Nouveau at the beginning of 1921. The ideas revealed by them lie behind his approach to almost any other topic between 1919 and 1927.

The Lipchitz and Gris texts were published just after the return to Paris of D.-H. Kahnweiler. In exile Kahnweiler had read mainly philosophy, especially, it seems, the writings of Immanuel Kant. Behind Raynal's thinking there also lies an intense study of philosophy, in particular of Plato's dialogues and Kant's theories of Beauty and the Sublime in The Critique of Judgement. It is known that a period of probing discussions between Kahnweiler and Gris followed Kahnweiler's return. Raynal was an old friend of both and certainly the same issues as he dealt with in his texts were explored in these conversations, so his writing can be seen as carrying the echoes of a current, more private debate.[91] Lipchitz, of whom Gris was very fond, was also probably in touch with that same debate.

The core of Raynal's presentation both of Lipchitz and Gris is his assertion of their freedom as individuals to invent their art for themselves, following no visual or methodological canon. Unlike Severini, they are presented as utterly liberated from the academic. Part I has shown how far the two of them learned from one another between 1918 and 1921 (theirs was as close to a common crystal Cubist style as any pair of Effort Moderne artists came (Plates 174 and 175)), but Raynal treats them both as if their art were so independent of all influence as to be hermetically sealed off from the rest of art history. In close collusion with the artists themselves, Raynal was a leading propagator of the myth of total originality which was created for them.

The Lipchitz monograph begins with an attack on all attempts to understand an artist by comparison with others: 'Comparative judgement', writes Raynal, 'is a scholarly method which does not perhaps agree with the freedom today demanded by our sensibility, and in particular by that of Jacques Lipchitz. It seems, rather, to be a second kind of servile imitation of nature, as fruitless as the first, and on which it is dangerous to base an affirmation.'[92] This leads him to attack the elevation of works of art from the past as models of a rigid standard of beauty, an ideal, in comparison with which all art should be judged. 'But how can we accept without question', he writes, 'that sculpture could be left shut up in eternal laws when scientific laws show themselves so fragile!'[93] According to Raynal, the fallacious elevation of a single ideal of beauty is the result of the ancient confusion between art and morality, which led to the belief that, since moral laws are necessarily fixed, so too must the laws of beauty be fixed. It was thus that inspiration was strangled in antiquity:

it could not have been otherwise, he insisted, 'in a time when the mathematicians represented the models for things and when there was inscribed on the pediment of the Academy: "No one enters here if he is not a geometrician".'[94] For Raynal, art is not related to the practice of good works in life and so is not subject to laws analogous with moral laws. Art, he believes, is the result of a kind of 'love' which is quite different from what he calls 'domestic love'.[95] Artists should not, therefore, submit to fixed laws as in life, they should follow 'their inspiration, even at the risk of error'. And the imperative for their decisions should come, not from reason, which measures and compares, but from what Raynal vaguely describes as 'the heart', which in his opinion neither measures nor compares.[96]

Raynal's study of Gris takes this discussion further into philosophy, and specifically fits it into the framework of Kantian thought, rather boldly adjusting Kant's terms and concepts as needed. His was an imaginative but certainly not very watertight interpretation of Kant, revealing more the strength of his prejudices than the clarity of his intellect. Here he tackles the central problem of the first part of Kant's Critique of Judgement: the problem of the universality of aesthetic judgements. Kant argued that aesthetic judgements of the Beautiful and the Sublime were entirely subjective, i.e. based on whether or not each individual was pleased or moved by what he saw. But he argued too that, in making such judgements, each individual necessarily believed them to be universal, i.e. shared by all, and that this was possible, on the one hand because the Beautiful set in play the faculties of cognition shared by all (imagination and understanding), and on the other because the Sublime moved men to realise their shared ability to think above the level of the knowable, to speculate on unknowable 'ideas', such as God. Kant argued that aesthetic judgements of these kinds were both subjective and universal.[97] Raynal did not accept this: for him aesthetic judgements could not be universal, and for him too the contention that the Beautiful is that which 'pleases universally' merely exposed a failure to distinguish Beauty clearly from the agreeable or the efficient.[98] Though Kant himself intended such a distinction, Raynal believed that his stress on the universally pleasing could mean only that he had not succeeded, and the point leads him back to his hatred of the popular and the accessible, to his élitist convictions. 'A work made solely to please', he writes, 'demonstrates a sort of diabolical beauty which seduces our senses for a moment, but leaves our heart untouched.' And later he dismisses the idea of Beauty as universal for being simply 'a more or less skillful concession to general demand'.[99]

He then attempts to say what his concept of 'aesthetic beauty' is, and he does so by re-examining Kant's eighteenth-century distinction between the Beautiful and the Sublime. Raynal's concept of aesthetic beauty is neither one nor the other, but a combination of the two. It is that which pleases not all, but one (the artist himself), and, of course, it is that which is not merely agreeable to him but which he loves. 'Each man', writes Raynal, 'creates his private beauty, the beauty which he loves, [or] more simply that which he loves only and not that which everyone else loves.'[100] Aesthetic beauty, for him, however, is more Sublime than Beautiful, for it is the manifestation of the unlimited, unmeasurable scope of the artist's sensibility. 'Our sensibility . . . is infinite', he declares; 'it is infinite like the sky, that prototype of the sublime according to the philosophical concept. Nevertheless, unlike that of the sky, its infinity resides in our heart instead of having its basis in our reason.' Raynal presents Gris's painting in L'Esprit Nouveau as a manifestation of the 'infinite depth of our sensibility'.[101] The stress is all on Gris's freedom

as an individual to follow the dictates of his own sensibility. Far from concerning himself with the pursuit of an absolute truth whose validity is universal, based on constant laws, Raynal is concerned with the pursuit of a completely subjective truth, the product of the immeasurable potential of each individual artist.

As much as, if not more than Gleizes, Reverdy and Léonce Rosenberg, Maurice Raynal gave cause for that hostile view of Cubism which high-lighted its apparent concern with absolutes and its apparent rejection of the individual sensibility. In fact, in the final analysis, it was he who argued for Cubism's freedom from constant pictorial or sculptural laws and for its dependence on individual aesthetic exploration the most determinedly. Raynal's compulsion to argue as intensely and deeply as possible the case for an art liberated from laws, directed by entirely subjective decisions, his determination to construct the strongest possible defence of the freedom exercised by so many of his Cubist friends (besides just Gris and Lipchitz) to explore their own sensibilities is in itself a demonstration of how important that specifically individualistic ideal of freedom was to them all.

* * *

The point has been made that, as Gleizes saw it, the individualism dominant in the art of the early twentieth century and the celebration of novelty that went with it was the direct consequence of the market system within which artists worked. Certainly at the time there was a perceived link between the boom in the world of *l'art vivant* and the creed of personality and invention. As shown in Part II, the Cubists for the most part developed relationships with their dealers that went further than the pursuit of profit through novelty, and were not taken up by the boom until after 1924; but, for all that,

they remained mostly individualists even when they made common cause of shared aesthetic principles.

Writing in *La Vie des lettres* in 1920, Jean Cassou is persuaded by Gleizes's propaganda to believe in the anti-individualistic, impersonal image of Cubism, and, pointing to the commercial context of the art of his time, he declares any such collective aspiration vain. There is no place left for an idealist impersonal art:

More than ever [the individual] must be free, the unique creator, accepting only those rules and traditions which are adapted to his organism. Even the work matters little, for never has mankind had less need of it. All that matters is the most private act, as detached from the public as possible, the most unique, the most profound: the moment of creation. . . . It is necessary to quit the socially impossible way of Cubism; it is necessary to re-integrate art with the Personality, all-powerful fantasy, the individual, Anarchy.[102]

The Cubists, throughout the period from 1916 to 1928, were all very much concerned with the durability of the work, its lasting capacity to move an audience, hence their absorption in the question of principles and laws. But what the young observer Jean Cassou did not realise and what others like Vauxcelles and so many of those who replied to the *Revue de l'Époque*'s *enquête* of 1922 did not realize, was that for most of the Cubists the lasting qualities of the work of art were no more important than the need to sustain an open, exploratory and essentially personal approach to the activity of making art: they too saw art as a 'most private act'. In spite of Gleizes and the Purists, most of the Cubists had no wish to escape what was, after the brief hegemony of the wartime collectivist ethos, the dominant individualist ethos of *l'art vivant* in the post-war decade. And the stylistic cacophony of late Cubism, in all its diversity, said as much to any who wanted to hear.

10
The Aesthetics of Purity

'In 1916', wrote Pierre Reverdy in the sixth number of *L'Esprit Nouveau*,

> the moment was come when *aesthetics* could be talked about, I did so in *Nord-Sud* because the era was one of organization, of the assembling of ideas, because fantasy had given place to a greater need for structure and because this feeling spoke strongly inside me, so that I founded a review to express and support an idea of reality . . . and a truly new aesthetic established itself vigorously attracting the attention that isolated works had left diverted.[1]

Reverdy refers here, above all, to the group of poets which formed around him in 1916 and 1917, with himself, Paul Dermée and Vicente Huidobro at the centre. But, though concerned with literature, his statement about the concerted attempt to formulate a general 'aesthetic' in *Nord-Sud* applies of course just as squarely to painting and sculpture, and was meant to.

The last chapter was concluded with a heavy stress on the actual importance of individualism for most of the Cubists and their defenders, despite Gleizes, despite the tendency to statements about absolutes from Raynal and Reverdy, despite the misconceptions of so many of Cubism's conservative enemies. This chapter starts from the point that Cubism was a recognizable phenomenon, and that the 'aesthetic' claimed by Reverdy (in his most expansive moments) to be the 'spirit' (l'esprit) of the time was actually no more than that baggage of basic principles held in common only by the small number of 'independent' artists who stood out as advanced Cubists in the decade following 1916. The aim here is to explore these basic principles in the light of what is known of the actual development of late Cubist art after 1916, because the attempts to formulate an 'aesthetic' begun by Reverdy in *Nord-Sud* did, in fact, succeed in making explicit the outlines of the approach to art and life which separated Cubism from all opposed to it, and which was the fundamental cause of every angry outburst against it.

Between 1916 and 1927 there was an unbroken development of these ideas, with the Purist periodical *L'Esprit Nouveau*, after the ending of *Nord-Sud* and *SIC*, providing an always encouraging platform for the debate from 1920 until 1925,[2] and the *Bulletin de l'Effort Moderne* continuing the job until 1927. There were, however, two major phases in which attempts were made to formulate Cubist principles. There was, first, the phase to which Reverdy refers. It occupied the years between 1916 and 1919, and most prominent as theorizers were Reverdy himself, Paul Dermée, Maurice Raynal and Léonce Rosenberg, with Braque's aphorisms in *Nord-Sud* the most important contribution from the artists. Then there was the phase between 1923 and 1925, in which the artists were the more prominent, especially Gris, Léger, Gleizes and, with a couple of influential interviews, Picasso. It began with Dr Allendy's series of lectures at the Sorbonne, and continued with statements published especially in the *Bulletin de l'Effort Moderne*. As a peripheral but insistent accompaniment to this latter phase were heard the arguments of the Purists, whose force had been as evident, of course, in 1920 and 1921 with the opening 13 numbers of *L'Esprit Nouveau*.[2]

*　　*　　*

Many of the poets, critics and artists in the Cubist circle (even Léger) relished the chance to write down and debate their theories, but it is important to add the qualification that there were those among the Cubists and their defenders who shied away from such pursuits and that all were agreed on the primacy of the work and of the creative act. Theory came *after* practice. Reverdy constantly excused himself for

his tendency to theorize about art, and, in the article quoted from at the beginning of the chapter, he explicitly stated his fear that theory invited not 'love' but merely 'understanding'.[3] The sense of guilt was too much for his erstwhile ally Dermée, who in *Beautés de 1918*, published in March 1919, lampoons his own earlier obsession with the formulation of an aesthetic. 'This was the time', he writes of the phase hardly more than months before, 'when I contemplated myself with curiosity./So much head! So much heart! Faust at thirty, who had sold your soul to drink of understanding, your stomach was completely turned by it. What phenomenal cookery! What intellectual drunkenness!/But in the end I was reborn in youth—tender lips each day—promises of a virgin beauty.'[4]

Picasso was notoriously disinclined to theorize. In the interview published by *Paris-Journal* in 1924, he became tired of the questions and asserted: 'Only the work matters';[5] while earlier, asked about his Cubism and specifically about the *Three Musicians* (Plate 89), he had replied disarmingly: 'I made that painting with complete simplicity and without pointless research; I cannot understand the reactions of the public in front of a canvas that I painted like a child. . .'.[6] He too, as a Cubist, could claim the innocent spontaneity some thought the monopoly of Naturalists like Vlaminck, Dufy or Bonnard, and his interviews of 1923 and 1924, however important as evidence of his attitudes, remain collections of fragmentary remarks rather than co-ordinated formulations. Braque's series of aphorisms published by *Nord-Sud* in 1917 add up to a more co-ordinated statement of a stance (and, of course, for a couple of years André Salmon took him as the leader of the Cubists on the strength of them), but his interview in *Paris-Journal* in 1923 avoids any such impression, hence the title: 'Georges Braque's Reticence'.[7]

Again, the common Cubist conviction that the work should precede the theory had the demonstrable support of the early history of Cubism behind it. There seemed little doubt: a period of artistic invention without any agreed theoretical basis (the period before 1914) had anticipated clearly the attempts to define such a basis from 1916 on. The Purists' assessment of the history of Cubism in 1924 made the point, so did Reverdy; and even Maurice Raynal, who revelled perhaps more unashamedly than any in the pure manipulation of ideas, could remind his readers sternly in 'Quelques Intentions du cubisme' that 'theories only ever come after the work'.[8]

These qualifications made, then, what *was* the aesthetic shared by the Cubists? What does their theorizing reveal of the approach to art and life that they held in common? Maurice Raynal's sharply drawn picture of the history of early twentieth-century French art, set out in his *Anthologie de la peinture en France de 1906 à nos jours*, provides a good starting-point. According to Raynal, after the self-indulgent hedonist failure of the Fauves to sustain their impetus, the achievement of Cubism was to take up again the task of renouncing Naturalism, and 'to dedicate itself to pure plastic analysis'.[9] He saw this not as revolutionary, but as a continuation of what had been begun in poetry by Mallarmé and Rimbaud, and in painting by Cézanne; he saw it as 'the natural evolution of a lyricism whose assumptions meet together in all the arts'. In his view:

The call of Cézanne to geometry was nothing less than the realisation of the creative faculty that every true artist carries in himself, the initial resort to plastic standards, with the intention no longer to imitate nature nor to order it, but to create in . . . turn a work carrying the mark of humanity, a genuine architecture, that is to say a work capable of making us believe for a time in our freedom.

And he sums up thus:

To create new compositions expressly constructed from elements known in reality, but without any sensual, decorative, psychological or other expression, became the sole rule, a rule which fundamentally constitutes the only and the very simple *theory* that the enemies of Cubism represent as difficult, obscure, mathematical and contradictory.[10]

Leaving aside the fact that Raynal himself could make it seem extremely difficult, he was right: this was the first principle for every Cubist, to some extent before 1916 and certainly after that date. As the Cubists (distinct from the Purists or artists like André Lhote) individually stressed further the 'synthetic' character of their art—their belief that it was built up pictorially or sculpturally independent of the 'motif'—more consciously than before, they insisted that their art was 'pure creation', not imitation.

This stress on painting and sculpture as 'pure' inventive activities went back as far as 1912 in the history of Cubist theory. As Lynn Gamwell has effectively shown, at this date Cubist theory was divided between one side that stressed 'the retention of a conceptualised subject' and another side, emergent in 1912, that stressed the purity of 'pure painting'.[11] Raynal was at this date, it has been demonstrated, the writer to clarify the conceptual view of Cubist art; it was Apollinaire, above all, who gave expression to the pure view with the formulation he applied to the Cubists whom he called 'Orphic' in his *Les Peintres cubistes* of 1913.[12] Yet, even in 1912 Raynal was capable of a statement that showed how his view could shift its emphasis from the conceptual to the pure. 'What more beautiful idea', he had written in *La Section d'Or*, 'than the notion of a *pure* painting . . . which is not to be as a consequence either descriptive or anecdotal or psychological or moral or sentimental or pedagogical or, finally, decorative? . . . Painting, in fact, need only be an art derived from the study of forms . . . that is to say without any [other] aims.'[13] By 1927, of course, his emphasis had shifted altogether in this direction and the definition of the 'theory' of Cubism quoted earlier from his *Anthologie de la peinture française* is simply an adaptation of this passage from *La Section d'Or* of fifteen years before. It had not been, however, until around 1917 that art as 'pure creation' became the agreed first principle of all the advanced Cubists, and it was above all Pierre Reverdy and his periodical *Nord-Sud* that did most to propagate it. As Waldemar George was to observe, the Great War saw a purification of both Cubist theory and practice.[14]

Reverdy puts the first principle of Cubist theory in its new guise with typical terseness in his opening attempt to clarify the Cubist stance, his essay 'On Cubism' of March 1917. 'Cubism', he writes, 'is an eminently plastic art; but an art of creation and not of reproduction or of interpretation.'[15] This was a principle that had been discussed as the very basis of the new painting and poetry throughout 1916, something which comes across in a lecture given by Vicente Huidobro, as far away as Buenos Aires, in July of that year. The work of art, said Huidobro, 'is a new cosmic reality which the artist adds to nature and which must, like the stars, have an atmosphere to itself and both a centripetal and besides a centrifugal force. Forces which give it perfect equilibrium. . .'.[16] How such a view of art's autonomy redefined art's relationship to nature is put compellingly by Reverdy in a text of 1927, *Le Gant de crin*: 'Nature is nature, it is not poetry. It is the action of nature on the make-up of certain persons which produces poetry./The poet is an oven which burns reality./Art which tends to approach nature takes a wrong turning for if it goes for the aim of identifying art with life, it will lose itself.'[17] Here, clearly stated, is the core

principle of the Modernist stance altogether: art is presented as invention; it is separated totally from any direct dependence on the stimulus of life. Art and life are set up as two distinct polarities. The purification of the Cubist stance and of Cubist art during the Great War led the movement to be identified with such an isolationist notion of art more exclusively and more uncompromisingly than ever before 1914. It was in this way that Cubism, the Cubism of the twenties in Paris, became the spring-board for those attitudes to art and avant-gardism that have come variously to be known as Formalism or Modernism in Britain and America, and that reached another moment of extreme purity in Anglo-American art and criticism during the sixties. In England, of course, a parallel was to be found from before 1914 in the less lyrically expressed stance of Roger Fry and Clive Bell.

The evidence is irrefutable: from around 1916 or 1917 *all* the Cubists accepted on both the radical and the conservative sides as Cubists shared Reverdy's commitment to the core Modernist principle. Braque, it has been seen in Part I, actually borrows Reverdy's brisk epigrammatic style to assert in his aphorisms of 1917: 'The aim is not . . . to reconstitute an anecdotal fact but to constitute a pictorial fact./It is not necessary to imitate that which one wishes to create.'[18] Gris writes to Kahnweiler in the summer of 1919, following the maturation of his 'synthetic' method: 'I have succeeded . . . in stripping my painting of too brutal and descriptive a reality . . . I hope to be able to express with great precision an imagined reality using the pure elements of the spirit.'[19] Then there were Auguste Herbin's and Henri Laurens's statements in the Italian periodical *Valori Plastici*, with their focus on the need 'to create', as Laurens put it, 'and neither to imitate nor to interpret'.[20] While, paraphrasing Lipchitz himself, Paul Dermée wrote thus of the sculptor in *L'Esprit Nouveau* late in 1920: 'The root idea ('idée-mère') of Lipchitz— and that which makes him the brother in arms of several new writers of which I am one—is that he wishes to make *pure sculpture* just as we wish to create pure lyrical poems. Sculpture only puts to work light and volumes in space, without interventions foreign to the plastic.'[21] As Part I showed, Braque, Gris, Herbin, Laurens and Lipchitz all worked as freely as they could with pictorial and sculptural elements, creating in or from the abstract, or at least believing that they did so. The distillation of their Cubist practice between 1916 and 1919 and then the continuing commitment to a 'pure' synthetic approach even of those Cubists who compromised was the complement to their profound belief in themselves as artist-inventors and in the work of art as a pure creation. Gleizes's collectivist and religious idealism might have set him ideologically to one side after his return to Paris in 1919, but his stress on creation as distinct from imitation was very much in tune. In *La Peinture et ses lois, ce qui devait sortir du cubisme* he takes the machine as a starting-point to assert the principle in his own particular way. For him the creation of machines as entirely new working organisms was a powerful stimulus for the creation of paintings which abandoned the imitation of appearances and constructed 'a new world of living forms'.[22]

Just as Maurice Raynal was always careful to distinguish between 'love' in daily life and the 'love' engendered by works of art, for Reverdy so wide and clear was the separation between the work of art and the phenomena of nature or life lived, that he needed to distinguish sharply between the experiences they offered and the emotions they aroused. Like Roger Fry, Reverdy contended that a special emotion was felt before works of art, an aesthetic emotion essentially different from the emotions felt before nature. This is how he puts the point in October 1918 in *SIC*: 'A work of art cannot content itself with being a representation, it must be a *presentation*. A child which is born is presented, it represents nothing.' And then: 'It is false to want the emotion from whence the work is born to be identical with the one the work will bring into being in its turn. The one is a starting-point, the other a result.'[23] Looking at Gris's drawing after nature of 1918, *The Tobacco-pouch* (Plate 38), alongside the painting it generated (Plate 37), and using Reverdy's terms, one might say that Gris's emotion felt when contemplating those things on a table is quite different from the emotion produced in the spectator by the Cubist invention that replaced the drawing.

It was the shared belief of the Cubists in the separate status of the work of art that led to the many attempts to define basic laws for painting and sculpture discussed in the last chapter and in Part I, from the generalized formulations of Léger and Gris to the more precise ones of Severini, Gleizes and the Purists. Since the work of art was considered a completely separate entity, it followed that, as with any other phenomenon, it should obey general laws peculiar to it. Almost certainly prompted by Metzinger himself, Paul Dermée makes the point thus in response to the Metzinger exhibition of 1919 at the galerie de l'Effort Moderne: 'Nature is one milieu. A picture is another. They are two different spaces which have particular laws. That which agrees in the first becomes discord in the second.'[24] Juan Gris makes the point by means of a memorable metaphor in a letter of 1921 to Ozenfant, replying to the latter's Purist argument for the clear presentation of objects in painting:

> Man dies of suffocation in water and a fish in air. Yet both have respiratory organs, though one only functions in the element air, and the other only in the element water. The same applies to the objects in my paintings: if you try to make them live in a world where they do not belong they will die. They will even die if you try to take them out of one picture and put them into another. They will die just as an object from the natural world would die in a painted world.[25]

It is so memorable a metaphor and so apt, because it presents the work of art as if it were an organism, dramatizing the separateness of its existence, and its subservience to its own very particular laws.

Pure Cubism may have claimed to be autonomous, but never abstract. Works like Gris's *Pipe and Tobacco-pouch* (Plate 37) or Metzinger's *Woman with a Coffee-pot* (Plate 45) may have been seen by their makers as new things, their own inventions, and not as likenesses, but they have very explicitly a subject. Even works like Léger's *Composition (Study for The Card Game)* or *Composition (The Typographer)* (Plates 57 and 59) overtly refer to the imagery of mechanization and the urban world, however far behind figurative starting-points have been left. While Gleizes's most abstract-seeming works, like *Orthogonal Composition* of 1922 (Plate 177), are best seen as stages on the way to a new practice dedicated to synthetically building up pictures and giving them a recognizable subject-matter (Plate 178). After 1916 the Cubists insisted on freedom from the imitation of nature, but none of them entirely severed contact with nature, and, so long as they did not direct their work towards a strictly ornamental or architectural end, none of them wanted such a severance. If the first principle of the Cubist stance was what we have called the core principle of Modernism, the principle of aesthetic purity and the autonomy of art, then the central problem that the Cubists spent most words trying to resolve was the problem of how artists could remain in direct contact with nature, constantly responding to it as the raw material

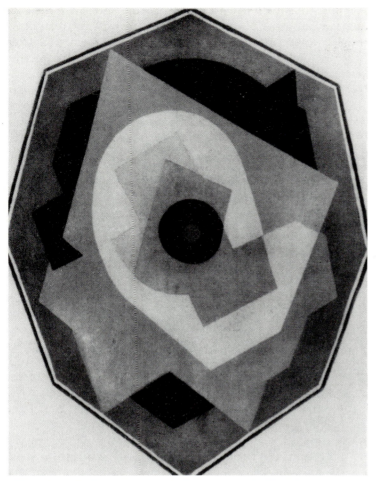

177. Albert Gleizes, *Octagonal Composition*, 1922. Oil on canvas, 35¼ × 27⅜in, whereabouts unknown.

of their art, and yet still arrive at works which were *free* of nature, their own self-sufficient creations.

As early as 1916 there was an elaborate published attempt to clarify the relationship between the Cubist and nature (nature usually being seen in a relatively unsophisticated way merely as what was commonly understood as 'natural' appearances). This was in a series of dialogues written by the artist-poet Pierre Albert-Birot for his periodical *SIC*, the curiously dubbed 'Dialogues nuniques'. The two characters in the dialogues are 'Z', a knowing painter with strongly Cubist convictions enviably endowed with the ability to say the right thing in the right way at the right time, and 'A', an ignorant friend bewildered by the new art and spinelessly amenable to the arguments of 'Z'. The first dialogue appeared in May 1916; it begins with 'A' indignant at a painting of a woman which bears no apparent resemblance to any actual woman. Albert-Birot would have had in mind a work like Gris's *Portrait of Josette* of that year (Plate 28). 'Z' is utterly unsympathetic at such a response from 'A': 'If this woman', he says, 'was made like what you call "nature" the painting would not be a work of art', and then, crushingly, he points out that everything from Egyptian stone carvings to Rembrandts is not 'like' nature.[26] In the June dialogue 'Z' goes on to declare that all artists deform 'nature', and then in order to answer the question of how and why, he leads the willing 'A' to distinguish between a photograph and a painting. The photograph is a mechanical image, a mere record, the painting is made by a 'living creature'; in 'A's words, a creature who 'feels' and who thinks. The photograph gives us a simple image of the object, the painting gives us a complex image of 'the object and at the same time its effect . . . on the feeling and thinking subject—the painter'. 'Z' sums up: 'The complex image contains the reaction of the thinking subject, that is to say, in the first case [the photograph]

the object acts on the subject and in the second case [the painting] the subject acts in return on the object.'[27] In the July 1916 number of *SIC*, 'Z' further concludes: 'The subject [he means here the artist] is the indispensable starting-point; the objective image only becomes an artistic representation after having been recreated by the subject. In other words, art begins in the subject [the artist].'[28]

Couched in unmistakable Platonic form, these dialogues are, of course, deeply idealist, and, in fact, they do no more than elaborate on the conceptual view of Cubism crystallized by Maurice Raynal in 1912 and extended by such critics as Olivier Hourcade, the view that Cubism is the painting of 'ideas', of things as thought not seen. Albert-Birot, however, does place a recognizably heavier stress on the positive, creative aspect of the artist's work considered thus: artists *add* to what they see, from within themselves. As was made clear in the last chapter, a few of the initial expositions of the Cubist stance convey the belief that what artists bring to nature from within themselves is an *a priori* idea of that which is eternal and absolutely true. Reverdy's essay 'On Cubism' associates this belief with the primary geometric forms above all, and these are thus identified implicitly as basic forms, standards which direct the selection and transformation of things from nature (the eternal aspect of a glass

178. Albert Gleizes, *Composition, Serrières*, 1923. Oil on canvas, 86½ × 49¼in. Sale: Parke-Bernet, New York, 9 April 1969.

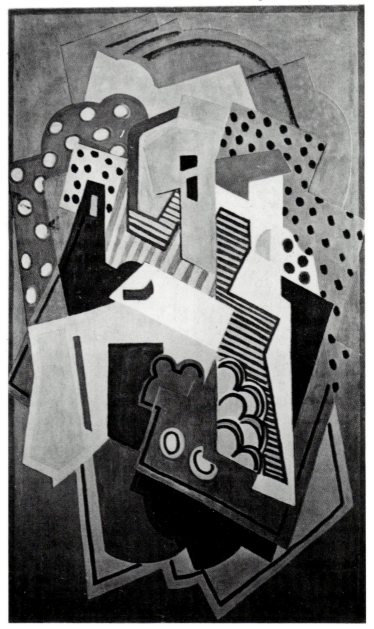

is, for Reverdy, its 'round form').[29] Raynal implies a comparable faith in the absolute character of primary geometric forms in 'Quelques Intentions du cubisme'. 'When [the artist] examines an orange solely by means of his senses', Raynal writes,

> he sees only a fruit with soft contours, a tasty appearance, with a grainy and shiny surface, etc., that is to say he sees only the simple fact of the orange, and *there* is a small certainty. But, if he considers the same fruit in its eternal and synthetic aspect, he will see no more in the orange than a sphere coloured orange, and the statement of this 'ensemble' of elements constitutes a primordial artistic fact.[30]

These idealist statements with their strong Platonic flavour are in themselves very ideal accounts of what actually happened when Cubist artists confronted nature and their work. Just how ideally simplified they are is obvious from the most cursory glance even at the most geometrically ideal Cubist compositions of 1918 and 1919, say those of Gris and Metzinger (Plates 174 and 179), or the sculptures of Lipchitz (Plate 175). Yet more so is it obvious if one looks at the still synthetic but much less geometric work of Gris or Braque in 1924–5. Works like these (Plates 180 and 148) can make such ideal accounts of the processes behind them seem frankly irrelevant. Just as Raynal's and Léonce Rosenberg's talk of universals oversimplified the Cubist's aim, so this talk of extracting the 'eternal' has little to do with the actual way in which the Cubists worked, something that Part I brings home.

179. Jean Metzinger, *Still Life with Fruit-bowl*, February 1918. Oil on canvas, 31½ × 21in. Sale: Parke-Bernet, Los Angeles, 20 November 1972, lot 19.

A more complex theory of the relationship between the Cubists and nature was necessary, one which was more responsive to the actual difficulties of the various Cubists in confronting both art and nature, and one which allowed for the wide distances between different artists, which allowed for the fact that actually they pursued not absolute but individual truths (as Raynal thought them). Gleizes, of course, was as ever the exception, and there were those who seem not to have bothered to think out the relationship between their art and nature at all rigorously; but several did bother: Gris, Léger, Braque, Lipchitz and Metzinger certainly. They were all given the firm foundation they needed by Pierre Reverdy. It was Reverdy and his friends who were the first to sketch out a theory which seemed acceptable, and Reverdy was already capable of defining its essentials within months of his essay 'On Cubism'.

He did so in an essay called 'Emotion' which was published in *Nord-Sud* in October 1917. The subject is poetry, but as ever Reverdy's ideas on poetry are directly applicable to painting and sculpture (a point on which he would have insisted). The essay develops a clear argument, but Reverdy's terminology is highly specialized and personal; the result is, therefore, not easy. He points out here that the work of art, though a 'pure creation', is constructed from 'elements' taken from life, and that the particular quality of these 'elements' is crucial to the quality of the work. They are selected, he then argues, by virtue of a certain sense of 'tact' (that is the word used in French) which is given the poet (artist) by what he calls 'the means of the spirit' ('les moyens de l'esprit'), an incomprehensible argument unless one understands what he intends by 'means' and 'spirit'.[31] By 'means' in this instance he intends technical devices: in poetry words, syntax, rhythm, etc., in painting or sculpture shapes and colours. By 'spirit' he intends one's general approach to the world, i.e. that which, as thinking and feeling beings, we bring to our perception of things: our preference for the soft or the hard, the vague or the precise, this rather than that sound or shape. So what Reverdy argues here is not that artists merely uncover eternal verities, but that they develop technical means according to their general approach to the world and the preferences which it dictates, and that these preferred shapes, colours, rhythms (these 'means of the spirit') prompt them to select particular kinds of 'element' from nature. 'The means of the spirit' are not, for Reverdy, universal. They are instead personal, the product of personal artistic exploration.

In 'Quelques Intentions du cubisme' Maurice Raynal might wrap Cubism up in an idealist vocabulary of absolutes and universals, but he can be less simplistic too, and when he is he approaches Reverdy's stance. At one point he tries really to come to grips with the creative process:

> When the painter finds himself in the presence of objects, the first work to be done by his imaginative spirit ['esprit' again] consists of an analysis of these same objects, which he studies in his sketches or in his rough preliminaries. Thanks to this analysis, he detaches the primordial elements which he considers the most beautiful and which, in his opinion, are the incontestable signs of their basic idea, or their purest form. Finally, by means of a synthetic process which he carries out using all his pictorial means, he establishes a new ensemble of all these elements.[32]

It is clear, of course, that by 1919 the advanced Cubists had broken the link between the analysis of things by observation and the synthesis of pictures or sculptures, and had consciously sought to do so; this is, therefore, a slightly misleading and out-dated interpretation of Cubist procedures. Yet at least it

allows room for the variable and the personal. Raynal might write about the 'primordial', but he makes it quite clear that the elements selected are 'primordial' for the artist only, in their (the artists') opinion ('à son avis'). And so, once again, artists are shown as selecting from nature according to the dictates of their spirit ('esprit'), their particular approach to the world, and it is this that establishes, in the last resort, the 'primordial' in their art.

There are several essays and pamphlets by Reverdy published during 1918 and 1919 which show how he continued to think in general terms much as he had in 'Emotion' in 1917. At this time too he began to use the term 'aesthetic' in a particular way within his theory, for instance in an article of 1919 called 'Cubism, Plastic Poetry'. He tended now to distinguish the 'spirit' ('l'esprit') from the artist's 'aesthetic'. The spirit is treated as a very general foundation of attitudes, philosophical or scientific beliefs, which dictate preferences. The aesthetic is treated as a personal set of preferred artistic means. These means are, of course, selected and developed as a result of general beliefs and preferences, the artist's spirit. Thus: 'To have a spirit', writes Reverdy, 'is consequently to have an aesthetic,' but 'without a personal and new aesthetic, nothing new is created'.[33]

Perhaps the most comprehensive attempt by Reverdy to unravel his idea of the theoretical basis of Cubism with all the terms ('means', 'spirit', 'aesthetic') deployed in their proper way came in 1921 with his essay 'Aesthetic and Spirit' published in the Purist periodical L'Esprit Nouveau. 'The aesthetic', he wrote here, '. . . is in the spirit and the spirit is the artist himself. The aesthetic is an armature, the spirit a measure which sustains it. . . . The spirit, I have said elsewhere, makes the epoque—the means differentiate the works.'[34]

Yet, Reverdy's taste for using his terms for suggestive phrase-making does not enhance clarity, and there is a clearer exposition of the theory in the very next number of L'Esprit Nouveau, number 7. This is an essay by Reverdy's admirer Vicente Huidobro called straightforwardly 'Pure Creation', an essay which seems to have been of some importance to Juan Gris. Huidobro's terminology is sometimes different, but the basic shape of his thinking on art and nature is very close to that of Reverdy's. Huidoboro describes how the artist who is neither abstract nor Naturalist, but who, as he puts it, 'adapts' nature, works selectively with 'elements' taken from nature to create an 'independent' work, and he calls the selection of those elements 'which are right for the work', the 'System'. This system is, of course, what Reverdy calls the artist's aesthetic; it is, Huidoboro explains, 'the bridge by which the elements of the objective world pass into the self or the subjective world'.[35] 'Technique', as he sees it, is the technical means (pictorial, sculptural or poetic) by which the elements chosen by the artist can be made objective again in the work of art—can find verbal, pictorial or sculptural form. Thus: 'Technique is the bridge established between the subjective world and the objective world created by the artist.'[36] A simple diagram encapsulates this simple idea (Plate 181). For Huidobro, 'style' is arrived at by artists when there is perfect equilibrium between what they select from the world (their 'system') and the artistic means they have selected as painters, sculptors or poets (their 'technique').

180. Juan Gris, *Fruit-bowl and Glass*, 1924. Oil on canvas, 9⅜ × 13in. Musée d'Art Moderne, Troyes. Donation Pierre et Denise Lévy.

'We say', he concludes, 'that an artist has a style when the means he uses to realise his work are perfectly in tune with the elements he chooses from the objective world'.[37]

Braque's use of the words 'means' and 'spirit' in his 'Reflections' published in Reverdy's *Nord-Sud* in 1917 demonstrates that he certainly thought about the relationship between art and nature in terms comparable with those of Reverdy's, Raynal's and Huidobro's argument, at least before 1920. Juan Gris was particularly close to Reverdy, and in fact the poet dedicated one of his most ambitious theoretical statements, *Self-Defence* of 1919, to Gris.[38] Gris's correspondence shows that, although he used language rather differently from both Reverdy and Huidobro at times, he too wanted by 1919 to bring to nature a system of formal preferences developed in the pure technical exercise of his art; he called the forms he selected 'intellectual elements'.[39] It was Gris who, in the second major phase of late Cubist theoretical activity, arrived at the most comprehensive formulation of the theory outlined first by Reverdy. He did so in his lecture given for Dr Allendy's Société des études philosophiques et scientifiques in 1924, 'On the Possibilities of Painting'.

For Gris, artists are defined as 'Those who feel the same intense emotion in front of a natural or industrial spectacle as they do in front of an artistic manifestation'.[40] And he explains that this is so because they 'modify' what they see while contemplating it:

> To use a simile, I would compare what is seen [by the artist] to a game of cards. The cards are the elements of which the spectacle is composed. When a man feels emotion at what he sees it means that he has made some personal modification in the arrangement of the cards or elements. Without abolishing or changing them, he has grouped them in a new way. He has shuffled the cards and sees them set out in a different manner. Naturally, a pictorial emotion will only be produced by a collection of pictorial elements: that is to say, elements which belong to the world of painting.[41]

A painter, therefore, sees a table, say, both according to the commonly held concept 'table' (as a flat surface with four parallel legs) and in modified pictorial terms (as 'a grouping of flat, coloured forms'). 'The pictorial elements' used by painters, Gris continues, 'have altered according to the preoccupations of each period', according to what Reverdy would have called the 'spirit' of the era. Thus, by implication, there is a link between the Renaissance development of the pictorial system of perspective and the Renaissance preoccupation with Euclydian geometry. Adapting Reverdy's notion of the 'aesthetic', he adds: 'The sum of these elements, with the influences to which they are exposed, represent at any one moment the aesthetic outlook of the period.'[42] The preferences according to which artists transform what they see, their particular aesthetic, reflect ways of thinking and seeing general to the period. 'Every aesthetic should bear a date', says Gris.[43] On technique he makes precisely the point that Huidobro had made: that artists must be able to order their 'pictorial elements' using an 'appropriate technique'. In other words, 'technique' is what allows artists to pull together a coherent work of art using the pictorial 'elements' they have extracted from nature according to their personal aesthetic. Gris even goes so far as exactly to echo Huidobro's notion of style, writing: 'Style is simply the perfect balance between aesthetic and technique.'[44]

Gris's terms are not quite either Reverdy's or Huidobro's, which tends to confuse issues, but all in all the theory of the relationship between the artist, nature and the work of art for which they struggled to find words was fundamentally the same. By the time Gris tried to articulate it the theory had become fairly elaborate, but still it can only be seen as an over-simplification of the shifting and immensely complex relationships between art and nature developed by the Cubists between 1916 and 1928. What is more, Reverdy and Raynal were right to point out that theory always followed the work, for certainly in this case the central concern with the problem of finding a place for nature in a non-representational, a formalist approach to art reflected a long pre-existent need of the Cubists, brought up in the shadow of Cézanne, not to withdraw entirely from nature. The argument that art should not simply be independent of nature, but should also convey a particular, selective way of looking at nature, was, in the final analysis, a belated rationalization of the Cubist resistance to all art which too completely separated itself from nature, and especially to abstract or non-objective art, a resistance which continued into the twenties, of course, but which was an established fact before 1917. It was perhaps a reflection of the depth of the Cubists' need to keep a grasp on nature, even as they sought the purity of synthesis, that so often they reached for natural metaphors of the most elemental kind to capture the essential character of their art: Braque, Reverdy and Gris all turned to the metaphor of the infant or child for the work of art, Huidobro to the metaphor of a newly created world.

However simplified and retrospective the theory outlined above can seem, it remains true that it reflects an approach to the relationship between art and nature whose general outlines were held in common by all the leading Cubists, from Gris to Braque to Léger to Lipchitz and even to Gleizes (though in his case as a less central concern). This theory was the way found by some of the most articulate from within the Cubist circle to define the most basic shared principles of all the Cubists, and it had the virtue of being open to very different approaches, styles and modes of expression.

A summing up seems helpful. As Reverdy, Huidobro and Gris elaborated it, the aim of the Cubists was to allow their own 'spirit' as individuals and the 'spirit' of their times to help them develop their own range of pictorial or sculptural elements. This personal 'aesthetic' would ideally at first emerge from a highly selective approach to nature, to the world of appearances, and could continue to be nourished by periodic returns to nature (as in Gris's bouts of drawing after the motif). Increasingly, however, the artist's personal range of elements would become detached from its origins in nature, and it would become possible for artists either to impose directly upon nature using their aesthetic as a transformer of appearances, or to build their own images autonomously, that is to say, synthetically. In this way, artists would be able to recreate the objects of the objective world as their own subjective inventions which were at the same time embodiments of the 'spirit' of the times. It could be said that certainly Picasso, Braque, Léger, Gris, Gleizes, Lipchitz and Laurens all recreated or transformed what they saw according to distinctly personal aesthetics which, very broadly speaking, can be understood as having developed in this way and as producing their very recognizable personal styles. The Purists stood to one side because, though they saw the spirit of the times as guiding the artist in much the same way, they played down the personal character of the artist's aesthetic in favour of searching for collective 'means', and at the same time played down the capacity of the artist to transform and to re-create synthetically. The Cubists remained deeply concerned with their subject-matter, but tended, unlike the Purists, to be drawn to *different* subjects even if within a fairly restricted range: Braque to his fruit, his white napkins and his nudes; Léger to engines, industrial architecture

181. Vicente Huidobro, *Diagram*, published in *L'Esprit Nouveau*, no.7, March 1921.

and manufactured products, for instance. What is more, they always aimed in the end to dominate what they saw, to *impose* upon it. For them, as Pierre Albert-Birot's Socratic artist 'Z' had insisted, art began in the artist, not in nature.

The Cubist stance, it should now be clear, brought together painters and poets. It was articulated in unison both by artists, from Braque in 1917 to Gris in 1924, and by poets, especially Reverdy, Dermée and Huidobro. At the same time, it applied equally to visual art and to poetry, as these friendly allies across the arts understood it. Something needs, therefore, to be said (by way of a gloss) about the relationship between visual art and poetry within this alliance.

Apollinaire's development of the 'calligramme', which used strings and clusters of words to give poems the shape of visual images, and his promotion of the verbal in post-collage Cubist painting had led to a blurring of the boundaries between poetry and visual art from 1913 which was to be taken a long way further by the Dadas. But, from 1917, within the Cubist circle, the distillation of Cubist theory and practice, with its increasing accent on the autonomy of the painting, sculpture or poem, led to a decisive attempt to separate clearly the visual from the verbal. It was this antipathy towards any hint of a fusion between the arts that in part prompted Reverdy to reject the use of the term 'literary Cubism' for his poetry, even though it was Dermée who was its inventor when he was still close to Reverdy late in 1916. 'There is', Reverdy writes, 'a kind of poetry which has, in fact, been called "Cubist" . . .; but why want to designate one art by a term which already designates another?'[45] As he makes very clear in this his most extended rejection of the term (in March 1918), his irritation is founded on the conviction that he and the poets close to him were attached: 'to a pure poetic tradition'.[46] And there is evidence that from among the painters Gris certainly saw the danger of thinking of Cubist painting as an off-shoot of poetry, that he too identified painting, by the same token, with its own 'pure' tradition.[47]

This decisive separation of painting from poetry did not, however, mean that even the most 'pure' thinking of the Cubist circle completely separated the previous histories of painting and poetry, and did not conceal their conviction that fundamentally painting and poetry were to be approached following the same broad principles (as has been seen). 'An aesthetic', wrote Dermée in 1919, 'of which several primary truths were discovered long ago by Mallarmé and Rimbaud, has spread with marvellous effect into Cubist painting and the literature of the new spirit.'[48] As he and Reverdy presented it, Mallarmé and Rimbaud had been the first to lead the way to the detachment of art from the imitation of nature, the Cubists had been the first to exploit the implications of their discoveries (doing so in the visual arts), and now, following the lead of Apollinaire and Jacob, poets like themselves had followed.[49] Reverdy might not have accepted the term 'literary Cubism', but he believed enough in the fundamental unity

of his poetic practice and the practice of the Cubists, each within their own medium, to entitle the essay of 1919 in which he most thoroughly dealt with the relationship between Cubism and poetry after Mallarmé and Rimbaud: 'Cubism, Plastic Poetry'.[50]

If the key to the separation of the Cubist painting from nature in practice was the separation by the artist of a vocabulary of 'elements' to be used freely in composition, then the key to the separation of the poem from the merely descriptive and anecdotal, was the free use of words detached from their normal referential usage in daily life. This was the basic lesson taught poets by the example of Mallarmé and Rimbaud viewed from a great many directions at the end of the 1914–18 war.[51] In March 1918 Reverdy published a major if brief article in *Nord-Sud* called simply 'The Image'. Here he outlined a highly influential notion of the nature and function of the poetic image. It was a notion that isolated the poetic image as *the* vehicle for the detachment of words from the restricted meanings of daily use. 'The image', he wrote, 'is a pure creation of the spirit. It cannot be born of a comparison but [only] of the coming together of two more or less remote realities. The more the conjunctions of two . . . realities are distant and right, the more the image will be strong—the more it will have emotional power and poetic reality.'[52] He had in mind such 'images' from his own then current poetry as 'The sun punctures its eye-ball', or from Huidobro's as 'A rain of wings/Covers the ground' (inspired by falling leaves), where the words 'sun' and 'eye-ball', or 'leaves', 'rain' and 'wings' take on new meanings within the framework of the poem because of their particular conjunctions.[53]

Attached to the whole structure of Reverdian and Cubist theory, this notion of the poetic image brings thinking about the practice of poetry close to thinking about the practices of painting and sculpting. The poet's 'elements' were words which were initially attached to everyday meanings, just as the painter's 'elements' were flat coloured shapes initially attached to natural appearances. The poetic image was endowed with such importance because it detached with remarkable effectiveness the poet's 'elements' (words) from their original attachment to things and engaged them in a new 'poetic reality' (a new and different field of connotative meanings). Just as in pictorial composition coloured shapes could combine to generate a new emotional response, so through the image could words in poems. The sun as a punctured eye-ball was neither the sun nor a punctured eye-ball but something else created by their conjunction. Sets of habitual connotative meanings were scattered, and new ones engendered.

As Kahnweiler was the first to show, Reverdy's notion of the poetic image directly affected developments in painting, because Gris's use of visual rhymes (similar shapes signifying different things), seems to have followed to some extent from it.[54] He too found conjunctions, as seen in Part I, between

the apparently unrelated: heads and fruit-bowls, grapes and guitars, eyes and buttons (Plates 46, 35 and 174). What is more, he was not alone in using the visual rhyme as a purifying device after 1918. Yet, the clear division in both Gris's and Reverdy's minds between the visual and the literary was not blurred by this transference of the poetic image into painting, for the fact remains that Gris's 'poetic' images on canvas were considered entirely visual, that their pretext lay in the inter-action of flat coloured shapes, and that the initial formulation of Reverdy's notion of the poetic image was directed solely at poetry. Further, it was a notion that continued to be of far more central importance to the poets than to the artists, at least within the Cubist circle. In fact, as René de Costa has shown, Gris was himself actually a Reverdian writer as well as a Cubist painter, at least in 1917–18 (part-time). He played a frankly intrusive role in the translation of Huidobro's poems into French, often heightening both the purity and the impact of their images, and he even seems to have tried his hand at producing a couple of Huidobro-like poems himself. Yet, what is striking about these attempts is their sheer literariness: they are as exclusively literary as his paintings are exclusively pictorial.[55]

In February 1918 Reverdy published a curious poem in *Nord-Sud*. It is called, simply, 'Note', and it is a brief, oblique allegory of the passage between inspiration, creation and appreciation in art. It begins with twelve musical notes 'vibrating in the silence' which 'produce an emotion'. One is detached. Words shine on the table. They form 'a whole more alive than a music-hall performer'. The spectators watch as the table is fixed to the ground by 'luminous bands'. The words, the artificial light and the author have disappeared, the author 'carrying off his secret', but everyone knows what was said, and a 'unique emotion grips them'.[56] It is an allegory that can be transposed into terms that apply to Cubist art altogether as it was ideally thought of from within, both painting and poetry. Artists detach also from the world what moves them, and make a new whole, apart from the world—the painter using coloured shapes to create new figures and objects, the poet giving words new meanings by the invention of new poetic conjunctions or images. And artists also, thus idealized, aim to generate with their new 'wholes' an emotion in the spectator or reader whose force will not be diminished by the artists' absence. The work is made self-sufficient; it can do without its creator, in the end.

* * *

There is a final point to make about the basic theory first articulated by Reverdy and his friends. At one and the same time it rationalized the Cubists' resistance to abstraction and the return of so many of them to apparently traditional representational styles. For, though artists were incited to reject altogether the imitation of nature, the injunction was always there never to forget nature in their work; and the injunction was there as well to learn from the past, as will become clear later. It was a theory flexible enough to justify what so many saw as a betrayal of Cubism. As demonstrated in Part I, the Picasso who turned publicly to Ingres was repeatedly treated as no less a Cubist for doing so, especially by André Salmon. Even the rigour of Reverdy's thinking could be adapted to accommodate this apparently irreconcilable contradiction. Thus, in 1923, writing in *Paris-Journal*, he makes absolutely no distinction between Picasso's Cubism and his other, alternative styles (Plates 182 and 204): he considers them all equally 'pure'. 'Now the art of Picasso', he writes, 'has always been, as much in [his] Cubism as in the other manifestations of his personality, an eminently plastic

182. Pablo Picasso, *Glass, Bottle and Packet of Tobacco*, 1922. Oil on canvas, $13\frac{3}{8} \times 16\frac{1}{2}$in. Oeffentliche Kunstsammlung Basel, Kunstmuseum.

art which draws all its force of expression from the choice of exclusively pure means.' Picasso's aim in *all* his art, according to Reverdy in 1923, was: 'To arrive . . . at the production of works by using certain extremely simple, even rudimentary constitutive elements . . ., i.e. the elements of his own 'aesthetic'.[57]

Picasso himself developed an argument along these lines in the much quoted interview he gave earlier in 1923 to Marius de Zayas:

Naturalism is talked of in opposition to modern painting [Cubism]. I would like to know if anyone has ever seen a natural work of art. Nature and art, being two different things, cannot be the same thing. Through art we express our conception of what nature is not. . . . From the painters of the origins, the primitives, whose work is obviously different from nature, down to those artists who, like David, Ingres and even Bouguereau, believed in painting nature as it is, art has always been art and not nature. And from the point of view of art there are no concrete or abstract forms, but only forms which are more or less convincing lies. That those lies are necessary to our mental selves is beyond any doubt, as it is through them that we form our aesthetic point of view of life.[58]

By 'lies', he intends what Reverdy called 'means', pictorial devices (the French is actually 'truchements'), and his talk of an 'aesthetic point of view of life' is, of course, squarely Reverdian. 'Cubism', Picasso goes on, 'is no different from any other school of painting. The same principles and the same elements are common to all.'[59]

It was in this way that all who had been and still were within the Cubist circle and who, after 1920, apparently retreated into a more representational art, rationalized their new stance and convinced themselves that it did not mean a renunciation of Cubism. This is the attitude behind those comments of Metzinger's published by *Montparnasse* in 1922, of which this is a particularly telling sample: 'I know works whose completely classical appearance translates the most personal, the most original, the newest conceptions.'[60] It is also the attitude guiding Severini when he writes to Lipchitz in the autumn of 1921 obviously in response to accusations of retreat claiming not to see how it could be thought that he is reacting against Cubist construction. It is Severini's contention here that all he has done is to extract the aesthetic essentials from Cubist art so far as 'tradition' and the prac-

ticable allow.[61] One could remain primarily concerned with formal invention and yet court both the look of past art and of nature represented. Even Léonce Rosenberg took the point, after all he did not force a break with either Metzinger or Severini, and at almost the same time, in the autumn of 1921, he could conclude his criticisms of Léopold Survage's latest pictures for their 'too apparent' geometry thus: 'Certainly the true artist must invent forms, but it is necessary that he carries these into life, and to do that, he must wrap them in that living and supple envelope worn by all the creations of nature.'[62]

What mattered to the Cubists was that the artist's aesthetic should be dominant in the transaction between nature and the artist: that artists should extract only those elements from nature which conformed with their own special language. So long as this was so, the process of creation could either begin in the artist's imagination, in that play with abstract shapes which is the ideal starting-point of the synthetic Cubist composition, or it could begin in the artist's manipulative and selective observation of nature, with an autonomous repertoire of forms as it were carried intuitively into nature or imposed upon it. Both the alternative Picassos were therefore acceptable, and so were the new Metzinger and the new Severini of 1921; and they all in different ways sought to underline the continuity between their Cubist and their apparently non-Cubist art. Thus, in the end, the effect of the exaggerations and distortions to which Picasso treated the Neo-Classical figurative ideal in such works as the Biarritz *Bathers* and the *Three Women at the Spring* (Plates 75 and 74) was as much to accentuate that continuity with Cubist invention as it was to give an ironic twist to his acknowledgement of past styles; and the effect of Severini's easily discernible geometric armatures in the Montegufoni frescoes and of both his and Metzinger's distinctly artificial colour (sharp, on the one hand, sweet on the other) is comparable (Plates 69 and 65).

A theory or a set of attitudes with so accommodating a scope may seem to blur rather than to clarify distinctions, and yet in the Paris of the post-war decade it added up to a very distinct approach, and it lies at the heart of the manifold differences between the Cubists and their adversaries, indeed, between the Cubists and both their conservative *and* their radical adversaries. It is worth returning to the first principle agreed by all the Cubists, which remained at the core of all the elaborate theorizing in which they indulged during this period. Art, they agreed, might use nature, but it could never be *about* nature, it could only be art: different both in its means and in its ends; different, that is, in the emotion it generated. It was this fundamental conviction, the core of the Modernist stance, now crystallized and immovable at the heart of Cubism that was the ultimate justification for all that Cubism's enemies could not accept. It led to the Cubists' lack of stress on legibility, their apparent obscurantism, and, as a result of this, it led to their élitism. Those defenders of Cubism who accepted its élite position identified what the 'general public' liked above all with painting or literature that stressed life at the expense of the pure plastic values of art. It was this that Ortega y Gasset was to pick out as the key weakness of Modernism in his essay 'The Dehumanization of Art', written towards the close of this period.[63]

The Cubists were neither rule-bound, as many of their conservative enemies maintained, nor necessarily mathematical, nor unspontaneous, nor lacking in invention, but they were dedicated to an uncompromising notion of aesthetic purity, and they resisted any art whose prime *raison d'être* was nature or life. For some of their friends as well as their enemies, therefore, the obscurity and unpopularity of their art was not the transient result of its novelty; it was inevitable. Also inevitable was the fact that on the conservative side their most determined enemies were not so much those whom Raynal called 'Eclectics' as the Naturalists, those whose work was given its sole *raison d'être* by nature. So the next chapter takes up the arguments produced by the opposition between Cubism and Naturalism, and the whole range of attitudes to the relationship of art with nature that lay in between these two extremes in the world of *l'art vivant*.

11
Art and Nature

In 1912 Roger Allard had been a leading champion of the Cubists. By the end of the Great War he had turned against them.[1] Here is his reaction in his own little periodical, *Le Nouveau Spectateur*, to Picasso's Cubist work on show at the galerie de l'Effort Moderne in 1919:

> M. Picasso has shut up a number of painters and himself with them in a vast hall. M. Braque has put the key in his pocket. To entertain themselves the colours are changed as often as possible. Like that [there's] a slight lack of air, sometimes a prisoner kicks the wall, another, forehead stuck to the window, gazes with regret at the life which flows on outside. And all keep M. Picasso under surveillance out of the corner of the eye, reputed [as he is] capable of clandestine escape, through the key-hole.[2]

Picasso the demonic genius, Braque the willing accomplice, Cubism the airless prison, in metaphor all the facets of the conservative image of Cubism are there, but the metaphor has such force because of the clarity with which it captures the separation of Cubism from life, from nature.

From the date of Vauxcelles's earliest attacks on Cubism, it had been the Cubist's rejection of nature as the prime generator of their art that had sustained conservative hostility. Even as early as the aftermath of the Salon d'Automne and the Salon de la Section d'Or of 1912, Vauxcelles had considered the Cubist claim (made by Apollinaire and Raynal above all) to produce 'pure painting'. 'Good,' he writes in *Gil Blas*:

> We are concerned, then, with people who turn their backs on nature, O.K., it's here that I confront them. For I do not believe at all that one can create artistically without the help of nature. That one must add to her—*homo additus naturae*—every one knows, and to repeat it is a truism. What interests me is not Rome but what Poussin or Corot have seen in it. Those who commit themselves servily to copying the object, without recreating it, are useless . . . Imitation is the condition of art, not its end.
>
> But nothing valid is created without nature. One only creates with her. And without her, Cubist, you will end up only with spectres, with abstract phantasms, with bizarre arabesques, with 'hot chromatics', with 'kings traversed in fourth gear', that is to say with nothingness.[3]

As we have seen, the clearest division within the world of *l'art vivant* in the post-war decade was between Cubism and Naturalism. Terms are difficult again here, for the terms Naturalism, Realism and Impressionism were casually interchangeable as used by some critics after 1918; but Naturalism is perhaps the least misleading, used to refer to art directly concerned with the experience of nature. From as early as 1910 Cubism had consistently been presented as a reaction against Impressionism; it was thus the long-established opposite of such art. We have seen with what certainty and simplicity Léger, Lhote and Raynal made the distinction; to reinforce the point, here is Lhote again, writing late in 1920:

> There remains today only two possible orders of thought in art. There remain evident only, on the one side, the Impressionist ideal (to which are attached the bad imitators of Cézanne, the lazy disciples of Sisley and Monet and those 'fauves' now enraptured by their comfortable cage)— and, on the other, the Cubist ideal embracing all those painters who renounce the direct language.[4]

Later, of course, he was to divide Naturalism in two by recognizing the existence of a 'constructive Naturalism', and to see Cubism as divided into two tendencies, the 'pure' and the '*a posteriori*'; but basically the distinction was always a simple one for him.

The central purpose of this chapter is to explore the attitudes to the relationship between art and nature that lay across the spectrum from Naturalism and its conservative supporters to Cubism, and to see how those attitudes underlay the conflicting images of Cubism constructed by its friends and enemies. For most who were concerned or involved with *l'art vivant* after the Great War, these attitudes were inextricably an aspect of meaning. The artist, whether Cubist or Naturalist, communicated in each work his own personal stance *vis-à-vis* art and nature, the work and its declared subject-matter. Response was therefore dictated in a very immediate way by the spectator's awareness of this relationship, by acceptance or rejection of the work as signifying either an ideal aesthetic autonomy or the centrality of nature in art.

Having looked at the Cubist stance in some detail, the intention here is to flesh out the Naturalist stance before looking at the space between them. A start is to be made by giving a fuller idea of what Naturalists could produce, how their art could be seen by their own supporters and by making a few generalizations about the character of its development in individual cases by contrast with Cubism. There is to be no attempt here to give a balanced coverage of the entire range of Naturalist or near-Naturalist art during the period, nor of all the stances that occupied the space between the Naturalists and the Cubists; instead a few particularly revealing cases will be picked out and explored as a way of illuminating the matrix of attitudes and relationships. Later in the chapter Matisse, now as then the most respected figure to be identified at this period with broadly Naturalist attitudes, will come into the picture, but to begin with the focus will be on painters now considered much lesser. Most important here will be the cases of Maurice Vlaminck and Dunoyer de Segonzac. Considered at the time paradigmatic Naturalists, they were the authors of particularly telling statements of their convictions; much, therefore, is to be learned from them.

*　　*　　*

The first generalization to make about the development of the Naturalists is that it was almost always slow, as each artist gradually took to maturity a particular way of interpreting what was seen. Abrupt stylistic change is a characteristic of the development of Cubist art. It was especially obvious in the most exploratory years, between 1909 and 1914, and

183. Maurice de Vlaminck, *The Square at Bougival*, 1916. Oil on canvas, 28½ × 36in. Sale: Christies, London, 29 March 1977, lot 32.

184. Dunoyer de Segonzac, *La Foulie in the 1500 meters*, 1924. Pen and ink, whereabouts unknown.

the cases of Picasso and especially Gris reveal a greater openness to change within Cubism during the Great War than afterwards in the twenties.[5] But still Gris was capable of drastically switching the direction of his art in 1922 (Plates 98 and 108), and all the Cubists, even those who turned for a while to traditional styles, remained open to such major switches of direction; indeed, those very moves to traditional styles made by Metzinger, Severini and Herbin were expressions of that openness. By contrast, the Naturalists stressed individuality but not the importance of change. As Vauxcelles repeatedly insisted after 1918, what was wanted was to move beyond the stage of experiment into 'realisations'.

Maurice Vlaminck had spent many years after the excitement of his early Fauve phase attempting to adapt the discoveries so slowly and patiently made by Cézanne to his more mercurial, more hasty relationship with nature. In works of 1916 like *The Square at Bougival* (Plate 183) there was still a vague but visible link with the late Montagne Sainte-Victoire pictures of Cézanne. By the early to mid-twenties, however, when *The 14th July* (Plate 185) and *The Nantes Road* (Plate 186) were painted, the unmistakable planar fragmentation which gives a certain constructed firmness to the earlier composition had given way to a dominant bravura, and the thick paint, streaked and flicked and swirled here, had become a constant in his art, as had the dull hues of a distinctly Northern colour range. So minimal are the changes that dating by style becomes virtually impossible in the twenties, and the only reliable (if approximate) guide is evidence of what was shown in the Salons and the exhibitions of the period.

Dunoyer de Segonzac, like Vlaminck, had moved through a long exploration of the implications of Cézanne's work for him. This had included his grand personal gloss on the *Card Players*, his *Drinkers* of 1910 (Plate 157). But, although he never lost a firm sense of structure based on broad, balancing areas of browns, blues and greens (a sense of colour structure which was in origin Cézannist), by 1920 he had arrived at something that could no longer be called simply Cézannist. The underpinning of his art in the twenties was an astonishing facility as a high-speed draughtsman, a facility that he had exploited on the front during the Great War and that he continued to indulge in his studies of action at the sporting events so popular after it, especially the Paris Olympics of 1924 (Plate 184). Sequences of drawings lay behind the supple and often complex poses developed in his figure paintings, for instance *Nude with a Newspaper* of 1921 (Plate

185. Maurice de Vlaminck, *The 14th July*, 1923–25. Oil on canvas, $25\frac{1}{2} \times 31\frac{3}{4}$in. Sale: Sotheby & Co, London 1 December 1971, lot 67.

186. Maurice de Vlaminck, *The Nantes Road*, c. 1922–23. Oil on canvas. Sale: Parke-Bernet, New York, 17 April 1969, lot 84.

187. André Dunoyer de Segonzac, *Nude with a Newspaper*, 1921. Oil on canvas, 36⅜ × 23⅝in. The Tate Gallery, London.

188. André Dunoyer de Segonzac, *The Way to the Farm*, c.1923. Oil on canvas, 23 × 31¼in. The Tate Gallery, London.

187). Yet, his handling of paint was so bold and so broadly conceived that his pictures effectively conceal their graphic beginnings. He worked with the palette-knife, lavishly building up thick layers of pigment, the divisions between one patch and another broken and ragged, the surfaces rough. It is confident, decisive painting, as much in landscape (Plate 188) as in still life (Plate 191) or figure painting, and it was capable of large-scale, ambitious Salon statements like the

Boating of 1924 (Plate 189). Again, like Vlaminck's, stylistically it changed hardly at all in the decade after the Great War.

As was made clear in Part II, both Vlaminck and de Segonzac were central figures in the commercial and official success of *l'art vivant* during the twenties.[6] They were both chosen for the official exhibition of 1925, 'Fifty Years of French Painting', and their work had entered the Luxembourg by 1926. Their stature was almost taken for granted during this decade. Vlaminck enjoyed the accolade of a contract with Matisse's dealer Bernheim-Jeune, and by 1925 his commercial success was such that he had moved from the suburban Chatou of his youth to an old farm in the countryside not far from Dreux. There he converted a comfortable country-house, La Tourillière, and, as the journalist Georges Charensol recalls,

189. André Dunoyer de Segonzac, *Boating*, 1924. Oil on canvas, 78½ × 82in. Private Collection, Switzerland.

adopted the air of 'a gentleman farmer with his tweed jacket, flat hat and eternal red neckerchief', while taking great pleasure in driving fast round the country roads in his Chenard.[7] Charensol was then one of the writers employed by Florent Fels and Jacques Guenne on *L'Art Vivant*, and he also recalls many weekends spent at La Tourillière with Fels in the mid-twenties.[8] Vlaminck's involvement with Fels and therefore *L'Art Vivant* was close and it was natural that *L'Art Vivant* especially should have celebrated his success. A high-point was reached at the end of 1925 with a well-received exhibition at the galerie Bernheim-Jeune. Three years earlier Matisse had scored an unqualified success at Bernheim-Jeune, and Charensol was moved to compare the two exhibitions. 'Before these manifestations', he wrote, 'these painters were both celebrated and their talent universally recognized, but their works provoked argument, some still refused to . . . admire . . . After the exhibition put on by Matisse . . . no one dreams of resisting his charm; after the exhibition put on by Vlaminck now, no one will dream of resisting his power.'[9]

Throughout the period de Segonzac remained with the Left Bank dealer Léon Marseille of the galerie Marseille, but his success and reputation seem not to have suffered. According to Salmon, he was one of the leaders of the 'young movement' at the Indépendants of 1921,[10] and repeatedly from then on his influence at the Indépendants and the Salon d'Automne is commented on by Salmon who continued to respect his force of leadership but deplored what he saw as

the vapidity of his 'pseudo-disciples'.[11] His importance and his quality were hardly challenged, and even Maurice Raynal, who resented his success deeply and saw it as a dangerous threat to Cubism, could name him in 1924 as one of the four greatest living French painters, placing him alongside Picasso, Braque and Matisse.[12] The 100,000 francs paid for *The Drinkers* in 1925 and the generally high prices paid for his work at sales between 1924 and 1927 testify to the way that his reputation was reflected by a commercial success that was equally sustained through the mid-twenties.[13] There was no doubt that, after the War, he, like Vlaminck, was a major artist; both were artists whom no one in the world of *l'art vivant* could ignore.

The images of Vlaminck projected by his statements and by his admirers' interpretations in the twenties both contained contradictions and can be seen to have shifted a little. Throughout the period, those who wished to praise him celebrated his directness, his robustness and his spontaneity as a painter inspired directly by nature. Reviewing a mixed exhibition at the galerie Paul Guillaume in December 1918, Salmon writes of Vlaminck's 'robust hand like love'.[14] He was, according to Robert Rey in 1923, 'a born painter' and generally conservative opinion agreed with this sentiment;[15] he was a painter more to be associated with the immediacy of Barbizon School Naturalism, with Monticelli and Diaz, than with Cézanne, especially as he was presented by *L'Art Vivant*.[16] Yet, already in 1919 André Salmon was able to point to something more profound, which drew Vlaminck to the 'settings for tragedy', to subjects ignored by either 'Realist' or Impressionist forebears, and it was this expressive element that was particularly stressed at the time of his exhibition at Bernheim-Jeune in 1925.[17] Salmon again was to the forefront, writing thus: 'Vlaminck's landscapes are the most tender and the most tragic of all. This painter, who loses his temper when he hears psychological anxiety being preached at the young landscapists, has given the least joyful, the least flowering of the plains of the Ile-de-France the most tragic vision and, in their plastic nakedness, the most human evocativeness that they can contain. . .'[18] By 1925, when the writers of *L'Art Vivant* were intent on seeing around them the beginnings of a Romantic revival after the 'constructive Naturalism' considered dominant in the early twenties, a definite shift in Vlaminck's projected image took place, a shift towards the 'Romantic'. And, since his pure gifts as a painter were still, it was claimed, undiminished, and since these, following the broadest current definitions, could be called Classical, it was possible for Charensol to hazard the following contradictory judgement: 'Vlaminck is the first painter of our times who has reconciled by his genius the Romantic and the Classic', an achievement apparently made without loss either of directness or power.[19]

There was one sympathetic critic, Edmond Jaloux, who could write of Dunoyer de Segonzac in similar Romantic terms in 1925.[20] His was, however, an exceptional, even bizarre view, for de Segonzac was the very type of the constructive Naturalist, *the* vindication of Vauxcelles's belief that out of Cubism might come a more solid and structured Naturalism. 'M. Dunoyer de Segonzac is, first of all, a constructor,' wrote Salmon in 1918, 'rough, violent, absorbing himself into the matter [of his paintings].'[21] The roughness was characteristically balanced against the qualities of order and control. 'Nobility', 'sobriety', 'refinement': these are the epithets applied by Louis Léon-Martin to the de Segonzacs in the Salon d'Automne of 1920,[22] and, when in 1921 Salmon returned to him as a leader of the 'young movement' at the Indépendants, he eulogized thus: 'If we must recognize the new marriage of Painting and Architecture, we must see there de Segonzac in the costume of the bridegroom. Measure,

equilibrium. . .the words in capitals. . .are right to describe his work.'[23] Often he was seen (like Vlaminck) as having moved beyond Impressionism, though in the direction thus of order rather than Romantic expression. For the art critic of the *Revue de l'Époque*, Schneeberger, responding to de Segonzac's widely acknowledged triumph at the Salon d'Automne of 1922, he was the 'typical example of that very characteristic development' that has taken artists from the 'study of atmospheric flux to the study of formal densities'; he was actually a major factor in the reaction against Impressionism.[24] So commonly accepted was the image of de Segonzac as constructor that in 1925 *L'Art Vivant* could caricature him as painter-stonemason (Plate 190).

Yet, the image of de Segonzac as the constructor always balanced, never supplanted, the image of de Segonzac as the artist dedicated to nature, the arch-Naturalist of Maurice Raynal's *Anthologie de la peinture en France*, and perhaps the most telling indication of this is the ease with which commentators paired him with Courbet (a de-politicized Courbet, of course). Thus, for Robert Rey in 1922, he is a 'son' of Courbet, for Salmon in 1925 he is the 'great nephew' of Courbet, while for Edmond Jaloux in the same year he is a relative, unspecified but unquestioned.[25] He may have been seen as one reaction against Impressionism and he may have been seen as a constructor, but his profound antipathy to Cubism was obvious. 'Dunoyer de Segonzac arrived at full awareness of his powers at the moment when Cubism was imposing its rule upon almost all the young painters,' recalled Roger Allard. 'He was clever enough to lavish on the Cubists the benefits of his pleasantness and of his charming fantasy, while carefully keeping away from all influence, more strictly enclosing himself in his naturalism.'[26] His art taught a lesson of long-term resistance to Cubism, and long-term commitment to nature directly experienced.

190. Cartoon, published in *L'Art Vivant*, 15 January 1925, p.39.

Segonzac, ou le maçon des sous-bois

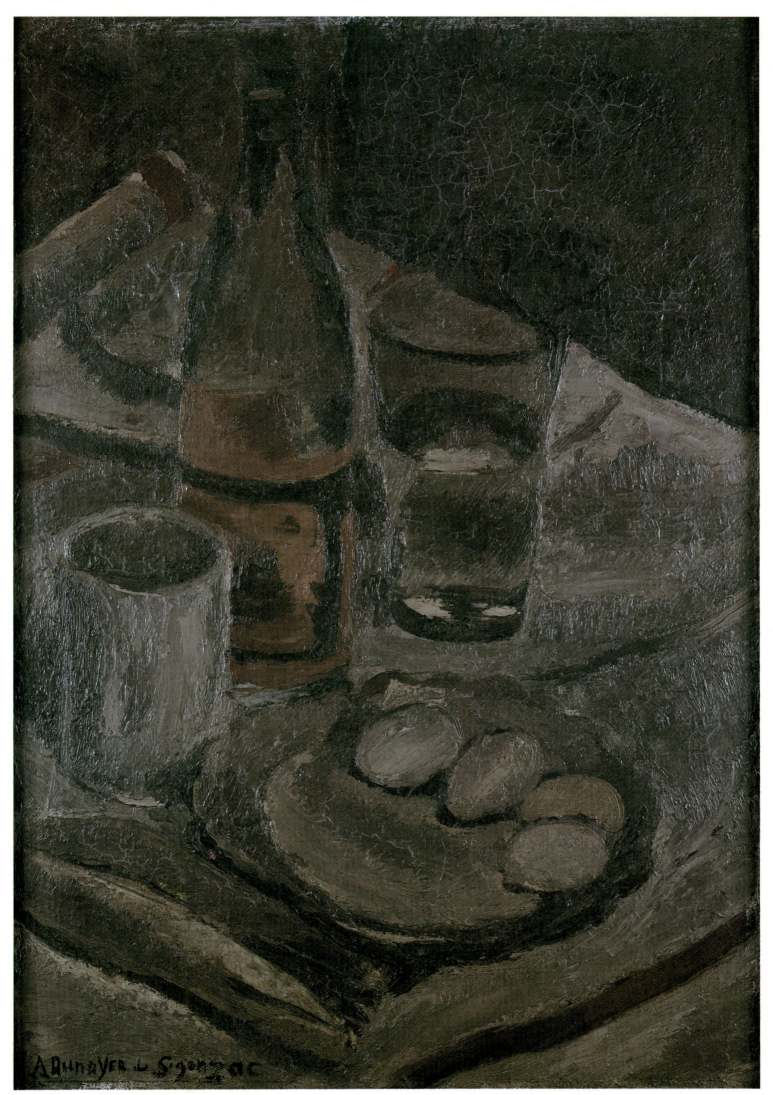

191. André Dunoyer de Segonzac, *Still Life with Eggs*, c.1923. Oil on canvas, 23¼ × 14¾in. The Courtauld Institute, London.

For those who especially admired their work, above all the contributors to *Le Crapouillot*, *Les Nouvelles Littéraires* and *L'Art Vivant*, Vlaminck and de Segonzac stood for qualities in art to a large extent beyond the reach of the Cubists. And essential to the qualities perceived in each was the closeness of their art to life, to the direct experience of nature. The qualities that these artists projected through their work to be celebrated by such writers were indeed beyond the reach of the Cubists, for, if Cubism is to be grasped more acutely by a realisation of what it was *not*, then the painting of Vlaminck and de Segonzac represents fairly comprehensively what it was not. The Cubists quite consciously saw their art in clear-cut contradiction to such painting and to the image constructed of it by its supporters, most obviously, of course, to the image that they constructed of painting totally dependent on nature responded to at first-hand. In the same way, Vlaminck and de Segonzac more or less consciously saw their work in clear-cut contradiction to Cubism, most obviously to its ideal of purity and freedom from nature. It is this that is conveyed so effectively by the statements published during the period by these two artists. The views of Vlaminck in particular were often recorded in the press in articles or in pithy quotes offered to helpfully attentive journalists, but there is one statement by each of the two that pulls together the total shape of their stance very conveniently. Indeed, these statements encapsulate in potent form the essence of the hostility towards Cubism and the commitment to nature that fuelled almost all the attempts to kill the movement off by polemic between 1918 and 1928, at least from the direction of conservative opinion. They were both made in interviews given by the artists which were published by *Les Nouvelles Littéraires*: de Segonzac's with Florent Fels was published in December 1923, Vlaminck's with Jacques Guenne in November 1924.

Cubism provokes both to indisguised rage. 'As for me,' says Vlaminck, 'I assure you that I sensed the threat of war from 1908. Already the era of folly was begun. For from 1908 dates . . . that folly which is called Cubism.'[27] Vlaminck was as brutally pugnacious an anti-intellectual as any, but de Segonzac it is whose rage against Cubism captures that insistent anti-intellectual note most directly achieved in the outbursts of critics like Robert Rey and especially Maurice Hiver.[28] 'There has been', de Segonzac declares, 'a desire to take things over: false African, . . . Hellenic art for today's taste, the aero-engine aestheticized . . . plastic syntheses, artistic distillations for the engineers of art. All this unheard of art, and all these distortions: death . . . French art! It's made into an export commodity . . . it's all ersartz.'[29] Having neared incoherence in his anger, de Segonzac finds a focus in his anti-intellectualism: 'An art critic should judge a work of art as a horse-dealer judges a horse, and above all should not find there a simple excuse for having fun with words. I have the feeling that they are learning to be natural again in France. Aestheticism is the death of art.'[30]

Vlaminck's and de Segonzac's anger against Cubism finds its equal in intensity in what is, of course, its origin, the unreserved commitment they express to nature. They rage against Cubism because it strikes at the very roots of their art, its roots in their deep and undoubtedly sincere feeling for the things they paint. De Segonzac puts it thus: 'As for me, I aim to express to the best of my ability, with all my love, that which I love: a French landscape, a beautiful woman with a noble body. One will see later if it is art.' 'I believe a great deal in solitary work; the state of grace is revealed in contact with nature. A French peasant said to me one day: "It's odd how the world becomes stupid when it has too much teaching".'[31] Vlaminck tries to make it seem as if there is no distinction at all between his art and his experience of nature, life. 'My secret', he says with typical gusto:

> I step into my painting as if into my house. I step into it with my life. And when I am healthy, and when I work optimistically as I should, I am not inferior to the job I've set myself. This landscape in front of me, I carry it like a mother carries her child, and I make it as I wish it to be in my heart. One day, beneath a stormy sky which clawed the black, bare trees, I knew the greatest happyness of my life. Forgetting all that any one else had done, all that I had done myself, up to then, I arrived, a man before nature, at the way I painted when I was sixteen years old.[32]

Like de Segonzac, Vlaminck saw his relationship with nature as an innocent, immediate relationship, though he made much more of his claim to innocence; his other most usual target besides Cubism was the knowledgeable respect for the art of the museums which his one-time Fauve companion, André Derain, now represented.

Writing in 1917 on portraits (not long after Reverdy had questioned the very possibility of a Cubist portrait in his essay 'On Cubism'),[33] Vauxcelles reflected thus on the ideal relationship between artist and nature: 'Copy with all your heart, thus commanded that good fellow Chardin, who had not anticipated the [Cubist] refusal to obey nature. To copy does not mean to copy everything . . . The aim of art is not at all imitation.' And then: 'Each [artist] paints according to his soul, his sensibility, his emotion . . .'[34] There was from time to time among the pro-Naturalist critics, including Vauxcelles, a tendency to imply an empathetic relationship with some inner spirit in nature, but the creed (Zola's creed) that art was nature seen through a temperament, was the dominant creed of the Naturalists and their friends. There was no acceptance for the view that Naturalist painting could, in some objective way, be unmediated and 'natural'.

Curiously, there is nothing fundamentally to separate the Naturalist view that art came of the artist's subjective vision of nature from the conceptual version, at least, of the Cubist view: the belief that the artist should paint or sculpt his 'idea' of things. Indeed, Vauxcelles actually echoed certain of the statements made by critics in defence of Cubism when he wrote against it, even as early as 1912. As he said in *Gil Blas* (as quoted at the beginning of the chapter), it was not Rome that interested him so much as 'what Poussin or Corot have seen in it'. And at the time, the contradictions in his position were noticed by some, including Olivier Hourcade in his published reply to that very statement. 'The true definition of Cubism seems to me to be', Hourcade wrote in *Gil Blas*: '*The return to style by way of a more subjective vision of Nature*', and he expanded on the point thus: 'If what interests you [Vauxcelles] in the work of Poussin, is what Poussin felt before Nature, I do not doubt that, before the work of one of the masters of this movement of liberation [Cubism], you will soon become interested . . . in what [that] painter has felt before Nature.'[35]

It was the extent to which the Cubists were prepared to go in pursuit of subjective interpretation that separated them from Vauxcelles and his like in 1912, coupled with the stress thay laid on the intellect rather than emotion as a transformer of appearances. Such a stress on intellect with its concomitant, the tendency to flirt with the notion of absolutes (however personal) and therefore to work with primary geometric forms, could not be tolerated. Yet, more fundamentally important was the fact that pro-Naturalist critics and Naturalist painters could not accept the Cubists' alliance of the conceptual, subjective view of nature with the Modernist belief in the

autonomy of the art-work. If it was possible to accept that nature was transformed by the interpretative power of the artist, it was not necessarily possible to accept that the artist could begin by the manipulation of abstractions before turning to nature at all, nor that the sculpture or painting existed quite apart from nature as the artist's own invention. Since by 1918 the side of Cubism that stressed 'pure painting' had become by far the dominant one, almost reducing the conceptual side to nothing, inevitably the schism between Cubism and Naturalism widened. Pro-Naturalist critics could never accept those who turned to so 'pure' an approach, but significantly they accepted those who, like Lhote, extended the earlier conceptual approach of the Cubists through into the twenties. It was while writing in a highly positive, celebratory way about André Lhote's painting in 1926 that Jacques Guenne produced some of the most explicit statements made on the subjectivity of the ideal Naturalist view of nature. 'If one examines all [those] works that are authentic,' he writes, 'one will see that art is essentially the interpretation of nature through a temperament.' And later: 'From now on the painter will not look for a direct representation of the object, but will ask his emotion to give him the dimensions [of things].'[36]

The Naturalist approach to nature, then, was subjective, but nature not the artist was seen as the starting-point, the generator of emotions whose quality and intensity had to remain in the work: the special quality of de Segonzac's 'love' of French landscape, or of Vlaminck's excitement at a stormy, winter sky. Reverdy and the Cubists at their most pure insisted that the work of art should give off its *own* emotional charge, a purely aesthetic one different from that given off by nature; Vlaminck and de Segonzac insisted that the work of art should generate an emotion as close as possible to the emotion generated in them by nature. So much did the Cubists think themselves in control of nature that they constantly changed the terms in which they presented it; style was openly revealed as arbitrary, as, in itself, a mode of signification. So dependent on their direct experience of nature and on the specific intensity of their emotional response were Vlaminck and de Segonzac that they tended to avoid the distractions of stylistic change; style was made to appear 'natural' to the artist who developed it. From their viewpoint and that of the pro-Naturalist critics, consistency was a measure of sincerity, and one of the most common charges laid against Picasso from this direction was that his shifts of style were merely a measure of his insincerity. Picasso's use of the vocabulary of deceit (the words 'trick' and 'lie') for the devices of painting in his interview of 1923 was acutely provocative to conservative opinion because of this; and in one of his 'Artistic Chronicles' for *Les Nouvelles Littéraires* in 1925, Florent Fels snipes at Picasso above all for such talk. Art, for Fels, is not 'a pious lie', it is 'the truth', by which he means not some notion of the absolute, but the truth about the artist's response before nature.[37]

Convinced that artists must be true to their own experience of nature, and confronted by the Cubists' synthetic rebuilding of nature as if from the abstract, Vlaminck took the simple step of charging the Cubists with a concerted act of destruction. This was what lay behind his bizarre attempt to connect the 'folly' of the Great War with the 'folly' of Cubism:

I have often said: 'Cubism, it is the War.' Why? Because I see in the two the same compulsion towards ugliness and destruction.

Have you sometimes really looked at a tree? It's beautiful, a tree which struggles in the wind. It came to me once, you see, to embrace the tree which I had just painted on my canvas, and to hold it for a few moments to my breast.

Well, how could you think that I could give the order to destroy these trees, these villages, these little villages which I love so much, when in the morning, on the banks of the Oise, the mist lifts. When for the past fifteen years each day . . . I have had the faith to create, how could you have me take part in a work of destruction?[38]

The very different meaning attached to the word 'create' by Vlaminck and by Reverdy or any of the 'pure Cubists' sums up the great distance between their views of art in relation to life. For Reverdy, to create was to invent a new thing, its humanity the product of the creator's humanity; for Vlaminck it was to convey intact an experience of nature. For him, to invent anew figures, objects or landscapes from abstract elements was tantamount to destroying nature by neglect. For Reverdy and the Cubists, truth was what the artist's 'aesthetic', guided by his 'spirit', *added* to nature: it was nature recreated by the artist's intelligence and imagination. For Vlaminck and the Naturalists, truth was the artist's immediate experience of nature: it thrived on ignorance, or, to use a more sympathetic term, innocence.

Complementary to the Naturalists' desire for an art rooted in an innocent, unintellectual response to nature, one that was essentially personal and emotional, was their appreciation of qualities in painting obviously opposed to the intellectual control and the distilled formalism associated with Cubism. In the first place, there was a taste for work that encouraged interpretations of a biographical kind, stressing the bond between lives lived and art; then second, there was a love of conspicuous spontaneity and sensuality which led to the writing of eulogy redolent with suggestions of the simplest sensual pleasure.

Neither Vlaminck nor de Segonzac lived lives adaptable enough to romantic fiction to invite biographical interpretation, and the pro-Naturalist writers turned to others for stimulus of this kind, perhaps most often to the life and work of Maurice Utrillo, one of those carried to prominence by the art-market boom of the twenties.[39] Utrillo's painting in the mid-twenties was based on a highly professional concern for method in picture-building, and yet he had moved after 1919 towards a more stressed naïvety in his treatment of figures and urban space to go with a loosely Impressionist treatment of light, and it was his directness and his innocence that were dwelt on by sympathetic writers (Plate 192).[40] The expressive, biographical factor was indissolubly bound up with this image of innocence; a melancholy was habitually

192. Maurice Utrillo, *Bernot's*, February 1924. Oil on canvas. 39¼ × 57½in. Musée de l'Orangerie, Paris. Jean Walter and Paul Guillaume Collection.

read into his depictions of Montmartre and of provincial towns which was seen as the inevitable expression of his life and the condition in which it had placed him, exposed so clearly because of the immediacy of his innocent vision.

His life, known largely through second-hand anecdotes and simplified legend, made such an interpretation compelling. Once an adolescent dypsomaniac, still unbalanced, he lived with his mother, the painter Suzanne Valadon, and her husband André Utter in protected isolation on the summit of Montmartre. Comparisons with Van Gogh were inevitable, and so too perhaps were such evocative interpretations as this of Florent Fels in response to the Utrillo exhibition of January 1925: 'I know of no other destiny more tragic than his: he has nothing, neither women, nor honour, and the money he earns is not for him, he is more alone even than the wretched Van Gogh.' From such a situation, Fels continues, 'he has bred a painting of solitude and melancholy'.[41] Writing a little later in *L'Art Vivant*, Edmond Jaloux rejects the tendency to see Utrillo's painting through a screen of anecdote, and yet his own interpretation is a classic instance of this suggestive biographical approach in action. Having insisted that the painter's 'dypsomania' is not a vice but 'truly a state of morbidity' integral to his life as a whole, he compares Utrillo with Prince Myshkin from Dostoyevsky's *The Idiot*:

This is a man who has not matured [who has retained much of his childhood]. When he has finished painting, he plays with model tramways or railways, or he plays tunes on the harmonium . . . He paints conscientiously and passionately, then he looks for his recreation like a worker who has done a good week's work. This state of innocence in which he is plunged is not without profound melancholy; this innocence and this melancholy, you will rediscover them in all Utrillo's canvases, they are the stuff of his genius, for one cannot doubt that this man has genius, as had Edgar Poe, Nerval and Coleridge.[42]

Whatever Jaloux might have said as a disclaimer, he, like Fels and many others, took the anecdotal myth of Utrillo's life as the natural counterpart to discussion of his work: his life and art were treated almost as inseparable.

Both Vlaminck's and de Segonzac's painting invited the praise of pro-Naturalist critics appreciative of conspicuous spontaneity and sensuality. But perhaps the most telling responses of this kind were generated by the painting of Henri Matisse and, less prominently, of André Favory. Consistently these two brought out the desire of pro-Naturalist critics to stress the senses at the expense of the intellect.

It was, of course, a relatively superficial response to the painting of Matisse that stressed spontaneity and sensuality above all else, for, as much in the twenties as before or afterwards, Matisse worked with exacting control of his means based on deep understanding. But it cannot be denied that from the end of the Great War through the early twenties Matisse's painting not only gave the appearance of easy innocence, but did not disguise its starting-point in the direct observation of nature.[43] Maurice Raynal was right to point out in 1927 the strong element of Naturalism in the art of Matisse, though it is debatable whether this element undermined the pure spatial and colouristic qualities of his pictures. Certainly Waldemar George, in a review of 1920, was able to admire his work still for what he called its 'purity', using the term as Reverdy and the Cubists did, and he was not alone in this.[44] Yet, just the year before, when Matisse's exhibition at Bernheim-Jeune followed Braque's at the galerie de l'Effort Moderne, André Lhote could write that the two exhibitions dramatized 'the struggle of the two most violently opposed aesthetics of our time', setting Matisse diametrically against

the Cubists.[45] The fact remains that Matisse could be and was treated as a Naturalist opposed to Cubism. Repeatedly he was named the leader of one of the major tendencies in modern art, with Picasso the leader of the other.

Just how closely life and art could seem to such writers to be joined together in Matisse's painting is expressed in Jacques Guenne's introductory remarks to his interview with the artist in 1925:

All those who, set free from sleep on a summer morning by the first rays of the sun through the blinds, have known the intense pleasure of opening the window to the sun, all those who have joyfully welcomed into their eyes and hearts the shifting clarity of the sea, will appreciate the often violent emotion asserted by Matisse's canvases, where one finds fixed with the same ardour as in nature the pure colours of life.[46]

Guenne's interview concentrated above all on the artist's past, but at one point the focus shifted to two recent studies on the wall of the studio at Clamart, and Matisse's replies certainly substantiate the Naturalist image of him constructed at the time: 'Yes, he said to me, I copy nature, and even strive to put the times of day into my canvases. This one was painted in the morning, that one late in the afternoon . . .'; the Impressionist image, so obviously underlined in the most calculated way, comes over scarcely diminished even when he confesses that one of these pictures was done 'without the model'.[47] The image was already so strong that even in 1922 he could be called by a conservative writer 'One of our most noted Impressionists', committed to the rendition of 'the most fugitive atmospheric appearances'.[48]

Matisse could seem not just a Naturalist, but the freest, most direct and most sensual Naturalist of all. His sumptuously relaxed 'Odalisques', his patterned interiors splashed with sunlight, sometimes opening through windows into a bright outdoors, often decorated by pretty women enjoying nothing in particular with quiet lethargy (Plate 193), these paintings all would have fulfilled the demands made by de Segonzac that art should communicate the quality of the artist's emotion before nature, and should have its starting-point in nature. Apparently set firm against Picasso and the Cubists, apparently Naturalist and, as a colourist, irresistibly direct in his appeal, it is no surprise that Matisse so often attracted unashamedly sensual responses from those who saw Cubism as cold, intellectual and calculating. Typical is the obvious pleasure with which Paul-Sentenac, writing in *Paris-Journal*, revels in his colour-by-colour evocation of the pictures Matisse showed at Bernheim-Jeune in 1922. He writes of 'that canvas where a woman, shoulders covered by a pistaccio-green shawl, is placed in front of leaves of a closely related tonality' (Plate 194); of a 'bouquet, peonies, full-bodied, rose-red, flung here and there in an ambiance of indefinable grey-bistre'; of 'a seascape presenting the blue band of the sea beside a blond strand of sand' (Plate 155). 'All the paintings of Henri-Matisse [*sic*]', he sums up, 'are an enchantment for the eyes.'[49] The effort behind such celebratory writing goes into finding the precise words to communicate the simple colour sensations experienced, but significantly Paul-Sentenac ties each bunch of words evoking each colour effect to the subject-matter of the pictures shown at Bernheim-Jeune: the woman in a shawl, the peonies, the Etretat seascape. Matisse may encourage an awareness of purely pictorial colour relationships (the harmony of greens, the rose-red against grey-bistre, the blue against blond yellow), but he is habitually presented as the colourist working from experiences of nature.

André Favory was, of course, a minor figure alongside

193. Henri Matisse, *Odalisk with Red Culottes*, 1921. Oil on canvas, 25½ × 35¾in. Musée National d'Art Moderne, Centre Georges Pompidou, Paris.

194. Henri Matisse, *Woman with a Green Umbrella*, 1920. Oil on canvas, 27½ × 22½in.

Matisse, but he was considered, as we have seen in Part I, among the most talented and important of the young artists and one of special significance because he had flirted with Cubism only to reject it. The responses he generated among pro-Naturalist critics were particularly sensual. It has to be remembered that he was considered a museum-oriented artist, one of Raynal's 'Eclectics', an artist who consciously looked back to Mannerist, Baroque and Romantic prototypes. He was not, therefore, considered a Naturalist in the un-adulterated sense that Vlaminck, de Segonzac and even Utrillo were, but he was almost unanimously supported by the pro-Naturalist critics, Vlaminck bought his pictures,[50] his hedonism was far more gross than Matisse's, and his painting inspired the most full-bodied, the least pure effusions of a simple sensual kind to be found in the critical literature.

Just one example is enough to show how, for sympathetic critics confronted by Favory's work, life and art could seem to merge in a single, mindless pleasure. This is Robert Rey's delight in the unself-conscious lustiness of Favory's *Under the Bower* (Plate 195) shown at the Salon d'Automne of 1924. Intermittently Rey does remark on the painter's control over his pictorial means, but there is no mistaking the straight-forward thrust of his enthusiasm for this straightforward picture. 'A very beautiful canvas . . .', he writes:

It is heavy, I know, there is some vulgarity [here]; who denies it? Reds [and] roses are still got by strokes of lacquer . . . Here are couples, under a bower, in a lovely landscape, whose agreeable brightness is all their eyes, a little troubled by wine and still unsatisfied desire, appreci-ate. Six individuals in search of bed. They will get there,

they are on their way. Everything swims together harmoniously in their golden youth; their dreams sail on across beautiful waves rounded like fresh buttocks, which *are* in reality buttocks.[51]

He goes on to write of the logic of the contrasts between tones and textures, but his appreciation is not simply of pictorial qualities, for the relationships are not simply between colours or surfaces, but, for instance, between a 'pearly' torso and the shivering surface of the material which covers another. Nothing could be more sensually indulgent than his final words on the still life in the painting. The fruit here, he maintains, by contrast with the fruit in Fantin-Latour's still lives, is made 'to be bitten [into] by two mouths together playing at kisses in the squashy pulp'.[52]

195. André Favory, *Under the Bower*, 1924. Oil on canvas, size and whereabouts unknown. As illustrated in *L'Amour de l'Art*, 1924.

There were many exceptions to the rule that the Cubist resistance to the idea of art as nature seen through a temperament should go with a rejection of the sensual. Between 1914 and 1917 Picasso and Gris had periodically made frank and shameless appeals to the eye, especially when tempted by the surface sparkle of a Neo-Impressionist use of the colour dot: in particular Gris had used shifting skeins of colour to give a warm luminosity to a group of still lives at the beginning of 1916.[53] Again, as we have seen, Braque had invited a refined but clearly sensual response increasingly from 1918 (Plates 196 and 203), and so did Gris and Marcoussis, between 1922 and 1924 especially (Plates 180 and 197), alongside the softened sculptural styles of Laurens and Lipchitz. What is more, of the pro-Cubist critics Waldemar George positively encouraged such developments, despite their flavour of compromise, and, though critical writing on most of the Cubists remained far from sensually indulgent, besides Braque, Marcoussis certainly was recognized as a painter not at all resistant to visual pleasure, a painter indeed who could at once be called a Cubist and compared with Matisse.[54] Thus, when he showed a picture called *Window overlooking Sacré-Cœur* at the Salon des Tuileries in 1923 (Plate 197), which combined airy sun-lit colour with the thick *pâte* found in all his still lives of the time, Salmon could welcome it as a canvas that made 'something like a double allusion', an allusion at once 'to the formal law of Cubism and to the miraculously

balanced amorphousness of Matisse'. He could see it as a resolution of the 'Matisse-Picasso duel'.[55]

Yet, the fact is that Gris's sweetened blandishments in pictures like *Young Girl* (Plate 98) went unnoticed as such when he showed them at the galerie Simon in 1923, and no 'double allusion' was ever pointed out in the work of Lipchitz or Laurens, while all these artists could be included by the Purists in their category of Cubists moving 'towards the crystal' even in 1924–25.[56] As emphasized in the last chapter, there is no doubt that the crystal Cubism dominant in the Effort Moderne circle between 1916 and 1920 fixed for Cubism an austere, Puritan image, and that inherent in the Cubist claim not merely to create pure autonomous works of art, but still to create concepts of things; there was a tendency to avoid anything too readily associated with the sensation of things experienced directly: a tendency that went with the resistance to 'easy art'.

On the one hand, the now dominant Cubist determination to create works which generated an aesthetic emotion of their own, led to a suspicion of anything that would arouse emotions felt in life: desire, hunger, physical well-being. On the other hand, the now secondary desire to create representations of things at their most essential led to a neat coupling of the pursuit of essences with processes of refinement, stripping down, of excision. Both Reverdy and Raynal saw it clearly and said so. 'Certain artists', writes Reverdy in *Self-Defence* of 1919, 'create works which are stripped down; they are the result of an austere effort, a severe spiritual stance, of many sacrifices and restrictions.' And in the same text he directly links this voluntary sacrifice to the desire for purity and for aesthetic liberation from nature: 'No element becomes pure unless it is detached from the feeling associated with it in its situation in life. It is necessary to strip off this feeling, since in the work it plays a role detrimental to the work's completeness.'[57] How his friend Gris was able to reconcile the cosmetic allure of *Young Girl* or the almost edible painting of the fruit in *Fruit-dish and Glass* (Plates 98 and 180) with such an austere pairing of the aesthetic and the ascetic is not at all clear; but neither he nor anyone on his behalf disassociated him from such a stance between 1922 and 1925.

An intuitive limitation of means supported by a resistance to the sensually attractive was the key to Raynal's notion of the 'science of measure', which, in his 'Quelques Intentions du cubisme' of 1919, he saw as crucial both to Cubism and to the French tradition;[58] while in the early twenties he repeatedly made a division between what he called the 'painters' and the 'artists': the 'painters' who did without intellectual guidance, the 'artists' who depended on it and were in consequence always superior.[59] By 1920 it was entirely to be expected that a severe anti-hedonism should be singled out as a central characteristic of Cubism, for instance by Jean-Gabriel Lemoine of *L'Intransigeant*. For him, Cubism stood 'with fervour [for] that disgust of our generation's for the sensualist painting which reaches its summit with Bouguereau. . . .'[60]

Of the Cubist painters it was perhaps Fernand Léger who most pointedly associated the Naturalist drive to representation with sensuality: as he saw it, the two were inseparably linked. 'Renoir is peripheral,' he wrote to Léonce Rosenberg in 1922.'

Basically, it's 'fruity' women that started off the rot. Sensuality is taken to excess. From the moment that Messrs Raphael and da Vinci reproduced their mistresses on canvas because they were beautiful, the day was lost. Imitation won. The bourgeois, born to hearty eating and living in general, were not surprised; . . . Demand calls forth supply. . . . What decadence![61]

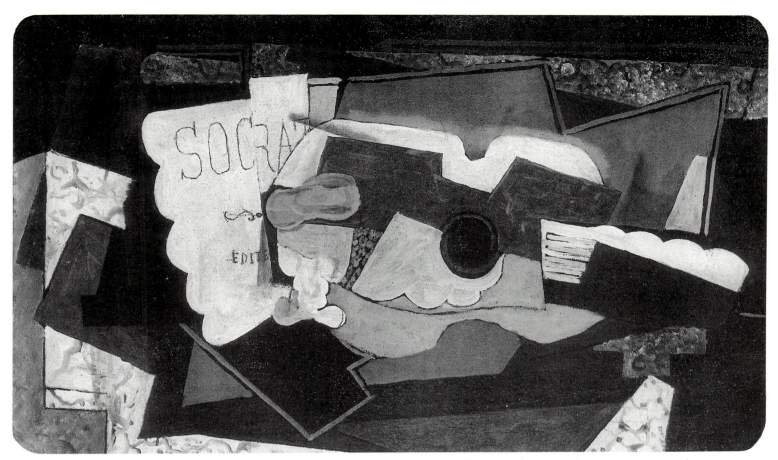

196. Georges Braque, *Guitar and Glass (Socrates)*, 1921. Oil on canvas, $17 \times 28\frac{3}{4}$in. Musée National d'Art Moderne, Centre Georges Pompidou, Paris

197. Louis Marcoussis, *Window overlooking Sacré-Coeur*, 1923. Oil on canvas, size and whereabouts unknown. Exhibited at the Salon des Tuileries, 1923.

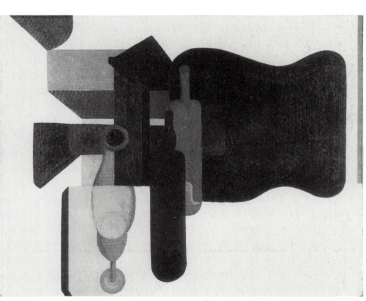

198. Amédée Ozenfant, *Guitar and Bottles*, 1920. Oil on canvas, $31\frac{1}{2} \times 39\frac{1}{4}$in. Peggy Guggenheim Collection, Venice; The Solomon R. Guggenheim Museum, New York.

Such resistance to temptation in the interests of aesthetic purity made at least Léger proof against the attractions of Waldemar George's proposed fusion of the structural and colouristic possibilities opened up by Cézanne and Renoir. Together with Valmier, Léger remained a strict anti-hedonist right through into the mid-twenties.

Yet, if hedonism in independent art found its extreme in the public images of Matisse and Favory sustained by the critics, then the puritanism associated with Cubism found its extreme in the painting and the public image of the Purists, Ozenfant and Jeanneret (Plates 198 and 199). They too were proof against Waldemar George's promotion of Renoir as a model, a point made in no uncertain terms by Ozenfant (under the pseudonym 'Vauvrecy') in response to the concurrent exhibitions of Renoir at Durand Ruel and of Cézanne

at Bernheim-Jeune late in 1920: 'We have known for a long time that Cézanne is the greatest creator of the last fifty years and that Renoir is an agreeable artist who often produced very beautiful things; Cézanne made the revolution which made Cubism possible, Renoir has produced a few honest imitators.'[62] It was for the sheer severity of their puritanism that Raynal most admired the Purists when he looked back to what they had achieved between 1918 and 1925 from the vantage-point of 1927. 'The value of Purism', he considers, 'is above all in its distinction between painting liable to please and that which moves. From passing pleasure, fragile works, from deep emotion, lasting works.' But he adds the qualification: 'This, like all formulae, created at all points, transgresses perhaps from an excess of rigour.'[63] In the end, even he who so despised the easy or the sensual, and who

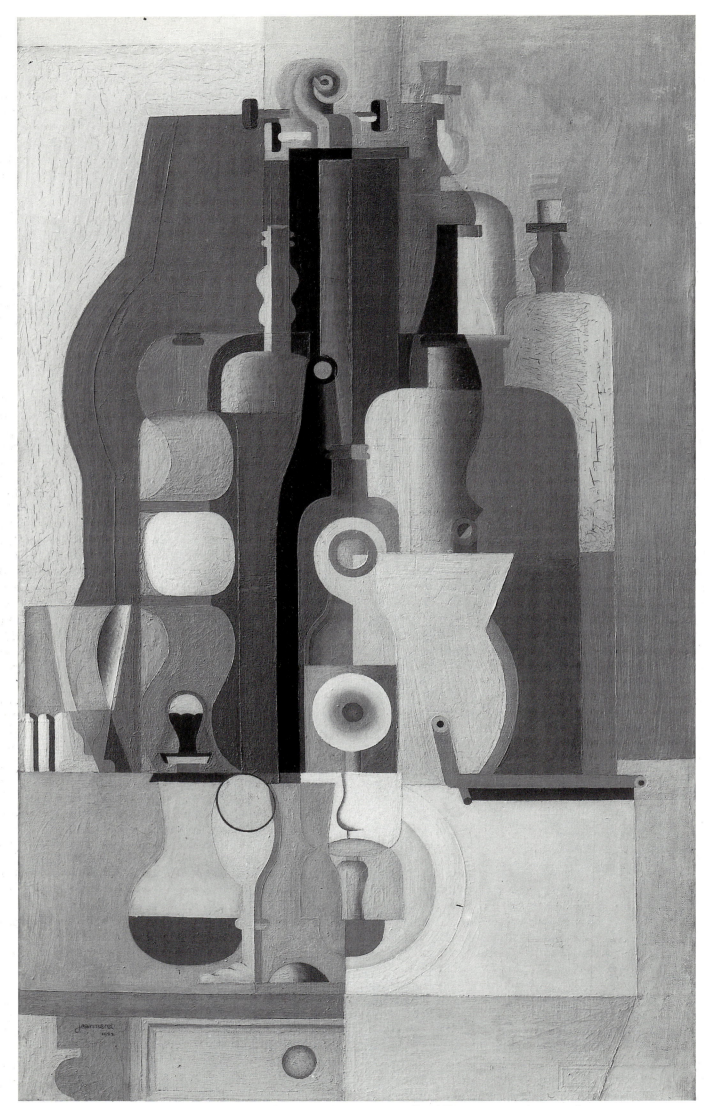

199. Charles-Edouard Jeanneret, *Vertical Still Life*, 1922. Oil on canvas. Oeffentliche Kunstsammlung Basel, Kunstmuseum.

had always supported the Purists, could not altogether accept their total refusal to compromise.

Theirs was indeed an unrelenting stance, and it was sustained throughout the brief life of their 'movement'. In *Après le cubisme*, painting for the sake of painting is dismissed above all for its appeal to the grossest appetites: 'Cookery', they remind us sharply, 'is not equivalent to high painting, it is the equivalent instead of all art which has as its aim nothing more than to caress.'[64] The tone is just as ascetic when they write thus in the penultimate number of *L'Esprit Nouveau* six years later:

> The error was to take as the criterium for beauty the idea of pleasure, ultimately a personal and variable reaction. . . . The Parthenon is pleasing for no one. Great art is not agreeable art . . . the aim of art is to move emotionally. . . . The Parthenon moves everyone powerfully . . . it is even possible to say that no true masterpiece gives pleasure, for the great emotions do not correspond to this word.[65]

Léger, of course, was not afraid to paint the female nude after 1920, but, if we are to believe his letter of 1922 to Léonce Rosenberg later published in the *Bulletin de l'Effort Moderne*, he did so in the spirit of a challenge to the nude in its habitual role of vicarious seducer: he did so in the hope (possibly vain) of un-sexing the nude and amplifying his belief in the asexual purity of painting.[66] The Purists avoided the nude as a subject altogether, and in their still lives, significantly, painted only musical instruments, vessels and containers, never fruit or any of the foods often found in the Cubist still lives so easily associated with appetite and its satisfaction. Even if the softening of the styles of Braque, Gris, Marcoussis, Laurens and, to some extent, Lipchitz weakened the anti-hedonist image of Cubism, the writing of Raynal and the work of Léger and the Purists meant that the puritan connotation, with all its manifold anti-Naturalist implications, was not altogether lost.

So to sum up thus far: if one sees the broad spectrum of *l'art vivant* from the Great War to the mid-twenties in terms of a clear-cut confrontation between Naturalism and advanced or pure Cubism, each represented by groupings of artists and critics, the character of the opposition can be stated clearly enough from either view-point. From the Naturalist view-point, Cubism was anathema because it imposed upon nature, indeed could be said metaphorically to destroy nature; because it appeared to be based on restrictive aesthetic theories which stressed the abstract rather than living experiences; because it therefore appeared cold, calculating and puritanical; and because all this made it seem obscure and élitist. By contrast, from the Cubist view-point, the Naturalist stress on emotions felt before nature, its lack of intellectual toughness, its failure to release in the artist developing inventive powers, and its tendency towards the charming, the sensual and the easy, all this exposed it to scorn. With only partial and passing exceptions, the Cubists worked to negate all these perceived failings in the independent art of their time whose starting-point was nature. Naturalism was indeed most clearly what Cubism was *not*, and an instant grasp of that fact with all its implications informed any response, even relatively ignorant, to any of the paintings that Vlaminck or de Segonzac, Matisse or Favory, Léger or Gris or the Purists produced in the decade following the Great War.

* * *

At the beginning of this chapter it was a quotation from André Lhote that reasserted the point that the opposition between Naturalism and Cubism was perceived clearly at the time, and it was, of course, Lhote who saw Matisse at Bernheim-Jeune in 1919 in terms of this straightforward opposition. Now in this latter article of 1919 Lhote expounded on the distinction between Naturalism and Cubism not so much in terms of spontaneity and lack of spontaneity, the biographical and the pure, hedonism and intellectual discipline as in terms of opposing *creative processes* in relation to nature. He attempted, in his words, 'to fix the mental processes of the two opposed schools', and concluded concisely thus: 'Where M. Matisse proceeds from the sensation to the idea, the Cubists proceed from the idea to the sensation', adding in a nuts-and-bolts footnote: 'For example: M. Matisse needs to see a plate in order little by little to see the virtue of a circle plastically. The Cubists conceive a circle in the first place, and condescend to give it a point as a plate.'[67]

The central core of the opposition between the Cubists and the Naturalists lay indeed in their attitudes to the relationship between art and nature, in the stress they put on such qualities as spontaneity, expression and sensuality, and in their understanding of the notion 'truth', but all this was linked to the way they *practised* their art, and once one turns to the question of practice the distinctions become not quite so straightforward and clear-cut. Lhote's own position sums up the difficulty. Broadly, his stance could seem that of a Cubist: *against* dependence on nature, *for* the conceptual transformation of appearance; *against* the overtly spontaneous and sensual, *for* the overtly controlled and intellectual. But, as Guenne's support from the Naturalist side quoted earlier demonstrated, he could not be thought of as a Cubist in the 'pure' sense, in the sense that the most advanced were Cubists after the Great War. From his rejection of the Effort Moderne group in 1918 onwards, he stood in between Naturalism and Cubism, and it was the way he and the Cubists proper thought of the *practice* of their art with the contrasting priorities that implied which established the distinction between himself and the Cubists proper. Again, as we have seen in Part I, there were many independent artists in Paris who occupied the space between Naturalism and Cubism, from Bissière to Marchand to Gromaire; but the clarity with which Lhote articulated his position in *La Nouvelle Revue Française* makes his the most paradigmatic case to take.

Writing on Matisse in 1919, the opposition Lhote describes between Naturalism and Cubism is as straightforward as any: this is one of the first definitions of the synthetic process (beginning in the abstract) as opposed to the analytic (beginning in nature).[68] He seems not yet to have defined, in between, either the category constructive Naturalism or a position for his own art. It was in 1920, after the Cubist successes at the Indépendants and the Section d'Or, that he defined such a position, and he did so, as explained in Part I, by writing of two separate tendencies *within* Cubism: what he called *a priori* and *a posteriori* Cubism. At this point it is worth expanding on what these two tendencies entailed as he saw them. At the Indépendants of 1920 he named the following as *a priori* or 'pure Cubists': Braque, Gris, María Blanchard, Metzinger, Severini, Marcoussis, Hayden, Lipchitz and Laurens (because of the urban subject-matter of his contributions he did not include Léger). 'M. Metzinger', he wrote,

> likes to talk of 'pure effusion'. This term perfectly characterizes the intention of the artist for whom the work is first of all but a milieu into which only the elements of the spirit ['l'esprit'] enter. Inspiration here is not of a sentimental kind, but uniquely plastic; it produces a combination of differently coloured forms whose dimensions, placing and tone are obtained by a rigorous process. The picture is

200. Juan Gris, *Still Life with Garlic Sausage*, 1920. Pencil, 9¾ × 12¾in Musée National d'Art Moderne, Centre Georges Pompidou, Paris. Kahnweiler-Leiris Collection.

finished once the completely abstract surfaces which divide it are organized; the rest of the work consists of nothing more than choosing from a limited repertoire of acquired forms [he means the forms of objects] those whose geometric essence coincides with each of the parts of the picture. The plate justifies the circle, and the box the rectangle. . .the use of the particular is for them only a *concession*, never a *motif*.

They no longer have the need of motifs, Lhote continued, because 'Their memory has given them an arsenal of disassoci-

ated forms, completely ready to be organized following the scientific laws of Cubist composition.' He summed up: 'They project their plastic ideas onto the object as if onto a target.'[69]

Despite the misleading talk of essences and 'scientific laws' in composition, this is as lucid an outline of the ideal synthetic Cubist's practice as is found anywhere at the time, and the stress on the detachment of 'arsenals' of elements from the direct experience of nature is plain enough. Lhote's *a posteriori* Cubists (of which he is one) are to his mind as distinct from the Naturalists as from the *a priori* Cubists, since their aim he says, is the general Cubist aim of applying as artists 'the highest possible faculties of man'; since their aim is to see *intelligently*. Extending, as he does, the conceptual aspect of Cubist theory, he stresses the potency of intellect just as Raynal always had. The *a posteriori* Cubists, however, do not impose the intellectually generalized on the particular, they paint 'the new combination which is born for them from *that glass*, from *that plate*, perceived in an unexpected context which will modify the forms and will force out from their spirit an expressive geometry'. They derive a generalized concept *from* an experience in nature. Lhote concludes: 'While the pure Cubists depart from a "concept", the emotive Cubists, whom I itch to call Impressionist Cubists, depart from a sensation. If the first are idealists, the second are realists in the image of Cézanne.'[70]

Basically Lhote's distinction is between the synthetic and the analytical, and certainly most fundamentally it was his refusal of the synthetic picture-building approach with its detachment from nature that set him apart from the Cubists proper after his shift of stance and style in 1918. For him, and for those whose stance was close to his (Bissière and Gromaire, for instance), it was this refusal of Modernist purity that gave them their identity in relation to Cubism. They could believe

201. André Lhote, *Nude*, 1918. Oil on canvas. Size and whereabouts unknown. As illustrated in *L'Art Vivant*, 1 March 1926.

202. André Lhote, *Nude*, 1925. Oil on canvas. Size and whereabouts unknown. As illustrated in *L'Art Vivant*, 1 March 1926.

203. Georges Braque, *Waltz*, 1918. Oil on canvas, 13 × 17¾in. Sale: Christies, New York, 16 May 1977, lot 39.

in the conceptual, metamorphic power of the artist's 'aesthetic', and they could do so to a far greater extent than could the Naturalists, but they could not bring themselves to set it to work without nature as the prime inspiration.

Moreover, in Lhote's case his commitment to a direct, warm relationship with nature was perceived by conservative critics to have steadily deepened in the period between 1918 and the mid-twenties. Robert Rey interpreted the jovial *14th July at Avignon* in this way in 1923 (Plate 222), and to underline the point Jacques Guenne, writing in 1926, contrasted a full-bodied, Renoiresque *Nude* of that year (Plate 202), with the far dryer, more structured figures of 1918-1919 (Plate 201). Still not seen quite as a Naturalist, he was seen as increasingly far from the purity of Cubism.[71] Among those close to Lhote, Gromaire sums up the awareness they shared of their distance from such Cubist extremes. He is considering the 'pure Cubists' at the end of an interview of 1926: 'They have sought to destroy the subject. . . . The theoreticians of pure painting feel a vague disquiet, masked by the words: ''The picture is a plastic object, etc. . .''. In fact, four broken lines make a subject as tyrannical as a face. I believe that it is useless to try to escape. This is a benign tyranny.'[72] For him, as for Lhote or Bissière, the subject *had* to be the controlling factor, and in thus submitting to its 'benign tyranny' he arrived at his sense of his own position *vis-à-vis* the Cubists.

Yet, if the opposition between Naturalism and Cubism was as stark as between black and white, the opposition between this median stance and that of the pure Cubists was in the end as vague as between two tones of grey. Lhote's *a posteriori* or 'emotive' Cubists might have refused the purity of the pure Cubists, but, as has emerged in Part I, the pure Cubists themselves never utterly refused a direct relationship with nature. The last chapter demonstrated how from within the mazy edifice of Cubist theory an art that started in nature *was* acceptable to the most rigorous of the theorists, so that neither Reverdy nor Picasso himself made any important basic distinction between Picasso's Cubism and his alternative styles, and Metzinger, so committed in 1920 to the idea of art as 'pure effusion', could see his return to representation as an extension of his Cubism.

It should be said, however, that certainly two of the most rigorous theorists of 'pure Cubism', while they accepted the validity of art whose starting-point was in nature, made it clear that, for them, such art was always inferior to the products of synthesis. These two were Juan Gris and, most explicitly, Maurice Raynal. Gris's own sensitively finished pencil drawings after nature, made especially in 1916, 1918 and again in 1920–21 (Plate 200), are in themselves expressions of his belief that the really strong artist could confront nature directly and force it to submit to his 'aesthetic'. But his published pronouncements on synthesis between 1920 and 1927 carry the unmistakable implication that art whose starting-point is in the abstract must be greatly superior. Raynal's regular column as art critic for *L'Intransigeant* often shows him willing to enthuse over art which begins in nature: he could praise Bissière, he could admire the 'brio' of Utrillo, the 'authority' of Kisling, the rigorous draughtsmanship of Suzanne Valadon, but he too held up art which begins in the abstract as something higher.[73] Thus, confronted by Picasso's portraits at Paul Rosenberg's in 1924 (Plate 77), he makes his preference for the synthetic against the analytic plainer than Gris ever did. His was not Reverdy's even-handed response to both of Picasso's alternatives. 'The figures shown here', he writes,

are based on direct observation of nature [the sitters had indeed sat]. The aim in all of them is first to translate the feelings, the personalities of the sitters, then to group the forms according to an idealization of the appearances of nature. . .we feel emotion here only as a result of things simply translated (and added to, if you wish) from reality . . . what is offered by the artist [here], if I can express it thus, is to some extent life stuffed. Our emotion is of the same kind as that we would feel in front of the same thing in life. . .we feel less the hand of man than the primary data of creation.[74]

Cubism proper, for Raynal, is concerned with a 'spirit of creation', and the emotions it generates have nothing at all to do with the emotions from life generated by these pictures; Cubism is, it goes without saying, infinitely superior.

* * *

Even with the intermediary position of Lhote included, between the two polarities of Cubism and Naturalism the spectrum of attitudes to the relationship between art and nature sketched in this chapter is inevitably a simplification of a very various and volatile situation, as suggested in Part II. Between these polarities there were an infinite number of possible stances. Even within the categories dealt with there has been a tendency to smooth over differences, both within the Naturalist camp between the 'direct' Vlaminck and the 'constructive' de Segonzac, and within the Cubist camp between, say, the still-life and figure painter, Gris, and the painter of the city and the machine, Léger; also within the intermediary camp between, say, Lhote and Gromaire. What is more, nothing has been said about distinct and major figures like Bonnard, Dufy, or Soutine, who are not necessarily subject to exactly the same generalizations as either Vlaminck or de Segonzac. The hope is that enough has been said to build an awareness of the existence of two opposing extremes during the period, which were clearly perceived as such at the time, and of the distance that separated them. Then too, the hope is that, by taking the case of Lhote, the point has been made that any artist who took up a position between these polarities inevitably situated themselves and their art in relation to them by a pattern of acceptance or refusal of the attitudes and practices that went with them. To amplify just how effectively actual works could signify such patterns of acceptance and refusal, one can take briefly a few instances across the range of possible styles and stances.

De Segonzac's *Still Life with Eggs* and Vlaminck's *Nantes Road* are both from the early twenties and are both comprehensively Naturalist (Plates 191 and 186). Neither uses colour to dazzle or to soothe; neither treats a subject which is especially appetizing or alluring or to be associated with the high points of physical pleasure; but together they make a great deal of the artist's excitement and involvement in the subject and the act of painting it. The sweep of Vlaminck's handling, the roughness and the ragged edges of de Segonzac's surfaces (often built with the palette-knife) are unmistakably left to act as signs of the impulsive and the personal, of the immediacy of their response to nature and to their medium. Handling here is the signature of innocent vitality and sincerity. Appearance, however, is not merely depicted as accurately as possible; the paint presented so materially as paint gets in the way of that, and so do certain lapses or stressed inexactitudes: the break in the horizon-line marked by the tall gabled house in the Vlaminck, the tipping up of the table-top and the minor but telling 'passage' fusions of objects and setting in the de Segonzac (one is reminded of Vauxcelles's 'Imitation is the condition of art, not its end'). But neither

painter has allowed either *matière* or pictorial inexactitude to undermine the dominant effect of solids in a particular space adventitiously lit. Vlaminck's picture coheres around the plunge of the road into depth, its colour meteorologically unified; de Segonzac's picture (atmospheric too in its silvery indoor shadows) coheres on the unbroken, stage-like surface of the tilted table-top. Every skill is used to produce the image of things seen, responded to impulsively and almost simultaneously translated into the terms of a brushed and palette-knifed paint medium applied to a flat canvas. An ideal personal and 'natural' relationship between painting and nature is certainly one meaning of these paintings; at the time of their making it was not the least important.

Léger's *The Beer Mug* was painted at about the same time as the Vlaminck and de Segonzac, in 1922; Braque's *The Round Table* right at the very end of the period (more in 1928 than 1929) (Plates 227 and 149).[75] The one uses colour to dazzle, the other sumptuously, almost ornamentally, to please; the Braque presents its fruit with an appetizing flush and softness of shape. Neither could be called puritan in the strictest sense. What is more, though the Léger, with its traces of pencil squaring-up and its dry, filled-in areas of colour, acts to signify the control of a careful designing intelligence, there are in the idiosyncratic forming of things in the Braque, in the tactile surfaces and the wavering, freely drawn line (of the table-edge for instance) the marks of an intensely engaged, individual sensibility, of the sensual rather than the deliberate. The Braque is certainly Cubist, but it is also personal, and says so.

Yet, neither the brilliance of the Léger nor the quirky finesse of the Braque are left to appear the result of a particular individual experience of nature. Every skill is exploited to produce an image of things invented by the painter for his own use in his own invented pictorial space, not of things responded to in nature. In line with the entire tradition of Western naturalist or realist painting, de Segonzac and Vlaminck conceal the status as sign of their representations of things in light and space by working for consistency and coherence in the image they create, whether or not they draw attention to their own personal intervention by pointed lapses and heavy handling. Léger and Braque, by contrast, do everything in their power to *reveal* the status as sign of their representations, to thrust into the forefront their sheer arbitrariness. Nothing is left to seem 'natural' in these pictures, everything is obviously shaped and manipulated. In both what can appear at first glance a coherent if condensed perspectival box-space in which the tables stand is with every further scrutiny revealed to be not at all coherent and in an uneasy, conflicting relationship with other spatial suggestions created in terms of planar overlappings (for instance, that fusion of the still life in the Braque with the perspectivally converging walls behind, that is so effectively contrived by the way the planimetric superstructure built up from the objects on the table unfolds into the wall surfaces). In both, contrasting signs denote different objects as if we are being given glimpses of spaces within a pictorial Tower of Babel: the grey, tonally modelled objects and the flat, polychromatic beer-mug in the Léger; the flat, willfully shaped guitar and the rounded, 'naturally' formed fruit in the Braque. An ideal of the painter as inventor and sign-maker extraordinary, whose dependence on the direct experience of nature has been finally broken, is certainly one meaning of these paintings; at the time of their making, it was central.

André Lhote's *14th July at Avignon*, his contribution to the Indépendants of 1923 (Plate 222), was again the near contemporary of the Vlaminck and the de Segonzac. Its subject is an event: an event dedicated to pleasure. It is left,

however, without the marks of either personal touch or personal delight. Though no traces of a designing process can be seen, it is as drily handled, as explicitly controlled as the Léger. The subject itself is a statement of a commitment to painting as a celebration of life lived, people and their entertainments experienced with immediacy; its handling is a statement of a commitment to painting as a *métier* with its own rules which have to be understood and conscientiously applied.

Neither the space nor the men and women who populate it are allowed any inconsistency in their representation; that this is a contrived, an artificial representation is revealed clearly enough, but not the arbitrariness of its idiom, of the pictorial sign as such. The effect left is of an event seen and then transposed into the language of a particular pictorial style; the stress is both upon style as such *and* upon nature (or life) as instigator. Again, an ideal relationship between painting and nature is one central meaning of the painting, and was especially at the time of its making, but in this case a relationship which could never simply have been called 'natural', a relationship guided by artifice. The *14th July at Avignon* gives us an event corrected for the discipline of painting, not the painting as an event in its own right; and says so.

Late Cubist art could either mute its autonomy or even convey a reinforced connection with life lived. There are, on the one hand, the results of, say, Gris's or Laurens's compromise in 1922–23, where a false impression is given (perhaps knowingly) of nature seen and then transposed or corrected, much as in Lhote's paintings (Plates 98 and 103). And there are, on the other hand, Léger's urban and machine element paintings, where the city or machine as instigator is given a leading role, easily interpreted, however clear the distance between the forms and colours of the painting and those of the motifs to which they refer (Plates 159 and 230). But in general, like Braque's *The Round Table* and Léger's *The Beer Mug*, late Cubist works signified more or less effectively the guiding role of the artist as inventor; and we have seen in Part I how each such work, presented as one 'moment' in the *œuvre* of a single artistic personality with a distinctive artistic practice, could signify, too, an over-riding individuality and a continual openness to change.

My contention, however, throughout these last three chapters has been that these statements of an ideal freedom from nature and an ideal creativity, made so variously in work after work, contained within them an unspoken yet explicit set of refusals: refusals of those equally ideal relationships between art and nature signified in the de Segonzac, the Vlaminck and the Lhote, and that these latter in their turn combined both positive and negative statements of this kind. Ultimately the meaning of these works in the twenties *vis-à-vis* the relationship between art and nature was something that could be grasped and responded to instantly by the habitués of *l'art vivant* only within a setting of dissention, of conflict. It was grasped as much through the apprehension of things rejected as of things accepted, of what paintings or sculptures did *not* say as of what they did say. Cubist images, like Naturalist images or the products of Lhote's *a posteriori* alternative, were read then (and still can be read) in terms of an adversarial rhetoric. Each painted and sculpted composition delivered a powerful polemic on art and nature, without a word.

204. Pablo Picasso, *Olga Picasso in an Armchair*, 1917. Oil on canvas, $51\frac{1}{4} \times 34\frac{5}{8}$ in. Musée Picasso, Paris.

12
Tradition and the Progress of Styles

In 1921 the shrewd reactionary Paul Léon, Director of the Beaux-Arts, top bureaucratic protector of official art, offered the following thoughts on innovation:

> If willed and conscious imitation is the poorest employment for human thought, is it certain that the innovators are always as foreign to the traditions they repudiate as they believe? Audacious revolutions are often nothing but a return to the procedures of the old masters. New errors and truths are often but forgotten errors and truths.
>
> In the great army on the march, we are alarmed to see the adventures of some avant-garde detachments. The Latin poet [sic] Terence in one of his comedies jeers at those who claim to reproduce the human form by geometric figures. Is it not right to conclude that Cubism itself is a legacy of the Ancients?[1]

This is a remarkable demonstration of how widespread across the art worlds of Paris after the Great War was the notion that *l'art vivant* was not a new art to be built upon entirely new foundations, but in some sense a return to the past, a resurrection of ancient ways, which embraced not only its conservative but even its radical, Cubist wing.

If every painting or sculpture within the range of *l'art vivant*, from the Cubist to the Naturalist, stood as a wordless polemic on the relationship between art and nature, it stood too, often very explicitly, as a polemic on the relationship between modern art, modern life and the past, between the constancy of tradition and the inconstancy of progress. It is the opposing Cubist and conservative attitudes to this relationship that form the theme of this chapter and the one that follows, and these are attitudes which were as much fused into the meaning of the works as were attitudes to nature. In the period of their making and their first exposure each work communicated instantly to its audiences at the galleries and the Salons a distinct pattern of refusal or acceptance *vis-à-vis* the past and the present, sometimes quietly and indirectly, but sometimes very directly indeed. The character of that particular set of meanings was, of course, closely linked to the whole question, discussed in Part II, of the shift in the status of *l'art vivant*, its growing identification with Establishment and official perspectives. Put perhaps over reductively, to identify *l'art vivant* with any notion of tradition, especially in the nationalist atmosphere of the post-war years with any notion of a French tradition, was to adapt it comfortably to dominant ideological positions, to help give it an image reassuring enough for official recognition and Establishment support inevitably to follow.

* * *

From among the champions of *l'art vivant* the writer who perhaps most insistently of all advocated an accommodation with tradition that was broad enough to embrace both the Cubists and the Naturalists was André Salmon. In 1926, indulging in the gleeful contemplation of the success of *l'art vivant* that he so enjoyed, he summed up his position succinctly. For him, 'a valid art' combined 'health (that is to say tradition) and novelty (that is to say the unexpected flourishing of that tradition)'.[2] The danger of success, he maintained, was that the traditional element in *l'art vivant* would freeze it into immobility, but that traditional element was an essential which held no dangers so long as the new artists did not pursue it by the mere imitation of past models. The aim was a balance between progressive innovation and an awareness of tradition that forbade the dependence on models, which was the mark of the academic.

Salmon's view of innovation and tradition consciously

directed the strategies he followed in his assault upon the official art world of the Beaux-Arts after the Armistice. In 1925 he had celebrated the exclusion of academic art from the huge official exhibition 'Fifty Years of French Painting' at the Pavillon Marsan as a triumph for independent art which showed plainly how 'our revolutionaries overturned nothing but academicism, . . . [how] our revolutionaries have tended only towards the rediscovery of the ways of Classicism'.[3] For him, the art of Courbet, Renoir, Van Gogh, Picasso and Derain established above all the continuity of the French tradition in the new painting, a point made at the time by many who saw it as extending a line that went back at least as far as Poussin and Claude. He does not bother to delineate the character of this tradition, but his casual use of the term 'Classicism' implies qualities of order and structure, and the sweet paradox in his position is clear enough, for what he stresses is his conviction that a true return to tradition does not mean the revival of fixed values or the imitation of models, but a continuing evolution, an *extension* of tradition that strikes at the very foundations of academicism. 'What is there to say?' he writes.

> That all combat with academicism is healthy. That all academicism is absurd and fatal. That the discredit will be total in which one must hold those bodies of masters authorized by a Church where Dogma (that is to say, principles) will be worse than misconstrued, the works of a moment [in time] being held up as eternal models, the work being taken as an immutable principle when it is but an instant in inescapable evolution.
> It is against this that genius will always rebel.
> . . .Thus, the true restorers of order will always be those. . .treated in the fashion that the conservatives treat rebels.[4]

The independent artists were engaged in the restoration of a lost order whose fundamental character was not static. Their success was ensured by the fact that legitimacy was thus, as it were, built into their insurrection. Paul Léon and his bureaucrats would not be able to resist long.

Salmon's dynamic view of the restoration of tradition as anti-academic and progressive was not altogether brand new; it reflects Mauclair's notion from the beginning of the century of tradition as progressive,[5] as well as the view expressed in wartime (1916) by Pierre Albert-Birot: 'The French Tradition: is to break the shackles. . .The French Tradition: is to search, discover, create. . .Therefore the French Tradition is TO NEGATE TRADITION.'[6] Albert-Birot did not think in terms of anything even loosely describable as ordered or 'Classical', but (as argued elsewhere) such an attitude, hitched onto a growing attention to the art of the past as a positive stimulus to new things, was almost inevitable after the war. For the years following the Armistice saw not only more and more exhibitions of new independent art, but at the same time the reopening in 1919 and 1920 of the Louvre and the Musée de Cluny.[7] The art of the past in these great collections was suddenly, in the rarest of ways, fresh and new again; an excitement that pointed forward. There was too in 1920–21 a succession of large exhibitions and events in Paris which could not have been better judged to nourish a sense of continuity with the past in the atmosphere of reconstruction that followed the war. 'One-hundred Years of French Painting' held in 1922 and 'Fifty Years of French Painting' in 1925 were the blockbuster sequels to an impressive introduction.

Thus, in July 1921 Salmon writes in the *Revue de France* of a 'miraculous season'.[8] Great excitement had been caused at the end of 1920 by the retrospective of Renoir at the Salon d'Automne and then by the seemingly confrontational exhi-

bitions of Renoir at Durand-Ruel and Cézanne at Bernheim-Jeune. These had been followed in 1921 by another confrontation between Renoir and Cézanne at an exhibition in the rue de la Ville l'Evêque, and by an equally complementary pair of shows in Paris: a large Fragonard exhibition at the Pavillon Marsan and the Ingres exhibition also at the rue de la Ville l'Evêque. Moreover, 1920 had seen the fourth centenary of Raphael, which had generated much noise in the art press, and a eulogy from Derain in the newspaper *Le Matin*. For Salmon, all this was confirmation, as it were, from the past, of the continuing validity of the new art and especially of its broad new commitment to Classicism, though again he left Classicism undefined.

More superficially, the position of both Renoir and Cézanne as intermediaries between the past and the present was firmly established, above all by Lhote in *La Nouvelle Revue Française* alongside Salmon. Salmon might have left his image of tradition vague, but it was from the beginning of the post-war period an image of order and control. Recently it has been argued that Cézanne's centrality came under threat after the War;[9] the response to the exhibition at Bernheim-Jeune in 1920 and in the rue de la Ville l'Evêque in 1921 demonstrates, however, that it was not seriously or widely threatened, and certainly for Lhote and Salmon Cézanne remained *the* example for a constructive approach to nature (Plate 205).[10] At the same time, Renoir as a leading carrier of tradition both for Lhote and for Salmon could not merely be accepted according to the easy standards of hedonism; his position alongside Cézanne was justified because of the constructive pictorial control of his means that was considered to give pictorial force and substance to the sensuality especially of his late nudes (Plate 206). In Lhote's opinion, he distorted in basically the same way as Cézanne or Ingres as he sought out new relationships of colour and form on the canvas, his pictorial 'intelligence' quite as active as his response to what he saw;[11] and Salmon too presented him as a painter whose ordering intelligence balanced his hedonism:

> The painter of voluptuous roses as much as of beautiful girls and populist nymphs as plump as roses, has said. . . 'They gave me a horror of one of my canvases when they baptized it *Thought*.' Renoir is right. But one must not exclude Thought. It is [thought], if I dare use an everyday image, which does the housework, which gives order to the painter's studio. After that, a beautiful, thoroughly animal girl can take the floor as model.[12]

In his words, the 'silly cult of false simplicity' created around Renoir was to be challenged.[13] Even the champion of the immediate and the sensual could qualify as a herald of Classical order.

Tradition, then, in Salmon's view was 'Classical' even if it was progressive rather than revivalist, and even if it was open to the hedonistic as well as the disciplined. It was also French, decidedly French. The image of order complemented the mood of post-war reconstruction, as Kenneth Silver has shown;[14] the image of Frenchness complemented the xenophobia of bitter victors after the Armistice. The nationalist image of tradition, however, did not necessarily go with an untempered xenophobia, and Salmon's certainly was tempered with an openness to the infusion of energy from outside France. He deplored the decision to hang the Salon des Indépendants from 1924 onwards by nationalities (a decision Lhote associated with a dangerous 'wave of nationalism' throughout Europe), and in the wake of discussions following 'Fifty Years of French Painting' in 1925 he deplored the tendency for assertions of Frenchness in painting to justify racist attitudes, in particular the attack on 'Jewish art' mounted

205. Paul Cézanne, *Still Life with Apples and Peaches*, 1905. Oil on canvas, 32 × 39⅝in. National Gallery of Art, Washington, D.C. Gift of Eugene and Agnes Meyer 1959.

206. Pierre Auguste Renoir, *The Bathers*, c.1918–19. Oil on canvas, 43½ × 63in. Musée d'Orsay, Paris.

by Vanderpyl (a writer-friend of Vlaminck) in *Mercure de France* (nationalism allied to naturalism inevitably tended towards 'blood-and-earth' attitudes in France as well as in Germany).[15]

Yet, though he accepted the contributions of such as Picasso or Modigliani, Chagall or Lipchitz, to the developing French tradition, Salmon insisted that such foreigners had become part of that tradition, that France had been and remained still the crucible of modern art in Europe and that, most importantly of all, Germany was its submissive follower in all things aesthetic. At the beginning of the century, said Salmon, Paris had become the 'Mecca of modern art, truly the new Rome', and so it had remained after the Great War.[16] 'Young French painting', he claimed, 'has never submitted to foreign influence', and: 'The Germans in particular. . . have never been anything but our clients or our pupils.'[17] Among the least attractive of his chauvinist outbursts at this period came in 1921, stimulated by the Uhde and Kahnweiler sales at the Hôtel Drouot. Loyal to his artist-friends, he attacked the sales, but his attitude to one of the victims, Wilhelm Uhde, was harsh, uncharitable and patronizing, an unashamed appeal to prejudice. Uhde was, Salmon wrote, 'the very type of the German artist, pupil or client of the French masters, getting everything from them, giving nothing to them and not even claiming to do so'.[18] Though he identified Expressionism as the only truly national style of the twenties (since French Modernism was to be considered international in its impact and importance), his attitude generally to German art was characterized by this contemptuous, victor's sense of superiority, the natural successor to that ostracism of all things German as barbaric which had been the wartime rule.[19]

As has been said, Salmon's attitude to the relationship between modern art and tradition was wide enough to embrace the whole range of *l'art vivant* from Naturalism to Cubism, but it is clear that the vaguely Classical and distinctly

French image of tradition that he disseminated was closer to conservative than to Cubist attitudes. The view that the new art was a return to the order of a long-lived French tradition which had been obstructed and diverted by the rigidity of academicism was a conservative cliché throughout the decade after 1918, as *l'art vivant* attempted its take-over of the Establishment and official art institutions. Thus, when in 1926 Jacques Guenne advocated the belief that art was in its essence nature subjectively interpreted, and looked to Cézanne as the painter who had guided French art back to this truth, he made the point just as Salmon might have: 'In this way, by renouncing the *imitation* of the object to pursue interpretation, Cézanne had retied the knot with the great tradition, and rediscovered the eternal order in nature fixed but for an instant by the Impressionists.'[20] All the elements of the standard view are there as Vauxcelles characterizes the new art in 1921, calling it concisely 'the return to the rules [of the true tradition] abolished, diverted, bastardized by Italianizing academicism.'[21]

So far the convergence of chauvinism and a broad, indefinite notion of Classicism has been considered almost solely as a post-war phenomenon, a phenomenon reflective of the mood of post-war reconstruction. In fact, the strength of this set of values applied to culture followed from the depth of the roots it had set down during the war, roots which found their sustenance in the ambiance of the 'Union Sacrée', in the prevailing mood of cohesive nationalism. Again Kenneth Silver is the historian most effectively to have brought this out. His analysis has shown how that alliance between an ideal of Classicism which was essentially Latin and a deep sense of French identity propagated on the far Right before the war by Charles Maurras and *Action Française* had been so thoroughly and widely absorbed in France that it had become acceptable even to those who were obviously hostile to the political Right, such as Paul Dermée and Amédée Ozenfant—the necessary adjunct to their accelerated feelings of patriotism.[22] A dominant theme (echoed by Cocteau as well as by Dermée and Ozenfant) had been the War as a new starting-point, a trauma which would drive the French back to the most basic and most healthy aspects of their tradition, those aspects which were most rational and classical, most 'Latin'. Again, from an initial impetus on the Right, a simplistic tendency to oppose French and Germanic culture in terms of an opposition between Latin order and barbaric anarchy, classic reason and Gothic mysticism had become a dominant, with such texts as Léon Daudet's *Hors du joug allemand* of 1915 in the background.[23] Silver has noted how by 1917 the claims made across the worlds of art for a coming 'classic age' were paralleled by a clear tendency in the literature of wartime propaganda to evoke the classical and the antique in the service of France and civilization, pointing to the publication of works like Ferrière's *L'Esprit latin et l'esprit germanique*, Anatole France's *Le Génie latine* and Mathieu's *La Rôle de la France dans la civilization*.[24] In this context it is hardly surprising that the post-war need to see reconstruction as a kind of progressive reaffirmation of tradition expressed itself through the highlighting at once of Frenchness and of Classicism. Peace gave a newly positive character to a set of values whose weight and durability had been established by the ideological shifts experienced in war.

Before, during and after the War, the dominant notion of the French tradition was one of reason, limitation and order. The idea of absolutes or of inflexible formulae might have been abhorred, and on the conservative side especially the qualities of directness and spontaneity might have been advocated, but as Guenne talked of an 'eternal order', so Vauxcelles talked of rules and Salmon of Classicism with all

that it implied. Predictably, therefore, there were those on the Naturalist side (those who would not have been described as 'constructive Naturalists'), whose suspicion of logic and rules set them against the lure of the museums and all the talk of tradition. The most conspicuous such artist was Vlaminck. 'Frequenting museums bastardizes the personality just as frequenting curés destroys faith.' This often-repeated statement of his introduces his interview with Jacques Guenne, published in 1924.[25] Yet, even Vlaminck under the pressure of the times could qualify this sentiment, for the year before, challenged by Salmon that his hatred of museums was exaggerated, he confessed that his claim never to visit them was only, for him, 'a way of replying to the pedants', a claim, in other words, to be interpreted 'symbolically'.[26] Indeed, in that interview of 1924 he did admit that it might actually help an artist to look at Poussin and Corot as he had once looked at Van Gogh and the Douanier Rousseau.[27] Even still, however, his bombast was not entirely undermined, and he continued to point to the danger of such lessons taken too seriously, to plead the importance of innocence and to insist that a 'living lesson is not to be taken from the museums...'. His egotistical self-image as an individual outside all traditions remained—a kind of updating of Courbet's: 'To forget, d'you see, that for me is perhaps the whole secret of painting.'[28]

By 1925, as already mentioned, one of Vlaminck's most favoured butts for insult publicly and privately (after Sunday lunch at 'La Tourillière') was his old Fauve companion from Chatou, Derain;[29] and at the other extreme on the conservative wing of *l'art vivant* stood Derain as the ideal new traditional artist, deeply aware of the past, especially the French past, unafraid of comparisons and compulsively drawn to Classical values in art. Derain's art had enjoyed a considerable wartime success when Paul Guillaume had held a one-man exhibition in the autumn of 1916; between 1918 and 1922 he was not contracted with any dealer, but in 1923 he moved decisively to Paul Guillaume. He did not, however, hold another major one-man show during the entire period (something that did nothing to diminish his reputation or influence), and he made few public statements either. From these statements he emerges a believer in formal invention almost as pure as the Cubists themselves, for instance here, as recorded in 1923 in *Les Nouvelles Littéraires*: 'The transposition of figures and objects is a result of original plastic creation. It allows the identification of styles, it is the basis of all creative genius, be it El Greco or Delacroix, Giotto or Foucquet [*sic*]...'.[30] Furthermore, the way that he adapted, for instance, a knowledge of Cézanne's late portraits to produce his *Greek Girl* of 1919 (Plate 208), or of Corot to guide his treatment of the Roman Campagna in 1921 (Plate 209), or of Chardin to give firmness and clarity to his *Laden Table* of 1921–22 (Plate 158), was not unlike the use made of models from the past (at times the same) by Picasso, Metzinger or Severini during the period. Yet, his classicizing styles were not given the foil of an alternative Cubist practice, and he had remained aloof from Cubism since its beginnings; the fact is that, as conveyed by his pictures and the statement quoted, his belief in formal invention was fused indissolubly with his sense of belonging to a continuous tradition. It is not difficult to see how Raynal could identify him with an idealist tendency related to that of the Cubists, but name him as a painter dangerously apart from them, the leader of a return to *dependence* on the Museums.[31] To take him as such might have been to misinterpret, but such misinterpretation was apparently rife, as Lhote maintains without actually naming names in 1922. Contemptuously he comments on 'this academic renaissance which, under the term Neo-Classicism, pursues the most despised end of all, to ''redo the museums'' by modernizing the works of Giotto,

207. Gino Severini, *Mother and Child*, 1916. Oil on canvas, $36\frac{1}{4} \times 25\frac{1}{2}$in. Collection, Jeanne Severini (1976).

208. André Derain, *The Greek Girl*, 1919. Oil on canvas, $36 \times 28\frac{2}{3}$in. Collection, Raeber, Basel.

Botticelli and Ingres', and he picks out as its source: 'a false understanding of the art of Derain'.[32] Even Lhote, who accepted Derain's independence as an artist, could not deny the strength of the image his art created of a return to the museum as pattern-book.

In fact, for Derain his concern not only with compositional order, but also with the plastic autonomy of the work of art was what tied him to the great stylists of the past, and, as will be seen, it was in just such a way that the Cubists and the Purists identified themselves with tradition. But, if Salmon and even the arch-reactionary Paul Léon could see Cubism in terms of the past, there was within conservative opinion a distinct tendency to discredit it by excluding it from the conservative notion of tradition, or, more particularly of the French tradition. This kind of attack, like the alliance of nationalism and Classicism, had roots in the mood of war-time France, for it was a sequel to those attacks that had dismissed Cubism as 'boche', associating the movement with pre-war German influence, ludicrously.[33] After the War, in the world of *l'art vivant*, such attempts to exclude Cubism from the protective security of the French tradition came from a more moderate direction; they were less ignorant and more sophisticated and they did not require the fabrication of a link with things German.

This post-war exclusion of Cubism was something achieved perhaps most effectively of all by Lhote's neat division between 'Pure Cubism' and art based on nature as a division between conflicting national traditions, the one analytic and French, the other synthetic and not German but Italian; the one rooted in life, the other in abstraction. As he elaborated it in 1919 and 1920, this was Lhote's own theory initially, but the conviction that the *French* tradition was characterized by a deep dependence on the experience of nature at first hand was long-lived and was shared by several leading conservative critics, along with the belief which logically followed that

209. André Derain, *The Road to Castelgandolfo*, 1921. Oil on canvas, $24\frac{1}{2} \times 29\frac{1}{2}$in. Collection, Raeber, Basel.

Cubism was therefore alien to the French.[34] The fact that Picasso and Gris were Spanish greatly helped such thinking. Closest of all to Lhote was Bissière, whose 'Notes sur Ingres' in the fourth number of *L'Esprit Nouveau* in January 1921 are like a gloss on Lhote's earlier articles. In Bissière's words, for Ingres, 'It is by analysis whilst observing the world that he wishes to get as far as the divine Raphael', and as substantiation Bissière quotes Ingres's declaration that the artist must find beauty 'in the model'.[35] Taking Ingres's *Portrait of*

Mme de Senones (Plate 210) and Raphael's *La Fornarina* (Plate 211), he sums up:

> . . .the Italian and the Frenchman in these two works show themselves both to be dominated by the need for order and the choice of architecture as generator. . ., but the one has already made his choice before approaching nature, the other has only made it after close contact with [nature] and only among the elements found there which are offered him.[36]

Like Lhote, he saw Raphael's synthetic approach as essentially foreign, and when in July 1921 he wrote about Picasso he came to interpret the Spaniard's unresolved pursuit of Cubism alongside traditional representational styles as the inevitable result of an unresolved involvement in contradictory national tendencies, one Spanish and one French—a unique condition.[37]

More widely influential than Bissière, of course, was Louis Vauxcelles, and he too made so much of the importance of nature to the French tradition as to exclude the Cubists. He did so especially tellingly in an article of 1920 published in the newspaper *Eclair* as a response to the revived Section d'Or. The article was so telling because it centred on the relationship between Cubism and one of the accepted lynch-pins of every independent's idea of the French tradition, Cézanne; it was called 'From Cézanne to Cubism'. Here he acknowledged that the importance of Cézanne to the Cubists was great and gave it a twofold character, at once 'architectural' and 'intellectual', stressing Emile Bernard's statement that 'Cézanne's optics were "not in the eye, but in his brain".' He was not against, he said, either the impulse towards construction or the rejection of 'pictorial debussyism', that is, of purely sensory painting. 'But,' he declares, 'Cézanne, like all the masters, never took his eyes off nature and life. He reconciled in himself sensibility and reason, and was not a man in a closed system.' The Cubists, 'possessed by the demon of abstraction, [had] turned their backs on nature', and so had turned their backs on Cézanne and the French tradition.[38] According to this view, Cézanne had renounced the mere painting of sensation without renouncing nature and in this lay his significance to the recrudescence of tradition. It was in 1920 that Joachim Gasquet's recollections of Cézanne in conversation, were published in *L'Amour de l'Art* as a strong endorsement of such a view; happily, at the time, Vauxcelles was still editor and one can imagine his pleasure on first reading them.[39]

Lhote's determined attempt to exclude Cubism in its 'pure' form from the reassuring national support of the French tradition was not, then, at all isolated, and among conservatives the various kinds of Naturalism acquired a special status as major representatives of that tradition. And, because of Renoir's newly established status as the 'instinctive' rebuilder of the French tradition alongside the 'intellectual' Cézanne, it was as possible thus to honour an 'instinctive' Naturalist like Vlaminck as it was a 'constructive' Naturalist like de Segonzac. Just as 'order' could be found in late Renoir, so 'Classicism' could be found (to an extent) in the Vlaminck of the mid-twenties. What bound them all to their French past was most profoundly their respect for nature, and so, in the eyes of Vauxcelles or Guenne, Lhote or Bissière, Cubism could appear only either foreign or a break with the 'great tradition' of France. For them, to resist the basic tenets on the one hand of Naturalism and on the other of *a posteriori* Cubism was to resist the basic tenets of national identity.

* * *

210. Jean Dominique Ingres, *Portrait of Mme de Senones*, c.1814. Oil on canvas, $41\frac{3}{4} \times 33\frac{1}{8}$in. Musée des Beaux-Arts, Nantes.

211. Raphael, *La Fornarina*, c.1516–17. Oil on panel, $34\frac{1}{4} \times 24\frac{3}{4}$in. Museo Nazionale, Rome.

The idea of the 'French tradition', however, was infinitely adaptable, and, of course, the more sympathetic interpreters of Cubism, from André Salmon right across the radical spectrum of *l'art vivant*, insisted that Cubism was an essential feature of the return to that tradition. It was from this that was derived the symbolic force of the repeated claims (discussed in Part I) for the importance of Ingres as a trigger in the initiation of Cubism, and for Ingres's continuing role as the benevolent sponsor of the movement through the mediation of Picasso, claims made by no one more insistently than Salmon.[40] The artists themselves were not slow deliberately to underline this traditional aspect of their art, as well as, from time to time, its Frenchness. In 1924 the Russian Jacques Lipchitz wrote the following memorable reply to the *enquête* organized by the *Bulletin de la vie artistique* asking for reactions to the decision to hang the Salon des Indépendants by nationalities: 'I know that if there were sitting on the Committee of the Indépendants Fouquet, Poussin, the Le Nain brothers, Philippe de Champaigne [*sic*], Chardin, Boucher, Watteau, Ingres, Delacroix, Corot, Manet, Cézanne, their decision would have been completely different.'[41] He, a foreigner, a Jew, and a Cubist, had no doubt where he stood in relation to the French tradition.

It is one of the richest ironies of the Cubist stance, even in its distilled Modernist form after 1917, that it sought not so much to associate its most profound values with the twentieth century as with the values promoted by a notion of tradition, seeing such an association as the key to its legitimacy. Post-1917 Cubist art (the model for Modernism in all its Western forms) was less self-consciously revolutionary than traditional, and, surprisingly, this identification with the past went back to the Cubists' most revolutionary phase, to before 1914. As early as 1912 Raynal had linked the Cubist pursuit of the essence of things by the use of shifting view-points to the multiple perspectives of Giotto and of 'primitive' Italian art generally, and this notion of Cubism as a conceptual art was, of course, widely associated with Cézanne in the way we have seen responded to by Vauxcelles.[42] Earlier, in 1911, Gleizes had tackled the problem of relating so innovative a movement to the past in a way which was obviously a stimulus for Salmon's attempts after 1918.[43] He too had characterized it as a progressive continuation of an unbroken tradition, a chain of evolution which always linked it to earlier art, his model here being the philosophy of Henri Bergson and in particular the Bergsonian idea of 'duration'. Then, in 1913, Gleizes had published an article in *Montjoie!* called 'Cubism and Tradition' which anticipated many of the essentials of the relationship later to be claimed between Cubism at its most pure and the French tradition. His argument was that the Cubists' primary concern with form in its own right and with the values of lucidity and order were what joined it to that tradition. Naturally, he named Cézanne as a great prophet who had guided artists back to the true path, and he named as the masters of the French tradition, the French primitives, then Fouquet, Clouet, Poussin, Claude, Philippe de Champagne, the brothers Le Nain, Chardin, David and Ingres. Gleizes already in fact had separated those he saw as influenced by Italian art (Poussin, Claude, David, Ingres) from such as Clouet, the Le Nain brothers, Chardin and Courbet, and he was further to redefine the leadership of the French tradition, but the masters he named in 1913 (most of whom were on Lipchitz's list in 1924) were to remain for the rest of the Cubists the acknowledged leaders.[44]

During the Great War and the twenties the argument for a continuity between Cubism and tradition became almost a truism for the Cubists themselves and their sympathizers: a crucial supplier of confidence in their combat both with conservative and radical opinion. It is there behind the answers of two peripheral Cubists to the *enquête* on the death of Cubism in the *Revue de l'Époque* during 1922. For Léopold Survage Cubism was 'an art which has rediscovered the true plastic foundations of painting and sculpture—after centuries of confusion when they were forgotten. . .'.[45] For the Norwegian friend and follower of Léger, Thorvald Hellesen, Cubism was 'a novelty, which advertised itself by way of one thing alone from which it will certainly not die: Respect for the most ancient and eternal laws, the laws of the surface' (he referred here to painting alone, of course).[46] As Auguste Herbin was to put this unquestioned assumption, replying to another *enquête* in 1924 (this one in the *Bulletin de la vie artistique*): 'True Cubism was invented from the first steps taken by humanity onwards.'[47] Replying to the same *enquête*, Laurens wrote: 'Concern with composition; representation of the plastic fact; to retain and express the essential with simple and personal means; to rejoin tradition; there you are, that's what seems to me the aspiration of Cubism. Tradition is continuous beneath the different appearances of epochs.'[48]

Such convictions were easily adapted to the complicated shape of advanced Cubist theory from 1917. After all, Pierre Reverdy's talk of the 'eternal' and the 'constant' in his essay of 1917 'On Cubism' carried obvious implications of a traditional kind. For the most rigorous of the theorists it was important to limit the scope of the relationship between Cubism and the past so that the newness and individuality of the artist's 'aesthetic' could not be challenged, but at the same time all agreed on the importance of the past to the present. As Gris would have argued in 1924 at the time of his lecture 'On the Possibilities of Painting', an artist's aesthetic reflected the spirit ('esprit') of the time, his range of pictorial or sculptural elements and the way he used them reflected preferences formed in his lifetime, but that did not render the lessons of the past irrelevant.[49]

Gris's position was close to that of Raynal. According to Raynal in his 'Quelques Intentions du cubisme', it was on a purely compositional level that the artist could learn from the past: on the level of how he constructed with a particular range of elements. 'Now these researches, these too', he writes, 'will be based on the examples of tradition. The artist will transpose, and transform them following the state of modern sensibility, but he will always conserve for them the same spirit of equilibrium.' He went on to comment on the pleasure of finding curves that repeat those found in Egyptian art, but especially to comment on the discovery of 'transposed constructions' which rejuvenated and amplified those of Chardin and Watteau confirming their 'fruitful influence'.[50] Elsewhere in the same text he was to call this 'spirit of equilibrium', as manifested in purely formal, structural terms in the French tradition, 'the science of measure', a quality neither scientific nor measured in the literal sense but ordered, rather, in an intuitive way, as has been seen.[51] Already by 1919 Gris had found his own way of articulating what amounts to the same belief in a volatile, developing art whose basic formal, compositional qualities were constant and linked to the past. Thus, he writes to Kahnweiler in August that year of wishing 'to continue the tradition of painting with plastic means while bringing to it a new aesthetic based on the intellect', and amplifies the point as follows: 'I think one can quite well take over Chardin's means without taking over either the appearance of his pictures or his conception of reality.'[52] But it was in his lecture of 1924 that he expressed the idea most clearly, most effectively resolving in words the paradox of an art that could be at once new and traditional, changing and static: 'Certain technical methods are common to all periods; others are less constant and vary according to

the aesthetic. . .Only the purely architectural element in painting has remained constant. I would even say that the only true pictorial technique is a sort of flat, coloured architecture.'[53]

Much earlier than this lucid explanation of the central Cubist stance in relation to the past, earlier even than the letter to Kahnweiler of 1919, Gris had explored the implications of the stance graphically and pictorially in his series of drawings and paintings which developed variations on works from the past, above all from the French tradition, by Corot and Cézanne. The best known of these variations is *Woman with a Mandolin (after Corot)* (Plate 212), which was based on a reproduction of its model (Plate 213) and painted at Beaulieu-près-Loches in 1916. It is the result, in effect, of a complete rebuilding of Corot's idealized peasant girl in terms of flat geometric shapes, and can seem to deny altogether the demure softness of its source. The impression is given of a newly fabricated Cubist structure imposed upon the Corot, not at all of a structure extracted from it. And yet, as suggested in Part I, the underlying armature of overlapping triangles which gives unity to the composition and fixes the angle of every line in the figurative structure was almost certainly extracted from a sympathetic formal analysis of the Corot. Gris seems to have discerned in it a basic armature of triangles following the contours of the arms and other telling guidelines like the division up the middle of the blouse and the vertical of the nose, and then to have constructed his variant on just such a basis. This was a kind of geometric armature which became, as we have seen, typical of his painting between 1916 and 1920, and here he openly used it to supply the linkage between himself and Corot, just as he was to in a later variation on a Cézanne portrait of his wife which Gris based on drawings initially made at Beaulieu in 1916.[54] Then again, as shown before, these instances of direct transposition of lessons learned from selected models from the past were supplemented at the turn of 1922—23, as Gris softened and sweetened his figure painting, by pictures which less directly but undeniably emerged from a similar study of Raphael as a pictorial composer. Here too it was the extraction of a basic architecture that concerned Gris, a cursive kind of architecture which he then adapted to his own purposes (Plates 99 and 214). There are few other Cubist works directly and recognizably based on specific models from the past, though more generalized links are common; but the way that Gris looked for an underlying structural order in Corot, Cézanne and Raphael, an order that rendered irrelevant at a deep level the more superficial differences of style, almost certainly echoes the way that all the other Cubists looked at such models and understood in formal terms their attachment to their various notions of tradition. It was to such deep-lying connections that Picasso referred when he told Marius de Zayas in 1923: 'Cubism does not differ from the usual schools of painting. The same principles and the same elements are common to all.'[55]

It was in just this way too that Ozenfant and Jeanneret, the Purists, understood their attachment to tradition, and it was they who took such thinking about past and present to its most elaborate, far-reaching extreme in *Après le cubisme* and *L'Esprit Nouveau*. They too, of course, stressed the modern developing character of their art as a product of the new spirit (l'esprit nouveau'), and rejected any idea of the past as a supplier of models academically to be imitated; but more exactly and more elaborately than any of the Cubists they attempted to detail the formal and compositional laws (of proportion) applied to all art, the 'constants' they believed complemented the basic receptive characteristics of eye and brain. Their continual application to the examples of the

212. Juan Gris, *Woman with a Mandolin (After Corot)*, September 1916. Oil on canvas, 36¼ × 23⅝in. Oeffentliche Kunstsammlung Basel, Kunstmuseum.

213. Camille Corot, *Dreamer with a Mandolin*, 1860—5. Oil on canvas, 20¼ × 14½in. City Art Museum, St Louis, Missouri.

214. Juan Gris, *The Blue Cloth*, 1925. Oil on canvas, 32 × 39⅜in. Musée National d'Art Moderne, Centre Georges Pompidou, Paris.

past was, therefore, to be expected. As they said in *Après le cubisme* in 1918, the laws of art are timeless: 'The Egyptians, the Assyrians, the Greeks, the Persians and the Gothics knew them. . .'.[56] In 1921, under the pseudonym De Fayet, Ozenfant wrote as follows in the seventh number of *L'Esprit Nouveau*: 'Today we are in search of fixed points, words which signify something, elements which are organized, healthy and viable. . .The strongest words have always been the simplest and these words are permanent across the ages.'[57] The subject of his article was Poussin, and of this pillar of the French tradition he writes: 'Poussin knew how to create words; these words are formed of elements taken from the spectacle of life, but they are chosen with measure and science from the elements of. . .geometry, of tight organization.'[58] Seurat, Cézanne, Ingres, Corot, the Le Nains and Fouquet all figured with Poussin in the first nine issues of *L'Esprit Nouveau*, each as an artist who had 'known' the constant and simple laws of the pictorial language the Purists believed they too were using in tune with the new spirit. And the lesson of fundamental constancy taught by the art of the past was not forgotten in the later issues of *L'Esprit Nouveau* by either of the Purists. Moreover, they spread their net outside the French tradition more expansively to take in not merely (as in *Après le cubisme*) the hieratic art of the Egyptians and the Assyrians, but also Roman mosaics,

Michelangelo in the Sistine Chapel and Greek vases.[59] For Ozenfant, the Sistine Ceiling was *par excellence* a 'machine for emotional arousal', simply because of Michelangelo's use of 'primary physical elements capable of satisfying the eye, sufficiently clearly shown, clearly presented, clearly assembled' to give what elsewhere he called 'joy' to all who saw it.[60] While for Le Corbusier, writing most particularly in praise of the Romanesque and the Egyptian, the high-point of the 'hieratic' was reached at 'the time of full understanding, of possession of all the means,. . .the time exactly of choice, the time when the superfluous is abandoned, the time of concentration, the time of abnegation, the moment *par excellence* of elevation, the platform of great art. . .'[61]

The Purist approach to pictorial order was, of course, highly restrictive, and accordingly theirs was not an all-inclusive view of tradition as a whole. As has been seen, it excluded Renoir. More important from the vantage-point of the Cubists, the way the Purists presented the French tradition in those first nine issues of *L'Esprit Nouveau* was exclusive in that other sense found in the more chauvinist writings of Lhote and such pro-Naturalist conservatives as Vauxcelles and Jacques Guenne. Since Purist painting, most obviously at the beginning of the twenties, made an anti-Cubist point of starting with the object and dealing with it analytically in order to arrive at a purely 'plastic' order, it was logical that

215. Juan Gris, *Pierrot*, 1923. Oil on canvas, 45⅝in × 32in. Galerie Louise Leiris, Paris.

216. Jean-Antoine Watteau, *Gilles*, c.1721. Oil on canvas, 72 × 59in. Musée du Louvre, Paris.

Bissière as the paradigmatic Italianate synthetist, but the fact is that only a few months later he could paint Pierrot (Plate 215), one of a couple of pictures which just as obviously confront the Watteau of *Gilles* in the Louvre (Plate 216) and thus place himself in the 'earthy', *a posteriori* French tradition. Moreover, he never explicitly declared an exclusive attraction to obviously synthetic models. It does not seem to have been difficult for Cubists committed to the purity of synthesis, to establish an unproblematic relationship with what was generally considered unsynthetic. As has been seen, the image of Picasso the Cubist became literally bound together with the image of Ingres as the model for the future, while Braque's *Canéphores* (Plate 71) asserted an entirely positive relationship with Poussin and late Renoir. Cézanne, of course, was almost every Cubist's hero, the unspoken memory against which almost every Cubist still life was measured (Plate 205).

There were, however, a few on the Cubist side who tended towards a more definite and exclusive commitment in favour of the synthetic in the past. This is true in the influential case of Léonce Rosenberg who put together a particularly complete and concise statement of his position in relation to Cubism and the past in the reply he sent to the *enquête*, 'At Home with the Cubists', published by the *Bulletin de la vie artistique* in 1924. Here he expanded a view of his time, its thought and its art closely related to that of the enlightened psychiatrist Dr Allendy. For him, in all spheres the history of mankind oscillated between the two poles of 'analysis and synthesis'. After the Renaissance, as a direct expression of its 'epoch', art had developed in the direction of analysis, reaching a climax in Impressionism; it had been followed by

217. Master of 1456, *Man with a Glass of Wine*, oil on panel, 24⅜ × 17¾in. Musée du Louvre, Paris.

L'Esprit Nouveau should align itself with the idea of the French tradition as essentially committed to just such an analytical stance in relation to nature. When Ozenfant (as De Fayet) celebrates Poussin's creation of the 'words' for a basic pictorial language, it is noticeable that he makes a point of adding that these words have their origin in the 'spectacle of life'.[62] Significant in the same way was the decision to invite Roger Bissière to contribute the articles on Seurat, Ingres and Corot alongside Ozenfant's on Poussin, and not surprisingly Bissière found as much room for his anti-synthetic, anti-Cubist view of the French tradition when writing on Seurat and Corot as he did when writing on Ingres. For Bissière, Corot and Ingres together constituted 'the point which attaches us to that long line that begins in Fouquet', and, as with Ingres, he made much of the assertion that 'Corot never took a determining attitude to nature, he approached it with no pre-conceived idea, sensitive to the internal rhythm by which it is animated.'[63] It was just such a balance between life and art that was picked out too in the unsigned article on Fouquet, as central to the *Man with a Glass of Wine* (Plate 217), then considered one of Fouquet's most celebrated works: 'All the virtues of the race are found there, carried to the highest degree, that measure, that honesty, that respect for facts, the need always to incline to the earth [so as] to draw from it strength and to reach the divine.'[64]

If synthesis and the autonomy of the work of art were fundamental to the Cubist stance, it might seem that there inevitably followed a dominant tendency among the advanced Cubists to identify with styles from the past and traditions which could be given a synthetic image. Yet, as has been seen, Lipchitz and Gris were not alone in identifying with the French tradition, however pervasive the image it gained of promoting a commitment to nature as the starting-point. Gris may have turned to Raphael as a stimulus in 1922 partly because of the reputation created for him by Lhote and

'the return of man to the spirit of synthesis', whose counterpart was Cubism, which would create 'a renaissance of the plastic' in a new monumental art. As Rosenberg saw it, from this 'spirit of synthesis' there naturally followed a distaste for the Renaissance and its sequels, and a desire to search further afield, from whence came the new passion for 'the arts of the Chaldeans, of Egypt, of Greece, of China, Persia and of the Middle Ages'. In particular, he picks out the 'primitives of the thirteenth and fourteenth centuries' as attuned to the new movement.[65]

Among the artists, Léger, of the Effort Moderne Cubists, seems have been especially drawn to such an exclusive response to the styles of the past and the idea of tradition. The main body of his reply to the enquête of 1924 in the Bulletin de la vie artistique was as follows:

On returning from Italy I have been able to judge the totality of the work of the Italians. I believe that we should heartily dislike everything more or less related to the Renaissance. All the 'great workmen' who have encumbered mankind from the fifteenth century are ill-fated. The primitives, the artisans of the mosaics and the frescoes are admirable.[66]

It is well known that on his trip to Italy in 1924 with Léonce Rosenberg, he had been drawn above all to the mosaics at Ravenna and to the Italian 'primitives'.[67]

Léger's stance at bottom was that of all the Cubists. Thus, in his lecture 'The Machine Aesthetic' of 1923 he had asserted his conviction that beauty, whether found in ancient architecture or in machine-made, modern objects, was based on geometric principles underlying all architecture.[68] He therefore echoed Gris's or the Purists' assertion of the permanence of structural order in art. But, for him, it was equally clear that such beauty was only to be created if the accent lay on invention rather than representation, on the abstract manipulation of form rather than the subject. For him, the Renaissance (especially the sixteenth century) produced 'almost total decadence', because its artists were victims of the beautiful subject'.[69] Just how far he turned to the artists of the past according to their capacity to 'invent', to synthesize, is given its bluntest expression in a letter to Léonce Rosenberg dated 1922, which, with typical indiscretion, the dealer published in the Bulletin de l'Effort Moderne two years later. The crucial point, according to Léger, was 'whether or not the forms are invented', and he expanded thus: 'Renaissance painters copied, the pre-Renaissance invented; Ingres, the brothers Lenain [sic] and Cézanne invented sometimes, Poussin often, Clouet and Fouquet almost always, and with Renoir the case is less definite.'[70] Only grudgingly did he allow Ingres, the Le Nain and Cézanne into the pantheon, Renoir is set on one side (where the Purists put him), and the acknowledged heroes are Fouquet, Clouet and Poussin. Further, these latter are picked out not merely because of the 'architectural' beauty of their paintings, but as significantly because of a suggested willingness to approach nature inventively, synthetically, as he did.

From 1920, far more than Gris, Léger made a habit of styling his figures and even the presentation of still life objects so as to embed in his pictures signals judged to arouse manifold memories of images from the past with all their conflicting associations. Thus, The Mechanic of 1920 (Plate 171) signals its connections with Egyptian and Assyrian reliefs clearly enough while up-dating the theme of the Man with a Glass then attributed to Fouquet.[71] By restyling Fouquet in hieratic terms Léger rid the image of any associations it might have had with the Realist or Naturalist notion of the French tradition; the look of the hieratic made dominant the

'right' connotations with 'purer' traditions. The Grand Déjeuner of 1921 (Plate 66) and most of the more elaborate figure compositions of 1921–24 (Plate 218) signal more complex and contradictory attachments to the past. Here Léger creates strong pictorial contrasts by pitching a figure style reflective of Poussin and David against a treatment of still life and space reflective especially of the Master of the Flemalle and his contemporaries.[72] For Léger, both sets of associations were positive: they were different aspects of the 'inventive' tradition, as were the Assyrians, the Egyptians and Fouquet. But the conflict is superficially more potent, and both the post-Renaissance and the 'primitive' connotations combine to strike in a rather different way against another reference: Renoir. At the Salon d'Automne of 1921 where the Grand Déjeuner was first seen in public, any alert and aware visitor would have seen how decisively these polished, heavily modelled nudes contradicted the fleshy image of the nude created by Renoir, especially at the end of his long career (Plate 206). After all, it had been at the Salon d'Automne of 1920 that the late Renoir had enjoyed perhaps the highest prestige he would ever achieve as a component in any classical concept of the French tradition.

Léger's pictures as well as his published statements conveyed forcefully a particular stance in relation to the past, and for the most aware a stance that highlighted synthesis against any sort of obvious, direct dependence on nature. But he was not the Cubist to attach himself most exclusively of all to traditions considered synthetic. Gleizes was the one to take this tendency to its extreme, and he did so in his own atypical, maverick way, though in a way which Léonce Rosenberg must have viewed very sympathetically. At Léonce Rosenberg's Geneva exhibition of Cubist art in 1921, Gleizes gave a lecture called 'The Rehabilitation of the Plastic Arts'. The title referred to his belief (generally consistent with Salmon's, Gris's or Léger's) that Cubism had restored the true values of all art, but his notion of where those formal values were most purely to be found was very much his own and rather different from the suggestions he had made in 1913. His choice of which art of the past was most truly a model for the art on show in Geneva was guided by convictions alien to those of the other Cubists in most respects, convictions already touched on in earlier chapters.

Gleizes's new and passionate religious faith and its coming together with a more purified, synthetic version of Cubism led in his lecture to a new attitude to primitive, medieval and post-Renaissance art. It was an attitude underlying all his writings of the early twenties. He completely dismissed Classical and post-Renaissance art. He saw them as rooted in an idealist worship of the human form and nature, the product of decadent societies, of cultures which were materialistic and non-spiritual.[73] In their place he set up as the only acceptable models the art of non-western or 'primitive' cultures, and above all medieval art (especially French medieval art).[74] His accent on the 'collective' character of medieval art and architecture carries obvious echoes of post-Puginian Arts and Crafts attitudes, but, as has been seen, he linked these to a thoroughly distilled late Cubist accent on the basic abstractness, the presumed 'synthetic' character of medieval mural painting and sculpture, which he declared had reached its apogee in the thirteenth century. For Gleizes, such figures as Poussin, David and Ingres were not positive examples, his art in the early twenties with its mural aspirations (Plate 178) was a continuation of the French tradition of the Middle Ages, and at the same time a denial of the Classicism of antique art as well as the entire post-Renaissance tradition in France.[75]

There went with Gleizes's dismissal of the Classical a dis-

218. Fernand Léger, *Mother and Child*, 1922. Oil on canvas, $67\frac{1}{2} \times 94$in. Oeffentliche Kunstsammlung Basel, Kunstmuseum.

tinctly anomalous attitude to Romanticism and to Cézanne. He deplored the tendency to dismiss Romanticism and to celebrate Classicism. As he saw it in his Geneva lecture of 1921, Romanticism was not merely anarchic, but, stemming from a deep inner anxiety, had prophetically called for a return to the spiritual springs of art, something he discerned in Hugo's nostalgia for the Middle Ages and in Delacroix's submission both to 'Christian' and to 'oriental influences'. Here too he presented Cézanne as above all a Romantic, a painter whose sense of the universal was neither rational nor considered, but essentially intuitive.[76] Cézanne's art thus became for him a signpost, but not in any important sense a guide or a model, and in 1922, in *La Peinture et ses lois*, he deliberately played down its significance. 'Cézanne has shown the direction to follow,' he wrote. 'In himself he is almost nothing, so far as profitable lessons are concerned: his formal methods are empirical . . ., his technique is disastrous for the survival of his works.'[77] The theoretical contributions of Denis, Sérusier and Signac were, for Gleizes, far more important than the painting of Cézanne.

Such views of the relative roles played by Romanticism and Cézanne in the recent history of painting were alien to the Naturalists as much as to the Cubist generally. They emphasize the uniqueness of Gleizes's stance. Yet, it remains true that even Gleizes's maverick identification of Cubism with the French tradition (or rather *a* French tradition) was built on the same broad foundation as was that of all the other Cubists. For it was, of course, at the level of compositional laws governing rhythm on a flat surface (what Gris called 'flat, coloured architecture') that he too found the actual connection between *his* French tradition and the new art.[78]

* * *

If Léger as a Neo-Classicist, like Picasso, Severini or Metzinger in their various traditionalizing styles, embedded into his pictures of the early twenties unmistakable cues connecting the image to various memories of the past, so specific a signifying of connection or disconnection was not the rule in Cubist art, except in a very general sense. It is perhaps best to end this chapter, therefore, by turning to the ways in which this kind of linkage, with all the implications that followed from it, could be disclosed by paintings and sculptures at the time without the inclusion of highly focused or highly specific references to the past.

When in the spring of 1924 Georges Charensol visited Gris in his studio at Boulogne-sur-Seine, he described finding a simple room with a divan, two easels and 'as ornament just a few photos on the bare walls: figures by Corot and Fouquet look at still lives by Cézanne'. During the interview Gris considered the question of how far his work was willed and how far felt. He claimed that it was altogether felt: 'Will plays no part in my paintings.' This led him to dismiss the idea that consciously he could follow the painters from the past whom he admired: 'I am attracted, thus, to certain painters: Corot, Cézanne for example, but [even] if I *wanted* to imitate them I could not: it is my temperament that prevails.'[79]

Gris might occasionally have created images that divulged debts to Raphael or Watteau for those willing to look for them, but his painting alongside this statement displays a distinct preference for avoiding too obvious an indebtedness to specific styles from the past. Indeed, his painted adaptations from Corot and Cézanne (Plates 212 and 213) as much transform their sources as announce them: the most distinctive marks of indebtedness are erased. As Gris saw it within his Reverdian structure of concepts, his 'temperament' was guided

by his 'aesthetic', by that pattern of preferences and priorities that manifested the 'spirit' of his time; it therefore would always distance his art on the most superficial or immediate level from the styles of the past that he admired, even if at a deeper level the constant laws of pictorial 'architecture' assured continuity and connection.

This avoidance of too obvious a *stylistic* relationship between their art and the artists of the past was generally the rule amongst the Cubists after 1914 as before. Where sources were very specific, as in *Woman with a Mandolin (after Corot)*, or even fairly specific, there were significant occasions when the formal vocabulary of synthetic Cubism was used almost as camouflage to conceal the source. A case in point is Picasso's bright adaptation of a broadly Corotesque subject, *The Italian Girl* of 1917 (Plate 219). Like Gris, Picasso here seems to have taken off from a specific source, but a photographic one rather than a specific Corot figure painting; for the seated figure (save her basket) is echoed closely in an elaborate representational drawing made two years later from a postcard kept after Picasso's trip to Rome of 1917 (Plate 220). Yet, like Gris's Corot variant, Picasso's picture is in effect a denial of its sources, both in Corot's fancy-dress peasant figure pieces and in tourist postcards of the same 'genre'. It is in almost every respect the obverse of the nuanced modelling and soft tones of Corot's painting and of the illusionist black and white of photography: sharp of edge, bright and flat of colour. Another case in point is Picasso's *Man Leaning on a Table* of 1916 (Plate 15), whose origins, as suggested in Part I, lie in drawings of an openly Cézannist kind (at least in subject and in the awkwardness of

219. Pablo Picasso, *The Italian Girl*, 1917. Oil on canvas, 64 × 48in. Stiftung Sammlung E.G. Bürhle, Zurich.

proportions) (Plate 12).[80] Those origins have completely disappeared from view as Picasso has overlaid them with a Cubist planar architecture: in the end, only that synthetic cladding, enriched and elaborated, have been allowed to remain.

In this latter case Picasso obscures the memory of Cézanne far too effectively to convey that relationship even in the most abstruse or perverse way. A knowledge of the drawings is needed to make the link at all. By contrast, in Gris's adaptation from Corot or in Picasso's *Italian Girl* (Plate 219), enough is left legible to announce to an attentive audience, well primed with notions of the French tradition, their relationship with Corot. It was most often by the straightforward and legible use of *subjects* which in themselves were the signs of a relationship with the past that the Cubists publicly situated their art in their chosen traditions. By thus making subject-matter the banner, as it were, of a style or a cluster of related styles, while rebuilding that subject-matter in the new stylistic terms of synthetic Cubism, the artists could at once signify the link and dramatize the distance between past and present. They could thus embed into their images a whole gamut of connotational meanings to be read off from the character of their relationship with particular carriers of tradition, particular 'masters', periods and styles; and they could do so without anything like the degree of explicitness found in Gris's adaptations from Corot and Cézanne. More than Picasso's *Italian Girl*, the most telling case of all in Cubist figure painting of the period was Braque's use of a limited range of standing and reclining nudes from the *Canéphores* onwards (Plate 71) to juxtapose his figure painting by the most general of analogies with Renoir's late nudes and thus with that current revision of the prevalent notion of the French tradition which gave Renoir a place as prominent as Cézanne. A very great deal was signified here merely by the use of the nude posed and generously proportioned in a particular way.

It was not, however, in figure painting but rather in the predominant use of the still life subject that the Cubists most effectively made the subject into a banner proclaiming their desired relationship with particular styles and a particular tradition, the French tradition. This was possible on the one hand because of the schematic way that, by 1920, the still-life genre had come to be associated with Cézanne and Cézannism, and on the other by the sheer size of Cézanne's reputation as a mediator between the eternal verities of the past and the dynamism of the present. Just how *un*specific the still-life subject could be in its relationship with prototypes in Cézanne, yet effectively signal the link is conveyed by the reductive, condensed way that the example of Cézanne could be referred to verbally in the twenties. Thus, when in 1920 Picabia wishes to insult Léonce Rosenberg and the Cubists for their admiration of Cézanne, he needs only to mention the 'apples and napkins' favoured by the 'master of Aix' to summon up his entire pictorial achievement;[81] and when in 1922 Léger writes to Léonce Rosenberg of his preference for modern subjects it is enough for him to mention 'four apples on a table' without even naming Cézanne, to achieve the same end.[82]

Just as he used his nudes to announce Renoir as the presence behind his figure paintings, so it was Braque who most conspicuously used a particular range of still-life props to announce Cézanne as the prevailing presence behind his Cubist still lives. This is especially so after 1920, and is a factor as much in large compositions like *Fruit-bowl and Fruit on a Table-cloth* of 1924 (Plate 96), as in smaller pictures like *Still Life with Brown Jug* of 1922 and *Pitcher, Fruit-basket and Knife* of 1924 (Plates 235 and 79). Yet, it is important to insist on the point that very little was needed in the way of

220. Pablo Picasso, *The Italian Girl (After a photograph)*, 1919. $24\frac{3}{4} \times 18\frac{7}{8}$ in. Private Collection, California.

clear-cut specific references effectively to signify the link between a Cubist still life and Cézanne. Certainly it was enough to introduce a fruit-basket and a napkin cunningly unfurled to break the line of the table-edge, as in Marcoussis's *Still Life and Bottle* of 1923, and even enough to place a few

apples on a table-top, as Léger does to accompany his ornate *Beer Mug* in the picture of 1921 (Plates 97 and 227). Indeed, even those ubiquitous Cubist still lives where the violin or guitar act as centrepiece almost certainly announced the link effectively enough, not because they related in subject to

any specific prototype in Cézanne, but simply because of their internal relationship in the well-known linear history of Cubism with the hermetic pictures of Picasso's and Braque's pre-war phase. It was an acknowledged truism by the early twenties that behind these earlier pictures lay the dominant example of Cézanne. It could be said, as already suggested, that almost every Cubist still life more or less directly asked to be measured against the memory of Cézanne, that the entire genre of still-life painting had become inescapably linked with that memory and thus with everything that Cézanne's art implied as a representative of the French tradition.

As Gris told Georges Charensol, the styles the Cubists identified with or admired were never to be imitated or willfully used as a starting-point (except, he might have added, in the most elementary kind of compositional analysis). The visible distance between a Cubist picture or sculpture and any particular past style that it referred to was as crucial as the signalling of a link. Yet, once again it must be stressed that the signalling of such links with Renoir, Corot, Cézanne and other 'masters' or styles, not only dramatized the modernity of the Cubists' 'aesthetic' within the 'new spirit', but under-lined for them the constancy, the continuity of Cubist art as an extension of tradition at the deepest level, the level of form and structure. In the final analysis, Picasso's and Gris's Corotesque figure paintings, Braque's nudes and every Cubist still life carried connotations that were profoundly conservative. For the attitude to the relationship between Cubism and the past that permeated these images was at root anti-avant-gardist. Though they used it to give substance to a new and radical stance diametrically opposed to the conservatism of the Naturalists and the academics, the fact is that it marked out a route to eventual legitimacy, to Cubism's incorporation into the range of the accepted and safe. In general outline the always ordered, always formalist and often chauvinist idea of tradition that was disclosed by their compositions was difficult to separate from that of André Salmon, Louis Vauxcelles or even the arch-reactionary Paul Léon and the war-time patriots of the Right from Léon Daudet to Maurice Barrès.

13
Modern Life and Modern Art

'The spirit. . .makes the epoch', Reverdy wrote in 1921 not for the first time, and he went on to consider briefly how the spirit of the time permeates the priorities, sensibilities and actions of its artists: 'in an overall way similar tastes and dislikes determine the acts of the artists of a [particular] time—habits are established, life is otherwise organized, everything takes another form and another colour—this is the epoch.'[1] The Cubist attitude to the relationship between their art and the life of their own time was both more obviously radical and more obviously distinct from that of the conservatives than their attitude to the relationship between the art of the present and that of the past. It was an attitude clearly differentiated both from Raynal's museum-going 'Eclectics' and from the Naturalists. Where the Naturalists (constructive or not) saw no *necessary* parallel between their art and modern life, the Cubists did, and took every opportunity to insist on it. Always after 1917 the Cubists and their defenders presented Cubism as necessarily modern. Naturalism was not necessarily modern; the paraphernalia of modern life could seem frankly irrelevant to some, though not all Naturalists. Dunoyer de Segonzac, with sharp sarcasm, made his position absolutely clear in his interview of 1923 with Florent Fels: 'One of the converted said to me,' he recalled: ''It's not possible any longer, in this era of elevators and aeroplanes, to paint after nature.'' From this it seems that Delacroix and Corot in their paintings took account of the great novelty of their era, railway locomotives.'[2]

The rejection of a *necessarily* dependent relationship between the artist and the epoch did not mean, however, that the defenders of Naturalism were altogether against the invasion by the modern subject of *l'art vivant*; they could accept and even welcome it. The Baudelairian analogy between modern art and modern subject-matter had created at the end of the nineteenth century the possibility of an alliance between Impressionist or Neo-Impressionist naturalism and modern themes, an alliance cemented in the early part of the twentieth century by such as Maximilien Luce: his renderings of steelworkers and construction-workers had been much noticed at the Indépendants and the Salon d'Automne before 1914. This alliance still lived in the twenties.

As has often been seen, one of the key organs for the propagation of pro-Naturalist attitudes was the periodical *L'Art Vivant*. Its first number in January 1925 opened with a short address to 'our readers'. 'Through living art', the editors wrote, 'art is really going to become absorbed into life to exact its revenge on this blood-stained century.'[3] After the destruction of the Great War, art and life were to interpenetrate, both shaping the other in positive ways. The periodical was designed by its editors Florent Fels and Jacques Guenne always to underline this possible fusing together of current art with the life of the times. There were regular articles on the *arrondissements* of Paris, on posters and fashion (especially where they were influenced by *l'art vivant*), on such topics as fairground and folk art, the circus and the aesthetics of the automobile, all intermingled with art news and art criticism. Further, if the Cubists and Léonce Rosenberg's *Bulletin de l'Effort Moderne* had in Fernand Léger their own leader among modern-life painters, *L'Art Vivant* claimed a new leader in this field who plainly set himself against the 'pure Cubists', Marcel Gromaire.

It was in 1925 that Gromaire emerged as such a figure. He did so with a belated but much celebrated war painting shown at the Indépendants; it was called simply *The Trench* (Plate 221). Salmon had criticisms to make of the element of calculation that seemed to lie behind the styling of the figures, but commented on the 'prodigious mastery' of 'its blue and brown scumbles'.[4] A little later in 1925 Vauxcelles predicted that Gromaire would be 'one of the leaders of tomorrow'.[5]

221. Marcel Gromaire, *The Trench*, 1925. Oil on canvas, 51¼ × 38½in. Musée d'Art Moderne de la Ville de Paris. Girardin Collection.

Florent Fels went overboard in his enthusiasm: 'Gromaire. The king-pin of the Salon. I have very great admiration for him. To some extent he is the inheritor of Seurat. . .'.[6] To be mentioned in the same breath as Seurat was praise indeed, and Seurat, of course, was for the Naturalists a leading model of the modern-life painter, to be emulated.

222. André Lhote, *The 14th July at Avignon*, 1923. Oil on canvas, 58¼ × 70in. Musée des Beaux-Arts, Pau.

Encouraged by Gromaire and *The Trench*; Fels reflected thus in his commentary on the Indépendants of 1925:

To paint well is not enough. It is necessary to show original gifts, to express some unexpected aspect of our life. Everything has not been said and the lyricism of the aeroplane, the sudden sight of the motor car. . ., the deformation of places by speed, and power pylons which replace shrines on the corner of roads, the factories, people in the street and the workshops, all this remains still to be expressed. All who are painters. . .should give a plastic representation to our epoch.[7]

With Gromaire as his theme, Jacques Guenne expanded on this positive attitude to the modern subject, in 1926. 'It is as normal', he wrote, 'to represent a car, an aeroplane on canvas, searching for what is permanent in its lines. . ., to light up a Flemish night with the red blaze of the high furnaces, as to depict, in the pictures of another time, a carriage or a tilbury.'[8] His insistence on the 'permanent' is, of course, far from Impressionist; his focus however was not on the structure of modern machines or constructions, but in a fundamentally Impressionist sense on the direct visual experience they offered and on the way this inevitably changed all artists' perception of the world. Guenne pleaded for an indiscriminate acceptance of modern subjects, a realisation that the world of the Impressionists had changed, and, despite his accent on the directly visual, an awareness of enduring formal qualities:

When we talk of a return to the subject, we ask only that painters go down into the street, which has changed since Daumier, that they look at women and not only at their models; that they go out onto the roads, into the fields, which have changed since Courbet; into the pleasure gardens where there is singing, which have changed since Renoir; that they give play to all the spectacles of life. They will see that modern life has made changes right into the landscape. Do the old paved roads of other times resemble these long tarmacked ribbons which with one breath suck up the automobiles?[9]

The artist might search out the permanent, but to ignore all this was to ignore life.

Gromaire had followed up the success of *The Trench* at the Indépendants of 1925 with a large-scale solo exhibition at the galerie Barbazanges early in 1926, where some fifty works of the period 1919–26 were shown, including, among the more recent, *The Beer Drinkers* (Plate 223) and *The Banks of the Marne* (Plate 224). An event of great importance to the circle of *L'Art Vivant*, it was this that stimulated Guenne's article of 1926 and the interview with the artist that followed it. Just how far Gromaire's modern subjects could in themselves be seen as the carriers of meanings for the 'epoch' is conveyed by Guenne's passage on *The Banks of the Marne*, with its accent on implicit anecdote and especially the instant awareness it assumes on the part of the reader of the significance

embodied in the very idea of the Marne itself, as a symbol of French victories won in a war now half a decade away:

> But you see how the Marne is no longer a miracle [as the battles had been for the French]. It has become since the peace a wide and restful river, good for the revels of boating. On the jetty, at the point of diving into the cool water, the bathers have stopped. They will remain surprised for ever. Because there passes by in a boat, turning her head with a touch of indifference, a female rower whose beauty solicits happier victories. And high up on a viaduct modern life is unfurled in the tumult and the fracas of an express train.[10]

Guenne interprets the picture as a very specific image of peace and optimism at a very specific juncture in the aftermath of war, and the elements are clearly there to trigger such an interpretation.

Like *The Trench*, *The Banks of the Marne* then provoked memories of the War (though of course more indirectly and with a more positive underlying theme); both thus set up a chain of connotations at a deep level. These kinds of connotation were, however, not often carried by Gromaire's paintings in the twenties. Generally the more recent pictures he showed at the galerie Barbazanges in 1926 were concerned with post-war France, the focus sharp enough to eschew reminiscences of the War. Specifically they were concerned with the peasants and the working people of North Eastern France where Gromaire came from; *The Beer Drinkers* is an instance. For Guenne, Gromaire's pursuit of the permanent in things led him to extract from what he saw enduring characteristics and thus to present his hay-cutters, bargees and beer-drinkers as 'types' in the universalized sense. The critic rationalized thus Gromaire's tendency to idealize or geometricize his subjects, stressing the personal character of his idealized types in order to justify them.[11] But at the same time, both Guenne and the painter himself stressed the importance of a

223. Marcel Gromaire, *The Beer Drinkers*, 1925. Oil on canvas, 39¼ × 32in. Musée d'Art Moderne de la Ville de Paris. Girardin Collection.

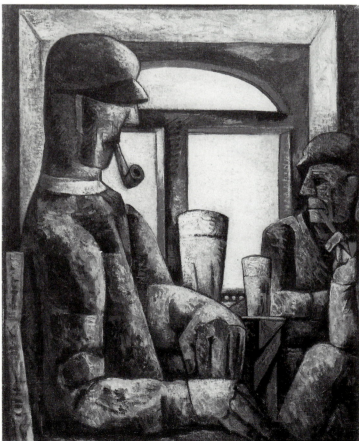

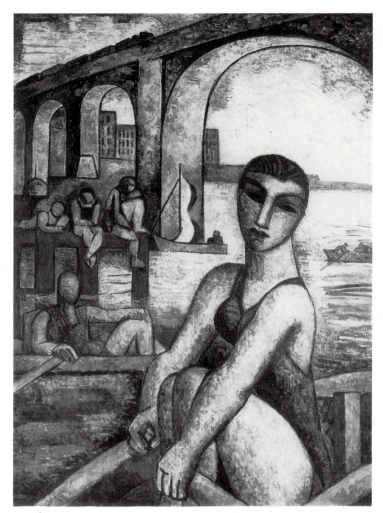

224. Marcel Gromaire, *The Banks of the Marne*, 1925. Oil on canvas, 51¼ × 38¼in. Musée d'Art Moderne de la Ville de Paris. Girardin Collection.

basic commitment to the subject analytically observed at first hand.[12] Gromaire's self-image and the image projected by *L'Art Vivant* was of an artist, like André Lhote, whose art was orderly, distilled and solidly constructed but which was dependent on the direct experience of things; and significantly in his interview with Guenne, Gromaire identified his work exclusively with 'the great franco-flemish tradition', again like Lhote, and dismissed all that was 'inspired by Italy'. Named as his forebears, alongside Seurat whose technical influence he acknowledged, were Brueghel the Elder, Fouquet and especially Rembrandt.[13] He was a painter of modern subjects whose broad stance *vis-à-vis* nature and the French tradition was altogether easily tolerated within the Naturalist set of values, and whose celebrity in the circle of *L'Art Vivant* as the one artist who 'truly deserved the title of painter of modern life' is entirely predictable.[14]

The fact is, however, that Gromaire's stance was situated somewhere in the gap between pure Cubism and Naturalism. It was indeed close to Lhote's, and it should be remembered that Lhote also painted popular modern subjects in the Baudelairian line of modern-life painting (Plate 222). Gromaire, along with Lhote, was accepted and his art eulogized by Florent Fels and Jacques Guenne, but he was by no means a Naturalist in the full sense of the term. Yet, pro-Naturalist writers, including Fels and Guenne, could as freely admire an accepted constructive Naturalist like Luc-Albert Moreau, de Segonzac's friend, for his depictions of modern-life subjects from the trenches to the boxing-ring,[15] and even Vlaminck, the very type of the instinctive Naturalist, could present himself and be presented as a painter of the up-to-date.

Vlaminck himself put it this way when quoted early in 1924: 'I paint what I love. . . I paint life close to me, the men

and the phenomena of 1923, the life of my time.'[16] And, though he painted still lives and landscapes whose subject-matter is not at all specifically of its time, he did not avoid the new bric-à-brac of the countryside: the level-crossings, the village garages, the newly laid roads for the newly ubiquitous mass-produced cars, the wall-sized advertizing hoardings designed for the motorist passing at speed. *Garage* (Plate 225) was one of his contributions to the Salon des Tuileries of 1925, and it can seem almost a response in anticipation to Guenne's plea a year later for pictures that accepted the transformation of the French landscape. The posters —'Automobile', 'Motos Harley', 'Réparations'—and the

225. Maurice Vlaminck, *The Garage*, 1925. Oil on canvas, size and whereabouts unknown. As illustrated in *L'Art Vivant*, 1 October 1925.

vanishing rank of telegraph poles along the tarmacked road signal the fact of penetration and violation with brutal panache. In fact, it was actually possible for Jacques Guenne to modernize, as it were, the image he created for Vlaminck of a Romantic painter of 'the tragic': to present his sense of tragedy as essentially modern. 'How well [Vlaminck] has known', he writes in 1926,

> where to find what has changed in eternal nature! His landscapes, are they not the settings where the men of today do things? Are they not as up-to-date as those of Brueghel, the great Dutch painters and Corot were in their time? His blushing skies, agitated by all the anxieties of the world, that atmosphere saturated by electric waves which flow towards every point on the horizon, carrying the anguish of man, each day more disturbed to achieve miracles which seemed till now reserved to God, are they not the skies which always seem to threaten our head[s]?[17]

At the furthest extreme it was actually possible, from within the pro-Naturalist circle of *L'Art Vivant*, to see the painting of André Favory as essentially contemporary in spirit and subject-matter. He could stand on the one hand as an exponent of that dependent attitude to the past most respectably represented by André Derain, he could seem the emulator of Rubens, Jordaens and Renoir, but at the same time he could stand as a painter of the up-to-date to be mentioned in the same breath as Vlaminck. Responding to a one-man show of Favory held in Amsterdam in 1925, Vanderpyl could contend that, 'Like Maurice Vlaminck who, with a stroke of lyricism, brushes the road where the automobile slips by, Favory is of today. I do not compare their painting: I declare [merely] the contemporaneity of their effort.'[18] Certainly Favory's subject-

matter in his Salon pictures had self-consciously represented an up-dating of a range of late nineteenth-century modern-life themes, the brothel and, in *Under the Bower* (Plate 195), the suburban pleasure-garden theme of Renoir's *Boating Party*. Later in 1925, at the Salon d'Automne, he was to exhibit another ambitious canvas which even more explicitly modernized such a theme, his reply to Manet's *Déjeuner sur l'herbe*, where men in the flannels and blazers of the twenties caress unclothed women, with, discreetly parked in the background, a mass-production car (Plate 226). Not only the modern clothes but especially the sexual engagement of the men struck Guenne as essentially of the time and altogether

226. André Favory, *Country Outing*, 1925. Oil on canvas, size and whereabouts unknown. As illustrated in *L'Art Vivant*, 1 October 1925.

more shocking than Manet's prototype, though he found the car an unnecessarily heavy touch. Both Fels and Guenne found the combination of traditionalism and contemporaneity impressive rather than contradictory or pretentious.[19]

Across a wide range of artists, then, from Gromaire and Lhote to Luc-Albert Moreau and even to Vlaminck and Favory, an anti-Cubist stance towards art and nature, as well as towards tradition, could go with an open attitude to the imagery of modern life which was welcomed by pro-Naturalist opinion. It is clear, however, that pro-Naturalist writers saw no *necessary* link between art and modern life at its most

227. Fernand Léger, *The Beer Mug*, 1921. Oil on canvas, $36\frac{1}{4} \times 25\frac{1}{2}$ in. The Tate Gallery, London.

quintessentially modern, and were keen to support art and artists that stood against (or seemed to stand against) the actuality of change, and for the enduring values of France before industrialization. Jacques Guenne might have styled Vlaminck a painter of modern life, but if one analyses his eulogy of 1926 one extracts the image of an artist whose relationship with the modern was not at all positive: the miracles of progress usurp the power of God, we are told, and ultimately they are a threat upon our heads whose force is captured in the glowing mobility of Vlaminck's skies. Indeed, Vlaminck was seen far more compellingly as an earthy Naturalist, at his most profound opposed to all that menaced the natural. Writing in 1925, Florent Fels saw this opposition clearly: 'This love of nature, this instinctive need to live close to the earth is at the opposite pole from degeneration, I mean to say from civilization. This is the survival of the primitive man, who stamps out the stormy or the beautiful in signs unappreciated by virgin sensibilities. Thus, he brings back the landscapes which we no longer know how to see.'[20] The ideal of innocence could not comfortably co-habit with the ideal of industrial progress and the fact of the countryside's transformation. For Vlaminck, the paraphernalia of modern life was a part of life even outside the city, and therefore it was a part of his painting. But he could never endow it with heroism, and the litter left in his landscapes of signs to mark modernization was almost invariably read by his most supportive commentators in the least heroic light.

Yet, far more definitely than Vlaminck, it was Raynal's arch-Naturalist, Dunoyer de Segonzac, who was held up as the painter of nature at its most essential, least changing, most set against industrial progress. Everywhere he was presented as *the* painter of 'the earth', of France in its most fundamental guises. 'Segonzac', writes Christian Zervos in 1924, 'has a kind of physiological sympathy for the forms of nature. The plenitude of this sympathy gives to his work a great element of truth. It seems far closer to nature than all of us. It possesses the very essence of rusticity, it is in touch with the spirit of the earth. . .'.[21] Claude Roger-Marx in 1921 told the story of his pre-war rejection of Cubism as most profoundly a return to the earth and, by inference, a rejection of the urban home of the new movement. He wrote of how de Segonzac 'got back to the fields of the Ile de France or Provence, and dressed as a fisherman or a peasant, in jersey and clogs, found once again strength in contact with the earth. . .'.[22] For pro-Naturalist critics his Courbet-like Naturalism could signal, through its choice of landscape motifs rarely invaded by the markers of modern life and its heavy, substantial *pâte*, a deep sense of national identity, a sense of national identity comfortably in tune with the most chauvinist current notions of the French tradition (Plate 188). This is Jacques Guenne, again in celebratory mood, writing in 1926:

> For the foreigner. . .who would never have visited France, who never knew my country,. . .the powerful gestures of the trees of the Ile de France, the immense logic of the architecture of its forests. . .our sky suddenly swollen with storm, at once opened out into blueness, the calm and careful life of our peasants, under the sensible roof, if I wished to show [him] the genius of the country which embraces the earth, the water, the sky, the trees, the houses, the atmosphere, the entire order of out climate, our race, I would show him a landscape by de Segonzac.[23]

As imaged in the writings of many commentators, de Segonzac was so closely bound to the rural regions of France that he painted as to be inevitably identified with them and not simply with some vague if powerful idea of essential Frenchness. In 1921 Claude Roger-Marx calls him 'the country

gentleman' of the type found 'in Burgundy or du Quercy'. 'He loves to rediscover the gestures, the accent, an entire aristocratic and provincial atavism. How long it is,' he concludes, 'since the voice of the earth made itself heard with such authority.'[24] In his short study of de Segonzac, published in 1922, René Jean can write: 'His art is very much the expression of the Ile-de-France which M. de Segonzac loves above all and which is the land of his birth.'[25] Then, making things a little muddling, Jean can add to these qualities, others from other regions of France: 'He owes to Gascony, the land of his father's family, that beautiful and warming enthusiasm tempered by the stubborn solidity of the France-Comté, land of his maternal grandmother.'[26]

Vlaminck too identified himself and was identified by critics with his particular landscapes. In an interview in *Les Nouvelles Littéraires* of 1922 with Florent Fels he stresses his Northern European identity, his feel for the dark bravura of stormy landscapes, and his rejection of the sun-lit dazzle so characteristic of his Fauve work, which he considered now to be something foreign. Again, it is the environment outside the city in which Vlaminck lived and worked that Jacques Guenne emphasizes as fundamental to an understanding of the man and his painting when introducing his interview with him in 1923, the changing but then still-countrified commuterland of Auvers-sur-Oise which was his home until the move further out to the properly rustic La Tourillière. Guenne had taken the train out of Paris to meet Vlaminck, and the painter is identified with a retreat from the dynamic life of the city. He may not be identified as de Segonzac had been with the countrymen of rural France, but Guenne brings out the hostility of the inhabitants of this outer suburb to the urban life they try to escape:

> The passengers in these suburban trains are the workers whom the city disgorges each evening, out into landscapes which are no longer sun-lit, where the pleasures of the countryside too have been fenced in. They do not much like the Parisians, who, on Sundays, pick the flowers by the railings of their gardens, leaving waste-paper by their doors, and giving a bad example to the children.[27]

Guenne crystallizes here that core of anti-urban, anti-modern meaning to be found within much Naturalist art of the twenties, even where modern motifs were allowed to play a conspicuous part. Gromaire and Lhote welcomed the modern positively with hardly a hint of qualification; Vlaminck did not ignore it, but, essentially, he and de Segonzac stood against it, and their painting of landscape carried powerful signals read as unmistakably antagonistic to industrial change and the ideal of progress at the time. Theirs was, in the final analysis, an anti-modern, anti-urban Naturalism as was much Naturalist painting in the twenties. De Segonzac at least, in pictures like *Way to the Farm* (Plate 188), produced what could almost be called conservationist painting. His stance was clearly in sympathy with the survival of Regionalism in architecture, with its emphasis on local materials and local vernacular styles. His landscape painting was the obvious counterpart to the so-called 'garden city' developments built after the Great War in the hinterland of Paris as leafy refuges from the intense geometries of the city. Both were aspects of a single Regionalist phenomenon, whose shape is emerging more clearly as the period is more fully researched, another aspect of which was the success of a related genre of novel, most important that of Henri Pourrat's *Gaspard de Montagnes* at the end of the twenties.[28] Combined with the dominant chauvinistic view of all *art vivant* as a continuation of the national tradition, such blood-and-earth convictions made for a deep-dyed conservatism which was to take Vlaminck

and de Segonzac ideologically far to the right. Despite *L'Art Vivant*'s concern for contemporary life as well as art, and despite its editors' championing of Gromaire as a positive painter of modern life, it is clear that, on the Naturalist side of the *art vivant* spectrum conservative opinion rejected any *necessary* connection between art and modern life and refused the optimism of an unquestioningly forward-looking acceptance of industrial progress. The work of Vlaminck and de Segonzac subsumed into the image created of it by such as Guenne and Fels is a clear enough demonstration in the end.

* * *

It is perhaps predictable that in his *Anthologie de la peinture en France* Raynal should condemn both Naturalism and 'Eclecticism' not merely for their dependence on nature, but also for their failure to produce an art for the time—a modern art. 'It was to Cubism', he writes, 'that the task of renewing the art of our time was delegated.'[29]

Picasso, Braque, Gris and many others close to them (Metzinger, Lipchitz, Laurens, María Blanchard) rarely, as Cubists, painted specifically modern subjects. Where they often designedly used a subject as a sign-post to a tradition, their typical motifs—the posed figure, the still life and landscape—carried few signals of an engagement with the self-evidently up-to-date. But, as the quotation from Reverdy with which this chapter opened was intended to show, Reverdian thinking on Cubist art kept a prime place for the analogy between the modernity of Cubism and the modernity of post-war life. This was so from the very beginning of the attempt to arrive at a basic Cubist theory in *Nord-Sud* from 1917 to 1919. The difference was that the Cubists themselves along with their defenders believed that the modernity of life so permeated their work that the banner sign-posting used to declare allegiances with Cézanne or Corot or Renoir and hence links with the past was simply unnecessary to make the link with the present day. Thus Waldemar George can write in this fashion in his Picasso monograph of 1924 and expect instant understanding from those sympathetic in his audience: 'It is because he has grasped the secret and invisible relations that exist in a latent state between the phenomena of thought and of modern life that he has succeeded in admitting them [into his work], that Picasso must be recognized as the first artist to incarnate the spirit of his epoch. . .'.[30]

Fundamental to the assumptions that lie behind this passage is the key Reverdian notion of 'the spirit' ('l'esprit') and its complementary notion of 'the aesthetic', first expounded in 1917 and 1919. As outlined in Chapter 10, in the fully formed theory the individual artist's 'aesthetic', according to which nature is transformed or re-created, was considered subordinate to the general 'spirit' of the artist's time. The artist's aesthetic priorities and preferences were seen to be guided by the new scientific and philosophical beliefs that impinged upon the thinking of all and by what was new in the environment. That which was not constant in Cubist art—the variable within the basic structure or 'coloured architecture' of the work—was seen to be new and the inevitable product of its time. The writings of Reverdy, Raynal, George, Rosenberg, Huidobro and Gris make it clear that, for them, what was new in their art directly reflected what was new in their thinking and in their lives. There was a *necessary* analogy between Cubist art and progress in the most general sense, an analogy visible not so much in the subject-matter the Cubists painted or sculpted as in the way they treated it: visible on a purely pictorial or sculptural level.

Once again, the most succinct illumination of the way this could work is provided by such cases as Gris's adaptation from Corot and Picasso's Cubist treatment of the Corotesque in *The Italian Girl* (Plates 212 and 219). It is in the clear-cut planar elements, in the lack of tonal modelling or perspective and in the sharp contrasts (light and dark in the Gris, reds, greens and blues in the Picasso) that these images are distanced from Corot or the Corotesque; it is by these pictorial features that they were to be read as permeated by the 'spirit' of France in 1916–17 rather than the later nineteenth century. In the broadest sense, for the central Cubist theorists, all the major factors picked out for analysis in Part I as characteristic of Cubist painting and sculpture were to be seen most profoundly as aspects of each artist's modern aesthetic evolved in response to the spirit of the time: in particular, the flexibility and arbitrariness of Cubist signs, the perspectival and planimetric contradictions of Cubist space, the insistence on the architectural analogy and on flatness. And this was so perhaps most tellingly when the model or motif denoted were *not* distinctively modern: in Gris's crisply structured *Harlequin at a Table* of 1919, say, or in Lipchitz's pierced and opened up *Pierrot* of 1925 (Plates 46 and 150). Together these factors were the unmistakable banners of modernness. Again, questions of style are found in the end to bear directly on aspects of meaning.

Paradoxically, however, it was for these theorists above all a stylistic aspect of late Cubism which underlined its *constant* structural foundations rather than its transitory formal or spatial characteristics that conveyed its modernity especially well. From 1917, it was most often their habit to stress certainty, precision and discipline—the prerequisites of compositional order—as the essence of modernity both in art and in the modern world. 'An aesthetic idea enlivens [the epoch],' writes Reverdy in 1921. 'A need for certainty preoccupies it. A taste for pure, simple, personal means characterizes it. In the last analysis, a spirit of discipline reigns. . .'. He sees it as a time when 'We must build not destroy', and sums up: 'Every effort comes together in an assembly of means. . ., in their severe purification with the aim of art solidly structured and synthetic.'[31] The control, the order that those sympathetic to Naturalism often found so cold was for the champions of Cubism, especially before 1923, an essential aspect of the identification of their art with the 'new spirit'.

The geometric armatures easily read off from the surface of crystal Cubist works (the sculptures of Lipchitz or Laurens as much as the paintings of Gris or Metzinger) were, of course, one very direct means by which this 'modern' call to order was conveyed, so that those controlling structures were read both as the signs of an underlying traditional 'measure' and of an inherent modernity (Plates 166 and 179). And these were easily enough to be discerned as controls even in such compromised Cubist images as Gris's *Pierrot with a Book* and *Fruit-bowl and Glass* of 1924 or Laurens's *Reclining Nude* of 1921 (Plates 101, 180 and 228). At the same time the carefully built-up and finished paint-surfaces, the firm edges and well-defined forms of not only crystal Cubist painting but even the more informal, less cool Cubist painting of 1922–24 could signify a modernness of sensibility; in this respect such painters as Braque and Marcoussis were the exceptions (Plates 96 and 97).

As with the vein of anti-hedonist puritanism which ran so deep, however, this precise, ordered notion of the contemporaneity of Cubism found its clearest and most extreme expression in the work of Fernand Léger and of the Purists, Ozenfant and Jeanneret. This was so both in the control and exact finish of their painting and in the explicit content of their many written statements (in Léger's case especially

228. Henri Laurens, *Reclining Nude*, 1921. Terracota, length 13¾in. Whereabouts unknown.

after 1920). One of the chapters of the Purist manifesto of 1918, *Après le cubisme*, was called 'Modern Life Today'. It included the following strongly Corbusian passage:

> There rise everywhere the constructions of a new spirit ['esprit nouveau'], embryos of an architecture of the future; already everywhere there reigns a harmony whose elements come of a certain rigour, of respect for the application of laws. . .The bridges, the factories, the dams and these kinds of giant structures carry within themselves the viable germs of development. In these utilitarian works is sensed a Roman grandeur.[32]

The first number of *L'Esprit Nouveau* declared: 'There is a new spirit: it is the spirit of construction and of synthesis guided by a clear conception.'[33] The container for the Purist belief in the essential modernity of the qualities of order and precision was the Reverdian idea of the spirit. The Purists asserted that the character of the modern was ordered and precise and that inexorably it had established those qualities as the fundamentals of the new spirit.

The two early declarations of their faith in such a new spirit quoted above give primacy in its creation to the gross manifestations of engineering and construction, and, of course, in the early numbers of *L'Esprit Nouveau* Jeanneret in his architect's role as Le Corbusier was to give the American grain-elevator and the factory the status virtually of icons of the new spirit.[34] To them were quickly added the motor car, the aeroplane and the ocean liner as such symbols, straightforwardly linked by the juxtaposition of illustrations to the ideal image of antique architecture.[35] By 1922 and the fifteenth number of *L'Esprit Nouveau*, the type-writer, the typed page and the printed page had been included as the products of 'a new clarity and precision', generators of 'an internal elegance', 'almost a new morality, the morality of THE GOOD JOB'.[36] And by 1924, with the twenty-first number of *L'Esprit Nouveau*, a profusion of makers of the new spirit were recognized, all manner of manufactured objects from pipes to purses: 'The rows of shops each thrust on us the innumerable products of modern industry, all characterized by that imperative precision which is the inescapable consequence of machinism:

objects of all kinds which are presented to us in impeccable good order. . .'.[37]

It was not that the constructions and products of industrialization had fundamentally *changed* the human need for order, for the 'joy' offered by what the Purists thought of as a well-proportioned beauty, the point was that this constant need had been intensified, made more exacting. There was a deeper awareness of the primary aesthetic quality to be found in elementary geometric forms, their ordered inter-relations and precision of placing and finish, so the Purists believed. As they put it in 1924, environmental change on the level of the large *and* the small had produced an effect tantamount to 'the education of the eye'.[38] The basic formal, compositional and colouristic laws of painting would, of course, remain constant, making the art of the time continuous with tradition, but, since the spirit formed each period's particular preferences, its aesthetic, and since the spirit was thus formed by the ordered and the precise, painting would inevitably engage those laws with greater conviction and decisiveness. 'Our senses and our spirit have become more demanding,' the Purists wrote. 'They demand an art of intensity and precision.'[39]

Just as the Purist theory of the enduring constancy of the laws underlying all art from every period led them to believe that the structure and formal harmony of their paintings alone was enough to link these images to the idea of tradition, so their theory of the new spirit led them to believe that their paintings needed no conspicuously up-to-date subject to announce their contemporaneity. They carried the Reverdian notion of the modern spirit to a mechanistic extreme, but remained discreet in their use of subject-matter from this point of view: as discreet as Picasso, Braque and Gris, or as Lipchitz and Laurens. Their writings created a wide field of modern life associations for the spectator well read in the articles of *L'Esprit Nouveau*, but, without the help of this running commentary, their still lives (Plates 198 and 199), as much as the Commedia dell'Arte figures or the still lives of Gris or Lipchitz, demanded of the spectator a fine tuning in response to certain aspects of the urban world that would make the link with modern life a hardly conscious act of recognition.

Léger was the sole Cubist of stature to set to work in his pictures the modern subject. He did so throughout the period, from the war pictures, *Soldier with a Pipe* of 1916 and *The Card Game* of 1917 (Plate 56), through the urban imagery of *The City* (Plate 159) in 1919 and the heroically rendered *Mechanic* in 1920 (Plate 171), to the machine element pictures of 1924 and the compositions which give leading roles to the manufactured object of 1924–27 (Plates 230 and 160). Even his Classical figure paintings were often endowed with interior settings which were far from timeless, especially the *Mother and Child* of 1922 (Plate 218). Léger made his commitment to modern life explicit, and inevitably thus he came to be taken as the very type of the modern-life Cubist to be set against the Naturalists' candidate for the title of painter of modern life, Gromaire.

Increasingly from 1920 and certainly by 1922 Léger's view of modernity was predominantly an ordered one, which, as will be seen, was closely allied to the Purist faith in their new spirit. But even after 1922 there was another, conflicting aspect of his response to the modern world which cannot be ignored. In 1926 he was still able to say: 'Speed is the law of the modern world',[40] and that other aspect was his excitement at the dynamism and the dissonant visual force of what he called 'the spectacle'. It was this aspect that was the dominant one in his immediately post-war painting, between 1918 and 1920; that dictates in the cylinder paintings which came out of *The Card Game* (Plate 56), in the disintegrated compositions like *The Typographer* pictures (Plate 59), and in *The City* itself. The rotational compositions of the cylinder paintings obviously came of Léger's awareness of the machine as something at least potentially mobile; the dissonances of *The City* (Plate 159) and the relative scale of figures, letters and broad, flat colour planes came, according to Léger, of his response to the energy of the Place Clichy with its huge, new advertizing hoardings.[41]

Between 1921 and 1924 Léger found a direct outlet for this dynamic aspect of his response to the modern in his design work for the Ballet Suédois and in cinema, with his work for the film director Marcel L'Herbier and as a film-maker himself with the rhythmically cut *Ballet mécanique*. It was in this way that he was able simultaneously and separately to allow his developing notion of precision and order as a fundamental in modern life to take control of his painting. Such a notion was already a dominant by the time of his letter of 1922 to Léonce Rosenberg later published in the *Bulletin de l'Effort Moderne*, and it was already indelibly marked by Purist thinking. Thus here he stresses the role of the ordinary 'manufactured object' in creating a persistent preference for the geometric, he writes of it as 'slowly subjugating the breasts and curves of women, fruit, the soft landscape . . .'. 'Their spirit', he insists of manufactured things, 'dominates our era'.[42] His version of the Purist idea of the new spirit reached its fullest and most mature form in 1923 with his lecture 'The Machine Aesthetic' and the interview published in *Les Nouvelles Littéraires*. The text for his lecture, as published in 1924, was simply an adaptation from *L'Esprit Nouveau*: 'More and more modern man is living in an order geometrically directed. Every man-made mechanical and industrial creation is dependent on geometric forces.'[43] He too, as has been seen, conjured up the example of the antique to pair with that of modern, utilitarian products; he too celebrated the aesthetic judgement and the precision of the window-dresser in the smallest of shops, alluding to their nocturnal efforts as composers with consumer items observed clandestinely in the company of Maurice Raynal.[44]

We have seen how it was not enough for Léger merely to compose in a precise and orderly way to situate his painting

within the new spirit, how he hung on to the modern subject, or at least references to the modern subject, in order to signal clearly his commitment to the inter-relationship of his art and modern life. It was this that inspired one of the most trenchant criticisms made of his position as painter of the machine, the criticism that followed his lecture on 'The Machine Aesthetic' made by Maurice Hiver in *Montparnasse*. 'But you, Léger,' the critic wrote in anger, 'who doubtless possess but the vaguest trace [of a knowledge] of geometry and mechanics, you are ridiculous with your pseudo-machines "which do not work" and give the impression not of dynamic power, but of inertia and useless monotony.'[45] The difficulty was that Léger was caught between his Cubist belief in the purity of painting coupled with the importance of pictorial invention, and his desire to make the dependence of his art on the modern world explicit; it was a difficulty of which he was very well aware. In the first place he rejected the idea that he should simply depict the manufactured objects or the machines he admired; there was no question of painting machines that looked as if they might work, and, if after the experience of *Ballet mécanique* he incorporated simplistic representations of pipes or hats or compasses into his pictures, he always lifted them out of their working context into a carefully purified pictorial context where they could only have 'plastic' point (or so he hoped). 'I have never amused myself by copying a machine,' he said in his interview of 1923. 'I invent images of machines, as others make landscapes from their imaginations.'[46] In typical Reverdian fashion he

229. Photograph of the corner of the rue Scribe and the Boulevard Haussmann, Paris. Published in *L'Art Vivant*, 1 January 1926.

saw modern life as a supplier only of the 'elements' for painting, 'elements' attuned to his technical practice which were to be used freely. 'I try', he said, 'to create with mechanical elements a *beautiful object*.'[47] And so autonomous did he consider this 'created' object that he could actually think of it as a *rival* for the 'manufactured object'. 'The manufactured object is there, absolute, polychromatic, clean and precise, beautiful in itself; and it is the most extreme competition that the artist has ever experienced.'[48]

The Mechanic (Plate 171) is not a particular mechanic observed in a local bar, as Gromaire's *Beer Drinkers* (Plate 223) are workers observed and monumentalized; he is a figure invented, built up out of a kit of hieratic and mechanical parts and given the identity of a mechanic. For Léger, his invented mechanic both celebrated and challenged all current ideas of the real mechanic. *Mechanical Elements* of 1924 (Plate 230) does not illustrate the innards of an actual mechanism; it is

232. Cassandre, *Huile de la Croix Vert*, c.1926. Poster.

231 (top). Loupot, *Huile Raoul Citroën*, 1925–6. Poster.

230 (left). Fernand Léger, *Mechanical Elements*, 1924. Oil on canvas, $57\frac{1}{2} \times 38\frac{1}{2}$in. Musée National d'Art Moderne, Centre Georges Pompidou, Paris.

an invented machine, again a challenge to as well as a celebration of the machine. Yet, though he thus pitched painting against life, though he could not merely depict the mechanic or the machine even in idealized form, he did not uncouple the connections. Even in his Classical nudes and his most abstract *Mechanical Elements* (Plates 66 and 143) he left enough of the surface appearance of polished metal components and enough of a sense of their possible mechanical interaction to make the relationship plain. His 'pseudo machines' indeed were useless, unfunctioning, but their mechanical identity was inescapable. In a sense, Hiver's taunts were invited.

Léger, then, was enough of a Reverdian Cubist to claim a separate autonomy for his art even to the extent of conceiving of art as in competition with the raw 'beauties' of the industrialized environment. But not only did he make clear his art's indebtedness to those beauties, there is also irrefutable evidence that by 1925–26 his pictures had begun actually to

stimulate changes in the urban environment itself, and that he saw this reverse influence of his painted inventions *back* on the city, on modern life, as a real reason for optimism. It became possible to see Léger's painting, and to a lesser extent Cubist art altogether, as a force capable of re-shaping the look of Parisian streets on a large scale, amplifying the impact of the city spectacle.

L'Art Vivant's regular, well-illustrated articles on the poster and on the changing urban scene leave no doubt that by 1925–26 the boulevards and the streets of Paris had been invaded as never before by advertising hoardings, often of a truly enormous size, as one illustration of the corner of the boulevard Haussmann and the rue Scribe shows (Plate 229). In the words of Louis Cheronnet, *L'Art Vivant*'s regular contributor on the art of publicity, the poster 'has draped the city in colours worthy of her. It has introduced mobility into inert façades. Its lines give completeness to architectural

decorations and its colours move in the sun as much as all the animation of the vehicles and the passers-by [put together]. It is a joy to the eyes. . .'.[49] By this date several of the most successful poster-designers in Paris had learned directly from Léger's painting (and to a lesser extent that of the other Cubists). Thus, for instance, the Léger of 1919–20 could combine with the memory of Delaunay's disks to inspire Loupot's 'Huile Raoul Citroën' poster of 1926 (Plate 231). Most telling of all, however, was Léger's influence (along with that of Gris and the Purists) on the poster-designer known professionally as Cassandre. He admitted his debt to Léger and also to Delaunay, and approached the practicalities of poster-designing in a self-consciously Purist way, working from his brand-new concrete house, designed by the architect Auguste Perret, in a drafting-room as close as possible to his idea of an engineer's drafting-room.[50] His famous and ubiquitous 'Bûcheron' and 'Nicolas' posters did not directly reflect Cubist influence, but such posters as 'Huile de la Croix Verté (Plate 232) and 'Pivolo' certainly did, particularly Léger at his most Purist. In 1925–26 Cassandre's posters, along with many plagiarizing his clean-cut style, were all over Paris, and L'Art Vivant's record of the city shows one of the most Léger-like bearing down on the street from the height of an entire building (Plate 233).

when interviewed as a popular muralist who dreamed idealistically of wall-papering the streets to transform the city in an act of pure aesthetic altruism.[52] The actuality of his achievement and that of the other poster-designers was powerful enough and the possibilities obvious enough for the editors of L'Art Vivant to solicit a response from both Delaunay and Léger.

Towards Cassandre and his like Léger's praise was unstinting, and he had no doubt as to the force and scope of the new phenomenon. 'In the street', he said, 'posters must go beyond the impact of the exhibition/salon.'[53] However, his belief in the anti-Naturalism of art whatever its form, and his belief in the profound good to be gained from an ordered, harmonious 'new spirit' in painting was so dominant that, unlike the indiscriminate enthusiasm of the supporters of Naturalism for all things modern, he would not accept with equal enthusiasm the whole range of street advertising. He set the flat, anti-Naturalist style of Cassandre against the startling illusionism of such designs as the 'Bébé-Cadum' poster (Plate 234), also to be seen everywhere, and held up the possibility of a poster art which would act like his mural paintings to introduce a compelling balance and optical calm into an urban world that he called 'too dynamic, . . . crushing and stressful'.[54] The two aspects of his response to modern

234. Photograph of an advertising hoarding with the 'Bébé Cadum' poster. Published in L'Art Vivant, 15 August 1926.

life were presented as opposed, and the order of the new spirit was to be imposed upon a world still too visually dominated by the enervating anarchy of dynamism:

> I repeat, it is necessary to organize the outdoor spectacle according to an order such that values are in their true places . . . If you like, this will be no more nor less than the creation of a polychromatic architecture. . .embracing all the manifestations of industrial and commercial publicity. . .
>
> In this way the city will tend towards the plastic serenity it needs.[55]

To an extent, the new spirit of precision and order had become for Léger an ideal by which the visual character of modern urban life could be tamed and reshaped. He saw his art as the product of the modern world, but also as a potential reformer of that world's visual aspect.

Relating to Léger and the Purists, a final question arises: how far was the new spirit that they encouraged to correct and discipline their painting actually a response to things, and how far was it, in fact, the imposition upon things of an ideal? Though Léger favoured a shift towards visual order on the street by means of an advertising strategy imposed by artists, he still undoubtedly would have argued alongside

233. 'Les Boulevards'. Photograph of a street corner in Paris. Published in L'Art Vivant, 15 August 1926.

Many, including Delaunay, saw the Exposition Internationale des Arts Décoratifs as a triumph for Cubism, a demonstration of how far interior design and such luxury crafts as bookbinding and jewellery had been changed by the Cubists;[51] but the transformation of the streets and the possibilities that were thus offered were altogether larger and more far-reaching. The product of capitalist competition in the post-war consumer boom, Cassandre could still project himself

the Purists that the new spirit was a response to an order that did already exist in modern life, and that the new spirit was inevitably shared by everyone in French society of every class (though by some more than others). Yet, it is difficult to deny the contention first made by Reyner Banham that theirs *was* a superimposed idealist view,[56] and from outside the Purist and the Cubist circles it was easily seen as the corrolary of that approach to the world which gave the artist a determining power *over* nature, as an inventor, a pure 'creator' no longer subservient to the look of things whether rustic or urban. It was thus that Marcel Hiver, anticipating Banham, saw the distance between Léger's claims in 'The Machine Aesthetic', his pictures and the actual character of machines in their then state of development. He picked especially on Léger's announcement in his lecture that: 'The locomotive more and more tends towards the absolute [quality] of the perfect cylinder.' 'Geometry', Hiver writes,

> has become a new esotericism which, furthermore, affects people in inverse relation to their real mathematical culture.
>
> And then, what Léger says about locomotives is not true; to the extent that machines become better adapted and more efficient, their external as well as their internal forms approach the forms of living organisms, which alone have the character of art. The speed-boat or the racing-car suggest the fish; these complex curves are still dependent on geometry. . ., but they are far from the pure spheres, cones and cylinders which roll around in Léger's mind.[57]

From the direction of Naturalism Léger's and the Purists' new spirit could easily be seen as an attempt aesthetically to colonize the world, to project onto it an alien, geometric ideal, which was initially and fundamentally the abstract creation of the intellect.

And indeed, it was demonstrably the case that for both Léger and the Purists, the will to synthesize, to think abstractly, was itself a key factor in the new spirit. As the Purists said in the first issue of *L'Esprit Nouveau*, it was not merely 'the spirit of construction' but also the spirit of 'synthesis guided by a clear conception'.[58] According to this interpretation, the work of *all* the 'pure' Cubists who self-consciously adopted a mode of synthesis, however loosely and informally, came within the limits of the new spirit. Not merely the vestiges of a controlling geometric order or the precision of a perfectionist technique worn on the sleeve, but the explicit accentuation of the gap between the invented image and appearance, between art and nature, became the sign of modernness. In this way, not only Léger, the Purists and the crystal Cubists, but even Marcoussis in 1923 (Plate 97) or the Braque of the *Canéphores* (Plate 71) stood for the new spirit in painting. For the look of naturalness in certain features of their work, in the painting of the fruit and general treatment of light especially, did not conceal the unnaturalness of others, of the proportions and lack of solidity of the *Canéphores* themselves, or Marcoussis's bottle and glass in their flat, angular aspect. Casual and informal they might have seemed, but, despite their concessions to naturalness, these were still obviously synthetic works, they still lacked idiomatic consistency, and they left just enough markers of their status as 'pure paintings' to make it explicit. Only where the Cubist compromise of such as Gris and Laurens was taken so far as to give a misleading impression of nature stylized rather than invented anew was this not the case.

Léonce Rosenberg, of course, had made synthesis much more than precision or order the central feature in his notion of the spirit of the time: his statement of 1924 in the *Bulletin de la vie artistique* described the early twentieth century as 'the return of men to the spirit of synthesis', as has been seen, and in this way promoted Cubism as a modern art for the modern world.[59] Such a stress on the synthetic factor, however, was taken furthest of all from within the Cubist circle by Albert Gleizes.

Gleizes, like Léger, opposed the dynamic, broadly Futurist view of modern life, to the ordered, broadly post-war view. As he saw it though, the dynamic view was to be rejected altogether, not because of its socially undesirable, enervating effects on people, but because it was founded on the brute evidence of the senses alone; because it depended on vision rather than conception. Futurism was a phenomenon of 'the eye', Gleizes said in 1922, it stood, therefore, for 'death'.[60] Concerned as art was with universals which went beyond the transient sensation, for Gleizes it necessarily was generated at its deepest by the mind and the imagination. His faith in the modern world, his hyperbolic optimism (naïve as it seems now), came of his conviction, alongside Léonce Rosenberg's that with technological and scientific progress had emerged a growing accent on the power of the mind to create for itself, a growing 'spirit' of abstraction. Synthesis in Cubism was the most significant sign of the times and one of its most telling outward manifestations was the quiet calm of Cubist art by contrast with the clattering excitement of Futurism.

'A new cycle is roughed out', Gleizes wrote in 1922, 'where intelligence must become recognized as the regulator of sensibility.' 'In fact,' he continues, 'it is thanks to this active, silent intelligence, that understanding is widened, that the laws of harmony are registered.' The senses are brought under control by 'calm intelligence': 'It has turned man from a slave into a creator.'[61] So it was too among artists. The Purists took the machine as a lesson more of method than of form, of the importance of abstract thought working logically according to the exacting standards of the new spirit, but Gleizes went further. In his writings the external form of the machine becomes almost an irrelevance by contrast with the inner lesson that can be learned from it. His was the furthest extreme that the Cubist stance reached in its opposition to that Naturalist stress on the changing variety of modern forms, represented, for instance, by the eulogies of Jacques Guenne, and by the colourful topicality of the pages of *L'Art Vivant*. As he moves towards the heady climax of *La Peinture et ses lois*, Gleizes takes up the theme thus:

> The plastic work will accord well in its evolution with evolution generally. An epoch which the motor, whose organism is entirely created by man, characterizes, cannot find it surprising to note that the same will towards creation is manifested in the plastic domain. If industry today can be a lesson and a source of inspiration for the arts, it is, not in the temporary formal aspects that artists would copy or interpret as they have until now, but in the revelation it can lead to that the human-being begins to expand the day he abandons appearances, [and] distances himself from imitation so as to benefit a little from that general truth on which he constructs a new world of living forms.[62]

In his essay of 1922 'From "isms" to a Plastic Renaissance' he sums up: 'Never has the love of truth been more manifestly visible, never has Realism been more completely capable of satisfying sensibility.'[63] His anti-materialistic response to the machine is paired with a notion of 'Realism' very far from that of the Naturalists: the machine for Gleizes is another route to the *nuomenon*, to God.

* * *

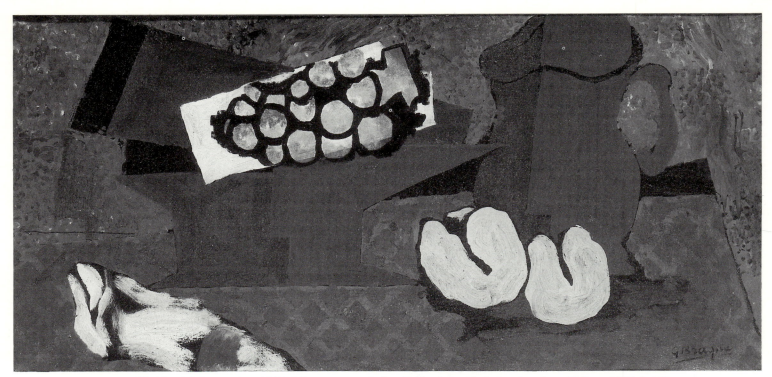

235. George Braque, *Still Life with Brown Jug*, 1922. Oil on canvas, 12¼ × 25½in. Sale: Christies, London, 27 June 1972, lot 59.

The stances of Léger, the Purists and Gleizes towards the relationship between art and modern life were all comparatively extreme within the range of Cubist stances, it must, however, be repeated that *all* the Cubists (the artists as well as their defenders) saw the newness of their work as the direct outcome of what was new about modern life and modern ways of thought. It is the final paradox to be pointed out here in the conflict between the Cubist and the Naturalist stances that, where the Naturalists tended to blur the distinction between art and life, yet insisted on no necessary link between the art they admired and what was special to life in their own time, the Cubists stressed the distance between art and life, yet insisted on such a link. For the Naturalists life was simply life; it was not necessarily modern, and for many of them (especially de Segonzac) it was found in better health outside the city. Cubism was wedded to an emphatically modern idea of life, and often an urban one.

Both these final chapters in Part III have been based on the premise that the various relationships between the artist, the life of the time and the art of the past which have been their subject were not merely available as attitudes communicated in published statements or interviews, but were absorbed into the very character of the paintings and sculptures the artists made, from Vlaminck or de Segonzac to Gris or Léger. These were attitudes, it is claimed, that determined the character of images to so visible and graspable an extent that, for the interested spectator of the day, they were an integral part of the meaning signified. In just the same way, the claim is that the relationship between artist and nature (understood in its very broadest sense) was something absorbed into the meaning of images. And, of course, all these attitudes, to the present, the past, art and nature, in the case of each artist at any moment come together as one integrated position communicated through the work; while the notion of tradition signified, and the attitude to things uniquely modern in the city and the country were ultimately always determined by a single question: how far artists believed themselves the creators of autonomous images obedient to their own 'plastic' laws, and how far they believed themselves the communicators of their subjective feelings about nature, the makers of images dependent directly on that response. Put another way, the claim that lies behind the major part of Part III as a whole is that a pattern of acceptance or rejection, of positive

or negative assertions, could be read from these images and instantly responded to during the period as one source of their specific power, and that the determining factor behind each pattern was the way images signified a particular stance towards art and nature, art and life, culture and society. The quality of the response was itself crucially inflected, it is suggested, by the various prejudices and expectations of spectators across the spectrum of possible stances offered within the world of *l'art vivant*.

Pictures like Braque's *Still Life with Brown Jug* (Plate 235) or Gris's *Guitar, Book and Newspaper* (Plate 173) shown at the Indépendants in 1920 declared, as seen in the previous chapter, the Cubist link with Cézanne and so with the various versions of the French tradition by the simple fact of their subjects alone. So too did a picture like de Segonzac's *Still Life with Eggs* (Plate 191). Yet, that willingness to manipulate formally and to dislocate normal perspectival space drastically in the interests of surface relationships as clearly signifies an approach to nature which is altogether different from de Segonzac's in the case of the Cubists, as we have seen, an approach which infers, of course, a very different interpretation of Cézanne's importance as a carrier of tradition. For the hostile, this was a dangerous misinterpretation of the entire character of a tradition which in its Frenchness was fundamentally rooted in the experience of nature, a misinterpretation underlined by the continuing existence of work like de Segonzac's which so manifestly embodied such a notion of tradition. For the more positive and sympathetic, it was an extension of the inventive factor which was to be found not only in Cézanne but in all those worthy of belonging to tradition whether Classical or non-Classical, Italian or French. For the sympathetic too, those qualities of pictures like de Segonzac's that communicated dependence on the direct study of nature were the opposites that threw inevitably into sharp relief what was inventive about the pictures of the Cubists, while that which was inventive in the formal vocabulary, syntax and space of Cubist art was what made it essentially modern, the product of a new spirit. Further, the rough sense of intuitive approximation conveyed by the actual working of a canvas like de Segonzac's still life was, again as we have seen, instantly to be grasped as the mark of the direct, the down-to-earth, the 'honest' approach to nature that was taken to lie behind it, while at least in the case of the Gris still life

the crystalline sense of the calculated and precise conveyed by the smooth paint surfaces and the clean-cut edges was instantly to be grasped as the mark of the new spirit in its fullest post-war form.

Cubist images like Braque's *Still Life with Brown Jug* and Gris's *Guitar, Book and Newspaper* have habitually been analysed in the course of Modernist art histories as part of a simple linear development, as they were in the narrative of Part I, their meaning to be elicited entirely in their own terms, isolated from such alien images as de Segonzac's *Still Life with Eggs*. Yet, they were pictures made fully in the knowledge of the existence of such de Segonzacs and of all that they stood for in relation to modernity and tradition, art and nature; and their first audiences in the decade of their making received their meanings in full possession of that knowledge. To explore them without a grasp of their situation in the world of images of their time, to ignore the oppositions and rejections contained in them, is to lift them out of history and to place out of our reach whole dimensions of their significance in the discourse of culture now and then. And there is another dimension to the oppositions and rejections contained in them, the dimension that relates them as well to the emergent avant-gardes of the post-1918 decade; international non-objective art, Dada and Surrealism.

IV
Radical Alternatives

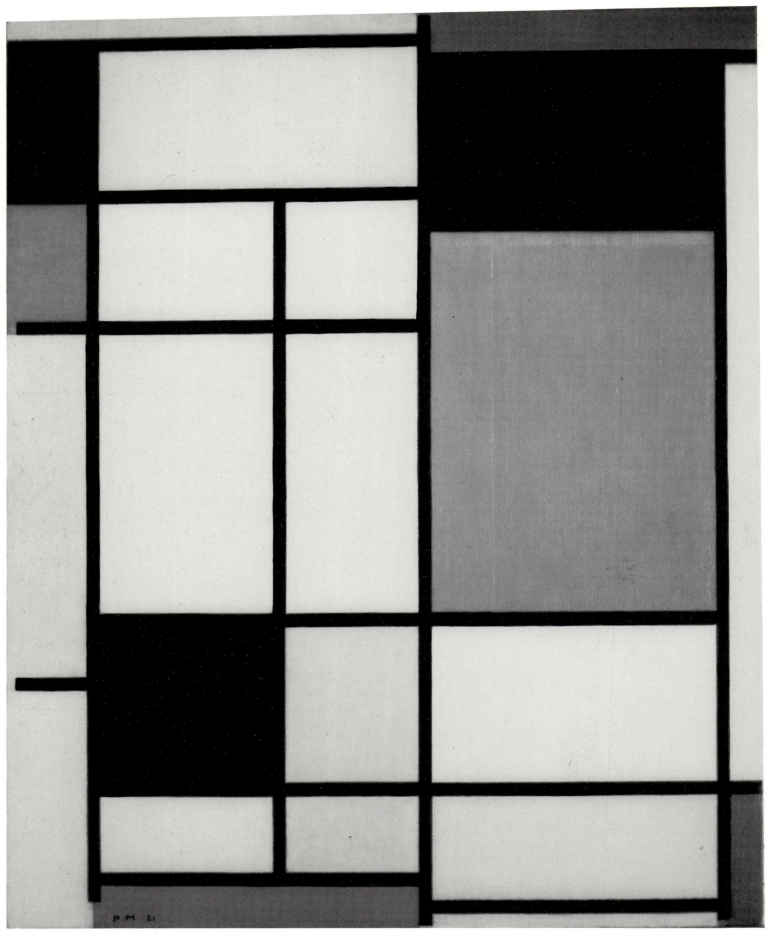

236. Piet Mondrian, *Composition*, 1921. Private Collection, Switzerland.

14
Non-Objective Art and Cubism: Style, Progress and the Metaphysical Factor

This final section requires a few words of introduction, for with the shift from a consideration of the conservative opposition to the radicals, a shift of emphasis is to take place in these chapters. Throughout the previous section there was intended a rough balance between the attention given the conservatives, including those left in the middle of the road like Lhote and Gromaire, and the Cubists. In this section the emphasis will move away from Cubism towards its opposition. This change of emphasis is a response to the fact that, whereas the conservative opposition never seriously challenged the future of Cubism as an avant-garde phenomenon and actually reinforced the Cubists' sense of identity, the radical opposition, as Part I showed, presented a serious challenge indeed, and threatened with increasing effect to rob the Cubists of their sense of avant-garde status and identity. Because of the radical challenge, from 1924 the Cubists could no longer see themselves or be seen as at the head of any linear, progressive history of French art in the twentieth century, except by transparent intellectual legerdemain.

By far the most serious threat was presented by Dada and especially Surrealism, for not only were the Cubists themselves unable to accept any aspect of the Surrealist alternative, but the Surrealists were able both to distort the image of Cubism for their own purposes and to realign the image of Picasso so that he became *their* figure-head in painting.[1] The challenge presented by abstract and non-objective art, even in its most uncompromising forms (in the work of Mondrian and Van Doesburg), was less serious, again as Part I showed, because it could be absorbed by the Cubists.[2] In France at least the international development of the non-objective set of styles closely associated with the emergent International Style in architecture could be made to seem an aspect of Cubism itself (though limited in its application), however fundamental the differences between, say, Mondrian and Gris, or Van Doesburg and Braque. For this reason, the change of emphasis away from the Cubists will be less marked in this and the chapter that follows than in the chapters devoted to Dada and Surrealism.

* * *

The Platonic dialogue was an attractive device often used. At once, it provided a simple vehicle for clarification in the face of bewilderment and gave expression to the fact that stances defined themselves in terms of oppositions which could easily be dramatized in conversational terms. Just as Pierre Albert-Birot had, in 1916, presented the argument for the Cubist transformation of nature in his 'Dialogues nuniques', so did Mondrian, in 1919, present the argument for non-objective art by means of a dialogue. In both these dialogues the 'modern artist' is faced by an untutored but amenable version of the ordinary art lover of the time, interested in the new, but deeply hostile to any move by artists away from nature. For Mondrian's ordinary art lover, 'A', '*life* is the main thing', not art, and the non-objective painting of the 'Neoplastic' artist 'B' leaves him unmoved and uncomprehending.[3] Like Albert-Birot's ideal Cubist, Mondrian's ideal artist 'B' answers such prejudices and doubts by pointing to the subjectivity of the artist's experience of nature. Albert-Birot's ideal Cubist insists on the artist's power as a 'feeling and thinking subject' to act *on* things;[4] Mondrian's 'B' asserts with total confidence that nature becomes more 'inward' in 'Art' because, in Art, man transforms things according to his own 'deepest being'.[5]

These two dialogues reveal certain alignments between the Cubist stance and that of the artists who advocated non-objectivity: a common anti-naturalism together with a common belief in the individual artist's subjective capacity to trans-

form appearances. Mondrian's dialogue, however, reveals a crucial difference. Albert-Birot's stress is entirely on subjective transformation; Mondrian stresses instead his belief that through this subjective transformation a truth is revealed which is universal and objective, basic to all human beings and to all nature.[6] For Mondrian, as for all the advocates of a non-objective or completely abstract art during the period, the painter was to reject natural appearances in order to penetrate to a permanent and objective 'truth'. It was to be above all the Cubists' refusal to accept such a possibility (except in the case of Gleizes), and their continuing stress on their subjective, time-bound relationship with nature or the modern spectacle that set them against abstraction and the non-objective.

Albert-Birot's 'Dialogues nuniques' ended with the ordinary art lover, persuaded by the modern painter, making the suggestion that a more 'absolutely subjective art' must surely lead to works in which the object would be completely excluded.[7] It *was* possible for so thoroughly subjective a view of art as the Frenchman's in 1916 to end with the idea that the future could lie in a completely abstract art, and Albert-Birot in the guise of the ideal Cubist (or post-Cubist) pointed to his own woodcut *War*, published earlier that year in *S.I.C.*, as a pioneering example that looked forward to such a future. Yet, the woodcut and its painted variant (Plate 237) are remarkable within the French context precisely because they remained so isolated; and the suggestion made in the 'Dialogues nuniques' remained equally isolated in the history of Cubist theory between 1916 and the mid-twenties. The Cubist stance in the distilled form it was given during those years led rather, as suggested earlier, to a stubborn rejection of the totally abstract.[8]

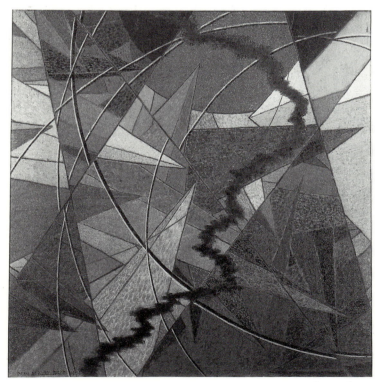

237. Pierre Albert-Birot, *War*, 1916. Oil on canvas, $49\frac{3}{8} \times 46\frac{1}{2}$ in. Musée National d'Art Moderne, Centre Georges Pompidou, Paris.

From within Cubist and Purist circles a simplistic but damning correlation was made between abstract or non-objective art and decorative art. Gamwell has shown how, after 1910, the term 'decorative' increasingly took on a perjorative meaning in writings sympathetic to Cubism,[9] and certainly by the end of the Great War decorative art could be set against the emerging view of Cubist art as 'pure' and

self-sufficient in the most obviously disadvantageous way. Thus, when Paul Dermée wished to underline the purity of Metzinger's Cubist pictures at the galerie de l'Effort Moderne in 1919, he made a point of insisting that they were 'neither decorative nor ornamental', and commented: 'The Cubist painter aims to harmonize the picture *in itself* and not *with* something outside it.'[10] For the Cubists, decorative art was, by definition, subordinate to a whole of which it was merely a part; the work of art, properly speaking, was a whole in itself, subordinate to nothing. If abstract or non-objective art was to be called 'decorative', it was inevitably to be dismissed as inferior; and the ease with which the correlation between abstraction and decorative art was made and then used dismissively comes across clearly in Maurice Raynal's critical response to Jacques Villon's paintings at the galerie Povolozky in 1922: 'Jacques Villon', he writes, 'puts over in his attempts a concern with composition which is perhaps a little decorative as a result of the almost total abstraction he makes of reality.'[11] The causal connection in his mind between abstraction and the decorative is direct, and the deflationary tone unmistakable.

Nonetheless, it was the Purists who made this correlation between abstraction and the decorative most damningly. It was already obvious that Ozenfant and Jeanneret would reject the geometric non-objective painting of Mondrian and De Stijl when they wrote at the end of 1920: 'An art which is only to be based on primary sensations through the employment alone of primary elements [primary geometric forms], will be only a primary art, rich, it is true, in geometric aspects, but stripped of all sufficient human resonance: it is ornamental art.'[12] After that it is no surprise to find them marginalizing the De Stijl exhibition at the galerie de l'Effort Moderne in November 1923 as: 'a negative demonstration',[13] and specifically singling out Mondrian for attack in 1924, while writing: 'A picture which is merely a symphony of colours and forms, which uses only the primary reactions of forms and colours, will rarely be anything else but a decorative ensemble.'[14]

Between 1918 and 1928 there was no denying the extensive influence of Cubism on the decorative arts in France; it was a frequently observed fact. Indeed, several commentators believed that this was Cubism's most significant effect, and for Robert Delaunay, it will be remembered, it was the reason for understandable self-satisfaction at the Exposition Internationale des Arts Décoratifs in 1925.[15] As Florent Fels remarked: 'Cubism: arm-chairs, barges, cakes, palaces, hats are made of it.'[16] Pierre Chareau's lamps and cabinet-work, Pierre Legrain's book-bindings, Mallet-Stevens's 'Hall for a French Embassy' at the exhibition, Sonia Delaunay's Orphist textile designs all showed the truth of such an observation, and that such a transference from painting to the decorative arts came as no surprise in 1925 is plain. The work of Picasso, followed by Braque, Léger and Gris, designing costumes and sets for the Ballets Russes and the Ballets Suédois, had spectacularly led the way. It was Léger's sets for the Ballets Suédois production of *Skating Rink* that had encouraged the critic Eugène Marsan to write in 1922: 'Cubism in painting will be dead a long time when decorative Cubism is going on developing its resources.'[17] Yet, though the Cubists backed decorative developments, there remained for them a sharp distinction between fine and decorative art that always consigned the decorative to an inferior status. Fine art as easel painting was both self-sufficient and necessarily in touch with nature by way of subject-matter; decorative art could accept the imprint of Cubist motifs and manners, could be non-objective or completely abstract, but was always lesser.[18]

How then, despite Albert-Birot's dream of complete abstraction in 1916, was the essentially time-bound subjectivity of the Cubist stance made the accomplice of so firm a resistance to the non-objective and the abstract in easel painting? The answer, of course, is implicit in the entire structure of the theory elaborated between 1917 and the mid-twenties by Reverdy, Raynal, Braque, Gris and the others; but it is perhaps most explicitly there to be seen in Gris's lecture 'On the Possibilities of Painting', delivered in the spring of 1924 just a few months after the De Stijl exhibition at l'Effort Moderne.

Within the notion of the synthetic process in painting at its most distilled, there seems to lie the possibility of non-objective art, just as there does in the notion that the artist subjectively transforms nature. If artists begin by arranging coloured shapes without reference to nature, surely one day they may end there. Reverdy, however, from 1917 had insisted that an artist's vocabulary of forms was always derived from the selective study of nature and the extraction of 'elements' observed there, and in practice this was certainly the common experience of the Cubists from Gris to Léger. They all had begun fixed to the motif, guided by Cézanne; analysis had *in fact* preceded the kind of synthesis developed in late Cubism. So much was this the case that a complete severance from nature in the use of form could seem actually impossible, not just undesirable. According to Victor Servranckx, Picasso responded to the question of complete abstraction thus in 1923:

> Draw a circle and in this circle place two small horizontals and a little vertical; put these marks in the middle of the circle, on the left or on the right, at top or bottom, it doesn't matter, the head of a man will always be seen there. If you use forms without objective meaning, the spectator will always look for such meaning in them. Art cannot go beyond a certain naturalism.[19]

Gris, of course, based his synthetic method on the power of simple shapes to suggest subject-matter thus.[20]

The question of abstraction, however, was both more profound and more important for the Cubists than such simple statements and practices might indicate. For the Reverdian theory of the relationship between art and nature gave the practice of referring to nature in art a particularly telling role in the signification of meanings, as has been established. If the artist's spirit and the spirit of the time was to be conveyed only by the particular, selective way artists *saw* nature and extracted its elements, then only by establishing contact between art and nature could the special, timebound character of the aesthetic or spirit be made apparent. These are the assumptions and this the argument that lie behind Gris's notorious refutation of non-objective art in his lecture:

> Painting for me is like a fabric, all of a piece and uniform, with one set of threads as the representational, aesthetic element [that which comes of the painter's selective approach to nature] and the cross-threads as the technical, architectural, or abstract element. These threads are interdependent and complementary, and if one set is lacking the fabric does not exist. A picture with no representational purpose is to my mind always an incomplete technical exercise, for the only purpose of a picture is to achieve representation.[21]

And for the Cubists altogether a picture had to 'achieve representation', because only then could it signify at all; meaning essentially existed, after all, in the particular relationship between the spirit of the time, the artist as an individual, and nature, something made visible only by the relationship between the work and the 'natural'.

There is one further point to make about the character of the late Cubist resistance to abstraction and the non-objective, and it is a point that allows clarification of both these terms—'abstraction' and 'non-objective'—in relation to art. The point is that Cubist resistance to abstraction went with a strong antipathy both to idealism (when unadulterated) and to processes of idealization. To work from an arrangement of coloured shapes before giving them identities and 'discovering' a subject was to avoid working away from the model or motif; it was to avoid the process of abstraction from appearances. In 1920 Gris specifically called 'synthetic' art *anti-idealistic*, and differentiated his Cubism from Greek art which he considered started from 'the individual and *attempted to suggest* an ideal type.' He wanted, by contrast, to 'individualize' the ideal by returning from form to recognizable subject-matter.[22]

Now there has long been discussion of how the term 'abstraction' can legitimately be applied to art during the period. It has often been pointed out that 'abstract art' is a misnomer for art which is not abstracted from nature, and the alternative term 'non-objective art' has been offered to cover such cases. The argument for this is persuasive enough, and after 1918 the painting both of Mondrian and Van Doesburg is better called non-objective than abstract. But recently, while re-iterating the distinction, Gladys Fabre has introduced a further confusion. Since the forms of Léger's *Mechanical Elements* (Plate 230) make no clear reference to a machine subject and yet relate to such a subject, she has applied to them and their relatives the term 'abstract'.[23] They are, however, the product not of a reductive, abstracting process, but rather of an open, free-wheeling process of synthesis, where a vocabulary of 'elements' liberated from any particular source in reality is combined dissonantly, and then associations with machines are brought out by the working up of metallic surfaces and the addition of mechanical details. This is neither non-objective nor abstract painting, it is late synthetic Cubism. In what follows all three terms will be used as carefully as possible: non-objective, abstract or synthetic. Late Cubist art was almost never either non-objective or completely abstract, except where it could be called decorative or architectural.

The scene is finally set for a full discussion of the stances behind synthetic Cubism, abstraction and non-objective art and the way they interrelate, once the main areas of their confrontation are established. The most basic confrontation of all was the one between Mondrian's Neo-Plasticism and Cubism, from the Dutchman's post-war return to Paris in the summer of 1919, on.[24] This was complicated by the general relationship between Cubism and De Stijl, especially after Van Doesburg's decision to settle in Paris in the spring of 1923 and the exhibition at l'Effort Moderne at the end of that year. Then there was the isolated and peripheral case of the Czech painter František Kupka, whose pre-war and post-war abstract and non-objective painting was exhibited in 1921 and 1924 on a large scale,[25] and the equally peripheral case of Jean Crotti's so-called 'tabu' painting, a non-objective manner he introduced at the Salon d'Automne of 1921.[26] Then there were the successive and varied attempts to develop abstract or non-objective styles, both fine and decorative, from a Cubist starting-point: those first of Villon (after Albert-Birot's brief foray), of Gleizes, Herbin and Léger as decorators, and then (after 1923) of Léger as a muralist and of his pupils at the Académie Moderne. The rest of this chapter and the one that follows will range across these major areas of confrontation.

* * *

The Cubists themselves might have disclaimed any real connection between Cubism and either abstract or non-objective art, but the fact is that all who most dedicatedly stood for the non-objective presented it as the logical sequel to Cubism (with the single exception of Kupka). For Mondrian and Van Doesburg, this was a self-evident truth for two interconnected reasons. In the first place, it followed from a particular idea of history, and so of their own non-objective art (modern art) in relation to the past; in the second place, it followed from a convenient misunderstanding of Cubism which bolstered their sense of radical identity.

There were actually important points of contact between the Cubist view of modern art in relation to the past and the views of Mondrian and Van Doesburg. Most basic of all; Mondrian especially agreed with the Cubists' identification of constant compositional values as the structural foundation of all art. He deals with this idea most extensively in the series of articles in 1917 and 1918 which were his first contribution to *De Stijl* and which find French echoes in the pamphlet published by Léonce Rosenberg, *Le Néo-Plasticisme*. Here Mondrian uses the term 'style' both for what he believes is the unchanging structural essence of natural appearances and for the individual artist's sense of order. There is 'style' in nature, and individual artists have a 'sense of style' that leads them to divine it (what is called a 'sense of style' here, of course, is close to what Gris calls the artist's 'aesthetic').[27] For Mondrian, all style has both 'a *timeless content* and a *transitory appearance*. The timeless [universal] content', he writes, 'we can call the *universality of style*, and its transitory appearance the *characteristic* or the *individuality of style*.'[28] Gris too was to contend (with the rest of the Cubists) that all art combines the ephemeral with the timeless. And Mondrian along with the Cubists insisted that the 'timeless content' in art and nature was revealed in painting by structure: 'In all art it is through composition . . . that some measure of the universal is plastically manifested and the individual is also more or less abolished.'[29] Following up this point, his view of Cubism was not altogether a distortion. Unaware before 1919 of Gris's, Metzinger's or Severini's use of the Golden Section and 'regulating lines', he still could present Cubism as the prelude to his own painting because it had laid bare the bones of composition, and thus shifted attention to what for him was the universal.

Mondrian's view of the constant in nature and art carried, however, a very different stress from the Cubists', essentially because of its universal pretentions. The Cubists (including Gleizes) treated compositional constants as fixed foundations on which to build individual structures that carried the mark of the artist and the epoch; their stress was on the always changing character of the artist and the times and the way that this was conveyed by the transformation of the 'natural'. Mondrian's stress was on the fixed foundations; he looked forward to a stripping away of the ephemeral superstructure of the individual interpretation until the foundations were all that was left. In his painting, he believed, '*composition itself is expressed*'—and with it the universal.[30]

Since the Cubists' emphasis was on the individual capacity of the artist to impose an aesthetic on things, their idea of art, like André Salmon's, had its progressive side, as the last two chapters showed, whatever the attractions of 'tradition'. They saw Cubism as caught up in a continuous Bergsonian 'creative evolution'. But it was an evolution without any definite goal, and so the idea of history to which it was attached tended to emphasize change as such more than progress. There were exceptions here: on the one hand, Léonce Rosenberg and Gleizes with their belief in a coming 'spirit of synthesis', and on the other, the Purists, with their

belief that the 'new spirit' of order revealed the eternal more clearly; but none of them looked forward to a stage when art *only* conveyed the primary and the eternal. Mondrian however, did; his goal was very definite, and so he presented a far clearer progressive idea of history, at the sharp end of which he placed himself and Neo-Plasticism. Van Doesburg did too, and in the dissemination of this idea of history he played at least as important a role in France, at the same time shaping the idea in much greater detail.

Writing in 1924, Mondrian expressed the conviction that, though still in its youth, humanity, and therefore art, had just reached full maturity.[31] He saw this manifested directly and simply in the withdrawal of art from nature, and he called Naturalist art 'an art of children'.[32] For Mondrian here, as in his early articles in *De Stijl*, the recent history of art was integral with the recent history of man, and both revealed a movement towards abstraction. Such a movement went with a process of spiritual maturation, that is, a deepening of man's awareness of the universal. Life and art came together in a highly idealized evolutionary view of history whose roots lay in theosophy.[33]

Van Doesburg's view of history was also articulated in terms of a spiritual evolution which brought together the history of humanity and of art. It was given its first complete form in a text dated 1918 which was published in French by Léonce Rosenberg in 1920 as well as in Dutch: *Classique-Baroque-Moderne*. The idea was further refined in Van Doesburg's lecture of 1922, 'The Will to Style', which, however, was delivered in Germany and, for all its importance, not published in French.

As Allan Doig has shown recently, Van Doesburg's view of history was more firmly embedded in the German philosophical and art-historical tradition than Mondrian's. It reflects a critical awareness both of Wilhelm Worringer's *Abstraktion und Einfühlung* and of Heinrich Wölfflin's *Kunstgeschichtliche Grundbegriffe*, to supplement its debt to Hegel and especially to Schopenhauer's idea of 'true history'.[34] Following Schopenhauer, Van Doesburg saw history in the largest human terms as the repeated surfacing of a single central theme from the chaos of events, and in art as in life that theme was the evolution towards a final synthesis of the spiritual and the material sides of man: mind and matter.[35] It was as a reaction against the cyclical view of history with its inherent failure to discern such a progressive evolution that Van Doesburg published *Classique-Baroque-Moderne*.[36]

Like Mondrian, Van Doesburg identified a single, essential need for 'harmony' as the drive behind all art: harmony to be contemplated in formal 'relationships'. Following from this he divided every kind of art into the three categories that gave the title of his text: Classic, Baroque and Modern. His definition of Classic art was art that achieved 'harmony' by 'natural forms', 'therefore in the manner of nature'.[37] The Baroque entailed a lack of harmony which came of a dominant involvement with 'the particular' rather than the general and therefore a predominance of arbitrary and capricious natural forms.[38] The Modern was defined as art that achieved harmony by means of 'abstract forms and colours', without reference to natural forms, therefore 'completely in the manner of art'.[39] Van Doesburg allowed the possibility that the Classic, the Baroque and the Modern could all exist concurrently in time, but still he identified a dominant central evolution whose shape was broadly dialectical, the Classic (thesis) giving way to the Baroque (antithesis) and then finally to the Modern (synthesis).[40] In this way he went one stage further than had been suggested by Wölfflin's distinction between the Classic and the Baroque, and he did so in order to squash any temptation to return to Classic models and in order to establish

the non-objective or abstract achievement of harmony in art as the direction of the present and the future.

This picture of a dominant dialectical evolution in the history of art towards Neo-Plasticism's 'synthesis' was refined a little in 1922 with 'The Will to Style'. In diagrammatic form here he showed the history of art as a progressive series of oscillations between the two poles of the natural and the spiritual, the goal being the balanced unification of the two, the fusion of outer and inner. They are represented in balance in the art of Egypt and Greece, there is a shift to the natural in the art of Rome, back to the spiritual in the Middle Ages, then to the natural in the Renaissance and the Baroque period; there is another move towards the spiritual 'at the time of Idealism', until in 'the period of Neo-Plastic Expression, the road towards the unity of matter and mind is regained'.[41]

The Cubists' sense of tradition was guided by their desire to legitimize their art by establishing its continuity with the past; it was ultimately conservative. Mondrian's and Van Doesburg's idea of history was radical—uncompromisingly so. Their commitment to progress replaced rather than merely balanced any sense of tradition. They believed not in continuity, but in rupture. This is most obvious in the career and statements of Van Doesburg, with his sudden switches of direction as an artist and his admiration for the destructiveness of Dada; but Mondrian's taste for the abstract was not necessarily sedate. Even he could write in 1922: 'In spite of all, the arts continue and seek renewal. But their way to renewal is their *destruction*. To evolve is to *break with tradition*.'[42]

If the Cubists used their subject-matter to embed into their work connotations with the dominant notions of tradition, Mondrian's and Van Doesburg's non-objective paintings offered up in relation to the styles of the past a kind of blankness, a silence. A painting like Mondrian's *Composition* of 1921 (Plate 236), shown at the galerie de l'Effort Moderne that year, gave no sign of any relationship at all with tradition; and when Van Doesburg introduced the diagonal in such paintings as *Counter-Composition XVI* (Plate 242), he did so partly, he claimed in *De Stijl*, to get rid of the last vestiges of association with Classic modes of composition.[43]

Seen alongside the Cubist pictures shown in Léonce Rosenberg's 'Group Exhibition' of 1921, Mondrian's *Composition* declared a clear enough break with all current notions of tradition; and Van Doesburg, looking back in 1926 to this kind of dispersed Neo-Plastic composition with its accent on the peripheries, contrasted Mondrian's work of the early twenties against the more centralized, concentrated compositions of the Cubists (Plate 174 and 178).[44] Yet, the link between the bare bones of crystal Cubist compositions (their geometric armatures) and such a Mondrian painting would also have been clear enough, and there is nothing surprising about Mondrian's and Van Doesburg's idea that Neo-Plasticism was the logical result of Cubism. Nor is their misinterpretation of Cubism surprising, for it made the idea that Neo-Plasticism superseded Cubism all the more plausible. Quite simply, where in the terms of Van Doesburg's *Classique-Baroque-Moderne* they saw their own art as 'Modern', they insisted on seeing Cubism as 'Classic', as an art which achieved harmony by means of natural forms. For Cubism to be 'Classic' was to consign it to the past and to bolster their conviction in their own leadership; to have accepted Cubism as a synthetic art where the painter built on non-objective beginnings would have been to weaken that conviction.

This is not to say that Mondrian's and Van Doesburg's misinterpretation was dishonest, merely that it was convenient. In both cases it was encouraged by the timing and quality of their first encounters with Cubism. Van Doesburg's came second

and from the detached vantage-point of wartime Holland, especially between 1914 and 1916. As Robert Welsh has remarked, it was an encounter as much with theory (the writings of Apollinaire and Gleizes and Metzinger) as with actual work, and it took place when the guidance of Kandinsky's ideas was still an active factor.[45] Mondrian's was the first and by far the most intimate encounter: he had been in Paris for the Section d'Or of autumn 1912, and had seen the whole range of Picasso's, Braque's, Léger's and Gris's work at first hand during 1913 and 1914. But he had arrived in Paris with many of his basic convictions ready-formed, and the view of Cubism that he found dominant there had been the conceptual view given its clearest exposition by Raynal at the Section d'Or. The image of Cubism as concerned with the representation of 'ideas' had not yet given way to the late Cubist accent on colour and form as such, 'pure creation'. Apollinaire's, Delaunay's and Léger's pleas for 'pure painting' must have seemed just one aspect of Cubism then, and not necessarily a central one.

Most commentators have called the work that Van Doesburg produced in Holland during 1916 and early 1917 'Cubist'; *Tree* (Plate 238) is one of these pictures. The Cubism found here possesses both the two essentials of Van Doesburg's idea of Cubism then and later: it starts from the abstraction of natural form and it ends with an approximation of geometric form. Welsh has suggested that Apollinaire's definition of 'scientific Cubism' as geometric and Kandinsky's interpretation of Cézanne and Cubism in association with the 'mystical triangle' might lie behind the second of these essentials.[46] The example of Mondrian's plus-and-minus works and the actual experience of making works like *Tree* must have reinforced the belief that Cubism's geometry was the result of abstraction.

Already in a lecture and an essay of 1916 the outlines of Van Doesburg's view of Cubism had been defined. The Cubist,

238. Theo Van Doesburg, *Tree*, 1916. Oil on panel, 28 × 24in. Portland Art Museum, Portland, Oregon. Gift of Mr and Mrs Jan de Graaf.

he could write, 'abstracts natural form—his basic given—advances mathematical form, and thus creates a pure image—the spiritual'.[47] He himself was to work in just this way until Mondrian's non-objective paintings of 1917–18 led him out of abstraction. For Van Doesburg the logical link between Cubism and Neo-Plasticism was self-evident: his own non-objective De Stijl painting was the direct result of his period in abstraction or, as he saw it, in Cubism. From 1917 he was in touch with Parisian developments in the Cubist circle through Severini and Léonce Rosenberg, and early in 1920, on his visit to Mondrian in Paris, he saw the late synthetic Cubism of Gris (Plate 173), Metzinger, Gleizes and the others at the Indépendants and the revived Section d'Or.[48] But this fresh experience of Cubism in its distilled post-war form did not change his view. When he brought the Section d'Or to Holland and showed the new Cubist work alongside work by himself, Mondrian and Vilmos Huszar, he called De Stijl painting 'Neo-Cubist' to make clear its separateness yet connection, and insisted that where the Cubists 'abstracted from nature' (even still), the De Stijl 'Neo-Cubists' 'realised' their paintings directly.[49] He would not see that in between abstraction and the non-objective lay something else, the synthetic procedures and the aesthetic of purity of Gris, Reverdy *et al.* His belief that the geometric order of Cubist art was based on a direct response to nature and the abstraction of its forms was to remain undisturbed.

As one would expect, Mondrian's idea of Cubism was both more sophisticated and more perceptive than Van Doesburg's, but fundamentally the shape of his misunderstanding was the same and so were its implications. He too saw Cubism as rooted in the experience of nature: abstract and geometric. The essentials of his view are all there in the series of articles that he published in the opening phase of *De Stijl*, articles written in 1916 and 1917 as he reflected from the quiet of Laren on what he had seen in Paris. Besides abstraction and geometry Van Doesburg picked out the *flatness* of Cubist painting as significant. Mondrian stressed this more heavily, and at the same time brought out the dislocations of Picasso's and Braque's pre-1913 transformations of nature and the conceptual aspect of multiple perspective. The importance of Cubism, he accepted, was to emphasize the idea that 'everything visible has a geometric basis' (an idea he associated as usual with Cézanne); and the weakness of Cubism, he accepted, was its dependence on the observation of natural form.[50] But he expanded on this weakness rather differently than Van Doesburg. 'Cubism', he writes, 'still represents particular things, but no longer in their traditional perspective appearance. Cubism breaks forms, omits parts of them and interjects other lines and forms: it even introduces the straight line where it is not directly seen in the object.'[51] For Mondrian, the Cubists abstracted in pursuit of the geometric, but failed because of their inability to eradicate their fascination with 'the fragmentary character of natural appearance'.[52]

Just as Van Doesburg defined Cubism as if his own pre-Neo-Plastic painting were a sufficient demonstration, so did Mondrian. The end result was the same for him too: Cubism was thus fobbed off with the respectable status of precursor, and Neo-Plasticism was all the more firmly fixed at the sharp end in the progress of art and humanity. Living in Paris, constantly aware of what late synthetic Cubism was, Mondrian was not to change his mind. Another ideal history had been constructed, with another vanguard.

* * *

Maurice Raynal's division of French art into the two streams, Realist and Idealist, and his identification of Cubism as the apex of French Idealism to date, went, it will be remembered,

with an often repeated interest in 'the absolute'. His absolutes, however, were only *subjectively* credible. According to this common view within the Cubist circle, Gris's or Braque's fruit-bowls were only closer to some unchanging essence *for them*. It will be remembered too that Raynal made a point of dismissing Kant's claim that judgements of the Beautiful could be universal.[53] The move to abstract or non-objective art, as suggested above, went with just this claim: that art developed towards the revelation of an order which its champions called universal. How then did these artists hope to reveal the universal, and what did they believe it entailed?

Before seriously attempting to answer these questions, the one case of a Cubist who did approach both non-objective painting and a complementary belief in the revelatory power of art should be mentioned: that of Gleizes. Y.V. Poznanski, the organizer of 'L'Art d'aujourd'hui', was a follower of Gleizes, and Gleizes himself (with other followers) showed there. At this exhibition and often in the press Gleizes was considered a non-objective or abstract painter, and, as has been seen, his writings continually reiterated his belief that the formal and chromatic rhythms of painting expressed a dynamic universal order. He was undeniably an artist to be understood alongside self-styled modern 'religious' artists like Mondrian; and yet, though the parallels are many, he is best seen (as he has been in this book), in a Cubist context, because, working synthetically, he never freed himself of the Cubist need for subject-matter.

Gleizes was too intensively a Cubist for too long entirely to escape; Kupka, before 1914, had always worked outside the Cubist circle, never considered himself a Cubist and had developed as he had on a foundation of beliefs formed away from Paris, in the very different intellectual milieux of Prague and Vienna.[54] The paintings he showed in Paris in 1921 and 1924, and the stance behind them were direct extensions of that pre-war development *alongside* Cubism rather than within it. *Vertical and Diagonal Planes (Winter Reminiscences)* (Plate

239. František Kupka, *Vertical and Diagonal Planes (Winter Reminiscences)*, 1920–23. Oil on canvas, $70\frac{7}{8} \times 59\frac{1}{8}$in. Narodni Galerie, Prague.

240), shown in 1921 and 1924, and *Tale of Pistils and Stamens* (Plate 241), shown in 1924, combine the abstract and the non-objective, like all his work from 1912 on. Unlike Gleizes, Kupka made beliefs, which in their essentials come close to Mondrian's and Van Doesburg's, the basis for a real exploration of abstract and non-objective painting. The particular slant he gave his thinking is more exactly an echo of Kandinsky in Munich during the Blaue-Reiter years, but still it can provide a good starting-point for looking into what abstract or non-objective artists generally thought their goal was and how they thought they could reach it.

If Kupka's paintings were made easily available at the Salons as well as the Povolozky and La Boëtie galleries, the full complexity of his ideas was less so. Between 1910 and 1913 he had set his ideas down in detailed notes and in the manuscript of a treatise which he published in 1923.[55] His treatise, however, was published only in Czech, and in France his thinking was available exclusively through the medium of his monographer Arnould-Grémilly and in a shortish text, published in *La Vie des lettres* in 1921, with the title, 'To Create! A Question of Principle in Painting'.

Kupka's article of 1921 by no means covers the full range of either his pre-war notes or his treatise, and it tends to concentrate on attitudes he shared with the Cubists rather than those he did not. He focuses just like the Cubists on the capacity of the artist to create without reference to nature;

240. František Kupka, *Tale of Pistils and Stamens*, 1919–20. Oil on canvas, $43\frac{1}{4} \times 36\frac{1}{4}$ in. Narodni Galerie, Prague.

he insists that 'the aesthetic of art is not compatible with that of nature',[56] apparently sharing their desire to separate the two; and he sketches in a relationship between the artist and nature which is comparable to that outlined by Reverdy and Gris: the artist continually, 'like an automaton', searches the natural world for forms but yet works with his forms freely.[57] What separates him from the Cubists is the sheer clarity of the division he makes between art as representation and art as 'creation' (there is no question of a return to subject-matter, of moving back from the abstract to the concrete), and the stress he gives to the expressive, psychological potential of forms and colours. He associates the rejection of subject-matter with the aim of expressing pictorially 'intimate psychic events'. 'Thoughts', he writes, 'paint themselves, articulate themselves in elements like: lines, marks, points, spots, planes, values, colours, dimensions, proportions.'[58]

This expressive theory of art obviously distinguishes Kupka's stance from late Cubism, for it entails a rejection of the Modernist claim that art is self-sufficient, but in the text of 1921 Kupka did not go further, as he does in his notes and his treatise, to associate what the artist expresses with what are claimed to be universal truths. In fact, the key to Kupka's stance undoubtedly lay in what he saw as the metaphysical possibilities of painting, its potential for going beyond the expression of the subjective 'psychic event' to reveal an objective essence.

Arnould Grémilly did not miss the connection between Kupka's expressive painting and Kandinsky's; he saw it particularly in the analogies both brought out between painting and music (he seems, even in 1921, to have been aware of Kandinsky's activities in Moscow that year).[59] But there was a deeper parallel to be drawn, one he did not point out. Over many years, beginning in Vienna before 1896, Kupka had explored the ideas of German philosophers and writers, including Goethe and Schopenhauer, and had been introduced to theosophy.[60] And he, like Kandinsky in Munich before 1914 (who was drawn to the same sources), had adapted to his own experience Goethe's view of art and nature; at least Rudolf Steiner's version of it. He too came to believe that the rhythms and order of the universe were present but hidden in nature, could be uncovered by the artist and made manifest in art.[61] Pictures like *Tale of Pistils and Stamens* or *Vertical and Diagonal Planes (Winter Reminiscences)*, with the wide-ranging study of natural motifs that lay behind them, were the practical result of this belief (an intense visual knowledge of plants, rocks and the female form lay behind the first, of snow on trees behind the second).

The painter working in France whose stance seems closest to the broadly Germanic Expressionist stance of Kupka was the Swiss associate of the Dadaist Francis Picabia, Jean Crotti. *Chainless Mystery* (Plate 241), shown at the Automne of 1921 was plainly non-objective, was the result of a visionary religious experience and was accompanied by a brief manifesto which in typically direct Dada style set out objectives a long way from Dada: 'The field of action is infinite because we are trying to express the infinite itself; *TABU* is Mystery and seeks to express Mystery.'[62] Crotti opposed his new move-ment (of which he was the only devotee) to 'Materialism' and 'Naturalism' among other things, and, though he is not at all explicit about the expressive power of form and colour, his accent on the revelatory function of art and on 'mystery' carries unmistakable echoes of Kandinsky's Munich writings. The major difference between the stance behind his 'tabu' paintings and Kupka's stance is that, initiated as it was by an instant of revelation, the paintings were not given the under-pinning of a long and searching study either of nature or of the elements of art. Crotti worked and wrote in 1921 and 1922 as if the 'infinite' spaces and the hovering bodies of his compositions had simply come to him ready-made, mysteries that were given.[63] 'Tabu' was peripheral and short-lived in its impact, but nonetheless it underlines the closeness of the correlation in Paris during the twenties between non-objective painting and a metaphysical notion of the power and the role of art.

Crotti made a point of explaining nothing (to preserve the sense of mystery); Kupka left the question of how the rhythms and the order of the universe were actually to be defined distinctly vague in his writings; but broadly it is clear that Kupka's stance especially shared the essentials of Mondrian's and Van Doesburg's (and incidentally of Gleizes's). All (including Crotti) believed that in some profound way their art was religious. All (excluding Crotti) believed, as suggested at the beginning of this chapter, that objective universal truths were to be uncovered by a penetrating study of nature and a complementary study of the elements of painting (colour, line and form). And all (including Crotti) believed that the role of art was either to express or to embody these universal truths, though, like Kandinsky, Kupka emphasized particularly heavily the conviction that such truths were to be expressed through the personal intuitions of the artist ('psychic events').[64]

Altogether these were religious artists in a very complete sense. Their stances were built as much on faith as on abstract thought, a faith engendered by a visionary experience in Crotti's case, and, more importantly, in the case of the others given its strength by the actual experience of looking and painting. As Mondrian puts it the truths revealed by his painting were exposed 'through the process of working', and it was especially for this reason that he believed them 'irrefutable'.[65] The Cubists also insisted that practice came before theory and was the ultimate source of conviction, but theirs was a theory more narrowly about art and artists; Kupka's, Mondrian's, and Van Doesburg's claimed far more scope than that.

Where Kupka was vague on just how the universal was to be defined or discussed, Mondrian and Van Doesburg were obscure but not at all vague. For both of them it was possible to articulate explicitly the way in which the universal was embodied in their art, and both did so in fundamentally the same way, working from sources that were often the same. Their stances were not identical and diverged considerably after 1924, but in the essentials agreement was close, and both stances were verbalized with the same abstract vocabulary, with the same certainty. In fact, Mondrian's and Van Doesburg's sources were often Kandinsky's and Kupka's too; and, of course, Kandinsky's writings of 1912–13 were themselves one of their sources. But their approach was shaped within a rather special Dutch context. Thus, the philosophy of Hegel and Schopenhauer was seen through a screen of Dutch interpretations and variations, provided, in the first place, by the Dutch Hegelians, G.J.P.J. Bolland and Dr A. Pit, and in the second place by Mondrian's friend at Laren, Dr Schoenmaekers, whose thinking formed the immediate background to Mondrian's 'Neo-Plasticism in Painting'.[66]

Within the framework of both Mondrian's and Van Doesburg's thought there was one basic belief from which much else followed. This was the belief that everything was to be understood by its opposite. 'We all know', writes Mondrian in 'Neo-Plasticism and Painting', 'that nothing in the world can be conceived in or by itself: everything is judged by comparison with its opposite.'[67] Here was the key to their understanding of truth: put simply, truth was to be under-stood as a structure of oppositions brought into unity. Behind all things lay such a structure. Society, history, art, culture all were to be understood in terms of polarities.

241. Jean Crotti, *Chainless Mystery*, 1921. Oil on canvas, $54\frac{5}{8} \times 35$in. Musée d'Art Moderne de la Ville de Paris.

One particular polarity was, for them, more important than all the others: the opposition between 'matter and mind'. This could be expressed in other ways, through a chain of equivalences: it could be the opposition between female and male, outer and inner, nature and spirit, subjective and objective, individual and universal. Van Doesburg in particular, it will be remembered, saw the history of art in terms of these major polarities, and sketched a process of evolution that was to end with their unification: with matter and mind, the individual and the universal coming together in art. In 'The Will to Style' he called the 'equilibrium of these extremes or the annulment of duality, the elementary subject of art'.[68] Mondrian often echoed this focus on the goal of matter and mind unified, though he thought it less credible as a goal for art, and with 'Neo-Plasticism in Painting' and his French pamphlet *Le Néo-Plasticisme* he elaborated the rather eccentric notion that tragedy was to be defined as any situation where matter and mind were out of balance.[69]

However, Mondrian and Van Doesburg did not consider art to be the only mode in which the relationship between matter and mind could be made manifest, they identified three modes: art, religion and philosophy. Art was neither religion nor philosophy, but its goal was ultimately the same, the realization of universal truth. With the unification of matter and mind that goal was to be achieved. Allan Doig has shown persuasively how the categories in which these Dutch artists thought, and the way they thought with them, broadly followed the Hegelian lines of Bolland's and Pit's writings.[70] Hegel's *Æsthetik* allows art 'its highest function' only 'when it has established itself in a sphere which it shares with religion and philosophy, becoming thereby merely one mode and form through which the *Divine*, the profoundest interests of mankind, the spiritual truths of widest range, are brought home to consciousness and expressed'.[71] These were the terms and underlying assumptions of Schoenmaekers's thinking on art and the 'truth' beneath appearances. But, naturally, Mondrian's and Van Doesburg's focus was on one issue above all others: the possible role of *art* alone in the realization of truth and its importance relative to religion and philosophy as a mode of realization. For them, this was the central issue.

In 'Neo-Plasticism in Painting' Mondrian tellingly quotes Bolland to establish that art manifests truth through aesthetic beauty, where aesthetic beauty is conceived as a harmony of opposing elements.[72] Both Mondrian and Van Doesburg agreed (at least before 1924) that truth was to be realised in the reconciliation of opposites and that it correlated exactly with the realisation of aesthetic beauty in art. Just as they insisted on the universality of their notion of truth, so they insisted on the universality of the aesthetic judgements of beauty that made it manifest in art. 'The truth that is manifested subjectively in art', writes Mondrian, 'is *universal*. It is therefore true for *everyone*.'[73] It was in this way, they believed, that the subjective/individual could be united in the work of art with the objective/universal: a subjective aesthetic experience of beauty was to make manifest an objective idea (truth). Matter thus, said the theory, could be unified with mind, or at least the two could be brought closer to unification.

For a harmony so charged with the metaphysical to be achieved in the visual arts, one preliminary task had to be tackled: the definition of the fundamental opposing artistic elements. Mondrian and Van Doesburg set about this task with a common energy and sense of direction. Gris, Léger and Gleizes all concentrated their search for the essential laws of composition, and therefore the permanent basis of art, on principles of contrast as well as proportional harmony. They too were concerned with oppositions. Mondrian and

Van Doesburg, however, because of the decisiveness of the division they made between the forms of nature and of art, presented a far more basic analysis of artistic elements and relationships. Like the Cubists, they insisted on the flat planar character of painting, but they reduced its elements to straight lines always in perpendicular oppositions and to the primaries and secondaries in opposition to grey, black and white in the case of Mondrian. Van Doesburg's was a less reductive approach than Mondrian's: he allowed the use of secondary colours, for instance. Yet, reduction remained the central principle for both in their analysis of elements, and the process of reduction was directly linked to their desire to release art from the individuality of natural form and colour. Of his reduction of colour to the three primaries, Mondrian wrote: 'the principle thing is *for colour to be free of individuality and individual sensations.*' The artist thus, he said, was able to '*interiorize its outwardness*'.[74] Matter and mind came together, he believed, in an aesthetic experience.

This insistence on reduction and on the total independence of the elements of art from nature went, of course, with Mondrian's and Van Doesburg's attitude to abstraction. Art was thought of not as the 'inner' extracted (or abstracted) from nature, but as the 'inner' made material, made real, by the direct use of opposing elements. Painting, sculpture and architecture, they hoped, would actually *embody* truth, not represent it. 'Representation or symbolism', wrote Van Doesburg in 1918, 'is not the same as giving plastic expression and must be considered as belonging to a stage in human consciousness of one-sided reality, in which the spirit was afraid, as it were, to imprint itself in the concrete material as form, colour or relationship of opposites.'[75] And from this dismissal of the abstracted or symbolic came Mondrian's invention of the term 'Abstract Real Painting' as a synonym for Neo-Plastic painting,[76] a term whose aptness Van Doesburg could still applaud in 1926, long after their alliance had been dissolved.[77]

It was, fundamentally, the different degree of significance that they attached to the idea of truth made real in art which was the key to the divergence and eventual break between Mondrian and Van Doesburg. Because he allowed art a more important role, Van Doesburg was able to place it above both religion and philosophy as a mode of realisation. Mondrian could never place it so high, he remained closer to Hegel, Schopenhauer and Bolland, for whom art came lower in the hierarchy than religion and philosophy. Mondrian's point was simple, though he expressed it in many different ways: since truth could only be experienced in art subjectively as aesthetic beauty, even Neo-Plastic painting with its utterly basic, universal, plastic means could never completely escape the individual. Truth—the complete union of the subjective and the objective—could only become finally manifest by way of an *internal* development (in individuals), never by way of an outward development (in art). For him, Neo-Plasticism could only become 'absolute' by overstepping the 'limits of art' and passing 'from the sphere of art into that of truth', just as for Hegel art gave way to religion and then philosophy before spirit could come to predominate. Such a move into the 'sphere of truth' was, Mondrian believed, a possibility for individuals, but it would mean the end of art.

From Van Doesburg's vantage-point the ideal of a final inner realisation merely retained the duality of spirit and nature, mind and matter, keeping the two apart. He believed that art *could* be a complete material and visual embodiment of truth, and that only thus *in art* could the 'annulment of duality' be finally achieved. It was this that gave him the incentive for moving outwards from painting into the development of a coloured architecture: he wanted to make the ideal a reality

not just in paintings but in the environment as a whole. Writing to Oud while visiting Mondrian in 1921, he complained that Mondrian still saw the 'spiritual as an ideal abstraction', that he was concerned too much with 'an ideal image outside of normal life . . .'[78] How this rejection of Mondrian's tendency towards idealism went with Van Doesburg's acceptance of a practical architectural role comes across in a lecture of 1923 published in *De Stijl*:

> The new vision of life demands that the world of duality be abandoned (by a 'world of duality' is meant the common concept of an imaginary world of the mind which is superior and opposed to the concrete world of matter), and it exhibits both a desire for unity, *an indivisible unity of the world*, and the will to materialize in architecture the ideal aesthetics established by the liberal arts.[79]

When eventually, after 1924, Van Doesburg introduced the diagonal into his painting, called what he was doing 'Elementarism', and broke with Mondrian's Neo-Plasticism, he rationalised his move by pleading that diagonal relationships more completely realised the spiritual because of the way they countered the gravitational stability of natural structure. He really seems to have believed that painting thus finally brought mind (in the counter-composition's equilibrium) and matter (in its material elements) together; the ultimate annulment of duality.

* * *

It was, of course, because Van Doesburg's accent lay more on a practical architectural role for non-objective painting that he rather than Mondrian opened the way to the acceptance of De Stijl as a positive influence in France; even within the circle of the Cubists. How this happened, and what it meant to those involved, will be one of the main topics of the next chapter. It seems right, however, to end this one with the point that it was above all the metaphysical factor in the stance that lay behind Van Doesburg's activities, as much as Mondrian's and Kupka's, which most profoundly set it against that of the French, not least the Cubists. However much the non-objective painting of De Stijl could be made acceptable to the Cubists as part of a polychromatic approach to architecture (an extension of the decorative arts), the definitive metaphysical role given to art (as religion and philosophy in the visual mode) simply was not acceptable.

Picasso in passing, but with unmistakable contempt, gives pointed expression to this prejudice against the metaphysical in art, a prejudice shared of course by many outside the Cubist circle, including the Naturalists. He does so in his interview with Marius de Zayas in 1923 (the year that Van Doesburg decided to settle in Paris), dismissing out of hand all 'who want to paint the invisible and the non-pictorial'.[80] Probably, in fact, he has in mind not the metaphysical aims of Mondrian and Van Doesburg, but the mathematical speculations of Cubist theoreticians like Severini and, earlier, Apollinaire and Maurice Princet, especially relating to the representation of the fourth dimension. But, whatever he had in mind, the force of his anti-metaphysical anathema is undeniable, and so is its sweep: it was all-embracing and applied as readily to Kupka and to the Dutch.

At its most stubborn the French resistance to abstract and non-objective painting stemmed from the shared conviction that art should be founded on the concrete, the visible (either nature or the elements of painting or both), and the refusal to believe that art could realise abstract universal truths. Gleizes was the exception who proved the rule.

15
Non-Objective Art and Cubism: the Individual, the Collective and Art as the Agent of Change

Van Doesburg left no doubt that the Modern stood higher than the Classic and the Baroque, and that, in art, his idea of the Modern, a harmony free of nature, was the counterpart to his idea of the modern in life, in society. If there is a clear contrast between the essential conservatism of the Cubists' idea of modern art in relation to the past and the unalloyed progressiveness of De Stijl, there is a close similarity between the Cubist and the De Stijl idea of modern art in relation to modern life. Both saw a *necessary* parallel between their art and modern life; indeed, both saw art and life simply as different products of one thing (if thing it can be called), the 'new spirit'.

There were two aspects of the Cubists' and the Purists' notion of the new spirit: the concrete aspect, the preference for precise, ordered structures, believed to be encouraged by the look of machines and the constructions of the engineers; and the abstract aspect, the tendency towards abstract calculation believed to be encouraged by the abstract intellectual processes of industrial design. The Cubists and the Purists, as the discussion of modern life has already shown, more often stressed the concrete aspect, which they hoped would be made manifest in the balance of their compositions and the precision of their forms. Gleizes, echoed by Dr Allendy and Léonce Rosenberg, tended to stress the abstract aspect which he saw made manifest in the move towards synthesis in Cubism.[1] Predictably, the abstract aspect played an even more predominant part in the De Stijl notion of the new spirit, to the extent that the concrete was almost suppressed.

The abstract aspect was most predominant of all in Mondrian's idea of modern man in modern life. He uses the term 'new spirit' in his pamphlet of 1920, *Le Néo-Plasticisme*, broadly as Reverdy and the Purists used it, to mean a general set of attitudes that tend to give priority to the balanced and the abstract, in consequence: 'suppressing description in art'. Only the weight of the stress on abstraction is distinctively different, this and the way he sees the new spirit as a reaction to the 'tragic' materialism of the industrialized world.[2] The idea of the new spirit is also explored a few years earlier in Mondrian's serialized *De Stijl* essay, 'Neo-Plasticism in Painting'. The piece begins with the assertion that the life of 'modern cultivated man . . . is becoming more and more abstract',[3] and later expands on the proliferation in the modern world of tangible manifestations of this abstract new spirit. For him, the modern age was both materialist *and* spiritual. It was an 'abstract-real age' just as Neo-Plastic painting was 'abstract-real', that is, it made the abstract manifest everywhere in actual phenomena. He specifies machines, dance-steps (the boston, the tango), 'social life', 'science and religion'.[4]

The concrete aspect of the idea of the new spirit is less obviously repressed in the thinking of Van Doesburg during the period. His main accent, however, remained very firmly on the abstract too. This underlying view of modern man and modern art as together tending towards abstraction is, of course, already there in the early numbers of *De Stijl* and in *Classique-Baroque-Moderne* with its 1918 date. But its extension into a really worked-out idea of the new spirit did not come until 1921 with a series of three articles published in the Dutch periodical *Bouwkundig Weekblad*.[5] He returned repeatedly to the topic afterwards, in 'The Will to Style' and in several of the pieces he wrote for *De Stijl* in Paris from 1923, but it was then that the main lines of his thinking on it were drawn.

Very significantly the three articles of 1921 were written in direct response to the first full statement of the Purist version of the new spirit, Le Corbusier's 'Three Appeals to Messrs Architects', which appeared a few months earlier.

242. Theo Van Doesburg, *Counter-Composition XVI*, 1925. Oil on canvas, 39 × 71in. Haags Gemeentemuseum, The Hague.

Each of Van Doesburg's articles was headed with a Le Corbusier quotation from the 'Three Appeals'. In the first of the articles the Dutchman established the fundamentals of his approach, finding a broad area of common ground between the pragmatic idealism of Le Corbusier and his own foreign, more cerebral creed. 'The power of the human will', he writes, 'and the command of the natural elements and materials by constructive calculation are becoming the basis of a new, logically consistent experience of beauty, and the new aesthetic . . . is the immediate consequence'.[6] There is here the record of a moment of recognition: Van Doesburg's recognition that his essentially abstract idea of truth in aesthetic beauty had a real counterpart in the Corbusian view of the machine, its products and the future of architecture (these articles were aimed at architects, not painters). Yet, the distinct anti-materialist flavour of his response is clear too: for Van Doesburg, the machine is almost exclusively a lesson of method, not of form, a force which extends the power of mind over matter. Writing in a Parisian context in 1923, Van Doesburg was to make a point of dismissing mere 'admiration of the machine [machine art]',[7] and in 1926 he summed up his view thus: 'Modern technology transfoms matter, *denaturalizes* it . . . Our own period's style is largely based on this *de-* or, rather, *transnaturalization*.'[8]

So far as the capacity of Van Doesburg's and Mondrian's work to signal their sense of contact with the modern is concerned, it is enough to note that they rejected anything *explicitly* mechanical. Like the Cubists, of course, they believed that there was so close a relationship between their art and the new spirit that it needed neither to be forced nor underlined. The equilibrium and the precision of the new spirit were simply there in Mondrian's *Composition* of 1921 (Plate 236) or in Van Doesburg's *Counter-Composition XVI* (Plate 242), as it was in any of their paintings or attempts at coloured architecture. What differentiated them from the Cubists and the Purists was the completeness of their rejection of *all* recognizable references to the mechanical, however unspecific, and this, of course, was the straightforward result of their stress on abstraction.

With Gleizes's, Allendy's and Léonce Rosenberg's accent on the abstract aspect of the new spirit went their more emphatic accent on the collective by comparison with those in the Cubist circle generally. In this too their stance was noticeably closer to both Mondrian's and Van Doesburg's. Having discussed the new style, Neo-Plasticism, as a manifestation of the new spirit, Van Doesburg set out what he thought were its basic characteristics in 'The Will to Style'. Among them were 'synthesis instead of analysis', 'mechanical form instead of handiwork' and 'collectivity instead of individualism'.[9] The anti-individualistic elevation of a collective ideal went logically with the setting of a goal for art which was universal rather than individual; here this collective ideal was quite clearly given a social resonance. The new spirit alongside the new style was called collective.

It has been established recently that Van Doesburg's collective ideal, complete with its social resonances, reflects an active interest in socialism and the Dutch Communist Party during the first couple of years of *De Stijl* and relates to H. P. Berlage's teaching from the early part of the century that a new style could only come with the establishment of a new Socialist order set against the fragmentary individualism of capitalist society.[10] As will be established more fully later, Van Doesburg's belief in art as a way of realising the universal left him with no alternative, in his opinion, but to reject the materialism of both socialism and the Communist Party out of hand, something he had done by the end of 1919. But he remained convinced that the new art would head a real change in society, one that would threaten the capitalist Western world as mortally as any political movement. Hence the alacrity with which he was drawn to associate De Stijl with the supra-national collectivist values of the Constructivist movement in its Western European form, something that happened in 1921 and 1922, immediately following his positive response to the Purists and *L'Esprit Nouveau*, and that lay behind the unsentimental toughness of many of his statements on his arrival in Paris in 1923.

In Weimar and Berlin in 1921 and 1922, especially through the roving propagandist Lissitzky, Van Doesburg clearly became aware of the issues that led to Kandinsky's break

with the hard-line Russian Constructivists in the Moscow debating circle known as INKhUK. He too came to see a sharp division between an expressive approach to art, centred on its psychological potential (associated with Kandinsky's individualism), and one which gave art the collective role of 'organizing man's progress', of becoming the agent of social and political change (associated with Constructivism).[11] It was as a Constructivist that Van Doesburg signed the Statement of the International Union of Progressive Artists at Düsseldorf in April 1922 along with Lissitzky and Hans Richter, the propositions of the statement being aggressively anti-individualist and pro-internationalist.[12] And it was well aware of the issues raised by Constructivism that he launched into 'The Will to Style' a little earlier with the declaration that 'the solution for both economic and artistic problems transcends an individual approach. . . . Only collective solutions can be decisive in the realms both of politics and art'.[13]

This alignment of De Stijl's anti-individualism with a Constructivist belief in art as the agent of social change was not merely theoretical; it directed Van Doesburg's behaviour as a proselitizer and his work as an artist. We shall return to the question of practice, but before doing so it is necessary to consider where Mondrian's equally strong anti-individualism led him, and where his conclusions place him in relation to the international Constructivism of the twenties.

The first point to make is that, although Mondrian must have been well aware of the Constructivist stance through Van Doesburg and De Stijl, he was not involved. Repeatedly and on many different levels he voiced his antipathy towards the individual and the subjective, and he asserted as often his belief that art not only expressed a new spirit but would herald changes in society. But the way he envisaged this spiritual leadership working and the character of its collective implications was very different from Van Doesburg's. The difficulty for Mondrian was that, however much he wrote of the universal implying the development of a general new spirit, his experience between 1919 and the mid-twenties in his aesthetically perfected studio (Plate 244), cut off from tangible group support and from the chaos of life outside, deepened his sense of actual isolation. From the years of the pre-history of De Stijl this real isolation had been a factor,[14] and in Paris, though visited by Van Doesburg and Vantongerloo, he must have felt his exclusion cruelly accentuated until the acceleration of interest that followed the De Stijl exhibition at l'Effort Moderne in October 1923.[15] It was this awareness of isolation that from the outset made him so sceptical of the hopes for the collaborative project commissioned by Léonce Rosenberg in 1920 from Van Doesburg and De Stijl that were eventually to lead to the Effort Moderne exhibition: asked by Van Doesburg to take a leading part, he could only dwell on De Stijl's failure as a group to have the necessary unity.[16]

In his awareness of his isolation Mondrian was like Kupka and Jacques Villon; for him, it was a simple inescapable fact. But he did not lose sight of his intention to instigate a spiritual change which would in the end reach far outside his studio. His vision of how this would happen was already clear enough in 'Neo-Plasticism in Painting'. Confronted with the actual 'tragedy' of a materialist world, Mondrian saw the development of the new spirit as an evolution that would take place at first in a few special individuals, like himself: 'In an uncultivated period, the style of the future can be recognized as that mode of expression which is the most direct, the most clear reflection of the universal—even though it appears only in a few individuals.' He advised his readers 'not to try to see the future style in the expression of the masses', and looked forward to a revolution which would begin in 'man-as-individual'.[17]

Mondrian, thus, did not put his faith in the collective solidarity of groups or political parties, he thought in terms of a revolution which would take place within the self. Once that revolution within the self had been achieved, the 'mature individual', he believed, would live what he called 'the abstract-real life', only one of whose manifestations would be Neo-Plastic painting, and that only at an early stage. 'Life today', he wrote, 'generally centres around outwardness and merely remains *on the surface* . . . whereas abstract-real life experiences the outward [individual] *universally* [abstractly]—that is, *in its essential nature.*'[18] The new 'mature individuals' would develop a new state of awareness which would bring within their reach another kind of experience of the world. An inner transformation would lead to the transformation of the outer in the way the outer was experienced. Curiously, it is an attitude to change which comes close in its essentials to the attitude that led André Breton and the Surrealists in 1926 to set their inner route to revolution through the imagination apart from the political route of the *Clarté* communists, and the result was comparable: an acutely uncomfortable alliance between broad social and cultural aspirations, and an actual focus on the self.[19]

In complete contrast, Van Doesburg worked hard throughout the history of De Stijl to see himself as the leader of a group. He aimed to prove himself part of a vanguard movement the solidarity of which was unimpeachable. In fact, like so many avant-garde leaders with such hopes, he merely achieved an expansion of his ego whenever he succeeded in convincing himself that solidarity was a reality or at least in reach. There is, however, no denying the sincerity of his belief in collective vanguard action, nor the energy with which he tried to give it substance.

Van Doesburg's activities in Weimar and Berlin during 1921 and 1922 as part of the fast-growing Western version of Constructivism were all, as we have seen, geared to identifying himself with a collective effort, international in scope. They were, though, simply an extension of the activity that had led to the publication of De Stijl and to his sequence of collaborations as designer of colour schemes and stained-glass with the architects Jan Wils, de Boer and especially Oud. It was in working collaborations that the desire for collective effort was most tangibly expressed.[20] By the end of 1921 Van Doesburg's partnership with Oud designing the colour enhancement of the latter's brick Spangen blocks in Rotterdam led to frustrating disagreement,[21] but it was immediately following this that he entered the collaboration which was most influentially to support his claims for collective action in France: that with the young architect Cor Van Eesteren on the three sets of designs for the Effort Moderne exhibition of 1923.

The exhibition had its origins in contacts made between Van Doesburg and Léonce Rosenberg long before Van Eesteren's appearance on the scene, as Part I has shown.[22] From the beginning Van Doesburg was aware of Rosenberg's own collectivist priorities. The embrace of Rosenberg's vision was clear enough in a remarkable letter he wrote to the Dutchman in August 1920. 'We are', he claimed, '. . . much closer to collective effort than we have been since the end of the epoch of the cathedrals and I do not despair that I shall witness the reign of a monumental art before my death. This art will be neither French, nor Dutch, nor Anglo-Saxon, it will be universal, for initiates from all nations are turning their attention to the great effort.'[23] These were sentiments to which Van Doesburg would have responded with instant warmth, and when only a few months later the invitation came for him and De Stijl to produce an exhibition he knew that this had to be a group exhibition, emphatically so. Mondrian's attitude might have been sceptical, but Van Doesburg's was not. He accepted

that in actual fact a few only would be in control (at first, he thought, himself, Oud and Mondrian), but not that the ideal of a group showing was self-deluding.[24]

In the end Mondrian proved more in the right, and it was because Oud, Wils and Rietveld did not submit plans for the initial exhibition commission (a design for a 'Large Private House'), that Van Doesburg was forced to collaborate with the newcomer Van Eesteren.[25] The front the two of them presented at l'Effort Moderne was thoroughly collective, however. They were equally credited with the axonometric projections, models and plans for the 'Large Private House' and the other two designs introduced during 1923, the 'Private House' and the 'Artist's House' (Plate 243). The manifesto which came of the exhibition concluded: 'The exhibition of the "De Stijl" group in the rooms of l'Effort Moderne (Léonce Rosenberg) . . . has the aim of demonstrating the possibility of creating collectively.'[26] Indeed, for a short while the two collaborators actually believed that behind the carefully contrived appearance of group solidarity there lay a real and significant collective achievement.[27] After all, the combination of the inexperienced but architecturally gifted Van Eesteren and the dominant Van Doesburg with his clear ideas on colour in architecture, *had* led to a successful working partnership, particularly in the designs for the 'Private House' and the 'Artist's House'.

Yet, ultimately, the group showing at l'Effort Moderne was collective only insofar as this particular partnership in these particular special projects was collective, even though other De Stijl work was included in the exhibition. And the success of the partnership depended above all on Van Eesteren's willingness to remain the supportive disciple, providing the necessary architectural framework for the realisation of Van Doesburg's aesthetic aims. Jean Leering, Joost Baljeu, Nancy Troy and Allan Doig have all agreed that the architect's role was fundamental, especially in the designing of the 'Large Private House'.[28] There is disagreement over how much Van Doesburg's aesthetic direction led the way in the second and third projects, the 'Private House' and the 'Artist's House' (Plate 243), but even if his ideas were determining, they depended for their application in architectural terms on the expertise and hard work of Van Eesteren. It must have taken great respect and humility to allow Van Doesburg equal credit for so much. The younger man did not remain so self-effacing for long, and Doig has traced the breakdown in the friendship between the pair from as early as the summer of 1924, not even a year after the exhibition. Van Eesteren came quickly to rue his enthusiastic submission to the force of Van Doesburg's

ego, and to accuse his mentor of overweaning personal ambition.[29] The appearance of a real collective effort in the collaborative designs for the Rosenberg exhibition proved in the end a passing illusion.

Van Doesburg's ability to evade inconvenient facts, however, remained only slightly diminished: his belief in the efficacy of collaborative action and the real hope presented by the collective ideal was not diverted by the breakdown of his partnership with Van Eesteren. Certainly 1923 and 1924 marked the high-point in his pursuit of collaboration, and the Rosenberg exhibition gave his collective ideal the highest profile it achieved in France, but there were one or two collaborative projects that followed. Most important of all was the interior remodelling of the Aubette in Strasbourg, begun in September 1926 and opened to the public in February 1928.[30] The commission was obtained through Jean Arp, and here Van Doesburg worked amicably enough in partnership with both Jean and Sophie (Taeuber) Arp, but it was not in any sense as mutually interdependent a working relationship as his partnership with Van Eesteren, and Van Doesburg was openly in overall control.

De Stijl, always centred on Van Doesburg, professed the collective ideal and its dislike of individualism in the making of art with a high-sounding single-mindedness approached only by Léonce Rosenberg and Gleizes in the Cubist camp. In fact, as many commentators have now recognized, it was never really more than a grouping of rather special individuals who shared basic beliefs but rarely arrived at exactly compatible visual conclusions. Mondrian's thinking on the individual as the generative point from which change would come started with a reluctant but unhesitating recognition of this fact; Van Doesburg would not recognize it, continued to assert the possibility of wide-ranging collective enterprises in art, and by sheer force of character was able to hang on to his credibility.

* * *

Both the Rosenberg projects and the Aubette interiors were expressions not simply of Van Doesburg's faith in collaborative effort, but also of his determination to change the face of the environment. This drive to change the *look* of things was far more important, and it was similarly met with failure (or at least very limited success), to which, again similarly, Van Doesburg responded with self-delusion. It was so important because it was the key to the De Stijl commitment to polychromatic architecture, and therefore it was what made the non-objective art of De Stijl the force it became in Paris.

The Cubist, the Purist and the De Stijl idea of the new spirit was essentially passive from the artist's point of view: the artist merely absorbed the new spirit and it was automatically carried into their art; artists did little actively to shape it. By contrast, the De Stijl idea of the way the artist affected society and culture was active; artists (in tune, it has been shown, with the Constructivist model) were the agents of social change, whether they acted as 'mature individuals' (in Mondrian's scenario) or as the members of groups working collectively (in Van Doesburg's). From the De Stijl viewpoint, art as the manifestation of truth simply *had* to change those who offered it full attention, or, if not, its audience itself had to change *in order* to offer it full attention; either way art made change inevitable in how life was lived, because people were changed. Along with the entire Constructivist movement, Western and Eastern, De Stijl thus threatened the careful separation of art as an active force from life as lived which tended to follow from the distilled late Cubist stance; neither Lissitzky and Moholy-Nagy nor Van Doesburg and Mondrian could treat art as an encapsulated perfection.

243. Cor Van Eesteren and Theo Van Doesburg, *Project for an Artist's House*, 1923. Exhibited at the galerie de l'Effort Moderne, Paris, October-November 1923.

The most obviously tangible reflection of this was the De Stijl artists' common refusal to dismiss painting for architecture as merely decorative, their refusal to assert the self-sufficiency of painting as an ideal, and their common promotion of the integration of painting with architecture in the shaping of the environment.

Before going into what this projection of painting into the environment meant in the key cases of Van Doesburg and Mondrian, it is necessary to underline the point that the integration of painting with architecture did not mean for them a blurring of the distinctions between the different media and the different arts. They distinguished between the visual arts, literature and music as sharply as any of the Cubists, and so they did too between painting, sculpture and architecture. Expressionists drawn to abstraction and non-objective art *were* tempted to blur the distinctions (Kupka's use of musical titles, most famously in *Amorpha, Fugue in Two Colours* of 1912, is a case in point);[31] the De Stijl artists were not. In his 'Neo-Plasticism in Painting' Mondrian is absolutely clear on the heresy of over-developed analogies between the arts: 'Although the content of all art is one, the possibilities of plastic expression are different for each. These possibilities must be discovered by each art and remain limited by its bounds.'[32] Van Doesburg's adaptation of dance themes, and the rhythmic, developmental character of his early stained-glass and coloured tile designs came of a weakness for the musical analogy, no doubt encouraged by his reading of Kandinsky, and later he admitted a conscious visual application of the structures of Bach's preludes and fugues between 1916 and 1918.[33] But he too came to stress the distinctions between the arts, something already clear by 1918, and, more sharply than Mondrian, came to insist on the different properties of painting (planar), sculpture (volumetric) and architecture (spatial), something set out perhaps most succinctly of all in his *Grundbegriffe der neuen gestaltenden Kunst*.[34]

In both Mondrian's and Van Doesburg's cases, the desire to establish elements basic to each of the arts and each of the visual media was the simple result of their reductive approach to the elements of all the arts (again something shared with the Constructivists). At the same time, their dialectical view of everything led them just as simply to treat each art as *opposed* to the others, and therefore thoroughly distinct. The blurring of differences was against the whole tenor of their thinking.

Mondrian's unwillingness to believe that visual art could ever fully realise the universal in material form meant that he saw least to be gained from changing the face of the environment. He was therefore less emphatic than Van Doesburg in switching the focus from easel painting in the studio to the transformation of the world, inside and out, by colour. Further, he started from the observation that painting had in his experience led architecture, and therefore needed to be perfected first. This was an opinion he had shared with Bart Van de Leck in Laren, and had expressed in his early letters to Van Doesburg before the foundation of *De Stijl*.[35] It did not weaken.

Yet, though Mondrian claimed primacy for the painters and strictly limited his idea of what a superficial change of the environment could achieve, he did look beyond easel painting. In the first place, he made a point of not separating the easel painting from its setting like the Cubists, but considering the one as part of the other. Both Nancy Troy and Jane Becket quote from a revealing interview given to the Dutch newspaper *De Telegraaf* in 1926 in which he specifically rejects the Cubist position as represented by Léger's distinction between mural and easel painting, and says: 'As my

painting is an abstract surrogate of the whole, so the abstract-plastic wall takes part in the profound content that is implicit in the whole room.'[36] In *Le Néo-Plasticisme* he recognized furthermore that architecture, though for the moment less advanced than painting was, by its very nature more suited to the abstract realisation of the universal, and wrote of it playing a possible key role with the application of colour to create the 'chromoplastic'.[37] In the same year, writing in *De Stijl*, Mondrian goes so far as to say: 'The abstract-realist (or Neo-Plastic) picture will disappear as soon as we can transfer its plastic beauty to the space around us through the organization of the room into colour areas.'[38]

Mondrian's vision of a time when easel painting will have been superseded by a coloured architecture (the 'chromoplastic') is given its most extensive treatment in an essay written in 1926 and published the next year in French, 'The Home—the street—the city'. Here he extended his oppositional theory of pictorial composition into architecture (not for the first time), finding an analogy between the opposition of surface and void and that of colour and non-colour, and reasserting in architectural terms his belief in the balanced relationship of the vertical and horizontal against the recent challenge of Van Doesburg's diagonals. His focus was on the home as the realistic first stage for change, but it was now not to be considered apart from the larger context of the world in which it was placed, for him, an urban world. The essay's concluding passage is worth quoting very fully:

> The Home can no longer be closed, separate . . . we must cease regarding the Home as a box or a void . . . Home and Street must be viewed as the City, as a *unity formed by planes composed in a neutralizing opposition that destroys all exclusiveness.* The same principle must govern the interior of the Home, which can no longer be a conglomeration of rooms— four walls with holes for doors and windows— but *a construction of innumerable planes in colour and non-colour unified with the furniture and household objects, which will be nothing in themselves but will function as constructive elements of the whole.*[39]

With admirable precision Nancy Troy has pointed to the fact that Mondrian's idea of coloured architecture was a rather simple projection of his two-dimensional, planar view of painting into three dimensions, and that it followed from an unusual application to architecture of the pre-1914 conceptual approach to multiple view-points in Cubism.[40] Throughout his years in Paris after 1919 he treated architecture as a 'multiplicity of planes', and used the Cubists' point, that we form an idea of an environmental whole by putting together its aspects in our memory, to explain how a unity was to be created from this multiplicity. As he put it in the trialogue of 1920, 'Natural and Abstract Reality', when a room is experienced, the eye flicks from plane to plane, 'and afterwards we form an inner image, which causes us to see the various planes as a single plane'.[41] So simple an approach allowed him to avoid the complex theories of space and time that currently claimed Van Doesburg's attention.

The vision of a new world outlined in 'The Home—the street—the city' is a vision of a world relatively freed of the 'tragic' by having been denaturalized. Natural materials were to be covered, disguised or not used at all; surfaces were to be 'smooth and brilliant'; pure colour or black, white and grey, in painted coats, was to replace natural colour; there would be no need 'to beautify. . .by means of trees and flowers'.[42] On the scale of the city, it was a vision of bleak, changeless perfection. But, of course, as Mondrian was well aware, the scope of his activities was only rarely to stretch outside his own home. He could transfer the beauty of his

244. Piet Mondrian's studio in the rue de Départ, c. 1926.

245. Piet Mondrian, *Coloured Rendering: A Room for Ida Bienert*, 1926. 15 × 22½in. Staatliche Kunstsammlung, Dresden.

painting only into the immediate space around him, his studio. That perfection, kept within that space, merely accentuated his inward-looking isolation. It was the complement to what he saw in the end to be a solitary spiritual maturity.

Mondrian did produce a design for a room that was not his own, the coloured interior for the Dresden collector Ida Bienert, commissioned towards the end of 1925; but, though taken as far as plans and coloured renderings (Plate 245), unsatisfactory financial terms meant that it was never carried out.[43] The design for the Dresden room was different from Mondrian's studio in two ways: it was so elaborately worked out on all six surfaces that the Neo-Plastic picture was effectively made redundant, and it was fixed, permanent. The perfection Mondrian sought might have *appeared* changeless, but in fact in his own studio, as in his progression from one painting to another, he continually achieved fresh and different balanced relationships. It was a room whose order was always only a phase in a process of change.

It is again to Nancy Troy that we owe most of what is now known of how Mondrian's studio looked in the twenties and how it changed. The painter did not move into the studio in the rue du Départ pictured in the photographs of the mid-twenties (Plate 244) until November 1921, well over two years after his post-war return to Paris. It seems that Vantongerloo was the first to paint that tall, irregularly shaped space, and that to begin with (at least at the time of Michel Seuphor's first visit in 1923) it was only very sparingly coloured, if at all.[44] But Troy has shown that by 1924 Mondrian

was definitely using his coloured paste-board rectangles affixed to the main long wall of the room.[45] The sparse furniture, the easel, sometimes with a painting upon it, and every other wall were each considered parts of the whole, but this long wall was to be the major area of interest for Mondrian. Photographs show how carefully he would place his pictures in relation to it, something he would have done as much for visitors as for the camera (Plate 244). This studio was indeed his home, or part of it, but, as Troy has stressed, it was also a place for display: it gave a context to his painting.[46]

Mondrian was able to transform his own environment and, as we have seen, he looked forward to a general transformation of architecture on the model of his studio home which ultimately would render easel painting irrelevant. But his refusal to place art above philosophy, his refusal to see the transformation of the outer as enough in itself, led him to look beyond this. He did not turn his attention from the need for 'inner' change, and in his most visionary writings he hoped for a time when the inner change would be so profound in so many individuals that art would no longer have a role. 'Then', he writes in 1922,

the 'artist' will be absorbed by the 'fully human being'. The 'non-artist' will be like him, equally imbued with beauty. Architecture, sculpture, painting and decorative art will then merge into *architecture-as-our-environment*. The less 'material' arts will be realised in 'life'. Music as 'art' will come to an end. The beauty of the sounds around us—purified, ordered, brought to the new harmony—will be satisfying. Literature will have no further reason to exist as 'art' . . . Dance, drama, etc., as art, will disappear. . . the movement of life itself will become harmonious.[47]

Mondrian, then, sustained himself on a dream, and has often been accused of retiring into an ivory tower of abstraction, not least by Van Doesburg; yet he did so because in the end he would not avert his eyes from the fact that the world was highly resistant to his kind of perfection. There is an unself-pitying kind of realism in his recognition that he had to start at home, and in the way he used dreams to give himself the courage to survive outside groups. And there is an irony in the fact that Van Doesburg, the professed realist, who gave himself courage by plunging into groups and programmes, and aimed to make the abstract a reality by *actually* transforming the street and the city, could keep his goal intact, as he did with the goal of collective solidarity, only by averting his eyes when the facts were unhelpful. He needed to believe that the world could be changed there and then according to his reductive, dialectical idea of truth, and that by changing its material fabric thus, people would be changed too. As early as 1916 he had written of 'a monumental co-operative art' as 'what the future holds',[48] and, both in the Dutch De Stijl context of 1917–20 and in the Constructivist context of 1921–24, this was always his ultimate aim. It was because it sustained that aim so effectively that the anti-art, materialistic side of exported Russian Constructivism, with its accent on realisation, appealed to Van Doesburg. He did not reject the idea of art, but the statement he signed as a Constructivist at Düsseldorf in 1922 included a demand for 'The annulment of the divorce between art and life (Art becomes life).'[49]

Just as his idea of the possible impact of his aesthetic vision on the world was far more ambitious than Mondrian's, so Van Doesburg's idea of what that impact would mean in architecture was more elaborate. Mondrian's approach was resolutely planar, two-dimensional, and it skirted the question of time in the experience of architectural space. Van Doesburg

was well aware of this in 1921 when he wrote to Oud that to deny the temporal factor, as Mondrian did, was to make really 'three-dimensional painting . . . impossible.'[50] What he calls here three-dimensional painting he qualifies as 'space/time painting', and in the statements that proliferated around the Rosenberg projects at the exhibition of 1923 he was to call it 'four-dimensional'; for him, De Stijl architecture was to be four-dimensional because in its planning and its use of colour it was to take real account of movement through space in time. Mondrian's Cubist notion that the results of such a mobile experience of architecture were resolved conceptually onto a single plane (in the mind's eye) was rejected.

Colour and space considered dynamically were the basic factors, then, in Van Doesburg's approach to the realisation of De Stijl in architecture. Truth was still to be realised, of course, through the balanced use of oppositions, it was simply that the key opposition in architecture was not merely to be between wall surface and void, colour and non-colour, but between the stability of architectural structure as such and the dynamism of colour and space taken together. From his earliest attempts in Holland to use colour in architecture, Van Doesburg had set the capacity of colour to evoke space on a flat surface and become part of a single spatial experience against the fixture of basic structural elements: walls, floors, ceilings. He wrote of colour as destructive in the context of architectural construction, a means of opening up the 'closed' planes of the buildings.[51] Colour for Van Doesburg was always to be an 'opener and *liberator*', which, set in balanced opposition against the 'closed' nature of walled structures, was essential for a complete architectural style.

This approach to colour and space in architecture was not basically changed by Van Doesburg's involvement with Lissitzky and the Constructivists in 1921 and 1922; it was strengthened and deepened. His notion of space/time received its more sophisticated, quasi-scientific gloss, his appreciation of how colour could be used came to stress the wall plane as a whole (at least with the Rosenberg projects), ignoring the openings that broke it up (doors and windows), and his sense of the importance of colour became even more emphatic. The echoes of the Russian notion of *faktura* carried by Lissitzky's writings and talk evoked a response in Van Doesburg's claims for colour: if the Russians saw 'construction' as based on the appropriate use of materials, their properties fully exploited (*faktura*), then Van Doesburg had to treat colour as if it *were* a material and make a point of it, in order to adapt his De Stijl priorities to his new Constructivist context.[52] Not only did he do this, but he went further to claim that colour was a material at least as important as any other in architecture; it was, he wrote in 1923, a material 'equivalent to other materials such as stone, iron or glass'.[53] The justification he offered for this claim in a lecture a year earlier was a characteristic blend of imaginative 'élan' and amateur science: he drew an analogy between his dynamic idea of colour and the 'concept of matter' as a 'unit of energy'.[54] But ultimately he needed to recast colour as a material in order to preserve his deeply felt conviction that its role in architecture was fundamental while taking sustenance from the hope for real change presented by the Constructivists. The Constructivists' accent on material realisation might have been crucial to him, but he could not accept the Constructivist tendency towards the uncompromisingly utilitarian, the tendency presented in its most condensed Western form by the Berlin group around the periodical *G*.

Between 1920 and 1924 Van Doesburg's work was almost exclusively architectural. His increasing stress on large-scale realisation meant that easel painting was marginalized; to treat colour as a material (the wall and its colour as integral in the conception of the space) was further to marginalize it,

because colour in easel painting became by implication merely a secondary, decorative addition. This is made explicit in the most important statement on architecture to come of the Rosenberg projects and the l'Effort Moderne exhibition, the text 'Towards Plastic Architecture' (dated 1924). Point 14 here talks of colour being used *organically* in the new architecture to articulate 'relationships in space and time'. Point 15 declares that colour in architecture is not 'decorative'. And Point 16 totally dismisses the use of easel paintings and sculpture as 'separate elements'.[55] The Rosenberg projects, especially the 'Private House' and the 'Artist's House' (Plate 243), were Van Doesburg's most completely worked out display of what this new, coloured but non-decorative architecture could be; they left no room for easel painting.

Another point made in 'Towards a Plastic Architecture' is the importance of planning to the spatial opening up of the new architecture. The opening up of closed wall surfaces by colour and the encouragement of a mobile experience of colour relationships between wall planes was dependent upon a kind of planning that worked from the centre outwards and that got rid of corners in order to direct movement from one space into another and finally outside the building (by implication). This kind of 'centrifugal' plan is there in a rudimentary way in the second project (the 'Private House'), and is fully developed in the third (the 'Artist's House').[56] Combined with the kind of anti-gravitational, 'floating' colour relationships elaborated by Van Doesburg, such planning would indeed have made his ideal dynamic experience of space in architecture a real proposition: the models and their plans gave visual credibility to a possible new built environment.

And yet two points underline the distance that remained between Van Doesburg's vision of a coloured space/time architecture and its realisation, even at the time of the Rosenberg projects and his successful partnership with Van Eesteren. First, there is the fact that he could completely visualize his 'floating' compositions of over-lapping colour planes only in his so-called 'counter-compositions', that is, the colour studies he made *without* reference to architectural form. Second, there is the fact that the most successful of the projects, where colour and architecture are best integrated and the structural fixture of architecture is most effectively challenged by colour, was the least feasible: the 'Artist's House' with its impossibly ambitious cantilevers (Plate 243). Van Doesburg's accent on realisation, for all the Constructivist toughness of his protestations, was not altogether convincing.

The 'Aubette', begun three years later, was undoubtedly Van Doesburg's most spectacular achievement in his campaign for a transformation of the environment; it was also almost alone. It gave him the chance to work on a large scale for a large public, even if only in a set of interiors. As has often been demonstrated, the axonometric projections and the related counter-compositions produced for the Rosenberg designs led him directly into the adoption of the diagonal for painting in architecture. Verticals and horizontals remained dominant on the walls and ceilings of the café-restaurant, the billiard-room and the large ballroom of the 'Aubette', but the ciné-dancing (Plate 246) was an elaborate display of his post-1924 counter-compositional approach to wall painting. This was an approach that gave most dramatic expression of all to Van Doesburg's oppositional idea of the relationship between colour and architecture, space and building. Colour planes were placed not simply to 'loosen' and 'open' the wall plane, but, because of the dynamism of the diagonals, to disrupt the sense of stability given by the architectural frame.[57]

The 'Aubette' was, as suggested, an isolated opportunity for Van Doesburg to realise a De Stijl environment on a large

246. Theo Van Doesburg, The Ciné-dancing at the 'Aubette', Strasbourg, 1926–28.

scale; he was offered nothing else comparable. For all the interest created by the Effort Moderne exhibition and manifestations related to Van Doesburg's environmental ideas, like Kiesler's 'City in Space' at the Exposition des Arts Décoratifs of 1925, the evidence that an actual transformation of the face of things was underway remained very slight. Yet, at least until the opening of the 'Aubette' in February 1928, Van Doesburg's faith in the imminence of change and its deep significance to the future held firm (so far as his public stance was concerned). And it is as the complement to this continuing faith that his attitude to the relationship between art and social change should finally be seen.

If art was too important to Van Doesburg for him to accept the rigorous functionalism of the Constructivists of *G*, then, it will be remembered, it was also too important for him to accept the implications of socialism. In the third De Stijl manifesto, 'Towards a Newly Shaped World', he spelt out his hostility to socialism; it appeared in *De Stijl* in German, Dutch and French, dated 1921. Here he opposed what he called 'the International of the Mind' to the third International, scorning socialism as 'merely words'.[58] The year he began work on the 'Aubette' (1926) he underlined the points he made here once again: 'Elementarism', would lead, he wrote, to 'a truly inner revolution of human attitude', which would supersede the current focus on 'material. . .prosperity'.[59]

Van Doesburg as much as the socialists wanted the end of a capitalist Europe, which he too associated with individualism and the amassing of property. But, where the socialist scenario took as its end the alteration of economic relations, Van Doesburg's took as its end, like Mondrian's, a spiritual change within the members of society. Thus far he too came close to the stance of André Breton and the Surrealists (in the broadest of terms),[60] but he went further to suggest, as we have seen, that to change the face of the environment was the way to hasten this inner revolution, that a large-scale *external* change was possible, and that such an external change would constitute, everywhere it occurred, a complete realisation of the universal. He located the key to inner revolution in outer environmental change, but dissociated that outer change from the pursuit of complementary changes in the economic structure of society. In other words, he believed that he could accept the capitalist world as he found it in Western Europe, could persuade enough of its leaders to take up what he offered for his new coloured architecture to make a material impact on the environment, and that thus change in the physical fabric of things would lead the way to a widen-

ing inner revolution among people which finally would destroy the materialistic and individualist foundations of capitalism.

It says a great deal for Van Doesburg's faith in himself that it took him so long to realise the hollowness of his hopes, for his was an attitude to art as the agent of social change far more difficult to sustain in the face of the facts than Mondrian's. Where Mondrian could quietly proceed by the transformation of individual attitudes to the world, Van Doesburg could proceed only by setting himself to transform the physical fabric of the world around him; he was forced to confront directly the reality of public resistance. Mondrian's approach (like the Surrealists') was actually well adapted to the world of independent art in France: it could sustain itself on a very few successes, the gain of such individual new followers as Michel Seuphor, Félix del Marle, Jean Gorin, etc., willing to pursue an inner development attuned to Mondrian's own, something that *was* possible where the ethos of self-exploration and self-assertion was indisputably hegemonic. Van Doesburg's approach was ill-adapted to that world: it laid itself open to failure by depending so much on extensive public success in a society that was fundamentally antipathetic.

Only the obvious public failure of the 'Aubette', something even he could not evade, forced Van Doesburg to doubt the beliefs that had been so effectively hardened by the advent of Constructivism. By November 1928, less than a year after its opening, he realised that the great hopes he had held for the project were doomed. Already the proprietors had begun to make changes in response to the demands of a clientele who found the new fun palace 'cold and uncomfortable', and Van Doesburg was moved to write of what this meant to him in a letter to Adolf Behne: 'The Aubette in Strasbourg has taught me that the time is not yet ripe for an all-embracing creation . . . The public wants to live in mire and shall perish in mire.'[61] The result of the 'Aubette' was disillusionment. In the end, the facts began to force even Van Doesburg back on himself as they had Mondrian from the outset.

* * *

Abstract and non-objective painting remained unacceptable to the Cubists in France on many levels. It was unacceptable as an idealization of nature (abstraction), it was unacceptable in the completeness of its separation from nature, it was unacceptable in the height of the metaphysical pretensions to universal meaning shared by its champions, Mondrian, Van Doesburg and Kupka in particular. But this blanket anathema applied only to easel painting, as I have suggested, that is, to painting as a self-sufficient art without ornamental or architectural purposes. Gleizes might have been the only Cubist to make metaphysical claims comparable to Mondrian's and Van Doesburg's, but he was not alone in accepting that there was a place for abstract and non-objective art in architecture. It was, of course, as painting for architecture that the Cubists found a future for abstract or non-objective art, and the key role in the identification of a possible architectural future for it was played by Fernand Léger in response to De Stijl.

The crucial years for Léger's adaptation of non-objective art were 1923–25—the years between Van Doesburg's decision to settle in Paris and the exhibition 'L'Art d'aujourd'hui'. But even before 1923 a place had been found for abstract and non-objective painting in an architectural context by artists from the Cubist circle. Gleizes, with his vision of a new mural art reviving what he saw as the abstract values of medieval wall painting, was an obvious case in point, but from among the artists of Léonce Rosenberg's Effort Moderne just as important was Auguste Herbin. The balanced symmetrical abstractions produced by Herbin between 1919 and

247. Auguste Herbin, *Polychrome Relief*, 1920. Painted wood, 33¼ × 26in. Musée d'Art Moderne de la Ville de Paris. Donation Henry-Thomas.

1921 (Plate 247) were the major products of Rosenberg's attempt to promote the development of a new style for architectural ornament in France, a new 'monumental art', as he called it.[62]

The narrative of Part I outlined how Herbin's schematic geometric arrangements were the result of an abstracting process which began with motifs rendered synthetically, a process of idealization not unlike Van Doesburg's so-called 'Cubist' practice of 1916–18.[63] Further, these abstractions were intended for the openly decorative embellishment of buildings. Yet, Christian Derouet's recent work documenting Léonce Rosenberg's relations with his artists has pointed to the fact that Rosenberg quickly made Herbin aware of De Stijl, that the painter had read Van Doesburg's *Classique-Baroque-Moderne* by July 1920, and that he considered himself more in tune with the Dutchman than with Gleizes.[64] Indeed, anticipating Van Doesburg, he could actually write to Rosenberg of colour as a material with which to construct in architecture.[65] Again, he too looked towards the architectural monument as the fulfilment of a great collaborative ideal. Still, however, it has to be stressed that Herbin did not go as far as Van Doesburg, and the differences are vital. For him, painting and sculpture in the ideal architectural monument were to keep their separate identities; they were not to fuse in a single synthesis. As the elaborate self-sufficiency of his abstract compositions makes visually obvious (with their enclosing accent on framing devices and on symmetry), painting in architecture remained ornamental, something added. He was not tempted to see the painter and architect as one and the same.

Again, the narrative of Part I has outlined how Léger's collaborative architectural project for the Indépendants of 1923 (Plate 248), carried out with the sculptor Josef Csaky, followed from a stance close to Herbin's as a decorative painter in 1920–21.[66] Léger's wall paintings here were highly abstracted too, but they were dynamic and in their effect explosive rather than cohesive, and so, even more obviously than Herbin's ornamental works, they failed to offer the hope of a complete integration of painting and architecture, a point Waldemar George was quick to make.[67] Yet, surprisingly, for André Salmon at least, Léger's abstract compositions at the Indépendants were to be praised precisely because, whatever the appearance, the painter *had* conceived them as integral with the wall. And, as if to underline this point, Léger knowingly called them 'frescoes'.[68] Salmon placed them in the context of Delaunay's efforts as what he called 'the pioneer' in this field, thinking no doubt of the large-scale Orphist canvases that Delaunay had shown in the pre-war Salons and was continuing to produce. But, though he recognized Delaunay's importance, he contrasted what seemed the Orphist's easel-painting approach to architectural painting with what he felt was Léger's realisation that the wall should be used as a whole.[69] Whatever the appearance, Salmon's remarks implied that Léger was already aware of the importance of drawing a clear distinction between easel painting and painting for architecture.

248. Fernand Léger, *Fresco (exterior) for the Hall of a Mansion*, 1922–23. Published in *L'Architecture Vivante*, autumn/winter 1924.

In fact it was just a few months after the Indépendants of 1923 that Léger first set out the principles that were to be fundamental to his stance as a non-objective mural painter. He did so in the interview of June 1923, even before the De Stijl exhibition at the Effort Moderne, with his work alongside Csaky still very much in mind. He could not have been more explicit about the distinction between easel and mural painting. As we have seen, on the one side, he asserts, there is the painting as 'art-object . . . *its value strictly its own*', and on the other, there is 'Ornamental art, dependent on architecture. . .respecting surfaces, living and acting only as the

destroyer of dead surfaces. . . .'[70] He sees himself in his muralist's role as 'a giver of light to dead surfaces', and, already reacting against the chromatic brilliance of the Indépendants project, adds the point that he does not wish to hypnotize with colour, but rather to use colour in a more subdued way.[71] Revealing his awareness of Constructivist developments outside France, he remarks further that only in Germany where 'the collaboration of architects and painters is close' did such a mural art exist.[72]

Much of what Léger said in this interview is in tune with Van Doesburg's attitudes to colour in architecture: the insistence on flatness and the integration of painting with the wall most importantly, but also the realisation that colour can be 'the destroyer of dead surfaces', setting it against the closure of architectural elements. Where Léger does not go as far as Van Doesburg is in the unmistakable suggestion that he still sees the painter in architecture as *subordinate* ('dependent on architecture'), and as adding to architecture rather than completing it, and in the fact that he still leaves an equally important role to easel painting even if he distinguishes it from wall painting. Aware, of course, of Léonce Rosenberg's vision of a transformed environment supplying the right visual accompaniment to social change, Léger was naturally drawn to the possibilities for the painter inside and outside buildings. But unable to believe that any environment could or should be made the realisation of a universal truth, Léger would never see the point in *exclusively* turning his attention to colouring the world at the expense of the 'concentration and intensity' of easel painting. The De Stijl exhibition in the autumn of 1923 did not alter the basic principles outlined in Léger's interview of June that year; it had the dual effect of deepening his belief in the importance of the painter to architecture and of consolidating his determination to achieve a more stable mural style that kept the sense of the wall as a complete entity more effectively than the style of the Indépendants project.

It was a year later in the text 'Polychromatic Architecture', published in *L'Architecture Vivante*, that Léger made his first full statement of his approach to painting for architecture in its post-De Stijl exhibition form. He still calls 'surface colour' in architecture 'decorative', but insists that it must become a 'natural function of architecture'. And the main points are there again, especially the accent on flatness and on the vitality of colour.[73] He adds two major new points, however, and both sharpen his distinction between mural and easel painting, between the one as architectural and therefore subdued and the other as equivalent to life and therefore aggressively energetic.

His first new point is that architectural painting should create 'a calm and anti-dynamic atmosphere, a plastic order in colour inside or outside';[74] his second is that this 'calm ensemble' is not self-sufficient, not a complete realisation and hence an end in itself, but simply a backcloth against which 'the sharp and the unexpected' are to be seen in life as lived, in people and things. 'Against these big calm areas', Léger writes, 'the human face assumes its proper status. A nose, eye, foot, hand or jacket button will become a precise reality.' Life and its complement easel painting remain the focus of Léger's attention, the one rivalling the other in this vision of an ideal coloured environment; and the picture, he says, 'does have the right to a place in this organization'.[75]

There is another aspect of 'Polychromatic Architecture' which sets it apart from Van Doesburg and De Stijl, an aspect that pervades the entire text: its simple pragmatism and its complete lack of metaphysics. There is a kind of idealism in the Classical concept of beauty that informs Léger's view of architecture (a reflection, of course, of Le Corbusier's values),

but this is left in the form of bald statements, as if it were an accepted given. Otherwise everything is presented on the level of elementary empirical observations, from the observation that 'most men' need to 'decorate' surfaces to the observation that colour appears to expand. Léger was a Cubist whose faith in the self-sufficiency and power of easel painting never weakened, who had no interest in the Hegelian pursuit of the absolute to which Van Doesburg and Mondrian were drawn. He was a Cubist, however, who did want to help shape the physical fabric of the industrial world, as has been seen, and so he was ready to respond positively to the environmental possibilities opened up by Van Doesburg's and Van Eesteren's Rosenberg projects. It is ironic that the lessons he took from those projects and the ideas of the collaborators should actually have enhanced his faith in easel painting by clarifying his understanding of its special qualities and his belief in its special relationship with modern life (the concrete aspect of the new spirit). De Stijl in the end helped him to push mural painting more thoroughly into the background. He no longer considered it decorative in the old, subordinate sense, but he still, patently, considered it a lesser art however large its impact.

Léger's interview with Florent Fels and his text in *L'Architecture Vivante* presented, of course, intentions rather than a consideration of work completed. As pointed out in Part I, he did not paint a single actual wall following the attitudes outlined; he produced nothing during the mid-twenties to rival Van Doesburg's ciné-dancing in the 'Aubette' or even Mondrian's studio in the rue du Départ. Instead he produced a few non-objective canvases which he called mural paintings, and which, in any architectural context, could only have stood out as if self-sufficient, in no evident sense becoming an integral part of that context (Plate 121).

The fact remains, however, that Léger was open and positive about the arrival of abstract and non-objective art after 1923 in France: positive enough to welcome into his classes at the Académie Moderne in the rue Notre-Dame-des-Champs between 1924 and 1926 those young artists who we have seen were already working in such a way, among them Marcelle Cahn, Otto Carlsund, Franciska Clausen, Axel Olson, Joseph Mellor Hanson and the Poles Stanislas Grabowski and Nadia Khodossievich Grabowska.[76] With their ready-formed post-Suprematist and Constructivist ideas, the willingness of many of these to accept non-objective art (even as easel painting) was often much stronger than Léger's.[77] He seems, however, to have welcomed them for their youth and vigour, and his tolerance at the centre of this group of students is perhaps the final and conclusive demonstration of the generosity of spirit that allowed him to accept the lessons of artists as different from himself as Mondrian and Van Doesburg. Indeed, Léger was open enough (unusually for one in the Cubist circle) to accept the metaphysics as well as the non-objective art of others.

In 1931 he summed up his attitude to the metaphysicians of De Stijl thus:

> This direction is dominated by the desire for perfection and complete freedom that makes saints, heroes and madmen. It is an extreme state in which only a few creators and admirers can maintain themselves. The danger of this formula is its very loftiness. Modern life . . . will batter furiously at this frail structure, luminous and delicate, that calmly emerges from the chaos. Do not touch it . . . ; it had to be made; it will stay.[78]

He saw the reality of the situation within which Mondrian and Van Doesburg worked, and wished to take nothing from the respect they had earned.

* * *

Léger, the Cubist, found room in the wide range of his activities for abstract and non-objective painting, but he did so, of course, without in any way narrowing the gap between Cubist art at its self-sufficient core (in easel painting), and non-objective or abstract art. And Léger's ability to tolerate Mondrian, Van Doesburg and the erstwhile admirers of the Berlin Constructivists in the Académie Moderne, even to learn from them, hardly mitigates the intolerance of Raynal and the impenetrable resistance of Picasso, Gris, Braque, Lipchitz and the other 'pure' Cubists, who found no room for non-objective forays into art for architecture. Just as most Cubist art from 1917 presented an immediately understood denial of all Naturalist and Lhote-like attitudes to art and nature, so it presented an unmistakable denial of abstract or non-objective art and the attitudes that went with them. Léger's mural diversion could not diminish the essential antipathy between the Modernist stance at the centre of late Cubism and the fundamentally anti-Modernist stance of the early abstract and non-objective artists. To the Cubist belief in the autonomy of the aesthetic experience was opposed the belief that aesthetic experience was not self-validating but significant only as a carrier or embodiment of an idea (a universal truth); to the Cubist tendency to separate art from life was opposed a tendency to work for an ideal continuity between art and life: the absorption of art's 'perfection' into life.

By their very blankness in relation not only to the styles of the past but also to the motifs available in nature, the paintings of Mondrian and the work of Van Doesburg in its many manifestations conveyed very simply the completeness of their dismissal of subject-matter and all its connotations. The Cubists' dismissal of abstraction and the non-objective was conveyed with comparable ease, by no more than asserting the presence of subject-matter, of whatever kind. It could well be significant in this connection that subject-matter became so much more obvious a factor in the Cubist work of Gris, Braque, Marcoussis and others between 1923 and 1925 (Plates 215, 71 and 197). With the need to compromise in the direction of Naturalism in its more sensual forms there went a complementary need to amplify resistance to the abstract and non-objective, then so strongly in evidence as a new avant-garde phenomenon. It could be significant too in this connection that it was then that these Cubists introduced more quirky, individualized formal vocabularies, more suggestive colours and a more overtly sensitive working of paint to replace the sharp coolness of crystal Cubist geometries. Clearly this was a development that amplified Cubist resistance to the reductiveness of abstract and non-objective art with all that it signified of a search for the fixed, the absolute, the universal.

With the process of distillation that characterized the development of late Cubism there went a tendency to close off other avenues, or to turn back for support rather than to look forward for new challenges. Both Picasso and Léger were major exceptions here, but generally the tendency is clear enough in the Cubist circle. The contrast with Van Doesburg and Mondrian is noticeable, as it is with Breton and the Surrealists. Where the Cubists looked at new alternatives either

249. Francis Picabia, *Volucelle II*, 1922. Ripolin on canvas, 78 × 98in. Private Collection.

with obvious hostility or with, at best, a strictly limited kind of interest, the radicals tended to look at anything new confidently, positively and without instantly applying limitations. Van Doesburg and Mondrian did not feel the need to attack Cubism, after all they did not see it as a threat, and, even more revealingly, they felt no need to attack Dada either, although it could not more thoroughly have threatened all their most precious beliefs. Early in 1920 Van Doesburg was already in touch with Tzara and Picabia in Paris (he had been in touch with Tzara since 1918), and in May 1920 *De Stijl* published a poem by one I.K. Bonset who two years later was to edit a Dada periodical, *Mecano*. Only after his death did it become widely known that Van Doesburg was I.K. Bonset and also another self-professed Dadaist, Aldo Camini.[79] For him, the destructive challenge to all established modes of art (including Cubism) offered by Dada gave it a role which was actually of positive importance for De Stijl: it prepared the way. To act subversively in secret as a Dadaist, and openly to involve Dada with De Stijl, was to aid the revolution that he wanted to lead. Mondrian, of course, had nothing to do with Dada, but even he was open enough to the new to sign a few of his letters to Van Doesburg 'Dada Piet'.[80]

It was from the direction of Dada that there came in the early twenties one of the clearest demonstrations of how deep the divergence was between Cubism and abstract or non-objective art; it makes a convenient conclusion to these two chapters. By 1922 Cubism had been identified as a regular victim of Picabia's talent for insult, and it seems very likely that his decision that year, prompted by Jean Crotti's 'tabu' paintings, to exhibit apparently non-objective paintings too (Plate 249) was partly encouraged by the realisation that to do so was to treat with suitable contempt the Cubist anathema against all such things. I shall return to this in the next chapter when Dada and Surrealism are the focus of attention; for the moment it suffices to note that non-objective art could actually become a Dada weapon in Picabia's hands, one of whose targets was Cubist orthodoxy.

16
Dada and Surrealism: Anti-Art and Automatism

'Cubism,' wrote André Breton as a Dadaist, 'was a school of painting, Futurism a political movement: DADA is a state of the spirit. To oppose one against the other is to reveal either ignorance or bad faith.'[1] As he puts it here, Cubism and Dada exist on such different planes that there can be no route to the illumination of one by way of its opposition to the other. And indeed, even in the unforgiving guise of Dadaist, he offers a glimpse of the fact that he feels no deep, irreconcilable hostility towards the movement that Dada, he believed, had supplanted. Two years later, in 1922, Breton went further to suggest that Cubism, Futurism and Dada were all part of one movement whose 'direction' was still to be established: 'to consider Cubism, Futurism and Dada in succession is to follow the ascent of an idea which at the moment has reached a certain height and which awaits only a new impulse to continue to trace the curve assigned to it.'[2] Between 1922 and 1924, as he saw it, that curve was to lead into Surrealism.

For Breton, there was never so sharp a divide between the Dada-Surrealist tendency and Cubism as could be defined by simple rejection. And indeed it can be argued that Dada and Surrealism were the direct offspring of Cubism, however disobedient, as will be seen from time to time in these final chapters. Yet, it will also emerge that Breton's attempt to smooth over differences in this generalized picture of seamless progress towards Surrealism concealed a strategy which at the deepest level threatened all the most fundamental Cubist convictions. The fact is that his intention remained (in 1922 as in 1920) to proclaim Cubism obsolete, a movement succeeded by something altogether more far-reaching than a school of painting, something to be described as a 'spiritual state'. Undeniably, to oppose Cubism to the Dada-Surrealist 'ascent' *is* to illuminate both, and certainly after 1919 the meanings of what was produced within both were often grasped in terms of their opposition, just as were those of Naturalist or non-objective art in relation to Cubism.

Later, looking back, Breton presented Dada in relation to Surrealism much as he had Cubism in relation to the two: 'Dada and Surrealism can only be conceived in correlation, like two waves overtaking one another in turn.'[3] For him, they were to be understood together. Out of the tendency to fuse Dada and Surrealism into a single coalescent phenomenon has come a tendency to see Dada, at least when Paris alone is the centre of attention, as merely the threshold of Surrealism, and this applies as much to the consideration of literature as to that of the 'plastic arts'. This is how William Rubin has seen it in terms of the visual arts,[4] and so too Marguerite Bonnet in terms of literature. The following chapters will, in fact, establish Dada as a distinct phenomenon, but, inescapably, the relationship of Surrealism to it, through the personalities and activities of Breton, Aragon, Eluard, Arp or Ernst, imposes also the need that they be discussed together, as the different aspects of a single agglomeration of interrelated attitudes and practices. And at root, much of what made each so grave a threat to the Cubists will emerge as the result of convictions that were deeply in tune: convictions regarding the creative potential of the individual, the status of the artwork, and most fundamentally of all the relations between art and life, culture and society.

There is one final pre-ambulant point to make here. For Pierre Reverdy in particular, as has been seen, there was the clearest possible boundary between the visual arts and literature, and, in the same way, the more conservative supporters of Naturalism and the radical supporters of non-objective art knew where to draw the clearest of lines between word and visual image. For Breton and his friends, as for Picabia or Tzara, such was not the case. The visual and the verbal as art or anti-art were for the Dadaists and the Surrealists essentially

one. As a result any discussion of Dada and Surrealist visual art, to be telling, must be embedded in a discussion of literature; and so it will be here.

* * *

The Cubists lived through the 1914–18 War in danger or discomfort like most others. It marked their exit from youth; it gave the lie to any sense of immortality their pre-war vigour might have engendered in them. Yet, they emerged still positive about their work as artists. Alongside Purism, sympathetic to the chauvinism and sense of continuity that embraced Salmon as much as Florent Fels or Louis Vauxcelles, Cubism was aligned with reconstruction.[5] Francis Picabia and Marcel Duchamp, like Tristan Tzara and Jean Arp, avoided the War. Max Ernst, like André Breton and Aragon, could not. Together, as Dadaists, they all emerged from those years with their faith in the value of art apparently gone. It was from this realisation that their rejection of the Cubist stance and Cubist art made its first step.

'I doubt', wrote Breton (again as a Dadaist), 'that a single man has not, at least once in his life, been tempted to deny the external world. He realises then that nothing is so serious, so definitive. . . .'[6] For him, the realisation that objective truth and therefore objective standards (of whatever kind) cannot exist was the common experience of writers and artists who moved out of youth into adulthood during the Great War. From this followed the rejection of aesthetic standards and thence the 'state of the spirit' that was called Dada. Louis Aragon began *Une Vague de rêves*, published in 1924 as the sibling to Breton's Surrealist Manifesto, with his own account of this realisation: for him too it was the vital prerequisite of the Dadaist in him and thus of the Surrealist in him as well.[7]

It was not least this realisation that Breton picked out as the underlying factor behind Duchamp's and Picabia's rejection of Cubism;[8] and certainly by every means available to him Picabia made his total rejection of objective standards public. He did so, for instance, in an open letter published in the press in 1920 as a reply to the claims of the playwright, one Monsieur H. R. Lenormand, that Dada could be understood by way of Freud and the theories of psychoanalysis. Picabia dismissed psychoanalytical theory as but another attempt to explain, an attempt which naturally started from the assumption that what is observed exists, is objectively so and can be penetrated by rational analysis. Who can judge, he asks, what is true or false, ugly or beautiful, when 'everything is nothing but intrapersonal', when 'Nothing exists outside. . . .' He counters Freud with the pseudo-scientific notion that all of us are subject to forces beyond our control (even subconscious control). Our minds are 'magnetic fields' subject to 'natural magnetic phenomena', and he even suggests that the metallic paint he used in mechanomorphic works like *Child Carburettor* (Plate 62) actually consolidated both his and the painting's subordination to larger magnetic forces.[9] Picabia had no doubts: everything was inexplicable and nothing had any ultimate meaning except that given it for the moment by each individual. 'There is nothing to understand,' he declared in his most notorious Dada publication, *Jésus-Christ Rastaquouère*, 'nothing but the value you yourself give to everything.'[10]

Picabia's refusal of objective truth was grounded in a failed attempt to build an expressive abstract art on a belief in such truth; it was above all supported by his reading, it seems, of Nietzsche.[11] Breton's refusal, as Marguerite Bonnet has shown, was not actually the result of the War as such, but grew out of a profound pre-war sympathy with anarchism in the writings of such as René Schwob and Rémy de Gourmont.[12] Aragon's, Breton's, Picabia's indeed the entire Dada-Surrealist refusal of objective truth had deep roots besides in late nineteenth-century French literature: striking antecedents in Laforgue and Mallarmé have been exhumed by Anna Balakian.[13] But the point that needs to be made most insistently *vis-à-vis* Cubism (and incidentally non-objective art) is the *completeness* of the refusal and of its inevitable sequitor, the refusal of the belief in the separate, autonomous validity of the work of art as such and in the existence of aesthetic standards, however general, determining the success or failure of the work of art.

As the artists of De Stijl, the Purists, Gris, Gleizes and Severini outlined with varying precision quasi-scientific laws of composition, the Dadaists ridiculed them, whether from within the *Littérature* group around Breton or from the more independent positions of Picabia and Tzara. Picabia's ally of 1920, Paul Dermée, introduced his own Dada periodical *Z* with this sentiment among others: 'Dada is annoyed with those who write "Art", "Beauty", "Truth" with capitals and who make them entities superior to man.'[14] Dada was indeed. When Picabia showed his poised, abstract water-colours in Barcelona in 1922 (Plate 250), the preface Breton wrote for the exhibition gave them specific anti-aesthetic point, rendered perhaps the more acute by their apparent likeness to the offerings of the current 'machine aesthetic' side of Cubism.[15] Breton reduced all aesthetic products to the level of working conventions whose success or failure was predictable within the terms of the convention and had nothing to do with any objective 'need for harmony'. In his opinion, if certain 'recipes' were used, it was 'as easy to make a good picture as a good dish'. 'Plastic values', he insisted, were no more important in Picabia's images than

250. Francis Picabia, *Sphinx*, c.1922. Ink, gouache and watercolour on paper, 29½ × 21⅝in. De Menil Collection, Houston, Texas.

their titles and his signature. They only *pretended* to be 'pure' art.[16] It may be simply coincidence that Picabia had already published a cookery recipe in 1920 as an anti-poetic poem in his Dada periodical *Cannibale*.[17]

The complement to Dada's refusal of objective standards on all levels was its total commitment to the subjective: meaning, in Picabia's words, was 'intra-personal'. With the refusal of any notion of truth went a complete acceptance of self. Tzara's contribution to Picabia's graffiti painting shown at the Salon d'Automne of 1921, *L'Oeil cacodylate* (Plate 251), was: 'I find myself very Tristan Tzara'.[18] This acceptance of the self, like the refusal of objective truth, was another Dada first step carried through by Breton, Aragon and their friends into Surrealism. Breton himself had, in his almost didactic essay 'For Dada' of 1920, utterly dismissed the group ideal of solidarity for an ideal of self-centredness.[19] He was, of course, in his guise of Surrealist leader to turn this rejection of movements on its head, but the fragmentary belief in self nonetheless remained a basic component of the Surrealist stance, and within Surrealism Louis Aragon was its most passionate apologist.

Self had been the centre around which Aragon had composed his two Manifestos for the anthology of Dada manifestos that made up the May 1920 issue of *Littérature*. In the first, called simply 'Me', he announced: 'Language, whatever it seems, comes down to "I" alone. . . . There is only me in the world.'[20] The claim finds a clear echo in *La Révolution Surréaliste* late in 1925. 'The first person singular', Aragon insists, 'expresses for me all that is concrete in man. All metaphysics is in the first person singular. All poetry too. The second person is still the first.'[21] Such was his commitment to the centrality of self that it formed the basis of his Surrealist notion of liberty, as he made plain in the second number of *La Révolution Surréaliste* early in 1925. Here, in the short piece 'Free for You', he rejects scornfully the notion that freedom comes of each individual's respect for the freedom of others—a 'false freedom,' he calls it, 'the basis of all forms of moderation'. His contention is that 'there is no morality but the morality of the Terror, no liberty but an implacable masterful liberty: . . . Man is free, but not men. There are no limits to the liberty of each one, there is no liberty for all. *All is an empty idea, a clumsy abstraction.* . . .' 'Here ends the social history of humanity', is his conclusion.[22]

* * *

Pierre Reverdy, it will be remembered, looking back from 1921 to the last years of the War and its immediate sequel, wrote of 'an era . . . of organization, of the assembling of ideas'.[23] The Cubists and their champions may have been themselves individualists as much as anti-individualists, and their art for most of them a manifestation of their own subjectivity; but, for the Cubists, such a belief in themselves led to the enhancement of the status of art. Art became the expression of the artist's god-like creative ability, the artist's ability to challenge nature. And it did not undermine their faith in the possibility of understanding, and of defining aesthetic laws. For the Paris Dadaists, the elevation of the subjective and the devaluation of the objective inevitably meant the devaluation of art. The single connecting thread through their activities as image-makers was the pursuit of such a devaluation: as total as possible. For Breton in 1919, as for Tzara and Picabia, the era was one of *dis*organization to be promoted by 'demoralization' in the arts.

As Breton put it in a letter to Picabia at the beginning of 1920, he and Soupault and their new periodical *Littérature* had taken the tack of Tzara, and there was one word more

than any other that expressed the direction of their enterprise: 'demoralization'.[24] It was impelled by their determination to devalue art that Breton, Soupault and Aragon were drawn away from the sustenance of Reverdy's positive Cubist stance towards other models, especially to Lautréamont and Rimbaud (whose significance Reverdy believed they exaggerated), and to Tzara and Picabia, especially after their reading of Tzara's manifesto of 1918.[25]

If Picabia and particularly Tzara were at once models and allies for the future Surrealists as Dadaists, there was one model of their generation who could not be an ally and instead acquired the more secure, more dependable status of a legend. This was Jacques Vaché, a memory from Breton's wartime posting at Nantes, re-enforced only a few times by occasional meetings before his death (either suicide or accident) from a drug-overdose in 1919.[26] Breton began *Les Pas perdus*, published in 1924, by listing those figures (other than Reverdy, significantly), who had guided his early steps: 'In literature, I was smitten in succession with Rimbaud, Jarry, Apollinaire, de Nouveau, Lautréamont, but it is to Jacques Vaché that I owe the most.'[27] He calls his period with Vaché at Nantes in 1916 'almost enchanted', he claims never to have 'lost him from view', and he defines his debt to him decisively: 'Without him I would perhaps have been a poet. . . .'[28] Vaché, more than any writer or painter, continually returns as the dominant presence in *Les Pas perdus*. An ex-Beaux-Arts student, while a patient at Nantes he preferred spending hours arranging his bedside table to painting. He talked poets with Breton, always in bad faith. At a time when Breton was in the thrall of Mallarmé and Valery, he introduced a persistent note of scepticism which prepared him for the impact of Tzara's Manifesto in 1918 and which was to be sustained right through into *La Révolution Surréaliste*.[29]

The painting, the sculpture or the poem were the essence of Cubist activity. The gesture was the essence of Dada activity; the painting, sculpture or poem became a gesture. Picabia and Tzara led the way, and at least during the early months of 1920 Breton and the *Littérature* group were avid followers. The status and meaning as much of visual images as of the texts emitted from Dada came to be determined by the manner of their presentation or publication (in exhibitions, periodicals and broad-sheets). The efficacy of the exhibit as provocation had been established years before Picabia's and Tzara's convergence in Paris at the outset of 1920: Duchamp's exploitation of the New York Independents of 1917 as a very public amenity for his urinal *Fountain* had shown the way.[30]

There are two moments at which the contradictory character of the Cubist work as a self-referential statement and the Dada work as a disruptive gesture meet head-on, perhaps most cacaphonically of all, during the months of Dada's climax. The first came at the event which opened the first real Dada 'season' in Paris, the 'Vendredi de *Littérature*' where the forces of Tzara, Picabia, Breton and his friends were combined on the 23 January 1920. The opening half of this event was dedicated to the 'great ancestors', of Dada, and included were Léger, Gris and Lipchitz, whose works were actually shown to illustrate their statements, which were read by Breton. Yet these Cubist declarations of aesthetic faith seem only to have been there to be 'set up', as it were, because they were followed by Breton's introduction to the audience of a Picabia entitled *Double World*, which was dominated by the letters L.H.O.O.Q., as a phonetic invitation to obscene thoughts. Protest, it is reported, led only to the presentation of a blackboard picture consisting of chalk marks which Breton proceeded to rub out.[31] The point (and its Cubist butt) was plain enough.

251. Francis Picabia, *The Cacodylatic Eye (L'Oeil cacodylate)*, 1921. Ink, gouache and collage on canvas, $57\frac{1}{2} \times 45\frac{1}{4}$in. Musée National d'Art Moderne, Centre Georges Pompidou, Paris.

The second moment came at the Dada 'Soirée' held on 27 March 1920 at the Théâtre de l'Oeuvre. The Cubists did not figure, but it was just as direct an anti-Cubist gesture. It consisted of the presentation on stage of Picabia's so-called *Dada Picture* (Plate 252), which said enough in itself to fix its target and make its anti-Cubist point.[32] The suggestively preferred monkey's tail is both impotent phallus and impotent brush, making monkeys of Cézanne and Renoir (honoured alike in 1920 by both Cubists and Naturalists) and of the unquestioned master, Rembrandt. All great artists, it is implied,

are in the end merely as apes (animals like the rest of us), and all, even in life, are as if dead ('natures mortes'), subject to dominant physical laws, to those 'magnetic forces' outside our control which are the crux of Picabia's letter to Monsieur H. R. Lenormand. The studied confusion between self-portraits and still lives unmistakably completes the debunking of Cubist pretentions: the self creates its portrait, as it were, in still life, and both are made as meaningless and risible as the impotent toy monkey.

Picabia's practice as a Dada image-maker was to present images like these either through his periodicals *391* and, in 1920, *Cannibale*, or through the medium of events, with the Independants and the Automne as his favoured arenas. It was in the Automne of 1921 that *L'Oeil cacodylate* extended his attack on art by making the signature the basic unit of composition; and it was at the Indépendants of 1923 that *Volucelle II* made its ironic anti-aesthetic point (Plates 251 and 249).[33]

There was another method of subverting art widely practiced by the Dadaists, both visually and verbally; it was to have more far-reaching consequences, particularly for those who moved on into Surrealism. In the guise of painters or poets it was the way of all the Dadaists (including Picabia) to challenge painting and poetry, on the one hand, by producing works which appeared to have nothing to do with the creative abilities of their makers (if they had any), and on the other by destroying the linguistic cohesion of the work, its structural order and sense. The attack on linguistic cohesion was, of course, at its most obvious in Dada poetry (in the tendency of Dada poets to avoid the usual structures of grammar and syntax), and most brazenly of all it was launched in the poetry of Tristan Tzara. There was, however, something wilful in such escapes from syntactical coherence; Tzara *actively* got rid of sense, so that the work is felt very much to be *his* product (however destructive his contribution). It was from the direction of the visual arts, and ironically from a Cubist innovation, 'collage', that the impetus came for practices that would destroy cohesion and sense, and at the same time break any apparent connection between the work and the will of its maker, the work and the artist-subject.

The collage principle, of course, with its off-shoot the found or 'chosen' object converted into an 'art object', lay as much behind Picabia's mechanomorphic 'drawings' in *391* (Plate 288) as behind such anti-art images as Duchamp's con-verted Mona Lisa recaptioned 'L.H.O.O.Q.' But in Paris Breton himself as an anti-art poet played an important part in giving collage destructive Dada point. Apollinaire (to whom he had been very close in 1917) supplied the stimulus with his own adaptation of collage techniques to poetry (his use of press announcements or advertisements and of snatches of conversation, coupled with his belief in the ordinary as the richest raw material for the writer). In collage practice adapted to poetry Breton found a way of remaining a poet without actually writing poetry. Later, in the Surrealist Manifesto, he asserted: 'It is permissible to call a POEM what is obtained by the freest possible arrangement (observing, if you like, syntax) of titles and fragments of titles cut out from newspapers.'[34] And this is precisely how he composed the piece 'Le Corset mystère' in 1919. It was an assemblage of fragments from newspaper advertisements, with the original types carefully preserved to make no secret of this fact. Coherence was threatened by the apparently random juxtapositions, and none of it had actually been written by Breton, but the piece was so presented that it could be read *as if* poetry, just as Duchamp had presented *Fountain* as if art, and in this way it struck hard at the status of the poet as creator: something that could be read as if poetry, that could even generate 'poetic emotions' of the kind that Reverdy discussed, could be produced without a writer to fashion the lines. 'Le Corset mystère' was Breton's first clear challenge to the notion that the poem must be a structure of images *created* by a poet. It was first published in *Littérature*, but most significantly of all was used to close Breton's collection *Mont de Piété* in 1919, thus subverting, as Marguerite Bonnet has said, the poetic pretentions that lay behind all the poetry he had composed over the previous five years which formed the substance of that little book.[35]

It was in 1919 that Breton came into contact with Max Ernst in Cologne, and the entire *Littérature* group contributed to Ernst's, Arp's and Baargeld's Dada review *Die Schammade* in 1920 (introduced by Tzara).[36] Ernst's route into collage owed nothing to Breton; Cubist collage, the torn paper compositions of Arp and Picabia's *391* 'drawings' all provided the necessary impetus.[37] But the instant rapport Breton recalled feeling when first he saw examples of Ernst's collages came partly of the fact that their different routes led to convergent destinations: Ernst's collages were the visual counterpart of Breton's 'Le Corset mystère'. Altogether more richly and variously they broke the link between artist and work, and disrupted the expected coherence of visual art. The importance Breton gave them as the stuff of a major Dada demonstration, the exhibition of May 1921 at the galerie Au Sans Pareil, was deserved; particularly *vis-à-vis* Cubist standards and assumptions, they were acutely effective instruments of 'demoralization'.

As Ernst later defined it, his use of collage technique with the exploitation of 'fortuitous' or 'engineered' encounters between 'incompatible realities', was geared to the production of 'poetry' in the 'spark' which leaps across the gap between these realities.[38] But, at least up to the exhibition (a year before Ernst's actual arrival in Paris) it seems likely that what most mattered to him was the *incompatibility* of the components of his collages, contradiction pursued for the sake of contradiction as so often the case in the poetry of Tzara.[39] Again, what 'poetry' was there added a disruptive anti-art inference, because the suggestion was made that such a poetic spark could be emitted if the spectator was prepared to see it without the artist having willed it at all.

Characteristically Ernst's practice was to set up a circuit of abrupt contradictions. *The Sand-worm* of 1920 was one of the exhibits at the galerie Au Sans Pareil (Plate 253). It was

252. Francis Picabia, *Dada Picture*, 1920. Media, support, size and whereabouts unknown.

made, while Ernst was working in his father-in-law's hat-blocking shop, by taking a brochure for childrens' hats, turning it upside down and then transforming the hats into bizarre crustaceans in some sub-aquatic world by overpainting with watercolour and gouache; the final stage was to add an extended caption without thought for sense.[40] First Ernst made nonsense of the hats, then he gave them new identities with a brush and then he made nonsense of them all once again by words, the words like those so often of Tzara's and

was as far as possible haphazard, and the evidently random relationship of the caption to the image makes of this an overt effect. The appearance is of a series of chance encounters. It was thus—by making the chance encounter an overt factor in their work, something plainly signified—that the Dada adaptation of the 'ready-made' and 'collage' challenged the Cubists' ideal of artistic creativity most deeply; and this was so from Duchamp and Picabia to Breton and Ernst (as well as Arp).

253. Max Ernst, *The Sand-worm*, 1920. Collage, gouache and pencil on paper, $9\frac{1}{4} \times 19\frac{1}{4}$in. Private Collection.

Picabia's poems, defying rational interpretation. The process was a sequence of contradictions producing a many-levelled incoherence within an image that *seems* coherent and demands consequently to be seen *as if* coherent and because of its art-context, *as if* art. Out of the fragmentary image-making of collage came the paintings of 1921–22, *The Elephant of the Celebes* and *Oedipus Rex* (Plate 254), and here the challenge to art was naturally an amplified one, for as paintings in frames the demand that they be treated as if art was the more inescapable.

The very use alone of the ready-made fragment to challenge the cohesive structure of poetry or painting carried with it an implied diminution of the creative role of the artist, but the point was most effectively made by highlighting the determining role of chance. When Ernst defined collage in retrospect he stressed the 'fortuitous', and so did Breton when he recalled Ernst's collages of the Dada period in 'Surrealism and Painting', writing of the care with which the German avoided 'all preconceived intention' in their making.[41] The sequence of contradictions that produced *The Sand-worm*

Chance was to be welcomed both publicly and privately; it was not merely a weapon to use against art, but a discipline willingly submitted to as a constant confirmation of deeply held convictions. It is symptomatic that Picabia and Tzara celebrated their meeting early in 1919 by a chance encounter in print, published in the eighth issue of *391*, prepared by them together in Zurich. Page six of that issue consists of two texts, one by Picabia, one by Tzara, the latter printed above, upside down, the two meeting in the middle. They were written simultaneously in Picabia's hotel room with no comparing of notes, according to Sanouillet, and simply reproduced as they stood.[42] In private, Ernst himself, it has recently been shown, submitted to the operation of the 'laws of chance' with especially striking nonchalance when he first collaborated with Eluard to produce the collection of poems *Répétitions* illustrated by his collages (a new type of collage, using woodblock engravings from the nineteenth century) (Plate 255). The collages were juxtaposed with the poems by Eluard without consulting Ernst (the poet in Paris, the painter in Cologne), and, just as the collages were not inspired by the poems, the

254 (far left). Max Ernst, *Oedipus Rex*, 1923. Oil on canvas, $36\frac{5}{8} \times 40\frac{1}{8}$in. Private Collection, Paris.

255. Max Ernst, *Invention*, collage from Paul Eluard's *Répétitions*, Paris, 1922.

poems were scarcely inspired by the collages, being fabricated from the fragments of earlier writings as if themselves collaged. The visual does not illustrate the verbal here nor *vice versa*; their confrontation is arbitrary.[43]

When Breton wrote of Ernst's avoidance of 'all preconceived intention' in the making of his collages he made a connection which, after 1924, was of capital importance to him: he implied that, far from being willed, they were the result of an automatic process. Chance did not offer the only way of challenging the role of the creative will in making verbal or visual images; already by 1919 in Cologne, Zurich and Paris experiments were being made with another way, processes of making or writing that cut out as far as possible conscious control. In *Dada 4–5* Tzara praised Picabia the poet thus: 'He writes without *working*, he presents his personality, he does not control his sensations',[44] and in much of Tzara's own as well as Picabia's poetry, in Ernst's collage captions (including for *The Sand-worm*), and in Arp's poems 'La Pompe des nuages' and 'Perroquet supérieur', the destruction of syntax seems not always to be willed, but sometimes to be a symptom of a break-down of control, something close to automatism.[45]

There was, however, one Dada experiment in automatic composition that was to take on more significance than all the others. This was the collection of texts by Philippe Soupault and Breton, *Les Champs magnétiques*, written in collaboration in the spring of 1919 and published in 1920. Four years later Breton was to pick it out, in the Surrealist Manifesto, as the paradigm of the Surrealist work; it never lost its status as the first such work for Breton. Within the Dada context of 1919–20, the automatism of *Les Champs magnétiques* was just one of many ways of producing images that threatened the ideal of the artist as creator; it existed alongside the painting or poem as gesture, the 'collage', and the overt exploitation of chance. Yet, already when *Les Champs magnétiques* was written automatism had (for Breton at least) a greater and deeper significance. The full realisation of that significance was what took Breton, Aragon, Eluard and their new allies in the *Nouvelle série* of *Littérature* away from the essentially negative stance of Dada. Automatism was to be at the core of the positive alternative to Cubism that Surrealism provided. Within Surrealism the role of automatism was to expand so as finally to absorb or subordinate all the other means of demoralization in the Dada armoury.

* * *

Picabia's excursions into automatism took in a Dada direction his pre-war pursuit of expressive spontaneity in painting;[46] Ernst and Arp had both been deeply marked by the Expressionism of the Blaue Reiter and similarly turned spontaneity and chance against the belief in self-expression that went with its expressive use. Breton approached his collaboration with Soupault on *Les Champs magnétiques* with, behind him, a very different introduction to the efficacy of the uncontrolled.

Until 1975 and the publication of Marguerite Bonnet's fundamental study of Breton in the years leading up to Surrealism, it had become normal to play down the significance of Freud to Breton especially prior to *Les Champs magnétiques*. Anna Balakian, taking up a heavy hint left by Soupault, had attached a determining role to Pierre Janet's *L'Automatisme psychologique* far more important than Freud's;[47] and Michel Sanouillet had laid special emphasis on Picabia's and Tzara's Dada contribution.[48] The dismissive Dada tone of Breton's famous account of his visit to Freud in 1921, published both in *Littérature* and *Les Pas perdus*, supported such arguments, and so does Aragon's description (in *Le Paysan de Paris*) of Freud as a 'little dog' who trails after the swaying walk of the 'Libido' in the Passage de l'Opéra.[49] Yet, now Freud's role is far clearer, and it was undeniably determining.

Freud's mark was made, Bonnet has shown, in 1916 when Breton was working as an intern with Dr Raoul Leroy at the psychiatric hospital in Saint-Dizier. Freud's actual writings were only to be translated into French from 1921,[50] but Breton was given access to the theories of psychoanalysis through the clear, condensed explanations found in Régis's *Précis de psychiatrie* and Régis's and Hesnard's *La Psychoanalyse*, both lent him by Dr Leroy. Whole passages of the *Précis* version of Freud were copied out in his letters to Théodore Fraenkel, so powerful was their impact, including a crucial summing up of the technique of free association in the diagnosis of complexes. 'The subject', Breton copied obediently, 'must himself note, with the absolute neutrality of . . . , if you want, a simple recording apparatus, all the thoughts, whatever they are, that cross his mind ["esprit"].'[51] At the hospital, Breton got the chance actually to use the technique on patients. Bonnet's account of his discovery of Freud in 1916 and her searching criticism of Janet's theory of automatism in relation to Surrealist theory leaves no reason to doubt Breton's open admission in the Surrealist Manifesto that Freudian free association above all gave the impetus for the undirected monologues of *Les Champs magnétiques*.[52]

Breton's and Soupault's experiments, however, were in no sense an attempt at self-diagnosis, the uncovering of complexes for analysis. The experiment of *Les Champs magnétiques* could not have occurred without other antecedents which allowed the deflection of free association towards ends that were at once poetic and anti-poetic, at once Dada and an anticipation of Surrealism. It has long been recognized that two of these literary antecedents were especially crucial: Rimbaud and the Lautréamont of *Les Chants de Maldoror* (of which the title *Les Champs magnétiques* is, of course, a phonetic echo).

Again as Bonnet has established, it had been in the months just before Breton's discovery of Freud that Rimbaud had begun to make a really powerful impression on him, though it is not known when he saw the implications of the famous passage from Rimbaud's correspondance with Paul Demeny which has so often been isolated as the poetic spring-board for automatism, that passage where the poet 'becomes a seer by a long, enormous and reasoned *derangement of all the senses*'.[53] Lautréamont was above all a discovery of the summer of 1918, and there is no doubting the importance of *Les Chants de Maldoror* for the experiments of the following spring.[54] The *Chants* carried within them a destructive lesson, certainly, but also they seemed the product of the imagination run free from control. Freudian free association combined with the flow of images found in *Les Chants* to release the imaginations of himself and Soupault in the experiments of 1919; essentially that was how Breton saw it.

And what emerged in *Les Champs magnétiques* as in *Les Chants de Maldoror* may have been nonsense, but, for Breton, it yet had a positive poetic contribution to make. That it was seen as more than an attack on the coherence of language and the pretensions of the poet was already clear when he published 'For Dada' in 1920: 'Today', he wrote, 'is not the first time poets have abandoned themselves to write according to the inclination of their mind. . . . Almost all "finds" of images appear to me as spontaneous creations.'[55] What emerged in *Les Champs magnétiques* were poetic 'images', as it were *found* without (it seemed) the intervention of the conscious, and Breton picked them out thus for special mention even as, significantly echoing Picabia's views, he went on to call the Freudian attempt at systematic analysis of the unconscious a grave threat. It was the 'image' and its unimpeded generation

that mattered, not systematic analysis. Freud had helped him make a start; Freud's conclusions were to be suspected.

The 'find' with which Breton illustrated his notion of the image in 'For Dada' was Apollinaire's exemplary cliché 'lips of coral', for his notion of the image was still in 1920 essentially that defined first by Reverdy in 1918 which Apollinaire's cliché perfectly represents.[56] The image, for Breton, was the coming together in writing or visual art of two 'distant realities' to create a new unity as did the coming together of lips and coral in the cliché. Reverdian images in this sense, but of remarkable force and unexpectedness, were what he 'found' automatically emitted in Les Chants and Les Champs. He found them too in the visual and verbal incompatibilities of Max Ernst's Dada collages, and they gave rise to a famous passage in his preface to the catalogue of the exhibition at the galerie Au Sans Pareil in 1921: 'The faculty of the marvellous, [the capacity] to grasp two distant realities, without leaving the field of experience, and from their meeting to extract a spark . . . [the capacity], by depriving us of a system of reference, to disorient us . . . , that, for the moment, is what occupies Dada.'[57] Breton presented Ernst's collages as triggers for the imagination with the image as the release, and, pointedly, set the collage thus exploited, in direct opposition to the Cubist collage, where the 'accepted meaning' of the found object or fragment remained, he suggested, fixed. Cubist collage, of course, was rarely as inelastically used as Breton suggests, but the scope for the imagination invited by Ernst's collages was certainly of a different order.

Just as the Reverdian image became for Breton fused with his idea of 'the marvellous', so in 'For Dada' it was fused with another still ultimately Cubist idea, Apollinaire's concept of 'Surrealism'. In the Apollinairian sense (as outlined in 1917) 'Surrealism' meant the translation of the real onto another plane, that of the poem or art-work.[58] It was a concept attuned to Reverdy's elevation of art above reality, and to the Reverdian notion of the image as creating another order of relations between things which lifted them out of the world of everyday relations.[59] Right from 1918 Breton had been sceptical of Reverdy's notion of the 'image' as a purifying device,[60] he could not long associate such images as these and his own or Soupault's in Les Champs magnétiques with such a notion and with the essential aestheticism of Apollinaire's 'Surrealism'; it was difficult to call the emotional charge released by them pure. By the end of 1922 he had given the term a new meaning. He and his 'friends', he announced, had 'agreed to designate by it a certain psychic automatism which corresponds quite well to the dream state . . .'.[61] So far had that 'psychic automatism' become, for Breton and his friends, the prerequisite for the discovery of the image (as they understood it), the 'marvellous', that Apollinaire's term could now be redirected to apply specifically and only to automatism. The key to the translation of reality into 'the marvellous' was automatism and so automatism became Surrealism. Where Reverdy (and the Cubists) focused on the product, the art-work, Breton and his friends focused on the process, the act. By doing so they devalued the art-work as such, but not the image. The image, the 'marvellous' convergence, remained the point.

Breton's public recasting of the term Surrealism to mean 'psychic automatism' comes in the essay 'Entrance of the Mediums', which appeared in number 6 of the nouvelle série of Littérature in November 1922. It came, then, some months after the débâcle of the Congrès de Paris and the final break with Tzara, after the formation of the new grouping around Breton that went with the Nouvelle série (Jacques Baron, Robert Desnos, René Crevel, Benjamin Péret and Max Morise included),[62] and as a response to the new spate of experiments in the line of Les Champs magnétiques that followed immediately upon these developments. The first number of Littérature's Nouvelle série (March 1922) had contained three 'Dream Accounts', giving dream narratives almost the status of poems, and in September Crevel had initiated the intense engagement with hypnosis and spiritualist practices in pursuit of the trance that dominated the group's activities at the end of the year.[63] With the 'faculty of the marvellous', the image, still the quarry, it was now that automatism and the 'dream state' became almost the sole centre of interest for Breton and his friends. The experiments with spiritualist techniques of inducing the trance might have come to a sudden halt by the beginning of 1923, when their danger was recognized, but they reinstated grippingly the power of the imagination released from rational control. As Aragon saw it in Une Vague de rêves, there was no denying the crucial role of the 'epidemic of trances' in taking Surrealism back (in his words) 'to its point of departure the dream';[64] and, unmistakably, the image is the central point in his account: its emission, magnified impact and capture. They met as 'hunters' of images, he remembers, allowed the images that they generated to become in effect so real that they took on 'the characteristics of visual, auditive, tactile hallucinations', and ultimately 'lost the power to manipulate them'. They became themselves, as he put it, subject to images, 'their domain'.[65]

Made wary of the hypnotic trance, Breton, Aragon and the rest wanted now, more than ever, to continue 'subject' to images. Desnos, in particular, adapted the play with homonym and alliteration developed so strikingly in his trances as if by mediumistic contact with Marcel Duchamp as Rrose Sélavy, and made poems thus.[66] At the end of 1923 Breton published his collection Claire de terre, which opened with five dream narratives and then a selection of texts which were the product of different degrees of automatism just as Les Champs had been. In Breton's case more essays in automatic writing followed, and in the spring of 1924 the texts of Poisson soluble were produced and with them the intention formed to write a preface.[67] That preface became the Manifeste du Surréalisme, published in October 1924 with Poisson soluble in tow. It was this along with Aragon's Une Vague de rêves that finally fixed the centrality for the group of automatism and the dream; here, finally, the fusion of the term Surrealism with the aspiration to automatic composition became an irrefutable fait accompli. Aragon too, like Breton, picked out the texts of Les Champs magnétiques as the 'first Surrealist experiments', identified Rimbaud and Lautréamont as the essential forerunners and exemplars, dwelt on the 'epidemic of trances', and made of Surrealism the pursuit of the 'dream'. Breton's famous definition identified Surrealism once and for all with 'psychic automatism . . . in the absence of all control by reason', and gave it a goal, the image: 'Once and for all: the marvellous is always beautiful . . . in fact, it is only the marvellous that is beautiful.'[68]

Now, the identification at the core of Surrealist production of a poetic element given so high a value, the image, and the recognition of an aim, its pursuit, inevitably meant Breton's dissociation (together with his friends) first from Tzara, in 1922, and then finally from Picabia, in 1924. Tzara's and Picabia's uncompromising belief in the sovereignty of the self and in the instantaneous as the only certain truth dictated a relativism that could accept neither value judgements nor aims. October 1924 saw not only Breton's Manifesto, but Picabia's response, the final issue of 391, number 19, with its plea for a revival of the true spirit of Dada, what Picabia called 'Dada, Instantanism'. He could not better have underlined the gap between the aimless subjectivity of Dada and the purposeful subjectivity of Surrealism: 'Instantanism: believes only in today . . . Instantanism: believes only in perpetual movement.'[69]

At the outset, then, Surrealism was set firmly against Dada, whatever was owed Dada, and in the same way, it was set firmly against that branch of the Cubist movement from which, apparently, it had grown, the 'Surrealism' of Apollinaire. 1924 was a year chequered with incidents provoked by the 'theft' of Apollinaire's term, the opposition led by a small, disparate group of those who wished to preserve the stress on transformation originally given the term by Apollinaire. Most prominent were Paul Dermée and Yvan Goll, and their most concerted protest came in the form of Goll's periodical which attempted to wrest the term from Breton's grasp by calling itself *Surréalisme*.[70] Goll even published his own manifesto of Surrealism in order once again to define Surrealism in the Apollinairian sense, as the transposition of the real onto a superior artistic plane. But he failed: his periodical lasted just one issue, and died as the new Surrealist periodical, *La Révolution Surréaliste*, opened with its first of many. Goll, like Breton, gave a central importance to the Reverdian notion of the image as the meeting of distant realities, but preserved the fundamentally Cubist stress on the separate, structured character of the art-work and allowed a role for conscious direction (composition) in its making.[71] For Breton, the image could be Surrealist only if it was produced automatically, as far as possible without conscious direction; Surrealism could exist only at the expense of the role of composition.

Curiously, Reverdy at least seems not to have wished Breton's Manifesto to open an unbridgable gap between himself and his one-time protégé. His notion of the image and the art-work remained as aestheticist as it had been in 1918, but letters reveal that he was willing to agree on the automatic character of its discovery. When, however, earlier in 1924 Reverdy was called a Surrealist publicly, Breton's denial had been outright, specifically because of the imposition of compositional control ('l'esprit critique') in Reverdy's poetry.[72] Breton knew well enough, for all his respectful admiration, where he stood in relation to the purest and most orderly of Cubism's theorists.

* * *

The Surrealists quickly found something approaching an equivalent of 'psychic automatism' in visual art. Breton, Aragon and their friends had already found in the collages and the collage-based painting of Max Ernst images that could be associated with automatism. After 1924 Ernst took on more conspicuously the guise of an artist working automatically, and already by the end of 1924 André Masson had provided a model of what automatism in drawing might be. Arp lent support and they were quickly joined by Joan Miró. In this way a comprehensive challenge was mounted against the assumptions, practices and priorities that went with Cubism, a challenge in visual art as much as in poetry. Based on a belief only in the reality of the self, rooted in a Dada scepticism directed against aesthetics, the superior status of the art object and the artist as god-like creator, it was yet a challenge that held up a positive alternative, an alternative that required a radical change of attitude to art and its making. The nature of this challenge and of the actual practice of Surrealist automatism are the theme of the next chapter.

256. Joan Miró, *The Birth of the World*, 1925. Oil on canvas, 96½ × 76¾ in. Collection, The Museum of Modern Art, New York.

17
Surrealism in Practice: Automatism and Cubism

Psychic automatism, Breton asserted in the *Manifeste du Surréalisme*, was the 'dictation of thought, in the absence of all control by reason';[1] in 'Entrance of the Mediums' he found that it corresponded 'quite well to the dream state'.[2] Both are fairly definite statements; they infer the existence of some boundary across which reason no longer operates, where the 'dream state' takes over. In fact, of course, automatism was not something definite at all, it was something towards which the Surrealist aspired and something achieved only to a variable degree.

Studies of *Les Champs magnétiques* have established that Breton's and Soupault's texts were produced at varying speeds and consequently with a varying hold over thematic continuity and coherence as well as over syntax.[3] Breton was almost certainly aware of the variability of automatism right from the outset.[4] Similarly, the Surrealist rejection of conscious control, apparently so total in the 'official' definition, was actually relative, and Breton made no secret of this, even in the Manifesto. He wrote there of how important it was for the 'strange forces' deep in 'our spirit' to be first captured and then submitted 'to the control of our reason'.[5] If pure automatism could have existed, the implication is that it would not have been enough, that despite the Surrealists' rejection of the 'critical spirit' so prominently in control of Reverdy's writing, such control *was* allowed a role, at least at the stage of collection, recollection and presentation (editing). The complex interweaving of Breton's and Soupault's contributions in 'La Glace sans tain', 'Eclipses' and 'Barrières' from *Les Champs magnétiques* had clearly required a certain editorial control.[6] What is more, not only was pure automatism beside the point, but the practice of automatism did not have to be true in any absolute sense. Aragon provides significant evidence here in *Une Vague de rêves*. His description of the extraordinary events and outpourings that came of the trances, especially in the case of Robert Desnos, leads to the suggestion that simulation could have played a part. It worries him not at all, since, of course, truth is subjective. 'As for me', he writes, 'I have never been able to arrive at a clear idea of this idea [simulation]. To simulate something, is it anything else than to think it so? And what is thought, is.'[7]

In fact, then, automatism was variable, open to simulation, and its freedom from control was relative. At the same time, if the Surrealists identified the image as its most valuable result, they did not see the image as the most basic component of automatic activity. Its most basic component was that of language itself; in writing, the word. Pondering the phenomenon of hallucination in *Une Vague de rêves*, Aragon advanced the hypothesis that there was a 'mental material' quite separate from 'thought', of which thought was only one manifestation (the image being another). This 'mental material', he went on, 'finally appears to us . . . vocabulary itself: *there is no thought outside of words* all Surrealism supports this proposition'.[8] There was in such an attitude to language, such a desire to treat words as entities capable of acting apart from the chains and structures that produce everyday sense, little difference between the Surrealist, Dada and even the Cubist stances. Jacques Rivière saw this fundamental point of agreement in 'Recognition to Dada', the essay published with Breton's 'For Dada' in the *Nouvelle Revue Française* of 1920. 'Even though', he wrote, 'they dare not admit it, the Dadas continue to tend towards that surrealism which was the aim of Apollinaire. . . . Deprive language of all utility; assure it of a perfect vacuity, and we instantly will see there the unknown. . . .'[9] This at least was one lesson taught by Rimbaud and Mallarmé, conveyed too by the example of Apollinaire, on whose importance Reverdy, Raynal, Aragon and Breton were all agreed. The basic stuff of Surrealism was the basic stuff of Dada and

Cubism, the stuff of language itself intentionally separated from ordinary usage. In the early history of Surrealist writing there follows directly from this the special importance given to Duchamp's and Desnos's elaborate games with words and their legacy in Michel Leiris's 'Glossaire: J'y serre mes gloses' (of which more later).[10] In one crucial respect, however, the Surrealist and Cubist attitudes to language were as far apart as Breton's and Reverdy's notions of the image. Just as Breton countered Reverdy's aestheticism by underlining the power of the image to act outside the strictly aesthetic realm, so the Surrealists detached the word or sign from the usual realm of its signification not in order to shift the focus to form (syntax), but rather to expand its capacity to signify, to expand its possible meanings.

Breton included André Masson in his Manifesto as one of the painters to be related to Surrealism, adding that he was 'so close to us'.[11] Masson was picked out too by Aragon for special mention in *Une Vague de rêves*. From the first issue of *La Révolution Surréaliste* his drawings (later called automatic) were reproduced, and accompanying them came the first serious attempts to consider what automatism might be in painting. The first such attempt came in Max Morise's article 'Enchanted Eyes' in the first number, and a drawing by Masson illustrated it (not, however, conspicuously automatic) (Plate 129). 'We have every reason in the world', wrote Morise, 'to believe that the direct and simple element which is the touch of the paint brush on the canvas carries meaning intrinsically, that a pencil line is the equivalent of a word.'[12] It was made clear at once that the language of painting reduced to its most basic component element, the painted or drawn mark, was to be treated just as was the language of literature; and Morise had high hopes for an automatism of the mark in painting. Pierre Naville, famously, was to challenge such confidence in visual automatism, but only with temporary effect.[13] The point was made: the mark executed automatically (more or less) could, like the word, become a generator of images.

To concentrate on word and mark as the basic unit of automatism is to imply that the *act* of writing, painting or drawing is considered the basic mode of automatic production. In fact, of course, there was another: the dream and its counterpart in waking, or half-sleep, the hallucination. The dream as such plays a relatively minor part in the Manifesto; it is in Aragon's *Une Vague de rêves*, with its central focus on the 'epidemic of trances', that the dream and the hallucination are given an obviously leading role in the early discussions of Surrealism. Dream and hallucination were a prominent feature of *Le Paysan de Paris*, and indeed parts of 'Le Passage de l'Opéra' (dated 1924) read almost as accounts of hallucinatory experiences. There is, for instance, the moment when the shop that sells umbrellas and canes is suddenly bathed in phosphorescent light, and the sea seems to fill the 'Passage', introducing a fantastic siren-like spectacle.[14] Dream and hallucination were for all the Surrealists important, important enough for dream narratives to continue from the very first to the penultimate issue of *La Révolution Surréaliste* as a regular feature alongside automatic texts.

In *La Révolution Surréaliste* number 1, a group of such narratives appeared, three by Breton and one by Giorgio de Chirico. De Chirico's dream reads like a description of his pictures; painting and dream seem to fuse. Unmistakably there are the renowned piazzas with their scrubbed skies, and the presence of his father as it is pictured in *The Child's Brain* (Plate 257). 1925 brought the full revelation that de Chirico had rejected his 'metaphysical' phase, but Breton's regret and the anger of his friends could not entirely submerge the contribution he had made. Still, in 1926 Breton prefaces

257. Giorgio de Chirico, *The Child's Brain*, 1914. Oil on canvas, $32 \times 25\frac{1}{2}$ in. Moderna Museet, Stockholm.

his displeasure with the confirmation that de Chirico had been incomparably *the* exponent of 'dream painting';[15] and in the piece on him included in *Les Pas perdus*, he is placed beside Lautréamont and Apollinaire as one of *the* guides who had led the way to a new appraisal of the imagination.[16] De Chirico's dream painting had first made its mark on Breton from the richly populated shadows of Apollinaire's apartment on his visits there in 1917. It went with his strongest impressions of the older poet and with his earliest impressions of Lautréamont's power as an image-maker.[17] Apollinaire's transformation of the ordinary, of a label, say, or a top-hat, lips or coral, and Lautréamont's unprecedented encounters (the notorious umbrella and sewing machine) were to be understood in the same bracket as de Chirico's transformed piazzas and combinations of the unlikely. But in more concentrated form than either of the others, de Chirico through his paintings demonstrated for Breton the directness of the possible connection between the dream and art (whether or not there actually was so direct a connection in his work).

When Breton wrote in his preface to Ernst's exhibition of 1921 about the spark to be extracted from the encounter of unlikes, the 'marvellous', he set Ernst's collages in much the same context, alongside (by inference) the transformations of the ordinary discovered in Apollinaire, Lautréamont and de Chirico. The positive link between Ernst's collages or, as Spies has called them, 'clichés' (after the *Fiat Modes* of 1919), and reproductions of de Chirico he found in *Valori Plastici* is uncontroversial.[18] This was yet another reason for Breton's attraction to the collages: both he and Ernst were equally drawn to the dream illusion and the intensification of the image offered by de Chirico. Ernst's use of nineteenth-century illustrative prints from the spring of 1921, with their plodding illusionism, and of the slicker illusionism of photography in 1920, brilliantly extended the potential of de Chirico's discovery that painting could masquerade as frozen dreams (Plates 255 and 258). It was a potential most fully realized in

258. Max Ernst, *Here Everything lies Floating*, 'fatagaga', 1920. Photocollage and pencil, $4\frac{1}{4} \times 4\frac{7}{8}$in. Collection, The Museum of Modern Art, New York.

the collage paintings, *The Elephant of the Celebes* and *Oedipus Rex* (Plate 254) which quickly became part of the domestic scene for the *Littérature* group (as de Chirico's paintings were), brought almost instantly to Paris by Eluard.[19] Schneede is probably right to suggest that the pursuit of contradiction for its own sake, the destructive Dada dimension, was for Ernst himself dominant in the making of the collages and the 'fatagagas' (with Arp) of 1919 to early 1921, but the fact is that he had read Freud on dreams in the original even before 1914, while the *look* of the dream illusion was noticeably heightened by the influence of de Chirico.[20] And certainly by the end of 1921 (by the time of *The Elephant of the Celebes* and the collages for *Répétitions*) the look of the dream illusion was increasingly obvious.

There existed, then, when the *Manifesto of Surrealism* and *Une Vague de rêves* appeared, two prominent instances of dream painting as a major mode of psychic automatism. The question remains: how was this route to the image viewed by the Surrealists in relation to the route that started with the line or the mark? Reverdy's essay 'The Dreamer among the Ramparts' was one outcome of his thoughts on automatism and the image in the immediate wake of the Manifesto. It demonstrates how elastically the word 'dream' could be used in the early discussions of automatism, for Reverdy wraps up in the word all the possible modes of automatic practice. Reverdy thinks of the dream here as simply that state (of whatever kind) in which thought (he means rational thought) is replaced by images: the state in which poetry is inspired.[21] Within the Surrealist circle itself the distinctions between different kinds of automatic practice were far clearer, and during the early period (between 1924 and 1926) the dream in painting lost its precedence to the automatism of the mark, with André Masson the first obvious model. Max Morise's 'Enchanted Eyes' provided a starting-point in the same opening number of *La Révolution Surréaliste* as 'The Dreamer among the Ramparts'.

Morise draws a firm line between the major modes of automatism and decisively rejects the dream. The difficulty with dreams, he asserts, is that their depiction in paint (as in de Chirico) requires the intervention of memory, and therefore distortion: 'The images are Surrealist, their expression is not.'[22] Verbal automatism works so well, he feels, because words so immediately convey visual images, and his simple equation between the mark and the word naturally suggests

that automatism through mark-making must supplant dream painting. Breton does not exclude dream painting from 'Surrealism and Painting' (the importance allowed early de Chirico shows that), but there can be no doubt that its role temporarily contracted as the reputation of de Chirico was eclipsed. Between 1924 and 1926, therefore, Surrealism in painting meant, most of all, the automatism of the mark.

* * *

The Dada use of art (or the appearance of art) as a weapon against the preservation of aesthetic standards and the elevated status of the artist mounted an obvious challenge to Cubism as it did to the entire world of *l'art vivant*. The point has already been made that for Breton Cubism was never so unambiguously to be dismissed, even when he was a professed Dada. The Surrealist promotion of automatism as the sole effective source of the image in poetry and painting could seem (from within the Surrealist group anyway) at once attuned to Cubism and a threat to it. Most of the rest of *l'art vivant* was rejected comprehensively enough, but Cubism could not be seen so brutally and simply. The ambivalent position of Reverdy was, of course, one reason for this muffling of relationships; another, crucially, was Picasso. Surrealism as psychic automatism in poetry and painting did, in fact, pose a profound threat to cubism, actually far more profound than the quickly spent vigour of Dada. But before the character of that threat can be explored, the position of Picasso *as a Cubist* (indeed, the then-acknowledged 'first' Cubist) must be considered from the vantage-point of the Surrealists.

Of Picasso's heroic stature in the lore of Surrealism, there can be no doubt. The Dada dislike of heroes or leaders of any kind had led Picabia and Tzara to direct the odd insulting reference against him, but Breton's admiration was unconcealed from at least 1921.[23] By the time he, Aragon and their companions disrupted the performance of *Mercure* in June 1924 to shout the praises of Picasso at the expense of Satie, they had come to see him as an artist who had moved beyond Cubism. Aragon named him among his 'Presidents of dreams' in *Une Vague de rêves*, and wrote in the press that his sets for *Mercure* revealed a new manner 'which owes nothing either to Cubism or to Realism, and which surpasses Cubism as [Cubism itself] does Realism'.[24] Yet, Breton in particular ascribed to him, in his role as 'first' cubist, a very special importance, fundamental to the newly realised possibility of painting as a source of the marvellous. The Picasso he holds up in 'Surrealism and Painting' as proof against Naville's scepticism that Surrealist painting exists is the Picasso of pre-war Cubism whose work he had bought for himself and for Jacques Doucet at the Kahnweiler Sales of a few years before: 'The Woman in a Chemise (1914)' is mentioned (actually *Woman in an Armchair* of 1913 (Plate 301)), and 'that still life where the inscription "VIVE LA" bursts out on a white vase above two crossed *tricolores*' (Plate 259).[25] And it was specifically Picasso the Cubist who was celebrated in *Les Pas perdus*, above all in the Barcelona lecture reprinted from 1922.[26]

The role given Picasso by Breton, especially in this lecture, was a simple one, but its implications once seen in the perspective of the Surrealists' myth of their own emergence are profound. Picasso is seen simply and momentously to have broken away from the conventions of representation, helped by the example of African art. Cubism in general is rejected stingingly at times in Breton's writings for its materialist character, its dependence on the given and on a fixed relationship with the subject, for instance in his dismissal of Cubist collage by contrast with the imaginative elasticity of Ernst's collages.[27] But Picasso's invention of Cubism is seen in very

different terms, it *is* Surrealist painting in its beginnings, and it is such, for Breton, because his break-away from representation is seen as a break-away from the fixed materialism of painting as an art into a 'virgin land' where 'fantasy' can be freely pursued. Before Picasso, Breton insists, painting with its dedication to representation and techniques of representation had been even more materialist than literature. Picasso had freed it from this enslavement and turned it towards the imagination; at the same time he had freed it from any subservience to laws (he had discovered for art 'a certain aspect *outside law*').[28] Breton never suggested that Picasso's Cubism was automatically produced (though such suggestions could be made by others, as will be seen shortly), but the role he gave him as Cubist is that of opening painting up to the unlimited action of the imagination and thence to Surrealism as psychic automatism. Since the word freed from ordinary usage (sense) was the starting-point of automatic writing, the freeing of the mark or form from normal denotational or descriptive usage, and of the figure or object from normal situations, was the starting-point of automatic painting in all its modes. Cubism otherwise (Braque excepted) might have failed to capitalize on this liberation, but Picasso's achievement had been to open the way, first.

Crystal Cubist works like *The Guitar* of 1918 (Plate 16) or the Dinard still lives of 1922 fit so special a view of Picasso's Cubism poorly enough, as do many of the more sobre pictures of the period 1910–12 that the Purists held in particularly high regard during the early twenties, but the expressive force of *Les Demoiselles d'Avignon* (bought for Doucet by Breton and Eluard), the metaphorical elasticity of works like *Woman in an Armchair* (Plate 301) and the bright claustrophobia of *Studio with Plaster Head* (Plate 137) make Breton's response at least comprehensible. Picasso's Cubism, early or late, *was* Surrealist to Breton.

* * *

It was Max Morise in 'Enchanted Eyes' who suggested within the Surrealist ambit that the earlier Cubism of Picasso, and indeed of the Cubists in general, was actually automatic. More broadly and more fully than Breton, Morise was willing to accept Cubism in its beginnings as if it were Surrealism. He followed his assertion that the mark was the key to visual automatism thus:

> The first Cubist pictures: no preconceived idea imposed the responsibility of any representation whatever; the lines were organized just as they appeared and it might be said *according to chance*; pure inspiration, it seems, presided over this manner of painting, before it found in itself a model and reunited taste with its ancient priviledges.[29]

Collage too was rethought in the light of automatism; it was invented, said Morise, as a way of placing the ready-made at the instant disposition of the painter's imagination.[30] Seemingly, for him, there was no fundamental difference between Picasso's and Braque's pre-1914 Cubism and the automatic drawings of Masson, or between early Cubist collage and the dream collages of Ernst.

Strong arguments can indeed be advanced for the intuitive open-endedness of the leading Cubists' work-practices during the period 1909–14, and collage did make the ready-made instantly adaptable. Again, there are equally strong arguments (which have been developed in Part I) for a direct link between the practices of late synthetic Cubism and the flexible automatic practices of both Masson and Miró.[31] Yet, however open-ended and intuitive Cubist modes of working were, the fact is that they were always considered by the Cubists the exercise of their own, unique powers of invention, and were always directed towards the making of art objects whose success was believed subject to aesthetic laws. For them, practices that approached Surrealist automatism did not compromise the two fundamental beliefs that had made them as much as the conservatives the target of Dada: their belief in their art as their own special creation, and their belief in the painting or the poem as something separate, with its own status—a unique man- or woman-made thing. Within the terms of the Dada challenge, in the overtly uncontrolled writing of Picabia and Tzara, automatism had been a weapon aimed at pride in authorship, at the self-inflationary myth of total creativity; it had operated in tandem with the undisguised exploitation of chance, as has been seen. Within the terms of Surrealism, it operated against Cubist convictions in just the same way with just the same central target (whether directly associated with Cubism or not); and chance continued to be exploited alongside. When Aragon in *Une Vague de rêves* described himself and his friends becoming *subject to* the image, he illuminated with sharp clarity the distance between Surrealist experiment and Cubist art. The *image* had the power, he implied, not he Aragon; it was not *his* creation. The author as culture hero was dead, or at least was said to be.

The depreciation of the creative will and especially of talent had, of course, an extensive background in Dada epigrams, insults and images. Picabia's *Jésus-Christ Rastaqouère* ended with a passage levelled against creativity: 'In no work,' he wrote, 'whether it be painting, literature or music, is there superior creation; all these works are equivalent.'[32] With the publication of the Manifesto and the first numbers of *La Révolution Surréaliste* the devaluation of talent was at once a central Surrealist preoccupation, as the legend of Jacques Vaché was kept alive, and it was instantly linked to the practice of automatism. 'We have no talent,' Breton confessed proudly in the Manifesto, '. . . we who have made ourselves, in our works, the deaf receptacles of so many echoes, the modest *recording devices* that are not hypnotized by the designs they trace. . . .'[33] The marvellous is not confined to the special scope of special individuals however strong the Surrealist belief in self. Boiffard, Eluard and Vitrac, in their preface to the first number of *La Révolution Surréaliste*, firmly deny any manipulation or modification of the images they receive and record. It is as if the author is not there, they suggest.[34] With absence of conscious control went absence of authorial direction, and chance remained a feature of Surrealist practice entirely because it underlined so effectively this lack of authorial direction. The discovery of the image is neither the preserve of artists and poets alone nor the result of effort in any accepted sense of the word. Work alongside talent becomes, therefore, something especially undesirable, to be rejected and ridiculed. On the cover of *La Révolution Surréaliste* in July 1925 appeared a mannequin figure in long evening dress ascending a grand staircase; she is bracketed by the words: 'And war on work'.[35] It follows up Breton's attack on the elevation of the 'idea of work' in a 'quasi-religious' way in communist writings, an attack set out in 'The Last Strike' at the beginning of the year; it follows up too the refusal of work that gives force to Aragon's public exchange of letters with Jean Bernier and Marcel Fournier of *Clarté* at the same time.[36] Surrealism set imagination against materialism and set automatism against work, this was both Breton's and Aragon's argument.

Discoverer of images by means outside conscious control, explorer of a faculty shared by all, the imagination, the Surrealist (according to the Surrealists) was not a creator and was not, fundamentally, a special individual. This ideal picture

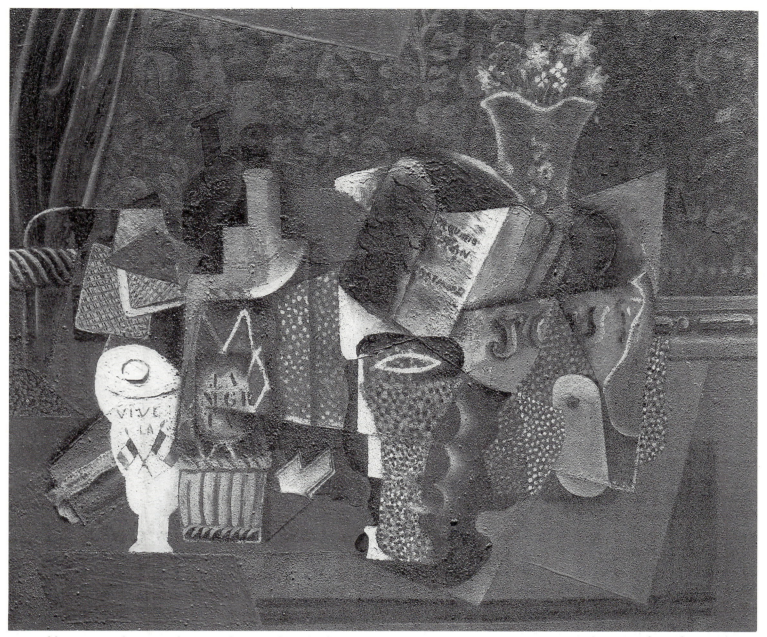

259. Pablo Picasso, *Playing-cards, Wine glasses and Bottle of Rum (Vive la France)*, 1914–15. Oil and sand on canvas, 21⅜ × 25¾in. Collection Mr and Mrs Leigh B. Block, Chicago.

was one that was heightened constantly, and yet it has to be admitted that it could be qualified. Just as Léger in his lecture 'The Machine Aesthetic' of 1923 claimed to find art and artists everywhere across the social spectrum and still preserved a distinct role for an artist like himself, so Breton saw potential Surrealists in everyone but preserved a role for the poet (or artist) which remained special.[37] The point is made in the essay with which he tried at the end of 1926 comprehensively to set out his position *vis-à-vis* the cultural policies and attitudes of the Communist Party, 'Legitimate Defence'. 'Once again,' he wrote of himself and his friends, 'all we know is that we are to a certain degree gifted with the word and that, by means of it, something large and obscure tends imperiously to be expressed through us, that each one of us has been chosen and designated himself among a thousand to formulate what must be formulated . . .'.[38]

The Surrealists were, after all, in this sense leaders; yet still the central point held: they were leaders who, by example, would make it possible for all to take up automatism in its various modes and so to become the 'modest recording devices' celebrated in the Manifesto. Ideally Surrealism remained a pursuit for all, free of the shaping power of the individual will, a long way indeed from the Cubist belief in the heroic role of the author as creator.

* * *

Automatism of the mark seems to have developed, at least in Masson's case, before the appearance of Breton's Manifesto. Carolyn Lanchner has convincingly established that Masson's earliest so-called automatic drawings accompanied a group of pictures and related drawings made in the winter of 1923–24.[39] Masson himself has consistently claimed that the discovery anticipated his first meeting with Breton in February 1924. He was deeply immersed in German Romanticism, and had been reading Rimbaud and Lautréamont for himself, so there is reason to believe that a thoroughly independent impulse to be an artist-seer in the Rimbaudian sense lay behind it, but already late in 1923 the doings of Breton's circle must have impinged at least peripherally on his consciousness, for he was in touch with Robert Desnos who surely conveyed something of what had gone on during the 'epidemic of trances' and at least mentioned something of his own pre-occupations as a writer in search of automatic procedures.[40] Again, it seems certain that Masson and his writer-friends (Roland Tual, Michel Leiris, Artuaud, Limbour and Salacrou) had access to *Littérature*, where Breton's 'Entrance of the Mediums' had appeared at the end of 1922 giving a certain prominence to Desnos for his capacity to lose consciousness articulately.[41] Yet, that Masson was for the moment relatively free of Breton's circle is underlined by the fact that his painting emerged into the public eye in February 1924 at

Kahnweiler's galerie Simon and that he was for a while very much involved in Kahnweiler's circle, an admiring friend of Juan Gris.[42]

However much Masson's automatic drawings from the winter of 1923–24 developed on one side, there can be no mistaking the welcome and the status given them within Surrealism. As has been seen, they were instantly picked out to accompany Max Morise's plea for a pictorial automatism of the mark in *La Révolution Surréaliste* at the end of 1924, and continued regularly to be reproduced there. They were quickly given a Surrealist identity, and their relatives in painting figured prominently at the exhibition of 'La Peinture Surréaliste' in November 1925, *The Armour* (Plate 263) being one of the works included. Throughout the period 1924–26 they and the discoveries made in them dominated Masson's work and assured him of his Surrealist reputation; something consolidated late in 1926 by the unquestionably automatic sand paintings, though, surprisingly, resistance to their sheer lack of control seems to have been encountered among the writers of the circle.[43] The automatic drawings and their painted relatives developed to some extent independently, acquiring only later a Surrealist identity in the fullest sense; the sand paintings were always Surrealist in the fullest sense, their automatism a direct response to a desire to be more completely and truly a part of the movement.

That they were always Surrealist in this full sense could be said of both Max Ernst's and Joan Miró's excursions into an overt automatism of the mark after 1924, and both showed early results of the development alongside Masson's *Armour* at the exhibition of Surrealist painting the following year.[44] Ernst's involvement with Breton and the *Littérature* group from his first illegal entry into France in 1922 is not at issue. At the time of the Manifesto and the first number of *La Révolution Surréaliste* Ernst was away, in pursuit of Eluard in Indo-China, but back in France he reacted at once to the stimulus given by those publications. The development of *frottage* (a process of image-making by pencil rubbing) was the result while he was staying at Pornic on France's west coast in August 1925, and with it the related development of *grattage*. Between 1925 and 1927 the more conspicuously gestural automatism of *grattage* dominated his work. In 'Surrealism and Painting', Breton made no clear qualitative distinction between the automatism of *frottage* or *grattage* and what he presented as the automatism of Ernst's collages and their painted relatives; but there can be no doubt that Ernst's 'second manner' was an attempt to achieve, through the directness of mark-making deprived of conscious control, a Surrealism more thoroughly attuned to the Manifesto.

From 1921, as a winter Parisian, Miró had been Masson's neighbour at 45 rue Blomet.[45] By the end of 1923 he too was in touch with Desnos and aware of Rimbaud and Lautréamont, but it was not until, at the very earliest, the summer of 1924 that he himself was attracted to an automatism of the mark comparable with Masson's drawings. It was then that he sketched the simple curvy sign which, transposed into an equally simple painting, became known as *The Kiss*.[46] There followed in the winter of 1924–25 and through into 1927 a whole series of pictures characterized by the use of an ambiguous, rudimentary range of signs, and by spacious, unstructured grounds, highly evocative of airy depth: the pictures that Jacques Dupin has called the 'dream paintings'.[47] The dream pictures were rarely exhibited at the time and none were illustrated in *La Révolution Surréaliste*, but one at least, *The Music-Hall Usher*, figured in the Surrealist exhibition, and William Rubin has established that they were above all the reason for Miró's Surrealist status in the influential eyes of Breton, and that the largest, *The Birth of the World* (Plate 256), enjoyed a private reputation in Surrealist circles equal to any single painted image.[48] When Breton called Miró, notoriously, 'the most Surrealist among us', it was of the conspicuous automatism in these pictures that he thought, and the date of their emergence as dominant in Miró's Parisian work confirms that they were indeed a response to Surrealist propaganda, even if guided by different priorities, as will be seen.

There were others in the Surrealist circle who made contributions to visual automatism. Man Ray's 'rayograms' relate directly to Ernst's *frottages* and *grattages*, while Arp's biomorphic graphics and reliefs were important early manifestations. Both artists were included in the exhibition of Surrealist painting at the galerie Pierre. It is in the interests of economy alone that Masson, Miró and Ernst will be the exclusive subjects of this discussion of automatism in painting. All three, it has been established, set their automatism within a Surrealist context and were welcomed for it by the Surrealists. The question that remains then is not *whether* the Surrealist ideal of automatism guided their aspirations, but precisely *how* their automatism worked; how, therefore, it set up a challenge to the Cubist belief in the artist as creator, and how it said as much in actual images.

* * *

The challenge offered by visual automatism in the work of Masson and Miró was perhaps the more profound because the kind of practices from which it started actually originated in the practices of Cubism itself, both pre- and post-war. What this meant and how it happened are topics dealt with very fully in Part I.[49] It came of the flexibility of the synthetic Cubist approach to pictorial signs, and the key factor was metamorphosis. Both the rigorously 'pure' Cubism of Gris and the freer Cubism of Picasso provided models.

To recapitulate briefly, Miró learned especially from Picasso's synthetic Cubism that with simplicity in the use of pictorial signs went a much enhanced potential for signs to change their meanings, both denotational and conotational. The lessons were there in everything from the *papiers collés* of 1913 to the *Harlequin* of 1915 (Plate 11) and, within a Surrealist context, the dot-and-line drawings of 1924 which were published in *La Révolution Surréaliste* number 2 (Plate 90). Just as Picasso could make the sign for a head or a harlequin become the sign for a guitar or a bottle with the slightest change of accent, so Miró could make the sign for an apple or a pear become the sign for a breast, a sun become a spider or the female sex.[50] Analogously Masson learned especially from Gris (during their period of friendship from 1923) to exploit visual rhymes to encourage metamorphosis, but went further to adapt Gris's so-called 'synthetic method' to his own purposes. Just as Gris 'qualified' arrangements of initially abstract shapes so that they became figures or objects, so Masson's automatic or proto-automatic drawings (Plates 260 and 261) began with abstract mark-making which generated images.[51] Synthetic Cubism on the one hand, therefore, opened the way for Miró's highly suggestive fusions of still life, plants and figures, in such works of 1924 as *Portrait of Mme K* (Plate 290) and *The Hunter (Catalan Landscape)* (Plate 133), and on the other hand opened the way for Masson's automatic drawings and the paintings of 1923–26 directly related to them (Plates 266 and 295), where the marks of a cursive calligraphy were metamorphosed into the signs for anything from body-parts to pomegranates or constellations. In both cases, with the results of metamorphosis went structures reminiscent of the geometric armatures of Cubist composition, and a proliferation of visual rhymes reflective of the rhyming so often

260. André Masson, *Automatic Drawing*, 1924. Pen and ink, 9¼ × 7½in. Private Collection, New York.

found in the Cubist work especially of Gris (between 1918 and 1923). The lessons learned led away from Cubism, but the fact that they had been absorbed in the space between Cubism and Surrealism remained clearly visible, something the paintings pointedly signified.

In Cubist and Surrealist painting metamorphosis and the visual rhyme acted in basically the same way: it separated the sign from any fixed meaning, and thus made it available either for aesthetically directed manipulation free from the obligations of specific denotational meaning (in Cubism) or for imaginative fusions and transformations of meaning (in Surrealism). It was because the word was thought of in just this way—as freed from fixed meaning—that Max Morise, when introducing the automatism of the mark as the ideal in visual Surrealism, could draw so close a parallel between the word and the mark in the practice of automatism. Within both Cubist and Surrealist circles the parallel between the freedom of the word and the visual sign from the normal uses of representation was obvious, and it is therefore to be expected that literary and pictorial developments mirrored one another, sometimes one directly responding to the other. So it was in the case of Masson's automatic drawings, for Masson's use of visual rhymes to generate images from marks reflects and even responds to a parallel literary development within the Surrealist circle. This development was at least as important a stimulus to him as Gris's synthetic Cubism, and, since it was aimed towards the automatic and the Surrealist, it was probably crucial in deflecting the adaptation of rhyme for Cubist inventive purposes in the direction of automatism.

Masson's automatic drawing *Furious Suns* (Plate 261) was published in *La Révolution Surréaliste* in October 1925. It appeared alongside two late, distinctly Surrealist relatives of Apollinaire's calligrammes contributed by Michel Leiris, close friend of Masson from the earlier rue Blomet years. Both of these works use letters scattered in such a way as to make possible conflicting readings: in the first, *Le Sceptre miroitant* (Plate 262), the words 'MOI', 'MIROIR', 'AMOUR' and 'MOURIR' ambiguously coalesce in a single tightly packed form. Here

261. André Masson, *Furious Suns*, 1925. Pen and ink, 16½ × 12¾in. Collection, The Museum of Modern Art, New York.

262. Michel Leiris, *Le Sceptre miroitant*, poem published in *La Révolution Surréaliste*, 15 October 1925, p.7.

the very syllables of words are separated and allowed to act interchangeably together, and the analogy is obvious with the way that Masson pulls together the interchangeable parts of a male torso, fish and birds with his solar disks; the parts seem to emerge from lines (the raw matter of drawing) just as Leiris's words emerge from syllables. What is more, in both rhyme (or its partner, assonance) is crucial: 'amour' echoing 'mourir', just as the birds echo the fish in the drawing.

263. André Masson, *The Armour*, 1925. Oil on canvas, 32 × 21in. Peggy Guggenheim Collection, Venice; The Solomon R. Guggenheim Museum, New York.

Leiris's experiment with letters and syllables was an interlude in a whole series of word-games which he published under the title 'Glossaire: J'y serre mes gloses' in *La Révolution Surréaliste* between April 1925 and March 1926. His introduction stressed his desire to strip words of their 'accepted signification', to dissect them and thus to find 'their most hidden virtues and secret ramifications . . . , canalized by the associations of sounds, of forms and ideas'.[52] The rhythms and sounds of each word he chose generated by association its 'definition' or equivalent in the glossary, and one at least has been referred to as a verbal companion for a particular Masson, *The Armour* (Plate 263). 'Armure' in the glossary becomes 'ramure de larmes pétrifiées', and later 'Amour' becomes 'armure'.[53] Leiris was emphatic: his 'definitions' came to him automatically, he believed; they were not the result of conscious manipulation: 'Language', he wrote, '. . . is transformed into an oracle.'[54]

Leiris's 'Glossaire: J'y serre mes gloses' was a sequel to the earlier fad for word-games that followed the 'epidemic of

trances' in the circle of Breton, especially through 1923, the year when Masson began really to exploit the metamorphic possibilities of rhyming and produced the first of his automatic drawings as one application of those possibilities. Robert Desnos, of course, was the writer most elaborately to have taken to word-games in 1923, and it was he who was the one member of the *Littérature* group in touch with Masson and the rue Blomet group. That his exploration of an automatism of sound and syllable helped Masson take Cubist synthesis and visual rhyme towards an automatism of the mark seems almost certain; it offered indeed the most striking of examples, at least by analogy. What was especially relevant was Desnos's use of alliteration in the collection *Langage cuit* and of homonyms in *L'Aumonyme*, for both alliteration and homonyms (as much as assonance) are the partners of rhyme and are used here precisely to make language metamorphic.[55] In the same way that in Masson's drawings a single type of interlacing curve can become hands, breasts, birds or fish, alliteratively a single range of sounds can generate a remarkable verbal effusion: 'Mon mal meurt mais mes mains miment';[56] and homonymically an identical sound can make very different words: 'Les chats hauts sur les châteaux/d'espoir . . .'.[57] Homonyms and alliteration of this kind are not a feature of Breton's automatic texts in *Poisson soluble*, but assonance certainly is, as it had been in *Les Champs magnétiques*; in this way, during 1924, the connection between assonance, rhyme and automatism was to be persuasively reinforced in verbal terms, just as it was in visual terms by the published appearance of Masson's automatic drawings.

Masson's automatic practice was, then, directly related in complementary ways to synthetic Cubism and to the verbal practices of Desnos, Leiris and the Surrealists; but the questions remain, *how* automatic were they, and how far was their automatism carried into the paintings of 1924–25? How much in the end did he succeed in diminishing his role as author? Verbal and visual automatism might have seemed almost interchangeable when Morise discussed the word and the mark, but the technical problems of drawing and painting *are* different, and the automatism of the mark spawned its own particular problems and products.

An early automatic drawing like the one usually dated 1923 and here reproduced (Plate 260), or later ones like *Furious Suns* (Plate 261) and *Birth of Birds* (Plate 265) have invariably the look of having been made directly in one go. There is no pencil under-drawing, and the penned line is crisp, unhesitating. The earlier drawings are obviously less sure in their generation of images; in this instance, the hands and breasts emerge from a web of lines many of which remain abstract. In both *Furious Suns* and *Birth of Birds* the calligraphy has a much greater elegance, a practiced elegance, and almost every line forms part of a legible sign, the partial outline of bird, or breast, or hand, or flower. Masson undoubtedly learned as an automatic draughtsman through 1924 and 1925; however unconsciously, his capacity to make meaningful images from calligraphy became so overt as to look like talent. What is more, from the beginning his calligraphy generated a fairly limited range of images, almost as limited as Gris's range of *commedia dell'arte* characters and still-life objects, though very different. Masson's wrist and hand fashioned birds in flight, savage fish, hands, breasts, upper male torsoes. genitalia, stars, suns and a few other items in various combinations sometimes within partial architectural or mountainous environments of cornices or crags. This could be seen as the result of obsession, and certainly it was, but the effectiveness and economy of a drawing like *Birth of Birds* leaves an impression of decisive control: the direction of talent.

264. André Masson, *The Haunted Castle*, 1926. Oil on canvas, 18 × 15in. Collection, Mr and Mrs Claude Asch, Strasbourg.

Yet, these drawings were undoubtedly the product of a degree of automatism, and, for Masson, it was not so much drawing that was problematic as painting. There are paintings of the period, like *Nudes and Architecture* (Plate 270), which are to a large extent direct transpositions into oils of automatic drawings, and occasionally Masson may even have drawn fairly automatically on the canvas itself before painting.[58]

Much more commonly, however, the paintings of 1924–25 are carefully edited and ordered transpositions from automatic drawings. Often, as in *The Wing* (Plate 266), the sheer continuity with which one image opens out from another, retains the elastic, metamorphic character of the drawings. But technically these are the products of patient skill. They were carefully laid out as designs on the canvas in pencil before

265. André Masson, *The Birth of Birds*, 1926. Pen and ink, 16½ × 12¾in. Collection, The Museum of Modern Art, New York.

266. André Masson, *The Wing*, 1925. Oil on canvas, 21¾ × 15in. Nationalgalerie, Berlin (West).

being filled in, usually with the broken but routine *taches* of Picasso's and Braque's Cubism of 1910–12.[59] Masson's 'finds' may have been made initially in effortless drawings, but they were preserved in well-designed and crafted pictorial show-cases.

When *The Armour* was hung at the Surrealist exhibition in the galerie Pierre in 1925 it took on a Surrealist status and so did all the pictures by Masson reproduced in *La Révolution Surréaliste*; but Masson himself knew well how inadequately they met the demand for psychic automatism, and he must have known too that this was visible even at a glance. His response at first in 1926 was to develop a technique that depended less on thickly built up areas of *taches* and which allowed him to draw lightly and directly on the canvas both with the brush and from the tube, as in *The Haunted Castle* (Plate 264), a painting which finally does achieve the look of automatic drawing. Yet, here still his hand exhibited its talent for fecund calligraphy. There had, however, been at least one exhibit at the Surrealist exhibition in 1925 that offered a clue as to the ingredient needed if that talent was seriously and visibly to be challenged: it was Max Ernst's *frottage*, and the other ingredient that had gone into its making was chance.

* * *

Ernst came to an automatic practice based on mark-making from Dada, with Breton and Eluard especially as close companions. His collages, as has been seen, were already in 1920 a direct challenge to Cubism. There was, therefore, no significant or even partly positive relationship between synthetic Cubism and his plunge into an automatism of the mark. Unlike Masson and Miró, he never occupied a space between late Cubism and Surrealism, not even briefly.

Ernst's famous account of his discovery of *frottage* in *Au delà de la peinture* associates it with Leonardo (probably with an eye on Freud's interest in Leonardo), and presents it above all as a means of intensifying what he calls the 'hallucinatory faculties'.[60] Ernst makes a point of linking his reaction to the scrubbed floor-boards of his seaside room at Pornic with a particular 'vision in half-sleep' from his childhood which had similarly been provoked by a panel of mahogany; it was a 'vision' or dream recounted at length in *La Révolution Surréaliste* in 1927, where the image of his father and images of sexual potency and creativity come together in a way consciously, it seems, made available to Freudian analysis.[61]

If this account of the discovery of *frottage* seems too pat, the emergence from it of *frottage* pictured as a continuation of experiments with hallucination and dream rings true, and so does the heavily suggested background presence of Breton as the guiding genius, the Breton of the Manifesto, where another account of a vision in half-sleep is given so prominent and revelatory a role.[62] *Frottage* came as an impulsive response to the demand for a visual automatism of the mark made by Morise in the context of Breton's Manifesto. And, just as Breton's vision in half-sleep (his automatically conjured phrase: 'There is a man cut in two by the window') was connected in his mind with the verbal automatism of *Les Champs magnétiques*, so Ernst's *frottage* connected automatic mark-making to the Surrealists' engagement with dreams. *Frottage*, however, shifted the stress from the visual representation of dreams in the tradition of de Chirico, to the visual stimulus in himself, as hunter of images, of simulated or real hallucinatory states. And, as a former Dadaist ally of Arp's, it was natural that Ernst should have developed a

267. Max Ernst, *Beautiful Season*, 1925. Frottage, $7\frac{7}{8} \times 10\frac{1}{4}$in. Collection, De Menil, Houston, Texas.

268. Max Ernst, *One Night of Love*, 1927. Oil on canvas, $63\frac{3}{4} \times 51\frac{3}{4}$in. Private Collection, Paris.

practice that brought together automatism and chance to this end.

Wooden planks, pieces of cloth, wound and unwound spools of thread, leaves, all were used for his rubbings. In the *Beautiful Season* (Plate 267) fragments of *frottage* were put together (as it were, collaged), but the process was usually

269. Max Ernst, *Horde*, 1927. Oil on canvas, $45\frac{1}{2} \times 57\frac{1}{2}$in. Collection, Stedelijk Museum, Amsterdam.

270. André Masson, *Nudes and Architecture*, 1924. Oil on canvas, 29 × 36¼in. Collection, Mr and Mrs Nesuhi Ertegün, New York.

simple and the image was usually the result of rubbing alone, without the later addition of drawn lines to give emphasis or develop suggestions. *Grattage*, which was 'discovered' almost simultaneously, simply extended the *frottage* practice to painting. Ernst covered his canvas with several paint layers, then placed objects and textured surfaces underneath; he then scraped the surface layers away where the canvas was raised to 'find' his forms, their colour given by the paint layers thus revealed. At first in the work of 1925 the process was relatively simple too, but later in works of 1926–27 like *One Night of Love* (Plate 268) and the *Horde* pictures (Plate 269) he complicated the process by soaking string in paint and dropping it on the canvas to add other suggestive forms to those uncovered by scraping.

Arp's pursuit of chance was obviously a factor in Ernst's resort to the dropping of string, and both *frottage* and *grattage* as obviously took in a Surrealist direction his own earlier commitment to chance as a collagist. This was indeed the ingredient in *frottage* that saved it from the skilfully contrived look of Masson's automatic drawings and related paintings. Ernst of course *chose* the objects for his rubbings or scrapings, but just what they would produce on paper or canvas he could not control, and the initial process of forming at least was taken away from the shaping power of his mind and hand; his images, thus, far more than Masson's, could be 'found' rather than invented. The discovery of images occurred through rhyming analogy and consequent metamorphoses, but the way those metamorphoses were induced had nothing

whatever to do with the simple, interchangeable signs of synthetic Cubism; Leonardo's *Trattata della Pittura* was undeniably more relevant.

Yet, even still, *frottage* and *grattage* in action were only *relatively* automatic. Like Masson in his automatic drawings, Ernst was able to find in his arbitrary shadings and scrapings a distinctly restricted range of images only, in the *frottages* images which were almost all mutations of ones found and developed earlier. Thus (one instance among many), the forest wall image of earlier collages and paintings recurs in the *frottage Hugging the Walls* (Plate 271) to become a central motif in such *grattages* as *Vision Inspired by the Porte Saint Denis at Night* (Plate 272). The repetitive and limited character of Ernst's finds does not, of course, imply a conscious manipulation of his techniques in the direction of pre-selected images at an early stage; but it certainly indicates control and direction at a later stage. In *frottage* such control took the form of rubbing with varying hardness, of shifting the objects beneath the paper and of deciding when to stop and where not to rub; in *grattage* it became by 1927 more blatant, particularly since over-painting in order to isolate and develop images was the final stage of the process.

It has been suggested that this element of control sets Ernst's *grattages* apart from the Bretonian definition of Surrealism as psychic automatism,[63] but in fact it mirrors fairly accurately Breton's own recognition in practice of the need to edit the results of automatic phases of discovery, as brought out, particularly tellingly, by the mixture of automatism and

control in the series of poems included in *Clair de terre*, of which one was dedicated to Ernst. Marguerite Bonnet has noted how the corrections on the manuscripts for these poems show Breton editing invariably in the interests either of cohesion or the intensification of the image; precisely the same was true of Ernst's editing in the *frottages* and the *grattages*.[64] Such practices in no way undermined their Surrealist status.

271. Max Ernst, *Hugging the Walls*, 1925. Frottage, included in *Histoire Naturelle*, 1925.

272. Max Ernst, *Vision Inspired by the Porte Saint Denis at Night*, 1927. Oil on canvas, 19¼ × 32in. Collection, Marcel Mabille, Brussels.

* * *

It was with the development of the sand paintings towards the end of 1926 that Masson, encouraged by the example of Ernst, allowed chance to submerge his manipulative talent somewhat and approached a degree of automatism comparable with *frottage* and *grattage*. The story of Masson's discovery of the sand painting technique appropriately bears comparison with Ernst's discovery of *frottage*: it came at the seaside (Sanery-sur-Mer), it was sudden and, like the ideal Surrealist image, it was itself a 'find', not the result of directed experiment.[65] The sand on the beach (like Ernst's floor-boards) gave him the idea of randomly pouring glue on the canvas, sprinkling sand over it and using the patches where the sand stuck as a stimulus for his imagination. The random sand forms still required his ability to produce images by rhyming analogy, but when they *were* actually random his skilled hand could no longer lead the way, it could only follow.

In practice the degree of automatism achieved by Masson in the sand paintings was more obviously variable than in Ernst's *grattages*, let alone his *frottages*; at times they were no freer of his hand as guiding agency than pictures like *The Haunted Castle* (Plate 264). Acknowledged as the first of the sand paintings is *Battle of the Fishes* (Plate 273), and it shows that the discovery of the technique did not instantly lead to the take-over of chance from the hand as the initiator of images. It has been unquestioningly accepted that in this opening excursion Masson drew with the pencil only *after* the pouring of the glue and the scattering of the sand. Yet, in several places the pencil lines visibly go *under* the sand patches, and, very significantly, the contours of the patches often *continue* pencil lines. The indication therefore is that some drawing (more or less automatic) preceded the pouring and scattering and may even partly have guided it; chance and the hand seem to have been partners at the outset.[66] A small group of the later sand paintings, including *Man and Woman* (Plate 274) show the hand and drawing far more clearly as the initiator. Here there can be no doubt that Masson's first act was to draw quickly and lightly with charcoal on the canvas, and that not only the areas of glued sand but almost all the intervening calligraphy, drawn finally with the brush, was arrived at thus.[67] It is perhaps significant that this group takes up themes developed earlier, in particular that of *Children of the Isles*, introducing few fresh ideas as a result of the glue-and-sand technique. Then there is a case, spotted by Lanchner, where a rather slickly finished automatic drawing reproduced in *La Révolution Surréaliste* in June 1926 (before the first sand paintings) seems to have come to Masson's mind whole and in virtually every detail at the suggestion of the unevenly scattered surfaces of sand that covered one canvas.[68] The result was *Fish Drawn on the Sand* (Plate 275), whose open calligraphy of brushed lines and paint squeezed straight from the tube onto the evocative expanse of sand gives a particularly convincing impression of randomness, but which is actually a transferred automatic drawing like so many of the pictures of 1924–25.

There are, however, several sand paintings where the hand certainly did not lead the way and where chance was the main initiator. One of them is a figure loosely related to those where drawing was the starting-point, *Painting (Figure)* (Plate 276), but in this case the technique is far more complex,

273. André Masson, *The Battle of the Fishes*, 1926. Glued sand, oil and pencil on canvas, $14\frac{3}{4} \times 28\frac{3}{4}$in. Collection, The Museum of Modern Art, New York.

274. André Masson, *Man and Woman*, 1926–27. Oil and glued sand on canvas, $36\frac{1}{4} \times 23\frac{1}{2}$in. Private Collection, Switzerland.

275. André Masson, *Fish Drawn on the Sand*, 1926–27. Oil and glued sand on canvas, $39\frac{1}{4} \times 28\frac{3}{4}$in. Kunstmuseum, Bern. Hermann and Margit Rupf Collection.

different layers of sand being applied and sand too being mixed into the painted marks of black, red or blue. Here clearly it was the way that the glue was poured and the sand stuck to it that suggested the image brought out afterwards.

More clearly still is this so in a group of small canvases whose biomorphic shapes are less specific and less linked to Masson's earlier work; one of them is *The Villagers* (Plate 277). Here the enigmatic results are the closest Masson came to Miró's dream pictures of the previous two years. Their automatism is overt and to a high degree genuine.

Yet, however undirected the first stage of these sand paint-

276. André Masson, *Painting (Figure)*, 1926–27. Oil and glued sand on cavas, 18 × 10¾in. Collection, The Museum of Modern Art, New York. Gift of William Rubin.

277. André Masson, *The Villagers*, 1926–27. Oil and glued sand on canvas, 32 × 28½in. Musée National d'Art Moderne, Centre Georges Pompidou, Paris. Kahnweiler-Leiris Collection.

ings, the latter stages were inevitably guided by the hand. Masson edited too, and he edited very much like Ernst, to pull things together and to intensify his images. It could be said that *Fish Drawn on the Sand* came of one long process of editing by which the suggestions of the sand surface were directed towards the pre-existent image of the published drawing. But even in the far less predetermined *Painting (Figure)* or *The Villagers*, Masson ended by guiding his marks towards images that had an established place in his repertoire: headless nudes, savage fish, death in the shape of shadows were repeatedly found in the sand, like Ernst's forests and creatures in wood-grain. In the end, both Ernst and Masson gave the lie to Breton's hope that automatism would produce the 'unprecedented'; they almost always found what they had found before, and if chance threw up a genuine new discovery, like Ernst's *Hordes*, it gave rise to prolific repetition. They had become subject not simply to images but to *their* images, and the function of editing was to bring those images out once they were recognized.

*　　*　　*

Ernst and Masson, then, both produced kinds of visual automatism based on the mark that threatened the status of the artist as creator in a conspicuous way, though the active intervention of the conscious will was a great deal more important in practice than it was made to appear. Miró's

dream pictures also had the look, convincingly, of automatism, indeed of an especially complete kind of automatism, and Breton at least was persuaded.[69]

Between the beginning of 1925 and 1927 Miró did not break altogether with the elaborate anecdotal and metamorphic painting he had developed in 1923–24. But, for the most part, his dream pictures were the result of a clean break both in the way he used his signs and grounds, and in his way of working: they are less complex than the paintings of 1923–24, more open, more enigmatic or ambiguous, and they are not developed through sequences of preparatory drawings helped by squaring and 'regulating lines' as were *Portrait of Mme K* and *The Hunter (Catalan Landscape)* (Plates 290 and 133). Works like *Painting* (Plate 139), the picture-poems *Le Corps de ma brune* (Plate 278) or *Oh! Un de ces messieurs qui a fait tout ça* (Plate 279), and especially *The Birth of the World* (Plate 256) seem totally to fit Morise's ideal of automatism of the mark, the picture-poems actually fusing verbal and visual automatism as compatible kinds of automatic sign-making.

The picture which has always been taken as *the* exemplar of Miró's automatism is *The Birth of the World*. William Rubin, supported it seems by Miró's own comments, has given this work almost the status of a creation-myth image: an image whose subject is the very process of its own creation. He describes how the cryptic signs emerged from the actual practice of staining, sponging and splashing on paint to make the ground, and suggests that the process is left revealed for the spectator guided by the title (which was added with Miró's support by one of the Surrealist writers).[70] Now Rubin wrote this account (which the painting and the artist substantiated in every way) before the disinterment of Miró's sketch-books which are now preserved in Barcelona;[71] it sustained, indeed brought to its highest point, Miró's public image as 'the most Surrealist' of all. But the sketch-books have revealed that even the most automatic of the dream pictures were not quite so immediately automatic, and that

278. Joan Miró, *Le Corps de ma brune*, 1925. Oil on canvas, 51⅛ × 37¾ in. Sale: Christies, London, 12 November 1985.

The Birth of the World was not among the most automatic after all.

That Rubin's account was misleading was indicated with Gaeton Picon's publication of a very exact pencil drawing, so exact that pencil equivalents of many of the dribbles and spattered dots that appear so random on the canvas are there (Plate 280).[72] In the case of *The Birth of the World* another, more cursory sketch in the same sketch-book (Plate 281) shows incontrovertibly that the idea came at first from the metamorphosis of a simple image of a reclining figure beneath a fruit tree. This alone demonstrates that it was not an idea spawned by the process of working the ground, and it also suggests that the very exact sketch was not a record but

279. Joan Miró, *Oh! Un de ces messieurs qui a fait tout ça*, 1925. Oil on canvas, $51\frac{1}{8} \times 37\frac{3}{8}$in. Galerie Maeght, Paris.

actually the picture's final preparatory study. In fact, there are drawings related to *all* the dream pictures of 1925–27 recorded by Dupin, except two, and with most the relationship is just as exact. And a close perusal of the sketch-books establishes firmly that as a general rule they *were* preparatory studies, since in a significant number of cases the drawings differ in just enough ways from the paintings (items added or subtracted) for it to be inconceivable that they are records.[73] Most obvious of all are the word changes that occur between drawings and paintings in the picture-poems (Plates 282 and 278) and the works with elaborate verbal elements. *Oh! Un de ces messieurs qui a fait tout ça* is a case in point, where the French has been translated by Miró from the Catalan of the drawing (Plates 279 and 286). Almost all the dream pictures, it emerges, were actually meticulous replicas on canvas of small, quickly drafted pencil sketches; Miró's fastidiousness as a craftsman, so memorable a feature of his earlier work, still, surprisingly, had an outlet. Indeed, lists of different sized canvases

280. Joan Miró, *Study for the Birth of the World*, c.1925. Pencil, $10\frac{3}{4} \times 7\frac{3}{4}$in. Fundació Joan Miró, Barcelona (no.701).

281. Joan Miró, *First Sketch for the Birth of the World*, c.1925. Pencil, $10\frac{3}{4} \times 7\frac{3}{4}$in. Fundació Joan Miró, Barcelona (no.703).

with apparently ready-prepared grounds in blues, greys and beiges exist in one of the most important sketchbooks, suggesting that the ideas arrived at in the sketches were simply fitted to them, though this can only remain a speculation.[74]

Miró did not, however, completely exclude automatic mark-making as a process of discovery. The sketch-books also reveal a few fascinating cases where he did work thus. The most striking are the pencil drawings (all in one pad) for the freest of the *Circus Horse* paintings of 1927. The paintings, typically, are very exact replicas of drawings, but the drawings do seem to have been made by simply moving the hand randomly without conscious direction on the sheet. The process was to some extent automatic, but on the scale of

284. Joan Miró, *Study for the Circus Horse*, 1926–27. Pencil, 10⅞ × 7¾in. Fundació Joan Miró, Barcelona (no.684).

drawing not painting (Plate 284). Less easily seen are a few ideas for paintings that were evidently triggered by the pressings-through of one drawing onto the next sheet, Miró pressing hard with a well-sharpened pencil to encourage it. Here Miró used marks made as much by chance as design to stimulate fresh metamorphoses through rhyming analogy, very much as Ernst did in *frottage*, and on occasion he turned the pad in order further to distance the pressed-through marks from their origin and intensify the stimulus. *Sand* of 1925 (Plate 283) was partly initiated by pressings-through from the drawing for another work, and pressings from both the drawing for *Sand* and for another work helped

282. Joan Miró, *Study for Le Corps de ma brune*, c.1925. Pencil, 4¾ × 3¼in. Fundació Joan Miró, Barcelona (no.568).

283. Joan Miró, *Drawing for Sand*, 1925. Pencil, 7¾ × 10¾in. Fundació Joan Miró, Barcelona (no. 738).

285. Joan Miró, *Drawing for Painting*, 1925. Pencil, 7¾ × 10¾in. Fundació Joan Miró, Barcelona (no. 740).

initiate the drawing for *Painting* (1925) (Plate 285).[75] Unexpectedly, one or two of the large Montroig landscapes (not usually considered automatic) have such an origin too.[76]

Then there is the case of *Oh! Un de ces messieurs qui a fait tout ça*, which finally sums up the closeness of the relationship between the automatism of the mark and that of the word. Miró himself has said that in this case the rhythmic yet random marks drawn on the canvas came 'in response to configurations he might see on the page of a notebook or on a letter he received'.[77] In fact, the drawing for the picture (with the words in Catalan) is opposite the drawing for the picture-poem *Un Oiseau poursuit une abeille et la baisse* (Plate 286), which turned on its side in the book seems to have

saw there to intensify his hallucinatory faculty.[78] The habits instilled by his earlier metamorphic draughtsmanship (described in Part I)[79] turned every mark into a potential sign. His response heightened, he would rapidly jot down what he saw. These jottings are mostly what survive, it seems, in the sketch-book drawings for the dream pictures. It was relatively rarely that the actual process of mark-making released his images; more often he recorded as instantaneously as possible the things he 'saw' in his studio, and then meticulously transferred them onto canvas. And, in the final analysis, Miró's dream pictures do emerge as the most complete manifestations of visual automatism produced in the period, for they may be automatic only at second-hand,

286. Joan Miró, double-spread from sketch-book: studies for (a) *Un Oiseau poursuit une abeille et la baisse*, and (b) *Oh! Un de ces messieurs qui a fait tout ça*, (a) pencil, (b) blue ink, each sheet 10¾ × 7¾in. Fundació Joan Miró, Barcelona (nos 698 and 699).

triggered the image, for the rhythmic strokes of *Oh! Un de ces messieurs . . .* unmistakably echo the wavering calligraphy of the 'poursuit' as it was written. A word seen on its side, deprived of signification, becomes a suggestive mark which triggers the signs that Miró's caption asks us to read as men, 'ces messieurs'.

This last case is especially significant for the insight it offers into how automatism operated behind most of the dream pictures between late 1924 and 1927, for it shows just how Miró could use the chance sight of marks (almost any marks) as a stimulus for his finds. He has himself repeatedly recalled how at this time he would use 'hallucinations' induced by hunger to generate his ideas, and how when in such a condition he would contemplate the cracked and stained walls of his studio on the rue Blomet, using the marks he

but the very exactness with which they repeat the drawings in the sketch-books is a measure of Miró's determination to capture whole the original 'vision' or 'find'. His spacious grounds and his acute colour sense certainly act to highlight the image and set it in a suitably suggestive pictorial environment, but editing was kept to a minimum.

The dream pictures may have been shown little between 1925 and 1927 and seldom reproduced, but within the Surrealist circle they offered the movement's most uncompromising challenge of all through automatism to *l'art vivant* and specifically to Cubism. Here certainly were images whose appearance and whose making firmly set aside the widely hegemonic notions of artistic creativity and individual talent, images which signified an empty place where once the author had been.

18
Dada and Surrealism: Poetry in Painting and the Rejection of Modernism

In his essay 'Distances' of 1922, Breton insisted that 'Painting . . . will not have as its end the pleasure of the eyes . . .'.[1] The phrasing immediately brings to mind Apollinaire's plea in *Les Peintres cubistes* for 'pure painting', for an art constructed for 'pure aesthetic pleasure', from the elements of art not nature, and registers Breton's rejection of it.[2] The sentiment is memorably echoed in the opening lines of 'Surrealism and Painting' three years later: 'It is impossible for me to envisage a picture as being other than a window, and my first concern is then to know what *it looks out on* . . . and nothing appeals to me so much as a vista stretching away before me and *out of sight*.'[3]

For the Cubists, with their stress on the autonomy of the art-work, the painting was in the first place a flat material surface on which coloured shapes in paint or some other material were disposed. It was an opaque material thing with its own properties, which only secondarily, by the exploitation of those properties, might become 'transparent'. The refusal of such a view of painting lay behind Breton's and Aragon's criticism of Cubist art as too material, especially Cubist collage, and it reflected the clarity of the division the Surrealists drew altogether between the material and the imagination.[4] For Breton, the picture plane was a window because it was an opening out for the imagination, not because it was an illusionist representation; significantly he did not present it as a mirror held up to the world: it was transparent, not reflective. As an opening out for the imagination it could be only a denial of the fundamental Modernist tenet of late Cubism, just as the window denied the picture plane.

Writing at the end of the sixties, at the apex of post-1945 American Modernism, William Rubin characterized the '*programs* of Dada and Surrealism' as 'historically, a major interlude . . . of reaction against the main premise of modern art, which was in the direction of the *increasing autonomy of art as such*'.[5] Certainly in France, between 1917 and 1928, Dada and Surrealism represented a reaction against what has been established here as the Modernist stance of late Cubism and its aspiration towards 'pure painting', a conscious reaction. The pursuit of chance and automatism challenged Cubism at the level of process by setting aside invention and talent, and hence the primacy of the artist/subject. The pursuit of the image as a release for the imagination challenged the Cubist work in itself, exposed its limitations and threw into question the desirability of its autonomy.

The actual way in which the Dada or Surrealist image did this in painting is revealed in the clearest light by its relationship with poetry. The Cubists asserted the autonomy of the painting or sculpture by separating it increasingly from literature, thus to differentiate its material properties and potential. Mondrian, Van Doesburg and the non-objective artists drawn to Constructivism made as clear a distinction. The Dada and Surrealist painters or poets asserted the freedom of their images from material constraints by bringing painting and poetry together. There could be few more explicit refusals of the Modernist stance than the attempt to make a species of literature from visual images.

* * *

Ironically, of course, it was Cubism itself in its multifarious, expansive pre-1914 existence, before its distillation into its late form, that provided the impetus towards a fusion of painting and poetry. Breton, praising Picasso the Cubist, picked out the 'VIVE LA' of his 1914 still life (Plate 259), and it was precisely that kind of verbal injection into painting which led the way, echoed (again ironically) by Apollinaire's injection of visual shape as sign into poetry with the calli-

287. Max Ernst, *Dans une ville pleine de mystères*, 1923–4. Oil on canvas, 25½ × 20½ in. Baron and Baroness J.B. Urvator, Brussels.

grammes. As a Cubist or Orphist Picabia had used during 1913 and 1914 suggestive, sometimes cryptic titles written into the work to add a verbal dimension, and it was this practice, adapted from the Cubism of Picasso and Braque, which lay behind the complementary use of word and image that he developed in *291*, *391* and Dada.[6] Between 1914 and 1919 Parisian Cubism drastically restricted the use of words in painting and so underlined the independence of Cubist visual art from literature; at the same time, Picabia developed a kind of image whose meaning was totally dependent on words.[7] He was not alone in this: Jean Crotti did so too, in New York, and so with enormous sophistication did Duchamp;[8] but Picabia was the one to do so most noticeably as a Parisian Dadaist.

Jésus-Christ Rastaqouère begins with Picabia's assurance that he will not speak of cats or ears or this or that, and the

complaint that 'there are nothing but specialists' in the world. 'Specialists', he writes, 'separate man from the rest of men.'[9] By the time he published that central Dada piece in 1920, he was firmly established as the reverse of a specialist. For Gleizes he was a painter whose short-term nihilism and easy life had turned him against painting;[10] for Breton he was a poet.[11] Simply by being a poet-painter whose visual and verbal work fed off one another he struck effectively enough at the divisions of specialization, but it was in his decision to make words an integral, indeed a vital part of every visual image he published or showed that he undermined those divisions most effectively of all.

It was in his illustrations for *291* in 1915 that Picabia initially set up his verbal attack on the autonomy of the visual image, arriving at the basic principles he was to apply in all his visual work through into the early twenties. As has been seen, his decision to use the ready-made, mechanical diagrams or retouched photographs (of fans, lamps, sparking-plugs, etc.) (Plate 61), was directly related to Duchamp's a year or so earlier, and it had a comparable anti-art purpose. Specifically, however, its ironies were most damagingly directed against the creed of pure painting, which had reached a pre-war climax in Paris. The one great prohibition of that creed,

288. Francis Picabia, *Portrait of a Young American Girl in a State of Nudity*, drawing published in *291*, nos 5–6, New York, July-August 1915.

as promoted most notably by Apollinaire, had been the imitation of nature: the artist should present not represent.[12] In the *291* illustration *Portrait of a Young American Girl in a State of Nudity* (Plate 288) Picabia imitates nothing, but what he presents is a routine graphic representation of a sparking-plug, apparently unchanged except for the title. The visual image does not merely reflect this verbal accompaniment, it *requires* it, for the title totally transforms it, becomes the sole source of illumination. The contact made between the sparking-plug and the idea of a nude American girl is instant.

Earlier in *291* Picabia had reduced the relationship between image and title virtually to a formula in a passage which gently subverts the Apollinairian plea for the self-sufficient art-object: he wrote of the work as an object certainly, but one to which the title gave 'subjective expression'; in his memorable phrase, it became literally: 'the appearance of the title'.[13] It was this reverberation between the visual image (the ready-made, banal or meaningless representation) and verbally triggered connotations that Picabia was to explore with infinite variations in all the mechanomorphic drawings and paintings, from the cover images of the first issues of *391* in 1917 (Plate 61) with their verbally directed exploitation of visual punning, to *Child Carburettor* (Plate 62) with its more cryptic inscriptions shown in Paris at the Salon d'Automne of 1919. And when, early in 1920, he was interviewed with Dada in full spate and *Child Carburettor* still a recent memory, the formula of the 1915 statement in *291* still guided what he said. He spoke of 'giving to the diagrams we draw, to the words we align, a symbolic sense, a value of expression . . . which lasts only for the very instant we use it'.[14] This later statement, with its accent on the arbitrary and the transient, added the new Dada ingredient: the meaning of the words and hence the image was inevitably lost, he said, once the work was complete, and in a sense the work was thus erased by time. Certainly, the hidden references to his passion for cars and the embryonic results of his passion for women contained in the inscriptions of *Child Carburettor* were lost, until tracked down only recently by William Camfield.[15] Its meaning, like that of the early mechanomorphic portraits or later Salon provocations was quickly erased.

It was especially from Picabia, and especially from the covers and illustrations of *391*, that the subversive fusion of the verbal and the visual gained impetus in the Dada work of Ernst in Cologne alongside Baargeld and Arp. This is most obvious in the early 'clichés' made by Ernst from wood-block diagrams of stage machinery, like *Hypertrophic Trophy* (Plate 63), where the ready made, diagrammatic source comes closest to the *391* mechanomorphic works. But ultimately it was Picabia who showed the way to the contradictory combinations of automatic text and gouache or watercolour assisted collage that dominated the Paris exhibition of May 1921. Ernst's position, however, as a favoured member of the *Littérature* group, even when still based in Germany, gave his particular attempt to make word and image operate in conflict or together a special importance. It was most of all he who made possible a clearly Surrealist fusion of painting and poetry.

Undoubtedly the most significant of Ernst's engagements with literature in the brief period between Dada's climax and Surrealism's emergence was his collaboration with Eluard. They first collaborated, as already mentioned, on the publication in 1922 of *Répétitions*, actually being able to consult together only during the six days that Eluard stayed in the Ernst's Cologne flat in November 1921. In this case Ernst simply supplied newly made collages and Eluard placed them with the texts.[16] The second collaboration was for *Les Malheurs des immortels*, also published in 1922, and here the partnership was much more active, even though it mostly took place by

correspondance between Cologne and Paris. This time Ernst would produce texts to complement his collages which he would send to Eluard for revisions and additions; he was, in fact, a poet too, and there was a genuine exchange between visual and verbal images.[17] Recent analyses of the texts of *Les Malheurs* have revealed that Ernst's contributions (for instance, in 'Les Deux Tout', the first and final paragraphs) were markedly Dada in flavour, tending to disrupt and not to refer directly to the accompanying collages, where Eluard's (for instance, the second paragraph in 'Les Deux Tout') were more proto-Surrealist, tending to enhance the collages.[18] Where Eluard responded to the visual image, Ernst confronted it. The result, in a sense, was a verbal collage *alongside* the visual collage, with Eluard providing the link. However contradictory Ernst's approach, the prose-poems are thus to be read as verbal illustrations in a way not allowed in *Répétitions*—verbal illustrations which are sometimes intensely visual in quality.

Undoubtedly the Dada event that gave the highest public profile to the attempt at confusing the roles of painter and poet was the Salon Dada, originally planned by Picabia and Tzara as a dissident alternative to the Indépendants of 1921 but actually held that June in the 'Studio' of the Théâtre des Champs-Elysées. Ernst's collage *Bicyclette graminée garnie de grelots* was shown, but it hung amongst a bewildering array of objects and 'works' contributed by writers as much as painters (Tzara, Aragon, Soupault and Péret were all exhibitors), and painters became writers for the catalogue.[19] Tzara had consciously sought such a dissolution of divisions and that Cubism was a target was signalled at the top of one catalogue page by the simple message: 'Jesus (56×76) is a grape (50×65), he is really pretty.'[20] It was a message Picabia would have endorsed, but unfortunately, though he had led the way into the confusions of the Salon, by the time it opened the Byzantine internal politics of Dada in decline had forced his exit from the enterprise.[21]

Picabia's *291* formula for the fusion of word and visual image could be seen almost as a schematic variant of the Reverdian and the Bretonian idea of what constitutes a poetic image: to bring a sparking-plug and a young American girl together as he did in *Young American Girl in a State of Nudity* was indeed to bring together 'distant realities'; but Picabia's unrelentingly inconsequential Dada stance would not allow what he produced ever to be taken too seriously for long as 'poetry'. He could not have provided an early model for the painting of the 'marvellous', for, that is, a *Surrealist* fusion of poetry and painting. It was, as indicated, Ernst's role to do so. Breton had been the first of the *Littérature* circle to see his collages as 'marvellous' and to oppose them to Cubist collage, Eluard had been the one to work with him, but Aragon was the first clearly to articulate the Surrealist view of his art as visual poetry; he did so in a text, long unpublished, of 1923.

Aragon's text took in all Ernst's production of the previous three years, but its focus was on the collages and it took further Breton's view of them as the obverse of the Cubist collage. 'Collage', he writes, 'becomes here a poetic process, absolutely opposed in its ends to the Cubist collage whose intention is purely realist.'[22] Like Breton, he notes how, for the Cubist, the postage stamp or newspaper is a fixed element of reality around which to manipulate form, and contrasts this with the illusory character of Ernst's collage elements and his skill in making them part of a total new illusion. Ernst becomes a 'painter of illusions'; not of reflections but of illusions which *transform* given reality, making every object relative in a new way. He becomes an image-maker whose working process is 'absolutely analogous with that of the poetic image', and, as such, the target of those who think only of form, for whom his is nothing but 'Intellectual painting,

literature'.[23] For Aragon, simply by virtue of its capacity to generate images, to bring distant realities together, Ernst's art had become poetry. He appreciated the 'little poems' that accompanied the works, but the implication was clear: for him Ernst had only to make his collages or to paint to be a poet.

<p style="text-align:center">* * *</p>

'Our ambition', wrote Masson in 1972 of Miró and himself in the rue Blomet, 'was to be painter-poets . . .'.[24] If Miró is to be believed, Masson and his writer-friends (Leiris, Tual, Limbour, Artaud, Salacrou and Desnos)[25] led the way in this enterprise. The painting of both of them during 1923–24 often carries clear signals of their growing pursuit of meanings beyond 'the plastic', and sometimes these are so couched as to convey at the same time, irresistibly, their impatience with Cubist notions of purity. Masson's *Man with an Orange* of 1923 (Plate 289) and Miró's *Portrait of Mme K* (Plate 290) are enough to show just how they could convey such a pursuit in terms so directly hostile to late Cubism.

Man with an Orange was painted at about the time that Masson was with Leiris and Salacrou at Plestin-les-Grèves in Britanny (summer 1923).[26] It is a self-portrait, and Lanchner has brought out brilliantly how the still life elements around Masson, the sitter, have become his attributes in what is a metaphysical view of himself, the artist.[27] What she has not pointed out is that almost all these elements were associated with the then commonly received idea of the Cubist still life, and that their very evident new metaphysical function in itself made manifest an act of denial. The fruit, the orange, is at the centre of the composition, as so often in the Cubist still life, and Masson might have remembered that Raynal had chosen specifically the orange to dwell on when he talked of the idealization or conceptualization of the real in 'Quelques Intentions du cubisme'.[28] But here, as Lanchner remarks, rhyming makes it an echo of the suns that 'spill forward to touch the artist's temple', it is held like an orb, corresponds to the globe, and by its nature 'as palpable fruit to fertility and life'.[29] The artist's head is hemmed in on either side by wooden set-squares, the one on the left placed amongst palette-like curves. These are, patently, the instruments of Cubist structuring (especially in Gris), and to some extent such instruments have helped structure this very painting; their heavily stressed wood-graining, further, brings to mind the Cubist *leitmotif* of wood-graining.[30] But here they are not stable and inactive symbols of order: they plunge downward from the sky, one virtually piercing the artist's neck, and this suggestion of violence is intensified by their very obvious rhyming relationship with the knife on the table. This knife is still, but recently it has been used to cut the loaf of bread on the right; its potential for wounding is not in doubt. In the centre of the table are cards; but the other dimension, always there behind the cards and dice of Cubism, comes to the fore: the dimension of chance. This is not a Cubist image of the artist (the Cubist self-portrait was, anyway, rare).[31] Masson is not in control, he is instead subject to larger forces: even the set-squares have been taken out of his hands, and soon they would be altogether replaced by the knife.[32]

Miró too saw the potential of the knife on the table. The knife figures prominently and actively in his sketch-book still lives, where it peels a pear, slices an apple in two and pierces a pip (Plates 130 and 131). But in the *Portrait of Mme K* it is not so much the items of the Cubist still life that are made to act against the ideal aestheticism of Cubist painting, it is the very instruments and elements of Cubist structure: once again, the set-square and its product, the geometric armature. Not only in the figure paintings of 1924 did Miró use the regulating lines of Cubist and Purist painting as frameworks

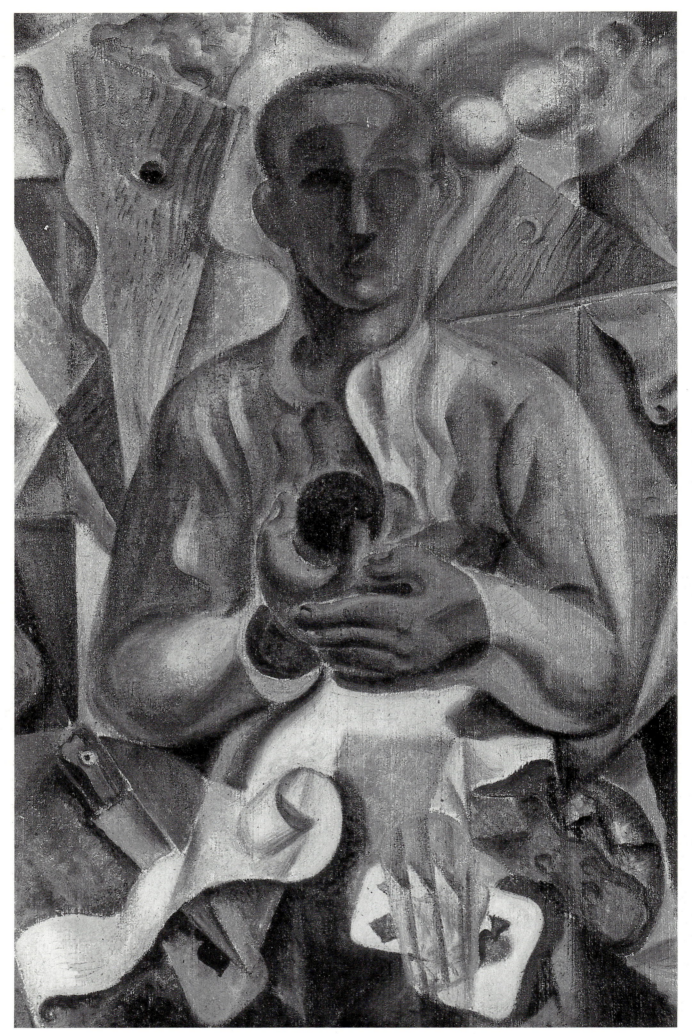

289. André Masson, *Man with an Orange*, 1923. Oil on canvas, $31\frac{3}{4} \times 21\frac{1}{2}$ in. Musée des Beaux-Arts, Grenoble.

290. Joan Miró, *Portrait of Mme K.*, 1924. Oil and charcoal on canvas, 45¼ × 35in. Collection, Mme René Gaffé.

on which to suspend male and female parts, but also in works like the *Portrait of Mme K* he transformed Cubist geometry with acutely subversive results by absorbing it into his erotic image of female sexuality. One breast is a compass-drawn circle that rocks on the end of a ruler-drawn line, but most decisive of all the very sex itself, framed by its fringe of pubic hair, is a set-square triangle, pierced by the usual thumb-hole just where the aperture would be. To those (no doubt including Masson and Miró) for whom Plato's eulogy in *Philebus* of forms drawn with ruler and set-square had become a Cubist or Purist cliché, this was a hilarious confusion of meanings.[33] Masson remembers Miró saying: 'I will break their guitar';[34] what he most carefully and conspicuously set up to shatter, in fact, was Cubist geometry. And he did so by absorbing it into his vocabulary of erotic signs.

There is a further, well-known point about Miró's and Masson's move into Surrealist painting to be made here, since it underlines the literary character of their enterprise: it is the guidance given by the example of Paul Klee. Masson discovered Klee through reproductions in a German book on the artist bought on the quays, probably in 1922. It was he who introduced him to Miró.[35] Both saw in Klee's art, as Lanchner crisply puts it, 'instinctive content married to a semi-Cubist syntax, and it was a revelation'.[36] If Masson's automatic drawings are a response, partly, to Klee, Miró's *The Hunter (Catalan Landscape)* (Plate 133) is much more obviously so (Plate 291). Yet, fundamentally more important than the

291. Paul Klee, Perspective of a Room and Occupants (exhibited as *Chambre spirite* at the Exposition de la peinture surréaliste, galerie Pierre, 1925), 1921. Pen and ink, 13¾ × 9⅞in. Klee-Stiftung Kunstmuseum, Bern.

superficial similarities of vocabulary between Miró and Klee is the fact that Klee was so manifestly a literary painter, and, like Ernst, a German literary painter. He endorsed Masson's and Miró's ambition to be painter-poets, that was his deepest importance to them.

In October 1925 the galerie Vavin-Raspail held an exhibition of Klee's work; the Surrealists were thrilled, and a month or so later four Klees were included at the galerie Pierre exhibition of Surrealist painting, amongst them a work entitled on this occasion *Spirit Room* (Plate 291). Maurice Raynal's reaction in *L'Intransigeant* to the Vavin-Raspail show might almost have been a reaction to Ernst, Miró or Masson: it sums up the distance between the aspirations to a painted poetry in Surrealism and the Cubist aspiration to aesthetic purity:

> there is [here] neither painting, nor drawing, nor plastic effort, but a compromise between literary and pathological aims presented by means of the language of painting. This could attach itself as logically to literature as to music, but above all it signifies the revenge of German sentimentality on the latin lyricism of Cubism, the return of German romanticism and, altogether a reaction which seems a little premature and too artificial.[37]

Miró's second Parisian one-man show took place, of course, also in 1925 in anticipation of both the Klee and the Surrealist exhibitions. Despite the fact that he had been the Catalan's mentor on his arrival in Paris, Raynal wrote not a word on the Mirós shown there in his *L'Intransigeant* column, so what precisely he thought cannot be known; perhaps he saw that here was an even more dangerous threat than Klee and thus that silence was the better strategy.

* * *

If the visual rhyme in Gris's synthetic Cubism was the distilled Reverdian image given pictorial form, the visual rhyme made metamorphic was the disruptive Bretonian image given pictorial form. Such at least was the case in the art of Masson and Miró between 1923 and 1927. Just as the fragmentary process of collage brought together 'distant realities' in Ernst's work before 1923 to give it, for Aragon and Breton, the force of poetic image-making, so the fusions of distant realities achieved in Masson's and Miró's work afterwards was what made it 'poetry' in the special, Surrealist sense of the word (for poetry, in Surrealism, was, of course, the image). Miró brought together fruit, a fish and a woman to make *Nude* of 1926 (Plate 300); Masson brought together a flame, a bird, a pomegranate and a woman's torso to make *The Armour* (Plate 263). Within the ambit of Surrealism the very processes of collage composition, metamorphosis and automatic mark-making were inherently poetic.

It has been shown in the last chapter just how clearly the Surrealists related automatism of the word to automatism of the mark, leading to the virtually literal absorption of the word into the mark with the generation of Miró's *Oh! Un de ces messieurs . . .* (Plate 279). It was, however, not so much the word and mark robbed of their habitual denotational usage that allowed the most striking exchanges or connections between Surrealist poetry and painting, it was rather the capacity of verbal images to stimulate visual images and vice-versa. The visual character of much of the imagery in *Les Champs magnétiques* has been mentioned, and this was again so of Breton's automatic images in the text of *Poisson soluble*; but these were predominantly not images actually stimulated visually—they were in fact visual images that emerged from a verbo-auditive automatic process: words themselves are the stimulus. Later Breton was to give priority

to such a process as the production of 'the most inspiring visual images' in automatic writing.[38] Yet, Surrealist writers could and did respond verbally to Surrealist painting, and when Surrealist painters actually used verbal images in paintings they too tended to use the visual as the generator.

Ernst's and Eluard's verbal response to the collages of *Les Malheurs des immortels* has already been discussed (especially Eluard's), but this was just one early instance of what became almost a minor Surrealist genre from 1924: the poem written in partially automatic response to a visual image. In a sense, Breton's and Desnos's preface for the Surrealist exhibition was an anthology of such responses to the whole range of works shown, and Masson's paintings especially stimulated poems: both Leiris and Artaud were thus inspired and so was Eluard, whose 'André Masson' published in the fourth number of *La Révolution Surréaliste*, pulls together responses to several Masson images.[39]

Masson, however, produced no picture-poems. It was left most of all to Ernst and Miró to *write* as painters, with Ernst leading the way. Ernst's collage captions, as has been seen, were written in contradiction to his visual images, but in 1923 he produced titles, occasionally verbal accompaniments and a couple of elaborate picture-poems in which his writing directly responded to his visual images, most obviously with the coloured words that swerve in and out of the Chirico-esque space of *Dans une ville pleine de mystères* (Plate 287) to make a verbal equivalent of the painted scene. Miró's sketch-books tend to indicate that for him too the visual was usually the generator of the verbal in the case of his picture-poems, and incidentally they show him editing as a poet far more than he edited as a painter in the dream pictures. The inscription 'Oh! Un de ces messieurs . . .' obviously followed the signs for the 'messieurs' in its original Catalan form in the sketch (Plate 286). But, most important of all, the poem written for *Le Corps de ma brune* (Plate 278) as obviously followed the simple visual image, for in the sketch-book a schematic study without words (except colour notes) appears alongside the final drawing for the painting which has the poem written in (Plates 292 and 282).[40]

'Oh! Un de ces messieurs qui a fait tout ça' has the tone of a line from Jarry, and the poem of *Le Corps de ma brune* reflects the imagery of Apollinaire's *L'Enchanteur pourrissant*, as Rowell has shown.[41] Miró the writer was, in his picture-poems, distinctly the representative of a poetic tradition, one that he further defines in his recollections of his reading in these years. He talks of 'gorging' himself on 'poetry principally in the tradition of Jarry's *Surmâle*', and Masson adds as passions of the Catalan's Lautréamont, Rimbaud, Mallarmé.[42] The tradition was, of course, that which the Surrealist poets had constructed and to which they had attached themselves.

It could be said that Masson's and Miró's conspicuous structuring of their work, and the way they occasionally, as it were, left set-squares in their pictures, signalled a kind of relationship with that ordered, French notion of tradition to which Raynal applied the epithet 'measure'. It was, however, as will now be very clear, a doubtful relationship indeed, one that amounted to a derisive renunciation of the self-sufficient aestheticism identified with that notion of tradition shared by Raynal, Salmon, Vauxcelles or Florent Fels, by both Gris and Derain. For the images these geometric structures supported and contained were, of course, deeply disruptive of the aesthetic. It was, in fact, specifically through the anecdotal or *poetic*, the extra-aesthetic character of their imagery that Masson and Miró made positive contact with a notion of tradition, and that alternative notion was the tradition erected and sustained first by the *Littérature* group within Dada and then by the Surrealists. If their painting

292. Joan Miró, *First Sketch for Le Corps de ma brune*, c.1925. Pencil, $4\frac{3}{4} \times 3\frac{1}{4}$in. Fundació Joan Miró, Barcelona (no.568).

was, for the Surrealists, to be treated as if poetry, it was to be seen inevitably as the continuation of a *literary* tradition above all.

Breton's plan in 1922 for a Congrès de Paris, which would draw together the factions of the avant-garde, from Léger and Ozenfant to himself, and which would consider the 'new spirit', can seem an enterprise of retrenchment. In reality, it was geared towards the future and his break with Dada, and so went with a far from conservationist view of the past. 'What this is about', Breton wrote in his appeal for co-operation, 'is, above all, opposition to a certain routine devotion to the past'; he dismissed the need for a 'return to tradition' and expressed instead a 'desire . . . to be placed at the beginning, outside the known and the expected'.[43] Yet, the *tabula rasa* imperative of Dada came increasingly to be balanced by the acknowledgement of precursors, and the Surrealism of the Manifesto came increasingly to be identified with lines drawn from the past.[44]

Besides the repeated celebration and publication of selected heroes, the *Nouvelle série* of *Littérature* made two particularly complete references to such lineages in 1923. There was first the mock theatrical sketch 'Comme il fait beau', signed by Breton, Péret and Desnos, which opens with two monkeys and a leaf-insect, deep in a tropical forest considering a genealogical tree. The tree bears the following names: Sade, Nouveau, Chirico, Hegel, Vaché, Labaudy, to which one monkey directed by the other adds: Lautréamont, Henri Rousseau, Roussel, Nero, Apollinaire, Mongolfier (the baloon-ist), Freud, Rimbaud, Jarry and so on.[45] Then second, there was the bemusingly entitled 'Erutarettil' cluster of names printed in various types and sizes in the October 1923 number, where, again, Sade, Rimbaud, Lautréamont and Jarry were given prominence.[46] In Breton's Manifesto and his selection of topics for *Les Pas perdus*, in Louis Aragon's selection of his 'presidents of the republic of the dream' for *Une Vague de rêves*,

and in the successive numbers of *La Révolution Surréaliste* another tradition was undoubtedly sketched in; and looked at from the outside both Dada and Surrealism were continually being attached to lineages. The Dada manifestos and events of 1920 did not prevent Jacques Rivière from writing of Dada in the *Nouvelle Revue Française* as a continuation of an approach to language that stretched back through the poetry of Rimbaud and Mallarmé to the Romantics; and Edmond Jaloux placed Breton's Surrealist Manifesto in line with Novalis's *Fragments*, Poe's *Marginalia* and Coleridge's *Kubla Khan*.[47] It could not, in fact, be denied that it *was* a continuation, and Breton asserted as much loudly and often, though the tradition he claimed for his own had not the exclusively Romantic shape discerned by Jaloux, and gave Mallarmé a relatively minor role. What is more, like Salmon's or Raynal's view of pictorial tradition or, even more, like the radical view of Mondrian and Van Doesburg, it did not provide models to imitate, it was not an invitation to look back; rather it provided the impetus to move on by drawing lines which could be extended. Neither its shape nor its influence was in any sense conservative, and, perhaps most important, it stood actively against all the closures operated by the nationalist idea of a French tradition.

The shape of this tradition might never have been absolutely clear, and its heroes might never have been secure, but among the most secure in the twenties were Rimbaud and Lautréamont, whose role in the development of automatism has already claimed our attention. It is significant that Reverdy believed both to be grossly overrated by Breton, Aragon and Soupault from before the beginning of *Littérature*. For him, and the poets broadly identified with the Cubist stance, Mallarmé and Apollinaire were of infinitely greater importance.[48] In a sense, during 1916 Breton had rejected Mallarmé *for* Rimbaud, and after 1917 Apollinaire had steadily diminished in importance for him. As he put it in his Barcelona lecture of 1922: 'The only interest in Apollinaire is that he appears to some extent [to be] the last poet, in the most general sense of the word,'[49] Automatism, for Breton, produced poetry, it was not the poet composing poems as literature who produced poetry. Jarry too, as a professional literary figure, though greatly respected for the creation of Ubu, was similarly reduced in importance, by comparison, in the Barcelona lecture.[50]

It can, then, be said that within the Surrealist idea of tradition in the mid-twenties, the corollary of Rimbaud's and Lautréamont's heightened status was a relative shift of interest away from Mallarmé, Apollinaire and Jarry. Others whose status was relatively high and secure were Reverdy himself (despite his Cubist stance and other sympathies), along with such nineteenth-century figures as Baudelaire, Poe and Gérard de Nerval, while a special regard was reserved for de Sade, the Raymond Roussel of *Impressions d'Afrique* and for the recluse Saint-Pol-Roux (to whom Breton dedicated *Claire de terre* in 1923).[51] Further, it has to be stressed that the Surrealist idea of tradition was not exclusively oriented towards either literature or fine art, and so extra-literary texts or personalities were easily absorbed into it, notably the texts of Freud, the 'Gothic' novels of Monk Lewis and Mrs Ratcliffe, the epigrams of the ancient philosopher Heraclitus, and the abstruse writings of the hermeticists and the alchemists (Camille Agrippa, Lulle, Flamel and Hermes Trismegistus are all included in the 'Erutarettil' cluster). Besides having little to do with 'high culture', many of these heroes were, of course, foreign: Freud stands out (specifically attacked in France for theories that appeared the very antithesis of the lucid, rational positivism of French thought),[52] and so too do the Gothic novelists (equally alien to the Latin ideal).

Before actually looking at the work of the painters in relation to Surrealist writing and to the writers of the Surrealist tradition, a warning needs to be sounded about the difficulties of such an exploration. This is by no means the first attempt: there are major precedents, particularly in Carolyn Lanchner's study of Masson, and in Margit Rowell's contribution on Miró to the catalogue *Magnetic Fields*. The latter most clearly illuminates the difficulties. Here in several important instances Rowell presents particular Miró dream pictures almost as illustrations of specific literary texts. That she tends to go too far in these analyses has been brought out by the evidence of the Miró sketch-books. A single example can suffice to make the point.

Besides convincingly relating the poem of *Le Corps de ma brune* (Plate 278) to Apollinaire's *L'Enchanteur pourrissant*, Rowell develops an extended parallel between the visual imagery of the work and Saint-Pol-Roux's poem 'Les Deux Serpents qui burent trop de lait' from *Les Reposoires de la procession*. She points to Saint-Pol-Roux's use of the phrase 'ma brune amante' as a telling coincidence and then relates the two white forms of the painting to the opaque white presences—like serpents that have drunk too much milk—of the poem; she even claims that Miró actually 'illustrates' the passage where the 'snakes' loop their tails around the shoulders of the loved one.[53] Now doubt is induced by the fact that the first sketch for the picture (Plate 292) has the woman to be coloured not white but at least partly in green (which seems to have led to the simile in Miró's poem: 'comme une chatte habillée en vert salade'), and it also becomes clear in the lines of Miró's poem excluded from the final picture and included in the second drawing (Plate 282) that the two flaming circles on the right are not breasts, but eyes. The excluded lines run: 'flamme de ses yeux / phosphorents / tombant comme de la / grêle. . . .'. 'Comme de la grêle' only, was kept for the painting. The phosphorescent flames of these eyes, falling like hail, touch the torso to the left, and it is at least plausible that this all-white imagery led to the change in the salad-green clothing for the torso to white, whispy nudity. Altogether the drawings relegate the reference to Saint-Pol-Roux's poem at best to a loose, fragmentary association.

What this and other examples show is the danger of too exclusively and completely interpreting particular works in terms of particular poetic sources;[54] it is not simply that further evidence can throw up new reasons for doubt, but that the nature of Surrealist painting makes such comprehensive references unlikely, the more so the more automatic the work, and this applies to Masson and Ernst as much as Miró. By its very nature, the open-ended generation of visual images through rhyme and metamorphosis tended to produce only *partial* reflections of the literature in which these artists were immersed: a glancing, sometimes blurred, often multiple evocation of half-remembered verbal images, like the fragmentary reflections of Rimbaud and Lautréamont that Marguerite Bonnet has brought out from under the surface of 'La Glace sans tain' in *Les Champs magnétiques*.[55] The most useful approach, therefore, is likely to be one that avoids the attempt to look for *complete* reflections or visual illustrations, and that looks, as Lanchner has done with Masson, at broad themes thrown up by the echoes. The more comprehensive and specific approach suits only one relationship, and that is not strictly speaking a literary one: the relationship between Surrealist painting, especially Ernst's, and sexual imagery in Freudian psychoanalysis.

* * *

Aragon's 'Max Ernst, Painter of Illusions' contained the following injunction to spectators of the collages: 'Treat these

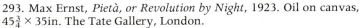

293. Max Ernst, *Pietà, or Revolution by Night*, 1923. Oil on canvas, 45¾ × 35in. The Tate Gallery, London.

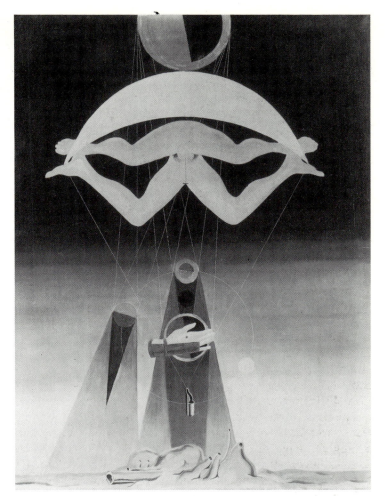

294. Max Ernst, *Of This Men Shall Know Nothing*, 1923. Oil on canvas, 31⅞ × 25⅝in. The Tate Gallery, London.

drawings as dreams and analyse them in the manner of Freud. You will find in them a very simple phallic meaning. The point is that in diverse respects Max Ernst is a primitive.'[56] Written in 1923, it was an injunction that applied to virtually all Ernst's work from the early collages to that point, and certainly it applied (if in a very blunt, unsophisticated way) to such current works as *Pietà, or Revolution by Night* (Plate 293) and *Of This Men Shall Know Nothing* (Plate 294). Ernst's childhood 'vision in half-sleep' provoked by a mahogany board was (it has been seen) an invitation to Freudian analysis, with its image of the father as artist equipped with a phallic pencil that becomes a whip, the father who himself becomes a spinning top. As published in *La Révolution Surréaliste* in 1927, it did not merely lend a special autobiographical significance to Ernst's myth of the discovery of *frottage*, it became itself one event in a larger myth, a mythical autobiography, whose first complete outline was traced in *Au delà de la peinture* in 1936.[57] Here autobiographical recollections, chosen, it seems, for their potency as the data for psychoanalysis, mingle with references to the over-determined imagery of his works, so that his art is absorbed into his autobiography and the two are offered up to a particular kind of response and understanding.

The visible traces of de Chirico and a collage practice lent Ernst's Dada work an aspect congenial to Breton, and so, very quickly, did the way this and the paintings of 1921–24 were made appealing to the psychoanalytically aware. The emergent tradition of psychoanalysis that went back through Freud to Charcot had, of course, given an important impetus to the practice of automatism alongside the impetus given by Rimbaud and Lautréamont, and had indeed acquired a strong Surrealist complexion. But for Breton and his allies, as for Ernst, the point of psychoanalytic practices was not the systematic diagnosis of complexes; for both they produced fresh and marvellous images, and at the same time a new

kind of mythic autobiography, most obviously of all in either verbal or visual dream narratives.

Just as there are difficulties in linking Surrealist painting to poetry so there are in linking it to psychoanalysis. The most obvious difficulty here is one common to all iconographic interpretation: the ease with which the possibility of making a particular interpretation can be confused with the intentional. This is especially problematic in the case of possible relationships between Ernst's collages and collage paintings of 1921–24 and Jungian psychoanalytic themes, since there is no solid evidence to document so early an involvement with Jung on Ernst's part, and since the crucial text, *Symbols in Transformation*, was untranslated and therefore unavailable to his French audience as a route to possible interpretations.[58] Of his involvement with Freud's case histories and theories, however, there is no doubt, and the question of prior knowledge is not problematic: he had read *The Interpretation of Dreams* and *Jokes in their Relation to the Unconscious* at least as early as 1913.[59] Yet, even in the case of Fruedian interpretation there are difficulties, as Elizabeth Legge's recent work brings out with new clarity, most prominent of which are the temptation to attach simple unitary meanings to composite over-determined images and the more insidious temptation to see Ernst's work as real rather than mythic autobiography, to use it for amateur diagnosis. As Legge points out, his images are multi-valent and his sophisticated use of them is too manipulative for us to read from them credible 'latent' meanings.[60]

Between 1921 and 1924 Ernst created a whole repertoire of images that opened up a variety of possible angles on Freud's view of the Oedipal predicament: paternity takes on various forms (most obviously monstrous in the bull-headed *Elephant of the Celebes*), as does the theme of the displaced Oedipal desire for the mother and ultimately for a return to the womb. This repertoire of images comes together in the

most condensed way in a sequence of works of 1922–23: one of the collages from *Répétitions* (Plate 255), its painted relative *Oedipus Rex* (Plate 254) and *Pietà, or Revolution by Night* (Plate 293). The collage conceals a cryptic Oedipal reference, since the hand holds a machine for piercing the feet of birds (a source revealed by Werner Spies), and it has been noted elsewhere that Oedipus was cast out lame by King Laius, and that the word *oedipus* in Greek means swollen foot.[61] In *Oedipus Rex* itself both the pierced walnut and the birds' heads are obviously over-determined images of great potency, the one open to connotations with penetration and at the same time the womb, the other to both phallic and paternal interpretations; and, further, the entire sense of scale is linked to childhood memories (Freud saw gigantic figures as characteristic of such memories in *The Interpretation of Dreams*).[62] *Pietà, or Revolution by Night* deals far more blatantly with the theme of the father and (Legge has suggested) that of the son's concealed desire for the mother, while Ernst's later biographical outlines have provided a suitable mythic autobiographical framework for its psychoanalytic appreciation: his recollection of himself at five years old painted by his father in the guise of the Infant Jesus.[63]

The question of just how far the works of 1921–24 were actually *designed* for Freudian analysis is impossible to answer, but, as Legge has established beyond doubt, a degree of conscious direction lay behind their imagery: as autobiography they were *meant* for a knowing audience, specifically for that made up of Breton and his friends, Ernst's most energetic champions, and the most enthusiastic early owners of his work. *Of This Men Shall Know Nothing* was dedicated to Breton, and the poem that went with it, so geared to this kind of analysis, was obviously written for him.[64] The possibility that these were the illusionist representations of *simulated* dreams was not, of course, a problem for this special audience, as Aragon confessed so disarmingly in *Une Vague de rêves*; what mattered was their *belief* in them as dream images.

Autobiographies (mythic or not) told by means of dream images available for Freudian analysis were evidently as alien to the doctrine of aesthetic autonomy as painted poetry, and it was this aspect of the works in the Surrealist exhibition that most angered Maurice Raynal in his *L'Intransigeant* column; he writes contemptuously of 'little medical histories' which are 'something other' than painting. As with the transference of poetry into painting in Klee, for him the result could only be dismissed. It was a return to 'anecdote'.[65]

Dream and anecdote as forms of autobiography were far more obviously encountered in Ernst than in Masson or Miró at the galerie Pierre in 1925: *Two Children Menaced by a Nightingale* was among Ernst's contributions and is of course autobiographical in just this way. But Masson's and Miró's work, nonetheless, was often anecdotal, could be read in terms of dreams and was obviously open to elaborate Freudian analysis; it carried clear echoes of Surrealism's involvement in the psychoanalytical.

Sleep and the dream play a more conspicuous role in Masson's paintings of 1923–25; they are directly or indirectly the theme of recurrent images in Masson's pictures in a way not found in Miró. The dormant, dreaming figure is, of course, the central character in *The Sleeper* of 1924–25 (Plate 295) and appears as a severed head in *The Vents* of 1924 (Plate 296). There are instances where sleeping figures are made literally to blend into the merging structure of transparent 'Cubist' planes, as if absorbed in dream into new labyrinthine spaces, full of depths and shadows, where everything is transformed. Such a fusion of the ambiguous, glinting planes of early Cubism with the image of the labyrinth as a dream space was developed

295. André Masson, *The Sleeper*, 1924–25. Oil on canvas, 29 × 23in. Private Collection, Paris.

296. André Masson, *The Vents*, 1924. Oil on canvas, 23 × 31¾in. Galerie Louise Leiris, Paris.

in a particularly overt way in a series of metaphysical figure paintings of 1924, where the figure is set in vaulted interiors derived from Piranesi's dungeon fantasies.[66] It is clear enough in the Cubist architectural setting of *The Vents*.

Sleep and the dream, then, were significant themes in the paintings Masson made alongside his automatic drawings, perhaps carrying the suggestion that his automatism of the mark was, like Miró's, so fecund because he believed it to be the generator in him of dream states; and his ambiguous Cubist spaces were quite deliberately associated with the space of dreams, however distinct they were from the agaraphobic, flood-lit spaces of de Chirico. At the same time, there is no mistaking how available his images were to readings as Freudian symbols carrying deep autobiographical meanings. The most obviously thus available was the picture that acquired the most indelible Surrealist reputation, because Breton bought it at the galerie Simon in 1924, *The Four Elements* (Plate 297). It was, in fact, not primarily a Freudian dream image at all (as will become clear shortly), but it came as close as Masson ever did to a Chirico-esque space, its imagery of birds and giant disembodied hands must have recalled for Breton the symbolism of Ernst's *Oedipus Rex*, the flame which rhymes with the vanishing figure could be endowed with clear phallic significance and the figure could be identified with the unobtainable object of desire. Headless torsos, candles aflame, knives or darts, savage flying fish (symbolic of the

297. André Masson, *The Four Elements*, 1923–24. Oil on canvas, 28¾ × 23in. Musée National d'Art Moderne, Centre Georges Pompidou, Paris, Kahnweiler-Leiris Collection.

phallus, Masson has said] all featured often in the labyrinthine, Cubist architecture of Masson's paintings of 1924–25, opening the way to speculative Freudian analysis.[67]

Between 1923 and 1927 Miró's paintings could never have been received as dream illusions, and yet there is a strong hint that the story-telling pictures of 1923–25 could be linked with the symbols and the landscapes of the dream, for when *The Tilled Field* was reproduced in *La Révolution Surréaliste* it appeared at the head of a series of dream narratives, immediately above the word 'Dreams'.[68] Built up detail by detail through one metamorphosis after another in the sketch-books, *The Tilled Field*, *The Hunter (Catalan Landscape)* (Plate 133) and *The Harlequin's Carnival* were not in any sense representations of dreams, but the way they described with disarming simplicity fantastic scenes, as if setting out on a flat diagrammatic table a new range of toys, was easily associated with childhood memories, just as the toy-like figures of Picasso's designs for *Mercure* set up such associations in the mind of Breton.[69] This flavour of the infantile alongside Miró's obsession with the scatalogical (urinating and defecating) and with the sexual parts of the body naturally opened these pictures up to autobiographical psychoanalytic interpretation. Here too was a range of imagery that could be analysed in the light of dream symbols, as if the displaced products of sexual anxieties whose origins lay in infancy.[70]

Yet, however full a Freudian analysis of Miró's anecdotal works could be made, the fact is that they were set far more clearly for him and the Surrealist audience in a literary rather than a psychoanalytic context. Later Miró himself confessed that he had read Freud, but he was careful to add: 'I preferred to read poetry.'[71] Where Ernst supplied a kind of anecdotal painting above all associated with the dream narratives of case histories, Miró supplied a kind of anecdotal painting above all associated with literary fantasy. In essence, his anecdotal pictures are very simple stories made fantastic by metamorphosis.[72] In principle, both *The Tilled Field* and *The*

Hunter were initially conceived, thus, as simple scenes set for story-telling, and the drawings that lie behind the less elaborate anecdotal pictures of 1925–27 demonstrate that the plainest descriptive sketches of the simplest incidents set them off. Miró jotted down a scene or incident and then made it something else. Behind *The Tilled Field* and *The Hunter* is an elaborate series of transformations; behind the simpler pictures often just one. *Hand Catching a Bird* started with the entire figure of a woman sketched either releasing or catching a bird; a particular sketch-book page shows how the huge enveloping hand of the picture was actually a metamorphosis of that figure, probably seen in a moment.[73]

Broadly this process of using the simply anecdotal as a springboard for the fabulous is comparable with Apollinaire's practice, and, in fact, it is especially the fantasy of Apollinaire that is echoed in the imagery and, most markedly, the magical atmosphere of Miró's more elaborate anecdotal paintings before 1925. There are echoes of Rimbaud, for he too, as he put it in 'Adieu' had 'tried to invent new flowers, new stars, new fleshly bodies, new languages';[74] but the echoes are strongest of Jarry and especially of Apollinaire.[75] Perhaps the most impressive and convincing of Rowell's and Krauss's interpretations of Miró's pictures in terms of specific poetic sources is their reading of the *Tilled Field* as a cluster of pictorial echoes of Apollinaire's *L'Enchanteur pourrissant*, his evocation of the entombed magician Merlin visited by all the beasts of the forest.[76]

Autobiography open to psychoanalytic speculation, anecdote open to fantasy or to Jarry's 'Umour', both these pictorial genres were self-evidently alien to the central tenets of the Cubist stance, and their identification on the one hand with the theories of Freud and on the other with Apollinaire and Jarry underlined their thoroughgoing impurity. Yet, Ernst, Masson, Miró and the other Surrealist painters challenged the aestheticism of the late Cubist stance most profoundly not by painting pictorial autobiography and telling bawdy or fantastic stories in pictures, but by taking into their painting the images and the themes of *current* Surrealist writing along with the *literature* of the 'Surrealist tradition'. It was in this way that Surrealist painting made most visible its status as a 'poetic' phenomenon, that it laid claim most irresistibly to a place in a tradition more of writing than of picture-making, that it demanded most persistently from its audience readings that ignored the boundaries set up by the late Cubist legislators between the visual and the verbal. The rest of this chapter will, therefore, be concerned more exclusively with the literary in the pictorial, and especially with the taking of what was read as a continuing literary tradition with its own major themes *into* Surrealist paintings, so that Surrealist painting could be read thus too.

The major themes that recur in the Surrealist tradition are many, but certain of them presented particularly marked challenges to the themes and principles of Cubism in its distilled Reverdian form: to the Cubists' refusal of the simply sensual, their promotion of the artist as the controlling centre of attention, and their insistence on the primacy of the artwork as a fixed and self-sufficient entity. Those major Surrealist themes that most obviously presented such challenges were the erotic, the theme of inward vision and, linked to it, of impotence, and the themes both of metamorphosis and of liberation. These are the themes, therefore, that will engage us in what follows.

* * *

More than any other source it was the Lautréamont of the *Chants de Maldoror* that gave impulsion to the Surrealists'

early engagement with psychoanalysis, and to Freud's focus on the 'libido'. For Breton, Lautréamont was not simply a pioneer of automatism and the liberation of language from normal usage; in *Les Pas perdus* he took him equally and more far reachingly as a moral example: a release from moral restriction.[77] It was most indelibly of all the savagery and the eroticism thus allowed exposure that left Lautréamont's mark on the Surrealist imagination, nowhere more than in the painting of Masson after 1923.

Violence, with strong sexual undertones, was a central theme for Masson throughout the period; sometimes it carries with it only the faintest reverberation of Lautréamont, but in one recurrent case the echoes are clear indeed. The image of the open wound, often subsumed in that of the open, bleeding pomegranate, only loosely connects, as does the image of the dead bird. But the image of the savage fish with cutting teeth carries unmistakable echoes of the *Chants*, most strikingly, as William Rubin has pointed out, in the first of the sand paintings, *Battle of the Fishes* (Plate 273). Here again there is no question of Masson simply illustrating a scene or a passage, but equally there can be no question that, as he 'found' and then intensified the image, somewhere in his mind were recollected fragments from the shipwreck scene in 'Chant deuxième' where the battle of humans and sharks ends with the mating of Maldoror and a shark.[78] The same echoes are there in *Furious Suns* (Plate 261), where fish (one with teeth exposed) swim among dismembered torsos, and in *Fish Drawn on the Sand* (Plate 275) with its characteristic blood stains. De Sade was to become a major stimulus for Masson especially after he had illustrated *Justine* in 1928, but at first the stimulus of Lautréamont seems to have been by far the most dominant in this merger of the erotic and the savage, and, like Apollinaire and Jarry for Miró, the *Chants de Maldoror* were a discovery he made without Breton.[79]

'The Marquis de Sade, the freest spirit that has yet existed'; Apollinaire's remark from the preface to his selection of de Sade's texts is footnoted in Paul Eluard's eulogy to the Marquis as a great moral revolutionary in 1926.[80] Alongside Lautréamont he was given a formidable reputation within the Surrealist circle, and it is his moral example with Lautréamont's that is felt in Ernst's move towards themes of violence from 1926: the violence of the *Hordes* (Plate 269), but also of bestial copulation in the *grattage*, *Paradise* (Plate 298), and of human sensuality experienced as the threat of animal violence in *One Night of Love* (Plate 268). Yet, the Lautréamont of grotesque metaphors, fascinated by the ugliest of animal features, is a powerful presence in *Paradise*, and there are earlier echoes of the *Chants* to be found in Ernst's work.[81]

Violence, copulation and bestiality often came together in Surrealist images, whether initiated by the dream or by the mark, but Surrealist eroticism was by no means always violent and neither did it always carry the mark of Lautréamont. In painting, as in writing, it often takes the form of a sensual celebration of the human body, and, being almost exclusively male, the subject of this corporeal celebration was most often female. Miró is much more able to ridicule the male than the female: the anxiety-ridden harlequin of *Harlequin's Carnival*, the urinating, defecating man-as-tree of *The Trap*, or any of the Ubuesque males of the dream pictures reduce masculinity to the absurd. Miró could deflate female sexual pride too, but typically his female signs are signs for the caressable, the edible, the sexually desirable. *Mme K* (Plate 290) is not ridiculous; she is a mysterious anthology of erotic signals. *Le Corps de ma brune* (Plate 278) is a floating, softly curvacious image of the just touchable. *Nude* (Plate 300) is the female body for eating, the orange breast ready-peeled, the fish (with leaf vagina) as if laid on a plate. All three are projected onto a ground of infinite spaciousness (black as night in the *Nude*), so that they seem to fill their pictorial world.

The male almost always has a role in Masson's painting, and it is never absurd: he can be victim (as in *Painting (Figure)* (Plate 276)), or transposed into flying-fish aggressor, or, as flame, can be lover. He can even be the erotic centre of attention, as in *Man* (Plate 124). But he too was drawn to the image of the female body as an all-enveloping sensual presence, from the earliest automatic drawings (Plate 260), where the profusion of breasts 'found' in the web of lines endows every curve with a sense of female virtuality, through the 'dream' of *Nudes and Architecture* (Plate 270), to the headless, entirely corporeal female presence in *The Armour* (Plate 263). Again here the eroticism of woman is made almost to fill the space of the image.

From within the Surrealist circle one early manifestation

299. Jean Arp, *Birds in an Aquarium*, 1920. Painted wood relief, $9\frac{3}{4} \times 8$in. Collection, The Museum of Modern Art, New York.

298. Max Ernst, *Paradise*, 1926. Oil on canvas, $23\frac{5}{8} \times 36\frac{1}{4}$in. Collection Paolo Marinotti, Milan.

300. Joan Miró, *Nude*, 1926. Oil on canvas, $36\frac{1}{4} \times 28\frac{3}{4}$in. Philadelphia Museum of Art. The Louise and Walter Arensburg Collection.

of this tendency towards an all-enveloping female formation of the image existed in the biomorphic shaping of Arp's reliefs after 1917; inevitably these carried a residual erotic feminine significance. Indeed, *Birds in an Aquarium* (Plate 299), which was one of the Arps shown at the Surrealist exhibition in 1925, could be read both in terms of its title and as a curvacious figure whose sex is not in doubt. Arp's relevance to Miró is obvious and it is in the context of Arp as well as of Miró that

the looping curves obtained by the dropping of string in Ernst's *grattages* can be felt. Unmistakably they introduce a pervasive, erotic sense of woman in *One Night of Love* (Plate 268) and in its relatives (Plate 135). Picasso too, as honorary Surrealist, made a powerful contribution to the theme; in a sense, his *Woman in an Armchair* of 1913 (Plate 301) was its most important pre-Surrealist pictorial preface of all.

Of woman in the Rimbaud of *Les Illuminations* Breton

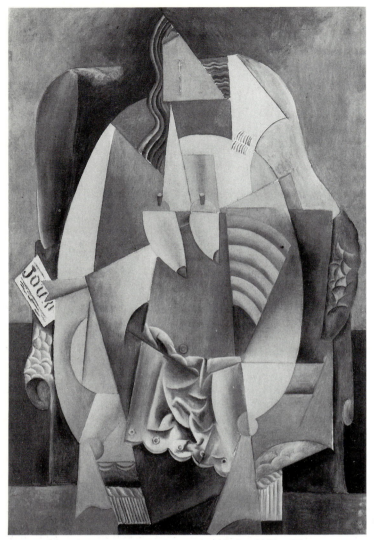

301. Pablo Picasso, *Woman in an Armchair*, 1913. Oil on canvas, 58¼ × 39in. Collection, Mr and Mrs Victor W. Ganz, New York.

wrote thus in the summer of 1920: 'It is simple, he confuses her with everything.'[82] The image of woman as a pervasive, erotic presence had an obvious place in the poetry of the Surrealist heroes from the past, and *Les Illuminations* read thus obviously finds reflections in the paintings of Masson, Miró, Ernst and Picasso. Yet, perhaps most fascinating of all are the reflections to be found there of then current Surrealist writing, and to pick out a few of these is more firmly to under-line how far the painters made visible their claim to the status of the poet, the Surrealist poet. If the faint glints of Saint-Pol-Roux's spectral eroticism in 'Les Deux Serpents qui burent trop de lait' can still be seen in Miró's *Le Corps de ma brune* (Plate 278), then there are reflections just as visible of Aragon's more materialized eroticism in 'Le Passage de l'Opéra', written the year before the picture was painted. Miró introduces the image of his loved-one's hair with the phrase 'ma brune', and from the first sketch the flowing contours of her body could be rhymed with the idea of its locks, though, as demonstrated, it is turned white in the painting, perhaps by the phosphor-escent glow of her eyes. The eroticism of the woman's hair had, of course, the widest of associations with Symbolist and post-Symbolist poetry, but Aragon provides a peculiarly apt analogy for Miró's image in his description of the 'coiffeur pour dames' in the 'Passage de l'Opéra'. 'I have seen the hair unravel in its grottos', Aragon writes, and introduces a passion-ate eulogy to hair thus: 'Serpents, serpents, you always fasci-nate me. One day thus, in the ''Passage de l'Opéra'', I considered the slow, pure rings of a python of blondness.'[83]

This particular reflection centres on a particular analogy or image—that of the female body, hair and the serpent all fused into one; at its most all-enveloping the theme of woman, as we have seen, found expression in a much wider analogy or image, that of the woman and the world (even the universe) fused into one. It is this that Breton saw in *Les Illuminations*, and Bonnet has seen just the same fusion in the poems of 1923 that complete Breton's *Clair de terre*: 'All nature', as she puts it, 'becomes feminine . . . the female body has no limit.'[84] The unbounded eroticism of Masson in works like *The Armour* seems especially to reflect Breton in this vein. And again the Aragon of *Le Paysan de Paris* finds in words images of a limit-less femininity which are reflected thus not only in Masson's painting but also in the dark sensuality of Ernst's *One Night of Love*.

The last section of *Le Paysan de Paris* concerns a nocturnal visit to the suburban park, the Buttes-Chaumont, with Breton and Marcel Noll as companions. There, a park bridge (dubbed the 'Bridge of Suicides' by Breton), triggers in Aragon's imagination the sense of a vast female presence. 'Woman', he writes,

> You take . . . the place of all form. Charming substitute, you are the resumé of a marvellous world, of the natural world, and it is you who is reborn when I close my eyes . . . You are the horizon and the presence . . . The miracle: and can you think of that which is not miraculous, when the miracle is there in her dress of night? Thus little by little the universe dematerializes for me, . . . while from its depths there rises finally an adorable spectre, there is finally traced a huge woman, who seems everywhere, with nothing to separate me from her. . . .

He, the writer, becomes no more than a 'drop of rain on her skin', and finally, with the coalescence of the imagery of woman and sea, it is as if he drowns in her.[85]

Le Paysan de Paris was not published until 1926, though Aragon dates the trip to the Buttes-Chaumont 1924, but the question of precedence is not fundamentally important in recording the reverberant relationship of this verbally evoked episode with the Masson of *The Armour* or the Ernst of *One Night of Love*; the point is that each, the visual and the verbal images, are manifestations of one theme whose antecedents are predominantly literary. Surrealist painting and poetry here could be experienced as one continuous phenomenon, the imagery of one fusing together with the imagery of the other. Aragon's picturing of the erotic in words was not at all distinct from Ernst's or Masson's picturing of the erotic in paint. And this particular convergence of a literary with a pictorial theme was, of course, especially unpalatable to Cubist aestheticism: nothing could more directly have challenged the Puritan severity that so often partnered the Cubist pursuit of aesthetic purity.

* * *

The dominant role of psychoanalytic themes in Ernst's collages and dream illusion paintings between 1921 and 1924 cannot obscure the existence of another important theme with its own recurrent imagery: the theme of inward vision, and, related to it, the impotence of the human will. The window opened by Surrealism was, for Breton, one that opened in-wards, and the price of opening it was the surrender of the power to determine what was seen.

Strikingly, images of inward vision and powerlessness offer an interplay of echoes between a few of the collages and poems of *Répétitions*, an indication of a real meeting of Ernst's and Eluard's obsessions, of a subliminal response to Ernst's visual initiatives on Eluard's part. The cover collage (Plate 302) carries strong suggestions, not just of sexual

302. Max Ernst, cover of the collection of poems and collages by Ernst and Paul Eluard, *Répétitions*, Paris, 1922.

penetration, but of the hand freed from the direction of the mind, and blinding by the piercing of the eye. The woman with birds of the collage accompanying 'La Parole' is headless and as such again an image of deafness and blindness, of a being without a directing intelligence or the more important of the senses. Most obviously Eluard's poems pick up the theme of these images in both the title and content of 'L'Oeil du Sourd', with its inferred meaning—the inner eye deaf to sensation—but it recurs often in the image of the blind man, almost the only character in the poems to move with assurance. The theme of power curtailed and blunted senses returns in both the collages and the poems of *Les Malheurs des immortels* and, in the paintings of 1923 especially, it is central to Ernst. The dead or dreaming alter-ego of *Pietà, or Revolution by Night* (Plate 293), the *Teetering Woman* rocked by mechanisms out of her control, her eyes replaced by sightless tubes, such works are images of inward vision and powerlessness, images which visualize in physical and human terms the inward direction of automatic creation and its pre-condition, the erosion of the will, the individual *subject* to forces.

The Surrealist release of the imagination from the material world could be imagined, then, as a turning-away from the will and a turning-inwards from the world of normal sight or hearing; and Ernst's images of sensory deprivation were reflected not only in the poetry of Eluard, but in the headless

303. Joan Miró, *Person Throwing a Stone at a Bird*, 1926. Oil on canvas, 29 × 36¼in. Collection, The Museum of Modern Art, New York.

or sightless torsos, and the sleepers of Masson. Even Miró gave such images his own form: they are there rendered slightly comic in the one-eyed, one-footed personnages of *The Statue* and *Person Throwing a Stone* (Plate 303), members perhaps of the same family as Apollinaire's 'divine invalid' from *Le Poète assassiné* who had been liberated from the human dimensions of time and space by the loss of an arm, eye, ear and leg, leaving him just one of each, and who could sense thereby eternity. For the Surrealists these were images to be seen against the distant background of Rimbaud's recognition that the poet became a 'seer' only *after* the disordering of the senses. And they complemented the other simpler image of the imagination released: the image of the journey into the unknown (as in Masson's labyrinths) or of falling, of plunging into the depths (as in Aragon's invocation of the legend of Phaeton—'he had the taste for vertigo and he fell'—and Miró's humorous parody of it, *The Somersault*).[86]

The Surrealist notion of creation, however, was not merely one of inward vision, release from control, and the plunge into the depths; it was, of course, metamorphic: a notion of unending change. In 'Surrealism and Painting', attempting to characterize the painting of Masson, Breton brought to bear a quotation from Poe: 'Now, by a singular analogy between natural chemical phenomena and those of the chemistry of the intelligence, it often happens that the meeting of two elements gives birth to a new product which recalls none of the qualities of this or that component, not even any of them.'[87] This applied neatly to the processes of Masson's automatism, where the collusion of lines or sand shapes could produce fish, birds and beings (and incidentally it gave an ironic twist to Gris's use of precisely the same chemical analogy for the Cubist 'synthetic process').[88] But it was also very apt because it reflected loosely another analogy that Breton had drawn with the creative process, one even more profoundly sympathetic to Masson; for it reflected the image of himself as a latter-day alchemist, engaged in the transformation of the 'Prima Materia', an image he had first sketched in the *Introduction au discours sur le peu de réalité* in 1924.[89] The fusion and interchangeability of the elements had already been one of the themes of the poems of *Clair de terre*, and it was at least partly in terms of alchemical images of metamorphosis that both he and Masson himself saw Masson's *Four Elements* (Plate 297), not just in terms of Freudian symbols.

Alchemy was a theme returned to often in Ernst's work between 1920 and 1924,[90] but of all the early Surrealist painters the alchemical analogy had the most central place in the work of Masson. For Masson, however, it was a ramification of another set of ideas which had another source whose impact on him had been early and profound: it was a ramification of the thinking of Heraclitus. Lanchner has summed up Masson's fundamental approach to life thus: it is centred 'on the concept of metamorphosis, the Heraclitan recognition that there is no reality except the reality of change, that permanence is an illusion of the senses; nothing is but is in a state of becoming.'[91] She has further established that this was an approach fixed long before Masson's entry into Surrealism, and has read *The Four Elements* as a key statement of his Heraclitan convictions: 'Fire lives the death of air, and air lives the death of fire, water lives the death of earth, earth that of water.'[92] The flame gives the fire, the flight of the bird gives the air, the waves and the fish give the water, the sphere gives the earth; all were to return, of course, repeatedly in the automatic drawings and related paintings of 1924–26, the fluid metamorphoses so visible in those images far more effectively conveying their infinite interchangeability. The breast as globe, the bird and the fish are all interchangeable in *The*

Wing (Plate 266) as the elements earth, air and water; the globe as breast, the flame and fish of *The Armour* (Plate 263) are all interchangeable as earth, fire and water. Miró, Masson's friend and ally from the rue Blomet days, was clearly affected by his thinking; the neat fit between such ideas and the metamorphic processes at the heart of his painting gave them obvious appeal. The imagery of the four elements is already there to be read in *The Hunter* (Plate 133): the flame as fire, the beach as earth, the waves and the sardine as water, the aeroplane, air; and in a few paintings of 1925 it plays almost as programmatic a role as in Masson's *Four Elements*, most noticeably in *Sand* (Plate 283), with its sail (air), waves (water), sand (earth) and flame-like motif above.

Ernst and Masson, quite independently of the *Littérature* group, seem to have introduced for themselves the imagery of

alchemy and of Heraclitan metamorphosis into their work, but, as has been seen, even before 1924 the alchemists had joined the magician of Apollinaire's *L'Enchanteur pourrissant* within Breton's notion of the Surrealist tradition, and Heraclitus was soon to be absorbed too.[93]

The imagery of alchemical transformation and the four elements is an imagery of creation in the widest sense; it implied inescapably a parallel between automatic creation through metamorphosis and the creation of the world, of life. It is, therefore, directly related to the creation myth theme embodied in Miró's *Birth of the World* (Plate 256), and it is no surprise to find that the imagery of birth, given the widest possible scope, could also be important to Masson as an adjunct to the imagery of the elements in transformation. If *The Birth of the World* has a pendant in Masson's production,

304. Joan Miró, *Catalan Peasant Head, No.1*, 1924–25. Oil on canvas, $18\frac{1}{2} \times 17\frac{3}{4}$in. Private Collection, Paris.

it is in the drawing *Birth of Birds* (Plate 265), which, though so different in scale and medium, is closely related in the character of its well-controlled automatism. Here the birds are born into the air from the parted thighs of woman which merge with the mountains of the earth; and breasts for the feeding of infants have become stars.

There is one final image of creation, found especially in the work of Masson, that requires mention; it is found too, less obviously, in the work of Miró. It is the ultimate consequence of the idea that the imagination released in automatism is creation in its widest sense, the creation of a world, even a universe with all its elements. This is the image of the self seen as if another, absorbed into the total fabric of creation: the image of the self as inseparable from its product, the 'universe' of the painting and hence life altogether. In Miró there is one particularly striking development of this theme: the four versions of the *Head of a Catalan Peasant*, the first and a later one of which are illustrated here (Plates 304 and 305). Though bearded and mustachioed, when seen alongside the static frontality of Miró's earlier 'detallista' *Self-Portrait*,[94] the Catalan peasant of these pictures takes on the significance of a displaced self-portrait opened up into the heavens: an other self which is absorbed first into a universe of teeming creatures complete with volcanic moon, but which at last, in the final version, becomes part of an empty yet pregnant space that stretches 'out of sight'. In Masson the theme is almost as ubiquitous as that of metamorphosis itself. It is already suggested in the self-portrait *Man with an Orange* (Plate 289), but is much more than a suggestion in such pictures as *Man* (Plate 124) or in *Man and Woman* (Plate 274), where the male self is absorbed into the female and both into a universe that is at once air and water.

Again this was a theme with deep roots in the literature of the Surrealist tradition; Gérard de Nerval's accounts, in *Aurelia*,

305. Joan Miró, *Catalan Peasant Head*, 1925. Oil on canvas, 57½ × 44⅞in. National Gallery of Art, Washington D.C.

of seeing himself hugely grown before his own eyes, and of feeling himself tied by a web of magnetic rays to all existence particularly come to mind.[95] Yet, again these pictures are reflective of *current* Surrealist writing too, in their development of these themes. The Breton of *Clair de terre* is once more in tune, but the clearest reflection of all comes from Aragon's *Le Paysan de Paris*. The account of the trip to the Buttes-Chaumont ends with a remarkable flow of images initiated by the idea of the writer's own head severed from his body and tossed away. The head rolls towards the sea while the body 'separated from its thinking' rises to become one with the universe and the stars: 'The man-fountain . . . rose amidst the worlds following his blood. His entire useless body was taken over by transparency. Slowly the body became alight. The blood rays. The limbs were fixed in an incomprehensible gesture. And man was nothing but a sign among the constellations.'[96]

As with the theme of eroticism, the themes of inward vision, impotence, metamorphosis and creation permeated Surrealist painting and writing so fully, so indiscriminately, that they could and were experienced as continuous with one another. To read Breton or Aragon was to 'see' images pictured by Miró or Masson or Ernst, and vice-versa—to 'see' them plainly even if for no more than an instant. And the imagery of inward vision, impotence and creation that traversed Surrealist painting and writing was in every case an imagery that challenged the Cubist idea of creativity and the Cubist heroic ideal: the artist-creator.

*　　*　　*

Ernst, and especially Miró and Masson, were all in their different ways drawn to the imagery of captivity and liberation, and the theme of liberation was, of course, bound up with every other aspect of their activity and convictions as Surrealists: with release from moral restriction, with release from conscious control, with release from the material world and with the release of the imagination. What is more, liberation was often imaged quite literally as the release of the imagination *from Cubism* and so it became the most visible, the most unmistakable sign of all of Surrealism's challenge to Cubist art.

Liberation as a release from Cubism is not, however, a theme in Ernst's art, and indeed he was drawn almost exclusively to images of captivity, where the stress is on the *desire* for escape, not its achievement, and which, ultimately, have no more than a loose relationship with the imagery of captivity and release as it emerges in the work of Masson and Miró. Of such imagery little needs to be said, since it will by now have become familiar enough and specifically in its adaptation of Cubist structures to anti-Cubist ends. Miró's spacious grounds, like limitless skies, were obvious images of liberation in dream and the imagination, which were given specific definition as such by the smudge of blue and the inscription in *Photo, This is the Colour of My Dreams*.[97] His use of Cubist or Purist 'regulating lines' in 1924 and sometimes in 1925 made of them obvious images of control against which to set his elastic metamorphic objects and personnages. In just the same way, the fluid calligraphy of Masson's automatic drawing, transposed into painting, was set as the image of imaginative flow in the tight structures of crystal Cubism, while in pictures like *The Vents* (Plate 296) those Cubist structures were turned into Piranesian prisons. The sand pictures of 1927, like most of Miró's dream pictures, are free of any reference to Cubism or captivity, but still in 1926 those references remain in *The Haunted Castle* (Plate 264). By the mid-twenties Cubist structures were highly effective images of pictorial restriction and control; the metaphor of the prison had come

easily to Roger Allard in his attacks of 1919,[98] and came easily again to Masson five years later.

It was in this way that the surface facture and particularly the structures of Cubism actually became a *poetic* component in early Surrealist painting (the richest irony of all), for they could be adapted as the signs of a generalized material, intellectual and artistic captivity against which to set the signs of Surrealist freedom: graphic mobility, flight and weightlessness, and, most complete of all, the image of unbounded space. Like the imagery of eroticism and creativity, such an imagery of liberation carried clear reflections from the literature of the Surrealist tradition: reflections of the imagery, again, of the journey without end (in Laforgue, Apollinaire, Saint-Pol-Roux or the Rimbaud of *Le Bâteau ivre*), reflections too of Mallarmé's unattainable spiritual 'azur'. But once more it best establishes the degree to which Surrealist painting could be read as poetry within a continuing poetic context to pick out a few of the reflections of *current* Surrealist writing, and it seems appropriate to end with Breton. The poems of his *Clair de terre* provide images enough.

Along with metamorphosis and the erotic, liberation is a central theme of these poems, and it supplies a stream of images that find echoes in the work not only of Masson and Miró but now and again of Ernst too. In 'Le Volubilis' Breton offers a cage where kisses become birds and 'the wing of flights' (Ernst's cages and Masson's *Wing* are instantly to be 'seen'). In 'Mille et mille fois' the lines: 'My construction my beautiful construction page by page / House intensely glazed open to the sky open to the earth', are a very exact picturing in words of the opened-up Cubist structures of Miró and Masson.[99] And perhaps most striking of all, there is the image in 'Angelus de l'amour' of eyes that have been blind-folded with the bandage of the sky. Breton's metaphor of painting as a window with a view 'stretching out of sight' was, after all, such an image of freedom, and perhaps it was in direct response to him that Miró wrote on his canvas in 1925: 'This is the colour of my dreams.' The poem 'Il n'y a pas à sortir de là' begins: 'Freedom, colour of man.' For Miró, it was the blue of the sky, a blue only rarely inscribed within a window-frame, a blue beyond 'architecture' (especially Cubist architecture), a blue without bounds.[100]

19
Dada and Surrealism: 'Plutôt la vie'

It was in February 1920 that *391* made Gleizes and Cubism its favourite targets, and it was with an accurate aim that Georges Ribemont-Dessaignes wrote there as follows:

> Now hope is turned towards the people . . . Animated . . . by good intentions, [the social revolutionaries] claim to pull the people from their spiritual sleep, and lift them as far as Art. And by Art, they understand serious Art, great Art, which is to say the ensemble of aesthetic religious rites . . . that extract the laws of harmony and equilibrium from the rustling of the autumnal wind in the hair [of the auto-suggestive] . . . The people are led to abstraction.[1]

Gleizes, *the* populist Cubist, was to be ridiculed above all for his populism. In December 1926 Breton published 'Legitimate Defence' in *La Révolution Surréaliste*; it was to some extent a reply to a request for Surrealist collaboration from Henri Barbusse, the literary editor of *L'Humanité*. Barbusse had asked for ideas suited, as he put it, to 'a great proletarian newspaper destined to illuminate and instruct the masses . . .'[2] Breton refused, partly because of Barbusse's literary stance as such (that of a story writer dedicated to stylistic innovation), but also because Breton could not compromise. He made clear his regret at the wide gap between the products of Surrealism ('what is thought') and the 'mass of men' in Western culture, but he would not write to 'seduce'.[3] Neither Dada nor Surrealism was anti-élitist in any simple sense, and within both there was a profound suspicion of the popular.

That this should be so, followed naturally from the intense subjectivism of both movements, just as it followed from the individualist focus on invention in the Cubist circle. Significantly, Van Doesburg's Constructivist emphasis on popular impact went with his and De Stijl's very different focus on shared, *objective* truths. 'Everything is nothing but intra-personal', Picabia wrote in his open letter to 'Monsieur Lenormand', and it is the Picabia of this statement and of 'instantanism' who most effectively encapsulates the special character of Dada anti-populism in his 'art' and his writings. If a single visual image sums up best of all the élitism of Dada, it is *L'Oeil cacodylate* (Plate 251) as it was shown at the Salon d'Automne in 1921. On canvas it immortalized a clique, a tight group of friends around the wealthy, fabulous focal point of Picabia, and many of the inscriptions it gathers together could only have been understood in 1921 within this group or by those who closely followed its activities: the fact that 'Paul "Z" final Dermée' is the Dermée of the little periodical *Z*, that 'Germaine' is Picabia's mistress Germaine Everling or that 'Pharamousse' is a well-worn *391* nickname for Picabia himself. Picabia's own 'intrapersonal' world was small and privileged, and the question of understanding simply did not concern him, except as something to dismiss.[4]

It was precisely this contempt for explanations that lay behind Picabia's reply to an interviewer, quoted above, a few months after the showing of *Child Carburettor* (Plate 62) at the Salon d'Automne of 1919, where he stressed the transience of the 'symbolic' meaning given such images by their titles and added inscriptions, and even claimed that almost immediately such meaning became 'unintelligible' to him also.[5] Here in *Child Carburettor* as a result of the sleuthing of William Camfield, we know that the enigmatic inscriptions 'Destruction and prolongation' and 'destroy the future' almost certainly relate to his complicated liaisons with Gabrielle Buffet and Germaine Everling, both of whom expected his children.[6] But again, such meanings were lost to all but those inside Picabia's entourage.

As Dadaist, Breton's broad agreement with Picabia's obduracy towards the popular demand for explanation was clear enough. 'The obscurity of our words is constant',

he wrote in his essay of 1920 'For Dada'. 'The divination of sense must remain in the hands of children. To read a book in order to acquire knowledge is to manifest a certain simplicity . . . The poets who have recognized this flee the intelligible. . . .'[7] The key to Breton's and the future Surrealists' attitude to the question of intelligibility and rational explanation lies not so much in their refusal of reason and the objective as in their attitude to language, and especially in their insistence that words must be freed from the restrictions of normal usage before the image will emerge. It is, therefore, integrally related to their exclusive stress on automatism, since the freeing of words or marks from sense was its prerequisite. It is no coincidence that 'For Dada' contained Breton's first reference to automatism.

Picabia's hermeticism and Breton's insistence on the sense-lessness of words actually come together most closely of all in the oddest of ways, in the article 'Words without Wrinkles' published by Breton in December 1922. The article just followed the showing of Picabia's abstract watercolours in Barcelona (Plate 250) and just anticipated his series of *Octophone* paintings and the showing of *Volucelle II* (Plate 249) (their close relative) at the Indépendants of 1923. The 'Octophone' of Picabia's paintings referred to a machine which purported to translate variations of light into sound, thus making theoritically possible the purely abstract representation of words: the final and total abstraction of meaning from words.[8] Breton seems to have it in mind in his article when he writes of the aspiration to a final liberation of language: 'It is by assigning a colour to vowels that for the first time . . . one will divert the word from its duty to signify. On that day it will be born as a concrete fact. . . .'.[9] It is at least feasible that the title *Volucelle* is a distortion of 'voyelles' (with the 'y' replaced by 'luc', inferring 'lux', light), and that a particular area of lost meaning,[10] known to Picabia and Breton, related to the conversion of vowels into colours and thus the final liberation of words from signification.[11] The accord between the Dada hatred of sense and Breton's basically Surrealist view of language would find no better expression if this were so.

It was, of course, such a view of language that gave impetus to Duchamp's and Desnos's word-games from late 1922, and these were the major pretext for Breton's 'Words without Wrinkles'. There is no surprise in finding it indissolubly linked with a continuing sense of separateness from the wider public in the early days of Surrealism. Thus in April 1925 Antonin Artaud introduced his account of 'The Activity of the Surrealist Research Bureau' in *La Révolution Surréaliste* in this way: 'Between the world and us the rupture is well established. We do not speak to make ourselves understood . . .'.[12] As for Reverdy and Raynal in the case of Cubist art, for Breton and the Surrealists the question of the obscurity or difficulty of Surrealist painting for a wider audience was not important even if it might be a cause for regret. The painting of the dream and the automatism of the mark inevitably separated the mark from fixed meaning and the represented element from normal contexts, as the word was separated from sense, and so, just as inevitably, painting narrowed its audience.

* * *

Of the non-objective artists in Paris, Van Doesburg especially did not accept obscurity as the natural condition of his work, and actively sought out an audience, though with a certain tactlessness that went with his confident sense of destiny. The Cubists, with the exception, it has been seen, of Léger and Gleizes, were élitist enough in their unpopularity not actively to seek the response of a wider audience after

the Great War. The Dadas and the Surrealists scorned popularity and understanding, but were extremely shrewd and energetic in seeking public exposure, especially, of course, the Dadas. This was perhaps the most extreme paradox inherent in the approach and the situation of both Dada and Surrealism between 1919 and 1928. Gleizes countered Ribemont-Dessaignes' contempt for his populism in 1920 with the exasperated exclamation a couple of months later: 'These men who say nothing, nothing, nothing are terrified of silence. They cannot live alone. They seek the crowd.'[13]

In his autobiography one of the witnesses of the time, Georges Charensol, treats with some amusement Dada's reputation for scandals. He recalls that the interruptions at the Dada events were few, that the noise was little and that the actions of the police at the Soirée du Coeur à barbe in 1923 (so often invoked in legend) consisted of asking the crowd, as it exited shouting, to mind out for their bikes.[14] Yet, the facts are that there was a good deal of notice given to the 'Premier Vendredi de *Littérature*', however small the room used, that there was a large attendance at the matinée of 5 February 1920 in the Grand Palais and again at the Salle Gaveau in May, and that especially for the Grand Palais Tzara showed enormous flair spreading rumours in the press to get people in (the most notorious being that Charlie Chaplin was to appear).[15] What is more, however exaggerated in later legend the noise at the events themselves might have been, the noise in the press was undeniable and it was heard not only in the literary periodicals like the *Nouvelle Revue Française* or *Les Nouvelles Littéraires*, but right across the popular press from *Comoedia* to *Le Figaro* and *Le Matin*, which later published in July 1920 a whole series of cartoons directed against Dada: 'If the Dadaists! . . .'[16]

Just how greedily Tzara and Picabia sought publicity and just how far they saw it as the real measure of their success can hardly be exaggerated. To Tzara's stunts for the attraction of audiences should be added Picabia's use of *Comoedia* as a platform for his open letters, rebukes to the establishment and provocations of his fellow Dadaists.[17] Both assiduously used press-cuttings bureaus to keep track of their success in generating response and expanding public notice. In 1920 Tzara was as careful to include a short piece ridiculing the obscurity of Eluard's *Proverbe* cut out from the *Journal d'Orient* (published in Galata-Constantinople) as he was to include the articles of the Paris journalists in the mass-circulation dailies.[18] While they made their noise they took time off to listen to it and make certain it would not be forgotten. The point was clear: Dada denied explicable meaning to everything, nothing more than its own products, but its strategy was to use the status of painting and poetry with their public outlets to fashion this denial into a weapon of 'demoralization' and so to spread its impact as widely as possible. Within Dada, therefore, the paradox of obscurantism married to a desperate search for audiences was in the end at once extreme and very simple.

Breton, Aragon and Eluard (the original core, along with Soupault, of the *Littérature* group) received the best of training in public relations from Picabia and Tzara, and as they moved away from Dada during and after 1922 they used it energetically. From the beginning Breton's Congrès de Paris was a plan given a high public profile with an announcement in *Comoedia* (3 January 1922), and a great deal of the conflict that followed, leading to its collapse, took place on Picabia's old stage.[19] *Littérature* itself may have had a small circulation (something Breton seems to accept with some nonchalance when interviewed late in 1923),[20] but its group behaviour remained distinctly extrovert, a contradiction which was to continue when *La Révolution Surréaliste* appeared with its

carefully contrived, unwelcoming look of a serious scientific periodical. Surrealist extroversion, however, *was* different from Dada's. Aragon's activities in 1923 as editor of the weekly *Paris-Journal* can hardly be considered as aimed at a mass audience: the paper had been bought by the impresario Jacques Hébertot in the autumn of 1922 as a broad-sheet to be sold to the audiences of the Théâtre des Champs-Elysées with the programmes, and its policy and public were made clear enough with the announcement that it would 'address itself to the élite: to those who wish regularly to be kept in touch with the literary, musical, artistic and theatrical movement of our times in all countries'.[21] After 1923 Surrealist extroversion, by contrast with the far larger popular ambitions of Dada, was aimed fairly exclusively in this direction: at penetrating the 'élite' audience for those brands of 'modern art' that were already respectable, a significant proportion of which was often to be found at the Théâtre des Champs-Elysées. The noise of the *Mercure* incident in the summer of 1924 was given its press outlet, significantly, in *Paris-Journal*, and, though Surrealist press releases ranged further, the movement's public relations policy for painting centred on the exhibitions of 1925 (Miró and especially 'La Peinture Surréaliste'), and afterwards on sympathetic dealers as a means of exposure (the galerie Pierre, Camille Goemans and the galerie van Leer), and on their own galerie Surréaliste. They wanted an audience and they wanted a response, but they rarely looked outside the existing public for *l'art vivant*; their refusal to encourage comprehension or explanation was, in fact, more easily reconciled with their particular restricted brand of extroversion than in the case of Dada.

Yet, however socially restricted their activities, the Surrealists *were* positively concerned with public awareness and to an extent beyond that of the Cubists and their supporters. What is more, the Surrealists could be seen to cultivate two key qualities of a modern art and a modern literature in search of an audience: the comic and the surprising, both, of course, crucial Dada qualities, and both excluded by the Cubists (those in the circle of Léonce Rosenberg, especially Gris and Lipchitz, had placed great stress on the avoidance of the 'monstrous').[22] Picabia's 'new laughter' and Jarry's 'Umour' were still factors (notably in the painting of Miró), and so was Apollinaire's notorious statement: 'Surprise is the most modern resource which one can use';[23] for Breton, the comic and the surprising were both sustained by the still influential myth of Jacques Vaché. Both were factors that followed from the very nature of the Surrealists' notion of the image, and therefore had an internal justification: surprise, the 'unprecedented', was built into the 'marvellous', the shock of a new rapport between 'distant realities'; and the comic came, like the image, from the sudden bringing together of the previously unrelated, as Aragon noted in his Surrealist appreciation of the Exposition du Concours Lépine.[24] Yet, both surprise and the comic remained latent without an audience; they *required* a response. In their extension from Dada into Surrealism was continued the Dada notion of the painting or poem as a gesture.

If the object of Dada's encouragement of a wide public awareness was to spread demoralization, the object of the Surrealists' cultivation of an audience was altogether different; ultimately it was positive. Something of the feeling from which it came is captured in this passage from Aragon's *Le Paysan de Paris*:

Men live with their eyes closed in the midst of magical precipices. Innocently they manipulate black symbols, . . . I will not speak of the unthinking use of mirrors, of obscene drawings made on walls, of the letter W used today without

wishing ill, . . . of the Morse code, whose name alone gives reason for reflection.[25]

It is a passage uncannily reminiscent in all but its substance of Le Corbusier's article 'Eyes that do not See', which had been absorbed into the propaganda tract *Vers une architecture*, and its point is clearly the same: the eyes of men must be opened. They must be opened, however, not to the functional geometric beauty of factories or motor-cars, but to the marvellous everywhere and in everything. Most importantly of all, those at the core of the Surrealist group saw the work of poetry or of visual art in this light. These were not self-sufficient objects of aesthetic delectation or embodiments of some absolute underlying truth, and neither were they just disruptive gestures, they were rather exhortations to all who read or saw them to 'see' the marvellous for themselves, to liberate their own imaginations from material restriction through dream and automatism, like the poets and the painters. Aragon, Breton and the others wanted a complete change in the way the world was seen, indeed known, no less; poetry and painting were their vehicles, and therefore, however inadequately, they sought a public for them.

* * *

Writing on Lautréamont and *Les Chants de Maldoror* in 1920, Breton pondered the question of 'a poetic morality', and was led to the assertion that it would be 'an error to see art as an end'. He went on: 'The doctrine of "art for art's sake" is as reasonable as a doctrine of "life for art's sake" seems to me senseless. One knows nowadays that poetry must lead somewhere.'[26] The underlying meaning of this famous passage, reprinted in *Les Pas perdus*, is revealed by a couple of letters written by Breton to Aragon and Théodore Fraenkel in 1919. For in these letters he identifies poetry as a kind of 'publicity', a means of *spreading* demoralization, and confesses that this will be the 'Death of art [for art's sake]'.[27] The sheer scope of his ambition as a Dadaist for such an art of 'publicity' aimed at demoralization emerges from another passage in the essay on the *Chants*: 'I believe that literature shows signs of becoming for the moderns a powerful machine for beneficially replacing the old ways of thinking.'[28]

With the shift that took place after 1920 to a Surrealist emphasis on the positive qualities of the marvellous, it was inevitable that this view of art as a vehicle should be attached to the positive purpose of advertizing the benefits of the marvellous. But it remained a view of art actively set against the Modernist ideal of 'art for art's sake' (even if that is an over-reductive description of the Modernist stance), something which is effectively conveyed in an amusing sequence from Aragon's 'Passage de l'Opéra'. Here 'Imagination', personified, is set in confrontation with the personifications of 'Sensibility', 'The Will' and 'Intelligence', and introduces himself thus, like a quack healer selling his wares:

I have brought you today a hallucinant from . . . the frontiers of the abyss. What have you searched for in drugs till now if not . . . the free exercise of your faculties in the void? The product I have the honour to present you achieves all this, it achieves also huge, unhoped for benefits, it exceeds your desires . . .; have no doubts, it is the enemies of order who spread this phial of the absolute. They secretly smuggle it under the eyes of the guards, in the guise of books, poems. The anodine pretext of literature allows them to give you at a price defying all competition, this mortal brew . . .'[29]

If for Mondrian and Van Doesburg art was the instrument of spiritual transformation, for the Surrealists, Surrealist

works were still ultimately vehicles 'for replacing the old ways of thinking', though in a very different way and with a very different end. They were exhortations to others to release *their* imaginations, delivered by exemplary, liberated individuals. Surrealist art and poetry were to be seen, as the 'marvellous' finds made by a few who lived their lives with a complete acceptance of their subjective isolation (by contrast with Mondrian and Van Doesburg), and a complete dedication to the power of the imagination. What Breton had written in 'Clearly', as he turned his back on Dada, still held true for the Surrealists after 1924:

> Poetry, which is all in literature that has ever smiled for me, emanates as advantageously from the life of men, writers or not, as from what they have written . . . We are hindered here by a great misunderstanding, life, as I see it, being not . . . the ensemble of acts finally attributable to an individual . . ., but the manner in which he seems to have accepted the unacceptable human condition . . . It is still, I do not know why, in the fields neighbouring on literature and art that life, thus conceived, tends towards its true fulfilment.[30]

Art came of a certain approach to life, and ultimately its object was the wide dissemination of that approach to life.

Bound up with this exhortatory view of the poem and the painting was the Surrealist view of morality and political action. To see art as an extension of life carried back into life, and to see the work as a kind of publicity was not fundamentally to challenge Dada attitudes; to see a positive goal for art and for living in the discovery of the image obviously was, and to make this the basis for definitive moral judgement was to do so in the most direct way. It will be remembered too that Raynal particularly, in his more elaborate analyses of the Cubist stance, made a point of *separating* the pursuit of beauty and inventive freedom in art from questions of morality; for him, such questions applied exclusively to life as lived not to art.[31]

Tzara's and Picabia's opposition to morality (any morality) and judgement (any judgements) was implacable. Picabia carefully capitalized the following epigram in *Jésus-Christ Rastaqouère*: 'THE JUSTICE OF MEN IS MORE CRIMINAL THAN CRIME.'[32] It was entirely appropriate that the first irreversible step in the split between the *Littérature* group and these two should have been Breton's plan to carry his hatred of conventional morality as far as a programme of mock trials, the first and only one of which was the Barrès trial, held on the evening of 13 May 1921; conventional, moral standards might have been the target, but inevitably by implication, other standards which were their opposite were elevated, standards for behaviour that always allowed the unrestricted action of the imagination priority.[33]

When three years later the *Manifeste du Surréalism* appeared the moral problem could be expressed somewhat differently, but essentially the attitude of Breton and his friends remained the same. The dimension introduced, of course, was automatism, and with its emergence as the central focus came another slant on the question of moral responsibility. Thus, in the Manifesto Breton reflects on the hypothetical case of a Surrealist brought to trial for the 'illicit' character of his automatic effusions. His point is neat: since the Surrealist is merely a humble 'recording device', noting down what is presented to him, he is actually not responsible. And the implication is plain: if the Surrealist is not responsible, but his discoveries are of ultimate importance in freeing humanity from the material and from the trap of reason, then he is not answerable to any moral code and he has a moral duty to resist any form of moral restriction.[34]

But the argument of irrelevance, the Surrealists knew well, would not have gone far in any existing court of law, and by contrast with Breton's neat dream of cases dismissed, Aragon in 'Le Passage de l'Opéra' imagines a time when 'savage' laws are passed and the 'propagators of Surrealism are broken on the wheel and hung, the drinkers of images are shut up in chambers of mirrors'.[35] Existing morality was, they knew, a formidable enemy, and had to be fought; hence, for them, the importance of the moral tract and the moral gesture aimed not just against the existing codes but *for* its possible alternatives. That is what Aragon's article 'Free for You' was, with its argument against the notion that individual liberty is limited by consideration for the liberty of others, and its plea for total, *un*limited individual freedom.[36] The statement signed by most of the group in 1927, 'Hands off Love', was in the same way a moral tract, and Ernst in particular, of the painters, could turn poetry and painting into an anti-Christian gesture, from such poems written with Eluard as 'Entre les deux poles de la politesse' in *Les Malheurs des immortels* to *Pietà, or Revolution by Night* (Plate 293), to, most spectacularly of all, *The Virgin Correcting the Infant Jesus before three Witnesses (A.B, P.E, and the Painter)*, published in *La Révolution Surréaliste* in 1926.[37]

If Lautréamont by example made a necessity of the Surrealists' plea for a new view of morality in relation to the imagination, it was de Sade especially who came to provide a model for its sober articulation. It was in the same number of *La Révolution Surréaliste* as Ernst's *Virgin Correcting the Infant Jesus* that Paul Eluard published his 'D.A.F. de Sade, Fantastic Writer and Revolutionary', quoting de Sade's anger against the sexually ordinary and his rhetorical questioning of a morality which excluded anything out of the ordinary.[38] Eluard moves towards the conclusion of his piece thus: 'For having wished to give back civilized man the force of his primitive instincts, for having wished to free the amorous imagination and for desperately struggling for the justice of absolute equality, the marquis de Sade was shut up almost all his life in the Bastille, at Vincennes and at Charenton.'[39]

Man Ray, Yves Tanguy, Georges Malkine, Arp, Ernst and Masson all signed 'Hands off Love', the Surrealist reply to the popular moral recrimination directed against Charlie Chaplin for the scandal surrounding his divorce in 1927, but, besides Ernst, the painters played only a peripheral part in the moral campaigns of Breton and his friends. The fact remains, however, that within the context of Surrealism their art was identified with such a stand *against* the restrictive and *for* the unbounded imagination, and the explicit erotic imagery of all their work coupled with the periodic savagery of Ernst's and Masson's inevitably opened it to censorious challenge and was sustained by the aggressive solidarity of the Surrealist position. Furthermore, painters were not free from the moral strictures and condemnations that followed from that position: de Chirico stood condemned by Breton most of all as a moral coward.[40]

The Surrealist desire to free the imagination from existing morality was the counterpart of its very special attitude to and engagement with extreme political activism. French Dada was a leaderless, directionless, and hence apolitical revolution; and this was so of Breton as a Dadaist.[41] At the outset, in the first year of *La Révolution Surréaliste*, it was this generalized sense of the revolutionary social implications of the Surrealist moral stance that prevailed. Revolutionary action was simply *any* action against the social and moral status quo. It was the results of such a supra-political revolution that Aragon envisaged when he wrote in 1924 of a time when Surrealism would have left the universities 'deserted', the laboratories 'closed', the army, the family and the professions gone.[42]

And again, it was such a hyperbolic, unreal vision that Robert Desnos presented in his 'Description of a Revolt to Come', which begins with a plea to the barbarians of the East who destroyed Rome and Athens, Thebes and Memphis, and which ends with the dream of a new 'Terror' where all the enemies of the Revolution would be wiped out from Léon Daudet and the Maréchal de Castelnau to Jean Cocteau.[43]

This supra-political atmosphere of visionary revolution expressed itself too in a specific hostility against the communist position which continued until late 1925. Already it has been seen how such a hostility, with its communist target clearly defined, was manifest in the Surrealists' rejection of work, for instance in Breton's 'The Last Strike'. Fundamental issues were raised thus: most importantly, not so much the antithesis between the communist ideal of heroic labour and the Surrealist ideal of effortless discovery, as the division between the Marxist stress on material wealth and the Surrealists' exclusive desire for the liberation of the imagination from material considerations. The latter was a sticking-point of disagreement that would remain, but at the end of 1925 developments briefly made it seem inessential, as the Surrealists' supra-political revolutionary stance was diverted all at once in the direction of the communist periodical *Clarté* and the Communist Party.

The story has been well told by Maurice Nadeau and needs only a brief résumé here.[44] The Surrealists' opposition to the Moroccan War left them with only the communists as political allies, and especially the revolutionary communists of *Clarté* led by Jean Bernier and Marcel Fournier. The immediate result was the manifesto, signed by a large grouping of Surrealists and communists: 'Revolution Immediately and Always', which appeared in *La Révolution Surréaliste* on 15 October 1925.[45] This conveyed a new sense of solidarity between the groups, and recorded a distinct shift of emphasis among the Surrealists towards a communist view of the pre-eminence of *social* revolution (not spiritual). There followed a period of collaboration between the Surrealist and *Clarté* groups, with plans for a new periodical and contributions to each others' periodicals. But, though Breton accepted the sheer scale of the Russian Revolution as evidence of the efficacy of Lenin's and Trotsky's ideas, and though he accepted the prime need for change to improve living conditions globally, he did not accept that the Surrealists should disengage from their spiritual revolt. The result at the end of 1926 was a challenge from Pierre Naville that the Surrealists should recognize that such individual action as theirs was insignificant beside the 'disciplined action of class struggle', followed by Breton's reply, 'Legitimate Defence'.[46] Here, at last, Breton clarified his position, a position independent of the Communist Party even though he was to join it within a month.

In the heart of his reply, Breton sets up the central question as Naville had asked it: 'Yes or no, is this desired revolution that of the spirit *a priori*, or that of the world of facts? Is it linked to Marxism, or to contemplative theories, to the purification of the interior life?'[47] For Breton, the antithesis is false, both revolutions are desired and possible. His support for Marxist revolution is complete: 'There is no one among us who does not want the transfer of power from the hands of the bourgeoisie to those of the proletariat';[48] but so is his championship of what for Naville is its opposite: 'It is no less necessary, in our view, that experiments in the interior life are pursued and these, be it well understood, without exterior control, even Marxist.'[49] The merger of the two revolutions he considers at least conceivable, but for the moment only ideally so, and therefore they are to be pursued without compromise, in parallel. It is a stance, as noted, oddly close to Van Doesburg's and even Mondrian's.[50] To his conclusion

Breton adds a final, vital series of reflections on the most profound cause of his disaffection with the Communist Party position: the antithesis between materialism and Surrealism. He dismisses out of hand the materialist panacea of technological progress, and, though he accepts that three-quarters of the world's population live by wages and are exploited by capital, he cannot accept that this is the 'determining cause' of the state of things. There is another cause, he declares, and it is in the state of men's minds, actually in their obsession with the material: 'What we are unable to allow, I say, and it is the entire subject of this article, is that a rediscovery of man's equilibrium, broken, it is true, in the West, as a result of his material nature, can be hoped for by agreeing to new sacrifices to his material nature.'[51]

Both Ernst and Masson signed 'Revolution Immediately and Always' at the end of 1925, and there are broad analogies to be drawn between their attraction to themes of violence after that date and the imagery of revolution. In particular, Ernst's *Horde* paintings of 1926–27 (Plate 269) can appear a celebration of the general notion of a revolt initiated by barbaric hordes from the East. What is more, again, as with the moral question, all Surrealist painting was inevitably identified with the revolutionary political stance of Breton and the writers; and this was so of both Arp and Miró, for instance, even though they kept aloof from political statements or action, and were not among the signatories of 'Revolution Immediately and Always'. To figure in *La Révolution Surréaliste*, to be promoted as a Surrealist by André Breton, was inescapably to be identified with Surrealist political engagement, at once by the Surrealists themselves and by those looking in from outside, whether with excitement, horror or fear.

* * *

The moral character and the political engagement of the Surrealist stance are both symptoms of its opposition to the Cubist stance which are particularly significant, for they follow from the single belief at the core of Surrealism which struck most deeply of all at the core of the Cubist stance in its late, distilled form. This is the belief in the essential continuity of life and art, the belief that art and life should become a single undifferentiated search for the marvellous. Only because there was this fundamental sense of continuity did the Surrealists feel the need to act with the ultimate aim of changing society and the day-to-day behaviour of its members. Nothing more radically challenged the Cubist belief in art as the autonomous creation of the artist than this, because the core of the Cubist stance in its late distilled form was, of course, the clearest possible separation of art from life. The total rejection of this constituted the Surrealists' most radical challenge of all to the Cubists, as it did, so very differently, Mondrian's, Van Doesburg's and the Constructivists'.

It was, however, representation with its connotations of materialism that the Surrealists saw as the first victim of their desire to open up the imagination; their rejection of Cubist aesthetic purity partnered an equally total rejection of Naturalism in both literature and painting. Breton began the *Manifeste du Surréalisme* with an attack on every kind of realism: what was merely observed could not be enough: 'Imagination alone accounts to me for what *can be* . . .'.[52] Yet, what the imagination was to discover, the Manifesto declared, *was* a sort of reality, it was not the invented rival to life that art had become for the Cubists: 'I believe', Breton wrote, 'in the future resolution of these two states, in appearance so contradictory, which are dream and reality, in a kind of absolute reality, *surreality*, one might call it.'[53] The dream or the 'find'

was to become as if concrete, indivisible from experiences in everyday life, that was the aim. Modernism and Naturalism were, therefore, equally unacceptable. What Breton aspired to was a state where the imagination could take over the everyday reality of life, so that everything became marvellous. Once again, though the differences are manifold and obvious, the broad sympathy between this view and that of Mondrian and especially Van Doesburg is striking. Aragon set Surrealism against idealism;[54] the strict separation of the ideal from the real was to be dismissed. But Van Doesburg especially, of course, worked from the conviction that the ideal *could* be embodied in the real, and this was the key to his determination to integrate art with life as well.

Breton's aspiration to the 'Surreal' went back to his realization that Ernst found his images *in* the débris of reality, and that de Chirico found another dimension in the ordinary objects he painted. This other dimension in de Chirico Breton had called 'mythical', and he had written of the formation of a 'veritable modern myth'.[55] It was the idea of such a mythology—the discovery of the marvellous *in* the everyday reality of his surroundings—that was the central underlying theme of Aragon's *Le Paysan de Paris*, and this book was the idea's most complete and most sparkling literary expression during the early period of Surrealism. The book begins with the 'Preface to a Modern Mythology' and it is here that Aragon attacks the separation of the real from the ideal; he attacks it both as manifested in Positivism and in idealism. Neither are acceptable. What he wants is a firm basis in the senses (what is heard, smelt, seen), but as a spring-board for the imagination. The senses (however misleading or mistaken) are to become the 'best paths towards an end which nothing but they can reveal'. 'New myths', he writes, 'are born at each of our steps. There where man has lived the legend begins . . .'.[56] Above all the book is a record of what Aragon has found thus, his imagination projected onto his surroundings, in the 'Passage de l'Opéra' and in the Buttes-Chaumont; and what he has found is a seeming fusion of dream and reality, and in the culminating passages of the final section, where he, the writer, becomes absorbed into the universe, a seeming fusion of life and death. This is the significance of his curt statement in *La Révolution Surréaliste* in 1925: 'Reality is the apparent absence of contradiction. The marvellous, is the appearance of contradiction in reality.'[57]

The notion of the image, or the marvellous, was in this way enormously enlarged, so that it no longer entailed merely the coming together of 'distant realities' to create a 'spark', but led the Surrealists to attempt to embrace in their imaginations (when they confronted the phenomenal world) the coming together of fundamental opposites, most fundamental of all: death and life. Though so sceptical of the notion of objective truth, they came close to a belief in some underlying order whose significance was absolute, and, yet again, very broadly, a kind of sympathy between their stance and that of Mondrian and Van Doesburg is revealed, apparent both in the scale and in the dialectical character of this belief. It was the scale of their ambition that led Breton and Aragon to talk of a 'mythology', and it allowed them ultimately to align the effusions of automatism and the dream with those of all visionaries and prophets, something very explicitly to be found in Aragon's *Une Vague de rêves*.[58] It was a perception of an underlying unity in the myths of peoples—a will to reconcile the irreconcilable—that they claimed to see, and they claimed to see it before it is likely they were aware of Jung, and long before the first observations of such a kind made by Claude Lévi-Strauss.

If the deepest belief of the Surrealists was in the essential continuity of art and life as the pursuit of the marvellous, and if their grandest ambition was the discovery of images that seemingly made real the fusion of such fundamental opposites as life and death, the question remains: how far did Surrealist *painting* keep true to that continuity and how far did it aim to achieve so grand an ambition? Much of what is needed to give an answer is in the substance of the last two chapters, it merely requires highlighting here with the help of a little more in the way of observations about the character especially of Ernst's, Masson's and Miró's painting in relation to extra-aesthetic experience, 'life'.

Like Aragon's view of himself in the park of the Buttes-Chaumont living and dead, merged into the universe, so Miró's and especially Masson's images of the self externalized as part of a limitless space took on the largest of the Surrealist themes, though it has to be said that the effect is more of illustration than of apparent materialization. More directly than this, the very process of metamorphosis fused the dead with the living: Masson's pomegranates fused with the guts or genitalia of his figures; the rope with the hair of *The Vents*; then, more strikingly still, the roots, the plants and the still lives ('natures mortes') as torsos, digestive tracts, genitalia and breasts in Miró's family of figures after 1924. The sheer scope of Masson's Heraclitan philosophy of transformative creation, with its alchemical focus on the elements metamorphosed into life through a continual process of birth and death, gave a Surrealist grandeur to the theme of metamorphosis, a sense of universality contained especially clearly in the four element theme. Ernst too embraced the theme of the fusion of living and dead when he moved into the automatism of the mark in 1925, though with less of a sense of its universal scope, for his *frottages* more directly than any other process of automatic discovery entailed the metamorphosis of the dead (wood-graining, cloth, spools of thread) into the seemingly alive.

Yet, certainly when seen in terms of the fundamental antithesis between the Modernism of late Cubism and Surrealism, it was not so much the grandeur of such themes contained in Surrealist processes and images that carried weight; more directly and deeply significant was the relationship between life and art embodied in Surrealist painting, both as act and image. Again, the example of Ernst was particularly direct. Breton and Aragon focused equally on his ability in the collages to take the most ordinary fragments from the débris of daily life and find for them new identities; the basis of the collages was, as Aragon put it, the 'commonplace'.[59] The Cubists shaped such débris to the *aesthetic* demands of the work and, as has been said, affirmed thus its material qualities. Ernst took commonplace *illusions* as givens and stressed their illusionism to create a new, far from factual image; and with the appearance of the wood-engraving collages after May 1921 at times he left the image almost as given. They were starting-points for the imagination and especially for the convincing presentation of the contradictory brought together as if in reality. Illustrations of unicellular creatures, photographs or engravings for popular scientific texts stimulated Ernst's imagination, and what he imagined as a result he made as convincingly realistic as possible with the aid of gouache and watercolour or just of scissors and glue. The aim was to preserve the sense of the imagination in contact with the commonplace, just as that sense of contact was to be preserved in Aragon's *Le Paysan de Paris*. In November 1920 Ernst sent one of the first 'fatagagas' he had made with Arp to Tzara for publication in *Dada*, and wrote thus in the letter: 'Can you have the photographer told to mask the points of juncture in the collages so that the Fatagaga mystery remains whole.'[60] The total preservation of the effect of halucinatory response was the point, as well as the illusion of the imaginary as real.

And again in paintings like *Oedipus Rex* (Plate 254) the effect of the dream was kept whole, the dream too being in itself a commonplace of daily life.

Masson and Miró were not involved with the transformation of the commonplace in collage or dream illusion as Ernst was, but both were transformers of the commonplace. Masson's most obviously Cubist pictures, painted in 1923, can certainly be seen in this light, and so especially can Miró's post-Cubist still lives of 1919–22, culminating in *Table with Glove* of winter 1921 (Plate 86). As we have seen, Miró was intensely attracted to the writing of Apollinaire, and it is in terms of Apollinaire's commitment to the ordinary as a starting-point for poetry that the special poetic character of such a still life can be seen. That character is most evident in the glove, a dominant feature. Rubin has reported that it was picked out because Miró saw how the cold had so stiffened it that it kept the shape of the hand as it lay on the table.[61] Here, prophetically, is a merger of the dead and the living, and one that reverberates tellingly with echoes from Apollinaire's poem 'Les Collines', the lines: 'A top-hat is on / A table laid with fruit, / The gloves are dead beside an apple.'[62] Miró's still life had neither fruit nor top-hat, but the dead-alive glove acts within its context just as forcefully. Breton had already celebrated Apollinaire (in the text which was to appear in *Les Pas perdus*) for his 'gift of enchantment', writing: 'It is only the great poets who can always give radiance to a blade of straw in the stable.'[63]

In the full range of its manifestations automatism of the mark, like verbal automatism, could be seen as virtually continuous with all lived experience; it was after all believed to be, in Breton's words, the 'true functioning of thought'.[64] But the way automatic practices were actually developed in painting between 1923 and 1928 tended always to emphasize the directness of the connection between painting and what was to be seen ordinarily in the painter's surroundings. This was most immediate in the *frottages* of Ernst, with their conspicuous dependence on found materials simply transcribed, and in the sand paintings of Masson, with their direct use of a natural material presented to some extent as in nature, not artfully mixed into paint as so often in the case of Braque. It was also, however, so in the dream pictures of Miró, since the raw material of the most automatic of these (Plates 139 and 256) was, as has been shown, the cracks and stains on the walls of the studio or smudges and marks on paper: in other words, the most ordinary of things *seen*. In Miró's case, though, the covertness of this connection with day-to-day experience does make a significant difference. Miró might have recorded what he 'saw' very directly in his sketch-books and then as exactly as he could transferred his jottings onto canvas, but, unlike Ernst in the collages, he made no attempt to preserve the sense of contact with the real stimulus for his image, with the wall or the sheet of paper. His evocative, sensitively handled grounds create another, immaterial context, which effaces the memory of such beginnings. In this way, he shifted the emphasis towards the retention of the painting as a crafted product; he remained to a marked degree an 'artist', just as Apollinaire (in Breton's mind) remained a 'poet'. Both Ernst and Masson in the editing of their 'finds' remained artists too, but the extent to which they preserved a visible sense of contact with the commonplace beginning of their works in found objects and materials or in sprinkled sand, tended to divert attention from that fact.

Altogether, then, in every phase early Surrealist painting did answer the central Surrealist demand for a continuity between life and art, and did threaten the Cubist insistence on the separateness of the art-object from day-to-day experience, though in differing ways and with differing degrees of em-phasis. Sometimes directly, sometimes indirectly early Surrealist painting did convey the belief that the marvellous was to be found everywhere.

* * *

Just as with the relationship between Naturalism and Cubism, so with that between Cubism and Surrealism the character of the opposition between them is brought out strongly when attitudes not simply to life in general but to *modern* life in particular are spot-lit. Picabia, Duchamp and Ernst as Dadaists developed a generally derisory use of machine imagery, but the machine figured hardly at all in Ernst's *frottages* and *grattages*, and played almost no significant part either in Masson's and Miró's painting between 1924 and 1928. Yet, the modern and the technological was, inescapably, an obtrusive part of even the Surrealists' environment in the mid-twenties, and they too, like the Cubists and the Naturalists, felt compelled to articulate their own attitude to it. Breton and Aragon particularly were responsible for this, and the stance they defined was indeed a special one.

Breton's points of departure were Apollinaire, collage and, most of all, the doctrine of 'surprise' launched by Apollinaire in 1917: surprise, for Breton too, was the essential feature of the modern. For him, however, the modern quality of the surprising was not to be understood as Léger understood it in his eulogies to the 'modern spectacle', it was not to be found in the sudden intrusions of the dramatically contrasting taken on the purely aesthetic level of form and colour; rather it was the surprise created by the 'unprecedented' character of the marvellous, by unexpected meetings on other levels of the contradictory. It was there, for Breton, in everything from Lautréamont's umbrella and sewing machine to Apollinaire's top-hat and gloves in 'Les Collines'.[65] As the 'new myth' in Aragon's *Le Paysan de Paris*, however, it took on at times a very focused, up-to-date and even technological character, almost certainly intended as a direct rebuttal of the idea of the 'new spirit' so influentially spread by the Purists and Léger's machine aesthetic. The way it took up and irreparably distorted that idea is worth dwelling on in quotation.

In the 'Passage de l'Opéra' the hairdresser's apparatuses are celebrated, not as symbols of order or technological precision, but as 'great modern wild animals'.[66] But most remarkable of all is a passage which reads almost as a Surrealist alternative to Léger's celebrations of the modern manufactured object; it comes in the section recounting the visit to the Buttes-Chaumont. Aragon begins, as if an imitator of Léger, by commenting on the incompatibility between traditional symbols and the 'principle of acceleration that governs the landscape today'. He writes of new gods in the countryside: 'great red gods, great yellow gods, great green gods, fixed on the side of speculative routes',[67] and then moves into his own oneiric vision of the new:

A strange statuary presides over the birth of these 'simulacres'. Almost never have men acquiesced to so barbarous an appearance of destiny and force. The nameless sculptors who have erected these metallic phantoms do not realise that they adhere to a tradition as living as that traced by cruciform churches. These idols have between them a parentage that makes them formidable. Garishly decorated with English and newly created words, with a single arm, long and flexible, a faceless luminous head, a single foot and a stomach with numbered disk, the petrol pumps have sometimes the fascination of Egyptian gods . . . Oh Texaco motor oil, Echo, Shell, inscriptions of great human portent![68]

Again, the image fuses the living and the dead, the machine is anthropomorphized and then deified, but the 'god' is new: *another* 'new spirit' is exploited. The materialism of modern technology, like everything else, is the source of the marvellous; it is simply a new kind of marvellousness, whose irrational, visionary character makes a striking contrast with the order and reason of the Purists' new spirit.

<div align="center">* * *</div>

Modern life, the new spirit, had its place, then, in the Surrealist view of art in relation to life, a special place. In fact, so continuous could the relationship between art and life seem according to the Surrealist understanding of things that the everyday and the modern could become not merely a supplier of the marvellous and therefore of poetry, but itself the equal of art. Léger exhibited manufactured objects when he spoke on the machine aesthetic in 1923, but he could never think of a gear-box or a sparking-plug as an adequate replacement for art: they remained 'raw material'. Breton, Aragon, Eluard and the other Surrealist writers, like Picabia and Tzara in Dada, saw the private surprises of life as often the equal in significance to poems or paintings, and could see them thus *as such*, not as raw material. This was the furthest extreme that their stance took them from the ideal Modernist separation of art from life.

Les Pas perdus opens with Breton's 'Disdainful Confession' of 1923, instantly placing the legend of Jacques Vaché in the foreground, and at the heart of his treatment of Vaché here, alongside descriptions, accounts of his disguises, disruptive gestures and attitudes, there is placed the story, simply told, of a chance encounter between Vaché and a girl at the gare de Lyon, and a trip by night out to Fontenay-aux-Roses which ends in the shelter of an undertaker whose nocturnal occupation is the extinguishing of street lamps.[69] Further on, Breton included a strange, inconsequential account of another chance encounter, this time between himself and a girl *en passant*, which, meaningfully, he called 'The New Spirit' (first published in *Littérature* in March 1922).[70] *Nadja*, to be published in 1928, was to focus especially on chance en-counters, the coincidences of life. Then too, Aragon's *Le Paysan de Paris* includes not only the oneiric and the visionary, but simple descriptions (for instance of the Café Certà), and, simply told, the story of a very ordinary visit to a brothel.[71] Yet, certainly the grandest scale on which life could take over from art was in the myth of the Rimbaudian exit. As Bonnet has pointed out, a central element in Breton's case against Maurice Barrès in the mock trial of 1921 was the contrast between Barrès's compromise with the world of respectable success and Rimbaud's refusal to compromise even when he gave up poetry.[72] For him, Rimbaud's decision to give up poetry in order to pursue trade in Abyssinia was, in fact, a decision to seek a new freedom. There was certainly one Surrealist writer who almost achieved oblivion in emulation of Rimbaud's example: Eluard, when he left France in March 1924 for the Pacific and Indo-China. Such a refusal of art remained, however, an extreme possibility, thinkable but rarely more. The point was that living, for the Surrealists, could conceivably provide as much as or even more than art.

If it was Reverdy from the circle of the Cubists who gave the clearest and most acute expression in words to the Modernist creed of aesthetic separatism, it was Breton who gave it to the Surrealists' belief that life and art can become fused together, and that life should ultimately be dominant. He gave the belief expression with great poise and intensity in one of the poems of *Claire de terre*; it is called 'Plutôt la vie'. There could be no more apt conclusion than the first few lines:

Plutôt la vie que ces prismes sans épaisseur même si les
 couleurs sont plus pures
Plutôt que cette heure toujours couverte que ces
 terribles voitures de flammes froides
Que ces pierres blettes
Plutôt ce coeur à cran d'arrêt
Que cette mare aux murmures
Et que cette étoffe blanche qui chante à la fois dans l'air
 et dans la terre
Que cette bénédiction nuptiale qui joint mon front à celui
 de la vanité totale
Plutôt la vie . . .[73]

306. Juan Gris, *Still Life with Plaque*, December 1917. Oil on canvas, 32 × 25¾ in. Oeffentliche Kunstsammlung Basel, Kunstmuseum.

Abbreviations

Books and Catalogues

Bonnet, *Breton* (1975): Marguerite Bonnet, *André Breton, naissance de l'aventure surréaliste*, Paris, 1975.

Camfield, *Picabia* (1979): William A. Camfield, *Francis Picabia, his Art, Life and Times*, Princeton, New Jersey, 1979.

Cooper, *Gris* (Catalogue, 1977): Douglas Cooper, *Juan Gris*, Catalogue raisonné of the painted work produced in collaboration with Margaret Potter, Paris, 1977.

Daix and Rosselet, *Picasso* (1978): Pierre Daix and Joan Rosselet, *Picasso, the Cubist Years, 1907–1916*, Catalogue raisonné of the paintings and related works, London, 1978–9.

Dupin, *Miró* (1962): Jacques Dupin, *Joan Miró, Life and Work*, New York, 1962.

Fabre, *L'Esprit moderne* (1982): Gladys C. Fabre, *Léger et l'esprit moderne (1918–1931)*, Musée d'Art Moderne de la Ville de Paris, 1982.

Green, *Léger* (1976): Christopher Green, *Léger and the Avant-garde*, London, 1976.

Kahnweiler, *Gris* (1968–9): Daniel-Henry Kahnweiler, *Juan Gris, his Life and Work*, translated by Douglas Cooper, London, 1968–9.

Krauss and Rowell, *Magnetic Fields* (1972): Rosalind Krauss and Margit Rowell, *Joan Miró: Magnetic Fields*, the Solomon R. Guggenheim Foundation, New York, 1972.

Rubin and Lanchner, *Masson* (1976): William Rubin and Carolyn Lanchner, *André Masson*, the Museum of Modern Art, New York, 1976.

Spies, *Ernst-Collagen* (1974): Werner Spies, *Max Ernst—Collagen; Inventar und Widerspruch*, Cologne, 1974.

Stott, *Lipchitz* (1978): Deborah A. Scott, *Jacques Lipchitz and Cubism*, New York and London, 1978.

Troy, *De Stijl* (1983): Nancy J. Troy, *The De Stijl Environment*, Cambridge, Massachusetts and London, 1983.

Zervos: Christina Zervos, *Pablo Picasso*, 33 vols., Paris, 1932–1978.

Dissertations

Doig, *Van Doesburg* (1981): Allan Doig, *Theo Van Doesburg: Painting into Architecture, Theory into Practice*, Dissertation presented for the degree of Ph.D, University of Cambridge, 1981 (to be published in revised book form by Cambridge University Press).

Gee, *Parisian Art Market* (1977): Malcom Gee, *Dealers, Critics, and Collectors of Modern Painting: Aspects of the Parisian Art Market, between 1910 and 1930*, Dissertation presented for the degree of Ph.D, Courtauld Institute, University of London, 1977 (subsequently published in its dissertation form by Garland Press, London and New York).

Silver, *Esprit de corps* (1981): Kenneth E. Silver, *Esprit de corps: the Great War and French Art, 1914–1925*, Dissertation presented for the degree of Ph.D, Yale University, 1981 (to be published in revised book form by Princeton University Press).

Source Texts

Breton, *Manifestes* (1972): André Breton, *Manifestes du Surréalisme*, Paris, 1924; in Breton, *Manifestes du surréalisme*, Paris, 1972.

Léger, *Fonctions* (1965): Fernand Léger, *Fonctions de la peinture*, Paris, 1965.

Raynal, *Anthologie* (1927): Maurice Raynal, *Anthologie de la peinture en France de 1906 à nos jours*, Paris, 1927.

Reverdy, *Oeuvres complètes* (1975): Pierre Reverdy, *Oeuvres complètes, Nord-Sud, Self Defence et autre écrits sur l'art et la poésie, 1917–1926*, edited with notes by Etienne-Alain Hubert, Paris, 1975.

Periodicals

A.V.: L'Art Vivant, Paris.
E.M.: Bulletin de l'Effort Moderne, Paris.
E.N.: L'Esprit Nouveau, Paris.
N.R.F.: La Nouvelle Revue Française, Paris.
R.S.: La Revolution Surréaliste, Paris.
D.S.: De Stijl.
La Vie des lettres: La Vie des lettres and *La Vie des lettres et des Arts*, Paris

Note: In the case of periodicals published in Paris, no place of publication is given.

Bibliographical Guidance

This book contains no general bibliography, the ground covered being too wide for such an enterprise to avoid the arbitrary.
The Notes, however, are designed with the need for bibliographical guidance in mind.

Notes

Introduction

1. There are major variations in the use of the term 'Modernism'. Most significantly, there is Modernism with a capital M and modernism without. C.f. the useful discussion by Francis Frascina in 'Modernist Studies: The Class of '84', *Art History*, London, December 1985, pp.515–29.

2. This is, quintessentially, Modernism with a capital M. It is the shape given recently, for instance, by Fred Orton in a paper delivered at the conference organised at the Courtauld Institute, University of London, to coincide with the Renoir exhibition at the Hayward Gallery, London, in April 1985; and in the catalogue contributions of the selectors of *The British Art Show* in 1984. See Jon Thompson, Alexander Moffat and Marjorie Althorpe-Guyton in *The British Art Show: Old Allegiances and New Directions, 1979–1984*, Arts Council of Great Britain, 1984.

3. Clement Greenberg's essays 'The New Sculpture' and 'Modernist Painting' are especially important to the articulation of this notion of painting and sculpture. For the former, see Clement Greenberg, *Art and Culture*, Critical Essays, Boston, 1961, pp.139–45; for the latter, see *Modern Art and Modernism, A Critical Anthology*, edited by Francis Frascina and Charles Harrison, London, 1982, pp.5–10.

4. C.f. Clement Greenberg, 'Collage' in *Art and Culture*, op.cit., pp.70–83.

5. This has been particularly clear in the writings of William Rubin. See especially William Rubin, 'Cézannism and the Beginnings of Cubism' in *Cézanne, the Late Work*, edited by William Rubin, New York, 1978, p.151ff.

6. Charles Harrison has associated English Modernism with a capital M 'with a concept of "purity" in art, where purity entailed the pursuit of technical autonomy'. See Charles Harrison, *English Art and Modernism, 1900–1939*, London and Bloomington, Indiana, 1981, p.17. This broad view of Modernism informs the course 'Modern Art and Modernism' developed by the Open University in Britain. Yet, oddly, the reader published to accompany this course concentrates almost entirely on British and American texts in its twentieth-century coverage, ignoring the contribution made to Modernist theory in France by the late Cubists and, most strikingly, Pierre Reverdy. See *Modern Art and Modernism*, op.cit.

7. The most recent and most extreme case of this was the exhibition *The Essential Cubism, 1907–1920*, held at the Tate Gallery, London, 27 April–10 July 1983.

8. One thinks, for instance, of the Bergsonian pursuit of 'simultaneity' and the Futurist-related celebration of modern life.

9. See especially Linda Nochlin, 'The Invention of the Avant-garde: France 1830–1880'; in *Avant-garde Art* (edited by Hess and Ashbery), New York, 1971; and Nicos Hadjinicolaou, 'Sur l'idéologie de l'avant-gardisme', *Histoire et critique des arts*, 6 July 1978.

10. C.f. Raynal, *Anthologie* (1927)

11. A unity comparable with that established by Foucault in, say, natural history at the end of the eighteenth century. See Michel Foucault, *The Order of Things, An Archaeology of the Human Sciences*, translated from the French, London, 1970, pp.125–57

12. Foucault writes of a 'tree of derivation' (a hierarchy of statements) which reveals what he calls an 'enunciative regularity' within a discourse. Such a tree, he maintains, must start with 'governing statements' which define the 'field of possible objects' and 'prescribe the forms of description and the perceptual codes' to be used, as well as 'the most general possibilities of characterization'. See Michel Foucault, *The Archaeology of Knowledge*, translated from the French by A. M. Sheridan Smith, London, 1972, p.147.

13. Both texts and art-works make statements, according to Foucault. For his very special notion of the statement, see Ibid., pp.86–105, and pp.144–6.

14. Foucault acknowledges the importance—for an analysis of the discursive—of non-discursive factors; see ibid, p.162 and pp.185–6. The history of institutions and of social and political change plays an important part in his later applications and developments of the approach arrived at in *The Order of Things* and *The Archaeology of Knowledge*. See especially his account of the formation of modern military, penal and educational institutions in *Discipline and Punish, The Birth of the Prison*, translated from the French by Alan Sheridan, Harmondsworth, 1977.

15. The discourse of nationalism is a central feature of the recent work both of Kenneth Silver and David Cottington, though neither tackles it as a discourse.

16. A great deal of pressure has been applied by such writers as Adrian Rifkin, Nicholas Green and Frank Mort to adopt an approach that as much as possible diverts attention from the separation of 'high' and 'low' culture, 'fine art' and the images of mass culture. It seems to me that these separations have to be confronted, not ignored or blurred. See Nicholas Green and Frank Mort, 'Visual Representation and Cultural Politics', *Block*, no. 7, London, 1982.

17. The paradox of critics like John Roberts (in Britain) declaring the end of the avant-garde and of cultural separation, from a clearly avant-garde position as a contributor to highly specialist periodicals aimed at small audiences of initiates, is striking indeed.

18. For Foucault the oppositions between, say, the natural histories of Buffon and Linnaeus, or, between the economic theories of Riccardo and Marx, are not what matter, it is the 'episteme' structuring their thought at the deepest level that matters. See Foucault (1970), op.cit., pp.125–208.

19. Foucault writes of 'the different *spaces of dissention*'. See Foucault (1972), op.cit., p.152.

20. See especially Raymond Williams, *Marxism and Literature*, Oxford, 1977, pp.108–27, and *Keywords*, London, 1983, pp.144–6.

21. This he did in *Culture and Society*, first published in 1958.

Chapter 1

1. Pinturrichio (Louis Vauxcelles), 'Le Carnet des ateliers', *Le Carnet de la Semaine*, 9 June 1918, p.9.

2. Pinturrichio (Louis Vauxcelles), 'De Profundis', *Le Carnet de la Semaine*, 28 July 1918, p.6.

3. Ramón Favela has established that Diego Rivera was one of the leading Cubists in Paris in 1915–16. His account of Rivera's development throughout the Great War is excellent. See, Ramón Favela, *Diego Rivera, The Cubist Years*, Phoenix Art Museum, 1984.

4. By spring 1917 Rivera was working with a homemade contraption called 'la chose', a specially gridded and articulated transparent screen through which he observed the objects he painted. He believed that by seeing things distorted by multiple refractions of light their forms could be grasped as if projected into more than three dimensions. The practice encouraged a return to the direct observation of his subject-matter. C.f. ibid, pp.130–43.

5. Favela suggests that these drawings represented not so much a decision to follow Picasso's Ingrism as a return to the Ingrism of Rivera's teacher at the Academy of San Carlos in Mexico, Santiago Rebull. See ibid, p.145.

6. Lhote's articles in the *Nouvelle Revue Française* begin with 'Exposition Braque', 1 June 1919, pp.153–7.

7. Pinturrichio (Louis Vauxcelles), 'Perplexité', *Le Carnet de la Semaine*, 18 August 1918, p.7. The best account of this campaign on the part of Vauxcelles is by Etienne-Alain Hubert in Reverdy, *Oeuvres complètes* (1975), pp.298–300.

8. Eugène Blot's gallery was in the rue Richepanse. It was set up in 1906, and Blot was an associate of Vauxcelles's from the beginning. The exhibition is reported by Vauxcelles in 'Epilogue', *Le Carnet de la Semaine*, 10 November, 1918, p.10.

9. The Lhote exhibition was of what were called 'transpositions décoratives'. It is reported by Jean-Gabriel Lemoine, in *L'Intransigeant*, Wednesday, 27 November 1918, and by Vauxcelles in 'Pluie d'expositions', *Le Carnet de la Semaine*, 24 November 1918, p.8. The galerie Branger exhibition is announced as a coming event and sequel to the galerie Blot show in Vauxcelles's 'Nos jeunes', *Le Carnet de la Semaine*, 2 February 1919, p.7. Reports appeared in March, see *L'Intransigeant*, Sunday, 9 March 1919 and Gustave Kahn, 'L'Heure artistique', *L'Heure*, 17 March 1919. Of Dufy's contribution, Kahn writes: 'Des *Régates de M. Dufy* sont d'une belle ordonnance. . .'. Rivera does not seem to have been included, but Lhote was prominent, and also to be seen was work by Roland Chavenon, Roger Bissière, René Durey, André Favory and Marguerite Crissay.

10. Ibid.

11. Waldemar George, 'M. Eugène Corneau', *Le Carnet-critique*, no.8, 15 January 1919, pp.41–3.

12. Quoted in: André Salmon, 'Cubisme et camouflage', *L'Europe Nouvelle*, no.39, 5 October 1918, p.1876. The lecture was announced for the afternoon of Sunday, 9 December 1917, at the Salle Huyghens (the headquarters of 'Lyre et Palette' where the exhibition was held). The exhibition brought together Kisling, Durey, Waroquier, Gabriel Fournier and Lejeune; see 'Les Arts', *L'Intransigeant*, 7 December 1917.

13. Ibid, p.1876.

14. Ibid, p.1876. Before the Great War Salmon had been a supporter of Metzinger, and in 1919 was to reiterate his view that Metzinger had been one of the first to follow Picasso and Braque, was a serious theorist, and worthy of respect. He probably, therefore, would not have been so dismissive towards him at least. See 'La Palette' (André Salmon), *Paris-Journal*, 30 September 1911, and André Salmon, 'Cubisme: Exposition Metzinger', *L'Europe Nouvelle*, 18 January 1919, pp.139–40.

15. A useful account of Roger Allard's criticism (before 1914) is to be found in David Cottington, *Cubism and the Politics of Culture*, Dissertation presented for the degree of Ph.D, Courtauld Institute, University of London, 1985. Allard had already turned against Cubism before the outbreak of war.

16. Blaise Cendrars, 'Modernités, I, Quelle sera la nouvelle peinture?', *La Rose rouge*, 3 May 1919, in *Aujourd'hui*, Paris, 1931, p.98.

17. 'Aujourd'hui, chez Thomas, 5 rue de Panthière, vernissage de la première Exposition d'Art Puriste (Orzenfant [sic] et Janneret [sic]).' *L'Intransigeant*, Saturday, 21 December 1918.

18. Amédée Ozenfant, 'Aux camarades des tranchées', *L'Elan*, no.8, January 1916.

19. Ozenfant particularly rejected current speculations on the fourth dimension. For a lucid discussion of this, see Françoise Ducros, 'Ozenfant et le soucis de la peinture', *Amédée Ozenfant*, catalogue of the exhibition held at the Musée Antoine Lécuyer, Saint Quentin, the Musée des Beaux-Arts, Mulhouse, the Musée des Beaux-Arts, Besançon, and the Musée des Ursulines, Mâcon, October 1985–July 1986, p.20. Ducros's analysis of Ozenfant's painting and his thinking here is the best to have appeared to date. Also useful is Susan L. Ball, *Ozenfant and Purism, the Evolution of a Style, 1915–1930*, Ann Arbor, Michigan, 1981.

20. Ozenfant spent much of 1917 supervising the construction of a munitions factory at Paimboeuf in the Loire for the family construction company. He arrived in the Bordeaux region at the end of March 1918.

21. During the summer of 1918 Lhote was based at Le Piquey and Rivera at Canon. Ozenfant recalls discus-

sions with Lhote in Bordeaux, see Amédée Ozenfant, *Mémoires, 1886–1962*, Paris, 1968, p.99.

22. Françoise Ducros has finally established that the meeting between Ozenfant and Jeanneret was at the end of 1917. Certainly by 24 January 1918 Jeanneret was writing to his friend William Ritter about dining with Ozenfant. See Ducros, op.cit., p.23, and p.28, note 35. On the basis of the account given by Maximilian Gauthier the Le Corbusier literature has perpetuated the false date of May 1918 for the meeting. See Maximilian Gauthier, *Le Corbusier ou l'architecture au service de l'homme*, Paris, 1940, p.40.

23. Amédée Ozenfant and Charles-Edouard Jeanneret, *Après le cubisme*, Paris, 1918.

24. They claim that one realisation lies behind the development of painting from Poussin on: 'Que la condition primordiale du grand art plastique est non l'imitation, mais la qualité des effets de la matière . . . que les objets visibles ou leurs éléments comptent dans l'oeuvre plastique, par la vertu de leurs propriétés physiques, leurs conflits ou leurs accords, quel que soit de sujet dont ils émanent.' Ibid.

25. As Ducros points out, a drawing closely related to this picture and dated 1917 is reproduced in the catalogue of the galerie Thomas exhibition. See Ducros (1985–6), op.cit., p.87.

26. Ozenfant and Jeanneret (1918), op.cit.

27. They are concerned to find the most revealing or essential view-point for an aspect of an object. Ibid.

28. Paul-Sentenac, 'Les Arts', *Paris-Journal*, Sunday, 2 February 1918.

29. J.-G. Lemoine, 'Le Purisme', *L'Intransigeant*, Thursday, 26 December 1918.

30. Pierre Reverdy, 'Sur le cubisme', *Nord-Sud*, no.1, 15 March 1917. See also Georges Braque, 'Pensées et réflexions', *Nord-Sud*, no.10, December 1917.

31. Pierre Reverdy, 'Arts', *Nord-Sud*, no.16, October 1918, in Reverdy, *Oeuvres complètes* (1975), pp.95–6.

32. Pierre Reverdy, 'Vociférations dans la clarté', *S.I.C.*, no.31, October 1918, in ibid, p.128.

33. Léonce Rosenberg, 'Une Lettre', *Le Carnet de la Semaine*, 15 September 1918. Vauxcelles replied in 'L'Effort Moderne', *Le Carnet de la Semaine*, 22 September 1918, and Lhote and Rivera followed with letters in the issue for 6 October 1918 under the title 'Au pays de cube'. Archipenko (who had been based in Nice) was the most important Cubist not connected with Léonce Rosenberg in 1918–19. See below, pp. 38–40.

Chapter 2

1. 'Essential Cubism' or 'true Cubism' is a notion introduced by Douglas Cooper in *The Cubist Epoch*, London, 1971, and in Douglas Cooper and Gary Tinterow, *The Essential Cubism, Braque, Picasso and their Friends, 1907–20*, Tate Gallery, London, 1983. For my view of the notion, see Christopher Green, 'London Tate Gallery, The Essential Cubism', *The Burlington Magazine*, London, July 1983, pp.439–43. The best introductions to pre-1914 Cubism remain: John Golding, *Cubism, A History and an Analysis, 1907–1914*, London, 1968 (revised edition); Robert Rosenblum, *Cubism and Twentieth Century Art*, New York and London, 1960; and the introductory text in Edward F. Fry, *Cubism*, London and New York, 1966. These can be supplemented by Virginia Spate, *Orphism, the Evolution of non-figurative Painting in Paris, 1910–14*, Oxford, 1979. Though the analysis of Cubist art and theory as such remains valid in these texts, there is a need for new work in the area in order to bring to bear upon it the critical and historical approaches that have emerged over the last decade. A start has been made on this in David Cottington, *Cubism and the Politics of Culture*, Dissertation presented for the degree of Ph.D., Courtauld Institute, University of London, 1985.

2. This point is dealt with in the only comprehensive text on French artists at the front, Elizabeth Kahn Baldewicz, *Les Camoufleurs— the Mobilization of Art and the Artist in War-time France, 1914–1918*, Dissertation presented for the degree of Ph.D., University of California, Los Angeles, 1980. See also Elizabeth Louise Kahn, 'Art from the front, death imagined and the neglected majority', *Art History*, June 1985, pp.192–208.

3. An excellent account of conditions on the home-front is given in Silver, *Esprit de corps* (1981), pp.1–6.

4. Ibid. Even before the declaration of war nationalism was powerful in France, a point Silver tends to under-estimate. C.f. Cottington (1985), op.cit.

5. For Picasso's involvement in the *Parade* project and the role of Cocteau, see Francis Steegemuller, *Cocteau, A Biography*, Boston, 1970. For the *Parade* project altogether, see Richard H. Axsom, *Parade: Cubism as Theatre*, New York, 1979, and Silver, *Esprit de corps*, pp.117–28.

6. *Parade* was performed by the Ballets Russes both in Madrid and Barcelona (only once in the latter, 10 November 1917).

7. C.f. Silver, *Esprit de corps* (1981), pp.117–19, and 120ff.

8. For Picasso's connection with Diaghilev generally, see Douglas Cooper, *Picasso: Theatre*, London, 1968; and Melissa A. McQuillan, *Painters and the Ballet, 1917–1926*, Dissertation presented for the degree Ph.D., New York University, 1979.

9. A crucial instance is *Still Life with Jug and Apples*, 1919, Musée Picasso, Paris, MP.64. These followed, of course, Diego Rivera's comparable still lifes of 1918, like the canvas in the Statens Museum for Kunst, Copenhagen.

10. Pablo Picasso to Gertrude Stein, 9 December 1915, Stein archives, Collection of American Literature, Beinicke Rare Books and Manuscript Library, Yale University. Quoted in William Rubin, *Picasso in the Collection of the Museum of Modern Art*, New York, 1972, p.98.

11. Zervos, vol.II, no.881.

12. A photograph of Picasso in front of the completed *Man Leaning on a Table* establishes that it was finished before Picasso's departure for the rue Schoelcher studio in spring 1916. That it was underway by August 1915 is established by Martín Luis Guzmán, a Mexican who visited Picasso that month and recalled in an essay written later that year seeing the picture in an unfinished state. C.f. Ramón Favela, *Diego Rivera, the Cubist Years*, Phoenix Art Museum, 1984, p.109, and footnotes 28 and 147.

13. Particulary important in the application of the distinction between analysis and synthesis to Cubism was D.-H. Kahnweiler. See especially, Kahnweiler, *Gris* (1968–9) and the first edition, Paris, 1946. A clear discussion of it is found in Golding (1968), op.cit., pp.114–16. See also Christopher Green, 'Synthesis and the "Synthetic Process" in the Painting of Juan Gris, 1915–19', *Art History*, London, March 1982, p.87 and p.101, notes 2 and 3

14. The nature of the process is especially well demonstrated by a comparison between the completed picture and a photograph of the work at an early stage of its development where the leaning-man subject is much more clearly legible. See Daix and Rosselet, *Picasso* (1978), p.359.

15. See, Musée Picasso, nos 859 and 866; and Zervos, vol.III, nos 390–403.

16. See, Musée Picasso, nos 258; and Zervos, vol.III, no.415.

17. Musée Picasso, no.258.

18. See Zervos, vol.III, nos 121 and 161.

19. Picasso first explored the possibilities of placing a synthetic Cubist figure in front of a mirror in *Man before a Fireplace*, 1916, Musée Picasso, Paris. Daix and Rosselet, *Picasso* (1978), no.891.

20. For Gris, see below, pp.33 and 36. In 1915 Diego Rivera painted two important pictures in which synthetic Cubist arrangements of still-life signs are placed in clearly represented out-door spaces, *Still life with a Fruit-bowl* (Plate 2) and the remarkable *Zapatista Landscape, the Guerrilla* (Institute Nacional de Bellas Artes, Museo Nacional de Arte, Mexico City).

21. See, Rubin (1972), op.cit., p.98.

22. The sketch book in question is catalogued as no.66 in: ed. Arnold Glimcher and Marc Glimcher, *Je suis le cahier, The sketchbooks of Picasso*, London (Royal Academy of Arts), 1986, p.319.

23. Laurens's response to Archipenko is perhaps clearest in his *Clown* sculptures, one of which survives in the Moderna Museet, Stockholm. These are related to *papiers collés* both on the clown theme and on the theme of a woman with a fan. Since one of the latter is dated February 1915, they are likely to be the work of the first half of 1915. They relate to Archipenko's *Medrano I* and *II* above all. For the exhibiting of Archipenko between 1912 and 1914, see Donald H. Karshan, 'Archipenko's Sculptural Revolution', in *Archipenko, the Sculpture and Graphic Art*, Tübingen, 1974.

24. Léonce Rosenberg's interest in Laurens was excited, when he visited Picasso's studio 'in 1915', by a photograph of one of the *Clowns*; this makes 1915 a reasonably secure dating for his subsequent visit with Picasso to Laurens. See Léonce Rosenberg, *E.M.* no.34, April 1927. Rosenberg also notes here that 'a little later we had a contract'. Laurens's initial interest in Cubist construction seems to have been stimulated not by Archipenko but by Braque, either in 1911 or 1912, just prior to Braque's experiments with paper or cardboard constructions at Sorgues. In 1915–16 he concentrated especially on the head and the figure as subjects both for *papiers collés* and constructions, though there were also still lives. The heads and figures relate most obviously to Picasso, the still lifes to Gris, particularly the Gris of late 1915. He was in close touch at this time both with Gris and with Pierre Reverdy. See Isabelle Monod-Fontaine, *Henri Laurens, Constructions et papiers collés, 1915–1919*, Musée National d'Art Moderne, Centre Georges Pompidou, Paris, 1985–6, pp.9–13.

25. Laurens's *Fruit-bowl and Grapes* is dated 1918 in Douglas Cooper and Gary Tinterow (1983), op.cit., p.388. They note that it came into the stock of the galerie de l'Effort Moderne in 1918. The forward-jutting plane with its cut-out fruit-bowl profile is anticipated by Picasso's construction *Mandolin and Clarinet* dated by Daix and Rosselet 'autumn 1913'. See Picasso (1979), p.311, no.632. Mention should also be made, however, of the most open and least flat of Laurens's constructions, the *Head* (1915) in the Kunstmuseum, Basel, which has no precedent in Picasso (sculpturally). See ibid, no.6. For the relationship between Laurens's constructions and Picasso's, see also Margit Rowell, 'The Planar Dimension, 1912–32, From Surface to Space', in *The Planar Dimension*, Solomon R. Guggenheim Museum, New York, 1979, pp.11–14.

26. There is an especially closely related *papier collé* dated 1917, as well as another constructed version of *Bottles and Glass*. See Monod-Fontaine (1985–6), op.cit., nos 59 and 18.

27. This crucial letter, dated 15 December 1915, is published in Monod-Fontaine (1985–6), op.cit., pp.12 and 20. In Picasso's case, perhaps the most striking instance of animated still life at this time is a series of works on paper done in 1915, where a fruit-bowl stands in for a head, and musical instruments take up the positions of gesticulating limbs. See Daix and Rosselet, *Picasso* (1979), nos 820–26.

28. *Man's Head* (Plate 26) has been dated 1920 in Marthe Laurens, *Henri Laurens, sculpteur, 1885–1954*, Paris, 1955. However, not only does it relate closely to the drawings of 1915–17 (including Plate 25), but it relates even more closely to a *papier collé* dated 1917 reproduced in the text by Marthe Laurens, see p.148, no.VIII–7. It could, therefore, have been done as early as 1917, and is so dated by Monod-Fontaine, ibid, no.100.

29. Laurens himself underlined this point. See Henri Laurens in Y. Taillandier, 'Propos de Henri Laurens', *Amis de l'Art*, no.1, June 1951, p.1.

30. *Guitar* is dated 1919 in Marthe Laurens (1955), op.cit., no.11–13, and in Douglas Cooper and Gary Tinterow (1983), op.cit., p.392, no.205. They give 1919 as the date for the piece's entry into the stock of the galerie de l'Effort Moderne. Monod-Fontaine dates it 'v. 1918–19'; ibid, no.103.

31. For a further analysis, see Green (March 1982), loc.cit., pp.92–3.

32. Perhaps the earliest definite reference to this working method are in: Paul Dermée, 'Jean Metzinger', *S.I.C.*, nos 42 and 43, 30 March–15 April 1919, p.13, and André Lhote, 'Exposition Matisse', *N.R.F.*, 1 July 1919, p.312.

33. Stott, *Lipchitz* (1978), p.51.

34. Ibid, p.51.

35. Lipchitz and Gris were particularly close in 1917, the year when the sculptor helped the Spaniard make his only sculpture of any significance, the painted plaster *Harlequin*, and when he himself made his sole surviving oil. Gris's *Harlequin* is dated by Cooper 'ca.November 1917'; see Cooper, *Gris* (Catalogue, 1977), no.S. I. Lipchitz refers to his Cubist oil (*Still Life with Fruit-Bowl*) in Jacques Lipchitz with H. H. Arnason, *My Life in Sculpture*, London, 1972, p.50.

36. The beginnings of this particular glass idea are to be found in a charcoal drawing, *Still Life with Syphon*, in the Art Institute, Chicago; it is a simplification of elements apparently developed on the basis of observation. For a full account of this, see, Green (March 1982), loc.cit., p.93.

37. The work is dated November 1917; it is therefore exactly contemporary with Gris's *Fruit-Bowl, Pipe and Newspaper*.

38. Having not dated his paintings to the month in 1914, Gris restarted the practice in March 1915, and continued it with very few exceptions until mid-1922.

39. Metzinger did not arrive until June: Gris writes to Dermée of his arrival 'mardi'; see Letter LXIX, 21 June 1918, in Douglas Cooper, *Letters of Juan Gris, 1913—1927*, London, 1956. Lipchitz, Huidobro and Blanchard had been there in the spring. Lipchitz left in September; see letter from Gris to Léonce Rosenberg, 23 September 1918, where his departure is mentioned 'après-demain, mardi'; quoted in Cooper, *Gris* (Catalogue, 1977), vol.II, p.40.

40. I am very grateful to Christian Derouet of the Musée National d'Art Moderne, who has allowed me to see his dossier of material relating to Léonce Rosenberg. Here he has recorded a letter from Gris to Rosenberg dated 10-7-18 which testifies to Gris's intense and direct response to the landscape at Beaulieu. This is crucial evidence of the fact that Gris may indeed have paused to reflect on Vauxcelles's campaign that summer, and may have turned back to nature as a result, though with far from Naturalist results.

41. For the relationship between *Houses at Beaulieu* and the motif, see Green (March 1982), loc.cit., pp.98–9. A motif photograph is illustrated here.

42. Pierre Reverdy, 'L'Image', *Nord-Sud*, no.13, March 1918, in Reverdy, *Oeuvres complètes* (1975), p.73.

43. 'Une pluie des ailes/Couvre la terre'. 'Poème', *Nord-Sud*, no. 3, 15 May 1917. Quoted in Christopher Green, 'Purity, Poetry and the Painting of Juan Gris', *Art History*, London, June 1982, pp.196–7.

44. Later Maurice Raynal was to insist that Gris's pictorial rhymes were, more than rhymes, metaphors, i.e. poetic conjunctions of the highest potency. See, Raynal, *Anthologie* (1927), p.174.

45. See Cooper, *Gris* (Catalogue, 1977), vol.II, p.80, no.298. According to Cooper, Léonce Rosenberg dates *The Glass* to March 1918. A related watercolour (no.298a) is inscribed with Germaine Raynal with the date '4-19', so the idea must have preceded *Guitar and Fruit-bowl* with its July date.

46. C.f. Stott, *Lipchitz* (1978), p.148; and Lipchitz and Arnasson (1972), op.cit., pp.51–2.

47. Stott illustrates both Beaulieu works, ibid, nos 39 and 40.

48. Some of these were exhibited at Marlborough Fine Art, London, in October–November 1978.

49. A good instance of such a preparatory drawing is the pencil study *Pierrot with Clarinet* shown at the Marlborough exhibition of 1978, see note 48, above.

50. It was among those in the Marlborough exhibition, see note 48, above.

51. C.f. André Salmon, 'Cubisme: Exposition Metzinger', *L'Europe Nouvelle*, 18 January 1919, pp.139–40; André Lhote, 'Le Cubisme au Grand Palais', *N.R.F.*, 1 March 1920, pp.468–9; and Paul Dermée, Jean Metzinger', *S.I.C.*, nos 42 and 43, 30 March–15 April 1919, p.13.

52. *Woman with a Coffee-pot* is more obviously related to Gris's work of mid-1919 than earlier, suggesting a later 1919 or even an early 1920 date.

53. A comparable instance is Metzinger's *Still Life with Bottle of Rum and Melon* almost certainly also of late 1917, sold: Sotheby's, 7 November 1962, lot 40.

54. Lipchitz himself was to call *Demountable Figure* his Cubist *écorché*. See Stott, *Lipchitz* (1978), p.119.

55. 'During this period, Lipchitz remembered that he was making detailed drawings, "blue-prints" even, as preparations for sculpture . . .'. Ibid, p.51.

56. He signed his contract with Léonce Rosenberg late in 1916. See Lipchitz and Arnasson (1972), op.cit., p.42.

57. Pierre Reverdy, 'Sur le cubisme', *Nord-Sud*, no.1, 15 March 1917.

58. Georges Braque, 'Pensées et réflexions', *Nord-Sud*, no.10, December 1917.

59. Paul Dermée, 'Quand le Symbolisme fut mort', *Nord-Sud*, no.1, 15 March 1917, p.3.

60. See, Part III, p.200, below.

61. Silver, *Esprit de corps* (1981).

62. The metaphor of the crystal was repeatedly in use after 1918 with reference to Cubism, and this led me to adopt the term crystal Cubism in 1976. See, Green *Léger* (1976), pp.130–1.

63. María Blanchard rejoined the Cubists in Paris in 1916. She had worked alongside Diego Rivera and Lipchitz in Madrid early in 1915 and had been with them in the Ballearics too that year.

64. Laura Miner quotes Herbin from an undated manuscript in the Claisse collection: '1917 presque plus de traces des objets. 1918 plus de traces des objets—formes couleurs, mouvement.' See Laura Miner, *Abstract Art in Paris*, Dissertation presented in part fulfilment for the degree of M.A., Courtauld Institute, University of London, 1971, p.2. Léonce Rosenberg remarked in 1921: 'Herbin fut le premier qui osa et sut s'exprimer subjectivement . . .', by which he meant without objects; see Léonce Rosenberg, *Cubisme et empirisme*, Paris, 1921, p.12.

65. This has been convincingly established by Miner, ibid. C.f. plates 17–20.

66. C.f. Gino Severini, *Tempo de 'l'Effort Moderne', La Vita di un pittore*, Florence, 1968, pp.51–5.

67. The decorative framing and general sense of the ornamental in this picture was inspired by the wallpaper where he stayed near Aix-les-bains. Severini recalls a particular wallpaper there: 'Qual che mi aveva sopratutto interessato in quella carta era l'impiego, sopra un tono grigio caldo, di punti neri e di puntini bianchi, utilizzazione questa molto giudiziosa e pittorica.' Ibid, p.52. In a footnote he directly relates this 'soluzione decorativa' to *The Guitar* itself; see footnote 18, pp.64–5. Its relationship with the Aix-les-bains house suggests an earlier rather than later date.

68. An autumn dating seems likely on the grounds that its combination of geometric structure and quasi-naturalistic objects compares closely to preparatory drawings dated September–October 1919 and January 1920, illustrated in the catalogue *Gino Severini 'Entre les deux guerres'*, Galleria Giulia Staderini Editore, Rome, 1980, pp.54–5. Also c.f. the drawing dated October 1919 illustrated in Martin Caiger-Smith, *Gino Severini—The Montegufoni Frescoes*, Dissertation presented in part fulfilment for the degree of M.A., Courtauld Institute, University of London, 1983, plate 26. Caiger-Smith provides a useful account of Severini in 1919, pp.21–3.

69. Severini (1968), op.cit., p.80. For further material on the use of the Golden Section in Cubist work, see William A. Camfield, 'Juan Gris and the Golden Section', *The Art Bulletin*, March 1965, pp.128–34; Lucy Adelman and Michael Compton, 'Mathematics in Early Abstract Art', in *Towards a New Art*, London (Tate Gallery), 1980, pp.74–8; and Favela (1984), op.cit., pp.18–19.

70. Severini (1968), op.cit., pp.79–80.

71. Archipenko was back in Paris by May 1919 at the latest, the date of his exhibition at Georges Crès et cie. C.f. Katherine Jánszky Michaelson, *Archipenko, A Study of the Early Works, 1908–1920*, New York and London, 1977, p.138, note 1.

72. Between 1919 and 1921 Archipenko showed in Geneva, Zurich, London, Brussels, Athens, Berlin and Munich. C.f. Karshan, *Archipenko* (1974), pp.53 and 157.

73. Raynal wrote the preface to the catalogue of the Archipenko exhibitions in Geneva and Zürich, 1919–20.

74. Archipenko's first use of a real mirror coupled with illusionistic painting in sculpture was in the assemblage *Woman in Front of a Mirror* of 1913 which was reproduced in *Les Soirées de Paris*, June 1914. Elaborate developments of the idea of the real and the mirror image in conjunction with one another are: *Woman before a Folding Mirror* and *Woman before a Mirror* both sculpto-paintings of 1916. See, Michaelson (1977), op.cit., S74 and S75, and p.134.

75. Michaelson discusses this move towards simpler and clearer images. Ibid, p.127.

76. The confusion is exploited in *Head and Still Life*, 1916, where still life elements are made to read as a head. See ibid, S79.

77. Archipenko's claims as an innovator in this respect have been strongly argued by Karshan. See, Karshan (1974), op.cit.

78. Michaelson seems to suggest that Lipchitz's and Laurens's coloured reliefs were a development from Archipenko's sculpto-paintings. See Michaelson (1977), op.cit., pp.136–7. However, the fact that Lipchitz certainly had made his move into coloured relief before Archipenko's return from Nice, and that he did so alongside Gris at Beaulieu, argues against any direct influence at least in his case. Laurens's painted plaster reliefs are much more to be compared with Lipchitz's than with Archipenko's.

79. C.f. Golding (1968), op.cit., p.119.

80. Especially relevant to *The Musician* is *Man with a Guitar* of spring 1914. See Nicole Worms de Romilly and Jean Laude, *Braque: Cubism, 1907–14* (Maeght Catalogue), Paris, 1982, no.230.

81. For the 'pedestal table' or 'gueridon' still lifes of 1918 and later, see Douglas Cooper, *Braque: the Great Years*, London, 1973, pp.39–44.

82. It has to be acknowledged that Braque could still paint severely geometric works in 1918–19, which are spatially confined and chromatically without warmth. One instance is *Guitar and Fruit-dish*, 1919, in the Musée National d'Art Moderne, Paris (AM 3167P).

83. André Lhote, 'Exposition Braque', *N.R.F.*, 1 June 1919, pp.153–7.

84. 'M. Fernand Léger, cubiste, est-il demeuré fauve, ainsi que je l'ai non point lu mais entendu dire?' The answer, Salmon says, is no, but he underlines the importance of colour in the work shown. André Salmon, 'Le Volume dans l'espace, l'air et la lumière', *L'Europe Nouvelle*, 22 February 1919, pp.388–9.

85. For a full account of his war experience, see Green, *Léger* (1976), pp.96–119. For an analysis which is sympathetic neither to Léger nor to my earlier account (1976), see Elizabeth Kahn Baldewicz (1980), op.cit. Léger himself was quick to acknowledge the impact of his war experience, see especially Fernand Léger, 'Correspondance', March 1922; in *E.M.*, no.4, April 1924, p.10.

86. Again, Léger himself was emphatic about this. For an account that stresses this particular aspect, see Peter de Francia, *Fernand Léger*, New Haven and London, 1983, p.31.

87. Salmon (22 February 1919), op.cit., p.388. Salmon calls *The Card Game* 'les joueurs' here.

88. Salmon (22 February 1919), op.cit., p.388.

89. This particular composition was abstracted from elements of the soldiers on either side of *The Card Game*, something clarified in Green, *Léger* (1976), p.137.

90. Karshan writes of four known versions of this idea, including the *Abstract Sculpture* in Liège (Plate 59). C.f. Donald Karshan, *Csaky*, Dépôt 15, Paris, 1973, p.35.

91. As I have shown before, the origins of the *Typographer* composition lie in two works on paper made at the front and dated January 1917. They are clearly legible studies of a seated soldier with bandaged hand. For a fuller discussion of this and of the disintegrated paintings generally, see Green, *Léger* (1976), pp. 145–57.

92. Spate (1979), op.cit. Here is found the best account of the interrelations between painting and poetry in Paris between 1912 and 1914 with reference to the Delaunays.

93. André Lhote, 'Le Cubisme au Grand Palais', *N.R.F.*, 1 March 1920, p.470.

94. Blaise Cendrars, 'Modernités, 1, Quelle sera la nouvelle peinture?', and 'Modernités, 6, Fernand Léger', *La Rose rouge*, 3 May 1919, and 3 July 1919; in *Aujourd'hui*, Paris, 1931, p.98 and p.121.

95. Léopold Survage's Nice paintings are clearly comparable; they were begun in 1915. Survage was, of course, in close touch with Archipenko in Nice.

96. The letter is published in D.-H. Kahnweiler's 'Un Grand Normand roux', *Hommage à Léger*, Paris, numéro spéciale du *XXe siècle*, 1972, p.4. It is quoted in Green, *Léger* (1976), p.141.

97. 'S'il faut un chef de cette école [Cubism], ce chef sera M. Georges Braque.' André Salmon, 'La Semaine artistique', *L'Europe Nouvelle*, 15 February 1919, p.340.

98. 'L'école cubiste a une existence réelle, multiple, variée.' André Salmon, 'Georges Braque', *L'Europe Nouvelle*, 29 March 1919, p.625.

99. Jean-Gabriel Lemoine, 'Oeuvres d'Henri Laurens', *L'Intransigeant*, Tuesday evening, 10 December 1918.

100. Gustave Kahn, 'Exposition Fernand Léger', *L'Heure*, Wednesday evening, 19 February 1919.

101. Roger Allard in the periodical that he edited, *Le*

Nouveau Spectateur, and Blaise Cendrars in his series 'Modernités' in *La Rose rouge*.

102. 'Pinturrichio' (Louis Vauxcelles), 'Carnet des ateliers', *Le Carnet de la Semaine*, 20 April 1919, p.11.

103. Jean-Gabriel Lemoine, 'Les Arts', *L'Intransigeant*, Thursday, 12 June 1919.

104. Gustave Kahn, 'Exposition Picasso', *L'Heure*, Friday evening, 27 June 1919.

105. Jean-Gabriel Lemoine, 'On a inauguré aujourd'hui le Salon des Indépendants, un laboratoire de l'art de demain', *L'Intransigeant*, Thursday, 29 January 1920.

106. Jean-Gabriel Lemoine, 'La Vérité sur le cubisme', *Le Crapouillot*, 1 April 1920, p.13.

107. Paul-Sentenac calls Gris's works at the Indépendants: 'un peu moins indéchiffrables'; see Paul-Sentenac, 'Le Salon des Indépendants', *Paris-Journal*, Saturday, 7 February 1920. Laure scorns the 'philosophie' attributed to the Cubists, but calls Severini, Gris, Hayden, Metzinger and Braque: 'prodigieux coloristes', declaring that: 'le cubisme s'assagit'; see Georges Laure, 'Le Salon des Indépendants', *Revue de l'Époque*, March-April 1920, pp.254–61.

108. 'Pinturrichio' (Louis Vauxcelles), 'Les Indépendants', *Le Carnet de la Semaine*, 1 February 1920, p.9.

109. Paul Dermée, 'Jean Metzinger', *S.I.C.*, nos 42 and 43, 30 March–15 April 1919, p.13.

110. Ibid, p.13.

111. Waldemar George, 'Albert Gleizes', *La Vie des lettres*, January 1921, p.353.

112. André Lhote, 'Peinture: d'un cubisme sensible', *La Vie des lettres*, April 1923, p.6.

113. Henri Laurens; in *Valori Plastici*, Rome, February–March 1919.

114. Lhote coined the term 'les cubistes a priori', which he used interchangeably with 'les peintres cubistes purs'. See André Lhote, 'Le Cubisme au Grand Palais', *N.R.F.*, 1 March 1920, pp.467–71. For further discussion of Lhote's view, see p.65, below.

Chapter 3

1. Louis Léon-Martin, 'Le Salon d'Automne, La Peinture', *Le Crapouillot*, 16 October 1920, p.9.

2. Pierre Reverdy, 'Sur le cubisme', *Nord-Sud*, no.I, 15 March 1917; in Reverdy, *Oeuvres complètes* (1975), p.16. For Etienne-Alain Hubert's comentary, see pp.238–9.

3. C.f. Camfield, *Picabia* (1979), op.cit., pp.77ff. Camfield's is by far the most important study of Picabia, but also of considerable interest is Michel Sanouillet's commentary in *Francis Picabia et 391*, vol. II, Paris, 1966.

4. C.f. Spate's discussion of the term 'Orphism', in Virginia Spate, *Orphism, the Evolution of non-figurative Painting in Paris, 1910–1914*, Oxford, 1979, p.73.

5. An indispensable chronicle of Dada in Paris exists in Michel Sanouillet's remarkable *Dada à Paris*, Paris, 1965. For his account of the founding of the review *Littérature*, see pp.102–4. No. 1 was published on 19 March 1919.

6. It is significant that still, when Soupault wrote to Tzara immediately after reading the Dada Manifesto of December 1918, he named Reverdy among those whose works should survive; Soupault to Tzara, Paris, 28 January 1919, quoted by Sanovillet, ibid, p.136. Certainly Tzara's increasing contact with the *Littérature* group soured their relations with Reverdy late in 1919, but the deterioration was only temporary.

7. C.f. Camfield, *Picabia* (1979), p.128.

8. Georges Ribemont-Dessaignes, 'Salon d'Automne, C'est Napoléon qui fit le portrait de David', *391*, no.9, November 1919, pp.2–3.

9. A very full account of the 'Section d'Or' quarrel is to be found in Sanouillet (1965), op.cit., pp.160–1. See also Camfield, *Picabia* (1979), p.139. Though strongly biased in favour of the Dadaists, the most informative contemporary account is: Paul Dermée, 'Excommunées', *391*, no.12, March 1920, p.6.

10. Dermée is the source for the sides taken; ibid, p.6.

11. Ibid, p.6.

12. Francis Picabia, 'Manifeste Dada', *391*, no.12, March 1920, p.1.

13. 'Marginalia', *391*, no.12, March 1920, p.2.

14. See Part II, Chapter 8, below.

15. Braque signed a new contract with Kahnweiler (for one year), 11 May 1920. Gris had started to make contractual arrangements with him even before his contract with Léonce Rosenberg expired in November; it was finally signed 23 December 1920. Laurens signed with him 1 April 1920. See Isabelle Monod-Fontaine, Agnès Angliviel de la Baumelle and Claude Laugier, *Donation Louise et Michel Leiris, Collection Kahnweiler-Leiris*, Centre Georges Pompidou, Musée National d'Art Moderne, Paris, 1984–5, p.29, 58 and 105.

16. Letters of September 1920 recorded by Christian Derouet in his dossier of material related to Léonce Rosenberg, demonstrate that Léger took Rosenberg's side in the dispute over Braque, Laurens and Gris.

17. See, especially, Jean-Gabriel Lemoine, 'La Vérité sur le cubisme', *Le Crapouillot*, 1 April 1920, pp.13–14; see also Jean-Gabriel Lemoine, 'Les Arts', *L'Intransigeant*, Friday, 19 March 1920.

18. The exhibition was in February 1921. It was called 'Paysages de Jean Metzinger'; see Jean-Gabriel Lemoine, 'Les Arts', *L'Intransigeant*, Monday, 14 February 1921.

19. Letter recorded in Christian Derouet's 'dossier'.

20. Waldemar George's criticism in particular argued for a return to colour, and Gris too was to join in the reaction against austerity by the end of 1922. See pp.82–4, below.

21. Jean Metzinger, 'Tristesse d'Automne', *Montparnasse*, 1 December 1922, p.2.

22. André Salmon, 'Les Arts et la vie', *La Revue de France*, 1 April 1923, p.585.

23. It appeared in *Montparnasse*, 1 December 1923. Material recorded in Christian Derouet's 'dossier' establishes that Metzinger had actually sent this letter two years previously (in 1921) to Florent Fels for publication in *Action*; evidently, not only did the periodical change the title, but it also stole the letter.

24. See Germain Seligman, *Roger de la Fresnaye*, with a catalogue raisonné, New York, 1969, pp.63–84.

25. Fernand Léger to Alfred H. Barr Jr., 20 November 1943; letter in the Museum of Modern Art Archives, New York; in Robert Herbert, *Léger's Le Grand Déjeuner*, the Minneapolis Institute of Arts, 1980, p.72. Inexplicably, when I was a research fellow at the Museum of Modern Art in 1969 working on Léger I was not informed of the important letters from the artist to Barr in the Archives. As a result, some aspects of the account given in my *Léger and the Avant-garde* (1976) are not adequate. Herbert's essay is indispensable, not only for *Le Grand Déjeuner* itself, but for the whole question of Léger's Neo-Classicism in the early twenties.

26. Ibid, p.19. Herbert points to changes made after its appearance in the Automne. He compares its present state with that recorded in a reproduction illustrated in *E.N.*, no.13, December 1921.

27. Severini's move began with the painting of a *Mother and Child* in the summer of 1920, which he later recalled took as its starting-point the Madonnas of Raphael and which also entailed the application of an elaborate proportional system as well as Chevreul's colour circle. See Gino Severini, *Tempo de 'l'Effort Moderne'*, *La Vita di un pittore*, Florence, 1968, p.153.

28. Ibid, pp.166–8. An excellent account and analysis of the Montegufoni frescoes is given in Martin Caiger-Smith, *Gino Severini—The Montegufoni Frescoes*, Dissertation presented in part fulfilment of the degree of M.A., Courtauld Institute, University of London, 1983. He deals with the commissions and contract, pp.3–4.

29. Severini (1968), op.cit., p.186.

30. C.f. Sacheverell Sitwell, *Cupid and the Jacoranda*, London, 1952, and Caiger-Smith (1983), op.cit., p.3, and footnote 4.

31. Caiger-Smith provides a useful section on technique; op.cit., pp.28–30. He also gives a clear account of Severini's application of theories of proportion in the frescoes, pp.9–12. A further detailed analysis is given by Carlo Cresti; see 'Geometria per Montegufoni', in *Gino Severini (1883–1966)*, Palazzo Pitti, Florence, 25 June–25 September 1983, pp.47–54. Their structure was based on a carefully proportioned geometric framework (an armature related to those that Gris, Severini and others had used around 1916 as Cubists). Severini applied here the theories that he elaborated in *Du Cubisme au classicisme*, published in 1921 while he was at work on the frescoes. These compare with Jay Hambidge's in *Dynamic Symmetry in Composition* and *The Elements of Dynamic Theory*,

New York, 1919. Caiger-Smith points out that Hambridge lectured in Europe in the winter of 1919–20. Vitruvius, Alberti, Pacioli, Leonardo and Dürer are all mentioned by Severini himself. See Severini (1968), op.cit., pp.104–6.

32. Caiger-Smith has shown this convincingly; op.cit., pp.8–9.

33. '. . . à da notare che gli ultimi guazzi dati a Rosenberg non avevano affato *l'apparenza* cubista delle cose anteriori; erano invece molto rappresentativi, ed à quindi a suo onore l'avervi scorto la construzione e lo spirito cubista a di là delle apparenze.' Severini (1968), op.cit., p.170.

34. Seligman (1969), op.cit.

35. For attitudes to Renoir, see p.188, below.

36. At the Salon d'Automne of 1920 Salmon had called Braque the only 'cubiste orthodoxe' there. See André Salmon, 'Le Salon d'Automne', *L'Europe Nouvelle*, 17 October 1920, p.1519. His long review of the *Canéphores* two years later reveals both puzzlement and disappointment. See André Salmon, 'Le Salon d'Automne', *La Revue de France*, December 1922, p.618.

37. Roger Allard, 'Le Salon d'Automne', *La Revue Universelle*, October 1922, p.486.

38. The date was October 1919.

39. Jean-Gabriel Lemoine, 'Les Arts, Picasso', *L'Intransigeant*, Wednesday, 29 October 1919.

40. Picasso's souces are discussed in detail in Phoebe Pool, 'Picasso's Neo-Classicism, 2nd Period 1917–1925', *Apollo*, London, March 1967; and Anthony Blunt, 'Picasso's Classical Period, 1917–1925', *The Burlington Magazine*, London, April 1968.

41. See André Salmon, 'La Semaine artistique, La Collection Degas et le mouvement contemporain', *L'Europe Nouvelle*, 2 March 1918, p.388; 'Le Pur et l'impur', *L'Europe Nouvelle*, 13 April 1918, p.679; 'Exposition André Lhote, Oser et choisir', *L'Europe Nouvelle*, 7 December 1918, p.2309.

42. André Salmon, 'L'Exposition Ingres', *L'Europe Nouvelle*, 21 May 1921, p.666. The passage quoted is italicized in the text.

43. C.f. André Lhote, 'Tradition et troisième dimension', *N.R.F.*, 1 October 1920, pp.619–26.

44. *E.N.*, no.7, April 1921.

45. Especially by Rubin; see William Rubin, *Picasso in the Collection of the Museum of Modern Art*, the Museum of Modern Art, New York, 1972, p.114.

46. In Jacques Guenne, 'Maurice Vlaminck', *Les Nouvelles Littéraires*, Saturday, 1 November 1924, p.2.

47. Mondrian to J. J. P. Oud, Paris, 1 December 1921. Archives of the Institut Néerlandais, Paris.

48. Gee's analysis is very full indeed. See Gee, *Parisian Art Market* (1977), vol.II, Appendix F, pp.19–78. Also on the sales and for the chronology of events leading up to them, see Isabelle Monod-Fontaine, 'Chronologie et documents', in *Daniel-Henry Kahnweiler, marchand, éditeur, écrivain*, Centre Georges Pompidou, Musée National d'Art Moderne, Paris, 1984–5, pp.129–38.

49. 'Pinturrichio' (Louis Vauxcelles), 'Moralité d'un séquestré', *Le Carnet de la Semaine*, 27 November 1921, p.8.

50. The enquiry was launched as 'Enquête sur le cubisme', in *La Revue de l'Époque*, March 1922, p.643. Replies had already been received.

51. It is mentioned in a letter from Gris to Kahnweiler (Céret, 22 February 1922). See Douglas Cooper, *Letters of Juan Gris, 1913–1927*, London, 1956, Letter CLXIII. There are references to it also in the press; see *L'Intransigeant*, Saturday, 11 February 1922, and *Paris-Journal*, Sunday, 12 February 1922.

52. 'Enquête sur le cubisme', *La Revue de l'Époque*, March 1922, pp.644 and 647.

53. See the answer given by J. Chaplin; ibid, pp.664–5.

54. See the answer given by Schneeberger; ibid, pp.652–3.

55. Ibid, p.647 and 659.

56. Ibid, p.649.

57. Maurice Hiver, 'Réflexions III', *Montparnasse*, 1 May 1923, p.7.

58. Ibid, p.7.

59. Maurice Hiver, 'Réflexions', *Montparnasse*, 1 March 1923, p.5.

60. Robert Rey, 'Le Salon d'Automne, La Peinture (suite)', *Le Crapouillot*, 16 November 1922, pp.11–12.

61. Claude Roger-Marx, 'Chronique artistique', *Les Nouvelles Littéraires*, Saturday, 12 April 1924.

62. *Revue de l'Époque*, March 1922, p.651.

63. Maurice Raynal, 'Exposition André Beaudin', *L'Intransigeant*, Tuesday, 30 January 1923; and 'Exposition Pierre Charbonnier', *L'Intransigeant*, Wednesday, 2 April 1924.

64. Léonce Rosenberg having professed ignorance of Favory's Cubist work, the latter wrote to *Le Carnet de la Semaine*: 'N'ayant exposé qu'une fois (*Art et Liberté*—décembre 1916) mes oeuvres que la critique qualifia "cubistes", il est naturel que cette phase de mon évolution picturale suit passé inaperçue du public et de M. Léonce Rosenberg.' André Favory, in *Le Carnet de la Semaine*, 13 September 1918, p.7. Favory had never been widely recognized as a Cubist.

65. Jacques Guenne, 'André Favory', 1 February 1926, p.88.

66. Simon Lévy was about the same age as Juan Gris. He enjoyed a solid reputation with André Salmon and the critics of *L'Art Vivant*, but was hardly thought of as a conspicuous talent like Favory. His direction had been set before 1914 by his earliest experience of Cézanne at first hand, an exhibition of watercolours, and then by the Pellerin collection. For him, what counted in Cézanne was not the simplification of form but the life given form by colour; he saw himself as taking further Cézanne's 'Chromaticisme', for, as he said, where Cézanne proceeded from half-tones, he worked with full tones, with primaries and secondaries. He saw his art as rooted in the study of the motif and as developing what Cézanne had begun. The best source for Lévy's own attitudes in the twenties is: Jacques Guenne, 'Simon Lévy', *A.V.*, 1 January 1926.

67. André Lhote, 'Le Cubisme au Grand Palais', *N.R.F.*, 1 March 1920, p.467.

68. André Lhote, 'Première Visite au Louvre', *N.R.F.*, 1 September 1919, pp.523–32. This identification of the French tradition with a direct response to nature was not new; it was anticipated at the beginning of the century by Adrien Mithouard in his review *L'Occident* (founded in 1901) and in his *Traité de l'Occident*, Paris, 1904. The theme in these earlier manifestations is picked up by David Cottington in *Cubism and the Politics of Culture, 1907–1914*, Dissertation presented for the degree of Ph.D., Courtauld Institute, University of London, 1985.

69. Robert Rey, 'Le Salon des Indépendants, La Peinture (suite)', *Le Crapouillot*, 1 March 1923, p.14.

70. Edmond Jaloux, 'Le Salon d'Automne, La Peinture', *Les Nouvelles Littéraires*, Saturday, 3 November 1923, p.5.

71. On Seurat in *E.N.*, no.1; on Ingres in no.4; on Corot in no.8; 'L'Exposition Picasso', *L'Amour de l'Art*, July 1921.

72. Gromaire's success came especially with the showing of his painting *La Guerre* at the Indépendants of 1925. See Part III, pp.203–5, below.

73. In 1917 a large exhibition of French art organized by Vollard took place in Barcelona; Reverdy, Raynal and (just possibly) Apollinaire visited the city with it. Raynal was to return again as organizer of another exhibition, 'Arte Francés de Vanguardia', in 1920. The second series of *Troços* (1917–18) was particularly important; it was edited by Josep Junoy and featured his 'calligrammes'. Miró contributed a drawing to the issue of March 1918. Also important was the periodical *Un Enemic del poble* edited by Salvat-Papaseit, which published the 'calligrammes' of Joachim Folguera. The activities of the Dalmau galleries and of these periodicals are usefully dealt with in Enric Jardí, *Els Moviments d'Avantguardia a Barcelona*, Barcelona, 1983. See also Marilyn McCully and Alicia Suarez in *Homage to Barcelona, the city and its art, 1888–1936*, Arts Council of Great Britain, Hayward Gallery, London, 1985–6.

74. Letter to J.-F. Rafols. Quoted but not precisely dated, in Dupin, *Miró* (1962), p.90.

75. See note 73, above.

76. Maurice Raynal, 'Préface', *Miró*, catalogue of the exhibition at the galerie La Licorne, Paris, 1921.

77. Rubin plays down the possible connections with 'cubist structure', and accentuates instead those with *naïf* art. He is right to take up the possibility of a relationship with the work of the Douanier Rousseau, something that goes with Miró's grasp of detail, but Braque and Léger seem equally relevant, and Rubin does not consider the work in the context of Cubism and the opposition to Cubism in Paris at the time. See William Rubin, *Miró in the Collection of the Museum of Modern Art*, New York, 1973, p.16; c.f.

Carolyn Lanchner and William Rubin, 'Henri Rousseau et le modernisme', in *Le Douanier Rousseau*, Galeries Nationales du Grand Palais, Paris, 1984–5, p.94.

78. Jean Metzinger, 'Tristesse d'Automne', *Montparnasse*, 1 December 1922, p.2.

79. André Salmon, in *La Revue de France*, 15 July 1924, p.377.

80. He is quick to deny any influence of Cubism when questioned by Florent Fels in 1924; see Florent Fels, 'La Jeune Peinture, Kisling', *Les Nouvelles Littéraires*, 5 April 1924.

81. Jacques Guenne, 'Portraits d'artistes, Kisling', *A.V.*, 15 June 1925, pp.10–12.

82. Fels (5 April 1924), loc.cit.

83. Roger-Marx (5 April 1924), loc.cit.

Chapter 4

1. Jacques Guenne, 'Portraits d'artistes, Kisling', *A.V.*, 15 June 1925, p.12.

2. According to Lipton, 'much cubist work' of the 1918–25 period was 'a restatement of a pre-war style'. Eunice Lipton, *Picasso Criticism, 1901–1939, the Making of an Artist-Hero*, New York and London, 1979, pp.77–8. According to Gamwell, 'the war put an end to the shared efforts of earlier years, as well, undoubtedly, to that particular view of reality that it cultivated in Cubism.' Lynn Wissing Gamwell, *Cubist Criticism: 1907–1925*, Ann Arbor, 1980, p.173. These are just two instances from the last decade.

3. See, especially, Douglas Cooper, *The Cubist Epoch*, London and New York, 1970, which settles on 1921, and Douglas Cooper and Gary Tinterow, *The Essential Cubism, Braque, Picasso and their Friends, 1907–1920*, Tate Gallery, London, 1983, which settles on 1920.

4. Maurice Raynal, 'Peinture, sculpture', *L'Intransigeant*, Tuesday, 15 April 1924.

5. For the gouaches, see Zervos, vol.IV, nos 64–73.

6. Theodore Reff, 'Picasso's Three Musicians: Maskers, Artists and Friends', *Art in America*, New York, December 1980, pp.124–42. Rubin and Lanchner suggest further ramifications concerning the Douanier Rousseau; see Carolyn Lanchner and William Rubin, 'Henri Rousseau et le modernisme', in *Le Douanier Rousseau*, Galeries Nationales du Grand Palais, Paris, 1984–5.

7. For the series of related drawings, see Zervos vol.V, nos 212, 213, 215, 216, 222, 223.

8. The opening night was 18 June 1924.

9. An instance from 1923 is *Musical Instruments*; Zervos, vol.5, no.89.

10. See Part IV, p.255, below.

11. See Robert Herbert, *Léger's Le Grand Déjeuner*, The Minneapolis Institute of Arts, 1980, nos 4, 5, 7 and 8.

12. The table with its spindly legs is a close relative of the table in the final *Grand Déjeuner*, and what is placed upon it relates closely to the smaller *Mother and Child* of 1920–21 where the still life threatens to oust the figures altogether (see Green, *Léger* (1976), Plate 154).

13. Other instances are: *The Green Chair*, Nordrheinkunstsammlung, Dusseldorf, and *Nature-morte*, Rupff Collection, Kunstmuseum, Bern.

14. C.f. Green, *Léger* (1976), pp.230–31.

15. This is especially clear in 'L'Esthétique de la machine, l'objet fabriqué, l'artisan et l'artiste', first published in *Der Queschnitt*, Berlin, 3, 1923, and in *E.M.*, nos 1 and 2, January and February 1924; and in Léger's interview with Georges Charensol, where he talks of 'mass-producing' his works; 'Chez Fernand Léger', *Paris-Journal*, December 1924.

16. Waldemar George, 'Etat de la peinture-moderne', *Paris-Journal*, 3 July 1924.

17. Again this stress on the calculated and precise is especially clear in Léger's lecture 'L'Esthétique de la machine' (1923), loc.cit.

18. See p.89, below.

19. C.f. Léger (1923), loc.cit.; in *Fonctions* (1965), pp.53–4.

20. The syphon, glass and hand of *The Syphon* were adapted from a Martini advertisement in *Le Matin*. See Green, *Léger* (1976), pp.272–3.

21. For a fuller discussion of this see ibid, pp.265–8.

22. The first to point out that the marble slab is not the table-top was Douglas Cooper in *Braque: the Great Years (1882–1963)*, London, 1973, p.58. Also see *Braque: Oeuvres de Georges Braque (1882–1963)*, Cata-

logue établi par Nadine Pouillon avec le concours de Isabelle Monod-Fontaine, Collections du Musée National d'Art Moderne, Centre Georges Pompidou, Paris, 1982, pp.86–91.

23. Rhyming is found in several of the more elaborate pictures of 1923–5. A good instance is *Guitar, Pipe and Music-book*, 1924, Sotheby & Co, 1 July 1980, lot 72. See Nicole de Romilly and Jean Laude, *Braque: Cubism, 1907–14* (Maeght Catalogue), Paris, 1982, *Peintures 1924–1927*, no.5.

24. For both the notes and the letter, see Isabelle Monod-Fontaine, Agnès Anglivel de la Baumelle, Claude Laugier, *Donation Louise et Michel Leiris, Collection Kahnweiler-Leiris*, Centre Georges Pompidou, Musée National d'Art Moderne, Paris, 1984–5, pp.28–9.

25. Some instances are: Jean-Gabriel Lemoine, 'On a inauguré aujourd'hui le Salon des Indépendants, un laboratoire de l'art de demain', *L'Intransigeant*, Thursday, 29 January 1920, where Braque is mentioned as especially sensitive to 'nuance'; Louis Léon-Martin, 'Le Salon d'Automne, La Peinture', *Le Crapouillot*, 16 October 1920, p.9, where he is admitted to have much talent; and Paul Husson's eulogy, 'Georges Braque, "Silhouettes d'exposants",' *Montparnasse*, 1 November 1921, p.5. These are quite apart from the support given by such pro-Cubist critics as Salmon and Raynal.

26. Marcoussis was a Montmartre artist, who retained connections with Braque, Gris and Gleizes after 1918 as well as with Reverdy and Huidobro. He was backed especially by the Polish critic Waldemar George, took part in the Section d'Or of 1920 and showed regularly at the Indépendants between 1920 and 1923. His compromise did not go unnoticed. See Part III, p.178, below. See also Jean Lafranchis, *Marcoussis, sa vie, son oeuvre*, Paris, 1961.

27. Dr Judith Yudkin of Edinburgh, when acquainted with the evidence, summed up as follows: 'First illness: Pneumonia and pleurisy, probably pulmonary tuberculosis. Evidence against: no "koch bacilli" in sputum. Evidence for: in a private ward next to a ward full of consumptive men spitting blood; weight lost followed by weight regained (not cancer); anal fistula (often associated with tuberculosis). Josette's finger amputation. "Old lesion" mentioned in x-ray. Final illness: high blood-pressure, uraemia, "asthma"; left ventricular failure (cardiac asthma) due to high blood-pressure. Cause of high blood-pressure unknown, but could have been due to tuberculosis of the kidney following untreated pulmonary tuberculosis (n.b. uramia).' The evidence all comes either from Kahnweiler, *Gris* (1968–9), or from the letters in Douglas Cooper, *Letters of Juan Gris, 1913–1927*, London, 1956. A second opinion given by Dr David Lomas concurs with these conclusions, but adds that a strong alternative possibility to renal tuberculosis is renal amyloidosis secondary to pulmonary tuberculosis, which would also have caused renal followed by cardiac failure. Since renal failure leading to death is relatively rare as a result of renal tuberculosis, he considers renal amyloidosis more likely.

28. For a reasonably full account of his movements and relative recovery, see Kahnweiler, *Gris* (1968–9), pp.33–4.

29. In 1919 he had written to Kahnweiler of 'at last . . . entering a period of realization.' That period was interrupted but not brought to a halt. Gris to Kahnweiler, 25 August 1919, Letter LXXX; in Cooper (1956), op.cit.

30. According to Mme Josette Gris, he owned neither a violin nor a guitar; conversation, 20 July 1977.

31. See Monod-Fontaine, Anglivel de la Baumelle and Laugier (1984–5), op.cit., p.58.

32. Gris's positive response to the Neo-Classicism of Picasso and Léger is clearest of all in *Pierrot with Guitar*, January 1922 (Cooper, *Gris* (Catalogue, 1977), no.385).

33. Kahnweiler, *Gris* (1968–9), p.48.

34. Georges Charensol, 'Chez Juan Gris', *Paris-Journal*, 7 March 1924.

35. André Lhote, 'Première Visite au Louvre', *N.R.F.*, 1 September 1919; Roger Bissière, 'Notes sur Ingres', *E.N.*, no.4, January 1921.

36. Charensol (7 March 1924), loc.cit.

37. The landscapes are: Cooper, *Gris* (Catalogue, 1977), nos 452, 453 and 454.

38. See ibid, nos 467 and 482.

39. Lipchitz corroborates Gris's response to Braque. He even tells of the Spaniard trying laboriously to re-

produce by calculated artifice the sensitivity of Braque's curving contours. See Lipchitz quoted in Stott, *Lipchitz* (1978), pp.52–3.

40. From 1 April 1920. See Monod-Fontaine, Angliviel de la Baumelle and Laugier (1984–5), op.cit. p.105.

41. This dating is found in Marthe Laurens, *Henri Laurens, sculpture, 1885–1954*, Paris, 1955; and most recently in *Henri Laurens, 1885–1954, 60 oeuvres 1915–1954*, Galerie Louis Leiris, Paris, June–July 1985, no.9.

42. The *papiers collés* are nos 66–70, 72–6, 88–91, and the constructions are nos 19 and 23 (the latter the last of Laurens's constructions), in: Isabelle Monod-Fontaine, *Henri Laurens, Le Cubisme, Constructions et papiers collés, 1915–1919*, Centre Georges Pompidou, Musée National d'Art Moderne, Paris, 1985–6.

43. Lipchitz's piece is entitled *Sculpture*, 1916. See Nicole Barbier, *Lipchitz, oeuvres de Jacques Lipchitz (1891–1973)*, Collections du Musée National d'Art Moderne, Centre Georges Pompidou, Paris, 1978, no.8.

44. For Doucet, see François Chapon, *Mystère et splendeurs de Jacques Doucet, 1853–1929*, Paris, 1984.

45. C.f. Jacques Lipchitz with H. H. Arnasson, *My Life in Sculpture*, London, 1972, p.57.

46. Ibid, pp.57–8, and pp.70–4.

47. Ibid, pp.69–70.

48. Stott, *Lipchitz* (1978), pp.36–7.

49. Paul Dermée. 'Lipchitz', *E.N.*, no.2, November 1920, p.171.

50. André Salmon, 'Aux Indépendants (II)—Le Bonnat du Cercle Volnay', *L'Europe Nouvelle*, 7 February 1920, pp.232–3.

51. Waldemar George, 'Sculpture, quelques aspects de la sculpture moderne', *La Vie des lettres*, April 1923, pp.21–2.

52. It is Kahnweiler who describes Gris's initial drawings as 'a sort of "automatic drawing"', see Kahnweiler, *Gris* (1968–9), p.146.

53. See Lipchitz with Arnasson (1972), op.cit., p.67.

54. C.f. Ibid, p.67 and 70; and Stott, *Lipchitz* (1978), pp.157–60.

55. Kahnweiler himself saw this as the key cause. See Kahnweiler, *Gris* (1968–9), pp.133–4.

56. Waldemar George, 'Robert Delaunay et le triomphe de la couleur', *La Vie des lettres*, August 1922, p.332.

57. For a fuller account of Gris's involvement with Diaghilev, see Kahnweiler, *Gris* (1968–9), pp.49–53.

58. This desire for success is particularly clear in the letters written to Kahnweiler from Bandol in April 1921 when Diaghilev first invited his collaboration; on that occasion only to change his mind. See ibid, p.38.

59. The highly abstracted, so-called 'tower figures' by Csaky of 1922 are already, as Karshan puts it, to some extent 'Egyptian in spirit'; but it is especially in such pieces of 1924 as *Bird* and *Head of Dog* that the hieratic and the easily legible come together to consolidate Csaky's own idiosyncratic compromise. See Donald Karshan, *Csaky*, Depot 15, Paris, 1973, p.55, plates 19, 20, and nos 20 and 21. Léonce Rosenberg included 'L'art du Haut-Empire égyptian' among the styles that he considered shared 'l'esprit constructif' and 'l'esprit de synthèse' with his own period. See *Cubisme et tradition*, Paris, 1920, p.14. By 1928 Csaky was himself to turn, however, to a merger of Cubism and French Neo-Classicism.

60. Letters from Rosenberg to Valmier (1920–24) are recorded by Christian Derouet in his dossier of material related to Léonce Rosenberg.

61. Georges Valmier, reply in 'Chez les cubistes', *Bulletin de la vie artistique*, 1 November 1924, p.480. That Valmier's work remained highly abstracted through 1923 and began to move towards greater legibility only in 1924–5 was underlined recently by the exhibition *Valmier, 1885–1937*, at the galerie Seroussi, Paris, 1985–6. Though more legible, his work of 1925–27 remained uncompromisingly synthetic, built up in planimetric rather than perspectival spaces. See the catalogue of the galerie Seroussi exhibition.

62. For instances of gouaches and watercolours where *papier collé* is used thus, see ibid, p.33, and nos 9, 10, 11.

63. Such sculptures in the round as *Woman*, 1921 (Karshan (1973), op.cit., no.12) show the full development of this idiom.

64. Maurice Raynal, 'Exposition Jacques Villon', *L'Intransigeant*, Wednesday, 21 June 1922.

65. Jacques Villon, reply in 'Chez les cubistes', *Bulletin de la vie artistique*, 1 November 1924, p.480.

66. The series is together in the Société Anonyme Collection, Yale University Art Gallery, New Haven, Connecticut. See Robert L. Herbert, Eleanor S. Apter and Elsie K. Kenney, eds., *The Société Anonyme and the Dreier Bequest at Yale University: A Catalogue Raisonné*, New Haven and London, 1984.

67. Villon (1 November 1924), loc.cit., p.480.

68. Lhote pairs Gleizes with Léger as 'les chefs de cette école'. André Lhote, 'Le Salon des Indépendants', *N.R.F.*, 1 March 1922, p.502.

69. Salmon, for instance, accused Gleizes of approaching a point beyond which there was nothing more, as he did Brancusi. See André Salmon, 'Les Arts et la vie', *La Revue de France*, 15 june 1923, pp.802–3.

70. For a fuller account, see, pp.198–9, below.

71. Waldemar George, 'Albert Gleizes', *La Vie des lettres*, January 1921, p.354.

72. See Albert Gleizes, 'La Peinture et ses lois', *La Vie des lettres*, October 1922, p.53.

73. Ibid.

74. Ibid.

75. Ibid, p.73. The caption reads: 'Dessin d'un tableau-objet réalisé dans le champ d'un plan octogonal. Selon les déterminants de la mécanique plastique particulière au plan, les aspects de l'évolution dans le temps et l'espace, rhythmique et spatiale, ont été fixés par le sentiment propre de l'artiste.'

76. Albert Gleizes, 'Choses simples', *La Vie des lettres*, October 1921, pp.735–6.

77. See, for instance, *Imaginary Still Life, Blue*, 1924, sold as lot 52 at the Palais Galliera, Paris, 26 November 1972.

78. Albert Gleizes, 'Des "ismes" vers une Renaissance plastique', *La Vie des lettres*, April 1922, p.181.

79. There were articles on Picasso, Lipchitz, Léger, Gris, Braque, Laurens and Metzinger. Paul Dermée was an editor of *L'Esprit Nouveau* at the outset and was in charge of the review for the first three numbers. See Françoise Ducros, 'Ozenfant et le soucis de la peinture', *Amédée Ozenfant*, catalogue of the exhibition held at the Musee Antoine Lécuyer, Sain Quentin, the Musée des Beaux-Arts, Mulhouse, the Musée des Beaux-Arts, Besançon, and the Musée des Ursulines, Mâcon, October 1985–July 1986, p.30.

80. Ozenfant and Jeanneret, 'Le Cubisme I', 'Le Cubisme II', and 'Vers le crystal', *E.N.*, nos 23, 24 and 25, May, June and July 1924.

81. Ibid (no.25, July 1924).

82. Amédée Ozenfant, 'Sur les écoles cubistes et post-cubistes', *Journal de psychologie normale*, January–March 1924, pp.290–302.

83. This is already clearly set out in *Après le cubisme* in 1918: 'Le Nombre, qui est la base de toute beauté, peut trouver désormais son expression.' 'Les lois verifiées sont des constructions humaines qui coincident avec l'ordre de la nature; elles peuvent se représenter par les nombres . . .'.

84. C.f. Kenneth E. Silver, 'Purism: Straightening up after the war', *Art-forum*, New York, March 1977, pp.56–63.

85. The idea of the 'objet-type' is elaborated in Ozenfant and Jeanneret, 'Le Purisme', *E.N.*, no.4, January 1921, and further discussed as 'l'objet standart' in 'L'Angle droit', *E.N.*, no.18, November 1923, and in 'Idées personelles', *E.N.*, no.27, November 1924.

86. Ozenfant and Jeanneret, *E.N.*, no.27, November 1924; cited in Susan L. Ball, *Ozenfant and Purism, the Evolution of a Style, 1915–1930*, Ann Arbor, Michigan, 1981, p.105.

87. Ozenfant and Jeanneret, 'Le Purisme', *E.N.*, no.4, January 1921.

88. Ozenfant and Jeanneret, 'Esthétique et Purisme', *E.N.*, no.15, February 1922 (reprinted from *Promenoir*, Lyon, 1921).

89. Ozenfant and Jeanneret, 'Le Purisme', *E.N.*, no.4, January 1921.

90. Ibid.

91. Enough evidence survives for the process behind the Purist pictures of 1919–23 to be clearly enough understood. Thus, a revealing group of studies on paper by Ozenfant dated 1919–20 (as well as later) was sold as lots 283, 283a and c, 284 and 284a at the Sotheby's London Sale 'Important Impressionist and Modern Drawings and Watercolours', Wednesday, 3 December 1980. These show Ozenfant working both from observation and, more purely, with different arrangements of objects; they are not, however, related to Plate 199. A relatively complete record of Jeanneret's working procedures is to be found in

the 'fichier' at the Fondation Le Corbusier, Paris, though more revealingly in the suites of drawings related to the two versions of *Still Life with Pile of Plates* than in any drawings related to Plate 117; see Fondation Le Corbusier, nos 1536, 1537, 1538 and 1542 especially. These show Jeanneret initially experimenting with slightly changed groupings of objects before fitting a final grouping to a system of 'tracés régulateurs'.

92. The work of 1921 is *Still Life with Syphon*, collection Heidi Weber, Zürich.

93. *Mother of Pearl* is wrongly dated 1922 in John Golding and Christopher Green, *Léger and Purist Paris*, London (Tate Gallery), 1970–71. Ball dates it ca1926; see Ball (1981), op.cit., p.83. The first version of the idea is a canvas in a Swiss private collection signed and dated '1923'; see Ducros (1985–6), op.cit., p.96, no.48. Both 1925 and 1926 are possible dates for the Philadelphia version.

94. Jeanneret's use of colour in 1925–6 is stronger and less nuanced that Ozenfant's, but, equally, he does not keep to the so-called 'grande gamme'. He too worked with transparencies and overlappings to develop a new kind of space, something briefly discussed by Stanislas von Moos in *Le Corbusier: Elements of a Synthesis*, Cambridge, Massachusetts, and London, 1979, pp.42–3. Significantly perhaps, two of the studies included in the Sotheby's sale of 1980 (see note 91, above), lots 283b and 284c, both dated '5 juin '24', show Ozenfant developing compositional ideas comparable with *Mother of Pearl*, using a combination of overlapping objects and overlapping non-objective shapes (rectangles, a couple of which in 284c take on the identity of tumblers).

95. Indeed, late in 1924, Ozenfant and Jeanneret still rationalized the fusion of objects by a common contour as a means of developing pictorial relationships without risking distortion. See Ozenfant and Jeanneret, 'Idées personnelles', *E.N.*, no.27, November 1924.

Chapter 5

1. 'Information et faits divers', *A.V.*, 15 October 1925 and 1 November 1925.

2. Georges Charonsol, 'Les Expositions', *A.V.*, 1 January 1926, p.35.

3. The catalogue records three Arps (two reliefs and one 'peinture'), two Ernsts ('Marines' and 'Forêts'), four Klees and three Massons.

4. The catalogue records eight items from Léger: 'Nature-morte', 'La Rose et le compas', 'Les Pipes', another 'nature-morte', two gouaches and a 'Peinture murale'. From his students it records: four Marcelle Cahns, three Otto Carlsunds, three Franciska Clausens, and also three items from his Norwegian associate Thorvald Hellessen. Otherwise, Van Doesburg is recorded as sending four works (Counter-Compositions VI, XI, XII and XIII), Domela two, Huszar four, Mondrian two, and Vordemberghe-Gildewart four.

5. Kupka's stance is discussed more fully in Part IV, below.

6. Letters dated 1 and 10 December 1921 (Archives of the Institut Néerlandais, Paris). Van Doesburg to Antony Kok, 18 September 1922, cited in Michel Seuphor, *Piet Mondrian, His Life and Work*, London, 1957, p.162.

7. This is especially clear in a letter from Léonce Rosenberg to Van Doesburg of 2 August 1920 (Van Doesburg Archive, Dienst Verspreide Rijkskollektie), quoted in Doig, *Van Doesburg* (1981), p.170.

8. The initial plan was formed on Van Doesburg's visit to Paris early in 1921. It entailed an opening date for the projected exhibition of January or February; Mondrian was to be involved in an advisory capacity. Troy provides a useful account of Van Doesburg's relations with Rosenberg; see Troy, *De Stijl* (1983), pp.75–81.

9. Both Doig (1981) and Troy (1983) provide important analyses of Van Doesburg's international phase, as does Joost Baljeu in *Theo Van Doesburg*, London, 1974. For the exhibition of 1923, its content and context, see especially, Yves-Alain Bois and Nancy Troy, 'De Stijl et l'architecture à Paris', in Yves-Alain Bois and Bruno Reichlin, *De Stijl et l'architecture en France*, Liège and Brussels, 1985.

10. Van Doesburg had fallen out with Oud over the importance of colour in the latter's Spangen housing

scheme in 1921; he met up with Van Eesteren in Weimar and Berlin in the spring of 1922. C.f. Troy, *De Stijl* (1983), pp.81–6 and 97–8; Doig, *Van Doesburg* (1981), pp.161–4; Reinder Blijstra, *C. Van Eesteren*, Amsterdam, 1971; and Bois and Troy (1985), op.cit., pp.32–46.

11. The exhibition was adapted as the core of a show called 'Architecture et les arts qui s'y rattachent' held in 1924 at the Ecole Spécial d'architecture in Paris, and was adapted again for presentation at the Museum in Nancy in 1926. See Troy, *De Stijl* (1983), p.215, note 69, and Bois and Troy (1985), op.cit., pp.55–74.

12. The Comte de Noailles commissioned Van Doesburg to design the colour enhancement of a small room devoted to the cutting of flowers in the new villa he was planning with Mallet-Stevens at Hyères. See Doig, *Van Doesburg* (1981), p.181. For Le Corbusier, *L'Esprit Nouveau* and De Stijl, see, especially, Bois and Troy (1985), op.cit., pp.34, 50–5; and Bruno Reichlin, 'Le Corbusier vs De Stijl', in ibid, pp.91–108.

13. Florent Fels, 'Propos d'artistes, Fernand Léger', *Les Nouvelles Littéraires*, Saturday, 30 June 1923, p.4.

14. For more on the Indépendants project of 1923, see Part IV, below. Léger himself is quoted in *E.N.* criticizing the project in the light of the De Stijl exhibition in this vein. See Le Corbusier, 'Le Salon d'Automne', *E.N.*, no.19, December 1923.

15. Fernand Léger, 'Architecture polychromie', *L'Architecture vivante*, autumn/winter 1924; translated by Charlotte Green in *Léger and Purist Paris*, London (Tate Gallery), 1970–1, pp.95–6.

16. Léger made the following statement at the time: 'Mallet-Stevens m'a dit: Voilà 80 centimetres de large sur 2m 40, faites-moi quelque chose. / J'ai fait un projet de décoration de peinture murale, à réaliser en mosaïque. / Je n'ai pas fait un tableau. / Un vestibule où l'on passe ne doit pas être orné avec un tableau de chevalet, qui a d'autres lois.' Florent Fels, '"L'Affaire" de l'Exposition des Arts Décoratifs', *Les Nouvelles Littéraires*, Saturday, 6 June, 1925.

17. Gladys Fabre, in *L'Esprit Moderne* (1982), pp.357–96.

18. Fabre's articles in the catalogue of *Léger et l'esprit moderne* and *L'Oeil* (Léger et l'académie moderne', March 1982, pp.32–9) have transformed the understanding of Léger's role and non-objective art in Paris in the mid-twenties.

19. Clausen had worked in Moholy-Nagy's studio in Berlin in 1922, while Nadia Khodossievich Grabowska, the wife of Stanislas Grabowski (later Léger's second wife), had studied with Strzeminski and Malevich in Smolensk. See Fabre, *L'Esprit Moderne* (1982), pp.376–83.

20. Félix del Marle was art editor of the small periodical *Vouloir*. He visited 'Art d'aujourd'hui', and, early in 1926, Mondrian's studio, after which he transformed his own studio into a Neo-Plastic space. By 1927 *Vouloir* was publishing Mondrian (most important, 'La Maison—la rue—la ville', *Vouloir*, no.25, 1927, pp.1–4). It was through *Vouloir* that Jean Gorin learned about De Stijl and Mondrian in 1926. Shortly afterwards he too visited the Dutchman's studio and then transformed his own into a Neo-Plastic space. See *Jean Gorin, peintures, reliefs, constructions dans l'espace, 1922–1968*, CNAC, Paris, 1969.

21. The 'Aubette' was opened in February 1928.

22. Maurice Raynal, 'L'Art d'aujourd'hui', *L'Intransigeant*, Thursday, 7 January 1926.

23. The initial announcement was made on 3 January 1922; it brought together, with Breton and Roger Vitrac, Léger, Delaunay and Ozenfant, as well as the composer Georges Auric. Tzara refused to take part in the organization of the Congrès, provoking a defamatory statement by Breton and subsequent chaos. Picabia's support of Breton was voiced in a scurrilous pamphlet entitled *La Pomme des pins*. The story of the Congrès is told in detail by Sanouillet; see Michel Sanouillet, *Dada à Paris*, Paris, 1965, pp.319–20.

24. André Breton, 'Après Dada', *Comoedia*, 2 March 1922; in André Breton, *Les Pas perdus*, Paris, 1924, p.105.

25. André Breton, 'Lâchez tout'; in ibid, p.110. See also 'Invitation au voyage', *Littérature*, 1 April 1922.

26. André Breton, 'Clairement', *Littérature*, 1 September 1922; in Breton (1924), op.cit., p.114.

27. André Breton (2 March 1922), loc.cit., p.105.

28. For a useful account of the 'Procès Barrès', see Sanouillet (1965), op.cit., pp.254–6. See also Bonnet, *Breton* (1975), pp.240–7.

29. André Breton, 'Max Ernst', preface to the catalogue of the exhibition at the galerie Au Sans Pareil, Paris, May 1921; in Breton (1924), op.cit., p.87.

30. Breton made a point of naming as friends Aragon, Eluard, Soupault, and then Baron, Desnos, Morise, Vitrac and de Massot in 'Clairement' (September 1922), loc.cit., p.113. For the significance of the 'Nouvelle série', see Bonnet, *Breton* (1975), p.259 and Dawn Ades, in *Dada and Surrealism Reviewed*, Arts Council of Great Britain, London (Hayward Gallery), 1978, pp.165–6. On reopening in March 1922, Breton and Soupault were joint-editors. From no.4 of the 'Nouvelle série', Breton was sole editor.

31. André Breton, 'Entrée des mediums', *Littérature*, 1 November 1922; in Breton (1924), op.cit., p.124.

32. Aragon gives some idea of the excesses to which these practices gave rise. See Louis Aragon, *Une Vague de rêves*, Paris, 1924, pp.22–3.

33. As brilliantly argued by Bonnet in *Breton* (1975), pp.259–313.

34. 'Groupe Littérature', *Paris-Soir*, 27 May 1924.

35. Yvan Goll edited just one issue of a periodical entitled *Surréalisme* (October 1924). It included a drawing by Robert Delaunay, and the 'collaborateurs' named included Albert-Birot, Paul Dermée, Joseph Delteil and Pierre Reverdy. Especially important was an unsigned 'Manifeste du surréalisme'. See Part IV below for further discussion.

36. For a full account of this, see Camfield, *Picabia* (1979), pp.203ff., and Bonnet, *Breton* (1975), p.324.

37. The group declared its unqualified support for Picasso in a public demonstration at the opening night of the ballet *Mercure* in June 1924, which was given an outlet in the press. See 'Hommage à Picasso', *Le Journal littéraire*, 21 June 1924, quoted in *391*, no.18, July 1924, p.3. For a full discussion of Picasso's relations with the Surrealists and Surrealism, see Elizabeth Cowling, '"Proudly we claim him as one of us": Breton, Picasso and the Surrealist Movement', *Art History*, March 1985, pp.82–104.

38. For Masson's relations with Kahnweiler, see Isabelle Monod-Fontaine, Agnès Angliviel de la Baumelle, and Claude Laugier, *Donation Louise et Michel Leiris, Collection Kahnweiler-Leiris*, Centre Georges Pompidou, Musée National d'Art Moderne, Paris, 1984–5, pp.132–4.

39. Max Morise, 'Les Yeux enchantés', *R.S.*, 1 December 1924, pp.26–7.

40. Masson's *L'Armure* and *L'Homme* are both mentioned in the preface to the catalogue of the exhibition, which is signed by Breton and Robert Desnos. Miró's *Music-Hall Usher* is illustrated.

41. This is the title of a piece on Ernst by Aragon written in 1923 but not published then, where Aragon concentrates on the collages and related images. See Louis Aragon, 'Max Ernst, Peintre des illusions', August 1923; in Aragon, *Ecrits sur l'art moderne*, Paris, 1981, pp.12–16.

42. The Picasso illustrated is *Head* of 1923. See Zervos, vol.V, no.357.

43. The work especially of Ronald Alley has established that *The Three Dancers* contains Picasso's response to the death of his friend Ramón Pichot. See Ronald Alley, *Picasso: the Three Dancers*, the 48th Charlton Lecture, University of Newcastle-upon-Tyne, 1966. More recently, the work of Elizabeth Cowling has suggested that *The Embrace* could possibly be read as a maternity, and that as such it would reflect the souring of his relationship with Olga and a deeply felt response to Freudian views on infantile sexuality. Elizabeth Cowling, 'Picasso's *The Embrace*', Lecture delivered at the Courtauld Institute, November 1984

44. *The Harlequin* and the crystal Cubist works from the end of the war were, of course, dominant at the Picasso exhibition of June 1919 which Miró could have seen in Paris; and this is the kind of Cubism that Miró would have seen most of on his visits to Picasso's studio after that date. The relevance of Picasso's synthetic Cubism to Surrealist painting was first seriously discussed by John Golding in 'Picasso and Surrealism'; see John Golding and Sir Roland Penrose, *Picasso, 1881–1973*, London, 1973. For Miró's first visit to Picasso on his first trip to Paris, see Dupin, *Miró* (1962), p.91.

45. *R.S.*, 15 January 1925, pp.16–17.

46. C.f. Kahnweiler, *Gris* (1968–9), pp.44 and 53. Gris and Masson holidayed together at Nemours in August 1924, in the company of Armand Salacrou, Michel Leiris and Roland Tual.

47. They mean especially the work of Picasso and Braque in 1911–12, which of course was freely available in Paris between 1921 and 1923 because of the Uhde and Kahnweiler sales. See William Rubin, 'André Masson and Twentieth Century Painting', and Carolyn Lanchner, 'André Masson: Origins and Development'; in *André Masson*, The Museum of Modern Art, New York, 1976, pp.14 and 88.

48. Lanchner states that Masson 'denies any influence' of Gris on his work, ibid, p.202, footnote 34. Kahnweiler was insistent that there was absolutely no question of Gris's influencing Masson. Conversation, 14 April 1977.

49. Kahnweiler, *Gris* (1968–9), p.146. In conversation (see note 48 above) he suggested that these 'automatic' drawings by Gris were begun only after his meeting with Masson, though he was not completely sure of this.

50. In the *Ear of Grain* of 1922–3 (Museum of Modern Art, New York) there is also a key rhyme picked up between the twisted metal of the strainer and the ear of grain itself.

51. There are seven sketch-books from the period ca 1922–7. They are all in the archives of the Fundació Joan Miró, Barcelona. A number of sketches from them were published in Gaëton Picon, *Joan Miró, Catalan Notebooks*, London, 1977. They were unknown before 1975, though Jacques Dupin implies awareness of them in his monograph of 1962. Since Picon's publication they have also figured in *Dessins de Miró*, Centre Georges Pompidou, Musée National d'Art Moderne, Paris, 1978–9; and in *Joan Miró: Anys Vint*, Fundació Joan Miró, Barcelona, 1983. No systematic study of their significance has yet appeared.

52. This is a substantial sketchbook containing forty sheets measuring 20×17cm. There are drawings of trees and the 'mas' at Montroig, some of which relate to *The Tilled Field*; these could be from 1923–4. And there are many drawings relating to paintings of 1924–5, none relating directly to works of later than 1925. The two still-life drawings referred to are among drawings related to works of 1924, for instance, *The Kiss*, and the *Head of a Catalan Peasant* theme.

53. C.f. the areas of sand in the insect drawing from the same sketch-book, illustrated in Picon (1977), op.cit., p.77.

54. There is no evident chronological sequence in the sketch-book; if this is accepted as the later drawing, the development from a more realistic representation of the bottle to the schematic sign used here fits well with what is revealed of the development of Miró's ideas otherwise in the sketch-books. Both the theme of *Head of a Catalan Peasant* (from its first version) and *Catalan Landscape (Hunter)* began with more realistic sketches, for instance, and there are many similar cases.

55. Perhaps the most direct use of the fusion of figure and still life was made in the painting of 1924 'Sourire de ma blonde', where the female subject becomes a bouquet of flowers, each of her salient features a single bloom on a single stalk. The drawing for this work bears the inscription: 'Fleurs en formes de membres humaines . . .' See Picon (1977), op.cit., p.70.

56. All the various items denoted in the work are catalogued one by one, following Miró's own indications, in William Rubin, *Miró in the Collection of the Museum of Modern Art*, New York, 1973, p.19.

57. It seems possible that the fragmentary way in which everything is presented operates as a parody of the analytical or conceptual version of Cubism in which the artist is said to present 'ideas' of figures or objects aspect by aspect, fragment by fragment. Certainly Raynal continued to distinguish between the visual and the 'conceptual' as he had in 1912. See Maurice Raynal, 'Quelques intentions du cubisme', dated 1919; in *E.M.*, no.1, January 1924.

58. For a fuller discussion of this, see Part III, below.

59. André Masson, 'Origines du Cubisme et du Surréalisme', Lecture, 1941; in André Masson, *Le Rebelle du surréalisme, Ecrits*, edited with notes by Françoise Will-Levaillant, Paris, 1976, p.21.

60. For a full discussion of Masson and Miró as 'painter-poets', see Part IV, chapter 18, below.

61. Maurice Raynal, 'La Peinture surréaliste', *L'Intransigeant*, Tuesday, 1 December 1925.

Chapter 6

1. It is significant that Léonce Rosenberg was still publishing his theoretical ideas of the early post-war years in *E.M.* in 1926. His 'Cubisme et tradition', first published as a pamphlet in 1920, reappeared in *E.M.* nos 26 and 27, June and July 1926.
2. See Part II, p.125, below.
3. *Cahiers d'Art* was especially supportive towards Cubist art. Thus, in the third year of the periodical (1928), there were, for instance, articles by Cassou and Tériade on Braque, and by Tériade on both Léger and Gris, all similarly fullsome in tone.
4. Jean Cassou, 'Georges Braque', *Cahiers d'Art*, 1928, p.5.
5. Christian Zervos, 'Les Expositions, P. Mondrian', *Cahiers d'Art*, 1928, p.94.
6. 'N.D.L.R', note under the heading 'Max Ernst', *Cahiers d'Art*, 1928, p.69.
7. Christian Zervos, 'Du Phénomène surréaliste', *Cahiers d'Art*, 1928, pp.113–14.
8. It is difficult to consider much of the work during the thirties of such artists as Ben Nicholson in Britain or Stuart Davis and George L. K. Morris in the United States outside the context of Cubism.
9. This particular fruit-bowl specifically brings to mind the fruit-bowl in *The Red Table-cloth*, 1924 (Zervos, vol.V, no.364).
10. One instance where marks are visibly the result of incising wet paint is *Mandolin and Music-stand*, 1923 (Zervos, vol.V, no.89). There are other instances in 1924.
11. See, especially, William Rubin, *Picasso in the Collection of the Museum of Modern Art*, New York, 1972, pp.120–1.
12. John Golding suggests this in 'Picasso and Surrealism'; see John Golding and Sir Roland Penrose, *Picasso, 1871–1973*, London, 1973, p.89.
13. Pins are a particularly visible feature of certain *papiers collés* made at Céret in the spring of 1913, e.g. *Guitar, Glass and Bottle of Vieux-Marc*, 1913, Zervos, vol.II, no.757, Daix and Rosselet, *Picasso* (1978), no.603.
14. Penrose records how Picasso told him that he considered embedding razor blades in the edges of the work, 'so that whoever went to lift it would cut their hands'. Sir Roland Penrose, *Picasso, his Life and Work*, London, 1958 and 1971, p.261.
15. C.f. Green, *Léger* (1976), p.284.
16. A substantial indication of the importance of work by Judi Freeman now coming to completion (for a dissertation to be presented at Yale University) is found in her book review, 'Léger re-examined', *Art History*, London, September 1984, pp.349–59.
17. Léger's stress on the 'plastic' is particularly clear in his attitude to the object in film. See 'Essai critique sur la valeur plastique du film d'Abel Gance', *Comoedia*, 16 December 1922, in Léger, *Fonctions* (1965); and 'Réponse à une enquête', *Le Théâtre et Comoedia illustré, Film*, March 1923.
18. Angelica Zander Rudenstine notes two other versions as well; see Angelica Zander Rudenstine, *The Guggenheim Museum Collection, Paintings, 1880–1945*, New York, 1976, vol.II, p.474.
19. Two other works where objects were exclusively synthesized seem worth mentioning: *Musical Instruments*, 1926, private collection, New York, and *The Accordion*, 1926, Stedelijk van Abbemuseum, Eindhoven.
20. C.f. my identification of a specific source in El Lissitzky: Christopher Green: 'Léger and L'Esprit Nouveau, 1912–1928', *Léger and Purist Paris*, London (Tate Gallery), 1970–1, p.77.
21. Fernand Léger, 'La rue: objets, spectacles', *Cahiers de la République des lettres*, 1928; in Léger, *Fonctions* (1965), p.69.
22. Parallels are especially clear with Louis Aragon's text of 1924 'Passage de l'Opéra', in *Le Paysan de Paris*, Paris, 1926.
23. Léger, *Fonctions* (1965), p.68.
24. Léger refers to Carlsund as his assistant in a letter of 7 November 1925 to Le Corbusier in the 'L'E.N. Pavillon' file at the Fondation Le Corbusier, Paris.
25. According to Fabre, Léger often noted that this accent on flatness in Carlsund was closer to Picasso. See Fabre, *L'Esprit Moderne* (1982), p.390. Also for Carl-

sund, see Inge Chambert, *Otto G. Carlsund et le France (1924–1930)*, Norköping, 1981.
26. See Fabre, *L'Esprit Moderne* (1982), pp.382–3.
27. The exhibition 'Léger et l'esprit moderne', at the Musée d'Art Moderne de la ville de Paris, in 1982, was the first occasion in France at which Clausen's work, including this painting, was given the public attention it deserves.
28. Metzinger's work of this period is distinct. Some minimal attention is given to it in the catalogue *Jean Metzinger in Retrospect* (ed. Joanne Moser), The University of Iowa Museum of Art, Iowa City, 1985.
29. Gerald Murphy was based partly in Paris from the early twenties. He was on friendly terms with Léger, who often visited him at his villa near Antibes. He left France in 1930. His entire output of oil paintings in the period 1921–30 numbered ten.
30. Valmier's work continued uncompromisingly Cubist, however. See *Georges Valmier, 1885–1937*, Galerie Seroussi, Paris, 1985–6.
31. Jean Cassou, 'Georges Braque', *Cahiers d'Art*, 1928; E. Tériade, 'L'Epanouissement de l'oeuvre de Braque', *Cahiers d'Art*, 1928.
32. Ibid, p.8.
33. Tériade (1928), loc.cit., p.409.
34. See André Salmon, 'Nouvelles Sculptures de Lipchitz', *Cahiers d'Art*, 1926, p.163; 'Jacques Lipchitz', *Art d'aujourd'hui*, no.10, 1926, pp.21–3; and 'La Sculpture vivante', *A.V.*, 1 May 1926, p.335; Waldemar George, 'Bronzes de Jacques Lipchitz', *L'Amour de l'Art*, no.7, 1926, pp.299–302.
35. A mark of his success was his commission from the Comte de Noailles in 1927 for a sculpture (*The Joy of Life*) to be set in the grounds of his villa at Hyères. See Jacques Lipchitz with H. H. Arnasson, *My Life in Sculpture*, London, 1972, pp.96–9.
36. The account is found in ibid, p.85.
37. C.f. Stott, *Lipchitz* (1978), p.170.
38. It is possible that Lipchitz's transparencies were a stimulus behind Picasso's two wire constructions of 1928. Lipchitz claims that Picasso 'spent half an hour' studying one of the pieces at Jeanne Bucher's gallery. See Lipchitz with Arnasson (1972), op.cit., p.93.
39. Ibid, p.95.
40. Laurens's nudes of the mid-twenties can seem heavily Neo-Classical, but they still fit into a Cubist context, like Braque's *Canéphores*. See Marthe Laurens, *Henri Laurens, Sculpteur, 1885–1951*, Paris, 1955, p.108, IV–35; also *Henri Laurens, 1885–1951, 60 oeuvres 1915–1954*, galerie Louise Leiris, June–July 1985, nos 18 and 20. Marcoussis too produced work closely related to Braque's, himself turning to the *Pedestal Table* theme in 1928. See Jean Lafranchis, *Marcoussis, sa vie, son oeuvre*, Paris, 1961, catalogue nos P.120, 123, 131, 132, 133.
41. The Chronicle is told with moving simplicity in Kahnweiler (1968–9), pp.53–62.
42. After mid-1922 Gris ceased to date his paintings to the month of their completion. Cooper's dating between 1924 and 1927 is, therefore, more approximate. He does not justify it, but the assumption must be that it is based on the Kahnweiler stock-numbers given and the way they relate to the accessioning of works for the galerie Simon. See Cooper, *Gris* (catalogue, 1977), vol.II, no.621.
43. There are many instances, but the following are worth singling out: ibid, nos 504, 505, 506, 525, 526.
44. Ibid, nos 543 and 530.
45. Text in Raynal. *Anthologie* (1927), p.172; in Kahnweiler, *Gris* (1968–9), p.204, translated by Douglas Cooper.

Chapter 7

1. He had done so both under the pseudonym 'La Palette' in the newspaper *Paris-Journal*, and in his 'Histoire anecdotique du cubisme' in *La Jeune Peinture française*, Paris, 1912.
2. André Salmon, 'La Peinture', *N.R.F.* 1 April 1921, pp.437–42.
3. Fernand Léger, open letter, *Paris-Journal*, 30 November 1921.
4. André Lhote, 'Réponse à un enquête', *Bulletin de la vie artistique*, 1 January 1924, pp.12–13.
5. He wrote regularly in the *Nouvelle Revue Française* especially between 1919 and 1923.

6. See Part I, p.65, above.
7. Raynal, *Anthologie* (1927), p.10.
8. Ibid, pp.14–16.
9. Ibid, p.21.
10. Ibid, p.22.
11. For a much fuller discussion, see Chapter 12, below.
12. Raynal does give some attention to Surrealism, seeing it as Germanic and Romantic in origin, and naming Joan Miró as 'le chef de l'Ecole', but he sees it as literary and as therefore outside the 'tendances de l'art de chez nous'. Ibid, pp.35–7.
13. André Salmon, 'Au Salon d'Automne', *L'Europe Nouvelle*, 8 November 1919, pp.2161–2. Salmon declares here that too many 'moderns' believe that they have won already, and contends rather that 'Ils ont encore besoin de propagande.'
14. Lhote elaborately develops this argument against Vauxcelles in 'Réflexions sur le Salon d'Automne', *N.R.F.*, 1 December 1921, pp.758–62.
15. André Salmon, 'A la veille du vernissage d'automne', *L'Europe Nouvelle*, 12 September 1920, p.1322.
16. André Salmon, 'Cinquante Ans de peinture française, 1875–1925', *A.V.*, 15 June 1925, p.1.
17. Léon Werth, 'La Peinture en province', *A.V.*, 1 August 1925, p.23.
18. A good account of the Indépendants is given in Gee, *Parisian Art Market* (1977), pp.12–16.
19. André Salmon, 'Au Salon des Indépendants—, I— Les Artistes et leurs oeuvres', *L'Europe Nouvelle*, 23 January 1921, p.121.
20. Allard's contribution as a critic is dealt with by Lynn Wissing Camwell in *Cubist Criticism: 1907–1925*, Dissertation presented for the degree of Ph.D., University of California at Los Angeles, Ann Arbor, 1980. A further analysis, which places Allard's pre-Great War criticism in an ideological framework and registers more closely the shifts in his stance at that time, is provided by David Cottington in *Cubism and the Politics of Culture*, Dissertation presented for the degree of Ph.D., Courtauld Institute, University of London, 1985, pp.358–69, 418–20, 498–500.
21. Roger Allard, 'Interversion des Salons', *N.R.F.*, 1 June 1920, p.929.
22. André Salmon, 'Du Sujet dans la peinture', *L'Europe Nouvelle*, 19 September 1920, p.1359.
23. Gee, *Parisian Art Market* (1977).
24. Gee discusses a wide range of collectors, including all those named here; ibid, pp.154–210.
25. One of the few significant faults in Gee's study is the implication left that the commercial boom for 'modern art' after the 1918 war was unprecedented. David Cottington's work has recently shown that boom conditions also existed in the 1900s; he points to the relatively quick commercial success of the leading Fauves in 1906–7, and the investment success of those who were included in the 'Société de la Peau de l'Ours'. See Cottington (1985), op.cit., chapter 4.
26. Salmon reported a move towards liberalization at the Nationale of spring 1920; Van Dongen and Dufresne had shown there in what he calls a 'Salle des Fauves'; 'Le Salon de la Nationale', *L'Europe Nouvelle*, 17 April 1920, pp.495–6. 'Salle X' and its implications are discussed by Salmon in 'Les Salons', *La Revue de France*, 1 June 1921, p.651; and by Guillaume Janneau in 'Au Salon de la "Nationale",' *Bulletin de la vie artistique*, 15 April 1921, pp.227–9.
27. Salmon, *L'Europe Nouvelle*, 17 April 1920, op.cit., p.495.
28. There were signs of liberalization even before 1914. Thus, David Cottington has pointed to the fact that the Indépendants of 1911 included certain exhibitors from the 'Artistes français', and that Gaston La Touche invited a few Fauves to show at the Nationale in 1910. See Cottington (1985), op.cit., chapter 3.
29. Janneau (15 April 1921), loc.cit., p.229.
30. André Salmon, 'Les Salons', *La Revue de France*, 1 June 1921, p.651.
31. See André Lhote, in 'Les Dernières Rétrospectives', *N.R.F.*, 1 July 1922, pp.111–15.
32. The *enquête* was headed 'Un Salon unique', and opened with an article commending the idea of an alliance between the 'Artistes Français', the 'Société Nationale' and the 'Automne' by Guillaume Janneau. See *Bulletin de la vie artistique*, 15 September 1921. Replies came in the number for 1 October 1921.
33. Salmon argues this in his article in *La Revue de France*, 1 June 1921, p.653.

34. André Salmon, 'Les Arts et la vie', *La Revue de France*, 15 June 1923, pp.795–7.

35. André Salmon, 'La Peinture. Consécration du Palais de bois', *La Revue de France*, 1 August 1924, p.589.

36. For Bénédite's role in the affair of the Caillebotte bequest (1894–97), and for his policies *vis-à-vis* 'art indépendant' at the Luxembourg, see Jeanne Laurent, *Arts et pouvoirs*, Saint-Etienne, 1982, pp.87–99.

37. Matisse's *Odalisque with red Culottes* of 1921 was bought in 1922. Considering its subject-matter and style it was not a very radical purchase, however.

38. Much of this derived from the bequest of Marcel Sembat's collection to Grenoble. It had been Sembat who had spoken out against the attacks on the Salon d'Automne of 1912 in the Chambre des Députés.

39. See 'A l'Exposition', *L'Intransigeant*, Tuesday, 18 August 1925; a quarter of a million visitors were reported for Sunday, 15 August, and approaching 200,000 for that Monday.

40. Salmon testifies to this pressure, though he gives no details. André Salmon, 'Cinquante Ans de peinture français, 1875–1925', *A.V.*, 15 June 1925, p.1.

41. It is the tone of critical exchanges that reveals this.

42. Hand-written, undated draft of a letter addressed to 'Monsieur le D^r des M.N.', in Carton 211, Fonds Vauxcelles, Bibliothèque Jacques Doucet, Ecole d'Art et Archéologie, Paris.

43. The letter to Vauxcelles is dated 26 May 1925, and is also in Carton 211 of the Fonds Vauxcelles. He had been a Chevalier de la Légion d'Honneur from as early as 1905.

44. The letter in question was sent to Anatole de Monzie. Among the signatories were: Friesz, Luc-Albert Moreau, de Segonzac, Charreau, Favory, Valadon, Utter, Kisling, Marcoussis, Lurçat, Vlaminck, Marchand, Utrillo, Maillol, Auguste Perret, plus Claude Monet, Frantz Jourdain and Guillaumin. This too is in Carton 211, of the Fonds Vauxcelles.

45. See p.138, below.

46. Undated letter to 'M. le D^r des M.N.', see note 42, above.

47. Replies to the *enquête* begin in the 15 July 1925 number. Masson's appointment is announced in *A.V.*, 15 August 1925.

48. An enthusiastic account of the reorganization and rehanging of the Luxembourg is given by Auguste Marguillier in 'Musées et collections', *Mercure de France*, 15 May 1926, pp.203–9. More information can be gleaned from the intensely hostile assessment given by Jacques Guenne in 'La Création d'un musée d'art moderne s'impose, La Réouverture du Luxembourg', *A.V.*, 1 May 1926, pp.325–6.

49. Georges Besson, 'Artistes et cie, VIII—Le Musée Luxembourg'; press-cutting in the Fonds Vauxcelles.

50. André Salmon, 'Peinture et sculpture', *La Revue de France*, 1 May 1925, p.189.

51. Georges Charensol, 'Les Expositions', *A.V.*, 15 March 1926, p.233.

Chapter 8

1. Léon Werth, 'De Quelques Confusions', *A.V.*, 15 June 1925, p.19.

2. André Salmon, 'La Peinture', *La Revue de France*, 15 August 1921, p.884.

3. This chapter is greatly endebted to Gee's work, which must be the starting-point for any analysis of the art market and the audience for 'modern art' in France between 1910 and 1930; see Gee, *Parisian Art Market* (1977). Though less specifically concerned with this period, another very useful source is: Raymonde Moulin, *Le Marché de la peinture en France*, Paris, 1967.

4. See Alfred Sauvy, *Histoire économique de France entre les deux guerres*, vol.I, Paris, 1965, and Gee, *Parisian Art Market* (1977), vol.II, p.229.

5. Gee gives a very clear account of the dealer system in Paris, see ibid, chapter III.

6. Braque was contracted to Léonce Rosenberg up to May 1920, at which point he signed a contract with Kahnweiler which was extended to May 1922. See Isabelle Monod-Fontaine, Agnès Angliviel de la Baumelle and Claude Laugier, *Donation Louis et Michel Leiris, Collection Kahnweiler-Leiris*, Centre Georges Pompidou, Musée National d'Art Moderne, Paris, 1984–5, pp.29–30.

7. C.f. Gee, *Parisian Art Market* (1977), pp.73–7.

8. Ibid, pp.73–4.

9. Ibid, p.38.

10. Ibid, pp.73–7.

11. Ibid, p.90. Breton's activities as a dealer/collector, touched on by Gee, require further research.

12. Gee describes the process by which artists progressed by moving from smaller to bigger dealers; ibid, pp. 39–40.

13. Ibid, pp.23ff.

14. These were all artists who commanded relatively high prices. The exchange rate of the franc to the pound sterling ranged from 31.80 in 1919 to 51.93 in 1921, 73.73 in 1923, 102.59 in 1925, and 123.87 in 1927. Figures taken from Dierdre Mapstone, *An Examination of Some External Influences on Modern Art in Paris in the 1920s*, Dissertation presented for the degree of M.A., University of Warwick.

15. See Gee, *Parisian Art Market* (1977), p.27.

16. The work had been discovered by Louis Vauxcelles in 1923 and sold via Henri-Pierre Roché to John Quinn. At the Quinn sale it was given special attention by Jean Cocteau in the catalogue. Basler discusses the whole affair in 'Le "Douanier" Henri Rousseau', *A.V.*, 15 October 1926, pp.777–83. See also *Le Douanier Rousseau*, Galeries Nationales du Grand Palais, Paris, 1984–5.

17. This instance is taken from Gee, *Parisian Art Market* (1977), p.164.

18. Both these developments produced responses in the art press; see Lhote's criticism in *La Nouvelle Revue Française* and Salmon's in *La Revue de France*, and also the *Bulletin de la vie artistique* and newspapers, especially *L'Intransigeant*.

19. Gee, *Parisian Art Market* (1977), pp.21–2.

20. André Salmon, 'Peinture et sculpture', *Le Revue de France*, 1 May 1925, p.188.

21. Léon Werth, 'Chronique Artistique, La Peinture et l'époque', *A.V.*, 1 June 1925, p.19.

22. See, especially, Albert Gleizes, 'A propos du Salon d'Automne', *La Vie des lettres*, January 1921, pp. 336–9.

23. Berthe Weill's reply in 'Pour un Musée français d'art moderne (suite)', *A.V.*, 15 August 1925, p.36.

24. Louis Marcoussis's reply in 'Pour un Musée français d'art moderne', *A.V.*, 1 August 1925.

25. Gromaire in *A.V.*, 15 September 1927, p.740.

26. Jean Cassou in *A.V.*, 15 September 1927, p.740.

27. Pierre Loeb in *A.V.*, 1 November 1927, p.892.

28. Alfred Flechtheim in *A.V.*, 1 November 1927, p.895.

29. Jean Cassou in *A.V.*, 15 September, 1927, p.740.

30. Paul Guillaume's reply in 'Pour un Musée français d'art moderne (suite)', *A.V.*, 15 September 1925, p.38.

31. Signac rejected all selection procedures and therefore the whole notion of a state Musée d'art moderne; see Signac's reply in 'Pour un Musée français d'art moderne', *A.V.*, 15 July 1925, p.37. J.-E. Blanche's reply was in the same number.

32. When Daniel Tzanck replied to the *enquête* of 1925, he signed himself 'Président de la Société des Amateurs et Collectionneurs'; he wrote that the society here mentioned had been acting as a pressure-group for a Musée français d'art moderne over the last year, and he named among those involved Waldemar George. See 'Pour un Musée français d'art moderne', *A.V.*, 15 July 1925. In April 1925 André Salmon had referred to the Société, commenting that Paris would one day owe it and Tzanck 'son Musée de l'art Moderne, rendu indispensible par la carence du Luxembourg'. 'La Peinture', *La Revue de France*, 1 April 1925, p.586.

33. This emerges both from his study of the public sales at the Hôtel Droûot, and from his study of the collectors and their collections; see Gee, *Parisian Art Market* (1977).

34. See Gee's extensive analysis, ibid, vol.II, Appendix F.

35. The Eluard Sale at the Hôtel Droûot was 3 July 1924; ibid, vol.I, p.28. It had been bought at the Kahnweiler Sales for 1,720 francs, however.

36. This is according to René Gimpel, as cited ibid, vol.I, p.59.

37. I am grateful to Malcolm Gee, who gave me this information. It comes from the Quinn-Roché correspondence held in the New York Public Library (Microfilm Reel 33).

38. Florent Fels, 'Le Salon des Tuilleries', *A.V.*, 15 May 1925, p.19.

39. Picasso's independent dealings with Roché and Quinn are evidence of this in 1922.

40. The correspondence with Léonce Rosenberg collected by Christian Derouet of the Musée National d'Art Moderne for his dossier on the dealer testifies to his toughness over financial arrangements with this artists.

41. See Monod-Fontaine, Angliviel de la Beaumelle and Laugier (1984–5), op.cit., p.58 and 104–5.

42. Gee discusses this in *Parisian Art Market* (1977), p.46.

43. See note 40, above. An important source of material on Léonce Rosenberg is M. Rheims, *La Vie étrange des objets*, Paris, 1963. Gee deals with him and his gallery, placing him in conjunction with Kahnweiler; ibid, pp.44–58. See also Christian Derouet, 'Les émois cubistes d'un marchand de tableaux', *Europe*, June-July 1982, pp.51–8.

44. This is especially clear in the correspondence with Kahnweiler published by Douglas Cooper. See *Letters of Juan Gris, 1913–1927*, London, 1956.

45. Lipchitz recalls Rosenberg's reluctance to see Lipchitz change as the reason for their parting of company. Jacques Lipchitz with H. H. Arnasson, *My Life in Sculpture*, London, 1972, p.57.

46. This is a point made by Gee; see *Parisian Art Market* (1977), pp.160–1.

47. Ibid, pp.175–83.

48. Oddly, it seems that Quinn considered the American market not right for Cubism in the early twenties.

49. Raynal, *Anthologie* (1927), p.16 and 21.

50. Georges Charensol, 'Conclusion, Pour un Musée français d'art Moderne', *A.V.*, 1 October 1925, p.37.

51. Kahnweiler, *Gris* (1968–9), p.53.

52. Gee had access to the 'cahiers' kept by the Vicomte Charles de Noailles recording purchases; see *Parisian Art Market* (1977), p.281. For further material on the de Noailles as collectors and patrons, see Shane Dunworth, *The de Noailles as Collectors and Patrons*, Dissertation presented for the degree of M.Phil., Courtauld Institute, University of London, 1983.

53. See Florent Fels, '"L'Affaire" de l'Exposition des Arts Décoratifs' (with statements by Delaunay, Léger and Paul Léon), *Les Nouvelles littéraires*, 6 June 1925; and Georges Charensol, 'Faits divers', *A.V.*, 15 June 1925.

54. February 1928.

55. See Gee, *Parisian Art Market* (1977), pp.274–5.

56. Ibid, p.200. The arrangement with Doucet was terminated in 1924 because of the text 'Un Cadavre'.

57. Masson showed first with Kahnweiler at the galerie Simon in May 1923 (alongside Braque, Derain, Gris, Lascaux, Laurens, Manolo, Picasso, Togorès and Vlaminck). His first solo show there was in February 1924. During 1924, after the sale to André Breton of the *Four Elements* (Plate 297), and in response to the *Manifeste du Surréalisme*, Kahnweiler's relations not only with Masson but with Breton too were surprisingly positive. C.f. Isabelle Monod-Fontaine, 'Chronologie et documents'; in *Daniel-Henry Kahnweiler, marchand, éditeur, écrivain*, Centre Georges Pompidou, Musée National d'Art Moderne, Paris, 1984–5, p.139. Monod-Fontaine quotes here from unpublished letters of October 1924 between Breton and Kahnweiler.

58. Gee, *Parisian Art Market* (1977), p.280.

59. For pre-1914 developments in this direction, see David Cottington, *Cubism and the Politics of Culture*, Dissertation presented for the degree Ph.D., Courtauld Institute, University of London, 1985.

Chapter 9

1. Robert Rey, 'Cubisme', *Le Crapouillot*, 16 March 1924, pp.8–9.

2. The prominence given to this passage is witnessed by Salmon in 'Un Conférence—Le Cubisme devant l'Eternel', *L'Europe Nouvelle*, 2 August 1919, p.1492.

3. See Part I, p.63, above.

4. E.g. in his piece written for the catalogue of the 'Salon de juin: troisième exposition de la Société Normande de la peinture moderne', Rouen, 15 June-15 July 1912. His élitism then closely relates to that of Olivier-Hourcade in 'La Tendance de la peinture contemporaine', *La Revue de France et des pays français*, February 1912, which was first given as a talk at the Société Normande in November 1911. C.f. David Cottington, *Cubism and the Politics of Culture*, Dissertation presented for the degree of Ph.D., Courtauld Institute, University of London, 1985.

5. This is especially so of the texts he published in *E.N.* and *E.M.*

6. Raynal, *Anthologie* (1927), p.206.
7. Pierre Reverdy, 'L'Esthétique et l'esprit', *E.N.*, no.6, March 1921; in Reverdy, *Oeuvres complètes* (1975), p.170.
8. Pierre Reverdy, 'Chronique mensuelle', *Nord-Sud*, no.2, 15 April 1817; in ibid, p.35. Reverdy is not quite as willfully obscurantist as he might seem; the full sentence reads: 'Et si je crois qu'il ne faut pas trop prendre de peine pour éduquer le "public" je crois aussi qu'il faut éviter de le tromper.'
9. *Montjoie!* had begun in February 1913 declaring its intention to: 'Give a lead to the élite!' Canudo's elitism was still totally unabashed in 'Esthétique et inspiration des poètes nouveaux', *La Vie des lettres*, January 1921, pp.303—8: 'Le peuple, lui, a ses chansons, qui nous émeuvent parfois. L'élite vraie de la nation, elle, a l'oeuvre courageux et fort des cerveaux nouveaux, inquiets et créateurs' (p.308).
10. Florent Fels, 'Le Salon des Indépendants', *A.V.*, 20 March 1925, p.16.
11. Ozenfant and Jeanneret, 'Formation de l'optique moderne', *E.N.*, no.21, March 1924, unpaginated.
12. Le Corbusier most insistently in his series of articles 'Trois Rappels à MM.les architectes' (*E.N.* nos 2, 3 and 4, November and December 1920, and January 1921).
13. Le Corbusier-Saugnier, 'Des Yeux qui ne voient pas', *E.N.*, no.8, May 1921, unpaginated.
14. See, especially, *Urbanisme*, Paris, 1925. Robert Fishman has provided an important discussion of Le Corbusier's hierarchical ideas concerning the governing and managerial élite, linking them especially to the Saint Simonian meritocratic ideal. He has also analysed Le Corbusier's development of a fused authoritarianism and egalitarianism in the Thirties and its implications for his élite'. See Robert Fishman, 'Le Corbusier's Plans and Politics, 1928—1942', in Russell Walden (ed.), *The Open Hand. Essays on Le Corbusier*, Massachusetts, 1977, p.244ff. A much more extensive discussion of Le Corbusier's attitudes to these questions throughout the twenties and thirties exists now in: Mary McLeod, *Urbanism and Utopia: Le Corbusier from Regional Syndication to Vichy*, Dissertation presented for the degree of Ph.D., Princeton University, 1985.
15. This point is made by Kenneth Silver in *Esprit de corps* (1981).
16. Ibid, pp.123—7.
17. Jean Cocteau, in *L'Excelsior*, 18 May 1917; quoted ibid, p.129.
18. Again this point is made by Silver, ibid, p.123—7.
19. For further material, see Melissa A. McQuillan, *Painters and the Ballet, 1917—1926: An Aspect of the Relationship*, Dissertation presented to New York University, 1979.
20. André Lhote, 'Les Dernières Rétrospectives', *N.R.F.*, 1 July 1922, p.113.
21. In June—July 1925 the Comité du Conseil of the Musées Nationaux agreed to accept Doucet's gift of *The Snake Charmer*, though it did not actually enter the collection until 1935. See *Le Douanier Rousseau*, Galerie Nationales du Grand Palais, Paris, 1984—5, p.189. The agreement was celebrated by André Salmon in 'L'Entrée au Louvre du Douanier Rousseau', *A.V.*, 1 November 1925. The photomontage appeared in the last issue of 1925: 15 December.
22. See, especially, Raynal, 'Les Arts', *L'Intransigeant*, Tuesday, 14 November 1922. Writing on the *naifs*, he remarks: 'Il n'a donc pas lieu d'ériger leur art en modèle, ni le comparer à celui des maîtres, comme on l'a fait, un peu légère, de l'oeuvre de bon Douanier.'
23. Paul-Emil Pajot was a seaman-painter who was 'discovered' at this time by Jacques Viot. Early in 1925 his paintings were shown at the galerie Pierre. See André Salmon, 'La Peinture', *La Revue de France*, 1 April 1925.
24. The works came from the collections of, among others, Lhote, Léger, Marcoussis, Masson, Raynal and Vlaminck, as well as Kahnweiler. See Isabelle Monod-Fontaine, 'Chronologie et documents', *Daniel-Henry Kahnweiler, marchand, éditeur, écrivain*, Centre Georges Pompidou, Musée National d'Art Moderne, Paris, 1984—5, p.137. Lhote described them thus: 'Natures mortes groupant des bibelots lourds de souvenirs; paysages pauvres ou redoutablement pittoresques; scènes de famille attendrissantes; batailles, chasses, scènes historiques reconstituées grâce au supplément du Petit Parisien; scènes de cirque; portraits comme figés par l'effet de l'application reciproque

du modèle et du peintre, tremblants tous deux de se sentir les artisans d'une opération magique; inévitables anecdotes plaisantes ou sentimentales . . .'. 'Les Artistes inconnus à la galerie Simon et le Salon d'Automne', *N.R.F.*, 1 December 1922, p.757.
25. Maurice Raynal, 'Les Arts,' *L'Intransigeant*, Tuesday, 14 November 1922.
26. The term used in French is, in fact, 'démonter'. George expresses his wish to '"démonter" les tableaux . . .' The analogy is, of course, mechanistic; 'Louis Marcoussis', *La Vie des lettres*, July 1921, p.619.
27. See Part I, pp.82—4, above.
28. Albert Gleizes, 'La Peinture et ses lois, "ce qui devait sortir du cubisme"', *La Vie des lettres*, October 1922, p.46.
29. Ibid, pp.37—43.
30. Albert Gleizes, 'A propos du Salon d'Automne', *La Vie des lettres*, January 1921, p.339.
31. Albert Gleizes, 'A propos de l'Exposition Lurçat', *La Vie des lettres*, June 1922, pp.330—4.
32. Albert Gleizes, *Du Cubisme et les moyens de le comprendre*, Paris, 1920.
33. Florent Fels, 'Propos d'artistes, Fernand Léger', *Les Nouvelles Littéraires*, Saturday, 30 June 1923.
34. His resistance to 'good taste' is especially clear in his statement in *Valori Plastici*, Rome, February—March 1919, p.3. The resistance to hierarchies of value and at the same time the insistence on 'plastic' qualities are both dominant themes in the lecture 'L'Esthétique de la machine' given in June 1923, and first published in *Der Querschnitt*, Berlin, vol.III, 1923, and in France in *E.M.*, nos 1 and 2, January and February 1924. See below.
35. Léger (1923); in Léger, *Fonctions* (1965).
36. Ibid, pp.55—6.
37. Léger in Fels (30 June 1923), loc.cit.
38. Léger (1923); in Léger, *Fonctions* (1965), p.58.
39. It seems likely that Brancusi's 'Princesse X' figured among these 'sculptures stylisés' and that the Indépendants referred to was that of 1920. This follows from the fact that it was precisely as 'sculptures stylisés' that Brancusi's work was criticized by those who took it seriously in 1920—1, and this by way of contrast with the Cubist work of Lipchitz. Thus, in 1920 Dermée tried to characterize Lipchitz's sculpture by setting it against all that came of 'stylization', i.e. abstracting from the real, a point echoed by Waldemar George in the same number of *La Vie des lettres* as this lecture by Gleizes. While Salmon, though he did not use the term 'stylization' at the time, took Brancusi to task precisely for abstracting from the real in his responses to the Indépendants of 1920. See Paul Dermée, 'Jacques Lipchitz', *E.N.*, no.2, November 1920; Waldemar George, 'La Sculpture de Jacques Lipchitz', *La Vie des lettres*, April 1921; André Salmon, 'Aux Indépendants (II) — Le Bonnat du Cercle Volnay', *L'Europe Nouvelle*, 7 February 1920, p.233, and 'Des Indépendants au Louvre', *L'Europe Nouvelle*, 14 February 1920, pp.281—2.
40. Albert Gleizes, 'Réhabilitation des Arts Plastiques', *La Vie des lettres*, April 1921, p.241.
41. Ibid, p.421.
42. Léger (1923); in Léger, *Fonctions* (1965), pp.53—62.
43. Mayakowsky recalled spending some time in Léger's company when he was in Paris in 1924. C.f. Mayakowsky in 'The Seven Day Review of French Painting' of 1925; the relevant passage dealing with Léger as an 'authentic painter worker' whose approach to the Russian Revolution is 'practical' is translated in W. Worozylski, *The Life of Mayakovsky*, New York, 1970. For the development of Constructivist theory in INKhUK and through *Lef*, see Christina Lodder, *Russian Constructivism*, New Haven and London, 1983, especially pp.73—108.
44. Léger (1923); in Léger, *Fonctions* (1965), p.61.
45. More light would undoubtedly be thrown on these issues by a study of Gleizes's and Léger's position in relation to then current Marxist debates in France centring on the problem of the artist in society. The research of Bryony Fer on such debates in the periodical *Clarté* should help in this respect. See her forthcoming dissertation for the degree of Ph.D., University of Essex.
46. Kahnweiler, *Gris* (1968—9), p.56, Kahnweiler names Allendy as one of the regular visitors to Gris's studio after the move to Boulogne-sur-Seine in 1922; see p.45.
47. The 'Société' was under way by June 1923, when

Léger gave his lecture 'L'Esthétique de la machine' (for report, see *L'Intransigeant*, 13 June 1923). In the autumn of 1923 it held a conference on 'les tendances actuelles de la psychologie' with lectures by Adler, Otto Rank and Piaget among others. Allendy himself spoke on 'Rêves et leur interpretation psychoanalytique'. The conference is reported in *La Vie des lettres* for October 1923, but an especially full report appears by Marc Plan in the December 1923 issue (pp.87—96).
48. Gris's lecture was delivered on 15 May 1924.
49. Dr R. Allendy, 'L'Orientation des idées nouvelles', *La Vie des lettres*, February 1923, pp.10—15. Allendy had written his thesis on *L'Alchimie et la médicine* (1912), and there had proposed a return to a philosophical science capable of dealing with the mental and physical as continuous with one another. This was still the basis of his thinking in 'Le Médicine synthétique', *E.N.*, no.13, 1922. His thinking on alchemy, medicine and psychoanalysis is discussed in Elizabeth Legge, *Conscious Sources of the Unconscious: Ernst's Use of Psychoanalysis Themes and Imagery, 1921—1924*, Dissertation presented for the degree of Ph.D., Courtauld Institute, University of London, 1985, pp.195—6.
50. See especially the answers of Frantz Jourdain and Georges Jamati in the 'Enquête sur le cubisme', *La Revue de l'Époque*, March 1922.
51. André Salmon, 'Les Arts et la vie', *La Revue de France*, 1 April 1923, p.581.
52. Léon Werth, 'Bonnard', *A.V.*, 1 May 1925, p.2.
53. Maurice Raynal, 'Conception et vision', *Gil Blas*, 29 August 1912. C.f. Lynn Wissing Camwell, *Cubist Criticism: 1907—1925*, Ann Arbor, Michigan, 1980, pp.46—7.
54. Maurice Raynal, 'Quelques intentions du cubisme', Paris, 1919; in *E.M.* no.1, January 1924, p.3.
55. Ibid, in no.2, February 1924.
56. Ibid, in no.1, January 1924.
57. C.f. Olivier Hourcade, 'La Tendance de la peinture contemporaine', *La Revue de France et de Pays français*, February 1912.
58. Pierre Reverdy, 'Sur le cubisme', *Nord-Sud*, March 1917; in Reverdy, *Oeuvres complètes* (1975), p.19.
59. Louis Vauxcelles, 'De Cézanne au cubisme, à propos de la "section d'or"', *Eclair*, 18 March 1920.
60. Léonce Rosenberg, 'Cubisme et empirisme' (1920—1926); in *E.M.*, no.31, January 1927.
61. Léonce Rosenberg, 'Cubisme et empirisme' (1920—1926); in *E.M.*, no.29, November 1926.
62. See pp.40—45, above.
63. Maurice Raynal, 'Ozenfant et Jeanneret', *E.N.*, no.7, April 1921.
64. Ozenfant and Jeanneret, 'No.27 et suivants', *E.N.*, no.27, November 1924.
65. Ozenfant and Jeanneret, 'Sur la plastique', *E.N.*, No.1, October 1920.
66. Albert Gleizes, 'A propos du Salon d'Automne', *La Vie des lettres*, January 1921, pp.336—342.
67. Albert Gleizes, *Du Cubisme et les moyens de le comprendre*, Paris, 1920.
68. Silver, *Esprit de corps* (1981).
69. Ibid, pp.15—17, 31—2, 108, 126—7, 218—21, 231—7.
70. David Cottington has attempted to associate Gleizes's pre-1914 stance with an ideological position which he situates towards the Right. This he does by focusing on Gleizes's nationalism and his attraction to the idea of tradition. See David Cottington, *Cubism and the Politics of Culture*, Dissertation presented for the degree of Ph.D., Courtauld Institute, University of London, 1985.
71. Albert Gleizes and Jean Metzinger, *Du Cubisme*, Paris, 1912.
72. See Part I, pp.50—52, above.
73. See Paul Dermee, 'un Prochain Age classique', *Nord-Sud*, January 1918. See also p.37, below.
74. Silver, *Esprit de corps* (1981), pp.209—30, 383—6.
75. André Salmon, 'Dessins de Picasso (galerie Paul Rosenberg), Peintures de Kisling (galerie Druet)', *L'Europe Nouvelle*, 25 October 1919, p.2065.
76. Jean-Gabriel Lemoine, 'La Vérité sur le cubisme', *Le Crapouillot*, 1 April 1920, pp.13—14.
77. Ozenfant and Jeanneret, 'Vers le cristal', *E.N.*, no.25, July 1924.
78. Ozenfant, 'Sur les écoles cubistes et post-cubistes', *Journal de Psychologie normale et pathologique*, March 1927.
79. A. Schneeberger, 'Fauves, cubistes et post-cubistes', *A.V.*, January 1921, p.362.

80. Pierre Reverdy, 'L'esthétique et l'esprit', *E.N.*, no.6, March 1921; in Reverdy, *Oeuvres complètes* (1975), pp.171–2.
81. As Etienne-Alain Hubert has pointed out, Reverdy's piece 'Critique synthétique' published in *Littérature*, May 1919, is essentially an attempt to ridicule Paul Dermée's *Beautés de 1918*, published that year; it contains a send-up of Metzinger's still-life painting since Dermée was associated with the painter; see Reverdy, *Oeuvres complètes* (1975), pp.148–51 and p.318.
82. Léger (1923); in Léger, *Fonctions* (1965), pp.53–4.
83. Juan Gris, 'On the Possibilities of Painting', Lecture delivered 15 May 1924 (translated by Douglas Cooper); in Kahnweiler, *Gris* (1968–9), pp.195–201.
84. Gris to Kahnweiler, 17 February 1920.
85. Stott, *Lipchitz* (1978), pp.41–2 and p.55.
86. Pierre Cèpe, 'Les Réticences de Georges Braque', *Paris-Journal*, 13 April 1923.
87. Auguste Herbin, 'Correspondance, Hors d'oeuvre', (January 1919), *E.M.*no.4, April 1924.
88. Maurice Raynal, 'Severini', *S.I.C.* nos 45 and 46, 15 and 31 May 1919, p.3.
89. Gino Severini, *Du Cubisme au classicisme*, Paris, 1922.
90. Maurice Raynal, 'Les Arts', *L'Intransigeant*, Monday, 7 August 1922.
91. Kahnweiler in particular reports a discussion which took place on 13 March 1920 between himself and Gris where the painter explained his new ideas on synthetic as distinct from analytic Cubism and at which the dealer took notes. See Kahnweiler, *Gris* (1968–9), pp.144–6.
92. Maurice Raynal, *Lipchitz*, Paris, 1920, unpaginated.
93. Ibid.
94. Ibid.
95. Ibid.
96. Ibid.
97. See Imanuel Kant, *Critique of Judgement*, translated, with an Introduction, by J. H. Bernard, New York, 1974, pp.35–175.
98. Maurice Raynal, 'Juan Gris', *E.N.*, no.5, February 1921, pp.535–6.
99. Ibid, p.537.
100. Ibid.
101. Ibid.
102. Jean Cassou, 'Cubisme et poésie', *La Vie des lettres*, July 1920, p.183.

Chapter 10

1. Pierre Reverdy, 'L'Esthétique et l'esprit', *E.N.*, no.6, March 1921; in Reverdy, *Oeuvres complètes* (1975), pp.173–4.
2. The dates of all the numbers of *L'Esprit Nouveau* are conveniently supplied by Susan L. Ball in *Ozenfant and Purism: the Evolution of a Style, 1915–1930*, Ann Arbor, Michigan, 1981, pp.197–8.
3. Reverdy (March 1921); in Reverdy, *Oeuvres complètes* (1975), p.170.
4. Paul Dermée, *Beautés de 1918*, Paris, 1919, unpaginated.
5. J. Savoldo, 'Chez Picasso', *Paris-Journal*, 7 March 1924.
6. Ibid.
7. Pierre Cèpe, 'Les Réticences de Georges Braque', *Paris-Journal*, 13 April 1923.
8. Maurice Raynal, 'Quelques intentions du cubisme', Paris, 1919; in *E.M.*, no.3, March 1924.
9. Raynal, *Anthologie* (1927), p.25.
10. Ibid, p.26.
11. Lynn Wissing Gamwell, *Cubist Criticism: 1907–1925*, Ann Arbor, Michigan; 1980.
12. Guillaume Apollinaire, *Les Peintres cubistes: Méditations esthétiques*, Paris, 1913, p.37.
13. Maurice Raynal, 'L'Exposition de "La Section d'Or"', *La Section d'Or*, 9 October 1912.
14. Waldemar George, 'Albert Gleizes', *La Vie des lettres*, January 1921, p.353.
15. Pierre Reverdy, 'Sur le cubisme', *Nord-Sud*, no.1, 15 March 1917; in Reverdy, *Oeuvres complètes* (1975), p.17.
16. Vicente Huidobro, Lecture given in Buenos Aires, July 1916. Quoted in Vicente Huidobro, 'La Création pure, propos d'esthétique'. *E.N.*, no.7, April 1921, p.775.
17. Pierre Reverdy, *Le Gant de crin*, Paris, 1927.
18. Georges Braque, 'Pensées et réflexions', *Nord-Sud*, no.10, December 1917, p.3.
19. Gris to Kahnweiler, 25 August 1919; see Douglas Cooper, *Letters of Juan Gris, 1913–1927*, London, 1956, Letter LXXX.
20. C.f. Auguste Herbin and Henri Laurens in *Valori Plastici*, Rome, February–March 1919, pp.2 and 3.
21. Paul Dermée, 'Lipchitz', *E.N.*, no.2, November 1920.
22. Albert Gleizes, 'La Peinture et ses lois, "ce qui devait sortir du cubisme"', *La Vie des lettres*, October 1922, pp.72–3.
23. Pierre Reverdy, 'Certains avantages d'être seul', *S.I.C.*, no.32, October 1918; in Reverdy, *Oeuvres complètes* (1975), pp.133 and 134. The parallel here with Roger Fry's notion of 'aesthetic emotion' is striking. Fry's article of 1909, 'An Essay on Aesthetics', opened *Vision and Design* in 1920.
24. Paul Dermée, 'Jean Metzinger', *S.I.C.*, nos 42 and 43, 20 March–15 April 1919, p.13.
25. Gris to Ozenfant, Bandol, March 1921; in Cooper (1956), op.cit., Letter CXXIV.
26. Pierre Albert-Birot, 'Dialogue nunique, Z et A devant des peintures modernes', *S.I.C.*, no.5, May 1916, p.58.
27. Pierre Albert-Birot, 'Dialogue nunique', *S.I.C.*, no.6, June 1916, p.5.
28. Pierre Albert-Birot, 'Dialogue nunique, Z et A, En marche', *S.I.C.*, no.7, July 1916.
29. Reverdy (March 1917), loc.cit.; in *Oeuvres complètes* (1975), p.19.
30. Raynal (1919), op.cit.
31. Pierre Reverdy, 'L'Emotion', *Nord-Sud*, no.8, October 1917, in Reverdy, *Oeuvres complètes* (1975), pp.56–7.
32. Raynal (1919), op.cit.
33. Pierre Reverdy, 'Le Cubisme, poésie plastique', *L'Art*, February 1919; in Reverdy, *Oeuvres complètes* (1975), p.147.
34. Reverdy (March 1921); in ibid, pp.174–5.
35. Huidobro (April 1921), loc.cit., p.773.
36. Ibid, p.773.
37. Ibid, p.773.
38. For a fuller discussion of Gris's and Reverdy's relationship, see Christopher Green, 'Purity, Poetry and the Painting of Juan Gris', *Art History*, London, June 1982.
39. See, especially, Gris to Kahnweiler, 25 August 1919; in Cooper (1956), op.cit., Letter LXXX.
40. Juan Gris, 'On the Possibilities of Painting', Lecture delivered 15 May 1924; in Kahnweiler, *Gris* (1968–9), p.195.
41. Ibid, p.195.
42. Ibid, p.196.
43. Ibid.
44. Ibid, p.200.
45. Pierre Reverdy in *Nord-Sud*, no.13, March 1918; in Reverdy, *Oeuvres complètes* (1975), p.79.
46. Ibid, p.79.
47. Vauxcelles reports Gris's reacting against Reverdy's claims for the primacy of poetry by insisting that it was he who had suggested the title for Huidobro's collection of poems *Horizon carré* and that the painters could and did lead the poets; Louis Vauxcelles, in *Le Carnet de la Semaine*, 20 April 1919.
48. Dermée (March–April 1919), loc.cit., p.13.
49. C.f. Pierre Reverdy, 'Essai d'esthétique littéraire', *Nord-Sud*, nos 4–5, June–July 1917; in Reverdy, *Oeuvres complètes* (1975), pp.40–1. See also Green (June 1982), loc.cit., p.200, notes 13 and 14.
50. Reverdy (February 1919), loc.cit; in Reverdy, *Oeuvres complètes* (1975).
51. It applied also both to Dada and to Surrealism, see: pp.253–4, below.
52. Pierre Reverdy, 'L'Image', *Nord-Sud*, no.13, March 1918; in Reverdy, *Oeuvres complètes* (1975), p.73.
53. 'Poème', in *Nord-Sud*, no.3, 15 May 1917. See Green (June 1982), loc.cit., pp.196–7.
54. Kahnweiler, *Gris* (1968–9), p.140.
55. De Costa publishes Gris's translation of poems from *El espejo de agua* of 1916 which were published in *Nord-Sud*. He also publishes two poems found in manuscript from among Huidobro's papers in Santiago, Chile, which he suggests are contemporary with the Chilean's war poems, written at Beaulieu in 1918, *Ecutorial y Hallali*, and which he attributes to Gris. See René de Costa, 'Juan Gris y la poesia', in *Juan Gris (1887–1927)*, edited by Gary Tinterow, Madrid, 20 September–24 November 1985, pp.73–92.
56. Pierre Reverdy, 'Note', *Nord-Sud*, no.12, February 1918.
57. Pierre Reverdy, 'Pablo Picasso', *Paris-Journal*, Friday, 14 December 1923. Reverdy also published a short

book on Picasso (*Picasso et son oeuvre*, Paris, 1924). Etienne-Alain Hubert argues that this was probably written in the second half of 1921, so that the *Paris-Journal* article seems to be later, at least in its composition.
58. Picasso, statement to Marius de Zayas, 1923; in Alfred H. Barr, *Picasso, 50 Years of his Art*, New York, 1946, pp.270–1.
59. Ibid, pp.270–1. The statement to de Zayas was published as if in an interview with Florent Fels in 1923; see Fels, 'Propos d'artistes, Picasso', *Les Nouvelles Littéraires*, Saturday, 4 August 1923, p.2. Here, the sentence from the previous quotation discussed above reads: 'Et du point de vue de l'art, il n'y a pas de formes concrètes ou abstraites, mais seulement des truchements plus ou moins conventionnels.'
60. Jean Metzinger, 'Tristesse d'Automne', 1 December 1922, p.2.
61. Severini to Lipchitz, Lozzano, 10 September 1920 (Jacques Lipchitz archives). From the dossier of material relating to Léonce Rosenberg and the galerie de l'Effort Moderne collected by Christian Derouet of the Musée National d'Art Moderne, Paris.
62. Léonce Rosenberg to Léopold Survage, 17 September 1921 (Archives du Musée National d'Art Moderne, Paris).
63. Ortega y Gasset, 'The Dehumanization of Art' (1925); in Ortega y Gasset, *Velasquez, Goya and the Dehumanization of Art*, translated by Alexis Brown with an introduction by Philip Troutman, London, 1972, pp.65–83.

Chapter 11

1. Though he has not discussed its post-war manifestations, David Cottington has shown how this change was already underway before the outbreak of war in 1914; see David Cottington, *Cubism and the Politics of Culture*, Dissertation presented for the degree of Ph.D., Courtauld Institute, University of London, 1985.
2. Roger Allard, 'Picasso', *Le Nouveau Spectateur*, 25 June 1919, p.67.
3. Louis Vauxcelles, 'Discussions', *Gil Blas*, October 1912.
4. André Lhote, 'Tradition et troisième dimension', *N.R.F.*, 1 October 1920, p.620.
5. See Part I, above.
6. See pp.136–7, above.
7. Georges Charensol, *D'Une Rive à l'autre*, Paris, 1973, pp.89–94.
8. Ibid.
9. Georges Charensol, 'Les Expositions', *A.V.*, 15 December 1925, p.34.
10. 'L'un près de l'autre, Dunoyer de Segonzac, Luc-Albert Moreau se comptent parmi les têtes du jeune mouvement.' André Salmon, 'Au Salon des Indépendants, I—Artistes et leurs oeuvres', *L'Europe Nouvelle*, 23 January 1921, p.122.
11. Salmon groups together de Segonzac's and Luc-Albert Moreau's 'pseudo-disciples' and dismisses them equally; see André Salmon, 'Les Arts et la vie', *La Revue de France*, 1 April 1923, p.578.
12. Commenting on the simultaneous showing in Paris of Picasso, de Segonzac, Matisse and Braque, he calls them: 'quatre des plus grands peintres du temps'. Maurice Raynal, 'Exposition Georges Braque', *L'Intransigeant*, Tuesday, 13 May 1924.
13. At the Quinn sale of autumn 1926, de Segonzac's prices were below both Matisse's and Derain's, but above both Braque's and Gris's. *Femme nue couchée* made 12,000 francs, *Le Chapeau de paille*, 20,000 francs, *Dans l'herbe*, 15,500 francs, and *L'Etable*, 26,000 francs.
14. André Salmon, 'Peintres d'aujourd'hui', *L'Europe Nouvelle*, 28 December 1918, p.2452.
15. Robert Rey on the Salon des Tuileries, in *Le Crapouillot*, 16 May 1923, p.12.
16. Roger Allard specifically makes this point, associating him especially with Diaz, Robert and Moticelli; see Roger Allard, 'Maurice Vlaminck', *A.V.*, 1 April 1925, p.4.
17. Having commented on the failure of Vlaminck's forebears, Salmon goes on: 'Il est à l'aise dans le drame, parce que le malheur exige un choix multiple: choix de moyen et choix de circonstances. C'est ainsi que cet homme robuste, c'est ainsi que ce

peintre vigoureux a été amené à peindre des ciels de désespoir qui sont parmi les plus beaux de la jeune peinture . . .' André Salmon, 'Maurice de Vlaminck', *L'Europe Nouvelle*, 8 February 1919. This was in response to Vlaminck's exhibition at the galerie Druet.

18. André Salmon, 'Vlaminck', *A.V.*, 1 January 1926, p.1.

19. Georges Charensol, 'Les Expositions', *A.V.*, 15 December 1925, p.34.

20. Jaloux accepts de Segonzac's debt to Cézanne, but contends that in his work (his *Drinkers* of 1910 (Plate 157) or his landscapes) there is: 'un pathétique que l'on ne voit guère dans l'oeuvre plus sereine du maître d'Aix'. Further, '. . . il y a quelque chose de tragique dans ces femmes couchées à travers l'ombre et qui ont souvent les postures de l'amour et de l'agonie; elles font penser à la luxure et à la mort; elles évoquent le souvenir de Baudelaire.' Edmond Jaloux, 'Dunoyer de Segonzac', *A.V.*, 15 January 1925, pp.1–3.

21. André Salmon, 'La Jeune Peinture française', *L'Europe Nouvelle*, 22 June 1918, p.1155.

22. Louis Léon-Martin, 'La Peinture', *Le Crapouillot*, 16 October 1920, p.11.

23. André Salmon, 'Au Salon des Indépendants, I—Artistes et leurs oeuvres', *L'Europe Nouvelle*, 25 January 1921, p.122.

24. A. Schneeberger, 'Le Salon d'Automne', *Revue de l'Époque*, December 1922, p.84.

25. See Robert Rey, in *Le Crapouillot*, 1 November 1922, pp.18–20; André Salmon, 'Peinture et sculpture', *La Revue de France*, 1 May 1925, p.189; and Edmond Jaloux, 'Dunoyer de Segonzac', *A.V.*, 15 January 1925, p.2.

26. Roger Allard, 'Le Salon d'Automne', *La Revue Universelle*, 1922, p.490. Cutting in the Fonds Vauxcelles.

27. In Jacques Guenne, 'Portraits d'artistes, Maurice Vlaminck', *Les Nouvelles Littéraires*, 1 November 1924, p.2.

28. For Hiver's attacks, see Part I, p.63, above.

29. In Florent Fels, 'Dunoyer de Segonzac, Propos d'artiste', *Les Nouvelles Littéraires*, Saturday, 1 December 1923, p.1.

30. Ibid.

31. Ibid.

32. Vlaminck in Guenne (1 November 1924), loc.cit., p.2.

33. 'Après ce qui précède on comprendra que nous n'admettions pas qu'un peintre cubiste exécute un portrait. Il ne faut pas confondre. Ce qu'il s'agit de créer c'est une oeuvre, un tableau en l'espèce [sic], et non pas une tête ou un objet . . .' Pierre Reverdy, 'Sur le cubisme', *Nord-Sud*, no.1, 15 March 1917; in Reverdy, *Oeuvres complètes* (1975), p.19. C.f. Etienne-Alain Hubert, 'Pierre Reverdy et le cubisme en mars 1917', *Revue de l'art*, no.43, 1979, pp.59–66.

34. Louis Vauxcelles, 'A propos du portrait', *Le Pays*, 13 October 1917.

35. Olivier-Hourcade, 'Discussions', *Gil Blas*, 23 October 1912. Quoted in Lynn Wissing Gamwell, *Cubist Criticism: 1907–1925*, Ann Arbor, Michigan, 1981, p.109.

36. Jacques Guenne, 'André Lhote', *A.V.*, 1 March 1926, pp.177 and 178.

37. Florent Fels, 'Chronique Artistique, Les Expositions', *Les Nouvelles Littéraires*, 31 January 1925.

38. Vlaminck in Guenne (1 November 1924), loc.cit., p.2.

39. Gee points to the commercial success of the two Utrillos in the Aubry sale of late 1924 and the six Utrillos of the Carco sale of early 1925 as indications; see Gee, *Parisian Art Market* (1977), pp.25–9.

40. Jaloux, at least, noted that along with this 'innocence' there was a firm grasp of method; see Edmond Jaloux, 'Maurice Utrillo', *A.V.*, 1 March 1925, p.3.

41. Florent Fels, 'Galerie Hodebert', *Les Nouvelles Littéraires*, Saturday, 17 January 1925, p.5.

42. Edmond Jaloux, 'Maurice Utrillo', *A.V.*, 1 March 1925, pp.2–3.

43. The problem of the relationship between Matisse's painting and nature is rarely discussed in the literature, since the 'Nice period' tends to be given relatively little attention. An exception is the chapter on Nice in Nicholas Watkin, *Matisse*, Oxford, 1984.

44. He actually uses the highly charged term 'peinture pure': 'La peinture pure qui est une fin en soi et dont *M. Henri Matisse* resta la plus illustre représentat exclut la figuration des objets et se sort de la nature

sans l'imiter ni obéir à ses principes essentiels.' Valdemar [sic] George, 'Le Nu (Galerie Georges Cres)', *Le Crapouillot*, 1 April 1920, pp.14–15.

45. André Lhote, 'Exposition Matisse', *N.R.F.*, 1 July 1919, p.308.

46. Jacques Guenne, 'Entretiens avec Henri Matisse', *A.V.*, 15 September 1925, p.3.

47. ibid, p.3.

48. A. Schneeberger, 'Le Salon d'Automne', *La Revue de l'Époque*, December 1922, p.84.

49. Paul-Sentenac, 'Les Arts', *Paris-Journal*, Sunday, 12 March 1922.

50. When Vlaminck's collection was sold at the Hôtel Drouet, 1 july 1937, five oils by Favory were included: Lot 115—*Couples dans une guinguette*, 46 × 45cm; 116—*Baigneuse de dos*, 41 × 25cm; 117—*Baigneuse de face*, 41 × 25cm; 118—*Jeune Femme à la corbeille de fruits*, étude pour une figure de *L'Enlèvement*, 81 × 60cm; 119—*Le Village*, 65 × 81cm. See *Tableaux de Vlaminck, Sculptures Africaines et Océaniennes*, Collection de M. Maurice de Vlaminck, Hôtel Drouot, Paris, Thursday, 1 July 1927. This was brought to my attention by Joachim Pissarro.

51. Robert Rey, 'Le Salon d'Automne', *Le Crapouillot*, 1 November 1924, p.21.

52. Ibid.

53. See Cooper, *Gris* (Catalogue 1977), nos161–6.

54. Waldemar George in particular, a fellow Pole and good friend, praised Marcoussis as an important Cubist; see Waldemar George, 'Louis Marcoussis', *La Vie des lettres*, July 1921, p.619.

55. André Salmon, 'Des Arts et la vie', *La Revue de France*, 15 June 1923, p.813.

56. See p.89, above.

57. Pierre Reverdy, *Self Defence, Critique-Esthétique*, Paris, 1919; in Reverdy, *Oeuvres complètes* (1975), pp.104 and 120.

58. Maurice Raynal, 'Quelques Intentions du cubisme', Paris, 1919; in *E.M.*, no.3, March 1924.

59. See e.g., the use of the terms 'artistes' and 'peintres' in Maurice Raynal, 'Juan Gris', *E.N.*, no.5, February 1921, pp.540–9. Also, c.f. Maurice Raynal, 'Les Petits Expositions; Exposition Henri Matisse', *L'Intransigeant*, Tuesday, 24 April 1923. For Raynal, Matisse was 'un peintre' because: 'chez lui, le goût de la couleur passe celui de la composition ou du dessin'; and, he commented, whereas one was *born* a painter, 'si l'on a le rigueur l'on peut *devenir artiste*.'

60. J.-G. Lemoine, 'La Section d'or', *L'Intransigeant*, Friday, 19 March 1920.

61. Fernand Léger, 'Correspondance' (1922); in *E.M.*, no.4, April 1924. Translated by Charlotte Green in *Léger and Purist Paris*, London (Tate Gallery), 1970–1.

62. Ozenfant ('Vauvrecy'), 'Les Expositions', *E.N.*, no.4, January 1921.

63. Raynal, *Anthologie* (1927), p.33.

64. Ozenfant and Jeanneret, *Après le cubisme*, Paris, 1918.

65. Ozenfant and Jeanneret, 'Idées personnelles', *E.N.*, no.27, November 1924.

66. Léger; 'Correspondance' (March 1922), loc.cit, pp.85–6.

67. André Lhote, 'Exposition Matisse', *N.R.F.*, 1 July 1919, p.312.

68. The first published elucidation of the 'synthetic process' known to me is in Paul Dermée's article 'Jean Metzinger', *S.I.C.*, nos 42 and 43, 20 March–15 April 1919, p.13. For a discussion of the process, see Christopher Green, 'Purity, Poetry and the Painting of Juan Gris', *Art History*, London, June 1982, p.185.

69. André Lhote, 'Le Cubisme au Grand Palais', *N.R.F.*, 1 March 1920, pp.468–9.

70. Ibid, p.33.

71. Robert Rey, 'Le Salon des Indépendants, La Peinture (suite)', *Le Crapouillot*, 1 March 1923, p.14; and Jacques Guenne, 'André Lhote', *A.V.*, 15 February 1926, pp.179–80.

72. Marcel Gromaire in Jacques Guenne, 'Marcel Gromaire', *A.V.*, 15 May 1926, p.383.

73. For Raynal on the 'brio' of Utrillo, the 'authority' of Kisling and the 'draftsmanship' of Valadon, see Maurice Raynal, 'Exposition de la Galerie Manuel frères', *L'Intransigeant*, Wednesday, 25 January 1922. For Raynal responding positively to Bissière's painting, see Maurice Raynal, 'Les Arts', *L'Intransigeant*, Wednesday, 2 November 1921.

74. Maurice Raynal, 'Peinture, sculpture', *L'Intransigeant*, Tuesday, 15 April 1924.

75. The Braque appears virtually finished in a studio photograph in *Cahiers d'Art* late in 1928.

Chapter 12

1. 'Les Idées de M. Paul Léon'; in *Bulletin de la vie artistique*, 1 August 1921, p.421.

2. André Salmon, 'Révolution et réaction', *A.V.*, 1 June 1926, p.413.

3. André Salmon, 'Cinquante Ans de peinture française, 1875–1925', *A.V.*, 15 June 1925, p.2.

4. Ibid, p.2.

5. C.f. Camille Mauclair, 'La Réaction nationaliste en art', 1905. This text is discussed in David Cottington, *Cubism and the Politics of Culture*, Dissertation presented for the degree of Ph.D., Courtauld Institute, University of London, 1985.

6. Pierre Albert-Birot, in *S.I.C.*, no.4, April 1916, unpaginated.

7. C.f. Christopher Green, 'Léger and l'Esprit Nouveau, 1912–1928'; in *Léger and Purist Paris*, London (Tate Gallery), 1970–1, pp.65–6; and Green, *Léger* (1976), pp.199–201.

8. André Salmon, 'La Peinture', *La Revue de France*, 15 July 1921, p.411.

9. Silver, *Esprit de corps* (1981), pp.368 and 393–4.

10. 'Les deux seuls génies authentiques de notre époque . . .' is Lhote's description of Cézanne and Renoir in 'Première Visite au Louvre', *N.R.F.*, 1 September 1919, p.542. In 1920 he expands on this, discussing the two as 'anti-impressioniste' in 'Renoir', *N.R.F.*, 1 February 1920, p.305. There follows a carefully thought-through appreciation of Cézanne's importance, 'L'Enseignement de Cézanne', *N.R.F.*, 1 November 1920, pp.649–72. Here Cézanne is described as: 'le grand architecte, le maître de l'oeuvre; possédant les secrets de la matière et traçant, sur le modèle de l'univers, le plan du temple nouveau'. Salmon's view of modern art history as a series of reactions gave a key place to Cézanne as one of the major stimuli behind the reaction against the Fauves; see André Salmon, 'La Peinture', *La Revue de France*, 1 April 1921, p.441. The Purists too, in *L'Esprit Nouveau*, made a point of stressing the contribution of Cézanne; see Ozenfant ('Vauvrecy'), 'Les Expositions', *E.N.*, no.4, January 1921. Also revealing of Cézanne's status are the recollections of him published in *L'Amour de l'Art* in December 1920 and January 1921; see note 39, below.

11. Lhote (1 February 1920), loc.cit., p. 308; 'Les belles rondeurs lisses de Renoir ne s'échelonnent pas en profondeur *mensurable* mais roulent les unes sur les autres, s'équilibrent et se superposent comme des mondes lumineux . . .'

12. André Salmon, 'L'Exemple de Renoir', *L'Europe Nouvelle*, 4 July 1920, p.923.

13. Ibid.

14. C.f. Kenneth E. Silver, 'Purism: Straightening up after the War', *Art-forum*, New York, March 1977, pp.56–63.

15. André Salmon, 'Chronique Artistique, Vingt ans après', *A.V.*, 15 October 1920, p.10. The subject of 'l'art juif' and attitudes to it has now been tackled for the first time by Kenneth Silver and Romy Golan in the important catalogue, *The Circle of Montparnasse Jewish Artists in Paris, 1905–1945*, the Jewish Museum, New York, 1985. Vanderpyl's anti-semitic articles are dealt with in Golan's essay, 'The "Ecole française" vs. the "Ecole de Paris", the Debate about the status of Jewish Artists in Paris between the wars'.

16. André Salmon, 'La Peinture', *La Revue de France*, 1 April 1921, p.441.

17. Ibid, p.441.

18. André Salmon, 'La Peinture', *La Revue de France*, 15 August 1921, p.881.

19. Salmon (15 October 1925), loc.cit., p.10. It is here that he points to Expressionism as the sole 'style national' while remarking on the cosmopolitan mix of nationalities producing art in Paris.

20. Jacques Guenne, 'Le Salon d'Automne de 1926', *A.V.*, 5 November 1926, p.811.

21. Louis Vauxcelles, 'Impressionisme et cubisme', *Le Monde Nouveau*, 1921. Press-cutting (undated) in the Fonds Vauxcelles, cited in Gee, *Parisian Art Market* (1977). p.141.

22. Silver, *Esprit de corps* (1981).

23. Ibid, pp.15–17, 31–2.

24. Ibid, pp.99—101.
25. Jacques Guenne, 'Portraits d'artistes, Maurice de Vlaminck', *Les Nouvelles Littéraires*, Saturday, 1 November 1924, p.1.
26. Salmon had questioned Vlaminck's resistance to the museums in *La Revue de France*, 1 December 1922. Vlaminck replied with a 'Lettre ouverte' in *Cahiers d'aujourd'hui*, February 1923, and Salmon commented on this in *La Revue de France*, 1 April 1923, pp.573—4.
27. Vlaminck in Guenne (1 November 1924), loc.cit., p.1
28. Ibid, p.1.
29. C.f. Georges Charensol, *D'un Rive à l'autre*, Paris, 1973, pp.89—94.
30. Derain in Florent Fels, 'Propos d'artistes, André Derain', *Les Nouvelles Littéraires*, Saturday, 20 October 1923, p.4.
31. Raynal, *Anthologie* (1927), pp.21—2.
32. André Lhote, 'Le Salon des Indépendants', *N.R.F.*, 1 March 1922, p.502.
33. These attacks, their roots and their effects are fully discussed in Silver, *Esprit de corps* (1981), pp.6—8, and p.50.
34. As David Cottington has shown, this insistence on nature directly experienced as the basis of the French tradition in painting, had been a central theme in the writings of Adrien Mithouard both in his review *L'Occident* (founded in 1901) and in his *Traité de l'Occident*, Paris, 1904. See Cottington (1985), op.cit., pp.45—6.
35. Roger Bissière, 'Notes sur Ingres', *E.N.*, no.4, January 1921.
36. Ibid.
37. Roger Bissière, 'L'Exposition Picasso', *L'Amour de l'Art*, February 1921, pp.209—12. Bissière terms Picasso's 'mysticism' Spanish and his 'realism' French, relating the one to his Cubism (abstract) and the other to his Neo-Classicism.
38. Louis Vauxcelles, 'De Cézanne au cubisme, à propos de la "section d'or"', *Eclair*, 18 March 1920.
39. Joachim Gasquet, '"Ce qu'il m'a dit . . .", le motif', *L'Amour de l'Art*, December 1920, pp.257—64. There followed 'Souvenirs sur Paul Cézanne' in *L'Amour de l'Art*, January 1921, with a telling statement on the importance of the motif for Cézanne by Charles Camoin.
40. See Part I, p.59, above.
41. Jacques Lipchitz, reply to an *enquête*, *Bulletin de la vie artistique*, 15 January 1924, pp.31—2.
42. He does this in the major article 'Conception et vision', *Gil Blas*, 29 August 1912, p.4.
43. Albert Gleizes, 'A propos du Salon d'Automne', *Les Bandeaux d'or*, November 1911. Metzinger had earlier taken up the question of Cubism and the past in the article 'Cubisme et tradition', *Paris-Journal*, 16 August 1911, p.5.
44. Albert Gleizes, 'Le Cubisme et la tradition', *Montjoie!*, 10 February 1913.
45. Léopold Survage, reply in 'Enquête sur le cubisme', *La Revue de l'Époque*, March 1922, pp.647—8.
46. Thorvald Hellesen, reply in 'Enquête sur le cubisme', *La Revue de l'Époque*, March 1922, p.662. For more material on this interesting but neglected artist, see Fabre, *L'Esprit Moderne* (1982).
47. Auguste Herbin, reply in 'Chez les cubistes—Notre Enquête I', *Bulletin de la vie artistique*, 1 November 1924, p.485.
48. Henri Laurens, reply in 'Chez les cubistes—Notre Enquête III', *Bulletin de la vie artistique*, 1 December 1924, p.509.
49. Juan Gris, 'On the Possibilities of Painting', Lecture delivered 15 May 1924; in Kahnweiler, *Gris* (1968—9), p.186.
50. Maurice Raynal, 'Quelques Intentions du cubisme', Paris, 1919; in *E.M.*, no.3, March 1924, p.5.
51. In *E.M.*, no.3, March 1924.
52. Gris to Kahnweiler, Paris, 25 August 1919; see Douglas Cooper, *Letters of Juan Gris. 1913—1927*, London, 1956, Letter LXXX.
53. Gris (1924) in Kahnweiler, *Gris* (1968—9), p.197.
54. See Part I, pp.26—7, above. Also c.f. *Interpretation du Portrait de Mme Cézanne*, March 1918; Cooper, *Gris* (Catalogue, 1977), nos 257 and 257a, b and c.
55. Statement by Picasso made to Marius de Zayas, 1923; in Alfred H. Barr, *Picasso, 50 Years of his Art*, New York, 1946, pp.270—1.
56. Ozenfant and Jeanneret, *Après le cubisme*, Paris, 1918.

57. Ozenfant ('De Fayet'), 'Poussin', *E.N.*, no.7, April 1921.
58. Ibid.
59. Roman mosaics are dealt with in *E.N.*, no.13, December 1921. Ozenfant as 'De Fayet' deals with Michelangelo and the Sistine Chapel in no.14, January 1922. Egyptian, Chaldean, Assyrian, Archaic Greek and other styles are dealt with by Ozenfant in no.15, February 1922. Again as 'De Fayet' Ozenfant turns to 'Les Vases Grecs' in no.16, May 1922.
60. Ozenfant ('De Fayet'), 'La Sixtine de Michel-Ange', *E.N.*, no.14, January 1922.
61. Le Corbusier, 'Le Respect des oeuvres d'art', *E.N.*, no.27, December 1924.
62. Ozenfant ('De Fayet'), (April 1921), loc.cit.
63. Roger Bissière, 'Corot', *E.N.*, no.9, June 1921.
64. Anon., 'Jean Fouquet', *E.N.*, no.5, February 1921.
65. Léonce Rosenberg, Reply in 'Chez les cubistes—Notre Enquête II', *Bulletin de la vie artistique*, 15 November 1924, pp.504—6.
66. Fernand Léger, Reply in 'Chez les cubistes—Notre Enquête I', *Bulletin de la vie artistique*, 1 November 1924, p.486.
67. C.f. Dora Vallier, 'La Vie fait l'oeuvre de Fernand Léger; Propos de l'artistique recueillis par Dora Vallier', *Cahiers d'Art*, 1954, pp.155—6. Léger here insists on the importance of the 'Italian primitives'.
68. Fernand Léger, 'L'Esthétique de la machine', Lecture given June 1923, first published in *Der Querschnitt*, Berlin, vol.III, 1923, and *E.M.*, nos 1 and 2, January and February 1924; in Léger, *Fonctions* (1965), pp.53—4.
69. Fernand Léger, 'Correspondance' (1922), *E.M.*, no.4, April 1924; translated by Charlotte Green in *Léger and Purist Paris*, London, (Tate Gallery), 1970—1, p.86.
70. Ibid, p.86.
71. C.f. Green, *Léger* (1981), pp.199—202.
72. Ibid, pp.230—1.
73. As Gleizes puts it, Greece and Rome were 'peuplé d'êtres corruptiles et corrompus,' and 'chez les grecs . . . Un type réaliste idéal est le seul voeu de l'artiste.' Albert Gleizes, 'Réhabilitation des Arts Plastiques', *La Vie des lettres*, April 1921, p.412. This reading of Greek and Roman art was then applied in adapted form to the Italian Renaissance: 'Avec la Renaissance une direction nouvelle se dessine. Le conflit du matérialisme et du spiritualisme se dénoue à l'avantage du premier.' Albert Gleizes, 'La Renaissance et la Peinture d'aujourd'hui', *La Vie des lettres*, December 1921.
74. In his lecture of 1921 (April 1921, op.cit.), Gleizes argued that a new culture emerged with the beneficient influence of the Francs from the North and the revival of the Gauls which, with the period of Charlemagne, had led to a new age in France: 'Ce n'est qu'au IXe siècle qu'on sent nettement un renouveau et un élan de jeunesse vers des régions insoupçonnées./ Alors la séparation est complète entre l'art chrétien et l'art d'Athènes et de Rome, sinon avec l'art byzantin. Les masses oublieront dorénavant le mauvais rêve de l'antiquité et vont réaliser enfin le monument de leur foi qui a accepté le revêtement chrétien' (p.413). Decline began, he says, with the fourteenth and fifteenth centuries (p.414).
75. The most complete statement of his attitudes to the past and to his own mural aspirations was *La Peinture et se lois* 'ce qui devait sortir du cubisme', published as a book in 1923, and in *La Vie des lettres*, October 1922, pp.26—74.
76. Gleizes (April 1921). loc.cit., pp.417—18.
77. Gleizes (October 1922), loc.cit., p.50.
78. See, especially, ibid, see also pp.87—8, above.
79. Gris in Georges Charensol, 'Chez Juan Gris', *Paris-Journal*, 25 April 1924.
80. See Part I, p.16, above.
81. 'Monsieur Rosenberg [sic] nous a dit: "les pommes et les serviettes de Cézanne représentent la grande tradition humaine des cathédrales comme le cubisme la cathédrale moderne". Monsieur Rosenberg, vous êtes un curé et la messe que vous dites dans votre cathédrale est une cérémonie pour les poires.—Quoi? quoi? quoi? quoi? quoi?' Francis Picabia, in *391*, no.12, March 1920, p.2.
82. Fernand Léger (1922), in *Léger* (Tate Gallery, 1970—1), op.cit., p.85.

Chapter 13

1. This is a quotation, in fact, from Reverdy's own *Self Defence* of 1919, and is used as such here: Pierre Reverdy, 'L'Esthétique et l'esprit', *E.N.*, no.6, March 1921; in Reverdy, *Oeuvres complètes* (1975), p.175.
2. Florent Fels, 'Propos d'artiste, Dunoyer de Segonzac', *Les Nouvelles Littéraires*, Saturday, 1 December 1923.
3. 'A nos lecteurs', *A.V.*, 1 January 1925, p.3. As the text states, this is, in fact, a quotation from the preface to André Salmon's *L'Art Vivant*, Paris, 1920.
4. André Salmon, 'Peinture et sculpture', *La Revue de France*, 1 May 1925, p.190.
5. The name is misprinted 'Fromaire': Louis Vauxcelles ('Pinturrichio'), 'Au Palais du bois', *Le Carnet de la Semaine*, 17 May 1925, p.6.
6. Florent Fels, 'Le Salon des Indépendants', *A.V.*, 20 March 1925, pp.16—25.
7. Ibid, p.16.
8. Jacques Guenne, 'Marcel Gromaire', *A.V.*, 15 May 1926, p.379.
9. Ibid, p.380.
10. Ibid.
11. 'Où les médiocres suprennent l'instant, il fixe l'éternité. Il atteint à la peinture de grand caractère. Il campe un type tel qu'il est dans la vie, mais ce type n'appartient qu'à lui seul. Il l'a recréé.' Ibid, p.380.
12. Ibid. p.382 (for Gromaire's own insistence).
13. Ibid.
14. Ibid, p.380.
15. Fels mentions Luc-Albert Moreau's *Combat de boxe* shown at the Indépendants in 1925; see Fels (20 March 1925), loc.cit., p.26.
16. Quoted from *Paris-Journal* in *Bulletin de la vie artistique*, 1 February 1924, p.54.
17. Jacques Guenne, 'Le Salon des Tuileries', *A.V.*, 1 June 1926, p.402.
18. Vanderpyl, 'Une Exposition à Amsterdam d'André Favory', *A.V.*, 20 March 1925, p.10.
19. Of the car, Guenne writes: 'Il me semblait que Favory poussait un peu loin le souci d'être actuel.' Jacques Guenne, 'André Favory', *A.V.*, 1 February 1926, p.87. Otherwise, however, he is entirely positive, as is Fels in 'Le Salon d'Automne de 1925', *A.V.*, 1 October 1925, p.7.
20. Florent Fels, 'Vlaminck', *Les Nouvelles Littéraires*, Saturday, 19 December 1925.
21. Christian Zervos, 'Dunoyer de Segonzac', *L'Art d'aujourd'hui*, vol.I, 1924, p.8.
22. Claude Roger-Marx, 'Dunoyer de Segonzac', *L'Amour de l'Art*, May 1921, p,141.
23. Jacques Guenne, 'Le Salon d'Automne de 1926', *A.V.*, 5 November 1926, p.813.
24. Roger-Marx (May 1921), loc.cit., p.141.
25. René Jean, *Dunoyer de Segonzac*, Paris, 1922, p.4.
26. Ibid, pp.9—10.
27. Jacques Guenne, 'Portraits d'artistes, Maurice Vlaminck', *Les Nouvelles Littéraires*, Saturday, 1 November 1924, p.1.
28. See the forthcoming Ph.D. dissertation of Romy Golan for the Courtauld Institute, University of London. It is she who pointed out to me the significance of Henri Pourrat's *Gaspard des Montages*.
29. Raynal, *Anthologie* (1927), p.16.
30. Waldemar George, *Picasso*, Rome, 1924, p.14.
31. Reverdy (March 1921), in Reverdy, *Oeuvres complètes* (1975), pp.177—8.
32. Ozenfant and Jeanneret, *Après le cubisme*, Paris, 1918.
33. Ozenfant and Jeanneret, 'Programme de l'Esprit Nouveau', *E.N.*, no.1, October 1920.
34. This is carried through in the articles signed 'Le Corbusier-Saugnier', 'Trois Rappels à MM.les architectes', *E.N.*, nos 2, 3 and 4, November and December 1920, and January 1921.
35. C.f. Le Corbusier-Saugnier, 'Des Yeux qui ne voient pas, I' and 'II', *E.N.*, nos 8 and 9, May and June 1921.
36. Ozenfant and Jeanneret, 'La Peinture des cavernes à la peinture d'aujourd'hui', *E.N.*, no.15, February 1922.
37. Ozenfant and Le Corbusier, 'Formation de l'optique moderne', *E.N.*, no.21, March 1924.
38. Ibid.
39. Ibid.
40. Fernand Léger, 'Le Spectacle, Lumière, Couleur, Image Mobile, Objet-Specacle', *E.M.*, no.7, July 1924, and no.9, November 1924 (there dated May 1924); in Léger, *Fonctions* (1965), p.131.

41. Entretiens de Fernand Léger avec Blaise Cendrars et Louis Carré sur *Le Paysage dans l'oeuvre de Léger*, Paris, 1956, C.f. Green, *Léger* (1976), p.182.

42. Fernand Léger, 'Correspondance' (1922), *E.M.*, no.4, April 1924; translated by Charlotte Green, in *Léger and Purist Paris*, London (Tate Gallery), 1970–1, p.86.

43. Fernand Léger, 'L'Esthétique de la machine', Lecture given in June 1923, first published in *Der Querschnitt*, Berlin, vol.III, 1923, and *E.M.*, nos 1 and 2, January and February 1924; in Léger, *Fonctions* (1965), p.53.

44. Ibid, p.57.

45. Maurice Hiver, *Montparnasse*, July or August 1923; excerpted in André Salmon, 'La Peinture et la sculpture', *La Revue de France*, 1 September 1923, pp.190–1.

46. Florent Fels, 'Propos d'artistes, Fernand Léger', *Les Nouvelles Littéraires*, Saturday, 30 June 1923, p.4.

47. Ibid, p.4.

48. Ibid.

49. Louis Cheronnet, 'La Publicité: La Gloire du panneau', *A.V.*, 15 August 1926, p.618.

50. Cassandre's debt and his overall approach are clear enough in quotations from him and the reporting of his views to be found in an article by Louis Cheronnet of 1926. Cheronnet considered that 'il sait bien combien sa élastique doit à des peintres chercheurs comme Léger et Delaunay et aussi au gros plan du cinéma américain'. Of Cassandre's approach to designing, he writes: 'Partant de ce principe que l'affiche doit être conçue à la façon d'une auto parce que, comme cette dernière, elle a un but utile à remplir, il veut en industrialiser les réalisations dès le début.' The Perret villa was at Versailles, and is illustrated in the article. Cheronnet supplies this description of the workroom inside it: 'Murs nus de ciment gris clair, dalles toujours propres, ainsi qu'en un hallede centrale électrique. Un radiateur, une glace sans cadre, comme éléments décoratifs. Un bureau américain pour traiter les affaires, une table d'architecte pour "fabriquer" les affiches. Et non pas un matériel de peinture, mais des instruments précis d'architecte: équerres, compas, règles, rapporteur, etc. . . . Des maquettes d'affiches comme des épures.' Louis Cheronnet, 'les Maîtres de l'affiche, Cassandre', *A.V.*, 15 November 1926, pp.845–5.

51. According to Delaunay himself, when he saw how shocked Paul Léon was by his and Léger's contributions to the 'Ambassade français' at the Exposition, he approached him and expressed his pride in the widespread influence on everything in the exhibition 'exercée par les quelques peintres qui exposèrent à la fameuse salle II des Indépendants de 1910 [sic], la première manifestation collective d'un art naissant.' See Robert Delaunay, Statement in '"L'Affaire" de l'Exposition des Arts Décoratifs', *Les Nouvelles Littéraires*, Saturday, 6 June 1925.

52. '. . . le rêve de Cassandre serait donc de faire du papier peint, du papier de tenture [sic] décoratif pour la rue.' Cheronnet (15 November 1926), loc.cit., p.855.

53. Fernand Léger, Statement published in Louis Cheronnet, 'La Publicité Moderne, Fernand Léger et Robert Delaunay', *A.V.*, 1 December 1926, p.890.

54. Ibid, p.890.

55. Ibid.

56. See, especially, P. Reyner Banham, 'Machine Aesthetic', *Architectural Review*, London, 1955.

57. Hiver, quoted in Salmon (1 September 1923), loc.cit., p.191.

58. Ozenfant and Jeanneret (October 1920), loc.cit.

59. Léonce Rosenberg, Reply in 'Chez les cubistes—Notre Enquête II', *Bulletin de la vie artistique*, 15 November 1924, p.505.

60. Albert Gleizes, 'Des "ismes" vers une Renaissance plastique', *La Vie des lettres*, April 1922, p.175.

61. Ibid, p.178.

62. Albert Gleizes, *La Peinture et ses lois*, 'ce qui devait sortir du cubisme', Paris, 1923 in *La Vie des lettres*, October 1922, pp.72–3.

63. Gleizes (April 1922), loc.cit., p.178.

Chapter 14

1. See Part I, p.100, above.

2. See Part I, pp.93–7, above.

3. Piet Mondrian, 'Dialoog over de Nieuwe Beelding', February 1919, *D.S.*, II, 4 and 5, February and March 1919; in Hans L. C. Jaffé, *De Stijl*, London, 1970, p.121.

4. Pierre Albert-Birot, 'Dialogue nunique', *S.I.C.*, no.6, June 1916, p.5.

5. Mondrian (February 1919), in Jaffé (1970), op.cit., p.122.

6. Thus, when 'A' questions Neo-Plasticism's justification in relation to nature, 'B' replies: 'If you understand that the new plastic expresses the essential of everything, you would not ask that question.' Ibid, p.122.

7. Pierre Albert-Birot, 'Dialogue nunique, Z et A, En marche', *S.I.C.*, no.7, July 1916.

8. See p.160, above.

9. Lynn Wissing Gamwell, *Cubist Criticism: 1907–1925*, Ann Arbor, Michigan, 1980, pp.35–6.

10. Paul Dermée, 'Jean Metzinger', *S.I.C.*, nos 42 and 43, 20 March–15 April 1919, p.13.

11. Maurice Raynal, 'Exposition Jacques Villon', *L'Intransigeant*, Wednesday, 21 June 1922.

12. Ozenfant and Jeanneret, 'Sur la plastique', *E.N.*, no.1, October 1920.

13. Ozenfant and Le Corbusier, 'L'Angle droit', *E.N.*, no.18, November 1923.

14. Ozenfant and Jeanneret, 'Idées personnelles', *E.N.*, no.27, November 1924.

15. See p.214, above.

16. Florent Fels, 'Chroniques artistique, Les Expositions', *Les Nouvelles Littéraires*, Saturday, 30 May 1925, p.4.

17. Eugène Marsan, 'Le Théâtre', *Paris-Journal*, Sunday, 5 February 1922.

18. One has to remember that by the 1925 exhibition the non-objective had found a place in Cubist art, but not as easel painting, only as mural painting; see Part I, pp.93–7, above.

19. It is Servranckx himself who dates the conversation from which he recorded this statement to 1923: see Victor Servranckx, '"Les Voies nouvelles de l'art plastique", conférence prononcé le 1er mars, 1925, au "Foyer des Artistes", à Bruxelles', *E.M.*, no.16, June 1925.

20. C.f. Juan Gris, 'On the Possibilities of Painting', Lecture delivered 15 May 1924; in Kahnweiler, *Gris* (1968–9), pp.199–200.

21. Ibid, p.200.

22. Juan Gris, Reply to an *enquête*, *Action*, April 1920; ibid, p.192.

23. Fabre, *L'Esprit Moderne* (1982), pp.359–60.

24. He returned to Paris in July 1919.

25. At the galerie Povolozky from 6 June 1921; and at the galerie la Boétie in October 1924.

26. Crotti showed *Mystere acatène* (Plate 242) at the Automne; see: William A. Camfield, 'Jean Crotti and Suzanne Duchamp', in *Tabu Dada, Jean Crotti and Suzanne Duchamp, 1915–1922*, edited by William A. Camfield and Jean-Hubert Martin, Kunsthalle, Berne, 1983, p.25.

27. Piet Mondrian, 'De Nieuwe Beelding in de Schilderkunst', *D.S.*, I, 2, November 1917; in Jaffé (1970), op.cit., p.50.

28. Ibid, p.40.

29. Piet Mondrian, 'De Nieuwe Beelding in de Schilderkunst', *D.S.*, I, 4, January 1918; ibid, p.59.

30. Ibid, p.59.

31. Piet Mondrian, in *E.M.*, no.9, September 1924.

32. Mondrian was responding here to two articles which had appeared in the opening numbers of the *Bulletin de l'Effort Moderne*; see Dr Jaworsky, 'L'Evolution de l'humanité est l'évolution d'art', *E.M.*, nos 1 and 2, January and February 1924.

33. The best account of the theosophical aspect of Mondrian's thinking is Robert P. Welsh's article, 'Mondrian and Theosophy'; in *Piet Mondrian, 1872–1944*, Centennial Exhibition, Solomon R. Guggenheim Museum, New York, 1971, pp.35–51.

34. Doig, *Van Doesburg* (1981), pp.15–21. Doig has provided by far the most exacting analysis of the philosophical and art-historical roots of Van Doesburg's thinking. His dissertation is to appear in adapted form as a book with Cambridge University Press.

35. C.f. ibid, p.118.

36. This view of history as 'constant progress' is first clearly set out by Van Doesburg in *Klassiek-barok-moderne*, Antwerp and Amsterdam, 1920, translated into French and published by Léonce Rosenberg's Editions de l'Effort Moderne in Paris in 1920. The text was republished in *E.M.* in 1925. 'Je parle ici d'un développement constant de l'énergie artistique, c'est-à-dire d'un progrès constant qui n'est pas compatible avec l'idée de la répétition ininterrompue des périodes d'origine, d'épanouissement et de décadence . . .' In *E.M.*, no.20, December 1925.

37. Ibid.

38. Ibid.

39. Ibid.

40. See also 'Classique-Baroque-Moderne', in *E.M.*, nos 21, 22 and 23, January, February and March 1926.

41. Theo Van Doesburg, 'De Wille zum Stil', lecture delivered in Jena, Weimar and Berlin, *D.S.*, V, 2 and 3, February and March 1922; in Joost Baljeu, *Theo Van Doesburg*, London, 1974, pp.117ff.

42. Piet Mondrian, 'De Realiseering van het Neo Plasticisme in verre toekomst en in de Huidige Architectuur', *D.S.*, V, 3, March 1922, and 5, May 1922; in Jaffé (1970), op.cit., p.163.

43. Theo Van Doesburg, 'Schilderkunst: Van Kompositie tot contra-kompositie', *D.S.*, XIII, 73–4, 1926; in Baljeu (1974), op.cit., pp.158–9.

44. Ibid, pp.158–9.

45. Robert P. Welsh, 'Theo Van Doesburg and Geometric Abstraction', in *Nijhoff, Van Ostaijen, 'De Stijl', Modernism in the Netherlands and Belgium in the first quarter of the 20th century*, The Hague, 1976, p.80.

46. Ibid, p.80.

47. 'De Nieuwe beweging in de Schilderkunst', 'De Ontwikkeling der moderne Schilderkunst', in *Drie Voordrachten over de nieuwe beeldende*, Amsterdam, 1919. Quoted in Joop Joosten, 'Paintings and Sculpture in the Context of De Stijl', in *De Stijl: 1917–1931, Visions of Utopia*, Oxford and Minneapolis, 1982, p.56.

48. C.f. ibid, pp.58–60.

49. *D.S.* (March 1921); see ibid, p.60.

50. Piet Mondrian, 'De Nieuwe Beelding in de Schilderkunst', *D.S.*, I, 11, August 1918; in Jaffé (1970), op.cit., p.87.

51. Ibid, p.87.

52. Ibid.

53. See p.162, above.

54. See especially, Ludmila Vachtová, *Frank Kupka, Pioneer of Abstract Art*, New York and Toronto, 1968, and *František Kupka, 1871–1957*, Solomon R. Guggenheim Museum, New York, 1973.

55. These survive in four manuscripts; see ibid (1973), pp.60–1, note 19.

56. František Kupka, 'Créer! Question de principe de la peinture', *La Vie des lettres*, July 1921, p.571.

57. '. . . Le peintre constamment en quête de formes plastiques, couleurs, lumière ou profondeur, figures de son mode d'expression, saisit sciemment, ou comme un automate, tous les phénomènes venant se dessiner sur le vitrail de sa rétine . . .' Ibid, p.572.

58. Ibid, p.573.

59. Louis Arnould-Grémilly, '"De l'Orphisme à propos des tentatives de Kupka", Extraits d'une conférence faite à la Galerie Povolowsky le 6 juin 1921, en vernissage de l'exposition d'oeuvres de Franck Kupka', *La Vie des lettres*, October 1921, pp.679–80. This was the text of Arnould-Grémilly's monograph.

60. C.f. *František Kupka* (1973), op.cit., pp.305–6. See also, in the same source, Margit Rowell, 'František Kupka: A Metaphysics of Abstraction', for discussion of Kupka's exposure to Goethe's ideas through Rudolf Steiner's editions of his writings, p.76. Quotations from H. P. Blavatsky's *Secret Doctrine* are found in the notebook by Kupka which is dated by Rowell 1910–11.

61. Rowell makes this point by paralleling a sentence from the notebook by Kupka which she dates 1910–11 with Steiner's interpretation of Goethe; ibid, p.76.

62. The phrases quoted here are from Jean Crotti, *Manifeste Tabu*, October 1921. The visionary experience in question is referred to thus by Crotti: 'Tabu je suis sûrement à présent 22 heures 12 février 1921 Vienne Autriche dans un trou de rue noir. Apparition lumineuse éclair.' Jean Crotti, *Courants d'air sur le chemin de ma vie, Tabu Dada, Poèmes et dessins, 1916–21*, Paris, 30 March 1941; quoted in Jean-Hubert Martin, 'Tabu: Mouvement artistique ou religion?'; in Camfield and Martin (1983), o.cit., p.72.

63. Extracts from Crotti's unpublished writings are included in Jean-Hubert Martin's article, loc.cit., pp.69–74. These writings are now in the Archives of American Art. Martin's article is the only serious discussion of Crotti's 'tabu' works, and offers a

number of convincing interpretations based on these texts.

64. 'Quand . . . l'objectif du peintre consiste en une extériorisation d'évènements psychiques, intimes, suscitées seulement par telle ou telle source d'impression, cette dernière y figure seulement comme sujet (si asujetti qu'un réalité il n'y joue plus aucun role) et ce sujet, dont l'aspect véritable a perdu pour ainsi dire tout son identité, n'a plus aucune raison d'être.' In this case, for Kupka, the painting will have 'toute la valeur (ou le charme) de l'imagination personnelle'. Kupka (July 1921), loc.cit., pp.572—3.

65. Piet Mondrian (August 1918), loc.cit.; in Jaffé (1970), op.cit., p.80.

66. Allan Doig is the first to have analysed in depth the mediating role of the Dutch Hegellians. My discussion of the philosophical orientation of Mondrian and Van Doesburg is endebted to him; see Doig, *Van Doesburg* (1981), especially pp.13—17 and 41—2.

67. In making this statement Mondrian cites G. J. P. J. Bolland; *D.S.*, I, 7, April 1918; in Jaffé (1970), op.cit., p.65.

68. Theo Van Doesburg, 'Der Wille zum Stil', Lecture delivered in Jena, Weimar and Berlin, *D.S.* V, 2 and 3, February and March 1922, in Baljeu (1974), op.cit., p.117.

69. See, especially, Mondrian, *D.S.*, I, 9, June 1918; in Jaffé (1970), op.cit., p.75.

70. Doig, *Van Doesburg* (1981).

71. Quoted, Ibid, pp.5—6.

72. Mondrian, *D.S.*, I, 9, June 1918; in Jaffé (1970), op.cit., p.71.

73. Ibid, p.71.

74. Mondrian, *D.S.*, I, 3, December 1917; ibid, p.55.

75. Theo Van Doesburg, 'Aanteekeningen over Monumentale Kunst naar aanleiding van twee bouwfragmenten (Hall in vacantie huis te Noordwijkerhout)' *D.S.*, II, 1, October 1918; in Jaffé (1970), op.cit., p.100.

76. Piet Mondrian, *Le Néo-Plasticisme*, Paris, 1920; in *E.M.*, no.25, May 1926.

77. Theo Van Doesburg, 'Schilderkunst: Van Kompositie tot contre-kompositie', *D.S.*, XIII, 73—4, 1926; in Jaffé (1970), op.cit., p.157.

78. Theo Van Doesburg to J. J. P. Oud, Paris, 12 September 1921; quoted in Troy, *D.S.* (1983), p.70.

79. Theo Van Doesburg, 'Von der neuen ästhetik zur materiellen verwirklichung' (Weimar 1922), *D.S.*, VI, 1, March 1923; in Baljeu (1974), op.cit., p.129.

80. 'The idea of research has often made painting fall into abstraction. The spirit of research has poisoned those who have not understood the positive aspect of modern art in its entirety, and who want to paint the invisible and the non-pictorial.' Statement made by Picasso to Marius de Zayas, 1923; in Alfred H. Barr, *Picasso, 50 Years of his Art*, New York, 1946, p.270.

Chapter 15

1. See pp.85—9, above.

2. Piet Mondrian, *Le·Neo-Plasticisme*, Paris, 1920; in *E.M.*, no.24, April 1926.

3. Piet Mondrian, 'De Nieuwe Beelding in de Schilderkunst', *D.S.*, I, 1, October 1917; in Hans L. C. Jaffé, *De Stijl*, London, 1970, p.36.

4. Piet Mondrian, 'De Nieuwe Beelding in de Schilderkunst', *D.S.*, I, 5, February 1918; in ibid, p.64.

5. Theo Van Doesburg, in *Bouwkundig Weekblad*, XLIII, nos 25, 28 and 18 June, 9 July and 13 August 1921. The three instalments of this article are fully discussed in Doig, *Van Doesburg* (1981), p.123.

6. Quoted by Doig, who makes the point about the connection between these articles and those of Le Corbusier; ibid, p.123.

7. Theo Van Doesburg, 'Vers une construction collective', Paris, 1923; *D.S.*, XII, 6—7, 1924; in Joost Baljeu, *Theo Van Doesburg*, London, 1974, p.148.

8. Theo Van Doesburg, 'Schilderkunst: Van Kompositie tot contra-kompositie', *D.S.* XIII, 73—4, 1926; in ibid, p.157.

9. Theo Van Doesburg, 'Der Wille zum Stil', Lecture delivered in Jena, Weimar and Berlin, *D.S.*, V, 2 and 3, February and March 1922; in ibid, p.123.

10. See Ger Harmsen, 'De Stijl and the Russian Revolution'; in *De Stijl: 1917—1931, Visions of Utopia*, Oxford and Minneapolis, 1982, pp.45—9.

11. For the role of the Constructivists and Kandinsky in the INKhUK debate, see Christina Lodder, *Russian Constructivism*, New Haven and London, 1983, pp. 78—83.

12. See Baljeu (1974), op.cit., pp.126—7.

13. Van Doesburg (February—March 1922); in ibid, p.115.

14. C.f. Robert P. Welsh, 'De Stijl, A Re-introduction', in *De Stijl* (1982), op.cit., pp.19—20.

15. Van Doesburg visited Paris and Mondrian in February—March 1920; c.f. Joop Joosten, 'Painting and Sculpture in the Context of De Stijl', in ibid, p.58. According to Troy, Vantongerloo visited Mondrian *en route* from the Netherlands to Menton at the end of 1921, and helped paint his studio on the top floor of 26 rue du Départ. See Troy, *De Stijl* (1983), p,210, note 37.

16. Piet Mondrian to J. J. P. Oud, Paris, 9 April 1921; quoted ibid, p.104.

17. Piet Mondrian, *D.S.*, I, 2, November 1917; in Jaffé (1970), op.cit., p.53.

18. C.f. Piet Mondrian, 'De Realiseering van het Neo Plasticisme in verre toekomst en in de Huidige Architectuur', *D.S.*, V, 3, and 5, March and May 1922; in ibid, p.166.

19. Piet Mondrian, 'De Nieuwe Beelding in de Schilderkunst', I, 9, June 1918; in ibid, p.78.

20. The theme of collaboration in De Stijl has been extensively and perceptively analysed by Troy; see Troy, *De Stijl* (1983). She is particularly revealing in her analysis of collaboration in practice.

21. See ibid, pp.81—91.

22. See Part I, p.93, above.

23. Léonce Rosenberg to Theo Van Doesburg, Paris, 2 August 1920 (Van Doesburg Archive, Dienst Verspreide Rijkskollektie); quoted in Doig, *Van Doesburg* (1981), p.170.

24. C.f. Baljeu (1974), op.cit., p.62; and Troy, *De Stijl* (1948), pp.76—7.

25. See Troy's discussion, ibid, pp.75—97.

26. Theo Van Doesburg and Cor Van Eesteren, 'Vers une construction collective', Paris, 1923; cited in ibid, p.140.

27. Leering quotes a letter from Van Eesteren to Van Doesburg, dated 15 August 1924, in which Van Eesteren writes: '. . . our collaborative work does not result in an addition of ability: C.v.E. + *Does* or *Does* + C.v.E., but in a *new unity*, a new existence, that we together have given life'. Jan Leering, 'De Architectuur en Van Doesburg'; in *Theo Van Doesburg, 1883—1931*, Stedelijk Van Abbemuseum, Eindhoven, 1968—9, p.21.

28. See ibid, p.22; Baljeu (1974), op.cit., pp.60—2; Troy, *De Stijl* (1983), pp.106—15; Doig, *Van Doesburg* (1981), pp.167—79.

29. Doig discusses the breakdown in relations between Van Eesteren and Van Doesburg; ibid, pp.173—7. A letter of 26 December 1926 from Van Eesteren to Van Doesburg marks the point of the final breakdown.

30. Doig's account and analysis of the 'Aubette' is particularly full and useful; see ibid, pp.189—204.

31. When Louis Arnould-Grémilly wrote on Kupka in 1921, one of his central themes was the fusion of the musical and the visual in the artist's work, and the key to it, for him, was non-objectivity: 'C'est dans ce rapport (both music and painting being abstract) que la peinture de Kupka peut-être dite musicale, qui ne veut ni décrire ni imiter, travail inutile et irréalisable.' Louis Arnould-Grémilly, 'De l'orphisme à propos des tentatives de Kupka', *La Vie des lettres*, October 1921, p.683.

32. Piet Mondrian, *Le Néo-Plasticisme*, Paris, 1920; in *E.M.*, no.27, July 1926

33. This Van Doesburg does in an article on stained glass in *Het Bouwbedrijf* VII, no.10, 9 May 1930. Quoted in Doig, *Van Doesburg* (1981), pp.202—3.

34. See Theo Van Doesburg, *Grundbegriffe der neuen gestaltenden kunst*, Dresden, 1925, translated as *Principles of Neo-Plastic Art*, by Janet Seligman, London, 1966, pp.42—3, figs 1, 2, 3. The text was written in 1919, and, as published in 1925, was not significantly changed.

35. Welsh makes this point. See Welsh in *De Stijl* (1982), op.cit., p.20. Van der Leck's view was articulated in two articles of 1917 and 1918: 'De Plaats van het moderne schilderen in de architectuur', *D.S.*, I, 1, 1917, and 'Over Schilderen en bouwen', *D.S.*, I, 4, February 1918; in Jaffé (1970), op.cit.

36. Piet Mondrian, Interview in *De Telegraaf*, 12 September 1926. Quoted in Jane Beckett, 'The Abstract Interior', in *Towards a New Art, essays on the back-ground to abstract art, 1910—20*, London (Tate Gallery), 1980, pp.117—18; and in Troy, *De Stijl* (1983), p.138.

37. Mondrian (1920), op.cit., in *E.M.*, no.25, May 1926, pp.4—5.

38. Piet Mondrian, 'Natuurlijke en abstracte realiteit', *D.S.*, III, 8, May 1920, p.59; quoted in Troy, *De Stijl* (1983), p.64.

39. Piet Mondrian, 'Le Home—la rue—la ville', *Vouloir*, no.25, 1927, pp.1—4; republished, translated by Harry Holtzmann and Martin Jones in *Transformation*, New York, 1950.

40. See Troy, *De Stijl* (1983), pp.62—3.

41. Piet Mondrian, 'Natuurlijke en abstracte realiteit', *D.S.*, III, 8, May 1920; in Michel Seuphor, *Piet Mondrian, Life and Work*, London, 1957, p.339.

42. Mondrian (1927), op. cit., in Holtzmann and James (1950), op.cit.

43. Troy, *De Stijl* (1983), pp.142—9.

44. Ibid, p.68.

45. Ibid.

46. Ibid, pp.135—42.

47. Mondrian (March—May 1922), in Jaffé (1970), op.cit., pp.164—5.

48. Theo Van Doesburg, 'De Nieuwe beweging in de schilderkunst', *De Beweging*, May—August 1916; in *Drie Voordrachten over de nieuwe beeldende*, Amsterdam, 1919. Quoted in Sergio Polano, 'De Stijl/ Architecture = Nieuwe Beelding', *De Stijl* (1982), p.89.

49. 'Gegenüber der union internationaler fortschrittlicher künstler', *D.S.*, V, 4, April 1922; in Baljeu (1974), op.cit., p.127.

50. Theo Van Doesburg to J. J. P. Oud, 12 September 1921; quoted in Troy, *De Stijl* (1983), p.70.

51. See, especially, Theo Van Doesburg, 'De Stijl de toekomst', November 1917, in Van Doesburg (1919), op.cit., as quoted in Troy, ibid, p.30.

52. For the Russian notion of 'faktura', see Lodder (1983), op.cit., pp.94—9.

53. Theo Van Doesburg, 'La Signification de la couleur', *La Cité*, May 1924, first published in *Bouwkundig Weekblad*, XLIV, no.21, 1923 (May); in Baljeu (1974) op.cit., p.139.

54. Theo Van Doesburg, 'Von der neuen asthetik zur materiellen verwirklichung' (Weimar, 1922), *D.S.*, VI, 1, March 1923; in ibid, p.129.

55. Theo Van Doesburg, 'Vers une architecture plastique', Paris, 1924; *D.S.*, XII, 6—7, 1924; in ibid, pp.142—51.

56. C.f. Troy, *De Stijl* (1983), p.110.

57. The text in which Van Doesburg most extensively discusses the 'counter-composition' as anti-architectural is: 'Schilderkunst: Van Kompositie tot contra-kompositie', *D.S.*, XIII, 73—4, 1926; in Baljeu (1974), op.cit., pp.151—6.

58. Theo Van Doesburg, 'Vers une nouvelle formation du monde', *D.S.*, IV, 8, August 1921; in ibid, p.114.

59. Theo Van Doesburg, 'Schilderkunst en plastiek: Elementarisme', Paris, December 1926—April 1927, *D.S.*, XIII, 78, 1926—7; in ibid, p.164.

60. C.f. p.295, below.

61. Theo Van Doesburg to Adolf Behne, November 1928; quoted in Troy, *De Stijl* (1983), p.176.

62. See Part I, p.93, above.

63. See Part I, p.37, above.

64. A letter from Herbin to Léonce Rosenberg of 24 July 1920 records his receipt of Van Doesburg's text, and it is here that he confesses himself more in sympathy with the Dutchman than Gleizes. The letter is recorded in the dossier of material relating to Léonce Rosenberg and the galerie de l'Effort Moderne collected by Christian Derouet of the Musée National d'Art Moderne, Paris.

65. 'On peut *construire* avec la *couleur* comme l'on construire avec des pierres. D'autre part, la couleur a des qualités plastiques. La couleur est aussi *constructive*. On peut expliquer le bariolage comme ceci— Couleur exposée pour le goût—par le goût—plus ou moins raffinée, plus ou moins equilibrée. Il y a aussi la petite couleur d'un Renoir désirée et appliquée comme la poudre de ris ou les fards. Les époques de bariolage ne connaissent plus la construction. Ne pas confondre *bariolage* avec *construction*.' Auguste Herbin, 'Correspondance' (24 July 1920), *E.M.*, no.12, February 1925.

66. See Part I, p.94, above.

67. Waldemar George, in *L'Amour de l'Art*, February 1923. C.f. my discussion in Green, *Léger* (1976), p.294.

68. The inscription on the back of one of the drawings

in the Musées Royaux de Belgique related to the project, reads: '1e état graphique, projet fresque 1922, exposé Salon Indép.22'. The date of the Indépendants is mistaken, but it remains significant that Léger uses the term 'projet fresque'. When a design probably again directly related to the project was illustrated in *L'Architecture Vivante* (autumn/winter 1924); it was captioned: 'Fresque (extérieur) pour un Hall d'Hôtel, 1922–3.' See ibid, p.293.

69. Salmon treats Léger's and Csaky's contribution as 'réalisations architecturales' and writes: 'Delaunay n'a-t-il pas commis l'erreur de vouloir ramener le monument, *moderne*, tel que son esprit candide l'avant conçu non sans grandeur, aux proportions du tableaux, fût-ce de cimaise plutôt que de chevalet, qui est, au regard de Delaunay, victime de quelques contradictions, une chose *ancienne*?' André Salmon, 'Les Arts et la vie', *La Revue de France*, 1 April 1923, p.580.

70. Florent Fels, 'Propos d'artistes, Fernand Léger', *Les Nouvelles Littéraires*, Saturday, 30 June 1923, p.4.

71. Ibid, p.4.

72. Ibid, p.4.

73. Fernand Léger, 'L'Architecture polychromie', *L'Architecture Vivante*, autumn/winter 1924; translated by Charlotte Green, in *Léger and Purist Paris*, London (Tate Gallery), 1970–1, pp.95–6.

74. Ibid, p.96.

75. Ibid.

76. C.f. Fabre, *L'Esprit Moderne* (1982); and Gladys Fabre, 'L'Atelier de Léger et l'académie moderne', *L'Oeil*, Revue d'art, March 1982.

77. C.f. Fabre, *L'Esprit Moderne* (1982), pp.376–96.

78. Fernand Léger, 'De l'art abstrait', *Cahiers d'Art*, 1931; in Léger, *Fonctions* (1965), p.41.

79. Doig discusses Van Doesburg the Dadaist perceptively; see Doig, *Van Doesburg* (1981), pp.138–43.

80. This fact is noted by Robert Welsh; see Welsh in *De Stijl* (1982), op.cit., p.32.

Chapter 16

1. André Breton, 'Deux Manifestes', *Littérature, 1e série*, no.13, May 1920; in André Breton, *Les Pas perdus*, Paris, 1924, p.64.

2. André Breton, 'Caractères de l'évolution moderne et ce qui en participe', Lecture given in Barcelona, 17 November 1922; in ibid, p.158.

3. André Breton, *Entretiens*, Paris, 1952, p.56; quoted in Dawn Ades, 'Littérature'; in *Dada and Surrealism Reviewed*, London (Arts Council of Great Britain), 1978, p.161.

4. William S. Rubin, *Dada and Surrealist Art*, London, 1969, p.111.

5. See pp.13–47, above.

6. André Breton, 'Pour Dada', *N.R.F.*, August 1920; in Breton (1924), op.cit., p.73.

7. The text begins: 'Il m'arrive de perdre soudain tout le fil de ma vie.' This led him to the realisation that: 'je ne suis plus la bicyclette de mes sens, la meule à aiguiser les souvenirs et les rencontres'. He goes on: 'Alors je saisis en moi l'occasionnel, je saisis tout à coup comment je me dépasse: l'occasionnel c'est moi, et cette proposition formée je ris à la mémoire de toute l'activité humaine.' Louis Aragon, *Une Vague de rêves*, Paris, 1924, p.9.

8. C.f. Breton (17 November 1922), in Breton (1924), op.cit., pp.158–9.

9. Francis Picabia, 'Lettre ouverte à Monsieur H. R. Lenormand', *Comoedia*, 22 December 1920; in *Francis Picabia, Écrits*, vol.I, Paris, 1975, p.216–17. The letter was a response to Henri-René Lenormand, 'Dadaïsme et psychologie', *Comoedia*, 23 March 1920.

10. 'Il n'y a rien à comprendre, vis pour ton plaisir, il rien [sic], rien, rien, rien que la valeur que tu donneras toi-même à tout.' Francis Picabia, *Jésus-Christ Rastaquouère*, 'Dessins par Ribemont-Dessaignes', Paris, 1920, p.18.

11. For Nietzsche and Picabia, see Camfield, *Picabia* (1979), pp.54–5, and Michel Sanouillet, *Francis Picabia et 391*, vol II, Paris, 1966, p.71.

12. Bonnet has established Breton's pre-war anarchist and anti-militarist leanings, and in particular the importance to him of Rémy de Gourmont's 'Le Joujou de patriotisme', *Mercure de France*, April 1891, and René Schwob's *Le Livre de Monelle*, Paris, 1894. See Bonnet, *Breton* (1975), pp.44–59.

13. C.f. Anna Balakian, *Literary Origins of Surrealism, A New Mysticism in French Poetry*, New York, 1965, pp.127–30.

14. Paul Dermée, 'Dadaiste Cartésien', 'Qu'est que Dada!', *Z*, March 1920, p.1.

15. André Breton, 'Francis Picabia', Barcelona, November 1922; in Breton (1924), op.cit., pp.134–5.

16. Ibid, pp.134–5.

17. Francis Picabia, 'Poésie pour ceux qui ne comprennent pas', *Cannibale*, no.11, 25 May 1920, p.6.

18. Also very relevant is Tzara's lecture at the Weimar 'Dada Kongress' of 1922, where he dismissed Beauty and Truth in favour of 'personality'. See Tristan Tzara, 'Conférence sur Dada' (Dada Kongress, Weimar, 1922), *Merz* II, no.7, Hanover, January 1924; quoted in Camfield, *Picabia* (1979), p.121.

19. 'On va jusqu'à prétendre que, sous couleur d'exalter l'individualité, Dada constitue un danger pour elle, sans s'arrêter à voir que ce sont surtout des différences qui nous lient.' André Breton, 'Pour Dada' (April 1920), in Breton (1924), op.cit., p.78.

20. Louis Aragon, 'Moi', *Littérature, 1e série*, no.13, May 1920.

21. Louis Aragon, 'Avis', *R.S.*, 15 October 1925, p.25.

22. Louis Aragon, 'Libre à vous', *R.S.*, 15 January 1925, pp.23–4.

23. Pierre Reverdy, 'L'Esthétique at l'esprit', *E.N.*, no.6, March 1921; in Reverdy, *Oeuvres complètes* (1975), p.173.

24. André Breton to Francis Picabia, Monday, 5 January 1920; 'Pièce no.112', in Michel Sanouillet, *Dada à Paris*, Paris, 1965, p.505.

25. Tristan Tzara, *Manifeste Dada, 1918*, read in Zurich, 23 March 1918; in *The Dada Painters and Poets: An Anthology*, edited by Robert Motherwell, Boston, 1981 (2nd edition), p.81.

26. The myth of Jacques Vaché, and many of the 'facts' known about him, are found in Breton's 'Confession dédaigneuse', *La Vie Moderne*, 18 and 25 February, 4–11 March and 18 March 1923, and in the essay 'Jacques Vaché', both of which were published in Breton (1924), op.cit., pp.7–22 and 59–63.

27. Breton, 'Confession dédaigneuse'; in ibid, p.8.

28. Ibid, p.9.

29. Bonnet provides a very full account of Breton's involvement with the poetry of Mallarmé and Valery; see Bonnet, *Breton* (1975).

30. Picabia was in New York at the time; See Camfield, *Picabia* (1970), p.102.

31. The best account of the 'Vendredi de *Littérature*' is in Sanouillet (1965), op.cit., p.143.

32. *Cannibale*, no.1, 25 April 1920, p.11.

33. The anti-aesthetic character of *Volucelle II* is to be divined in the context of Picabia's introduction to the catalogue of the Picabia exhibition of November 1922 in Barcelona; in Breton (1924), op.cit., pp.134–5.

34. Breton follows this statement with just such a 'poème', the original types left unchanged. Breton, *Manifestes* (1972), p.56.

35. My analysis here is indebted to Bonnet's invaluable discussion of 'Le Cornet mystère' and *Mont de Piété*; see Bonnet, *Breton* (1975), pp.156–7.

36. Sanouillet gives the 1919 date; see Sanouillet (1965), op.cit., p.249.

37. For Ernst's collages, see, especially, Spies, *Ernst-Collagen* (1974).

38. Statement by Max Ernst; in *Max Ernst*, Walraf-Richartz Museum, Cologne, 1962–3.

39. This is a point stressed especially by Schneede; see Uwe M. Schneede, *The Essential Max Ernst*, London, 1972, translated by R. W. Last.

40. The hat catalogue source is pointed out by Schneede; ibid, p.33.

41. 'Il ne s'agissait de rien moins que de rassembler ces objets disparates [a lamp, or a bird, or an arm in a photograph, for instance] selon un ordre qui fût différent du leur et dont, à tout prendre, ils ne parussent pas souffrir, d'éviter dans la mesure du possible tout dessein préconçu et, du même oeil qu'on regarde de sa fenêtre un homme, son parapluie ouvert, marcher sur un toit . . . d'établir entre les êtres et les choses considérés comme données, *à la faveur de l'image*, d'autres rapports que ceux qui s'établissent communément et, du reste, provisoirement, de la même façon qu'en poésie on peut rapprocher les lèvres du corail . . .' André Breton, 'Le Surréalisme et la peinture', *R.S.*, nos 9–10, 1 October 1927, p.39.

42. C.f. Sanouillet (1966), op.cit.

43. The point is well documented in Ingrid K. Jenkner,

The Collaboration of Max Ernst and Paul Eluard in 'Repetitions' and 'Les Malheurs des Immortels', A Cross-Fertilization of Genres, Dissertation presented in partial fulfilment for the degree of M.A., Courtauld Institute, University of London, 1979. Also c.f. Werner Spies, 'Une Poétique du collage'; in *Eluard et ses amis peintres*, Centre Georges Pompidou, Bibliothèque publique d'information, Musée National d'Art Moderne, Paris, 1982–3.

44. Tristan Tzara, 'Francis Picabia', *Dada*, 4–5, Zurich, 15 May 1919. In *Francis Picabia*, Galeries Nationales du Grand Palais, Paris, 1976, p.85.

45. There are many such instances, but one in particular deserves mention because from within a text full of dislocations it seems to sum up Tzara's faith in the virtually automatic. It is a sentence from the piece 'Aa paye et meurt', *391*, no.9, November 1919, p.3. It reads: 'Une pensée peut s'allumer comme la lumière électrique, sécher comme un bandage et sauter comme une certaine couleur que j'ai composer une fois avec le sang du colibri, le caoutchouc des bicyclettes à califourchon sur un fil télégraphique.'

46. Such a pursuit is particularly clear in Picabia's piece 'How New York Looks at Me', *New York American*, New York, 30 March 1913. Spate has convincingly linked his ideas on 'improvisation' with the tenor of Kandinsky's *On the Spiritual in Art*; see Virginia Spate, *Orphism, the Evolution of non-figurative Painting in Paris, 1910–1914*, Oxford, 1979, pp.317–22.

47. The source of the idea that Janet was of such importance is Philippe Soupault, *Profils perdus*, Paris, 1966, pp.166–7. C.f. Anna Balakian, *André Breton, Magus of Surrealism*, New York, 1971, pp.28ff. The work in question was: Pierre Janet, *L'Automatisme psychologique*, Paris, 1889 (9th edition, 1921).

48. See, particularly, Sanouillet's notes on *391*; Sanouillet (1966), op.cit. He sees the poems of Picabia's *52 miroirs* and *Poèmes et dessins de la fille née sans mère* (1917 and 1918) as an early form of automatic writing, and calls Picabia's and Tzara's combined texts for p.6 of *391*, no.8 (February 1919): 'le premier exemple incontestable de "poème" écrit *délibérément* sous la seule dictée de l'inconscient et palpitle comme tel'.

49. Louis Aragon, 'Le Passage de l'Opéra', 1924; in *Le Paysan de Paris*, Paris, 1926, p.44. Recent work of some importance by Elizabeth Legge has set Breton's 'Interview du Professeur Freud' within the context of Freud's contemporary reception by the French, and in so doing has questioned a simple negative interpretation of Breton's position; see Elizabeth Legge, *Conscious Sources of the Unconscious: Ernst's Use of Psychoanalytic Themes and Imagery, 1921–1924*, Dissertation presented for the degree of Ph.D., Courtauld Institute, University of London, 1985, pp.11–49. Furthermore, André Masson is absolutely unambiguous in his acknowledgement of Freud's importance: 'Et c'est tout naturellement que nous nous trouvons dans les années 1925–1926, admirateurs de Freud.' 'Le Peintre et ses fantasmes', *Les Etudes philosophiques*, October-December 1956; in *André Masson, Le rebelle du surréalisme, écrits*, edited with notes by François Will-Levaillant, Paris, 1976, p.31. See also Will-Levaillant's useful note, p.57.

50. Bonnet gives the translation dates of all the major texts by Freud to appear in France in the early twenties; see Bonnet, *Breton* (1975), p.102, footnote. *Psychoanalysis* was the first to appear, in 1921. *The Psychopathology of Everyday Life* appeared in 1923, as did *Totem and Taboo*. *The Interpretation of Dreams* appeared only in 1925.

51. André Breton to Théodore Fraenkel, 31 August 1916; quoted in Bonnet, *Breton* (1975), p.104.

52. Ibid, pp.103–8. Bonnet's analysis of Breton's notion of 'automatisme psychique' in relation to Janet's 'automatisme psychologique' is very persuasive.

53. The passage appears in translation in: Maurice Nadeau, *The History of Surrealism*, translated by Richard Howard, London, 1968, pp.74–5. The source is a letter from Rimbaud to Paul Demeny of 1871 first published, as Cowling points out, by Barrichon in *N.R.F.*, October 1912. See Elizabeth Cowling in *Dada and Surrealism Reviewed* (1978), op.cit., note to 8.66, p.183.

54. C.f. Bonnet, *Breton* (1975), pp.141–7; see also Cowling (1978), op.cit., p.182.

55. Breton (August 1920), in Breton (1924), op.cit., p.77.

56. Pierre Reverdy, 'L'Image', *Nord-Sud*, no.13, March 1918; in Reverdy, *Oeuvres complètes* (1975), pp.73–5.

57. André Breton, 'Max Ernst', May 1921; in Breton (1924), op.cit., p.87.

58. The term was defined by Apollinaire in his preface to the play *Les Mamelles de Tirésias* in 1917; see Guillaume Apollinaire, *L'Enchanteur pourrissant, suivi de Les Mamelles de Tirésias*, Paris, 1972, p.94. Keeping as close to Apollinaire as possible, Yvan Goll defined Surrealism as: 'Cette transposition de la réalité dans un plan supérieur (artistique) . . .' Yvan Goll, 'Manifeste de surréalisme', *Surréalisme*, no.1, October 1924, unpaginated.

59. See p.165, above.

60. This is demonstrated by an exchange of letters between Reverdy and Breton. There were four letters written by Reverdy to Breton: 1 August, 7 September and 2 December 1918 and 5 January 1919. The debate contained in them, which revolved around the question of *lyrisme* and the character of poetic emotion, is outlined and analysed by Bonnet, in *Breton* (1975), pp.130–3.

61. André Breton, 'Entrée des mediums', *Littérature*, *Nouvelle série*, 1 November 1922; in Breton (1924), op.cit., p.123.

62. See p.98, above.

63. An important stimulus was the publication of Charles Richet's *Traité de Métaphysique* in 1922. C.f. Sanouillet (1965), op.cit., p.354, and Bonnet, *Breton* (1975), op.cit., p.265.

64. Aragon (1924), op.cit., p.25.

65. Ibid, p.16.

66. Desnos produced two collections of poems in 1923 which focused on these practices: *Langage cuit* and *l'Aumonyme*. Poems from these collections appeared in *Littérature, Nouvelle série*, nos 10, 11, 12, 1 May and 15 October 1923.

67. Bonnet tells the story definitively; see Bonnet, *Breton* (1975), pp.314ff.

68. Breton, *Manifestes* (1972), pp.24, 37.

69. Francis Picabia, 'Dadaïsme. Instantanéisme', *391*, October 1924, p.1.

70. *Surréalisme*'s one issue appeared in October 1924.

71. A propos of Apollinaire's use of 'les mots de la vie quotidienne', Goll writes that: 'avec ce matériel élémentaire, il forma des images poétiques'. He further notes that: 'L'image est aujourd'hui le critère de la bonne poésie'; and continues: 'Les plus belles images sont celles qui rapprochent ces éléments de la réalité éloignés les uns des autres les plus directement et le plus rapidement possible.' Goll (1924), op.cit.

72. A note appeared in *Paris-Soir*, 22 May 1924, probably by Dermée, calling Reverdy, Jacob, Dermée and Apollinaire 'Surréalistes'. It was followed by a reply from the 'groupe Littéraire' in *Paris-Soir*, 27 May 1924, which contained the statement: 'Mais de nos jours, il apparaît pas que MM. Pierre Reverdy ou Max Jacob soient des surréalistes: ils sacrifient trop à l'esprit critique'.

Chapter 17

1. Breton, *Manifestes* (1972), p.37.

2. André Breton, 'Entrée des médiums', *Littérature, Nouvelle série*, 1 November 1922; in Breton, *Les Pas perdus*, Paris, 1924, p.123.

3. The most exhaustive such study is Bonnet's; see: Bonnet, *Breton* (1975), pp.160–97.

4. According to Breton himself, in annotations made to Valentine Hugo's copy of *Les Champs magnétiques*, differences of speed undeniably influenced 'the character of what was said'. Ibid, pp.174–5.

5. Breton, *Manifestes* (1972), p.19.

6. C.f. Bonnet, *Breton* (1975).

7. Louis Aragon, *Une Vague de rêves*, Paris, 1924, p.23.

8. Ibid, p.18.

9. Jacques Rivière, 'Reconnaissance à Dada', *N.R.F.*, August 1920.

10. See p.260, below.

11. Breton, *Manifestes* (1972), p.40.

12. Max Morise, 'Les Yeux enchantés', *R.S.*, 1 December 1924, p.27.

13. Pierre Naville, *R.S.*, 15 April 1925.

14. Aragon (1924), op.cit., p.16.

15. Louis Aragon, 'Le Passage de l'Opéra', 1924; in Aragon, *Le Paysan de Paris*, Paris, 1926, pp.30–3.

16. André Breton, 'Le Surréalisme et la peinture', *R.S.*, 15 June 1926, p.3.

17. André Breton, 'Giorgio de Chirico'; in Breton (1924), op.cit., p.94.

18. Spies seeks to distinguish between the works made by the use of printers' blocks and those using engraved or photographic sources; see Spies, *Ernst-Collagen* (1974), pp.41ff.

19. Eluard bought the first on his first visit to Ernst in Cologne in 1921, and the second on his second visit in 1922; see Sir Roland Penrose, *Max Ernst's Celebes*, Newcastle-upon-Tyne, 1972.

20. The sheer sophistication of Ernst's understanding of Freud's psychoanalytic theories, and in particular of Freud's approach to dreams and the dream-work mechanism has been touched on by Malcolm Gee in 'God, Max Ernst and Revolution by Night', *Arts Magazine*, January 1980. Elizabeth Legge's work has lifted understanding of this onto a new plane; see Elizabeth Legge, *Conscious Sources of the Unconscious: Ernst's Use of Psychoanalytic Themes and Imagery, 1921–1924*, Dissertation presented for the degree of Ph.D., Courtauld Institute, University of London, 1985.

21. For Reverdy, the dream is 'la forme particulière que mon esprit donne à la réalité'. It is: 'l'état où la conscience est portée à son plus haut degré de perception'. It is 'une forme plus libre, plus abandonnée' of 'la pensée'. Pierre Reverdy, 'Le Rêveur parmi les murailles', *R.S.*, 1 December 1924; in Reverdy, *Oeuvres complètes* (1975), pp.207–13.

22. Morise (December 1924), loc.cit., p.26.

23. C.f. Michel Sanouillet, *Dada à Paris*, Paris, 1965, pp.380ff.

24. Aragon (1924), op.cit., p.28. The only other painter named as a 'President' is Giorgio de Chirico.

25. André Breton, 'Le Surréalisme et la peinture', *R.S.*, 15 July 1925, p.28.

26. André Breton, 'Caractères de l'évolution moderne et ce qui en participe', Lecture delivered in Barcelona, 17 November 1922; in Breton (1924), op.cit., p.158.

27. André Breton, 'Max Ernst', Paris, May 1921; in ibid, p.86.

28. Breton (17 November 1922); in ibid, p.158. Much later André Masson developed this view of Cubism and Surrealism in his own way. Focusing on Cubism in 1911 and Surrealism in 1925, he stressed the contribution made by the Cubism, especially of Picasso, in freeing painting from the depiction of the perceptual. The Cubists and the Surrealists together, he said: 'décideront que l'art a droit à la liberté suprême: celle qui consiste, non plus à imiter ou à représenter des objets ayant un sens usuel, mais à CRÉER des CHOSES neuves—imprévues. . . .' Like Breton, this, for him, was the key to the release of the imagination in painting. See André Masson, 'Origines du Cubisme et du Surréalisme', Lecture, 1941; in *André Masson, Le Rebelle du surréalisme, Écrits*, edited, with notes, by Françoise Will-Levaillant, Paris, 1976, p.19.

29. Morise (December 1924), loc.cit., p.27.

30. Ibid, p.27.

31. See Part I, pp.100–103, above.

32. Francis Picabia, *Jésus-Christ Rastaquouère*, 'Dessins par Ribemont-Dessaignes', Paris, 1920, p.64.

33. Breton, *Manifestes* (1972), p.40.

34. 'Loin de nous l'idée d'exploiter ces images et de les modifier dans un sens qui pourrait faire croire à un progrès. Que de la distillation d'un liquide apparaisse l'alcool, le lait ou le gaz d'éclairage autant d'images satisfaisantes et d'inventions sans valeur. Nulle transformation n'a lieu mais pourtant,, encre invisible, celui qui écrit sera compté parmi les absents.' J.-A.Boiffard, P. Eluard, R. Vitrac, 'Préface', *R.S.*, 1 December 1924, p.2.

35. *R.S.*, 15 July 1925.

36. This exchange between Aragon and the editors of *Clarté* is discussed by Maurice Nadeau, in *The History of Surrealism*, translated by Richard Howard, London, 1968, pp.100–1.

37. See p.149, above.

38. André Breton, 'Légitime Défense', *R.S.*, 1 December 1926, p.34.

39. Carolyn Lanchner, 'André Masson: Origins and Development'; in Rubin and Lanchner, *Masson* (1976), pp.100–2.

40. I consider that Lanchner is too insistent when she writes that the remoteness of the rue Blomet from Breton's circle at the end of 1923 makes it unlikely that Masson was 'more than peripherally aware of Breton's and Soupault's *Champs magnétiques* or of the concern with psychic automatism that was central

to Breton and his friends during the *époque floue* from 1922 to 1924'. Ibid, p.102.

41. At one of the sessions at the end of September 1922, Desnos was given pencil and paper when in a trance, and what he wrote is included in Breton's 'Entré des médiums'; Breton (1924), op.cit., pp.127–30.

42. For Masson's relations with Kahnweiler and Gris, see Kahnweiler, *Gris* (1968–9), pp.44 and 53; and Isabelle Monod-Fontaine, Agnès Angliviel de la Baumelle and Claude Laugier, *Donation Louis et Michel Leiris, Collection Kahnweiler-Leiris*, Centre Georges Pompidou, Musée National d'Art Moderne, Paris, 1984–5, pp.132–4.

43. See pp.265–7, below. Masson recalls that, though his automatic drawings were reproduced in the periodical, and the sand paintings in the first edition of Breton's *Le Surréalisme et la peinture* (Paris, 1928), in fact these more genuinely automatic works did not hold 'l'attention de mes compagnons de route. Leur préférence allait à mes tableaux ou dessins plus ''laborieux''—plus arrêtés.' 'Propos sur le Surréalisme', *Méditations*, autumn 1961; in *Masson, ecrits* (1976), op.cit., p.37.

44. Reproduced in the catalogue are one of Ernst's first *frottages*, *Head of a Young Girl*, and one of the first of Miró's so-called 'dream paintings', *The Music-Hall Usher*.

45. Miró found his studio at 45 rue Blomet at the end of 1920. It was that of the Catalan sculptor Pablo Gargallo, which was left empty in the winter. Masson moved into a neighbouring studio in the same building at the end of 1921, and the two probably met that winter, apparently at the Café Savoyard via Max Jacob. Miró did not spend the winter of 1922–3 in the rue Blomet studio, however, though he returned for 1923–4. C.f. Dupin, *Miró* (1962), p.98; William Rubin, *Miró in the Collection of the Museum of Modern Art*, New York, 1973, p.110; especially, Françoise Will-Levaillant, in *Masson, Ecrits* (1976), op.cit., pp.110–11; and Lanchner in Rubin and Lanchner, *Masson* (1976), pp.85–6. Masson himself mentions the Café Savoyard and Jacob; see 'A Joan Miró pour son anniversaire', *Masson, Ecrits*, p.86.

46. It is Dupin who dates *The Kiss* to the summer of 1924; ibid, p.147. A drawing for it survives in one of the sketch-books preserved at the Fundació Joan Miró in Barcelona. Following the numbering of the Fundació, it is on sheet 642.

47. The 'dream pictures' have usually been separated from the large pictures painted at Montroig in the summers. But even in these latter a more or less automatic procedure was used, a fact revealed by the way that certain of them were generated in drawings using the pressings through of one page onto another as stimuli. The, *Landscape with Rabbit and Flower* was generated by pressings from the drawings for *Landscape (On the Shores of the River)* (Dupin, *Miró* (1962), catalogue 180 and 179). See sheets 790 and 789, Fundació Joan Miró, Barcelona.

48. Rubin (1973), op.cit., p.32. Rubin maintains that some of the 'dream paintings' *were* shown at the galerie Pierre.

49. See Part I, pp.101–4, above.

50. See Part I, p.103, above.

51. See Part I, p.101, above. Masson has given his own description of the process by which images are extracted: 'Les premières apparitions graphiques sur le papier sont geste pur, rythme, incantation, et comme résultat: purs *gribouillis*. C'est la première phase. Dans la seconde phase, l'image (qui était latente) reclame ses droits. Quand l'image est apparue, il faut s'arrêter.' André Masson 'Propos sur le surréalisme' (1961), in *Masson, Ecrits* (1976), op.cit., p.37.

52. Michel Leiris, 'Glossaires: J'y serre mes glosses', *R.S.*, 15 April 1925, p.7.

53. 'Armure' in *R.S.*, 15 July 1925, p.21; 'Amour' in *R.S.*, 1 March 1926, p.20.

54. Leiris (15 April 1925), loc.cit., p.7.

55. *Langage cuit*, Paris, 1923; *L'Aumonyme*, Paris, 1923.

56. Robert Desnos, 'Elégant cantique de Salome Salomon', in *Langage cuit*, op.cit., and in *Littérature*, Nouvelle série, nos 11–12, 15 October, 1923, p.3.

57. Robert Desnos, 'A Jacques Baron', in *L'Aumonyme*, op.cit., and in *Littérature, Nouvelle série*, no.10, 1 May 1923, p.27.

58. Of the works that I have been able to study at first hand, two in particular reveal underdrawing: *Woman of 1925* (Collection Larivière, Montreal), and *The*

Wing, 1925 (Plate 265). In the former there are many instances of changes made at the stage of painting, away from the initial drawn outlines.

59. Care is especially evident in the underdrawing and fill-in technique of *The Wing*.

60. Max Ernst, 'Au delà de la peinture', *Cahiers d'Art*, II, nos 6–7, 1936; translated in Ernst, *Beyond Painting*, edited by Robert Motherwell, New York, 1948, p.7.

61. Max Ernst, 'Visions de demi-sommeil', *R.S.*, 1 October 1927, p.7. Legge has offered a highly persuasive interpretation of Ernst's account as 'clearly contrived, drawing on images from Freudian analysis', citing Freud's comments on the ease with which dreams can be simulated (*The Interpretation of Dreams*, translated by James Strachey, London, 1977, p.126); See Elizabeth Legge, *Jungian Influences on Ernst's Work of the 1920s*, Dissertation presented in part fulfilment for the degree of M.A., Courtauld Institute, University of London, 1979, pp.1–2. She has taken this further in her current work; see Legge (1985), op.cit.

62. Breton describes a moment one evening 'avant de m'endormir' when a strangely compelling phrase came to him. Breton, *Manifestes* (1972), pp.31–2.

63. Schneede in particular has argued this; see Uwe M.Schneede, *The Essential Max Ernst*, translated by R. W. Last, London, 1972, p.72.

64. Bonnet, *Breton* (1975), p.298.

65. 'Je découvris tout à coup la solution [to the problem of 'la spontanéité' in painting], alors que j'étais au bord de la mer, contemplant la beauté du sable composé de myriades de nuances et d'infinies variations allant de la matité à l'étincellement.' Masson, 'Propos sur le surréalisme' (1961), in *Masson, Ecrits* (1976), op.cit., p.37. He, like Ernst, brings in Leonardo da Vinci: 'Je refaisais à ma mániére ce mur exemplaire de Léonard da Vinci.' See also Françoise Will-Levaillant's note, p.63. C.f. Lanchner in Rubin and Lanchner, *Masson* (1976), p.120.

66. Lanchner leaves the impression that drawing only occurred after the pouring and scattering; ibid. p.120.

67. The initial act of drawing is clear from a first-hand study of the work.

68. C.f. Lanchner in Rubin and Lanchner, *Masson* (1976), pp.124–5.

69. Breton later wrote of Miró achieving total spontaneity from this period on. See André Breton, 'Genèse et perspectives artistiques du surréalisme', 1941; in *Le Surréalisme et la peinture*, New York, 1945. p.94.

70. Rubin (1973), op.cit., pp.32–3.

71. In all there are seven of these sketch-books. They range from a tiny pad measuring 11.8 × 8.2cm to a couple of large pads measuring 27 × 21 and 26.5 × 20cm. A great many drawings (nos 591–668) are in a middle-sized pad, 20 × 17cm. All are in the Fundació Joan Miró, Barcelona, and the numbering given in these notes follows the Fundació's numbering.

72. Gaeton Picon, *Joan Miró, Catalan Notebooks*, translated by Dinah Harrison, London, 1977, p.71.

73. A few instances can serve. The drawing for *Head*, 1927 (Dupin, *Miró* (1962), catalogue 188), Fundació no.657, includes a profile inscribed within the 'head' form, which is not in the painting. The drawing for the virtually empty *Painting*, 1925 (Dupin, catalogue 149), Fundació, no.617, is identical except that the single element upper left is lit from the opposite side. There are significant differences between *Painting*, 1927 (Dupin, catalogue 196) and the drawing for it, Fundació, no.768.

74. These are at the back of the small sketch-book (11.8 × 28.2cm), which contains ideas for paintings of 1925–7.

75. These drawings are part of a sequence of sheets, where pressings from one idea led into another. They are in a pad measuring 26.5 × 20cm which contains ideas for paintings of 1925–6. The sequence starts with Fundació no.734, whose pressings were generative in no.735. Next, on sheet no.737 is a drawing for Dupin catalogue 114, whose pressings were used for a couple of elements in the drawing for *Sable* (Fundació no.738). Then there follow two more sheets, nos 739 and 740, ending with the drawing for *Painting*, 1925 (Dupin catalogue 138) (Plate 371).

76. See note 48, above.

77. Krauss and Rowell, *Magnetic Fields* (1972), p.94.

78. C.f. J. J. Sweeney, 'Joan Miró, Comment and Interview', *Partisan Review*, XV, no.2, 1948, p.209; and Dupin, *Miró* (1962), pp.162–4.

79. See pp.102–3, above.

Chapter 18

1. André Breton, 'Distances', *Les Pas perdus*, Paris, 1924, p.143.

2. The French in the case of Apollinaire's text is: Orphism —'C'est l'art de peindre des ensembles nouveaux avec des éléments empruntés non à la réalité visuelle, mais entièrement créés par l'artiste et doués par lui d'une puissante réalité. Les oeuvres des artistes orphiques doivent présenter simultanément un agrément esthétique pur, une construction qui tombe sous les sens et une signification sublime, c'est-à-dire le sujet. C'est l'art pur,' 'Un agrément esthétique' is not strictly speaking to be interpreted as referring solely to 'le plaisir des yeux', but is obviously relevant. Guillaume Apollinaire, *Les Peintres cubistes: Méditations esthétiques*, Paris, 1913; 1980 edition (edited with notes by L. C. Breunig and J. Cl. Chevalier), p.69.

3. André Breton, 'Le Surréalisme et la peinture', *R.S.*, 15 July 1925, p.27.

4. C.f. André Breton in 'Max Ernst', Paris, May 1921; in Breton (1924), op.cit., p.86; and Louis Aragon in 'Max Ernst, Peintre des illusions', August 1923; in Louis Aragon, *Ecrits sur l'art moderne, les écrits d'Aragon sur l'art publiés sous la direction de Jean Risart*, Paris, 1981, pp.12–16. The Surrealist notion of imagination and its relationship to the material is especially well demonstrated by Aragon in the mock-dramatic interlude figuring 'L'Imagination' in personified form in 'Le Passage de l'Opéra' of 1924; in *Le Paysan de Paris*, Paris, 1926, pp.76–9.

5. William S. Rubin, *Dada and Surrealist Art*, London, 1969, pp.14–15.

6. The essential discussion of words in the pre-1914 Cubist painting of Picasso and Braque is: Robert Rosenblum, 'Picasso and the Typography of Cubism'; in *Picasso 1881–1973*, edited by Roland Penrose and John Golding, London, 1973, pp.49–73.

7. See Part I, pp.49–50, above.

8. For Crotti's development alongside Picabia and Duchamp, see William A. Camfield, 'Jean Crotti and Suzanne Duchamp'; in *Tabu Dada, Jean Crotti and Suzanne Duchamp, 1915–1922*, edited by William A. Camfield and Jean-Hubert Martin, Kunsthalle, Bern, 1983.

9. Francis Picabia, *Jésus-Christ Rastaquouère*, 'Dessins par Ribemont-Dessaignes', Paris, 1920, p.14.

10. See, especially, Albert Gleizes, 'L'Affaire Dada', *Action*, April 1920, pp.26–32; in *The Dada Painters and Poets*, edited by Robert Motherwell, New York, 1951, pp.298–303.

11. This is clear in the letter Breton wrote to Picabia, 15 February 1920, quoted in Bonnet, *Breton* (1975), p.216.

12. This is clear in his definition of Orphism in *Les Peintres cubistes*; see note 2, above.

13. Francis Picabia, Untitled text, *291*, New York, no.12, February 1916; given in full in Jean-Hubert Martin and Hélène Seckel, *Francis Picabia*, Galeries Nationales du Grand Palais, Paris, 1976, p.74.

14. Statement by Picabia; in M.B., 'Le Dadaïsme n'est qu'une farce inconsistente', *L'Action française*, 14 February 1920, p.2. Quoted in: Camfield, *Picabia* (1979), p.137.

15. Ibid, p.130.

16. C.f. Ingrid K.Jenkner, *The Collaboration of Max Ernst and Paul Eluard in 'Répétitions' and 'Les Malheurs des immortels': A Cross Fertilisation of Genres*, Dissertation presented in partial fulfilment for the degree of M.A., Courtauld Institute, University of London, 1979, pp.16–17; and Werner Spies, 'Une Poétique du collage'; in *Eluard et ses amis peintres, 1895–1952*, Centre Georges Pompidou, Bibliothèque publique d'information and Musée National d'Art Moderne, Paris, 1982–3, pp.45–6.

17. See Jenckner (1979), op.cit., pp.31ff, and Spies, *Ernst-Collagen* (1974), pp.109–12, and ibid, p.50ff.

18. See Jenckner (1979), op.cit., and Spies (1982–3), *Ernst-Collagen* (1974).

19. The best account of the Salon Dada is in Michel Sanouillet, *Dada à Paris*, Paris, 1965, pp.277–9. Included in the catalogue are 'Inquiétude', a nonsense poem by Man Ray, and Arp's 'La Pompe des nuages'; *Salon Dada*, catalogue, Paris, 1921, unpaginated.

20. Ibid.

21. The Salon ran from 6 to 30 June 1921; Picabia marked his break from Dada with 'M. Picabia se sépare des Dadas', in *Comoedia*, 11 May 1921.

22. Louis Aragon (1923), in Aragon (1981), op.cit., p.13.

23. Ibid, pp.12–14.

24. André Masson, 'A Joan Miró pour son anniversaire'; in *André Masson, le Rebelle du surréalisme, Ecrits*, edited with notes by Françoise Will-Levaillant, Paris, 1976, p.87.

25. 'Through Masson I met them [the young poets of the day] . . . The poets Masson introduced me to interested me more than the painters I had met in Paris. I was carried away by the new ideas they brought and especially the poetry they discussed.' James Johnson Sweeney, 'Joan Miró, Comment and Interview', *Partisan Review*, XV, no.2, 1948, p.209.

26. C.f. Lanchner in Rubin and Lanchner, *Masson* (1976), pp.96–7.

27. Ibid, p.96.

28. See p.162, above.

29. Lanchner in Rubin and Lanchner, *Masson* (1976), p.96.

30. Many such works by Picasso, Braque and Gris of 1912–13 were familiar again, having passed through the Uhde and Kahnweiler sales between 1921 and 1923.

31. Gris produced what is possibly a self-portrait in May 1916; see Cooper, *Gris* (Catalogue, 1977), no.170; and Picasso's harlequins are increasingly interpreted as displaced or symbolic self-portraits. But in the early or mid-twenties there is no Cubist self-portrait by a leading Cubist known to me.

32. In 1924 Aragon was to write of Masson's knives as ready to be seized; see Louis Aragon, *Une Vague de rêves*, Paris, 1924, p.30.

33. The relevant passage from Plato's *Philebus* was quoted by Ozenfant in *L'Elan*, no.9, February 1916. From then on, allusions to it are relatively frequent.

34. Masson recorded by Dupin; in Dupin, *Miró* (1962), p.142.

35. Masson's discovery of Klee is fully discussed by Lanchner. The 'German book' in question was probably Wilhelm Hausenstein's *Kairuan oder Eine Geschichte von Maler Klee und von Kunst Dieses Zeitalters*, Munich, 1921; see Rubin and Lanchner, *Masson* (1976), p.102 and note 73.

36. Ibid, p.102. For a later statement by Masson, see 'Eloge de Paul Klee', *Fontaine*, no.53, June 1946; in *Masson, Ecrits* (1976), op.cit., pp.124–7.

37. Maurice Raynal, 'Les Arts', *L'Intransigeant*, Tuesday, 27 October 1925.

38. André Breton, *Point du jour*, Paris, 1934, pp.246–7.

39. Eluard's 'André Masson' is a prose-poem. The first paragraph reads: 'La cruauté se noue et la douceur agile se dénoue. L'aimant des ailes prend des visages bien clos, les flammes de la terre s'évadent par les seins et le jasmin des mains s'ouvre sur une etoile.' *R.S.*, 15 July 1925, p.5.

40. Another telling instance is the painting *Etoiles en des sexes d'escargot*, where the inscription which serves as title was clearly written *subsequent* to the initial sketching of the image. Here Miró increased the *verbal* force of the image by changing 'comme' to 'en'. The drawing is Fundació no.587.

41. Krauss and Rowell, *Magnetic Fields* (1972), pp.50–3 and 91–2.

42. For Miró, see Sweeney (1948), op.cit., p.209. For Masson, see 'A Joan Miró', in *Masson, Ecrits* (1976), p.256.

43. Quoted in Bonnet, *Breton* (1976), p.256.

44. Breton's continuing need to attack more conservative notions of tradition is clear in such incidents as the distribution of 'Un Cadavre' on the death of Anatole France. C.f. ibid, pp.339–40.

45. André Breton, Robert Desnos and Benjamin Peret, 'Comme il fait beau', *Littérature, Nouvelle série*, no.9, 1 February–1 March, 1923. pp.6–13.

46. *Littérature, Nouvelle série*, nos 11 and 12, 15 October 1923.

47. Edmond Jaloux, 'L'Esprit des livres', *Les Nouvelles Littéraires*, 21 March 1925.

48. This is particularly clear, and above all with respect to Apollinaire, in the single issue of *Surréalisme*, October 1924.

49. André Breton, 'Caràctère de l'évolution moderne et ce qui en participe', lecture given in Barcelona, 17 November 1922; in Breton (1924), op.cit., p.167.

50. Ibid, p.166.

51. André Breton, *Claire de terre*, Paris, 1923. The dedication reads: 'Au grand poète SAINT-POL-ROUX à ce qui comme lui s'offre LE MAGNIFIQUE plaisir de se faire oublier'.

52. Legge discusses this aspect of Freud's reception in

France; see Elizabeth Legge, *Conscious Sources of the Unconscious: Ernst's Use of Psychoanalytic Themes and Imagery, 1921–1924*, Dissertation submitted for the degree of Ph.D., Courtauld Institute, University of London, 1985, p.22.

53. Rowell, in Krauss and Rowell, *Magetic Fields* (1972), pp.50–3.

54. One other instance is worthy of comment here. Rowell convincingly relates *Portrait of Mme B*, 1924 (Dupin, *Miró* (1962), catalogue no.91) to Jarry's *Ubu Roi*, but goes so far as to see it as a literal illustration of its source in almost every respect. I do not dispute the connection, but an alien element is undoubtedly introduced by the fact that in the drawing for the work (Fundació no.601) the serpentine form, which Rowell identifies with the 'green candle' by which 'Père Ubu' swears, is indeed a serpent and not a candle at all. Again, Miró's use of his source is not literal but partial, though the references are more obvious and numerous here than is the rule.

55. C.f. Bonnet, *Breton* (1976), pp.176–7.

56. Louis Aragon (1981), op.cit., p.12

57. Max Ernst, 'Au delà de la peinture', *Cahiers d'Art*, II, nos 6–7, 1936; translated in *Beyond Painting*, edited by Robert Motherwell, New York, 1948. Ernst's conscious adapatation of his own life story to the themes of psychoanalysis is brilliantly discussed by Elizabeth Legge in *Jungian Influences on Ernst's Work of the 1920s*, Dissertation presented in partial fulfilment for the degree of M.A., Courtauld Institute, University of London, 1979, and in her later doctoral dissertation; see, Legge (1985), op.cit.

58. Legge follows through the possible relationships between Ernst's imagery and the Jung of *Symbols of Transformation* in her piece of 1979. She makes no secret of the difficulties here, but argues that Jung's influence on Ernst was central. Ibid.

59. According to Waldberg Ernst first read Freud as early as 1911 (*The Interpretation of Dreams*, *The Psychopathology of Everyday Life* and the *Introduction to Psychoanalysis*); see Patrick Waldberg, *Max Ernst*, Paris, 1958. Spies dates his reading of *The Interpretation of Dreams* and *Jokes in their Relation to the Unconscious* to 1913; Werner Spies, *Die Rückkehr de schönen Gärnerin*, Cologne, 1971, p.58.

60. She points out how effectively Ernst avoids symbols with obvious single meanings. The parts they play in complex wholes made up of inter-related symbols always open them to equally complex possible readings. See Legge (1985), op.cit.

61. Spies itemizes the *trouvaille* sources both for this image and for *Oedipus Rex*; see Spies, *Ernst-Collagen* (1974), pp.119–21, and Abb.570; and Spies (1982–3), op.cit., p.64. The point about lameness, foot-piercing and Oedipus is made by Jenckner; see Jenckner (1979), op.cit., p.29.

62. Sigmund Freud, *The Interpretation of Dreams*, London, 1977, pp.91, 533–4.

63. The story of Ernst as the Infant Jesus is told by the painter in 'Au delà de la peinture' (1936), loc.cit., Legge's dissertation (1985) provides a remarkable analysis of *Pietà* in terms of creams, the dream-work mechanism and the Oedipal theme. Gee offers a very interesting analysis, bringing in Freud's Schreber case; see Malcolm Gee, 'Max Ernst, God, and the revolution by night', *Arts*, 55, March 1981, pp.85–9.

64. For an analysis of this work which brings in both Freud (the Schreber case again) and alchemy, see Geoffrey Hinton, 'Les Hommes n'en sauront rien', *The Burlington Magazine*, London, May 1975, pp. 292–9.

65. Maurice Raynal, 'Peinture, sculpture', *L'Intransigeant*, Tuesday, 1 December 1925.

66. Looking back to 'l'An 1' of Surrealism, 1925, Masson writes: 'N'oublions pas l'ombre dans laquelle ont été laissés des oeuvres du passé qui par quelques côtés annonçaient le surréalisme contemporain. (Nous les regardons ensemble tout a l'heure.) Je pense aux inventions délirantes et narquoises de Jérome Bosch, aux "prisons" métaphysiques de Piranèse . . .' André Masson, Conférence, 1941; in *Masson, Ecrits* (1976), op.cit., p.22. C.f. Lanchner, in Rubin and Lanchner, *Masson* (1976), p.104. She specifies 'early in 1924'.

67. Masson writes: 'Et c'est tout naturellement que nous nous trouvons dans les années 1925–1926, admirateurs de Freud.' He recalls a copy of the *Introduction to Psychoanalysis* (translated into French in 1923) given pride of place alongside the popular novel *Fantômas* and *Les Chants de Maldoror* at the Bureau

de Recherches surréalistes. André Masson, 'Le Peintre et ses fantasmes', *Les Etudes philosophiques*, October– December 1956; in *Masson, Ecrits* (1976), op.cit., p.31; and Françoise Will-Levaillant's note, p.57.

68. *R.S.*, 15 October 1925, p.10.

69. André Breton, 'Le Surréalisme et la peinture', *R.S.*, 15 July 1925, p.30.

70. Again the complex inter-relation of images makes a simple univalent interpretation of symbols inadvisable.

71. Joan Miró, *Ceci est la couleur de mes rêves: Entretiens avec Georges Raillard*, Paris, 1977, p.64.

72. When recalling for Gaëton Picon the first drawing for *The Siesta*, Miró describes it just as if setting the scene for a story, itemizing every detail. See Gaëton Picon, Joan Miró, *Catalan Notebooks*, translated by Dinah Harrison, London, 1977, pp.73–4.

73. The idea began with a light pencil sketch of a woman either releasing or catching a bird; Fundació, no.748. In the same sketch-book opposite this initial drawing is a very closely related study for the painting; Fundació, no.749. When I saw the sketch-book, this had pinned to it a smaller sketch in pen for the picture which clearly showed how the female figure *became* the hand. These sheets are in a book whose sheets measure 19 × 14.8cm.

74. Arthur Rimbaud, 'Adieu', *Une Saison en enfer*, Brussels, 1873; in Rimbaud, *Poèsies, Une Saison en enfer, Illuminations*, Paris, 1965 and 1973, p.151.

75. Connections with Jarry are manifold. There are paintings which refer very specifically to Jarry's texts. Thus, Rowell has provided persuasive readings of the *Portrait of Mme B* in relation to the Ubu plays, and of *The Bill* in relation to *Le Surmâle*, though the connections are not as comprehensive as she suggests. See Krauss and Rowell, *Magnetic Fields* (1972), pp. 41–5, and my note 53, above.

76. Krauss and Rowell, *Magnetic Fields* (1972), pp.74–5.

77. See Breton (1924), op.cit., pp.69–72, 163–4.

78. Ibid, pp.109–11; the point is made by Rubin; see Rubin, in Rubin and Lanchner, *Masson* (1976), p.26.

79. Masson writes of Lautréamont: 'J'ai pris connaissance du météore en 1922. Le messager: c'était Roland Tual.' André Masson, 'Le roi fou a la couronne de flammes', *Les Cahiers du Sud*, January 1946; in *Masson, Ecrits* (1976), op.cit., p.67.

80. Paul Eluard, 'D. A. F. de Sade, écrivain fantastique et révolutionnaire', *R.S.*, 1 December 1926, p.8.

81. Legge makes a very convincing link between *Two Children menaced by a Nightingale* of 1924 and *Les Chants*; see Legge (1979), op.cit., pp.38–9.

82. Letter to Simone, dated 7 August 1920. Quoted in Bonnet, *Breton* (1975), p.230.

83. Louis Aragon (1924); in Aragon (1926), op.cit., pp. 51–2.

84. Bonnet, *Breton* (1975), pp.296–7.

85. Louis Aragon, 'Le Sentiment de la Nature aux Buttes-Chaumont'; in Aragon (1926), op.cit., pp.207–8.

86. Aragon (1924), loc.cit., p.36. Miró's *The Somersault*, 1924, in Dupin, *Miró* (1962), catalogue no.94.

87. Quoted in: André Breton, 'Le Surréalisme et la peinture', *R.S.*, 1 December 1926, pp.42–3.

88. C.f. Juan Gris, 'On the Possibilities of Painting', lecture delivered 15 May 1924; in Kahnweiler, *Gris* (1968–9), p.197.

89. Breton's involvement in hermeticism and alchemy went back further than 1923. He later claimed (in the *Entretiens*) to have known Eliphas Levi's *La Clef des Grands Mystères* since 1918.

90. C.f. Legge (1979), op.cit., pp.12–14 and 19–20; see also Hinton (1975), op.cit.

91. Lanchner, in Rubin and Lanchner, *Masson* (1976), p.85.

92. Quoted, ibid, p.102.

93. Appropriately, Breton's treatment of Masson in 'Le Surréalisme et la peinture', when it first appeared in *La Révolution Surrealiste*, was followed by a potted 'Vie de l'Héraclite' and an ambitious article on Heraclitus by Aragon, 'Philosophie des paratonnerres'. Aragon remarked that the only book in print in France devoted to Heraclitus at the time was Pierre Bise's *La Politique d'Héraclite*, published almost two years before; see *R.S.*, 1 October 1927, pp.43–54.

94. Dupin, *Miró* (1962), catalogue no.67.

95. Balakian refers to these accounts in her analysis of *Aurélia*; see Balakian (1965), op.cit., p.31.

96. Aragon, 'Le Sentiment de la Nature aux Buttes-Chaumont'; in Aragon (1926), op.cit., pp.229-30.

97. Rowell discusses blue in Miró and this work in

particular in: Krauss and Rowell, *Magnetic Fields* (1972), pp.60–1.

98. For Allard, see p.168, above.

99. André Breton, 'Mille et mille fois', *Claire de terre*, Paris, 1923; in Breton, *Clair de terre*, 'précéde de Mont de Piété, suivi de Le Revolver à cheveux blancs et de l'Air de l'eau', preface by Alain Jouffroy, Paris, 1966, p.80.

100. Ibid, p.63.

Chapter 19

1. Georges Ribemont-Dessaignes, 'Non-seul plaisir', *391*, no.11, February 1920, p.3.

2. Henri Barbusse quoted in: André Breton, 'Légitime Défense', *R.S.*, 1 December 1926, p,31.

3. Ibid, p.34.

4. The cover of *391* no.2, 10 February 1917 (Barcelona) carried a photograph of the inside of a grand-piano captioned 'Peigne'. Beneath was the injunction: 'Regarde de loin, ne regarde pas en arrière / on déraisonne / quand on veut toujours connaître les raisons.'

5. See p.27, above.

6. An intriguing interpretation is offered by Camfield; see Camfield, *Picabia* (1979), p.130.

7. André Breton, 'Pour Dada', *N.R.F.*, August 1920; in Breton, *Les Pas perdus*, Paris, 1924, p.193.

8. C.f. Camfield, *Picabia* (1979), p.193.

9. André Breton, 'Les Mots sans rides', *Littérature*, Nouvelle série, no.7, 1 December 1922; in Breton (1924), op.cit., p.138.

10. For another interpretation, see William A. Camfield, 'Volucelle', 1975, translated into French by Hubert Comte; in *Francis Picabia*, edited by Jean-Hubert Martin and Hélène Seckel, Galeries Nationales du Grand Palais, Paris, 1976, pp.114–17.

11. The two had after all been in close contact in the period leading up to and following their joint visit with Picabia's exhibition to Barcelona in November 1922, the period both of the *Optophone* paintings and *Volucelle II* and of 'Les Mots sans rides'.

12. Antonin Artaud, 'L'Activité du Bureau de Recherches Surréalistes', *R.S.*, 15 April 1925, p.31.

13. Albert Gleizes, 'L'Affaire Dada', *Action*, April 1920.

14. Georges Charensol, *D'Une Rive à l'autre*, Paris, 1973, pp.37–38.

15. C.f. Michel Sanouillet, *Dada à Paris*, Paris, 1965, pp.151ff.

16. *Le Matin*, 25 July 1920.

17. One could instance his letter to Monsieur H. R. Lenormand and his crucial article, 'Monsieur Picabia se sépare des Dadas'; *Comoedia*, 22 December 1920, and 11 May 1921.

18. *Journal d'Orient*, Galata-Constantinople, 14 May 1920.

19. Sanouillet gives a very useful chronology of the events leading up to the débâcle; see Sanouillet (1965), op.cit., pp.319–20.

20. Roger Vitrac, Interview with André Breton, *Le Journal du peuple*, 7 April 1923.

21. 'Un Journal', *Paris-Journal*, Friday, 6 October, 1922.

22. Kahnweiler on Gris: 'He had scruples of another sort; he wanted the appearance of his pictures to be as unobtrusive as possible; he wanted manifest simplicity. Very often he would say to me: "There's nothing monstrous about that violin is there?"' Kahnweiler, *Gris* (1968–9), p.134. Dermée touches on the same problem in his article on Lipchitz; see Paul Dermée, 'Lipchitz', *E.N.*, no.2, November 1920, pp.170–1.

23. 'Pour dépeindre le caractère fatal des choses modernes, la surprise est le ressort le plus moderne auquel on puisse avoir recours,' Guillaume Apollinaire, 'L'Esprit nouveau et les poètes', Lecture given 26 November 1917; in *Mercure de France*, 1918.

24. 'L'humour est une déformation de la poésie, en tant qu'elle établit un rapport surréel dans son complet développement.' Louis Aragon, 'L'Invention, l'ombre de l'inventeur', *R.S.*, 1 December 1924, p.23.

25. Louis Aragon, 'Le Sentiment de la Nature aux Buttes-Chaumont'; in *Le Paysan de Paris*, Paris, 1926, pp. 215–16.

26. André Breton, 'Les Chants de Maldoror', *N.R.F.*, 1 June 1920; in Breton (1924), op.cit., p.69.

27. These letters are dated 13 and 19 April 1919. They are quoted and discussed in Bonnet, *Breton* (1975), p.153.

28. Breton (1 June 1920); in Breton (1924), op.cit., p.70.

29. Louis Aragon, 'Le Passage de l'Opéra', 1924; in Aragon (1926), op.cit., p.81.
30. André Breton, 'Clairement', *Littérature, Nouvelle série*, no.4, 1 September 1922; in Breton (1924), op.cit., p.112.
31. See p.156, above.
32. Francis Picabia, *Jésus-Christ Rastaquouère*, 'Dessins par Ribemont-Dessaignes', Paris, 1920, p.36.
33. Sanouillet argues that Barrès was chosen because he represented the betrayal of all that Breton stood for, since he had argued in his youth for the overturning of convention and law in the interests of the imagination. See Sanouillet (1965), op.cit., p.256.
34. Breton, *Manifestes* (1972), p.60, footnote 1.
35. Aragon (1924), in Aragon (1926), op.cit., pp.82–3.
36. Louis Aragon, 'Libre à vous!', *R.S.*, 15 January 1925, pp.23–4.
37. *R.S.*, 1 December 1926, p.17.
38. Quoted in: Paul Eluard, 'D. A. F. de Sade, écrivain fantasque et révolutionnaire', *R.S.*, 1 December 1926, p.8.
39. Ibid, p.9.
40. André Breton, 'Le Surréalisme et la peinture', *R.S.*, 15 June 1926, pp.3–6.
41. In the Barcelona lecture, late in 1922, Breton still talked in terms of a 'révolution quelconque', and advocated a total liberation of the individual, re-establishing, as he put it: 'pour l'esprit, les lois de la Terreur'. See André Breton, 'Caractères de l'évolution moderne et ce qui en participe', Lecture delivered in Barcelona, 17 November 1922; in Breton (1924), op.cit., p.170.
42. Aragon (1924); in Aragon (1926), op.cit., pp.82–3.
43. Robert Desnos, 'Description d'une révolte prochaine', *R.S.*, 15 April 1925, pp.25–7.
44. See Maurice Nadeau, *The History of Surrealism*, translated by Richard Howard, London, 1968, pp.117–28.

45. 'La Révolution d'abord et toujours', *R.S.*, 16 October 1925, pp.31–2.
46. Pierre Naville, *La Révolution et les intellectuels (Que peuvent faire les Surréalistes?)*, Paris, 1926.
47. Breton (1 December 1926), op.cit., p.34.
48. Ibid, p.35.
49. Ibid.
50. See p.234, above.
51. Breton (1 December 1926), loc.cit., p.35.
52. Breton, *Manifestes* (1972), p.13.
53. Ibid, pp.23–4.
54. 'Alors je commençais de comprendre que j'avais encore devant moi un réalité honteux, comme sont aujourd'hui les hommes de bonne volonté, qui vivent sur un compromis entre Kant et Comte, qui ont cru faire un grand pas en rejetant l'idée vulgaire de la réalité pour lui préférer la réalité en soi, le nuomène, ce piètre plâtre démasqué. A ceux-ci rien ne fera entendre la vraie nature de réel, qu'il n'est qu'un rapport comme un autre que l'essence des choses n'est aucunement liée a leur réalité, qu'il y a d'autres rapports que de réel que l'esprit peut saisir, et qui sont aussi premiers, comme le hasard, l'illusion, la fantastique, le rêve. Ces diverses espèces sont réunies et conciliés dans un genre, qui est la surréalité.' Louis Aragon, *Une Vague de rêves*, Paris, 1924, pp. 12–13.
55. André Breton, 'Giorgio de Chirico'; in Breton (1924), op.cit., p.94.
56. Louis Aragon, 'Préface à une mythologicie moderne'; in Aragon (1926), op.cit., p.15.
57. Louis Aragon, 'Idées', *R.S.*, 15 April 1925, p.30.
58. Aragon (1924), op.cit., p.14.
59. This is clear enough in Aragon's treatment of the sources of Ernst's collages in 1923; see Louis Aragon, 'Max Ernst, Peintre des illusions', August 1923; in Louis Aragon, *Ecrits sur l'art moderne*, les écrits

d'Aragon sur l'art publiés sous la direction de Jean Ristat, Paris, 1981, pp.12–16. However, the notion of the 'lieu commun' and 'collage' are most clearly linked in Louis Aragon, 'Suicide'; in Jacques Baron, *L'An 1 du surréalisme*, Paris, 1969, p.83.
60. Quoted in Jenckner (1979), op.cit., p.51, footnote 65.
61. William Rubin, *Miró in the Collection of the Museum of Modern Art*, New York, 1973, p.16.
62. Guillaume Apollinaire, 'Les Collines'; in Apollinaire, *Calligrammes, poèmes de la paix et de la guerre (1913–1916)*, 1966, p.35.
63. André Breton, 'Guillaume Apollinaire', 1917; in Breton (1924), op.cit., p.26.
64. Breton, *Manifestes* (1912), p.37.
65. C.f. especially Breton, 'Giorgio de Chirico'; in Breton (1924), op.cit., p.94. His topic here is the 'mythical' in de Chirico's painting.
66. Aragon (1924); in Aragon (1926), op.cit., p.53.
67. Aragon, 'Le Sentiment de la Nature aux Buttes-Chaumont', ibid, p.144.
68. Ibid, p.144.
69. André Breton, 'Confession dédaigneuse', *La Vie Moderne*, 18 and 25 February, 4–11 and 18 March 1923; in Breton (1924), op.cit., pp.19–20.
70. Ibid, pp.101–3.
71. Aragon (1924); in Aragon (1926), op.cit., pp.126–30.
72. C.f. Bonnet, *Breton* (1975), p.241.
73. André Breton, 'Plutôt la vie', *Claire de terre*, Paris, 1923; in Breton, *Claire de terre*, 'précédé de Mont de Piété, suivi de la Revolver à cheveux blancs et de l'Air de l'eau', preface by Alain Jouffroy, Paris, 1966, p.72.

Index

Photographic Sources

Photographs have been supplied by and reproduced courtesy of the owners of works, with the exception of the following:

Jorg P. Anders, Berlin: 266
The Art Institute of Chicago: 68
Christies, London: 5, 235
The Courtauld Institute of Art, University of London: 42, 61, 69, 90, 104, 127, 129, 147, 172, 177, 194, 252, 262, 288
Lee Miller Archives: 253
Galerie Louise Leiris, Paris: 27, 36, 38, 98, 101, 102, 128, 154, 200, 228, 295, 296
Marlborough Fine Art (London) Ltd: 15, 43
Cliché: musées de la Ville de Paris © by SPADEM 1987: 55
The Museum of Modern Art, New York: 304
Galerie Simon, Paris: 274